OTHER A TO Z GUIDES FROM
THE SCARECROW PRESS, INC.

1. *The A to Z of Buddhism* by Charles S. Prebish, 2001.
2. *The A to Z of Catholicism* by William J. Collinge, 2001.
3. *The A to Z of Hinduism* by Bruce M. Sullivan, 2001.
4. *The A to Z of Islam* by Ludwig W. Adamec, 2002.
5. *The A to Z of Slavery & Abolition* by Martin A. Klein, 2002.
6. *Terrorism: Assassins to Zealots* by Sean Kendall Anderson and Stephen Sloan, 2003.
7. *The A to Z of the Korean War* by Paul M. Edwards, 2005.
8. *The A to Z of the Cold War* by Joseph Smith and Simon Davis, 2005.
9. *The A to Z of the Vietnam War* by Edwin E. Moise, 2005.
10. *The A to Z of Science Fiction Literature* by Brian Stableford, 2005.
11. *The A to Z of the Holocaust* by Jack R. Fischel, 2005.
12. *The A to Z of Washington, D.C.* by Robert Benedetto, Jane Donovan, and Kathleen DuVall, 2005.
13. *The A to Z of Taoism* by Julian F. Pas, 2006.
14. *The A to Z of the Renaissance* by Charles G. Nauert, 2006.
15. *The A to Z of Shinto* by Stuart D. B. Picken, 2006.
16. *The A to Z of Byzantium* by John H. Rosser, 2006.
17. *The A to Z of the Civil War* by Terry L. Jones, 2006.
18. *The A to Z of the Friends (Quakers)* by Margery Post Abbott, Mary Ellen Chijioke, Pink Dandelion, and John William Oliver Jr., 2006
19. *The A to Z of Feminism* by Janet K. Boles and Diane Long Hoeveler, 2006.
20. *The A to Z of New Religious Movements* by George D. Chryssides, 2006.
21. *The A to Z of Multinational Peacekeeping* by Terry M. Mays, 2006.
22. *The A to Z of Lutheranism* by Günther Gassmann with Duane H. Larson and Mark W. Oldenburg, 2007.
23. *The A to Z of the French Revolution* by Paul R. Hanson, 2007.
24. *The A to Z of the Persian Gulf War 1990–1991* by Clayton R. Newell, 2007.
25. *The A to Z of Revolutionary America* by Terry M. Mays, 2007.
26. *The A to Z of the Olympic Movement* by Bill Mallon with Ian Buchanan, 2007.

The A to Z of the Fashion Industry

Francesca Sterlacci
Joanne Arbuckle

The A to Z Guide Series, No. 96

THE SCARECROW PRESS, INC.
Lanham • Toronto • Plymouth, UK
2009

Published by Scarecrow Press, Inc.
A wholly owned subsidiary of
The Rowman & Littlefield Publishing Group, Inc.
4501 Forbes Boulevard, Suite 200, Lanham, Maryland 20706
http://www.scarecrowpress.com

Estover Road, Plymouth PL6 7PY, United Kingdom

British Library Cataloguing in Publication Information Available

Library of Congress Cataloging-in-Publication Data

The hardback version of this book was cataloged by the Library of Congress as
follows:

Sterlacci, Francesca.
 Historical dictionary of the fashion industry / Francesca Sterlacci, Joanne
Arbuckle.
 p. cm. — (Historical dictionaries of professions and industries)
 Includes bibliographical references.
 1. Clothing and dress—Dictionaries. 2. Clothing and dress—History—
Dictionaries. 3. Clothing trade—History—Dictionaries. I. Arbuckle, Joanne,
1954– . II. Title.
TT494.S84 2008
746.9'203–dc22—dc22 2007027938

ISBN 978-0-8108-6883-0 (pbk. : alk. paper)
ISBN 978-0-8108-7046-8 (ebook)

™ The paper used in this publication meets the minimum requirements of
American National Standard for Information Sciences—Permanence of Paper
for Printed Library Materials, ANSI/NISO Z39.48-1992.
Printed in the United States of America

Contents

Series Editor's Foreword

The subject of this volume is the "rag trade," as it is often affectionately and not at all disrespectfully called by those involved in it. Despite any image this term may evoke, fashion is one of the biggest businesses in the world, one that turns over hundreds of billions of dollars and employs tens of millions of workers. It is a profession, an industry, and, in the eyes of many, an art. This *Historical Dictionary of the Fashion Industry* approaches fashion from all three directions by presenting, among other things, talented designers and renowned houses of haute couture, mass merchandisers and more specialized sales outlets, numerous professional and technical production functions, inventions and innovations, and many other aspects that make this business intriguing, glamorous, and truly global in nature.

Fashion is one of the oldest industries in the world, as can readily be seen from the chronology, and it has grown out of rather simple beginnings to become one of the most dynamic and sophisticated of all industries, as detailed in the introduction. The dictionary provides hundreds of entries on items such as designers and models; apparel producers, ranging from elite couture houses to mass-market companies; significant articles of apparel and the most popular fabrics; the amazing variety of jobs offered by the sector; publications, trade unions, and international trade organizations; and current troubles like counterfeiting and pirating. While the focus remains on Europe and America, like the industry itself this book is also worldwide in its coverage, with information on countries with up-and-coming fashion industries. Many other useful details, such as on museums and fashion schools, are included in the appendixes, and the bibliography offers additional sources of information.

It would have been unfortunate if this book were written by only an academic or a practitioner, but, in an almost ideal situation, the authors combine both functions. Joanne Arbuckle and Francesca Sterlacci not

vii

only studied at the Fashion Institute of Technology in New York City, but they also taught there. In fact, Professor Arbuckle is presently the acting dean of the School of Art and Design at FIT. She has designed sportswear, intimate apparel, and childrenswear and continues consulting with the industry. Professor Sterlacci owned and operated her own clothing company and is an instructor at the Academy of Art University of San Francisco, Graduate Level. She has written extensively about the industry and is the author of *Leather Apparel Design*. Both authors are often quoted in the press and media.

Jon Woronoff
Series Editor

Preface

Fashion, according to any dictionary, is a word with many meanings. For the purposes of this book, the word *fashion* refers to men's, women's, and children's apparel and accessories, as well as the industries and professions that create them. Today, the fashion industry is a $320 billion global behemoth, employing millions of people worldwide. Products produced by this industry serve billions of people, all with different needs depending on their location, socioeconomic status, culture, and lifestyle.

From the first animal-skin body coverings to today's high-fashion collections, fashion has held an important role in the evolution of mankind and the industry has made major contributions to our cultural and social environment. It is an industry that responds to our inherent longing for tribal belonging, our socioeconomic needs, individual lifestyles, and status stratification and professional apparel requirements. The fashion industry is fast-paced, complex, and ever-changing in response to consumer needs. Throughout the world, vast numbers of people are employed and contribute to this industry, each with the shared goal of supplying an end product of a particular price point directed at a target consumer.

This book will trace the historical evolution of the fashion industry as well as the events, innovations, people, and companies that helped shape the fashion industry as we know it today. This text must be viewed as a work that will be ever-evolving and sensitive to changes within the industry and the world, and it offers a glimpse into the potential paths to be explored by the people who have yet to realize their passion—fashion.

ACKNOWLEDGMENTS

We would first like to thank our respective families for their constant support throughout this endeavor: Jeffrey, Colton, Thomas, and Robert. Their patience, understanding, and love have made this book possible.

A special thank-you to the series editor, Jon Woronoff, whose high standards and expertise proved invaluable. For her research assistance and editing, we would like to acknowledge Christine Welcher. We would also like to thank our colleagues at the Fashion Institute of Technology and the Academy of Art University San Francisco, whose input and extensive fashion industry experience have been invaluable. Each shared their own individual area of expertise within various segments of the fashion industry and provided useful research contacts. Thank you, Marc Jacobs, the Fashion Group International, Sean John, GIII Apparel Group, and the Museum at FIT, for supplying photographs of designers' work.

We owe our biggest debt, however, to the many people that we have encountered throughout our respective careers within the fashion industry—people such as our assistant designers, patternmakers, samplemakers, production managers, factories, sales reps, retailers, sales associates, fabric designers and suppliers, and the numerous others who we, as designers, count on in this industry. They have been and continue to be invaluable to the process and it is from our firsthand experience with them that we have learned so much. Their knowledge, guidance, and expertise continue to fuel our passion and desire to be a part of the most exciting industry in the world.

Acronyms and Abbreviations

AAFA	American Apparel & Footwear Association
AATCC	American Association of Textile Chemists and Colorists
AECQ	Quebec Clothing Contractors Association
AIM USA	Automatic Identification Manufacturers Association, Inc.
AMTAC	American Manufacturing Trade Action Coalition
ARTS	Association for Retail Technology Standards
ASTM	American Society for Testing and Materials
ATRC	Apparel Technology & Research Center
CAD	Computer-Aided Design
CAFTA	Central American Free Trade Agreement
CBO	Central Buying Office
CFDA	Council of Fashion Designers of America
CMPQ	Cut, Make, Pack, and Quota Sourcing
CMQ	Cut, Make, and Quota Sourcing
CMT	Cut, Make, and Trim
CPSC	Consumer Products Safety Commission
CRA	California Retailers Association
CRM	Customer Relations Management
DMM	Divisional Merchandise Manager
DNR	*Daily News Record*
EC	European Commission
EDI	Electronic Data Interchange
EPC	Electronic Product Code
ERP	Enterprise Resource Planning
ETA	Embroidery Trade Association
EU	European Union
EURATEX	European Apparel and Textile Organization
FBIA	Fashion & Beauty Internet Association
FFANY	Fashion Footwear Association of New York

FGI	Fashion Group International
FIT	Fashion Institute of Technology
FOB	Free-on-Board
GIDC	Garment Industry Development Corporation
IAC	Intimate Apparel Council
IFAI	International Fabrics Association International
ILGWU	International Ladies' Garment Workers' Union
IMRA	International Mass Retail Association
IRF	International Retail Federation
ISP	Institute of Store Planners
ITAA	International Textile and Apparel Association
ITGLWF	The International Textile, Garment & Leather Workers' Federation
ITMF	International Textile Manufacturers Federation
IWA	Wool Bureau
JIT	Just-in-Time
LDC	Less-Developed Countries
LIMA	International Licensing Industry Merchandisers' Association
MCA	Mohair Council of America
MM	Merchandise Manager
NACS	National Association of College Stores
NADI	National Association of Display Industries
NAFTA	North American Free Trade Agreement
NAICS	North American Industry Classification System
NARMS	National Association of Retail Merchandising Services
NASFM	National Association of Store Fixture Manufacturers
NAUMD	National Association of Uniform Manufacturers and Distributors
NCA	National Cleaners Association
NCTO	National Council of Textile Organizations
NIST	National Institute of Standards and Technology
NRF	National Retail Federation
NSGA	National Sporting Goods Association
NSRA	National Shoe Retailers Association
NTA	National Textile Association
OFC	Organic Fiber Council
OTA	Organic Trade Association

OTEXA	Office of Textiles and Apparel
PAA	Professional Apparel Association
PDM	Product Data Management
PDS	Pattern Design System
PFR	Planning, Forecasting, and Replenishment
PIA	Printing Industries of America Inc.
PLM	Product Lifecycle Management
POPAI	Point of Purchase Advertising Institute
RAMA	Retail Advertising & Marketing Association
RBO	Resident Buying Office
RFID	Radio Frequency Identification
RILA	Retail Industry Leaders of America
ROI	Return-on-Investment
RTV	Return-to-Vendor
RTW	Ready-to-Wear
SGIA	Screen Printing and Graphic Imaging Association
SGMA	Sporting Goods Manufacturers Association
SKU	Stock-Keeping Unit
SPESA	The Sewn Products Equipment Suppliers Association
TALA	Textile Association of Los Angeles
TCATA	Textile Care Allied Trades Association
TFA	The Fashion Association
TFBPA	Textile Fibers and By-Products Association
THA	The Hosiery Association
TITAS	Taipei Innovative Textile Application Show
TZMA	Taiwan Zippers Manufacturers Association
UNITE HERE	Union of Needletrades, Industrial and Textile Employees (UNITE) and Hotel Employees and Restaurant Employees International Union (HERE)
UPC	Universal Product Code
VCERP	Vendors Coalition for Equitable Retailer Practices
VICS	Voluntary Interindustry Commerce Standard
WWD	*Women's Wear Daily*
YMA	The Young Menswear Association

Chronology

50,000 BCE The first prehistoric human, Cro-Magnon man, learned to survive in cold climates by fashioning clothing out of animal skins, tree bark, and foliage. Paleolithic cave paintings such as those found in Lascaux, France, indicate that early man had learned how to fashion body coverings and headgear.

26,000–20,000 BCE A male skeleton, discovered in Northern Russia wearing highly decorated beaded garments, suggests people of this era had a preoccupation with fashionable clothing and the skills to create bone tools used to sew ornaments and skins.

3500–27 BCE Mesopotamia, the birthplace of Western civilization, influenced dress as evidenced in found objects such as statues, wall carvings, wall paintings, and jewelry. Discoveries from ancient civilizations suggest that the Akkadian, Assyrian, Babylonian, Sumerian (3500–612 BCE), and Persian (550–330 BCE) peoples had a mastery in the weaving of linen and wool and used clothing to express status. During the same period, the ancient Egyptians (3200–1070 BCE) used linen, and later cotton from India, to create garments that were pleated and woven into stripes and plaids. Queens, pharaohs, religious leaders, soldiers, and laborers adhered to specific dress codes with regard to the wearing of sandals, wigs, jewelry, cosmetics, headgear, and certain types of clothing designs. The Cretans and Mycenaean (2800–1100 BCE) are most known for their mastery at dyeing fabrics and skill in creating fitted garments that will eventually become precursors to the cut-and-sew tradition as we know it today. The early Greeks (1200–146 BCE), on the other hand, perfected the art of draping fabric, that is, letting the body create the three-dimensional form of the garment. Their contribution to the fashion world was to take square and rectangular pieces of fabric, then strategically drape them over the body to create inventions such as the

chiton, the *himation*, and the *kolobus*. These styles provided inspiration for designers throughout the ages. By forming the first known guilds, the Etruscans (750–200 BCE) contributed to the fashion industry with their expert craftsmanship and high-quality standards. They are especially known for their expertise in leather footwear and clothing and, although the early Romans (509–27 BCE) are credited with the invention of the toga, it was originally created by the Etruscans. The Chinese became masters of the wrap silhouette dating back to the Bronze Age with their highly skilled mastery of weaving, dyeing, and embroidery on hemp, cotton, and silk (worn by the upper class).

27 BCE–1204 CE During the first two centuries of the Roman Empire, peace prevailed and trade flourished. Emperor Constantine (305–337 CE) ended the persecution of Christians and created two capitals for the Roman Empire: Rome was based in the west and the Greek city of Byzantium, renamed Constantinople, was in the east. The Byzantine Empire (330–1204 CE), with its proximity to the rich textiles of Asia via the Silk Route and links to Western Europe, prospered for the next twelve centuries and became a major cultural inspiration for the emergence of the Italian Renaissance. In Western Europe, during the period known as the Dark Ages (400–900 CE), royalty depended on fashion from Byzantium, while in China, during the Tang Dynasty (618–907 CE), Chinese elite were influenced by Western fashion. Once Genghis Ghan conquered China during the Yuan Dynasty (1279–1368 CE), both China and Japan were heavily influenced by Mongolian dress.

1300s–1600s As the feudal system (in the eleventh and twelfth centuries) gave rise to status dressing in Western Europe, the Byzantine Empire continued to influence fashionable dress, spreading to Western European nobility, especially during the Middle Ages. As technological advances in weaving and textile processing took place and as guilds formed to preserve quality standards, the first evidence of fashion as a business emerged. Most historians agree that the origin of fashion trends started in the Middle Ages, a time when social and economic changes created a demand for fashionable goods. Later, when Marco Polo opened the trade route to the Far East in the 1300s, European royals established themselves as arbiters of fashion and they shifted away from the Gothic style of dressing to that of the Italian Renaissance. During the Renaissance (fourteenth and fifteenth centuries), especially

the first 60 years of the 1400s, Burgundy and Italy were considered major centers of fashion. Nobility in England, France, and Germany also set the tone for fashionable dress, as well as for etiquette and taste. Fashion trends moved from country to country either by marriage or by travel. Queens, namely Isabella of Spain (1474–1504), Catherine de Medici of France (1547–1559), and Elizabeth I of England (Elizabethan Period/1558–1603), were the fashionable role models of their time, as were the kings, including Francis I of France (1494–1547) and Henry VIII of England (1491–1547). Commoners worked to adapt and modify royal style into their own wardrobes. Beginning with the new Manchurian rulers of the Qing Dynasty (1644–1911), Manchu dress was introduced to the Chinese and the rest of the world.

During the 1600s, governments tried to regulate who wore what—in fact, Charles I of England tried with his sumptuary law of 1643, which was later canceled after his execution in 1648. Other rulers tried to ban the wearing of another country's styles, as national pride was closely tied to national fashion in countries such as Spain, France, and the Netherlands.

1600s European countries including England, France, and Italy took turns dominating the fashion scene; however, after Christopher Columbus landed in America in 1492, Spanish fashion prevailed. When the Puritans arrived in America from England in 1620, they opted for less ornate styles than those of their European contemporaries. Even though keeping current with European trends was slower due to distance, British and French fashion still prospered among the more affluent families. As the number of cotton producing colonies increased in the New World, textile production made fabric more affordable. Trade between countries flourished, creating a demand for fashionable clothing. The fashion plate (a drawing of the latest fashions) and the use of life-size wax dolls and miniature dolls dressed in new styles were instrumental in circulating and promoting fashion concepts in the courts throughout Europe and to the masses. The first French fashion magazine, *Mercure Galant*, published in 1672, helped promote French fashion throughout Europe and the New World. While American fashion at the time was heavily influenced by Europe, adaptations emerged in response to lifestyle differences and cultural influences. In the 1600s, the United States initiated its first population census, which began the process of tracking socioeconomic trends as people immigrated from all parts of Europe and Africa.

1700s The eighteenth century, known as the time of the Enlightenment, experienced tremendous growth in the applied arts both in Europe and in the United States, especially in the last quarter. Many discoveries made in the areas of science, archaeology, and medicine paved the way for the industrial and commercial revolution. Due to patronage of kings and nobles, the applied arts flourished. Beginning with King Louis XIV and later King Louis XVI and his wife Marie Antoinette (1774–1792), the arts were especially instrumental in promoting French fashion and textiles. In England, the cottage industry took off as the growing population of merchant capitalists bought the textiles and clothing that were produced in the home. Guilds, located in the cities, produced luxury goods for the rich. British technological advances sped up production and changed the face of fashion production. With the invention of the flying shuttle for textile handlooms and the steam engine, and their application to numerous power machines, productivity increased. England's relationship with the United States and its rich resources placed it in a position of world power. By the end of this century, England became the leader for male fashion throughout Europe. The French continued their dominance in womenswear, although it was curtailed a bit at the end of the century, namely as a result of the political events in the later part including the French and American Revolutions.

1767 James Hargreaves (British) invented the spinning jenny in England.

1768 William Lee's (British) original knitting machine was adapted and improved and the first power knitting machines were created in Nottingham, England.

1769 James Watts (British) patented his vastly improved steam engine, based on Thomas Newcomen's engine.

1770 *The Lady's Magazine* published its first fashion edition in England. Publications such as this kept men and women current on new fashion trends.

1774 Marie Antoinette was crowned the Queen of France and together with her husband King Louis XVI, actively promoted French fashion and textiles. Rose Bertin (French), the first widely celebrated fashion designer, designed clothing for the queen and numerous other noble ladies.

1785 With the invention of the first steam engine came the first steam-driven power loom by James Watts. Thus, the weaving of yarn into fabric on automated looms allowed for an increase in textile production.

1793 Eli Whitney (American) invented the cotton gin, a machine that automates the processing of cotton.

1794–1803 Nicholaus von Heideloff (German) launched an exclusive fashion periodical called *The Gallery of Fashion* in London.

1800s In England, during the reign of King George IV (1820–1830), the impeccably dressed George Bryan (Beau) Brummell helped to establish England as the center for men's fashion. Publications and newspapers that communicated the latest in contemporary fashion included *La Belle Assemblee* and *Godey's Lady's Book* in the United States and *Ackerman's Repository of the Arts* in England.

1804 Napoleon Bonaparte, emperor of France, and his wife, Empress Josephine, influenced contemporary French fashion during their ten-year reign. Joseph Marie Jacquard (French) invented a loom attachment (a textile-weaving attachment) that made it possible to weave complex patterns in cloth.

1810 The U.S. government expanded its census to include statistics on manufacturing, quantity, and value of products in addition to counting people.

1818 Brooks Brothers (American) produced handmade ready-to-wear men's suits for mass consumption.

1820 Joseph Courts (American) introduced a flexible method of determining body measurements—the tape measure.

1823 Charles Macintosh (Scotland) patented the first waterproof textile and named it India rubber cloth; the first raincoat made of this material was known as a Macintosh.

1825 The first all-female strike of seamstresses occurred in New York City; they protested wages and working conditions.

1830 Barthélemy Thimmonier (French) invented a chain-stitch sewing machine to make uniforms for the French army. It was later destroyed when French tailors feared losing work.

1837 Queen Victoria (British) took the throne and introduced the Victorian Era in fashion. The New York City garment center was born, producing $2.5 million worth of ready-to-wear clothing.

1846 Charles Frederick Worth (British) began to work at the dress-making firm of Gagelin et Opigez in Paris. Elias Howe (American) patented the foot-peddle lockstitch sewing machine after perfecting ideas from various sources. This invention kept the hands free thereby streamlining production time.

1849 The safety pin was invented by Walter Hunt (American). Levi Strauss (American) manufactured and sold pants made of a cotton fabric from France called *serge de Nimes* (later called *denim*) in his dry goods store in San Francisco, where he catered to thousands of men who traveled West during the Gold Rush. Harrods's of London began as a small grocery store but, by 1880, became Europe's largest department store.

1850 A total of 4,278 clothing manufacturers existed in the United States.

1851 Isaac Singer (American) perfected and patented his lock-stitch sewing machine, originally invented by Walter Hunt. By 1853, Singer was embroiled in a patent infringement battle with Hunt and Elias Howe, resulting in the first patent pool. By 1869, Singer mass-producined these machines at a thousand machines per day.

1853 Ellen Curtis founded Mme. Demorest, the first commercial pattern company.

1855 Swiss chemist George Audemars created the fiber known as rayon.

1856 Thomas Burberry (British), inventor of the trench coat, established a shop known as Burberry Outfitters in Basingstoke, England. Charles Frederick Worth opened the first haute couture house in Paris. He was considered the father of couture among his contemporaries, which included the Callot Sisters (French), Jacques Doucet (French), Jeanne Lanvin (French), and Jeanne Paquin (French). Paris remained the hub of international fashion for the next one hundred years.

1857 Pantalets became the choice of dress in children's clothing. They later gave rise to traditional children's trousers as we know them today.

1858 Rowland H. Macy (American) opened R. H. Macy's dry goods store in New York City. By 1924, the Herald Square location was the largest store in the world and ten thousand people watched the first Macy's Thanksgiving Day parade.

1863 Butterick Pattern Co. (American) patented size specifications for women.

1867 *Harper's Bazaar* magazine (American) was first published in New York and Paris.

1868 The Chambre Syndicale des Courturiers et des Confectionneurs, much like a traditional guild, was founded in Paris. Meanwhile, the rubber-soled shoe known today as the sneaker was born, becoming the preferred shoe of choice for aristocratic lawn games.

1869 The German chemist Eugen Bauman created polyvinyl chloride (PVC), but it was patented in 1913 by Fredrich Heinrich August Klatte (German).

1872 Aaron Montgomery Ward (American) created the first mail-order business selling home goods to people living in rural areas. His "satisfaction guaranteed or your money back" policy proved to be the key to his success.

1873 Davinsin Jacob created the first pair of jeans in Nevada. He and Levi Strauss joined to patent the first copper-riveted waist overalls garment.

1876 Messrs. Bradley, Voorhees, and Day (American) of Chicago formed their men's and women's underwear company called BVD.

1877 The May Company department store opened in Leadville, Colorado, by David May.

1880–1890 Designers and manufacturers created the concepts of *standardized sizing* and *separates* to satisfy the ever-increasing clothing needs of the Industrial Revolution's growing middle class. Also during this period, women became actively engaged in sports. The innovation of pants and sportswear was a departure from formality in women's dress and lead to a more casual trend in clothing design.

1881 Moses and Endel Phillips sold their handmade shirts to Pennsylvania coal miners from a pushcart until their son, Seymour, partnered

with John M. Van Heusen in 1919. Together they formed the Phillips-Van Heusen Corporation (PVH). By the twenty-first century, PVH had become one of the largest retailers and manufacturers in the world. Elsewhere, the Rational Dress Society was founded in London in protest of styles that deformed women's bodies. Its mission brought about dress reform.

1884 The U.S. Congress established the U.S. Department of Labor, responsible for occupational safety, wage and hour standards, unemployment insurance benefits, reemployment services, and gathering economic statistics.

1885 The first worker safety laws to protect "hatters" were passed, since these millinery workers used harmful chemicals in the making of hats.

1888 Thomas Burberry patented his invention—gabardine fabric.

1889 Isaac Merritt Singer invented the electric sewing machine.

1890 This year marked the era known in France as *La Belle Époque* that lasted until the advent of World War I in 1914. It was also known as a time of luxury and beautiful dress.

1891 Designer Jeanne Paquin and her husband, Isidore, opened the House of Paquin in Paris.

1892 *Vogue* was founded in New York as a weekly fashion publication.

1893 Richard Sears and Alvah Roebuck (American) formed Sears, Roebuck and Company, a mail-order catalog business that, by 1895, included 507 pages of clothing and household goods.

1893 Galeries Lafayette was founded by Theopile Bader and Alphonse Kahn (French) as a haberdashery store in Paris.

1895 The Austrian David Swarovski patented his crystal-cutting machine and, together with his brother-in-law, founded the crystal company Swarovski. Elsewhere, Joseph William Foster (British) created a handmade running shoe that was the precursor to the formation of the sport shoe company Reebok.

1898 Madame Lemarie (French) opened Lemarie House, a supplier of feathers to haute couture houses such as Balenciaga, Yves Saint

Laurent, and Givenchy. Also, the American Section of the International Association of Testing & Materials was founded but later changed its name to the American Society for Testing and Materials (ASTM).

1899 Sebastian S. Kresge (American) opened S. S. Kresge in Detroit, Michigan, the precursor to Kmart. John Barbey opened the Reading Glove and Mitten Manufacturing Company in Pennsylvania, which later became the VF Corporation, the largest American apparel company.

1900 The International Ladies' Garment Workers' Union (ILGWU) was formed in the United States as a reaction to appalling working conditions in garment factories known as sweatshops.

1901 John W. Nordstrom and Carl Wallin (American) founded a shoe store named Wallin & Nordstrom, which later became the department store Nordstrom.

1903 Frenchmen Paul Poiret opened his own couture house in Paris.

1904 Louis-Francois Cartier (French) invented the wristwatch.

1906 The newly invented electric washing machine was offered for sale. Also, Herman Bergdorf (American) opened a retail establishment that was subsequently purchased by Edwin Goodman and called Bergdorf Goodman.

1907 James Cash Penney (American) bought out his partners in the Golden Rule Store and, in 1912, forms J. C. Penney's, selling lower-priced merchandise in areas other than big cities. By the 1920s, Penney had opened chain stores throughout the country. Meanwhile, Madeleine Vionnet became the designer for the house of Doucet. Inspired by American dancer Isadora Duncan and her braless, barefooted performance, Vionnet created a collection of *déshabillé*—lingerie-inspired dresses presented on braless, barefooted models—and was the first designer to liberate women from the corset.

1908 Marquis M. Converse (American) founded Converse, an athletic shoe company. Elsewhere, BVD created men's two-piece underwear known as the union suit.

1909 Mariano Fortuny (Italian) registered a heat-pleating device to create unique dresses such as the Delphos. The newly formed International Ladies' Garment Workers' Union (ILGWU) conducted a strike

among twenty thousand shirtwaist makers in the United States known as the Big Strike.

1910 French designer Paul Poiret created the tango skirt. The skirt itself, styled to accommodate the movement of the dance, became a legend. Interestingly, he is also credited with liberating women from the corset, even though designer Madeleine Vionnet had done so two years earlier. Coco Chanel (French) opened her millinery shop in Paris. The U.S. Census Bureau became a permanent institution by an act of Congress. *Women's Wear Daily*, the first fashion industry trade paper, was published. Fiber acetate was invented but only becomes commercially popular in 1924. Alexander MacRae opened a hosiery factory on Bondi Beach, Australia, which later became the company Speedo. A strike in the United States by sixty thousand cloak makers, known as the Great Revolt, ended in a settlement known as the Protocol of Peace. Workers were granted a fifty-hour workweek, double pay for overtime, and higher wages and the *closed shop* concept was established, whereby employers could hire only union employees.

1911 Production began on the first waist overalls by Lee Mercantile (American). A fire at the Triangle Shirtwaist Factory in New York City killed 146 workers and led to the first workplace health and safety laws in the United States. Beginning in the seventeenth century, imports from China, Turkey, and India inspired designers and was known as Orientalism. The Chinese Revolution and the fall of the last imperial dynasty in 1911 had a major impact on dress not only in China but in the world at large.

1912 The company L.L. Bean (American) was founded and it introduced the Maine Hunting Boot. Frenchwoman Madeleine Vionnet opened her own house on rue de Rivoli.

1913 Italian designer Mario Prada opened his leather goods business—Prada. Coco Chanel showed her first clothing collection in Paris. Gideon Sunback, a Swedish-born Canadian immigrant, devised the concept of interlocking teeth called the "hookless fastener," later named the zipper.

1914 The men's garment workers union became the Amalgamated Clothing Workers of America. Mary Jacobs (American) patented the first bra.

1916 Stanford Mail Order marketed the first rubber girdle.

1918 U.S. Rubber introduced Keds sneakers.

1919 The International Chamber of Commerce was formed in Paris to promote world business.

1921 Coco Chanel opened her fashion house in Paris and created Chanel No. 5 fragrance.

1922 The House of Lesage opened its embroidery business catering to Parisian couture houses.

1923 L'Association pour la Défense des Arts Plastiques et Appliqués, an anticopyist society for haute couture, was founded in Paris.

1925 Virginia Pope (American) became the first well-known fashion journalist for the *New York Times*.

1926 Waldo S. Semon (American) discovered vinyl, a plasticized variation of polyvinyl chloride (PVC).

1927 Rene Lacoste (French) popularized the Lacoste shirt with its iconic alligator appliqué—which is technically a crocodile, Rene's nickname. France grants the United States most-favored-nation status whereby tariffs into France were eliminated in return for copyright protection for haute couture. However, this did not stop copyists from stalking French fashion houses.

1928 American designer Elizabeth Hawes opened her business in New York and retailer Lord & Taylor promoted her as an American talent. The Société des Auteurs de la Mode, an anticopyist organization, was founded in Paris with subsidiaries in several European countries.

1929 The American-born Main Rousseau Bocher (Mainbocher) opened his house in Paris.

1930 A group of women founded the nonprofit organization Fashion Group International to increase awareness of American fashion and women's role in that industry.

1931 A French organization known as the Protection Artistique des Industries Saisoniers (P.A.I.S.) was formed and headed by Armand Trouyet, a member of the fashion house Vionnet et Cie. B. S. Tanner

founded Doncaster, a direct-sales clothing company, in the United States. Licensed children's wear apparel emerged as a design avenue to draw attention away from the poor quality of affordable fabrics. The men's fashion quarterly *Apparel Arts* first published and later becomes *GQ* magazine.

1932 Dorothy Shaver (American), of Lord & Taylor, established a program known as the American Look to promote American fashion designers. Elsewhere, *Vogue* magazine launched Vogue Patterns, a paper pattern company.

1933 Arnold Gingrich (American) established the men's fashion magazine *Esquire*.

1934 Samuel T. Coopers patented the men's jockey short, eliminating the need for a jockstrap to be worn with underwear. The pantie girdle revolutionized the women's underwear market. Carmel White Snow was named editor-in-chief of *Harper's Bazaar* magazine.

1935 Frenchwoman Pauline Trigère reopened her clothing business in New York. DuPont scientists Gerald Berchet and Wallace Carothers (American) invented nylon, the first commercial petroleum-based synthetic fiber.

1937 Designer Charles James (American) showed his collection in Paris, the first highly respected American to do so.

1938 The Fair Labor Act was signed into law in the Unites States, which protected workers from low wages, overtime abuses, and unsafe working conditions.

1939 Southern textile workers formed the Textile Workers Union of America (TWUA). The commercial production of nylon stockings began.

1940 Claire McCardell (American), known as the innovator of casual American sportswear, designed a denim wrap dress called the popover. Meanwhile, the new nylon stockings on the market replaced silk stockings in popularity.

1941 The American Society for Testing and Materials (ASTM) issued body-sizing standards. Polyester was invented by two British chemists, John Rex Whinfield and James Tennant Dickson. However, it was only introduced as a miracle fabric in the United States a decade later, in 1951.

1942 The Cooperativa de Alta Costura was founded in Barcelona.

1943 Jules Leotard (French) pioneered the one-piece garment known as the leotard.

1945 American Dorothy Shaver was named president of the Lord & Taylor department store. *Elle*, a French weekly fashion publication, was founded in Paris. Dr. Klaus Maertens (German) creates the Dr. Martens boot in Germany. Fairchild Publications launched *Footwear News*, a weekly newspaper dedicated to the shoe trade. Sam Walton (American) opened his department store, later to become Wal-Mart.

1946 Louis Reard (French) designed the bikini bathing suit in Paris.

1947 The General Agreement on Tariffs and Trade (GATT) was signed. Christian Dior (French) showed his first collection and pioneered the New Look. American Eugenia Sheppard was named the *New York Herald Tribune*'s fashion editor and created journalistic fashion history in her time.

1949 The Communist Revolution ended the wearing of the traditional qipao for Chinese women. The Mao suit for men replaced the cheongsam (a long dress with Mandarin collar), which is the male equivalent of the qipao.

1950 The Italian designer Salvatore Ferragamo introduced stiletto heels. The Italian designer Emilio Pucci opened his store on the island of Capri.

1951 BVD revolutionized the sale of underwear by packaging them in polybags. The Italian Couture Collective was formed in Rome.

1953 Designer Pierre Cardin (French) showed his first collection in Paris. Men's polyester suits entered the market. The French designer Sonia Rykiel began designing maternity wear for her husband's shop in Paris.

1954 The Association of Canadian Couturiers was formed.

1955 Mary Quant (British), her husband, and their accountant, Alexander Plunket Greene, opened a hip, mod shop on Kings Road called Bazaar.

1956 Sparked by the Hollywood film, *Baby Doll*, pajamas became the staple of the lingerie market. New machinery helped to press, fold, and package soft goods in one operation.

1957 Cristòbal Balenciaga introduced the sack based on Norman Norell's (American) chemise. Yves Saint Laurent (French) was named the successor to the house of Dior upon the death of Christian Dior.

1958 Yves Saint Laurent created the dress shape known as the trapeze silhouette.

1960 Dior focused on designing nuns' outfits in France; the New York department store Bergdorf Goodman carried the line of habits. Designer Mary Quant trademarked the miniskirt.

1961 Frenchman Yves Saint Laurent opened his couture house in Paris.

1962 Some of America's foremost fashion and accessories designers founded the Council of Fashion Designers of America (CFDA), a nonprofit trade organization. Its most notable founding members included Bill Blass, Rudi Gernreich, Norman Norell, Arnold Scaasi, and Pauline Trigere. S.S. Kresge Company opened the first Kmart store in a Detroit suburb. The first Wal-Mart store opened in Rogers, Arkansas, by Sam Walton. The Hood Shoe Company (American) created the sneaker known as the PF Flyer. American designer Arnold Scaasi opened his couture collection. The Dayton Corporation entered the discount merchandising business with its first Target store in Minneapolis.

1963 François Pinault (French) founded a timber trading company known as the Pinault Group. After a series of mergers and acquisitions, namely with French department store Au Printemps SA and mail-order house La Redoute, it later became a leading luxury goods conglomerate known as Pinault Printemps-Redoute. American designer Geoffrey Beene opened his company in New York. Diana Vreeland (American) was named editor-in-chief of *Vogue* magazine.

1964 Rudi Gernreich introduced the topless bathing suit, named the monokini.

1965 Designer Norman Norell became the first president of the Council of Fashion Designers of America (CFDA).

1966 André Courrèges (French) introduced the high white boot that became the inspiration for the go-go boot craze.

1967 Ralph Lauren (American) designed ties and established the Polo brand of neckwear.

1968 Halston (American) presented his first collection under his own label in New York. Also in New York, Calvin Klein (American) opened his business with Barry Schwartz. Joseph Gerber (American) invented the first automated cutting machine, which revolutionized the apparel industry worldwide. He later went on to create one of the largest garment technology companies that provided product lifecycle management (PLM), computer-aided design (CAD), and computer-aided manufacturing (CAM) solutions to manufacturers and retailers in the sewn and flexible goods industries.

1969 Tommy Hilfiger (American) opened his first retail store in Elmira, New York.

1970 Kenzo was the first Japanese ready-to-wear designer to establish himself in Paris. Cotton Incorporated was formed. American designer Bill Blass opened his eponymous company in New York. Also this year, the midi-skirt is introduced. The length ranged anywhere between the knee and the ankle. Roy Raymond (American) established his lingerie shop, Victoria's Secret, in San Francisco.

1971 British designer Vivienne Westwood began designing for Malcolm McClaren's punk shop Let It Rock, in London. Grace Mirabella (American) became editor of American *Vogue* magazine. Fairchild Publications published *W* magazine, a monthly offshoot of *WWD*. Yves Saint Laurent created the peasant dress, a gypsy-inspired soft dress with gathering and loose fit. Pantsuit mania began in the United States.

1972 Hanes introduced their L'eggs stockings.

1973 Manolo Blahnik (Spanish) entered the shoe business and, by 1978, was designing his own footwear collection. The Fédération Française de la Couture, du Prêt-à-Porter des Couturiers et des Créateurs de Mode was formed in France. Issey Miyake was the first Japanese designer to be asked to show his collection at the prêt-à-porter in Paris. Diane Von Furstenberg created her famous wrap dress. French engineers Jean and Bernard Etcheparre founded the company Lectra and, in 1976, they launched their first apparel patternmaking and grading system.

1974 Italian jewelry designer Elsa Peretti partnered with Tiffany & Co.

1975 Mary McFadden (American) patented a unique silk pleating technique, Mari, and opened her own clothing company the following year. Ron Chereskin (American) received recognition as a designer of disco wear. Designer Karl Lagerfeld (German) formed his own company in Paris.

1976 Fruit of the Loom Ltd. bought underwear brand BVD; this year also marked the beginning of high-leg cut bathing suits by Norma Kamali (American) and Calvin Klein. The U.S. fashion giant Liz Claiborne Company was launched. Geoffrey Beene was the first American designer to show his collection in Milan. The Amalgamated Clothing Workers of America (ACWA) and the Textile Workers Union of America (TWUA) merged to form the Amalgamated Clothing and Textile Workers Union (ACTWU). The American designer Willi Smith, one of the first African American designers, opened WilliWear Ltd. Meanwhile, Diego Della Valle (Italian) created his iconic Driving Shoe for Tod's S.p.A.

1978 Gianni Versace (Italian) opened his own company, Versace Atelier Collection. American actress Diane Keaton inspired the Annie Hall look from the movie of the same name.

1979 The American businessman Paul Fireman negotiated the license for Reebok sport shoes and turned the company into a million-dollar business. Sara Lee Branded Apparel bought Hanes. Gloria Vanderbilt (American) lended her name to a line of jeans for Murjani.

1981 The first regional home-shopping cable television show, *The Home Shopping Club*, was created by Lowell "Bud" Paxon and Roy Speer in Tampa, Florida, and went national in 1986 as the Home Shopping Network. The Guess Company launched its jeans line in New York. The Tailored Clothing Technology Corporation, a bodyscanning technology firm known as [TC]2, was founded out of a concept generated by John T. Dunlop and Fred Abernathy of Harvard University.

1982 Legwarmers were a thriving fashion statement this year. Inspired by dancers and their need to keep their leg muscles warm, women everywhere sported these knitted cylinder-shaped leg covers that went from the thigh down to the ankle or arch of the foot. Meanwhile, Cyberware created a 3-D bodyscanning device in the United States.

1983 Karl Lagerfeld took charge of design responsibilities at Chanel. The Swatch Watch became a popular fashion accessory. Calvin Klein revolutionized the women's underwear market with gender benders. Sam Walton opened the first Sam's Club in Oklahoma. The British Fashion Council (BFC) was formed.

1984 Designer Donna Karan (American) opened her own company in New York.

1985 The vector-based illustration software Adobe Illustrator was invented. The Home Shopping Network show began to air nationwide.

1986 QVC was founded by Joseph Segal (American) as a home-shopping network; QVC is an acronym for Quality, Value, Convenience. Marc Jacobs (American) presented his first collection in New York. Nicole Miller (American) opened her first store in New York City. A group of Belgian designers showed their collection in London and were known as the Antwerp Six.

1987 The French fashion luxury goods conglomerate Moët Hennessey Louis Vuitton (LVMH) was formed between the Louis Vuitton SA holding company and the Moët Hennessey Christian Dior Group.

1988 Nike rolled out its Just Do It ad campaign to promote the brand. Anna Wintour (British/American) was named editor of *Vogue* magazine. The CAD/CAM computer software brand known as PAD System was founded. Bicycle attire including caps, shorts, and messenger pouches (later named fanny pacs) entered the market.

1989 Donna Karan opened her bridge sportswear collection, DKNY. Gianni Versace launched his company in Italy.

1990s This decade was most known for fashion minimalism and the age of the supermodel. The mass marketing of mass-produced clothing, together with the logo craze, catapulted fashion into a commodity business. Belgian designers Ann Demuelemeister and Dries Van Noten made an impact on fashion with their inventive and innovative clothing and the Wonderbra became a staple of women's undergarments.

1990 Vera Wang (American) opened her bridal boutique on Madison Avenue. Steve Madden (American) opened his trendy shoe store in New York's SoHo neighborhood. Dayton Hudson Corporation opened

the first Target Greatland store in Minneapolis, Minnesota. The Bonwit Teller department store closed, which indicated change for the retail community. The American Tom Ford was hired as creative director at Gucci. Thomas and John Knoll invented Photoshop, the graphics-editing software published by Adobe Systems.

1992 A new public company, Federated Department Stores, was formed, consisting of 220 department stores in 26 states. Stan Herman (American) was named president of the Council of Fashion Designers of America (CFDA). American rap mogul Russell Simmons launched Phat Farm, a young men's, hip-hop clothing line.

1993 Lacoste and Izod ended their affiliation and Lacoste marketed itself in the United States. American designer Kate Spade and her husband, Andy, opened a handbag company, Kate Spade, in New York. Richard Tyler (American) was hired to design the Anne Klein collection. Designer Oscar de la Renta took over as designer at the house of Balmain. The Treaty of European Union (Maastricht Treaty) was ratified, which created the EU confederation of nations. David Chu (American) opened his menswear company, Nautica, in New York. Chanel purchased Lemarie House, supplier of fine feathers to couture houses.

1994 The e-commerce mode of shopping was born with websites launched by Amazon and J. C. Penney's. The Wonderbra Push Up Bra was sold in the United States. Mark Simpson (American) coined the word *metrosexual*. The North America Free Trade Agreement (NAFTA) went into effect.

1995 The World Trade Organization (WTO) was formed as the successor to GATT. Stella McCartney (British) landed a design position at Chloé upon graduating from fashion school. The designer John Galliano (British) was hired to design at Givenchy. UNITE, a fashion industry trade union, was formed out of the International Ladies' Garment Workers' Union (ILGWU), the Amalgamated Clothing Workers of America (ACWA), and the Textile Workers Union of America (TWUA). The Dayton Hudson Corporation opens the first Target Superstore in Omaha, Nebraska.

1996 Emanuel Ungaro sold his company to Salvatore Ferragamo Italia SpA. John Galliano (British) was hired as creative director at the house of Dior.

1997 Gianni Versace was murdered and his sister Donatella took over as creative director. Jean Paul Gaultier (French) made his haute couture debut in Paris. Ilona Foyer (American) started her custom-made dressform company called Shapely Shadows, Inc., using 3-D bodyscanning technology. The North American Industry Classification System (NA-ICS) replaced the Standard Industrial Classification System (SICS). Diane Von Furstenberg reopened her clothing company.

1998 Marc Jacobs became artistic director at Louis Vuitton. Patricia Field (American) was hired as the costume designer for the TV series *Sex and the City*. After having been in development for more than a decade, the first commercial bodyscanning system was introduced by [TC][2]. Rapper Sean Puffy Combs (American) launched his hip-hop urban clothing line called Sean John.

1999 Issey Miyake created A-POC (A Piece of Cloth), a concept whereby clothes are made out of a single piece of cloth. The Council of Latin American Designers was formed. Yves Saint Laurent's ready-to-wear company was sold to Frenchman Francois Pinault. Peter Som (American), one of the new Asian wave of designers, presented his first collection in New York.

2000 Innovations in textiles inspired fashion design. Mass consolidation of stores and labels, coupled with mergers and buyouts, changed the face of fashion. Megabrands were created with music and sports icons posing as designers. Designers became concerned with brand image and licensed their names to many different products. Robert Halloway (American) founded Archetype and patented mass-customization software. The Dayton Hudson Corporation changed its name to Target and hired well-known architect Peter Graves to design a line of home products. The Gucci Group acquired the Yves Saint Laurent brand and appointed Tom Ford as creative director.

2001 Billionaire Warren Buffett's company, Berkshire Hathaway Inc., bought Fruit of the Loom. Stella McCartney launched her own label under the Gucci Group. Cynthia Steffe (American) was acquired by Leslie Fay Brands. Designer Julien McDonald (British) succeeded Alexander McQueen (British) as the creative director at Givenchy. AlvaProducts/Alvanon was founded by Dr. Michael Wang and the first dress forms, created using 3-D laser bodyscanning technology, were sold. Donna

Karan Company was acquired by French conglomerate Moët Hennessey Louis Vuitton (LVMH). Designer Yohji Yamamoto signed an agreement with footwear company Adidas to design a line of sportswear and sports shoes under the Y-3 label. [TC]2 was selected for the SizeUK study, an anthropometric research study using 3-D bodyscanning technology. Zac Posen (American) launched his first collection in New York. The Gucci Group acquired the house of Balenciaga.

2002 Intellifit Corporation licensed a patented radio-wave technology from the U.S. Department of Energy and created a bodyscanning unit that scanned the body while fully clothed. [TC]2 was selected for the SizeUSA study, an anthropometrics research study using 3D bodyscanning technology. U.S. President George W. Bush proposed the CAFTA Agreement, a free-trade agreement between the United States and five Central American Nations: Costa Rica, El Salvador, Honduras, Guatemala, and Nicaragua. Designer Yves Saint Laurent closed his couture house in France.

2003 The World Trade Organization met in Doha, Qatar, and announced the Dohar Agreement, which lasted until 2006. Isaac Mizrahi became the first popular designer to design clothes for Target. Recording artist Gwen Stefani (American) started her clothing company called L.A.M.B. [TC]2 released SizeUK anthropometric research study data.

2004 Tom Ford and Domenico de Sole (Italian) left the Gucci Group. Adidas launched the first thinking sneaker. The Union of Needletrades, Industrial and Textile Employees (UNITE) and Hotel Employees and Restaurant Employees International Union merged to form the trade union UNITE HERE. Karl Lagerfeld was the first popular designer to design a limited-edition clothing line for specialty store chain H&M. SizeUSA, the anthropometrics research study that used [TC]2 bodyscanning technology, revealed important information about the changing shape of Americans. Sean Puffy Combs provided financial backing to designer Zac Posen (American). All quotas, import licenses, or other special requirements relating to importing and exporting were lifted. Sears, Roebuck & Co. merged with retail giant Kmart. Jones New York acquired Barney's New York.

2005 Federated Department Stores, Inc., merged with the May Company to create the largest department store conglomerate in the United

States. Reebok was sold to Adidas for a reported $3.8 billion. Tommy Hilfiger acquired the Karl Lagerfeld trademark portfolio and produces the reality TV show called *The Cut*. Counterfeiting reaches $600 billion in lost revenue. Isaac Mizrahi launched a collection of made-to-measure clothes (semi-couture) in partnership with Bergdorf Goodman and debuted *Isaac*, a talk show on cable television. Cotton Incorporated opened its state-of-the-art research and development facility.

2006 Target signed British designer Luella Bartley to design a limited-edition collection. Liz Claiborne began distribution of a select number of its brands to the Middle East. Designer Christopher Decarnin brought new life to the house of Balmain. Nine West collaborated with designers Thakoon Panichgul, Sophia Kokosalaki, and Vivienne Westwood to produce a limited-edition ready-to-wear collection. Italy's La Rinascente department store bought the Printemps department store chain from French luxury conglomerate Pinault-Printemps Redoute (PPR). Tommy Hilfiger Corp. was sold to Apax Partners for $1.6 billion. Lord & Taylor was bought by NRDC Equity Partners for $1.2 billion. Diane von Furstenberg became president of the Council of Fashion Designers of America. Karl Lagerfeld showed his collection in New York for the first time. Tod's S.p.A. launched a limited-edition women's ready-to-wear collection.

2007 The Internet continues to transform the fashion industry. Fashion websites—including brick-and-mortar retail store sites, manufacturer sites, and some two million fashion blogs—and upstart fashion companies and fashion social-networking companies bring the industry into the twenty-first century. Shoutfit, a social-networking site, offered fashion-trend advice based on polls of people sharing their own personal style. Shopstyle, a high-style search engine, was launched to offer easy access to thirty other websites from Dillards to Barney's. Fashion conglomerates continued to seek acquisition opportunities which delivered growth to their shareholders and updated their image in new consumer markets. Fashion merger and acquisitions (M&A) moved into the non-giant world as brands and brand identity became increasingly important and were key to survival. The 1980s strategy of brand globalization was replaced with a trend to relocalize brands. Another major shift in online fashion marketing brought fashion into a new realm. Customers had the opportunity to interact with brands on websites like Craigslist and

Second Life, where more than 60 brands including Adidas, American Apparel, and Sears were marketed. A furor over the use of underweight models brought anorexia and other eating disorders to the fashion industry's attention. In 2006, 21-year-old Brazilian model Ana Carolina Reston died from complications due to anorexia; the Spanish fashion industry banned underweight and underage models from the runway. In early 2007, the major fashion capitals of France, New York, and Milan, along with their respective fashion organizations, took a stand on the issue. Italy and the United States created guidelines while France opposed regulation. Magazines and model agencies reacted to the controversy and many blamed Hollywood for promoting "skinny" actors who were believed to act as role models, especially for young girls.

Introduction

The history of clothing begins with the origin of man. While scientists believe that human beings began evolving in North Africa millions of years ago, clothing originated when Cro-Magnon man, the first hominid to look like today's human being, learned how to tan animal skins, roughly 50,000 years ago. As these modern hominids began to migrate to more northern and therefore colder climates in search of food, they learned how to soften and manipulate skins with oils. They also learned how to use other materials, such as tree bark and foliage, to create longer-lasting clothing and accessories. Later, they invented bone needles to sew their crude garments and accessories together.

Fashionable dress can be traced as far back as 25,000 years ago. Recent scientific explorations have uncovered graves in northern Russia with skeletons covered in beads made of mammoth ivory that once adorned clothing made of animal skin. Early man's desire for artistic expression has also been documented by prehistoric European cave paintings depicting men in ornamented robes and headdresses. Early superstitions and religious beliefs contributed to the prehistoric art of making clothing. Statues in ancient Mesopotamia were painted with the ceremonial religious costumes probably worn by people at the time. While animal skins were the medium of choice in prehistoric times, by 3000 BCE clothing made from woven cloth became more common, as evidenced by carved wall images found in several localities in the New World.

The Ancient Egyptians, Greeks, and Romans each made major contributions to fashion's legacy with their textile innovations, unique clothing designs, and early use of accessories, cosmetics, and jewelry. These civilizations understood that fashion requires organizational and manufacturing skills and thus formed guilds as early as the Etruscans (750–200 BCE), continuing throughout the Middle Ages. Guilds were the precursors of today's trade unions and industry organizations.

The late Roman Empire had two capitals, one in the East, Constantinople (also Byzantium), and the other in the West—Rome. These two centers of civilization did much to foster fashion as a business. Byzantium was the crossroads that linked Asia—a major supplier of raw materials for apparel-making including rare silk textiles—with Rome and its large, wealthy population of consumers interested in buying unique clothes.

During the Middle Ages, as trade and commerce thrived, a merchant class emerged among the common people who could afford to emulate the fashions worn by royals. This led to the beginning of what might be called fashion trends, that is, clothing styles which spread quickly between countries and whose popularity waxed and waned over time.

Historical events were major factors in the growth of the fashion industry. For example, after the Crusades in the twelfth century, many soldiers returned to Europe with exotic Middle Eastern textiles and treasures, thus creating a demand for these products. Marco Polo's opening of the silk route in the fourteenth century encouraged commerce with the Far East. Even the Italian Renaissance and Christopher Columbus's arrival to America in the late fifteenth century spawned new trends and new markets promoting fashion. These events, together with an increasing demand for fashionable clothing, inspired inventors to create faster and cheaper ways to produce clothing and textiles, setting the stage for the spectacular growth of the apparel manufacturing industry during the Industrial Revolution a few centuries later. It is widely believed that fashion really became an industry during the industrial and commercial revolution during the latter part of the eighteenth century. Since then, the industry has grown exponentially and continues to grow as world population increases.

HISTORY

While, without a doubt, early peoples fashioned and decorated clothing out of animal skins and, later, cloth, we know very little about what actually drove their fashion sense. After the Dark Ages (400–900 CE), however, a multitude of historical records show that the nexus of fashion centered around Constantinople, the capital of the Byzantine Empire. There, court dress, with its rich silks, elaborate embroideries,

and intricate weaves, drove that civilization's local fashion trends and soon spread to the Western world.

With the formation of the feudal system during the early Middle Ages (the eleventh and twelfth centuries), the upper classes in many European countries labored to dress as differently as possible from the lower classes. Rich European lords had access to fabrics not only from the Middle East but also from the Far East, thanks to Marco Polo's travels (1254–1324). Various guilds were formed to train apprentices, to oversee fashion pay scales, and to set apparel manufacturing work standards.

The French began showing dominance in the fashion arena as early as the thirteenth century. They created many popular medieval styles and went out of their way to name those styles with French names. The British were not far behind the French in influencing fashion tastes during this period, particularly when it came to menswear.

During the Renaissance (starting in the fourteenth century), Italian fashion and the arts caught the attention of European royalty. The Italians influenced the fashion world for several hundred years after the Renaissance.

Fashion trends spread from country to country. It was not uncommon for these trends to follow the nobility from one country to another, especially as countries' ruling families intermarried. Outside of the nobility, thanks to the advent of long-distance travel by ship or carriage, even the common people experienced new cultures, customs, fabrics, and costumes. However, the royal families set the overall tone for fashion. They had the funds to order custom-made clothing tailored to their exact measurements by dressmakers. Female designers were originally known as a *couturières*. Male designers were known as *couturiers*. To gain favor with the royals, wealthy landowners would order their dressmakers to copy the (often custom-made) clothing worn by royalty. Thus began the trend of a limited number of fashion leaders dictating fashion to everybody else.

During the sixteenth century, Spain's stature in the world started to increase in a number of areas, partly due to the celebrity of Christopher Columbus's arrival to America. Not surprisingly, Spain's unique style in clothing and accessories during this time began to gain favor in the rest of Europe.

However, during the Baroque and Rococo periods (seventeenth and eighteenth centuries), fashion leadership returned to England and primarily

France. In fact, the French dominated the fashion scene for the next one hundred years.

More recently, countries such as Belgium, France, Italy, Japan, and the United States have shaped the fashion industry as a whole, though many other countries have made their own significant marks. Latin American dress influenced fashion during the twentieth century. The literal translation of *fashionista* is born from the Spanish suffix, *-ista*, which translates into "devotee." Latin America brought the world Carolina Herrera (Venezuela) and Oscar de la Renta (Dominican Republic). Both of these designers are members of the Council of Latin American Designers, formed in 1999.

Germany was home to the company Escada, as well as to Jil Sander and Bernhard Wilhelm. Sander, a minimalist designer, and Wilhelm, known primarily for incorporating luxury fabrics and perfect workmanship, are both well-recognized players in global fashion.

Retail giants H&M from Sweden and Zara from Spain have placed these countries on the fashion radar screen due to their ability to capture the latest trends at a moderate price point. H&M had the shrewdness to commission Karl Lagerfeld to design a signature collection for the chain in 2004, solidifying the chain's image as a source for cutting-edge fashion.

The Netherlands, known mostly as a leader in architecture and product design, has not been focused on the commercialization of fashion. Dutch designers have had the luxury of governmental support, thus their work is pure and not influenced by the necessary "business" of fashion. Recent designers who have emerged from Holland are Mada van Ganns, Rozema Tevnissen, Janne Kyttänen, Jiri Evenhuis, and Viktor & Rolf.

NON-WESTERN CULTURES

A wide range of clothing, together with significant symbolism, defines the dress of non-Western cultures. Although this text focuses on the Western world, a similar domination existed in other parts of the globe where royalty, empires, and influential rulers impacted fashion. This impact by and large was limited to specific regions; however, when cultures interacted, a broader influence took place.

Other areas of the world that played a role in fashion's history include Asia (China, Vietnam, Korea, and Japan), South Asia (India, Pakistan, Sri Lanka, Bhutan, Nepal, and Bangladesh), Southeast Asia (Malaysia, Indonesia, and the Philippines), the Pacific Islands (Hawaii, Tahiti, Tonga, the Marquesas, and Cook's Islands), Central Asia (the areas formerly known as Turkmenistan), Africa (particularly Morocco), and South America. As empires and colonies developed, the trend of borrowing silhouettes, textiles, and embellishments deepened.

Europe's early contact with China not only stimulated trade, it directly influenced fashion. Silk from China and textiles from India and Turkey became the rage of royalty in Europe. By the seventeenth century this "borrowing" of dress from China, Japan, and South Asia was defined as influences or sources of inspiration known as Orientalism.

In reviewing some of the pure non-Western silhouettes, one can easily trace the sources of inspiration for some of the most dramatic and influential trends of the fashion world. Beginning in France in the eighteenth century and continuing through the nineteenth century, chinoiserie was a favorite inspiration for Mariano Fortuny and French designers Paul Poiret, the Callot Sisters, and Jeanne Paquin. Other designers drew inspiration from Japanese kimonos and butterfly prints. Non-Western cultures that have made substantial fashion contributions are Indonesia, defined by the sarong; the Pacific Islands, with the pareo; China, which presented the qipao, cheongsam, dragon robe, and Mao suit; Vietnam, with its the ao dai; and Japan, which offered the kimono. From India came the sari, kamiz, salwar, burga, kurta pajama, turban, and Nehru jacket; from Turkey came the harem pants; and from Morocco were the djellaba and Zouave pants. The African dashiki and South American gaucho pants are just a few examples of ethnic dress that has been adapted and reinterpreted by fashion designers.

The Chinese qipao, although not very old, became a staple of Chinese dress for women in the 1920s. It is, in fact, based on the traditional Chinese men's gown, the cheongsam. The evolution of the qipao took place in China's fashion capital Shanghai where the form-fitting, ankle-length garment with short cap sleeves is known today as the Suzie Wong dress or cheongsam. The Communist takeover of China in the late 1940s resulted in the end of the qipoa for women and the male cheongsam was replaced with the Mao suit. In Vietnam, the national costume, ao dai, has evolved with the current variation developed in the 1970s.

The emerging fashion industry of the 1970s and 1980s infused Western influences into traditional Chinese dress. Also, even if in a smaller way, Hong Kong became a fashion center, especially for ready-to-wear manufacturing. Today, the People's Republic of China is known mostly as a copier of designs sourced from Europe and the United States; however, the country is a mammoth force within the manufacturing sector. As it strives to become a respected design hub in the twenty-first century, it lays claim to Chinese American fashion designers Anna Sui, Vivian Tam, and Zang Toi.

Today, the Japanese kimono is worn almost exclusively for special occasions, such as significant events in life. Japanese brides wear a traditional kimono for the marriage ceremony and change into Eastern traditional bridal dress for the non-Western celebration.

Globalization has had a direct impact on the purity of Eastern dress. Fashion is no longer exclusive to the West and the East has adapted Western influences in creating "fashion" just as the West has adapted Eastern influences in creating "fashion." Designers Donna Karen, Yeohlee, Anna Sui, Valentino, and Yves Saint Laurent are just a few where traditional Eastern clothing has influenced their collections.

THE BIRTH OF FASHION AS AN INDUSTRY

With the emergence of the industrial and commercial revolution near the end of the eighteenth century, fashion trends started to drive the "fashion industry." A new world market, driven by Europe, Asia, and the British colonies in America, started to expand at unprecedented rates due to worldwide advances in trade, science, and technology. A new economic prosperity, the birth of new textiles, an increase in garment manufacturing capabilities, and better communication methods all spurred a greater interest in fashion.

Paris became the hub of fashion in the eighteenth century as French kings promoted French fashion in an effort to create dominance in this new emerging industry. The British followed and competed with the French by creating new textiles and steam-powered engines and perfecting the art of tailoring. Many believe that fashion became a global industry with the opening of the first couture house in France, founded by the Englishman Charles Frederick Worth in 1856. Other

French designers followed, including the Callot Sisters (Marie Callot Gerber, Marthe Callot Bertrand, Regina Callot Tennyson-Chantrell, and Joséphine Callot Crimont), Jacques Doucet, Jeanne Lanvin, and Jeanne Paquin. Ordinary tailors, who catered to the lower class, were copying "name designers." In response, these designers gradually produced their own ready-to-wear collections and created their own sales operations.

Although Barthélemy Thimmonier invented a chain-stitch machine in France in 1830, it was not until 1846 that Elias Howe's foot-treadle sewing machine made it possible, for the first time in history, to mass produce clothes.

MASS PRODUCTION

During the Industrial Revolution, the growing middle class fueled increasing clothing demand. Aided by Isaac Singer's electric sewing machine, which streamlined production time, the fashion industry responded by creating *standardized sizing* and *separates*. The concept of commercialism emerged alongside popular methods of mass communication, namely inexpensive mass publications, travel, and the invention of the radio in 1901. Catalog companies and department stores sold mass merchandise to the increasing sector of middle-class consumers. Retail stores multiplied and made clothing more accessible and cheaper to produce, offering a broader selection to the masses. This inevitably eroded the influence of the couture market.

TURN OF THE CENTURY

By the outbreak of World War I in 1914, designers and manufacturers in the United States were creating functional apparel for women as they replaced men working in factories. Frivolity was replaced by a new emphasis on masculinity, consistent with the burgeoning suffrage movement that ultimately led to women's right to vote in 1920. Due to rising labor costs, designers began to simplify clothing construction.

In Paris, designer trendsetters including Gabrielle "Coco" Channel, Paul Poiret, Jeanne Lanvin, and Jean Patou further liberated women by allowing them to express themselves via fashion. The cultural and

artistic atmosphere of Paris in the early 1900s created a breeding ground for change centered on youth and simplicity. An interest in sports and leisure-time activities fostered new markets for the fashion industry, as did the growing travel trends aided by the inventions of the automobile and airplane. Chanel was a major force in the creation of the "modern woman" through her innovative style that first graced the fashion scene in the 1920s.

By that decade, department stores were selling "ready-to-wear" clothing in dedicated "departments" featuring clothes for men, women, and children. Retailers in the United States worked with manufacturers to study Paris's trends and reinterpreted them to suit the needs of their own customers.

GREAT DEPRESSION

In the United States, the Great Depression had a profound effect on fashion, as people flocked to the movies to escape their worries. Costumes produced by American designer Gilbert Adrian began to influence international fashion. Despite the Depression, designers like Adrian produced some of the most glamorous fashion during the 1930s in response to the psychological needs of society. Under store presidency of Dorothy Shaver, the department store Lord & Taylor began promoting American designers. Known for her mastery in draping and cutting and famous for her bias cut, Madeleine Vionnet was one of the most prolific designers in fashion history. Designers such as Elsa Schiaparelli and Mainbocher left their native countries to set up shop in Paris. The invention of manmade fibers, such as rayon, acetate, and latex, lowered fabric costs and made fashion goods even more accessible to a variety of buyers.

WORLD WAR II AND THE POSTWAR ECONOMY

During World War II, women continued and reestablished the utilitarian trends they started during World War I. Even more so than during World War I, women entered the work force and often took on very labor-intensive jobs—such as building fighter airplanes for

the war effort—and therefore demanded appropriate clothing for their work, such as pants and overalls. In England, under the British Civilian Clothing Order CC41 in 1941, due to the need to focus most of the country's raw materials and resources on the war effort, the government had to severely ration the sale and use of cloth and fashion embellishments. Laws were introduced that made it illegal for a manufacturer or designer to use unnecessary buttons, stitches, pockets, pleats, or any embellishments that were not functional to garments. This was known as the Government Utility Scheme. The members of the Incorporated Society of London Fashion Designers were called upon to design clothes to help enforce the law and to boost morale during the war years. Well-known designers Edward Molyneux, Hardy Amies, and Norman Hartnell created thirty-four smart Utility Clothing designs, which bore the now famous Clothing Control Label CC41. The government issued a limited number of coupons, which women redeemed to buy these clothes.

Wealthy Americans accustomed to looking to Paris for their fashion needs were unable to do so during the war. As a result, a number of World War II–era American designers started to come into their own by creating clothes that were more in tune with America's increasingly casual lifestyle. Women on both sides of the Atlantic were attracted to the new concept of *sportswear*. By the end of the war, more and more designers, manufacturers, factories, and retail establishments fed the building consumer demand for this new style of dressing. Fashion retailers and magazines, in particular, got behind the push for American fashion. Lord & Taylor was an active promoter of American fashion under Dorothy Shaver, president of the store from 1946 to 1959. Carmel White Snow, American *Vogue* editor from 1929 to 1932 and later fashion editor for *Harper's Bazaar* from 1932 to 1957, was also credited with her instinctual fashion sense which often defined the casual American Look. By contrast, Paris was still favoring a more structured approach to clothes as epitomized, for example, by Christian Dior's New Look trend in 1947. While French couturiers such as Cristòbal Balenciaga, Coco Chanel, Christian Dior, Jeanne Lanvin, Jean Patou, Elsa Schiaparelli, Madeleine Vionnet, and Charles Frederick Worth would continue to influence the fashion scene for decades, designers from other countries, including the United States, would also strongly influence fashion.

By the 1950s, the fashion business exploded and new markets evolved thanks to the postwar baby boom and an increasing diversity of populations, especially in the United States. Although fashion trends continued to emanate largely from Europe, American designers such as Norman Norell and James Galanos strove to establish an "American haute couture." Moreover, thanks to their grasp of America's casual lifestyle, American designers such as Bonnie Cashin, Claire McCardell, Anne Klein, and Tina Leser became extraordinarily successful, viable competitors. During this period, Italian designers Emilio Pucci, Roberto Capucci, and the Fontana Sisters created the Italian Look.

Later, in the 1960s, Valentino Garavani rose to fame—and the Italian designers finally took their place on the world stage, second only to Parisian designers, in the 1970s. Most notable among these Italian designers were Giorgio Armani, Gianni Versace, Gianfranco Ferre, Missoni, Ermenegildo Zegna, Franco Moschino, Krizia, Prada, and Guccio Gucci.

A new subculture began to form in the 1960s and gained during the coming decades; it took its inspiration from pop culture and lifestyle. Designers, in sync with the film and music industries, started looking to the streets for inspiration. Fashion trends were given names such as "beat," "mod," "hippie," "punk," "grunge," and "hip-hop." These new fashion trends echoed the thinking of the often-revolutionary street counterculture and events taking place in world history. During this time, the impact of Europe's "fashion dictatorship" began to wane.

THE FASHION INDUSTRY TODAY

Fashion, as an industry, has come a long way since the early days when Parisian designers dictated fashion. Fashion design and manufacturing is now a multibillion-dollar global industry. While Paris was once the home of fashion—as evidenced by designers from other countries migrating there to show their collections, including Elsa Schiaparelli (Italian), Mainbocher (American), Kansai Yamamoto (Japan), and Katherine Hamnett (British)—today's designers not only come from many other countries, but they also regularly choose places other than Paris to introduce their lines. Whether they show in New York, Los Angeles, London, Milan, Rome, or in their home countries, today's designers embody the global fashion industry.

Belgium

During the 1980s, designers from Antwerp achieved global recognition with the innovative collections of Dries Van Noten, Ann Demuelemeester, Dirk Bikkembergs, Walter van Beirendonck, Dirk van Saene, and Marina Yee. It was at the 1988 British Designer Show in London that these six trendsetting designers became known as the "Antwerp Six." A major force in the Belgium fashion scene was its fashion schools, the Royal Academy of Fine Arts and the Antwerp Academy.

Britain

For centuries, British royalty dictated fashion. Credited as early as 1533, Ann Boleyn conceived of "lingerie." However, traditional fashion direction in Great Britain originated with the French and the Italians; after World War II, the American designers influenced British fashion. Norman Hartnell, the British designer responsible for projecting the fashion image of British royalty for three generations, including Queen Elizabeth's reign, did not deviate from conservative form. Not until the 1960s did fashion really explode in Britain. Young designers, the most noteworthy being Mary Quant, reinvented fashion by drawing on inspiration from the streets of London. Thanks to Quant, Kings Road and Carnaby Street became destination magnets for many young and hip fashion gurus.

Twiggy, the sixteen-year-old British "waif," became the most sought after model of the decade and revolutionized the "new look of fashion." The hippie look of the early 1970s had morphed into a punk antifashion look. Designer Vivienne Westwood was known for the decade's most outrageous and bestselling fashion statements. She created clothes out of safety pins, creating many fetish and vinyl bondage designs. Inhibition was out, freedom of expression was in, and London fashion provided the venue for these new freedoms. British design eccentricity continued with designer John Galliano and culminated with designer Alexander McQueen, who was credited with understanding the marketing value of "shock tactics" in design. More recently, British fashion—while retaining its signature style—has softened its edge, as exhibited by the designs of Stella McCartney.

France

Although Paris held the lead in fashion for more than 100 years, the fashion industry has expanded tremendously since the founding of Charles Frederick Worth's couture house in 1846. Were it not for the early French designers and their passion for fashion, the rest of the world would be at a loss today. French design houses not only set the standards for the industry but designers such as Christian Dior, who created a fashion frenzy with his "New Look," also started another trend whereby designers on both continents competed with each other to come up the next "big idea." Today, France is home to both ready-to-wear and haute couture. Fashion houses such as Chanel and Gucci are now owned by major fashion conglomerates such as Moët Hennessey Louis Vuitton (LVMH) and Pinault-Printemps Redoute (PPR).

Japan

The rebuilding of Japan after World War II, together with its technological explosion, set the stage for a new, reflective sense of design. The country as a whole became confident in its ability to preserve its rich heritage and simultaneously established itself as a source of cutting-edge ideas. Apparel design proved to be a perfect arena to showcase such success. Hanae Mori was Japan's first internationally recognized designer and was the first Asian to be admitted to the Chambre Syndicale. Although the least radical in terms of design expression, Hanae Mori set the stage for Rei Kawakubo, Junko Koshino, Issey Miyake, Junko Shimada, and Kenzo Takada, establishing Japan as a player in the world of global fashion. The designers accomplished this through their "ability to meld traditional Japanese art forms with 1960s American pop culture." Additionally, at a time when the West was concentrating on tightening and exposing the body, these designers set themselves apart—not only through their approach to changing the body through abbreviation but also most recognizably through the pioneering of the "deconstruction era" in the design world of the 1980s. While each of these designers maintains distinctive design personalities, all possess an innate sense of artistic expression that is collective. Whether it is through the juxtaposition of the coolness of synthetic materials with the warmth of unconventional natural materials, the pureness of geometric

form, or the art of distressing to evoke feminism and softness, Japan has added a dimension to the world of fashion that compares to no other.

Italy

Italy's prominence in the world of fashion dates back as early as the fourteenth century in Florence. Italian fabrics were in high demand especially among European nobility. Prior to World War II, designers such as Mariano Fortuny, Ermenegildo Zegna, Guccio Gucci, Salvatore Ferragamo, Elsa Schiaparelli (although based in Paris), and the Fontana Sisters created exquisitely tailored clothing and accessories. However, it was not until the 1950s, when the Italian government made a concerted effort to push Italian fashion, that Italian designers achieved their own identity, the Italian Look, drawing on their expert tailoring, craftsmanship, and high-quality materials. Emilio Pucci opened his house in 1948, Roberto Capucci in 1950, and Valentino in 1960. During the 1970s, Milan became the fashion center of Italy with labels such as Missoni, Krizia, Gianni Versace, and Giorgio Armani. In the 1980s and 1990s, other Italian designers—such as Romeo Gigli, Franco Moschino, Gianfranco Ferre, Laura Biagotti, Dolce & Gabbana, Miuccia Prada, and a reinvented Gucci—characterized the decades. The Italian fashion industry is also unique in that families and not corporations own and operate many of the major houses. Even today, Italian fabrics and luxury leather goods are the most sought after and the most copied.

United States

Despite the impediments of World War II, a unique American style was born out of both necessity and patriotism. American women, who traditionally were thought of as more independent and physically active than their European counterparts, embraced the freedom of American sportswear. With a keen understanding of the positive aspects of manufacturing, American designers like Claire McCardell and Bonnie Cashin set the stage for fashion in the guise of today's ready-to-wear. In the 1960s, while Britain had Mary Quant, the United States had Rudi Gernreich. Innovative and with a keen feel for "shock value," Gernreich has been generally credited with the "no-bra bra," which allowed breasts to maintain their natural shape, a philosophy in sharp contrast to

earlier generations' attitudes about the role of foundation garments. The 1970s gave birth to Halston, a designer who was all-American through and through yet who offered a new level of sophistication—and he could not help but get noticed. Halston loved the media. He received significant attention both for his clothing and his client list. Numerous scandals surrounded his personal life. He was one of the earliest celebrity designers. American fashion icons Donna Karan, Calvin Klein and Ralph Lauren pioneered the true "business of fashion" in creating lifestyle marketing and global branding of their collections and products. The marrying of American marketing with the traditional fashion world of Europe created a global fashion business that successfully melded the American and European design worlds.

ADVERTISING, MARKETING, AND BRANDING

Fashion advertising and marketing, it could be argued, dates back to ancient Mesopotamia when wall carvings and drinking vessels served as "advertisements" for the fashion of the times. Later, paintings of aristocrats in fashionable dress provided inspirational fashion images for the commoners. The first French fashion magazine, *Mercure Galant*, published in 1672, helped promote French fashion throughout Europe and the New World. The power of advertising and marketing would not be fully realized until the 1980s, when a plethora of vehicles such as fashion magazines, billboards, catalogs, newspapers, direct mail, television, radio, and the Internet could be maximized. As baby boomers matured, they rebelled against "fashion dictation." Designers sought alternatives to help sell merchandise. The first successful concepts were designer labels, selling status, and branding, targeted to the masses. Blue-blooded American Gloria Vanderbilt was the first to lend her name to a Hong Kong–based jeans company, Murjani, and thus began the designer jean craze of the 1980s. American Calvin Klein was one of the first designers to successfully utilize the media to drive sales behind his name and to understand the globalization of world markets. His seductive marketing campaigns—beginning with Brook Shields modeling his jeans and later with his controversial "heroin chic" advertisements—opened a whole new avenue for designers to utilize and promote their designs. Other companies

followed with controversial ads, such as those from Benetton and "quirky message" ads from Kenneth Cole.

Ralph Lauren pioneered the "status dressing" concept for the masses and he marketed it with the consumer's "need to belong." Beginning with his name change from Ralph Lifshitz to Ralph Lauren, he finely tuned his product-marketing strategy by combining English aristocracy and "old money" with "American classics." He invented, packaged, and successfully sold the concept of *lifestyle-dressing* and it didn't take long for others to follow. Tommy Hilfiger jumped on board and before long, classic merchandise became "fashion," and with that came "commoditization." Consumers in the 1990s were no longer seeking a designer's view of fashion; they wanted affordable, casual clothing and were happy to make their own style decisions. Fashion sales and promotion moved from the hands of designers to businessmen, who sought to reap greater returns on their investments.

The designer-market consumer, on the other hand, was still a slave to status dressing and logo-mania. Luxury-brand merchandise thrived throughout the late 1990s and well into the 2000s. Image marketing, popularized in the 1990s by designers Donna Karan, Ralph Lauren, and Calvin Klein, created advertising where the clothes were secondary to the image being conveyed. Karan's ads, featuring the New York skyline and the Brooklyn Bridge with her name at the bottom, evoked the persona of a chic city woman—a vision of the customer that Karan was targeting. Eventually, fashion promotion moved from the hands of designers to advertising agencies and corporate businesspeople who sought to reap greater returns on their investments as companies went public. Deluxe labels from old established companies, beginning with Chanel in the 1980s, were reinvented for the new marketplace. Today, companies such as Balenciaga, Hermès, Lanvin, Givenchy, Vuitton, Gucci, and Prada have been revitalized by hiring young design talent and by repositioning their brands with formidable image-promoting campaigns.

Following the formula of Ralph Lauren, today's designers are much more in sync with their target market and their customer's lifestyle needs. They design products geared toward lifestyle-dressing. While the creation of new trends is still an important factor in the fashion apparel business, manufacturers and retailers are also investing in sophisticated marketing strategies to target merchandise to their specific consumer. Time and exorbitant amounts of money are spent to build

brand identity to ensure success in maximizing a particular designer's or icon's market potential.

Today, advertising drives the fashion industry in an effort to maximize both awareness and brand recognition, both key factors in generating maximum sales. Runway fashion shows, television, publications, catalogs, the Internet, and eponymous stores are all vehicles utilized to promote the "image of the brand." Designers license their names to companies' products to build their own brand name, often achieving celebrity superstar status as a result. Realizing that they were often targets of copyists, many designers have elected to license their name to lower-priced collections. Relationships between designers and megastores, such as Isaac Mizrahi and Target or Karl Lagerfeld and H&M, have become another opportunity for designers and retailers to better capitalize on a famous designer's name.

In addition, manufacturers have licensed or are in partnerships with famous celebrities in sports and music, as well as with actors and models, to generate sales and build megabrands. Examples in the music industry are Jennifer Lopez (Jlo), Sean John, Jessica Simpson, Gwen Stefani (L.A.M.B), Beyoncé (House of Deréon), Russell Simmons (Phat Farm), Jay-Z (Rocawear), 50 Cent (G-Unit), and Bono (Edun). Sports icons with clothing licensees include Tiger Woods, Venus Williams, Michael Jordan, and others. Actors have also lent their names to clothing and accessories lines, including Kathi Lee, Pamela Anderson, and Hilary Duff.

MANUFACTURING

In the nineteenth century, manufacturing was done under the supervision of the couturier, usually in his or her attic (or atelier). As ready-to-wear evolved and sales volumes increased, factories were set up with production personnel hired to optimize the manufacturing process. Factories have proliferated in the countries that produce clothing for designers and manufacturers. Eventually, due to the high cost of labor in the more developed countries, new, more cost-efficient mass-production facilities have been created in less-developed countries. This trend toward offshore manufacturing is expected to last for decades, as long as there are disparities among the standards of living in different countries. In the

United States, both the textiles and manufacturing industries suffered due to increased economic globalization and technological advances. The industry responded by creating niche markets in the 1970s, promoting high-quality products, developing strong brand names, and investing in faster customer-response systems. Despite these efforts, almost one million U.S. textile and apparel jobs were lost from 1973 to 2005. Countries with more competitive pricing such as Hong Kong, India, China, and Mexico have became major players in the apparel offshore manufacturing business.

Unfortunately, it's come to light that some factories in these countries are sweatshops, employ children, use forced labor, and/or allow hazardous working conditions to exist for many employees. Many of these factories' situations were brought to the world's attention in the early 1900s and again in the 1980s. Activists launched campaigns against companies that manufactured products under these horrific conditions. Legislation was eventually passed in Europe, the United States, and, later, in many developing countries to protect workers from unscrupulous employers. Trade unions have also been created to protect worker's rights. However, these measures have not yet eliminated the many sweatshops that still exist around the world.

COUNTERFEITING, COPYISTS, AND PIRACY

Copying another designer's work dates as far back as the Middle Ages, when styles created for the royals and other nobles were frequently "reinterpreted" by other designers, usually with less expensive materials. The feudal society of the Middle Ages brought an increase in the number of workers who looked to the lords and kings for fashion inspiration and aspiration.

Today, we know a great deal about what the clothes looked like in many countries, from the Middle Ages and beyond, thanks to the many paintings made during the Italian Renaissance and other artistic eras. This has allowed us to see the wonderful clothing worn at the time by royalty and wealthy merchant families. Many designers copied the clothes depicted in paintings, often creating hot fashion trends. In 1770, the *Lady's Magazine* published its first fashion edition in England. The periodical *Gallery of Fashion* first appeared in England in 1794. Publications such as these kept men and women current on new fashion

trends and were often the prime source of blatant copying. *Godey's Lady's Book*, distributed in the United States, and *Ackerman's Repository of the Arts*, both of which were published in the early 1800s, whet the appetite of the American fashion elite. For those who could not afford to make the voyage to purchase the originals, their dressmakers and later their local specialty shops began copying them.

By 1850, the United States had 4,278 clothing manufacturers. Much of what they made were fashions that were copied or bought from Paris. Copying became so rampant that, to combat the problem, Charles Frederick Worth (1856) resorted to selling his patterns to several U.S. department stores. However, other designers felt that selling patterns was not the answer and chose to bring lawsuits against the copyists, which brought the matter into the courts. Designers Madeleine Vionnet, the Callot Sisters, Paul Poiret, Madeleine Cheruit, Charles Frederick Worth, Jeanne Lanvin, and Drécoll formed an anticopyist society in 1923 called Association pour la Défense des Arts Plastiques et Appliqués. Its mission was to lobby for international copyright laws. In 1928, another Parisian group known as the Société des Auteurs de la Mode tried to curb the rising trend of copying at French fashion houses principally by American department stores. Then, in 1930, another group was formed, L'Association de protection des industries des saisonnières (P.A.I.S.). This anticopying group, headed by Armand Trouyet of Vionnet et Cie, succeeded in conducting counterfeiting raids and bringing about laws regarding the illegal copying of designs from the couture. A landmark case, involving Vionnet and Chanel against copyist Suzanne Laneil, ruled that couturiers were entitled to the same copyright protection in France as artists and writers. They later succeeded in banning from their shows sketchers and model-renting services, that is, firms that purchased styles for the sole purpose of renting them to manufacturers to be copied. In 1934, the concept of admission cards began, whereby, for $200, a department store or manufacturer could attend the couture showing but had to promise not to copy.

Even after the much-publicized case in the 1970s between Yves Saint Laurent and Ralph Lauren involving Saint Laurent's "Le Smoking" suit (a case which Ralph Lauren lost), "knocking-off" still exists. The problem of stealing or illegally taking an idea or product design and passing it off or selling it as your own continues today. Counterfeiting or product piracy in 2005 accounted for approximately $600 billion in lost

revenue globally. It also accounted for the loss of more than 750,000 American jobs according to the U.S. Customs and Border Protection. China and other developing countries are the biggest offenders of trademark infringement today. Groups such as the World Trade Organization (1993) and legislation like the proposed Doha Agreement (2003) are addressing the issues relating to trade-related intellectual property rights (TRIPS) and international trade law.

INNOVATIONS

Just as the sewing machine revolutionized the fashion industry in the early nineteenth century, today the computer has taken on a major role in all aspects of the fashion industry. Computer programs, including computer-aided design (CAD) software, have been created to assist designers in creating their work. Designers have tools that can provide 3-D images of new designs, saving the manufacturer huge investments normally spent on samplemaking. Computerized pattern design systems (PDS) offer 2-D design functionality that can be combined with product data-management systems (PDM) to track a garment from creation through to production lifecycle management (PLM).

The future of designing and manufacturing clothing is on the cusp of monumental change. Computer technology developed by OptiTex PAD System, Gerber, and Lectra, provides a full range of software solutions ranging from design, patternmaking, grading, and marker making. These programs can now interface with interactive 3-D draping systems. Today, not only can 3-D samples be created but changes to these virtual designs automatically modify their associated digital patterns. Companies will continue to develop this software and eventually online shoppers will be able to customize their own wardrobes.

Bodyscanning technologies from [TC]², Cyberware, Bodymetrics, and Intellifit capture body dimensions more accurately than using tape measures. Body dimension information can be useful not only for creating custom-made patterns but also as a research vehicle for manufacturers who wish to update their patterns and sizing for better-fitting clothing, region by region. Bodyscanners are also being used by dress-form companies such as Alvanon and Shapely Shadows to create customized dress forms that help manufacturers standardize fit for a populace with

ever-changing size needs. Retailers, manufacturers, tailors, and designers acknowledge that these innovations are the future of the fashion industry and better connect them to their customers' needs.

Other innovations on the horizon involve clothing construction. Formafit has developed the Clothing Creator, a patented process of manufacturing clothing using ultrasonic cutting, bonding, and heat molding, which eliminates the conventional cut-and-sew process. Using this process, automated systems can manufacture a garment without any direct human labor within a 45-second cycle. Not only does this technology cut down the cost and labor-intensive process of garment manufacturing, but it also could drive the New Look for the twenty-first century.

Innovations involving technology within the retail sector have recently exploded with the invention of seamless and continuous product tracking systems referred to as radio frequency identification (RFID). Unlike traditional barcodes, RFID utilizes a numbering scheme called electronic product code (ePC) that has the ability to provide a unique ID for any product throughout the world. These tags, which cost pennies and can be as small as a grain of sand, are being used worldwide by major apparel retailers and manufacturers. Available systems have been created by Paxar, Envision, Intellitrack, Oasis, and Project Logic, to name a few. By tracking, in real time, which clothes move to and from racks and then through purchase stations, marketers will be able to monitor customer behavior and consumer product end use with unprecedented precision.

Beginning with popularity of the Home Shopping Network (HSN) in 1985 and QVC in 1986, alternative retail channels other than brick-and-mortar stores have emerged. The desire to reach the maximum number of people in the shortest period of time resulted in a burgeoning media-driven retail environment that today produces billions of dollars in sales. The Internet ranks right up there with television when it comes to amazing sales potential. By 1994, *e-commerce* and *e-tailing* were household words. According to the *State of Retailing On-Line* (version 8.0), a study conducted by Forrester Research for Shop.org, online retail apparel sales amounted to $10.2 billion in 2004 and $12.5 billion in 2005. Startup companies, as well as established retailers and manufacturers, utilize the Internet to build businesses and reinforce their brand image.

Another issue for retailers and manufacturers in a global marketplace is reducing the time to market. What once took eighteen months from the time of conception to the distribution center now takes between three

to six months. The decisions relating to finding the right place to make a particular product, negotiating costs and bids, managing the product (PDM), supplying, tracking, and distributing can now be accomplished by utilizing sophisticated Web-based on-demand software solutions. Pressures to reduce costs and improve performance to compete globally have elevated the strategic importance of supply management within most apparel enterprises. Companies such as New Generation Computing provide fully integrated product lifecycle management systems. This new wave of technology has eliminated many unnecessary non-value-added steps to the process, which, in turn, has reduced both time and costs. The import agent of the past has been replaced by "sourcing enablers," who use these advanced-speed sourcing methodologies to streamline the entire process, from creation to distribution. Sourcego, a leading sourcing enabler, was among the first full-service agencies based in the United States and China. Their success, and that of the companies they serve, is based on computer-driven technology, which ultimately increases return-on-investment (ROI).

The textile industry in both the United States and Europe, for the past century or so, has been searching for ways to revitalize the industry, having lost production to countries like China, India, Korea, and Turkey. Between 1994 and 1996, the textile industry in the United States lost 50,000 jobs alone—and the number continues to grow at a steady pace. Recent changes in trade agreements and trade regulations have greatly impacted the domestic apparel manufacturing and textile industry. According to the U.S. International Trade Commission, roughly half of the total capacity in the apparel industry has shifted from developed countries to less-developed countries (LDCs) over the past thirty years. The top five apparel-manufacturing countries are China, Hong Kong, Mexico, Taiwan, and South Korea. Apparel imports are growing most rapidly from Mexico, the Dominican Republic, Indonesia, and India. Industry estimates show that the average apparel worker in those countries earns about 10 percent of the hourly wage of a comparable worker in the United States. Profit margins throughout the fiber industry have also been squeezed due to offshore competition and the rising price of oil.

Research into renewable resources to create fiber is expanding for numerous reasons: to reduce our dependence on oil, for ecological purposes, to save money, and to act as a marketing tool. Beginning with the recycling of plastic bottles by Malden Mills in 1979, the textile industry

is exploring alternative sources of materials that would otherwise go to waste, items such as poultry feathers, peanut shells, coconut shells, and corn. In 2002, Cargill Dow launched Ingeo, a fiber derived from corn that has the same properties as nylon but is cheaper and produces less carbon dioxide than the production of polyester or nylon. The demand for products made from recycled, sustainable, organic, and renewable materials is expected to grow as today's younger generations get older and speak out about their concerns regarding greenhouse gases, global warming, and the long-term effects of carcinogenic pesticides on their lives.

ASSOCIATIONS, ORGANIZATIONS, AND TRADE UNIONS

Industry organizations not only help promote the fashion industry worldwide but serve as vehicles for industry peer recognition, events planning, fashion-trend reporting, career opportunity, industry forums, government lobbying, setting standards, philanthropy, education and scholarship, public service, and social responsibility. The most notable organizations in the United States are American Society for Testing and Materials (ASTM), Fashion Group International (FGI), Council of Fashion Designers of America (CFDA), the National Retailer's Association, American Apparel & Footwear Association (AAFA), and the trade union UNITE HERE. In France, the prominent groups are Fédération Française de la Couture du Prêt-à-Porter des Couturiers et des Créateurs de Mode, and the trade union, Force Ouvrière (FO). Other groups include, in England, the British Council of Fashion Designers and the Trade Union Confederation (TUC); in Italy, the Italian Trade Commission and the trade union Confederazione Italiana dei Sindacati Lavoratori (CISL); and, on a global level, the International Trade Union Confederation (ITUC). (See listings in appendixes 4 and 5.)

PROFESSIONS

The fashion industry is comprised of people who liaise with one another from around the world, working in an extensive range of jobs, ultimately bringing products to market. The industry is broken down

into eight different segments with boundaries that sometimes blur, both among the segments and between the jobs within those segments.

Textile Design, Development, and Manufacturing

This area of the industry begins with the selection of yarn. Whether the yarn is a plant fiber (cotton, linen, ramie, bamboo, corn), an animal fiber (alpaca, angora, mohair, silk, wool), or a synthetic fiber (acetate, acrylic, nylon, rayon, polyester, viscose), the fabric manufacturer will employ a textile designer to create knitted, woven, embroidered, and printed fabrics and trims. Woven textile designers work for fabric mills selecting yarn, designing the weave and construction, and choosing color combinations, usually done with CAD programs. Knit designers are specialists in selecting appropriate yarns, knit gauges, and stitches and are familiar with knit construction and technology such as cut-and-sew knits, whole garment technology (Stoll, Shima Sieki), seamless technology (Santoni), circular knitting machinery, and CAD programs such as U4ia and Primavision. Print textile designers create textile surface designs that are applied to knit and woven fabrics. Print design studios supply print designs to the fashion industry. Textile printing takes place either at the mill level or at a printing company. A colorist works with the textile designer in the textile development and design process. Converters are fabric suppliers who do not make their own textiles but instead buy greige goods from mills, then commission other companies to print, dye, and finish the goods. Lace, embroidery, and trim designers work to develop motifs and decorative stitches that can be used on clothing and accessories. Textile technologists work with designers handling various aspects of the textile manufacturing process.

Fashion Design, Wholesale Sales, and Manufacturing

The fashion design profession encompasses many different product categories and falls into three main levels: fashion designers with eponymous labels (Donna Karan, Oscar de la Renta, Tommy Hilfiger), creative directors who head design teams for brand-name companies (Gucci, Chanel, Versace), and designers who work for manufacturers or retail establishments. Apparel designers work as freelancers or as permanent design specialists in the following market areas: activewear,

childrenswear, intimate apparel, knitwear, menswear, leatherwear, outerwear, performance apparel, sportswear, special occasion, and womenswear. Other product categories are accessories, footwear, jewelry, millinery, and hosiery. Associate and assistant designers aid the designer in the creative process. Sketchers, sample cutters, drapers, patternmakers, and samplemakers are also employed in the designer's workroom. Tailoring shops employ tailors who create made-to-measure or bespoke tailored suits and shirts for men and women. Tailors are also hired by outerwear and suit manufacturers. Graphic designers design logos and other graphic images for clothing and accessories. The role of the technical designer and specification writer is to assist in the design process by communicating necessary information from the designer and product developer to the factory.

Each season, manufacturers sell their line by utilizing any number of the following means: having a showroom presentation by a showroom sales associate; selling through a sales representative or regional sales representatives; having a trunk show or trade show; and using media presentations like fashion shows, advertisements, TV, the Internet, direct mail and editorial coverage in fashion magazines, newspapers, and trade journals (*WWD*, *DNR*, and *FN*).

The production/manufacturing arm of a company is responsible for purchasing materials, pre-production fitting, pattern grading and marking, global sourcing of materials and contractors, production scheduling, costing analysis, quality assurance, plant management, and the final shipping of product. Personnel in the production area include the technical services manager, the fabric buyer, trim buyer, textile and materials planner, fit model, technical services manager, grader and marker, global sourcing director, contractor, operator, production manager, costing analyst, quality assurance manager, plant manager, import coordinator, and the import/export specialist.

Retail Store Management

The retail segment of the fashion industry can be broken down into five key areas: (1) retail merchandising, buying, planning, and product development, (2) retail store operations, (3) sales promotion, marketing, and visual merchandising, (4) financial management, and (5) human resources.

Retail Merchandising, Buying, Planning, and Product Development. The merchandising division of a retail store is centered on planning and merchandising, buying, and/or developing products. A general merchandise manager (GMM) directly reports to the store president. Under the GMM are the divisional merchandise manager, director of planning, planner/distributor, buyer, associate buyer, and assistant buyer. Buying offices employ buyers who either buy merchandise for their own stores, known as Central Buying Offices (CBO), or buy for many individual stores known as Resident Buying Offices (RBO). Over the past decade, the retail landscape has changed. Many stores now create their own merchandise in addition to purchasing lines from brand-name manufacturers. Product development teams work with the merchandising division to create private label merchandise for the store. The product development manager heads the team that includes a designer or product developer, products buyer, technical designer, specification writer, and production manager.

Retail Store Operations. The operations division of a retail store is headed by a store manager, who is responsible for directing the merchandise coordinator/selling specialist, salespeople, head-of-stock and warehouse personnel, maintenance, security, and customer services areas of the store.

Sales Promotion, Marketing and Visual Merchandising. Sales promotion is comprised of advertising, visual merchandising, and public relations. This division is headed by a promotion director, who works with a marketing account manager, online marketing manager, and visual merchandise director, as well as in-house advertising staff or outside advertising agencies for more specialized media such as television, video, and radio.

Retail Financial Management and Human Resources. The financial control division of a retail store supervises the store budget. This division is headed by a controller or chief financial officer (CFO) who manages all financial activities and controls the credit department, accounts payable, and the statistical department. Controllers work with the merchandising division of the store to prepare reports that are used to guide divisional merchandise managers and buyers in executing their merchandising plans. The human resources department hires and trains new employees in addition to maintaining employee benefit records.

Fashion Media

Fashion media encompasses members of the fashion press, such as fashion columnists, fashion critics, fashion editors, fashion journalists, fashion photographers and photojournalists, and fashion reporters. Other industry members and events that fall under the fashion media umbrella are fashion models, fashion shows, stylists, illustrators, fashion forecasting, fashion public relations, fashion advertising, and fashion Internet sites, blogs, and magazines.

Fashion Education

As the fashion industry grew and became a multimillion-dollar industry, it fostered the need for schools that could provide the necessary training for the many professional areas within the industry. European schools, beginning with Esmod in Paris, initially trained students in design, draping, patternmaking, and garment construction. Soon fashion schools opened in countries such as Italy, Britain, Belgium, and the United States with expanded programs in fashion design, textiles, production management, retail management, merchandising, sales, fashion advertising and promotion, and marketing. Due to the global nature of fashion and the shift in manufacturing to Asia and South America, existing fashion schools have formed partnerships with colleges and universities in countries including China, India, Japan, Thailand, Turkey, and Mexico and countries in South America. Today there are more than 650 fashion schools in approximately 27 different countries. (See appendix 7 for a listing.)

The Dictionary

ABBOUD, JOSEPH (1950–). The man behind the label began his business in 1987 and, prior to doing so, worked for **Ralph Lauren** from 1981 to 1985. He is the recipient of back-to-back **Council of Fashion Designers of America** (CFDA) awards. Abboud, who is of Lebanese decent, was born in Boston, Massachusetts, and attended the state university there. He is recognized for his use of earthy color and his classic style, and he draws inspiration from the colors and textures of North Africa. The line of **menswear** that bears his name is cut to fit the fuller American body. His label was acquired by J. W. Childs. In 2005, Abboud got back to what he does best: the creative process. The Abboud label, while still sold at better **department stores**, had lost its trendsetting edge. Armed with a new marketing campaign, the company staged its first runway show in five years. The tone at Abboud is hip and contemporary, yet still with a fit geared to the fuller American male. Abboud has several **licensing** agreements that include eyewear, hosiery, **footwear**, and a home collection.

ABERCROMBIE & FITCH. Established in 1892, the company was identified as conservative and catered to a traditional clientele. It was revamped in 1992 as a fashion-forward casual apparel business geared to young adults that, in 1998, had more than 200 stores. Abercrombie, as it is known, also has a **childrenswear** division. Its **target market** is hip, urban, and possessed of disposable income, which makes fashion purchases dependent upon acquiring a specific **brand**. *See also* ANDROGYNOUS LOOK; RETAILER.

1

ACCESSORIES. Spanning the contemporary as well as the historical world, accessories affect the defining dress of cultures in both the Western and non-Western world. Their role today, as in the past, continues to be one of function, fashion, and status. Items such as the aglet began as a functional means for attaching men's hose and doublet in the fifteenth century and later morphed into a fashion accessory for shoes, which during colonial periods in Europe could not be worn by the lower classes. African jewelry, which is beautiful as an accessory, can also be an item of sexual attraction—its movement creating sound to attract attention. Belts, gloves, handbags, hats, scarves, and shoes are the items that accessorize fashion. During the 1950s, accessories were the key to creating a "look," and it was the hat that took center stage. Gloves, handbags, and shoes matched in color and style. A "lady" always kept her hat on in public. At this time, **Hermès** created a **leather** bag that was fastened with a distinctive leather strap and hardware; it was worn by Princess Grace of Monaco (the former Grace Kelly, a Hollywood movie star). The "Kelly Bag," as it was known, has remained popular for more than fifty years. In 2005, the "hot" accessory became the cell phone cover. Designers were teaming up with wireless service providers. Accessories are a vehicle for many people to acquire ownership of high fashion. Firms such as **Ferragamo, Gucci, Prada**, and **Louis Vuitton** have become household names in the accessory arena. *See also* ACCESSORIES DESIGNER; FOOTWEAR; MILLINERY.

ACCESSORIES DESIGNER. A designer who specializes in the **accessories** market, designing belts, gloves, handbags, hats, scarves, and shoes. Although hats and shoes are part of this market category, designers traditionally concentrate in the **footwear** and **millinery** submarkets of accessories.

ACCOUNT MANAGER. A person who manages **department store** accounts for a **manufacturer**. An understanding of retail math and the ability to plan out a season and monitor receipts and margins are musts. This person is also responsible for following up on orders, communicating with internal business partners, and contacting clients, as well as entering purchase orders, tracking shipments, and compiling sell-through information.

ACETATE. A regenerated cellulose fiber created from chemically treated materials found in nature, such as **cotton** fibers or wood chips. Though the fiber was originally invented in 1910, it was not until the Celanese Company commercially produced acetate fiber in 1924 that it became popular for clothing. It is primarily used for linings and **special occasion** fabrics such as taffeta and satin. It can also be blended with other fibers.

ACKERMAN'S REPOSITORY OF THE ARTS. Rudolph Ackerman (1764–1834) was born in Germany into a family of limited financial means; Ackerman became a saddler and coach builder like his father. He plied his trade in numerous cities in Germany, France, and England and in 1795 established a print shop and drawing school. In 1809, he began his Repository of Arts, Literature, Commerce, Manufactures, Fashions, and Politics, known as Ackerman's Repository of Arts. **Fashion plates** served as a fashion guide for **dressmakers** because they communicated the latest in contemporary fashion. Approximately 450 fashion plates were released and the magazine ended in 1829. *See also* FASHION MAGAZINES.

ACRA, REEM (c. 1960–). Born in the United States of Lebanese decent, Acra is a name **designer** in the American bridal industry. She began as a **textile designer**, embroidery designer, and glove maker before turning to bridal accessories. Presently, the designer includes **accessories** such as veils, beaded jackets, and shawls. She is known for her ability to blend **vintage** and modern trends and create **separates** in a market that is traditionally driven by single items. She is inspired by handmade accents and embellishments. Acra moved to New York in 1995 to begin her bridal line. She presented her first collection of eveningwear in 2000. In 2003, she opened her first retail establishment in New York. A member of the **Council of Fashion Designers of America** (CFDA), Acra graduated from American University in Beirut in 1982 and also attended the **Fashion Institute of Technology** (FIT) in New York.

ACTIVEWEAR. While the designer **Charles Frederick Worth** is credited with working with stretch fabric as early as the mid- to late 1800s, it was not until designers began to marry textile development

and clothing performance that this specialized area of design exploded. In 1912 swimming became an Olympic discipline, and clothing that enhanced rather than restricted movement was required. Activewear began in earnest when the health-promoting aspects of sports generated the need for appropriate clothing, especially for women. Swimming and tennis were the first women's sports to be addressed, and pants were added as a sports undergarment. **Coco Chanel** was the **couture** pioneer of this category, with the creation of her leisure suit made from lightweight jersey. In 1927, designer **Elsa Schiaparelli** opened her first salon, *Stupidir le Sport*, and in 1931 designed a divided skirt for tennis player Lili de Alvarez that shocked the staid tennis crowd at Wimbledon. **Claire McCardell** (1940s) and **Rudi Gernreich** (1960s) linked true activewear to **sportswear** dressing. The DuPont Company worked with designer Giorgio Di Sant'Angelo from the 1960s to 1990s to develop stretch **silk** and **Lycra**-enhanced fabrications. In the 1970s, the fitness look was in and **fashionistas** began wearing activewear, even those who never planned to "break a sweat." In 1993, **Ralph Lauren** opened his Polo Sport **boutique** in New York City. Active sport companies were quick to see this market potential, and firms such as **The North Face** became household names. By 2000, high-performance textiles and designs made this the fastest growing market, especially with youth culture's interest in extreme sports such as BMX racing and skateboarding. Designers such as **Donna Karan**, **Marc Jacobs**, **Prada**, and **Hermès** became recognized names from **sneakers** to **sweatshirts**. The activewear clothing category now includes office attire, where performance, comfort, and flexibility are key elements.

ACTIVEWEAR DESIGNER. A designer who specializes in designing clothes that relate to active sports such as aerobics, exercising, cycling, yoga, horseback riding, jogging, skateboarding, tennis, swimming, and surfing. Activewear designers might also specialize in **performance apparel** for sports such as skiing, snowboarding, hiking, boating, and mountaineering.

ADELI, KATAYONE (1967–). Katayone was born in Iran and moved to the United States at the age of 10. She grew up in Los Angeles, California. She launched her line in 1996 and her perfectly **tailored**

pants were her signature. In 2000, she teamed up with **Jimmy Choo** to create a line of shoes and boots.

ADIDAS. A **sneaker** company formed by Adi Dassler in 1948 in Herzogenaurach, Germany, after breaking the partnership with his brother Rudolf, which had begun in the 1920s. Rudolf went on to form the rival company **Puma.** Adidas has grown to become the second-largest sport shoe **manufacturer** with innovation at the forefront of the company's success. In 2004, Adidas launched Adidas 1, the first "thinking sneaker" complete with a microchip that could modulate its cushioning depending on need. Adidas has also teamed up with fashion **designer Yohji Yamamoto** to create their Y-3 label, a **brand** that consists of **accessories,** apparel, and **footwear** for men and women. *See also* ACTIVEWEAR; BRAND IMAGE; FOOT-WEAR DESIGNER; WOMENSWEAR.

ADOBE ILLUSTRATOR. A standard illustration software package first developed by Adobe for Apple McIntosh in 1985. **Designers** and artists use this software to create vector-based flat sketches and illustrations.

ADOBE PHOTOSHOP. A graphics editor software program created by brothers Thomas and John Knoll and published by Adobe Systems in 1990. It is used by **designers** and artists to alter and manipulate images.

ADRIAN, GILBERT (1903–1959). The legendary film and fashion **designer** who created signature styles for Hollywood stars including Joan Crawford, Greta Garbo, Marlene Dietrich, and Carole Lombard. Adrian created a "look" for the stars he designed for, melding their personalities, the roles they played, and their individual physique into one recognizable fashion statement. The fashion industry capitalized on Adrian's designs by providing **knock-offs** which were sought after by the movie-going public. In part, it was the beginning of **lifestyle-dressing.** American women redefined themselves based on their favorite stars' clothing and **Seventh Avenue** sold a record number of these mass-produced copies. Adrian also had the ability to create fashion based on his client's physical attributes. Such was the

case with American actress Joan Crawford and her unusually broad shoulders. The dress designed by Adrian for Crawford for the movie *Lette Lynton* (1932), emphasizing the shoulder, served as the springboard for shoulder pads in women's clothing. Adrian was also the creator of the first **power suit** for women, again using shoulder pads as a significant design element. This style suit played a key fashion role in the 1980s when women took on the issue of equality with men in the corporate world of business.

Born Adrian Adolph Greenberg in 1903 in Connecticut, Adrian studied fashion at what is now **Parsons School of Design**. After his retirement from the film industry, Adrian continued in fashion with his own **couture** and **ready-to-wear** business located in Hollywood. He died in 1959 and will always be considered one of America's great designers. *See also* ARMANI, GIORGIO; FORD, TOM.

ADROVER, MIGUEL (1965–). This Spanish **designer** arrived in New York in 1991 and presented his first collection in 2000. Even though Adrover had no formal design education, his classic designs had a notable attention to detail and spoke "fashion" in every sense of the word.

ADVERTISING CO-OP MANAGER. A person who is experienced at working with internal and external (client) advertising budgets. This position requires strong communication and organizational skills, as well as an ability to work on advertising projects and manage financial and operational controls. Knowledge of the advertising/marketing industry is a must.

ALÄIA, AZZEDINE (c. 1940–). Born in Tunisia, this designer was raised by his grandparents and later studied sculpture at L'École des beaux-arts de Tunis. Aläia learned the high standards of **couture** when he entered the fashion industry as a dressmaker's assistant, a position in which he learned how to copy couture gowns. He left Tunis for Paris in 1957; he worked for **Christian Dior** then Guy Laroche until he began making clothes for private clients. He opened a small salon on the Left Bank where he catered to socialites, movie stars, and models while occasionally **freelancing** for name designers such as **Yves Saint Laurent, Thierry Mugler,** and **Charles Jour-**

dan. In 1970, he created a **ready-to-wear** line for his shop and in 1981 launched his first collection to rave reviews. By 1983, he had opened a **boutique** in Beverly Hills and was a hotly sought-after **designer** to the stars because of his contoured, clingy, curvy, body-shaping lines.

Aläia is famous for his expert tailoring and use of stretch fabrics as body **corsets**. The French Ministry of Culture awarded him the Designer of the Year award in 1985. His work has been shown in retrospectives at the Bordeaux Museum of Contemporary art in 1984, at the Groninger Museum 1998, and in an exhibition (*Radical Fashion*) at the Victoria and Albert Museum in 2001. In 2000, **Prada** acquired a stake in the company and he showed his first couture collection in 2003. However, Aläia shunned the overmarketing of his contemporaries and limited his ventures. After several decades in business, his only planned project is to launch a **fragrance**. His fashion shows are few yet his clients are numerous including Madonna, Tina Turner, Diana Ross, Kim Basinger, and Paloma Picasso, as well as **supermodels** and film stars.

ALFARO, VICTOR (1965–). Born in Mexico, Alfaro came to the United States in 1981 and graduated from the **Fashion Institute of Technology** in 1987. In the late 1980s, he designed for **Joseph Abboud**. Sought out by celebrities, Alfaro created his sexy and body-clinging designs in everything from **leather** to sheers. He is the recipient of numerous awards including the coveted **Council of Fashion Designers of America (CFDA)** Perry Ellis Award for New Design Talent.

ALPACA. A **natural fiber** sheared from the hair of the alpaca, a camel-like animal native to the Andes Mountains that was domesticated more than 5,000 years ago. The fiber is made into yarn and then woven or knitted into very warm yet lightweight apparel and **accessories**. Alpaca is considered a fabric of luxury.

ALVANON. A company that manufactures a customized dress form called Alvaform, either by using a **brand**'s measurements or by **bodyscanning** a **fit model**'s measurements. *See also* DRAPING; DRESS FORM; SHAPELY SHADOW, INC.

AMALGAMATED CLOTHING WORKERS OF AMERICA (ACWA). A trade union formed by the men's clothing **manufacturers** in 1914. It merged with the Amalgamated Clothing and Textiles Workers Union (ACTWU) in 1976 and later merged with the **International Ladies' Garment Workers' Union (ILGWU)** in 1995 to form the **Union of Needletrades, Industrial and Textile Employees (UNITE)**.

AMERICAN APPAREL & FOOTWEAR ASSOCIATION (AAFA). An organization comprised of members of the apparel and **footwear** industries. This organization's members also include those from the **childrenswear** industry since the Childrenswear Manufacturers Association dissolved in the late 1990s. The AAFA conducts industry seminars and addresses issues related to legislation, product review, and the Consumer Products Safety Commission (CCPSC).

AMERICAN LOOK. A fashion look that emerged after World War II that captured the American lifestyle of wearing casual, easy pieces, which was a sharp contrast to Europe's more structured silhouettes. **Designers** who pioneered the look in the 1940s and 1950s included **Claire McCardell, Bonnie Cashin, Tina Leser, Hattie Carnegie,** and **Anne Klein** and, in the 1960s, **Bill Blass, Geoffrey Beene,** and **Donald Brooks.** This fashion look not only gave American designers credibility as fashion leaders, but it also changed the way the world viewed fashion and its natural adaptation to lifestyles of the times. Travel by air meant lighter and more versatile clothing with all of the key components one expects of designer clothing. The intuitiveness of the American designer, together with unbridled talent, turned **Seventh Avenue** in New York City into Fashion Avenue, as it is known today. *See also* LIFESTYLE-DRESSING; LORD & TAYLOR; POPE, VIRGINIA; SHAVER, DOROTHY; SNOW, CARMEL WHITE; SPORTSWEAR.

AMERICAN SOCIETY FOR TESTING AND MATERIALS (ASTM). An organization founded in 1898, originally known as the American section of the International Association of Testing Materials. In 1902, the American section of the organization was renamed the American Society for Testing and Materials. Twelve thousand items are listed in the Annual Book of ASTM Standards.

AMIES, SIR HARDY (1909–2003). Born in London, he joined the house of Lachasse in 1934, where his mother worked, and he was soon promoted to chief **designer**. During World War II, Amies served as a liaison to the British and Belgian armies and contributed designs to the **Government Utility Scheme**, which raised money for the war effort by selling clothes for export to the Americas. He also worked with the **Incorporated Society of London Fashion Designers**, the governing body of British **couture**. He opened his own couture house on **Savile Row** in 1945. In 1955, he was appointed as the official **dressmaker** to Queen Elizabeth II, a position that ended when he turned eighty years old. Amies addressed the problem of being copied by selling **toiles** of his suits to stores and made numerous **licensing** deals for **menswear**, workwear, cosmetics, lingerie, and **ready-to-wear** clothing. He received the British Hall of Fame Award and was honored with knighthood in 1989. Amies, at the age of ninety-three, sold the company to the Luxury Brands Group in 2001. Since then, the newly created ready-to-wear collection, designed by Paolo Gabrielle in 2002, was poorly received and ceased, and the couture line has seen a parade of designers come and go — including Kenneth Fleetwood, Jon Moore, and Jacques Azagury. In 2004, Ian Garlant put Hardy Amies **haute couture** back on track. *See also* BRITISH CIVILIAN CLOTHING ORDER CC41.

ANDROGYNOUS LOOK. This is the term given to fashion that is neither masculine nor feminine. Popularized in the 1970s with the glam rock and **punk** rock movement, followed in the 1980s with the **grunge** movement, and continuing in the new millennium with **designer** Hedi Slimane's bi-gender designs, androgynous dress continues to be a mainstay of the fashion industry. Stores like the **Gap, Abercrombie & Fitch, J. Crew,** and Land's End were all founded on the unisex **separates** concept.

ANGORA. An **animal fiber** sheared from the hair of the Angora rabbit. Although angora was originally sourced in France and North America, most angora is produced in China today. Its soft, fine texture and warmth capability make it a desirable fiber for sweaters, hats, and gloves.

ANIMAL FIBERS. Fibers that are derived from the hair of animals, including **wool** from sheep, **alpaca** hair from alpacas (a relative of camels and llamas), **angora** from rabbits, camel hair from camels, and **cashmere** and **mohair** from goats. **Silk** fiber is made from the cocoon of the silkworm.

ANTHROPOLOGIE. Founded in 1992 by a group of individuals committed to offering consumers a retail "destination" focused on simple objects, one-of-a-kind designs, and merchandise that is fluid in both presentation and availability. With stores throughout the United States and a thriving **catalog** business, Anthropologie addresses the need for merchandise that is not built around an identifiable image; rather, it has created a following of consumers expecting nothing more than the unexpected. In 2006, Anthropologie opened a 22,000-square-foot store in New York City's Rockefeller Center and it continues to comb the world for apparel, **accessories**, and home furnishings that speak to its eclectic and individual style. Collaborations in fashion include **Anna Sui**, Tracy Feith, and Odessa Whitmire among those who have teamed up with the company. *See also* E-TAILING; RETAILER.

ANTOINETTE, MARIE (1755–1793). She was born at the Hapsburg Palace in Vienna as Maria Antonia Josepha Johanna von Hapsburg-Lorraine, the daughter of the Holy Roman Emperor Francis I and his wife, the Archduchess Maria Theresa of Austria. In 1770, at age fourteen, she was sent to France to marry the grandson of King Louis XV, Dauphin Louis-Auguste in 1770. In 1774, upon the death of King Louis, she and her young husband became king and queen of France. **Rose Bertin**, **designer** to the court, created Marie's magnificent coronation gown. During her reign as the queen of France (1774–1793), she and King Louis XVI strongly promoted French fashion and textiles. Their excesses and spendthriftiness resulted in rumors and bankruptcy and fueled the French Revolution, which ultimately led to their demise.

ANTONIO. *See* LOPEZ, ANTONIO.

ANTWERP SIX. The designers from Antwerp, Belgium, who achieved global recognition with their innovative collections during the 1988

British Designer Show in London. They were **Walter Van Beiren-donck, Dirk Bikkembergs, Ann Demeulemeester, Dries Van No-ten, Dirk van Saene,** and **Marina Yee.**

APPAREL DESIGNER. The title and function of a person employed by an apparel **manufacturer** who is responsible for studying the needs of specific customer segments (via market research), analyzing appropriate fashion trends, creating design concepts and sketches, selecting the fabrics, and overseeing all aspects of garment design. This employee manages a **design room** team comprised of an **assistant designer, associate designer, patternmaker,** and **samplemaker.** Designers must possess good illustration abilities and detailed flat-sketching skills, as well as a strong technical knowledge of **draping, patternmaking,** garment construction, and fitting. In the twenty-first century and beyond, apparel designers also need computer skills to proficiently supervise the operators of **CAD, bodyscanning,** and other computer-assisted design tools in both their own groups and **retail** organizations.

AQUASCUTUM. This British company was established in 1851. Known for its line of rainwear, Aquascutum also manufactures men's suits and **sportswear.** In 1992, the company broadened its look and incorporated more trendy items. This revamping trend in companies long respected for their traditional look became prevalent in the 1990s. Marketers saw the opportunity to take advantage of names identified with longevity and quality but not necessarily with the latest trends: Auqascutum was one of them, **Burberry** was another.

ARCHETYPE. A company founded in 2000 by Robert Halloway in Emeryville, California, that offers a patented mass-customization software used by Land's End, **Target,** and **J. C. Penney's.** Customers input several of their body dimensions into a company's website form and then select a style. The software will find the appropriate size and in some cases a customized **pattern** will be executed. Land's End and J. C. Penney's have always been associated as key players in the **catalog** world. This business was built upon convenience and, in the twenty-first century, *convenience* translates into fit. The consumer no longer accepts that they are not the appropriate **body type** for the

clothing; rather, the **manufacturer** must be the creator of the clothing that fits their body type. This category of software has become a necessary component of the fashion industry and continues to expand at a rapid speed. *See also* BODYSCANNING; E-COMMERCE; E-TAILING; ISO TAPE.

ARMANI, GIORGIO (1934–). Born in Piacenzi, Italy, Armani studied medicine before joining the Italian military. He then went on to work in window dressing before becoming a **menswear buyer**. Armani's design career began in 1964, working for Nino Cerruti, before he opened his own **freelance design** firm in 1973. In 1975, he founded his own company, Giorgio Armani S.p.A. Armani changed the way men and women perceived how each gender should dress. He blurred the lines and had men and women looking more alike. He is credited with introducing unstructured menswear in the 1980s, specifically in his radical approach to the men's jacket. He changed the traditional approach to men's tailoring and solidified **Italian fashion** as a major presence in the fashion world. Armani provided the ease of **sportswear** yet maintained the quality of **custom-made tailoring**. The Hollywood movie *American Gigolo* featured the actor Richard Gere as the model of this male sexuality; Gere was dressed solely in Armani suits. Thus, Armani became identified as the designer of choice for luxury **ready-to-wear** for men.

Armani's approach to **womenswear** was just as dramatic. He revitalized and created the **power suit** for women as they made their mark in the corporate world. The details long associated with traditional men's tailoring gave his suits for women the look, feel, and message the businesswomen of the 1980s demanded. Armani's signature continues to be softly tailored jackets in exceptional fabrics. In 2003, the Solomon R. Guggenheim Foundation funded a retrospective of Armani's work that opened in New York and traveled to the Berlin Neue National Galerie and the Royal Academy of Art in London. In 2004, Armani received the **Fashion Group International** Superstar Award. Hollywood stars were present to support Armani—the fashion icon—always a designer of taste. In 2005, Armani revitalized his couture line called Armani Privé Couture. It was also the year that he celebrated his 30th business anniversary. In 2006, Armani designed both the athletic and newscaster wardrobes for

the 2006 Winter Olympics in Turin, Italy. His empire also includes the AX/Armani Exchange, Giorgio Armani, Emporio Armani, and Armani Collection.

ARTISAN GUILDS. *See* GUILDS; TRADE UNIONS.

AS FOUR/THREEASFOUR. A fashion team started in 1999 by **designers** Kai Kuhne and his partners Adi, Ange, and Gabi. As Four legally became Threeasfour in the spring of 2006 following Kuhne's 2005 exit. Kuhne had a very different focus for the company and he seemed to often be at odds with Adi, Ange, and Gabi, the one-name monikers that are their identity. The now very successful **denim** line was the point of contention, and history has proven that Threeasfour had the vision and ability to create an original line in a "hot" fabrication and "hot" price point. The trio plans to develop a handbag and shoe line and create a lifestyle **brand** with worldwide recognition. They have also created apparel for **Kate Spade**. *See also* BRAND IMAGE; LIFESTYLE-DRESSING.

ASSISTANT DESIGNER. This is an entry-level position. The assistant designer works together with the **associate designer** or **designer**. They shop the **trim** market, make appointments, and sometimes accompany the associate designer/designer on fabric appointments. They may also do follow-up work on samples, **trims**, fabric cuts, and so on for the designer. A strong technical background and good sketching and **computer-aided design (CAD)** skills are necessary to create presentation boards. In some cases, the assistant will be required to make a first **pattern**.

ASSOCIATE BUYER. A person in this position is found only in large stores and trains as an understudy for the buyer's position. He/she works with vendors, tracks deliveries, places orders and reorders, assists in sales projections, coordinates markdowns, and is responsible for managing the day-to-day activities of the **buying office** department.

ASSOCIATE DESIGNER. This position is one step above an **assistant designer** (but not yet ready to be responsible for a complete collection), who assists the **designer** in all aspects of the design

process. The position requires strong technical knowledge in garment development and construction, fabric/trim sourcing skills, and good sketching skills to be able to create presentation boards. Communication and organizational skills are mandatory to facilitate follow-up with factories. The abilities to spec and flat sketch, together with strong computer skills, are a must. *See also* TECHNICAL DESIGNER.

ASSOCIATION POUR LA DÉFENSE DES ARTS PLASTIQUES ET APPLIQUÉS. This anticopyist society was formed in 1923 for the **haute couture**, founded by designers **Madeleine Vionnet, Paul Poiret**, Madeleine Cheruit, **Charles Frederick Worth, Jeanne Lanvin**, and Drècoll. One of the organization's missions was to address international copyright laws. *See also* COPYIST.

ATELIER. A French word that describes a couture designer's workplace or studio, a space that often originated in an attic. A French atelier is staffed with a première (female workroom head) or premier (male head), a seconde (assistant head), and petits mains (sewers). *See also* DESIGN ROOM; HAUTE COUTURE.

AVEDON, RICHARD (1923–). Born in New York City, Avedon was a first-generation American whose parents were Russian-Jewish immigrants. He studied philosophy at Columbia University. Avedon met art director Alexey Brodovitch in 1944 and began working for him at *Harper's Bazaar*. A photographer for more than 60 years, Avedon has photographed more fashion **models** than any of his contemporaries alive today. The majority of his work is in black and white, whether fashion or people of distinction. Each subject is beautifully photographed in the Avedon style: never with the anticipated mood but one that assists the viewer in recognizing another dimension of the subject. He is credited with creating the look of *Harper's Bazaar* magazine and being "the" fashion photographer of the 1950s. His most famous photograph was *Dovima with Elephants*. This 1955 photograph was of one of **Yves Saint Laurent**'s first designs for **Dior**, and is said to retain its freshness, even today. Avedon, unlike his peers, took his models into action, photographing them in fluidity and in real-life backdrops rather than in a studio. In the 1990s,

Avedon worked at the *New Yorker* where he maintained his special status of total independence in his work. *See also* FASHION PHOTOGRAPHY.

AZARIA, MAX (c. 1940–). Azaria is of Jewish decent and grew up in Paris. It was in Paris that he developed an affinity for design and spent a significant portion of his career in various fashion-related professions. After eleven years of designing **womenswear**, Azaria moved to the United States and opened several successful **boutiques**. In California, he founded his company, **BCBG** (bon chic, bon genre), in 1989. Devoted to his family, Azaria is also committed to breast-cancer awareness.

AZROUEL, YIGAL (1973–). Yigal Azrouel was born in Israel and moved to New York in 1995. He presented his first high-end **ready-to-wear** (RTW) line in 2003. His signature is beautifully cut jackets, **sportswear**, and eveningwear.

– B –

BABY BOOMER. A person in the generation of people born after World War II in the United States, 1943–1960. This group was born after those known as the Silent Generation. *See also* TARGET MARKET.

BABY PHAT. Launched in 1999, this sexy junior line was then a division of parent company Phat Fashions. The line is designed by former **model** Kimora Lee Simmons, ex-wife of Russell Simmons, the music artist/producer and former owner of Phat Fashions. Simmons sold Phat Fashions to Kellwood Co. in 2004. Kimora Lee Simmons was a model for the house of **Chanel** at the age of thirteen and credits her early connection with fashion in assisting her to develop the successful Baby Phat **brand**. In 2005, the over-the-top theatrical production of the Baby Phat line during fashion week in New York did not meet with success and the company refocused on design. In 2006, Baby Phat **intimate apparel** was launched; a total lifestyle brand inspired by its **hip-hop** roots. In continuation of the brand, Lee

Simmons was exploring the **childrenswear** and **fragrance** markets in 2006; this growth, together with her book, *Fabulosity*, speaks to the role of fashion in defining, shaping, and projecting a person's image or perceived image. *See also* JUNIOR SPORTSWEAR; LIFE-STYLE-DRESSING; PHAT FARM.

BADGLEY MISCHKA. Mark Badgley (1961–) and James Mischka (1960–) are the men behind the name. They began their business in 1987 and from 1992 to 2004 **Escada** USA was their parent company. Candies Inc. and a partnership with Groupe JS International have financially backed them since 2005. Often drawing inspiration from the 1920s and 1930s, they are known for various shades of blush in their soft, elegant eveningwear collections. In 2006, the duo teamed up with celebrities Ashley and Mary-Kate Olsen. The twins have a reputation for an energized and freestyle sense of fashion, which gives an edge that complements the soft Badgley Mischka look.

BALENCIAGA, CRISTÒBAL (1895–1972). Born in Guetaria, Spain, Balenciaga opened his first salon in Madrid in 1920. Civil war broke out in Spain in 1936 and Balenciaga was forced to close his three couture houses and relocate to Paris. In 1937, he presented his first collection and, by 1939, was receiving rave reviews and was declared an **haute couture** leader. He introduced the world of fashion to the tunic, sack, and **empire** styles, as well as the no-seam coat. His native country Spain served as a source of inspiration throughout his career and its influence is recognized in the rich embroideries that often graced his ball gowns. These were the creations of the man affectionately referred to as the "Master" by his world-renowned apprentices and colleagues. Both **André Courrèges** and **Emanuel Ungaro** studied under him. Balenciaga was a man devoted to his craft, a man who lived for perfection in his designs and the execution of those designs. He was known to personally rework a completed and approved design until its construction seams became invisible and the garment became one with the body. His client list included all of those women listed on the annual best-dressed lists.

Balenciaga stayed true to his reputation as a **couturier** and would not compromise his designs or craftsmanship by entering the world

of **ready-to-wear**. This, of course, may have allowed him to create a commercial business equal to that of his friend and contemporary **Christian Dior**. While he closed his Paris couture house in 1968, however, Balenciaga's scarves, purses, and perfumes continued. His final client, a rather unusual one for him, was Air France Airlines: in 1969, his charge was to create the women's flight attendant uniforms. He retired to Spain where he lived for the remaining few years of his life. From 1987 to 2001, the house of Balenciaga was owned by Jacques Bogart SA. In 1987, a ready-to-wear line was launched and, in 1995, French designer **Nicolas Ghesquière** began designing for the house. In 2001, the **Gucci** Group acquired a controlling interest in the company.

BALMAIN, PIERRE (1914–1982). Born in the Savoie region of France, Balmain opened his couture house, Maison Balmain, in Paris in 1945. He is known for his beautifully executed and luxuriously embellished designs. Balmain was a dear friend and colleague of **Christian Dior**. In 1993, **Oscar de la Renta**, the first American to head a couture house in Europe, refocused the house of Balmain on elegant fashion and did so for almost ten years. By the start of the twenty-first century, the house was struggling for an identity that could respect chez Balmain and yet appeal to the present clientele. In 2005, the company hired Christopher Decarnin, formerly at **Paco Rabanne**, to carry out this directive. The Balmain House came to life in 2006 with a nod to its past of beautifully draped and constructed pleated gowns with a contemporary twist. *See also* HAUTE COUTURE.

B. ALTMAN. A **department store** that originated in New York City in 1906. Steeped in tradition, ladies shopped and lunched at this elegant establishment. As the customers aged, this **retailer** did not have success at revamping its image and attracting new clientele. Altman closed its doors in 1989.

BANANA REPUBLIC. *See* GAP.

BARNEYS NEW YORK. A men's clothing store founded in New York City in 1923 by Barney Pressman. Through the efforts of Barney's son, Fred, and Fred's sons, Robert and Gene, the store

became the premier specialty retailer in New York selling high-end designer merchandise and catering to a tony client. The store ran into financial difficulty after an aggressive expansion plan in the 1990s and filed for bankruptcy in 1997. It emerged two years later, thanks to two majority investors, Whippoorwill Associates Inc. and Bay Harbour Management LC. It was sold to **Jones Apparel Group** in 2004. Today, Barneys operates a dozen full-price stores—located in New York City; Beverly Hills, California; Boston and Chestnut Hill, Massachusetts; Dallas; Seattle; Chicago; Tokyo and Yokohama, Japan; and Singapore—and twelve outlet stores and Barneys Co-ops, which focus on contemporary **sportswear, accessories**, and premium **denim**. *See also* RETAILER; SPECIALTY STORE.

BARTLETT, JOHN (1963–). A native of Cincinnati, Ohio, Bartlett is a Harvard University graduate who attended the **Fashion Institute of Technology** in New York. His first position in the industry was with **Willi Smith**. Bartlett began his **menswear** line in 1992 and was the recipient of the **Council of Fashion Designers of America (CFDA)** Menswear Designer of the Year Award in 1998.

BARTLEY, LUELLA (1973–). Bartley studied at **Central Saint Martins College of Art and Design** in London. Known for her signature handbags, Bartley showed her first line of womenswear in London in 1999 and another in Milan in 2001. She grew up with horses and the influence can be detected in Bartley's designs. In 2006, Bartley entered the world of middle-American teens when **Target** stores launched her clothing and **accessories** in the United States market. *See also* MASS MARKET.

BAUMER, LORENZ. Born in Paris, Baumer designs jewelry for **Chanel** and **Cartier**, as well as designing his own signature pieces. *See also* JEWELRY DESIGNER.

BCBG. Max Azaria, the man behind the BCBG label, began the company in 1989. A fashion-forward line at a price, Azaria was first recognized for his "body hugging" looks using spandex. In 2004, Azaria launched a **menswear** line under the BCBG label.

BEAT LOOK. This look was popularized by **Yves Saint Laurent** in the 1960s. He drew his inspiration from Paris streetwear: **leather**, turtlenecks, and short skirts, all in black. Saint Laurent broke from tradition and caused a stir with his new look. His commitment to have women be a part of the change as opposed to be a product of change was more than the House of **Dior** could bear. Saint Laurent soon departed Dior to create fashion under his own label.

BEENE, GEOFFREY (1927–2005). Born in Haynesville, Louisiana, Beene studied medicine at Tulane University before dropping out to pursue a career in fashion. He started his career as an apprentice at **Molyneux** in Europe before moving to New York in 1951. In 1963, he opened his own company and received a **Coty Award** in 1964. Beene would go on to receive eight Coty Awards and, in 1976, was the first American designer to show his collection in Milan. Known for his ability to break from tradition in regard to fabric end-use, his collections played on the innovative use of fabrics together with his exceptional ability to understand the human form. His ability to coax a seam either to move in a variety of paths or to starkly stand up straight, together with his vision to allow closures to add a design element rather than obscure it, is the heart of what makes a design by Mr. Beene one to be studied—and often held in awe. One of the "three American Bs"—as in Beene, **Blass**, and **Brooks,**—Beene is a significant part of the American foundation in fashion. In 2001, Beene decided to remove his signature collection from **department stores**, thus limiting it to a made-to-order business he conducted from his 57th street offices.

Beene was known to be as difficult as he was sweet—and was always very clear that things had to be done his way only. He had an ongoing feud with *Women's Wear Daily (WWD)* for years over his disapproval of an editor who was sent to him, the result being that *WWD* was barred from his shows into the late 1990s. In 2006, Geoffrey Beene Inc. was positioning itself for significant growth in its **licensing** arena while discontinuing its **custom-made** collection. In the same year, the company generated $600 million in retail sales with a focus on developing its women's and men's portfolios. *See also* AMERICAN LOOK; COUNCIL OF FASHION DESIGNERS OF AMERICA (CFDA); MADE-TO-MEASURE.

BENETTON. *See* UNITED COLORS OF BENETTON.

BERCHET, GERALD. An American DuPont scientist who, together with **Wallace Carothers**, invented **nylon** in 1935. It was the first commercial petroleum-based synthetic fiber.

BERGDORF GOODMAN. A retail establishment founded by Herman Bergdorf at a site in downtown Manhattan, New York. Edwin Goodman purchased the store in 1906 and moved it to where Rockefeller Center now stands. In 1928, it moved to its present location on 57th Street and today is owned by **Neiman Marcus**. Known for its high-end **womenswear** and **menswear**, it was also the first retailer to adapt Newgistics' **SmartLabel** for ease of return both in the store and online. "Bergdorf's," as it is affectionately referred to by customers and the trade alike, identified its changing customer needs and successfully adapted while still retaining its old-world elegance. *See also* DEPARTMENT STORE; RETAILER.

BERNARD, AGUSTA (1886–1946). She initiated the idea of using both her first and last name in an effort to maintain a unique identity. She opened her own business in Paris in 1919 and was known for her use of pale colors when designing eveningwear. Agusta Bernard began a marketing concept of name recognition that proves to be successful into the twenty-first century, since it specifically applies to identity in the fashion industry. **Hattie Carnegie** similarly employed this concept in 1889; the **Threeasfour** design team is an example of this in 2006.

BERTIN, ROSE. The first known **apparel designer** who designed clothing for Queen **Marie Antoinette** of France during the 1770s.

BESPOKE TAILORING. *See* SAVILE ROW; TAILOR.

BEYONCÉ. *See* HOUSE OF DERÈON.

BIAGIOTTI, LAURA (1943–). An Italian designer, Biagiotti presented her first line of **womenswear** in 1972. Her signature fabric is **cashmere**, her identifying color, white, and her silhouette, feminine.

In 2003, Biagiotti launched her first **childrenswear** line, Biagiotti Dolls. The Dolls line also uses cashmere in **knitwear** designs and is geared to girl's ages two to fourteen. Additionally, Biagiotti launched Laura B Bodywear in 2004. Biagiotti's daughter, Lavinia, designs for this as well as the Roma line.

BICYCLE CLOTHING. Clothing specific to this sport dates back to the late 1800s. The bicycle attire of the twenty-first century plays equally on fashion and function as well as displaying the latest fashion **logos**. *See* ACTIVEWEAR.

BIKINI. A bathing suit design consisting of two pieces, a top and a bottom piece, which cover a woman's breast and pantie areas. The bikini, which was originally designed by Louis Reard in Paris in 1946, is often characterized by its minimal dimensions, creating maximum bodily exposure. Bikini Island and Bikini Atoll in the South Pacific are the bathing suit's namesake. This article of clothing socially addresses an era when women felt it was their right to show off their bodies—and Hollywood and the movie industry took full advantage of the concept of a beach **lifestyle**. Bathing suits as fashion moved into mainstream attire and the fashion industry recognized the business potential ready to be tapped. Variations of the bikini have evolved, such as the French bikini and string bikini. In 2006, as the bikini celebrated its 60th birthday, performance fabrics, particularly advances with **Lycra**, keep the bikini fitting at its best. *See also* ACTIVEWEAR.

BIKKEMBERGS, DIRK. A member of the **Antwerp Six**, an avant-garde designer known to exploit the look of incomplete.

BIOMETRICS. A technology developed by Biometric Solutions as an Automated Fingerprint Identification System (AFIS) that is used to verify a person's identity through fingerprint, face, or retinal scanning. This technology was originally designed for use in helping law enforcement agencies track and identify individuals who have committed a crime. These solutions save time and increase accuracy in the identification, processing, and management of individuals for criminal and civil purposes. However, the fashion retail community

utilizes the technology to enhance customer service and to save time and money. For example, at the checkout counter, when a special transaction requires a store manager's approval, a biometric-equipped personal digital assistant (PDA) device enables the store manager to authorize a refund from wherever he may be in the store so that the customer does not have to wait. The manager simply logs on to his wireless PDA from anywhere in the store and, with the touch of his thumbprint, he can authorize the return. Another use of the technology involves a customer payment program. A customer's fingerprint can designate which payment method he/she wishes to use, eliminating costly and time-consuming credit card transactions.

BIRKENSTOCK. A shoe company that traces its roots back to Johann Adam Birkenstock, a German shoemaker in 1774. In 1897, Johann's grandson, Konrad, developed the first contoured insole to be used by shoemakers in the production of **custom-made footwear**. In 1902, he invented the first flexible arch support and, by 1925, the Birkenstock Company was exporting its arch supports all over Europe. In 1964, Carl Birkenstock's son Karl designed the first Birkenstock sandal. Two years after, American Margot Fraser discovered the health benefits of the sandal while in Germany. Fraser brought the sandal back to California where she founded her company, the Birkenstock Footprint Sandals Inc. Today, there are more than 300 styles based on the original comfort icon concept. *See also* FOOTWEAR DESIGNER.

BLAHNIK, MANOLO (1942–). Born in the Canary Islands, Blahnik entered the shoe business in 1973 when he bought a shoe store and, in 1978, he produced his own line of shoes. With a name synonymous with sexy as it relates to shoes, Blahnik has created **footwear** for the runway shows of designers such as **Saint Laurent**, **Calvin Klein**, and **John Galliano**. In the twenty-first century, Blahnik became a household American name due to the recognition his shoes received in the hot TV series, *Sex and the City*. *See also* BRAND IMAGE; FOOTWEAR DESIGNER.

BLASS, BILL (1922–2002). Born in Fort Wayne, Indiana, Blass opened his company in 1970. Credited with being the first American **designer** to print his name on a fashion label, Bill Blass combined

the elegance of **Adrian** with the practicality of American design. The king of the American **trunk show**, Blass was as much about charm as fashion. He was very much a part of the social scene; Blass brought the American designer out of the **design room** and into the spotlight. By 1991, Blass realized that providing the overall direction to his design teams did not sufficiently convey his look, so he took back control and sales confirmed the positive influence of the man behind the name. A successful **jeans** line was licensed in 1998 to Resource Club. In 2002, the firm added a **brand** extension in Bill-Bill Blass, securing a spot in the **bridge market** in **knitwear** and wovens.

Blass had retired in 1999 and sold the company the following year for $50 million. He passed away in June 2002, days before his 80th birthday. In his will, he bequeathed $1 million to the **Fashion Institute of Technology**; today, the Blass Design Center houses the latest knitwear technology and provides students the opportunity to prepare to make their mark as great American designers. Bill Blass Ltd. continued after Blass's death with a succession of designers: Steven Slowick, Lars Nilsson, and Michael Vollbracht. By 2005, the company recognized the need to add some spark and also decided to evaluate its **licensing** agreements. It reduced its agreements from 40 to 30. One of the "three American Bs"—as in **Beene**, Blass, and **Brooks**—Bill Blass was an American **lifestyle** designer and so is the company today, elegant but always with a **sportswear** undercurrent. *See also* AMERICAN LOOK; DENIM.

BLOOMER-ROMPER. A garment introduced in 1919 for girls, it allowed freedom of movement with its full pantlike shape. Its name is taken from the woman credited with the invention of the "bloomer," Amelia Jencks Bloomer of New York. Bloomer believed in functional clothing and introduced women to "Turkish" pants. It was a variation of these pants that became bloomers. When constructed as a one-piece garment, inclusive of a top, the bloomer-romper was born. Adaptations were developed in the sleepwear and junior sportswear markets in the 1980s. *See also* CHILDRENSWEAR.

BLOOMINGDALE'S. A **department store** founded in 1872 by Lyman and Joseph Bloomingdale in New York City. By the 1970s, "Bloomies" was the place to shop if young, hip, and affluent (or the

aspirations of affluence) were part of your makeup. By the turn of the century, it was a destination for those seeking the latest designer **ready-to-wear** fashions, as well as more moderate variations. *See also* FEDERATED DEPARTMENT STORES, INC.; RETAILER.

BODYMETRICS. A London-based virtual 3-D **bodyscanning** fashion technology, Bodymetrics was co-founded by Suran Goonatilake, a professor at University College London. Bodymetrics is credited with completing Britain's first national sizing survey in 2005. *See also* SIZEUK.

BODY PIERCING. The insertion of small-gauge jewelry anywhere on the body, but especially in the ear, nose, navel, tongue, eyebrow, cheek, vulva, or nipple, through holes pierced in the skin. This is a popular means of artistic and fashion expression that emerged as a mainstream trend in the late twentieth century.

BODYSCANNING. A system of measuring using a device employing either radio waves or laser technology to accurately measure the body. *See also* BODYMETRICS; CYBERWARE; [TC][2].

BODY TYPE. A description of a kind of body shape. Female body types are usually described by the fashion industry as *pear shaped*, small shouldered and wide through the hip area; *wedge shaped*, with broad shoulders and small hips; *oval shaped*, wide through the middle; *hourglass shaped*, as small-waisted and curvy; and *column shaped*, in which the shoulders, waist, and hips are of the same width.

BOHAN, MARC (1926–). A **couturier** who took over as artistic director at **Dior** after the departure of **Saint Laurent**. He continued in the position until 1989. Bohan ended his career attempting to revive the house of **Norman Hartnell** in London. *See also* HAUTE COUTURE.

BON MARCHÉ. A **department store** founded in Seattle, Washington, in 1890 by the Nordhoff family. It was named after the noted Paris retail establishment founded forty years prior and it catered to the working-class consumers in the Northwest United States. *See also*

DEPARTMENT STORE; FEDERATED DEPARTMENT STORES, INC.; LE BON MARCHÉ.

BOSS, HUGO. This German **menswear** firm, founded by Boss in 1923, grew to be one of the largest menswear producing companies of the twentieth century. The company is known for fashion-conscious suits that combine unusual details with cutting-edge textiles. Through **licensing**, the company continued to grow and went public in 1985.

BOTTEGA VENETA. This Italian luxury **leather** goods company was founded in 1966. It became known worldwide for its signature handwoven leather accessories. Today, it is owned by the **Gucci** Group and is joining together with a renowned Italian trade school to create an educational program addressing the craft of making luxury handbags. *See also* ACCESSORIES.

BOUTIQUE. An integral part of the retail fashion world, boutique shops began in the 1960s and are synonymous with **designer** names such as **Mary Quant**, who created fashion at affordable prices. These shops hold true to individual concepts and ideas. *See also* FRANCHISED BOUTIQUES; MOD LOOK.

BRA DESIGNER. This specialty designer must understand bra construction, attend fittings, make fit corrections, and work with the sample room to ensure accurate measurements. The bra designer creates illustrations and conceptualizes the entire bra line for a specific selling season. *See also* APPAREL DESIGNER; INTIMATE APPAREL.

BRAND. The personality of a product. What the consumer becomes attracted to and develops loyalty to. A strong brand maintains its following even after the departure of its founder. *See also* BRAND IDENTITY; BRAND IMAGE; LICENSING; MEGABRAND.

BRAND IDENTITY. Identifying qualities that distinguish a **brand** from its competition. All attributes, benefits, features, and qualities that a consumer expects from a brand. *See also* BRAND IMAGE; LICENSING; MEGABRAND.

BRAND IMAGE. The attachment of a name to a business or product. The way in which a consumer sees a **brand**. This is not always the same as the **brand identity**. *See also* LICENSING; MEGABRAND.

BRICK AND MORTAR. A company that has a physical location as compared to a virtual site to shop at. For example, a **department store** may have a physical location (brick and mortar) as well as a website. *See also* CHAIN STORE; E-COMMERCE; E-TAILING; MASS MARKET; SPECIALTY STORE.

BRIDGE MARKET. The market niche between the **designer** and **contemporary market**. The bridge market was originally suit driven and later became more casual. It was a way for designer collections to capitalize on their name by offering less expensive merchandise for the customer who is **brand** conscious. Examples are **DKNY**, **Dana Buchman**, and **Ellen Tracy**. *See also* BRAND IDENTITY; BRAND IMAGE; LICENSING.

BRITISH CIVILIAN CLOTHING ORDER CC41. A law passed in Great Britain during World War II making it illegal for a **manufacturer** or **designer** to use unnecessary buttons, stitches, pockets, pleats, or any embellishments that were not functional to the garment in order to save raw materials and labor. *See also* AMIES, SIR HARDY; GOVERNMENT UTILITY SCHEME; HARTNELL, NORMAN; INCORPORATED SOCIETY OF LONDON FASHION DESIGNERS; MOLYNEUX.

BRITISH FASHION COUNCIL (BFC). Founded in 1983, the BFC is a nonprofit limited company that is financed by industry sponsors. *See also* FASHION HOUSE GROUP OF LONDON.

BRITISH FASHION COUNCIL HALL OF FAME. An award given by the **British Fashion Council** to **designers** who have made a major contribution to British fashion and the British fashion industry. Some recipients of the prestigious award were **Zandra Rhodes**, **Mary Quant**, and **Sir Hardy Amies**.

BROOKS, DONALD (1928–2005). Born in New Haven, Connecticut, Brooks graduated from **Parsons School of Design** in the late 1940s.

He designed under his own label from 1965 to 1973. Brooks is the founder of the **Council of Fashion Designers of America (CFDA)**. He helped create the **American Look** along with designers **Bill Blass** and **Geoffrey Beene**—together they were known as the "three Bs." In 1966, Gimbels was the first American **department store** to carry the "three Bs" under their own individual labels. Brooks designed **ready-to-wear**, swimwear, lingerie, rainwear, furs, wigs, home furnishings, and **menswear**; and he is best known for use of prints in his clothing designs.

BROOKS BROTHERS. A **manufacturer** that began producing handmade **ready-to-wear** men's suits sold in their own stores for mass consumption since 1818. Marks & Spencer **department stores** bought it in 1988. Known for its traditional look, Brooks Brothers is a destination for classics such as blazers, flannel trousers, and penny loafers. Brooks Brothers also sells **womenswear** and boyswear. *See also* BRAND IMAGE; CHILDRENSWEAR.

BROWN SHOE COMPANY. George Warren Brown founded this shoe company in 1878 in St. Louis, Missouri. The company is best known for its children's shoe, the Buster Brown, introduced in 1904 and based on the cartoon character. In the 1950s, the U.S. Department of Justice filed a civil action against the merger between Kinney Shoes and the Brown Shoe Co., claiming that it would cause a monopoly in the shoe industry. Although the merger was approved in 1956, the Supreme Court ruled in 1962 that the merger was unconstitutional and ordered them to separate. In 1981, Brown Shoe purchased the thirty-six-store chain Famous Footwear and is now the number-one **retailer** of value-priced shoes in America with the following **brands**: Naturalizer, Life Stride, Dr. Scholls, Carlos, Franco Sarto, Via Spiga, Buster Brown, Connie, and Bass. *See also* FOOTWEAR DESIGNER.

BRUMMELL, GEORGE BRYAN (BEAU) (1778–1840). He was a British gentleman who helped establish England as the center for men's fashion during the reign of King George IV.

BUCHMAN, DANA (1951–). A graduate of Brown University and **Central Saint Martins College of Art and Design**, Buchman, who

was at the time designing for **Ellen Tracy**, joined the **Liz Claiborne** family where she became head **knitwear designer** and vice president of **sportswear**. In 1987, she began a **bridge** line for the company under her own label. Her look is classic and feminine and provides a fluid aesthetic for her coordinated sportswear. Currently the Buchman **brand** has five retail stores and plans to expand into the **accessories** market. *See also* BRIDGE MARKET; KNITWEAR DESIGNER; RETAILER.

BULGARI. The roots of this prestigious jewelry firm and **retailer** began in Greece in the early 1800s. Sometime during the 1880s, the family settled in Naples and soon moved to Rome. In 1894, the flagship store of this ancient Greek silversmith opened at #28 Via Condotti in Rome. The high-end company catered to the tastes of the world's jetsetters and offered unique jewelry designs touching on Greek and Roman art. Today, Bulgari is a luxury brand for not only jewelry but also watches, handbags, fragrances, and accessories. In the 1970s, Bulgari opened locations in New York City, Paris, and Geneva and today has more than 200 locations worldwide, including its own resort hotels. In 2007, Bulgari plans to open its biggest store in the heart of Tokyo. The Japanese market embraces the quality, tradition, and **brand image** Bulgari has created for its product. Known for its ability to creatively and beautifully mix colorful semiprecious stones and diamonds in jewelry to be worn every day, the Bulgari empire is directed by Paolo Bulgari, chairman, and Nicola Bulgari, vice chairman. *See also* BRAND; JEWELRY DESIGNER.

BURBERRY. A shop founded in England in 1856 by Thomas Burberry. Initially identified with upscale waterproof fashion, the name Burberry is most easily identified with its signature black, red, white, and camel plaid fabric, which it registered in 1924. In 1998, American Rose Marie Bravo was appointed Burberry's chief executive. Bravo previously was the president of U.S. retailer **Saks Fifth Avenue**. Bravo revamped Burberry, expanding it from its predictable raincoat roots through an innovative transition based on its tradition. The relocation of the famous Burberry plaid from the inside of the garment to the outside created worldwide recognition and thus consumers sought out everything from baby buggies and handbags to **bikinis** in

the famous Burberry plaid. Womenswear and **accessories** became a new focus and Bravo recruited Roberto Menichetti as design director. In 2001, after three years at Burberry, British designer Christopher Bailey, who had previously been senior womenswear designer at **Gucci** since 1996, succeeded Menichetti. Bailey was charged with reinforcing the company's British heritage. Its twenty-first-century collections build on the company's **brand identity** while constantly searching for fashion edginess. *See also* RETAILER.

BURDINES. A **department store** founded in 1898 in Miami. In 1998, Burdines celebrated its 100th year of business. In the twenty-first century, it is known as "Macy's Florida." *See also* FEDERATED DEPARTMENT STORES, INC.

BUREAU OF ECONOMIC ANALYSIS (BEA). A U.S. government institution that reports on gross domestic product by industry. This agency provides useful information of and for the fashion industry.

BURROWS, STEPHEN (1943–). Born in Newark, New Jersey, this designer made fashion history by turning seams and hems inside out and for making the "lettuce edge" a fashion statement. Burrows was given a studio at Henri Bendel in 1970, won three **Coty Awards**, and, after closing his business for several years, reopened in 2002, again with the help of the store Henri Bendel. Burrows embodies what the youth fashion of the 1970s was about: fluid knits charged with the energy of the disco scene. *See also* DISCO STYLE.

BUTTERICK PATTERNS. A pattern company founded by Ebenezer Butterick (American) in 1863. Initially, he manufactured **patterns** for men's shirts and **childrenswear**, and added women's patterns by 1866. Butterick is credited with being the first pattern producer to offer patterns in a full range of sizes; up until this time, patterns were sold as one size only. In 1867, he incorporated the company as Butterick & Co., and four years later boasted sales of four million patterns. His first patterns were made of stiff paper; however, once Mme. Demorest began selling soft tissue patterns in envelopes in 1872, Butterick followed. In 1916, Butterick included sewing and layout instructions (the Deltor) and was producing its own magazine,

The Delineator. The home sewing market remained strong until the 1960s. Several factors impacted the change: more women went to work as opposed to staying at home, clothing styles began to change at an increasing pace, and, as more manufacturing moved offshore, clothing prices fell. Suddenly, clothes were more affordable and consumers were more attracted to purchasing now rather than waiting to sew. In 1961, Butterick acquired **Vogue Patterns** and continued to work under its own signature. In 2001, **McCall's Pattern Company** bought Butterick and Vogue. *See also* DEMOREST PATTERNS; SIMPLICITY PATTERN COMPANY.

BUYER. The title and function of a person responsible for the selection and pricing of merchandise, as well as for maintaining profit margins, in a fashion retailing organization. Large retailers hire buyers who are responsible for a specific department, such as **outerwear, special occasion, designer merchandise, accessories, footwear**, and so on. This employee is responsible for growing the sales of a department or division and reports to the **divisional merchandise manager**.

BUYING OFFICE. Buying offices are classified into two types: the **Central Buying Office (CBO)** and **Resident Buying Office (RBO)**. The CBO represents its own stores and performs central planning, buying, and merchandising. An RBO works with a number of individual **specialty stores** and their buyers and acts in an advisory capacity although they may buy directly for a store. The primary responsibility of both types is trend prediction and merchandising. *See also* BUYER; CENTRAL BUYING OFFICE; RESIDENT BUYING OFFICE.

BVD. Messrs. Bradley, Voorhees, and Day of Chicago, Illinois, founded the men's and women's underwear company BVD in 1876. In 1908, BVD created the popular two-piece underwear model known as the union suit. In 1951, it introduced the concept of underwear sold in polybags and, in 1976, BVD was sold to **Fruit of the Loom** Ltd. It is a vertically integrated, international basic apparel company, emphasizing **branded** products for consumers ranging from infants to senior citizens. The company manufactures and markets men's and boys' underwear, women's and girls' underwear, printable **active-**

wear, casualwear and **sportswear**, **childrenswear**, and family socks. Brand names include Fruit of the Loom, BVD, Best, and Screen Stars. **Licensed** brands include Munsingwear, Wilson, Botany 500, and John Henry. Licensed apparel bearing the **logos** or insignia of the major sports leagues, their teams, and certain popular players, as well as the logos of most major colleges and universities, are marketed under the Fan's Gear brands. In 1999, the company filed bankruptcy but, in 2001, was sold to Berkshire Hathaway Inc., a company owned by billionaire financier Warren Buffett. *See also* BRAND IMAGE.

BYBLOS. This Italian company was founded in 1973 and is identified by its skillful applications of design in fine knits and its extensive use of new fabric development. **Gianni Versace** was the creative force in the company from 1973 to 1977. *See also* KNITWEAR DESIGNER.

– C –

CACHAREL. Cacharel is a clothing company that was founded in Paris in 1968 by Jean Bosquet, who in 2002 still maintained an 80 percent interest in the company. Corinne Sarrut was the first **designer**, however, other well-known designers have designed for the collection, such as agnes b. and **Azzedine Aläia**. In 2001, the company signed the design duo Ignacio Ribiero and Suzanne Clements, of **Clements Ribeiro**, as **creative directors** for the company. The company spent several years restructuring and, in 2006, announced plans to open a concept store in the Saint-Germain shopping district in Paris. It has fine-tuned its Cacharel line to be more sophisticated and will introduce its new lower price Baby Jane line. Cacharel designs **accessories**, **childrenswear**, **fragrance**, home goods, and **womenswear**. The company has numerous **licensed** products, including **intimate apparel** and **footwear**. In the United States, Cacharel is carried at **Barneys**, **Neiman Marcus**, and **Nordstrom** department stores. *See also* LICENSING.

CAD/CAM. An acronym for **computer-aided design** and computer-aided manufacturing. CAD/CAM implies that the system can design the product then control the manufacturing of it.

CAD OPERATOR/DESIGNER. This technology-driven position requires strong flat-sketching and spec knowledge, good color sense, and excellent verbal communication skills. Knowledge of the various **computer-aided design (CAD)** systems is mandatory for this position. The textile CAD operator executes textile/surface designs, colorings, and **pattern** repeats. *See also* TECHNICAL DESIGNER; TEXTILE DESIGNER.

CALLOT SISTERS. The four sisters, Marie Gerber, Marthe Bertrand, Regine Tennyson-Chantrelle, and Josephine Crimont, founded the Parisian **couture** house that bore their name in 1895. The house was best known for their luxurious use of **silk**, chiffon, and antique lace, as well as for drawing inspiration from Asian and African construction techniques. It was sister Marie Gerber who was drawn to the drape of the Asian kimono and was significantly inspired by it in her designs. She is also credited with designing some of the earliest variations of "Turkish" harem pants. Additionally, her appreciation of Asian design led to an incorporation of Oriental costume in her work. This, combined with the harem influence, gave birth to the "tango dress." The house remained active until the late 1930s. *See also* BLOOMER-ROMPER; HAUTE COUTURE.

CAPRI PANT. This tapered-leg pant that is above the ankle in length is credited to Emilio Pucci who, in 1949, sold them in his **boutique** on the Isle of Capri. The 1950s California beach lifestyle adopted the capri pant, as did designers of **American sportswear** such as **Claire McCardell.** The capri pant became a style that, to this day, continuously cycled in and out of fashion. *See also* AMERICAN LOOK; LIFESTYLE-DRESSING.

CAPUCCI, ROBERTO (1929–). An artist in the purest form, Capucci first showed his collection in Florence in 1952. He was hailed as one of Italy's promising young designers and, at the age of nineteen, participated in what is referred to as the "birth" of high fashion in Italy. His designs are sculptures created in cloth and fitted to the body. Best known for his "box shape," Capucci garments are timeless. His colors are intense and he is original in style, giving little thought to the latest trends. In 2003, Bernhard Wilhelm joined this well-respected firm. *See also* ITALIAN FASHION.

CARDIN, PIERRE (1922–). Born in Italy but raised in France as Pietro Cardini, Cardin studied architecture for a short time and then learned the trade by working at several important fashion houses: **Paquin, Dior,** and **Schiaparelli.** At Paquin, he had the opportunity to work on the costumes for the 1946 film, *La Belle et la bête*. However, it was at Dior (1946–1950) that he mastered his **tailoring** skills and opened his own business on the previous rue du Chevalier. He showed his first collection in 1953 in Paris. Cardin opened his first **boutique** for women in 1954 and a second for men in 1957. Always very much in tune with the shape of a garment, Cardin focused on the geometric sculpting of the fabric with the highest standards of craftsmanship. In the 1960s, Cardin embraced the world's fascination with space-age style and he experimented with **vinyl** and metal in combination with traditional **wool.** His clothing was minimalistic for both men and women. Unlike his contemporary, **André Courrèges,** he did not promote pants for women. Instead, Cardin created patterned tights that either blended with his mini dresses or complimented the dress's design. In 1970, Cardin took a radical approach to the **miniskirt** and created the controversial maxi dress.

Always a **trendsetter,** Cardin recognized the importance that stretch fabric had in the future of fashion and went so far as to send knit **T-shirts** down the runway with his beautifully tailored couture garments. He was a pioneer in the industry by being one of the first to commercialize **ready-to-wear** alongside the couture collection. Cardin took his famous name and attached it to the Paris restaurant Maxim's, which he purchased in 1981. By the mid-1980s, a chain of restaurants existed around the world. Cardin changed the business of fashion forever with his **branding** and marketing savvy and by creating a **licensing** empire. By the 1980s, the famous Cardin **logo** could be found on a vast range of products; and many in the fashion world felt Cardin had overexposed his name to the point of creating a negative connotation. Yet, Cardin built an empire that succeeded in making him one of the wealthiest fashion **designers**—one who boasts approximately 900 licenses. In 2006, the Pierre Cardin Museum opened in Saint Ouen, a northern suburb of Paris, containing more than 1,000 examples of his work. *See also* HAUTE COUTURE.

CARNABY STREET LOOK. Together with Kings Road, the boutiques of the 1970s in the Chelsea area of London exemplified the Youth Revolution. After World War II, the British youth, with a large share of disposable income, indulged in fashion and music. The Carnaby Look, championed by designers such as **Mary Quant**, celebrated the **miniskirt**, the ancient tunic without leggings, high boots, poor-boy sweaters, and shoulder bags. It began in Quant's first **boutique** shop, Bazaar, and the look showcased young women with boyish figures as opposed to the traditional female hourglass shape. America and the world were ready for this radical twist and the British waif **Twiggy** spearheaded the ideal fashion body of the day into thin, flat, and shapeless. *See also* MOD LOOK.

CARNEGIE, HATTIE (1889–1956). Born in Vienna, Austria, as Henrietta Kanengeiser, Hattie moved to New York City as a child. She took her name from the richest man in the world, Andrew Carnegie. She began her career in 1909, interpreting French couture. She named her company Carnegie—Ladies' Hatter. In 1918, she changed the name to Hattie Carnegie, Inc., and opened shops, a wholesale business, and factories to produce jewelry and cosmetics. She is best known for her wealthy clientele consisting of society and movie stars. Throughout the 1930s and 1940s, Carnegie gave many budding American designers a start, most notably **James Galanos**, **Claire McCardell**, **Norman Norell**, and **Pauline Trigere**. Carnegie is associated in the current fashion world as the creator of the "little Carnegie suit." *See also* BRAND IMAGE.

CAROTHERS, WALLACE. *See* BERCHET, GERALD.

CARRIAGE TRADE. Members of the upper class in need of equestrian accoutrements, including apparel.

CARTIER. A world-renowned jewelry establishment begun in 1847 in Paris by Louis-Francois Cartier and run by three generations of the Cartier family. In 1889, Cartier moved to the Place Vendome area of Paris, which became the center of the international jewelry trade. In 1904, the company popularized the first wristwatch. Cartier designed

the famous "tank" watch that became one of the most copied watches in the world. *See also* BRAND; COUNTERFEITING.

CASHIN, BONNIE (1908–2000). Born in California, Cashin began her career apprenticing in her mother's dressmaking shops. From there she went on to work as a Hollywood **costume designer** and during 1943–1949, she was the costumer for more than 60 Hollywood films. She did not devote herself to **ready-to-wear** until the early 1950s. It was fashion editor **Carmel Snow** who encouraged Cashin to go to **Seventh Avenue** in New York and design for the company Adler & Adler. Cashin, who developed an interest in clothing styles from various cultures, built her collections based on timeless favorites such as ponchos, tunics, and kimonos. Additionally, Cashin was commissioned to design World War II civilian-defense uniforms. Cashin had the vision to recognize the need for **lifestyle-dressing**, combining ease of dress without compromising look. She developed the layering system of dress and played a key role in setting the tone for American fashion. In 1953, Cashin designed **leather** clothing for the company Philip Sills and brought the use of leather into the world of serious fashion. In 1962, she became the first designer for **Coach** and pioneered the use of the brass toggle, which she later used on clothing. Her carriers fit perfectly into the Coach philosophy; the bags packed flat, were utilitarian, and maintained a timeless sense of style.

In 1985, Cashin retired from the industry and devoted her time to painting and philanthropy. She established several scholarships and educational programs at the California Institute of Technology and donated her entire archive of designs to the University of California at Los Angeles. Cashin was a five-time **Coty Award** winner and, together with **Claire McCardell**, is considered the creator of American **sportswear**. *See also* AMERICAN LOOK; LORD & TAYLOR.

CASHMERE. Cashmere is an **animal fiber** culled from goats originally of the Kashmir region in India, Afghanistan, Tibet, and Mongolia and the use dates back several thousand years. Processing the hair into fiber is a complex process but the results, when woven or knitted, produce a garment or accessory that is both warm and soft. The name *cashmere* was coined by the British in the early 1800s when Kashmir shawls, made from pashm, became the rage. Later, in

the late 1990s, the pashmina shawl was popularized but was mostly a blend of **silk** and pashm. Camel hair is a lesser grade of cashmere, produced from the hair of a camel.

CASSINI, OLEG (1913–2006). Born in Paris but raised in Italy, Cassini began as a sketcher for **Jean Patou** in Paris. He returned to Rome where he opened a **custom-made** clothing business. In 1936, he left for the United States with little else to his name than tennis racquets and a tuxedo. An unsuccessful first marriage to an heiress ended Cassini's days in New York and so he headed for Hollywood, where he began working as a **costume designer**. By 1950, he was back in New York and began Oleg Cassini Inc. on **Seventh Avenue**. Cassini was best known as the personal **couturier** to Jackie Kennedy, a U.S. first lady in the 1960s. He dressed Hollywood stars and socialites and also had the ability to make average women feel like stars in his clothing. He was also one of the first **designers** to recognize the importance of in-store appearances—and his charm and love of women only added to the success of these visits. In the **menswear** market, he was a key player in the introduction of vibrant colors and assisted in the Nehru jacket becoming a fashion trend. Cassini created elegant minimalism that was embraced by American women. *See also* MADE-TO-MEASURE.

CATALOG COMPANIES. Pioneered by companies such as **Sears, Roebuck, J. C. Penney's,** and **Montgomery Wards**, catalog shopping began as a means of reaching consumers who did not have ready access to **department stores**. Today, catalog sales are sought by all major **retailers** in conjunction with **Internet sales** to support the consumer's need to shop at home 24/7.

CAVALLI, ROBERTO (1940–). Cavalli entered the fashion world in Italy in the late 1960s. Credited with giving **denim** and **leather** luxury status, Cavalli's designs have a sexy edge. In 2002, he was awarded the **Fashion Group** Designer of the Year Award. Cavalli also designs **menswear** and **childrenswear**.

CAVALLINI, EMILIO (1946–). Born in Pisa, Italy, Cavallini creates shorts, tops, bodystockings, and fashion-forward designs in his line of tights. His family-owned company was started in 1970.

CELINE. This company was founded in 1945, in Italy, by Celine and Richard Vipianas as a children's **footwear** firm. It then expanded into high-end French footwear, women's **sportswear**, and **menswear**. In 1987, Bernard Arnault acquired the company and it became part of **Moët Hennessey Louis Vuitton (LVMH)** in 1994. The American designer **Michael Kors** designed for the firm from 1997 to 2004.

CENTRAL AMERICAN FREE TRADE AGREEMENT (CAFTA). A free-trade agreement between the United States and six Central American nations: Honduras, El Salvador, Costa Rica, Guatemala, Nicaragua, and the Dominican Republic. Proposed by President George W. Bush in 2002 and ratified by the U.S. Congress in 2005, it is thought that this agreement would create productive employment and raise income levels in Central America as well as open new markets.

CENTRAL BUYING OFFICE (CBO). The type of buying office that represents its own stores and performs central **planning, buying,** and **merchandising.**

CENTRAL SAINT MARTINS COLLEGE OF ART AND DESIGN. This college was originally established in 1854 as an industrial education venue by a parochial vicar, Reverend M. McKenzie. There, boys were taught basic design skills. By 1859, the school was independent of the parish and, by 1884, consisted of approximately 100 male and female students studying art. In 1894, the school received a grant from the Technical Education Board of the London County Council. It soon began to educate equal numbers of artists and artisans. By 1961, more than 500 students were studying for a national diploma or a diploma in art and design. It received university status in 2004 and offers both undergraduate and postgraduate degrees. The school is noted for its programs in fine arts, fashion, graphics, 3-D design, and performance. It has graduated many famous **designers** including **John Galliano, Alexander McQueen,** and **Stella McCartney.**

CERRUTI, NINO (1930–). Born Antonio Cerruti in Biella, Italy, he represents the third generation of management of Lanificio Cerruti, the high-quality **wool** textile production company founded in 1881.

He studied philosophy with hopes of being a writer but instead, in 1950, entered the family business at age twenty. In 1957, Cerruti launched a line of **menswear** called Hitman and designed costumes for plays. In 1960, he became head of the company and, in 1961, hired **designer Giorgio Armani** to design. Cerruti's first men's collection was shown in 1967 and was considered a revolution in menswear. The same year, he opened a Paris **boutique**, which became a frequent stop for movie studios and movie stars. Cerruti's charisma and penchant for theatrics were as famous as his clothes. He used publicity stunts to self-promote, such as when he painted Lancia convertibles blue then paraded them down the streets of Rome and onto the runway where a starlet broke a bottle of champagne on the hood. Cerruti became Hollywood's favorite **tailor** and his love for publicity made for a perfect marriage. His clothes appeared both on and off the big screen: on American, French, and Italian movie celebrities including Terence Stamp, Michael Caine, Jean-Paul Belmondo, Alain Delon, Richard Gere, Jack Nicholson, Clint Eastwood, and Harrison Ford and in the films *Pretty Woman*, *Wall Street*, and *The Witches of Eastwick*. In 1971, Armani left the company to open his own house and, in 1976, Cerruti launched a women's line. Then, the Cerruti Sports Line was launched in 1980 and, in 1995, Cerruti **jeans**. In an attempt to update a somewhat staid image, the company launched Couture Arte and hired American designer Narciso Rodriquez in 1996. However, Rodriquez was replaced a year later and for the next several years the company experienced a revolving door of designers. Cerruti retired and sold the business to Finpart in 2001. Roberto Menichetti (Italian) was brought in as creative director but lasted only six months; he was replaced by Yugoslavian Istvan Francer, who was replaced by David Cardona (American) in 2003. In addition to the clothing lines, Cerruti also offers **footwear**, watches, sunglasses, handbags, beauty products, and a dozen **fragrances**.

CHAIKEN AND CAPONE. Begun in 1993 by Julie Chaiken and Pam Capone, the duo launched its first line in 1994. The clothing's signature is its beautifully designed and well-fitted pants. Although Capone left the company in 1998, Chaiken continues to successfully produce popular products, to a reported $5 million in annual sales.

CHAIN STORE. A group of **department stores** carrying moderately priced merchandise. These chains of stores offer a wide variety of merchandise and they adhere to a high-volume, low-profit business strategy. *See also* H&M; KMART; MASS MARKET; SEARS, ROEBUCK AND CO.; TARGET; WAL-MART.

CHAMBRE SYNDICALE DE LA CONFECTION ET DE LA COUTURE POUR DAMES ET FILLETTES. A group organized by couture designer **Charles Frederick Worth** in 1868 for the purpose of dealing with issues relating to the manufacture of **haute couture.** Much in the tradition of the medieval **guild** concept, this organization tried to preserve the integrity of the haute couture and created a lobby that could protect the rights and interests of **made-to-measure** clothing and its workers and could differentiate them from those of **ready-to-wear.** In 1910, the name was changed to **Chambre Syndicale de la haute couture parisienne.**

CHAMBRE SYNDICALE DE LA HAUTE COUTURE PARISIENNE. Originally known as **La Chambre Syndicale de la confection et de la couture pour dames et fillettes** founded by **Charles Frederick Worth** in 1868, the name was changed in 1910 to more accurately define the organization's **haute couture** relevance. This organization set up specific rules for membership and held their members to certain criteria with regard to creativity, design, quality, and reproduction. In 1928, a school was established, known as **L'École de la Chambre Syndicale de la couture parisienne** under the French Ministry of National Education. The school still provides training for couture salons in the areas of sewing, tailoring, and the designing of **made-to-measure** garments. Chambre Syndicale merged with the **Fédération française de la couture, du prêt-à-porter des couturiers et des créateurs de mode,** in 1973.

CHAMBRE SYNDICALE DE LA MODE MASCULINE. The **menswear** division, created in 1973, as part of the **Fédération française de la couture, du prêt-à-porter des couturiers et des créateurs de mode.** This organization is comprised of **haute couture** houses and designers of men's **ready-to-wear.**

CHAN, PAUL (c. 1970–). Malaysian-born Paul Chan started his fashion career after leaving a music career in Australia. After having graduated from the **Fashion Institute of Technology**, he worked as a **designer** at Searle before starting his own collection in 2001. In 2002, he received the **Fashion Group International**'s Rising Star Award. Chan is best known for his pretty **separates** with great tailoring details. His clothes are also a hit with the Hollywood crowd.

CHANEL, GABRIELLE (COCO) (1883–1971). Born in Samur, France, Chanel began her career as a milliner in 1910 and then, in 1913, showed her first clothing collection. Coco Chanel shared the limelight as a gifted **couturière** with contemporaries of her time such as **Madeleine Vionnet, Cristòbal Balenciaga**, and **Paul Poiret**. Chanel, however, did stand alone in her ability to combine masculine and feminine design elements in her creation of comfortable, simple, and beautifully crafted clothing. She made pants and pajamas fashionable and gave them credibility as wardrobe pieces worthy of expense. A shrewd businesswoman, Chanel negotiated an agreement with Hollywood producer Samuel Goldwyn in 1931 to clothe his movie stars. It was for the sum of $1 million, notable during the time of the Great Depression. Chanel not only clinched a brilliant financial deal but also assured herself international acclaim.

Best known for her "little black dress" and the acceptance of costume jewelry in the world of couture, Chanel is also credited with presenting the world a unique perfume in 1921, her own Chanel #5. The perfume's sleek and masculine bottle style, combined with its natural and nonflowery scent, was yet another venue for Chanel to present to the world her female lifestyle philosophy—that women could be strong and feminine and thus free to pursue their individual dreams. It was during her comeback in 1954 that her famous "tweed suit" was born, which lives on into the twenty-first century. While it has had numerous variations, its core is intact and breathes Coco's philosophy of design.

The Chanel collection has been designed by **Karl Lagerfeld** since 1983. He appears to have a true understanding of the woman behind the name. His Chanel designs continue to offer clothes that allow women to grow into their own person as equals in a man's world. He invigorated the double C **logo** in the 1980s and paid homage to the

great "Mademoiselle" by developing Coco's look in the most unconventional ways, truly bringing it full circle. The Chanel women of the twenty-first century are all about class. The **brand** is as sought after by the ladies who shop couture as it is by the teenagers who shop street vendors. Her costume jewelry of the past has inspired the jewelry of today. It is fun yet classic and works with **jeans** as well as suits. Chanel remains a privately owned company that produces fashion, cosmetics, jewelry, and watches. It has a single **license** for its eyewear. In 2005, the Metropolitan Museum of Art in New York paid homage to the great Chanel in its exhibit *Chanel. See also* BRAND IDENTITY; BRAND IMAGE; COSTUME INSTITUTE OF THE METROPOLITIAN MUSEUM OF ART; HAUTE COUTURE.

CHARGEBACK. A fee charged to a vendor by a retailer for one or more of the following reasons: late shipment, improper shipping method, mislabeled merchandise, advertising fee, incomplete order, poor quality, and/or returned merchandise by customers. **Manufacturers** (vendors) are "charged back" for these infractions—which have in themselves become a lucrative money-making proposition for many **retailers.** For instance, vendors can be penalized thousands of dollars for mislabeling shipping cartons; retailers claim the mislabelings cost them time and money, which affects their profit margin. Saks Fifth Avenue's 33-page manual lists compliance requirements ranging from acceptable types of hangers and labels to mandatory use of **electronic data interchange (EDI)** mapping specifications on shipping cartons. Other retailers, such as **J. C. Penney's** and **Federated Department Stores, Inc.**, also have stringent regulations. Vendors are charged for **markdown** merchandise, product that does not sell fast enough, and for merchandise that is returned by customers due to poor fit or quality. In 2005, a class action suit was filed against Saks for improper chargebacks; the decision is pending. The Vendors Coalition for Equitable Retailer Practices (VCERP) was formed in 2005 to establish what is fair and unfair and to help monitor abuses regarding chargebacks.

CHELSEA LOOK. A style of dress that originated in the Chelsea district of London in the Beatnik culture of the 1950s but segued into the 1960s with a "look" that included capes, shoulder bags, geometric

pantyhose, **miniskirts**, and low-slung hip belts. *See also* BEAT LOOK; QUANT, MARY.

CHEMISE. A straight and unfitted dress dating back to the Middle Ages. The chemise became popular in the 1950s when **Christian Dior** and **Cristòbal Balenciaga** introduced the unfitted look.

CHERESKIN, RON (c. 1950–). An illustrator and painter, Chereskin is credited with introducing pastel colors for men's sweaters in the 1970s. "Disco fever" was the rage of the decade and Chereskin created casual **polyester** men's **sportswear**. In 2006, the Ron Chereskin label received a total makeover. The plan revolved around unifying the Chereskin **brand** into a cohesive product line. This has resulted in all **licensed** Chereskin, as well as all Chereskin main floor products, to be promoted under the Studio Ron Chereskin name. Additionally, a collection label and a **lifestyle** label are being developed. Chereskin is a recipient of a **Council of Fashion Designers of America (CFDA)** award for **menswear**. *See also* BRAND IDENTITY; BRAND IMAGE; DISCO STYLE; FASHION ILLUSTRATOR.

CHILDRENSWEAR. Prior to 1800, children were simply thought of as "little adults" in regard to clothing attire. Their clothing was a miniature version of adult society. As with adult fashion, direction was initiated in Europe and was further influenced by the parents' status in society. By the mid-1800s, boys and girls both wore simple dresses and, by 1858, pantalets became the choice of children's dress. During the nineteenth century, girls were wearing empire dresses. Simply shaped, the only definition to define the body was a sash at the high waist. The empire dress was often worn over short pants and aprons and became a practical means of protecting a little girl's dress. Boys in this period wore trousers with buttoned-fly fronts, wide-sleeved shirts, and suspenders. The multi-use bandana was worn by boys of all social classes. **Joseph Courts**, the inventor of the **tape measure**, created children's size specifications in 1850, resulting in better fitting garments. It was during the mid-nineteenth century that the school uniform was born, adopting the Eton suit which dated back to the Eton Charity School, England, in 1440. By 1798, Eton was a secondary school for upper class boys.

In 1900, **Sears, Roebuck and Company** began designing clothing for children of less affluence. Children's clothing design was building up momentum; the August 15, 1918, issue of *Vogue* featured children's clothing for the first time. Childrenswear departments opened in **May** and **Macy's department stores** in the 1920s. *Earnshaw's* magazine focused on Japan and the Philippines in its July 1931 issue, as a source of affordable European fashion looks. Just as World War II changed American fashion for women, so too did this time period have an affect on childrenswear design. Cartoon characters and child Hollywood idols played a key role in design direction. Gender expectations influenced "proper" design elements in the 1950s and, by the 1980s, children themselves were dictating fashion choices. The end of the twentieth century brought a mirror image of the adult market of fashion to childrenswear. **Branding, licensed** products, and **designer** lines drove the market. Previously "gender-appropriate" colors became nonexistent and the industry recognized the positive business opportunities in both apparel and related children's products. *See also* FASHION MAGAZINES.

CHILDRENSWEAR DESIGNER. A designer possessing the necessary skills of an adult designer, as well as an understanding of children's proportions and related **sizing** issues. An awareness and comprehension of safety issues and laws specific to this market are also required. The computer software of choice in the twenty-first century is **Adobe Illustrator**, and a designer's proficiency in this software application takes precedence over individualistic sketching ability. *See also* APPAREL DESIGNER; CHILDRENSWEAR.

CHITON. A style of clothing invented by the Ancient Greeks during the Greek Archaic Period (750–480 BCE), which is made of a single rectangular piece of cloth, then wrapped around the body and joined at one side. The Indian Sari is a descendent of the chiton.

CHLOÉ. The house of Chloé was led by **Karl Lagerfeld** from the 1960s to the 1990s. It was bought in the mid-1980s by the Swiss luxury group, Richemont. **Stella McCartney** was **creative director** from 1997 to 2001, and Phoebe Philo took over as creative director in 2001. This luxury **ready-to-wear** house remains an important player in fashion.

CHOO, JIMMY. This shoe company was founded in 1996 by Tamara Mellon, a former **accessories** editor at *Vogue* UK, in partnership with a couture shoemaker in London's East End, Jimmy Choo. Together with shoe designer Sandra Choi, it is best known for its **fashionista** appeal. Worn by celebrities and known as "Jimmy's," the shoes are sexy, high-priced, and sold in eponymous stores in New York, London, Beverly Hills, and Las Vegas, as well as in high-end retail stores around the world. In 2001, Equinox Luxury Holdings acquired Choo's share of the company and, in 2004, Lion Capital acquired a majority shareholding in the company. *See also* FOOTWEAR; HAUTE COUTURE.

CHU, DAVID. *See* NAUTICA.

CHUN, ELLERY (1909–?). In 1935, Chun trademarked the *Aloha shirt*, a design in a tropical Hawaiian theme. The clothing styles of the 1930s were deeply influenced by Hollywood and the casual look became a cool form of dressing. The tropics became a dream lifestyle in sharp contrast to the difficult times that the Depression cast upon society. *See also* LIFESTYLE-DRESSING.

CHUNG, DOO-RI (1973–). Born in Korea, Doo-Ri Chung graduated from **Parsons School of Design** and designed for **Geoffrey Beene** for six years. She launched her own line in 2001. The fall 2005 runway show brought *Vogue* senior editor **Anna Wintour** first row and center—the sign that this was a show of significance. It should be noted that Chung began her business in the basement of her parents' dry-cleaning store in a New Jersey suburb outside of New York City. In 2006, Chung was the recipient of the *Vogue*/**Council of Fashion Designers of America (CFDA)** Fashion Fund Award. Her signature is exquisitely draped clothing and, similar to those of her mentor, Mr. Beene, the clothes maintain an architectural form.

CLAIBORNE, LIZ (1929–). Born Elisabeth Claiborne Ortenberg in Brussels, Belgium, she worked as a **designer** for more than 25 years. In 1976 with Art Ortenberg, Leonard Bexer, and Jerome Chazen, she created Liz Claiborne. The company's concept was based on the need for affordable coordinated clothing for the increasing number of

women entering the workforce; in fact, it was one of the first apparel companies to recognize the need to merchandise its product in outfits. By the mid-1980s the company had grown to $555.6 million in sales and achieved *Fortune* 500 status, a first for a female-founded company. In 1987, **Dana Buchman**, a designer for Claiborne, launched her own **bridge** label for the company. The 1990s saw the birth of numerous lines and **brands** including a **plus-size** retail chain, a home collection, and **footwear**. By the turn of the century, sales had reached $3.104 billion and the company had twenty-five brands. This public mega-apparel company added Laundry by Shelli Segal, Lucky Brand Jeans, Sigrid Olsen, and **Juicy Couture** as members of the Claiborne empire. In 2002, the company acquired **Ellen Tracy**, the leading bridge brand in the market. The Claiborne success was built on a true understanding of the **target market** and a focus on building a **lifestyle** brand.

In 2006, Liz Claiborne Inc. took a significant leap in global development with an agreement to distribute selected Claiborne brands throughout the Middle East. The company is focusing on the Mexx, Liz Claiborne, Lucky Brand, and Juicy Couture lines and has also made a strategic plan to build on the strengths that were its beginning—casual and career clothes that were affordable. *See also* MEGABRAND; WOMENSWEAR.

CLEMENTS RIBEIRO (c. 1970–). Brazilian-born Ignacio Ribeiro and Briton Suzanne Clements met at **Central Saint Martins College of Art and Design**, then married and opened their own business in 1993. Best known for their whimsical **knitwear** and **sportswear**, they both became creative design directors of the French **brand Cacharel** in 2000, in addition to producing their own collection in London.

CLOTHING CONTROL LABEL CC41. Clothing that bore this label was created during World War II in compliance with the **British Civilian Clothing Order CC41** by a selected number of British **designers**. *See also* AMIES, HARDY; GOVERNMENT UTILITY SCHEME; INCORPORATED SOCIETY OF LONDON FASHION DESIGNERS; MOLYNEUX; NORELL, NORMAN.

CLOTHING CREATOR. Developed by the company Formafit, the Clothing Creator patented process of manufacturing utilizing heat

molding, ultrasonic bonding, and cutting as an alternative seaming method.

COACH. Inspired by the suppleness of an old baseball glove, Miles Cahn founded the company in 1941 in a New York City loft. Artisans hired by the Cahn family handcrafted soft **leather** into handbags and **Bonnie Cashin** was the company's first **designer**. In 1985, the Cahns sold the business to the Sara Lee Corp. and, in 2000, Coach went public. The company has grown to include men's and women's shoes and clothing, which are sold in stores throughout the world, as well as in their own stores. In 2006, Coach launched its first line of **knitwear**, designed by New York based Lutz & Patmos. From 2003 to 2006, Coach's revenues grew from $953 million to $1.71 billion. Its product line has grown to include watches, scarves, and **outerwear**. *See also* ACCESSORIES; BRAND; LICENSING.

COLE, KENNETH (1954–). Cole's fashion history began with his family business. The family made **footwear** history when their Candies shoe line became a household name in the **disco** crazed 1970s. Cole is credited with the development of the famous Candies slide shoe. In 1982, Cole decided to break out on his own and launch his own company. Unable to afford a showroom, he rented a trailer that he parked outside the prominent shoe tradeshow of its time. In order to comply with necessary city permits, Cole creatively marketed his shoe company as a movie production—and his marketing ingenuity has continued to shine. In 2000, he added a **womenswear** collection. Cole is recognized worldwide for his design sense and his philanthropic endeavors. The company went public in 1994 and today earns more than $430 million. The company lines consist of Kenneth Cole New York, Reaction Kenneth Cole, and Unlisted. In 2001, Cole teamed up with W Hotels to design the hotel associates' uniforms. His book, *Footnotes,* a retrospective, was published in 2003. *See also* FOOTWEAR DESIGNER; RETAILER.

COLORIST. A person responsible for the administration and tracking of the color/print pitching process of textile development and design. He/she creates seasonal color standards by delivery date and orders standards from external suppliers. The colorist also creates color

standard boards and color cards and then distributes the standards to product managers and vendors. He/she evaluates, communicates, and maintains records on lab dips, strike offs, and yarns, and monitors the initial bulk dye lot, yarn dye color pitching, and print pitching. Colorists also evaluate and maintain dye lots and shade bands and partner with **designers** on print/pattern selection. A working knowledge of a spectrophotometer is required.

COMME DES GARÇONS. This Japanese fashion label presented a new and different approach to fashion in the 1980s. **Rei Kawakubo**, born in Tokyo, founded the company in 1973 and was the **designer** behind the label—one that embraced unevenness and imperfection while simultaneously creating beautiful clothing. Today, Junya Watanabe designs the collection.

COMMODITIZATION. The process by which classic clothing can be easily created at a lower price than similar styles from a high-end **manufacturer**. A shift in the fashion industry during the early 1980s from highly designed clothing to minimalistic, classic looks made it easy for low-cost factories to produce this type of merchandise at far lower prices.

COMPUTER-AIDED DESIGN (CAD). Through the use of both proprietary and off-the-shelf software systems, CAD incorporates technology to assist in the design process. Color combinations and garment style lines can be quickly and easily manipulated to reflect design variations. Fabrications, textures, textiles, and prints can be incorporated in the design sketch to provide a detailed rendition of the garment without the labor- and time-intensive task of hand rendering. Technical design sketches are dependent upon CAD to execute detailed technical production instructional packages. *See also* TECHNICAL DESIGNER.

CONFÉDÉRATION FRANÇAISE DÉMOCRATIQUE DU TRAVAIL (CFDT). The French Democratic Confederation of Labor is one of the major **trade unions** in France, created in 1964 when a majority of the members of the **Confédération Française des Travailleurs Chrétiens (CFTC)** (French Confederation of Christian

Workers) decided to become secular. Today it coordinates its efforts with the **Confédération Générale du Travail (CGT).**

CONFÉDÉRATION FRANÇAISE DES TRAVAILLEURS CHRÉTIENS (CFTC). A French labor union (French Confederation of Christian Workers) founded by Roman Catholic workers in 1919. The CFTC was initially strong among white-collar workers and textile workers. However, the union was banned by the Vichy government during World War II. After the war, the union regained strength but, in 1964, the CFTC splintered, forming a new union called the **Confédération Française Démocratique du Travail** or CFDT (French Democratic Confederation of Labor). Together with the leftist **Confédération Générale du Travail (CGT)**, these unions fought for better pay and benefits but have lost strength over the years as jobs, especially in the fashion sector, have moved offshore.

CONFÉDÉRATION GÉNÉRALE DU TRAVAIL (CGT). The General Confederation of Labor is a French **trade union** founded in 1895. However, in 1948, members seceded to create the **Force Ouvière (FO)** union due to French Communist dominance in the CGT. Today, the union coordinates its efforts with the union **Confédération Française Démocratique du Travail (CFDT).**

CONFEDERAZIONE GENERALE ITALIANA DEL LAVORO (CGIL). The CGIL is Italy's largest trade union, originally founded in 1944 as a nonpolitical labor union consisting of Social Democrats, Christian Democrats, and Communists. However, in 1950, it splintered with the Roman Catholics and Christian Democrats to form its own union called the Libera Confederazione Generale Italiana dei Lavoratori (Free General Italian Confederation of Workers). This group later merged with the Federazione Italiana del Lavoro (Italian Federation of Labour) and now calls itself the **Confederazione Italiana dei Sindacati Lavoratori (CISL).** In addition, another non-Communist union known as the Italian Labour Union was founded in 1950 made up of republicans and socialists. The CGIL was a member of the International Confederation of Free Trade Unions and the European Trade Union Confederation.

**CONFEDERAZIONE ITALIANA DEI SINDACATI LAVORA-
TORI (CISL).** The CISL is Italy's second-largest trade union,
which was founded in 1950 by the merger of the Federazione
Italiana del Lavoro (Italian Federation of Labour) and the Libera
Confederazione Generale Italiana dei Lavoratori (Free General
Italian Confederation of Labour). Having ties with Roman
Catholics and Christian Democrats, this union has been a strong
opponent to the largest Italian trade union, the Communist **Con-
federazione Generale Italiana del Lavoro** (General Italian
Confederation of Labour).

CONTEMPORARY MARKET. This market category is fashion
forward with a price point below **bridge.** Examples of companies in
this category are Marc by **Marc Jacobs, Diane von Furstenberg,**
and **Juicy Couture.**

CONTRACTOR. In the production segment of the fashion industry, it
is the contractor's responsibility to cut and assemble the garment and
prepare it as ready to be shipped to the **retail** establishment or center
of merchandise distribution.

CONVERSE. An athletic shoe **brand** established in 1908 by Marquis
M. Converse. Converse is most famous for its All-Star high-top
basketball **sneaker,** created in 1918 in collaboration with a high
school basketball player named Chuck Taylor, who later turned pro.
In addition to the high-top version known as "chucks," the low-
cut version, the "oxford," continues to be one of the most popular
sneakers in the world. Converse has been and continues to play a
significant role in the athletic **footwear** market into the twenty-first
century. The famous **PF Flyers** were made by the Hood Company
in 1962. Goodrich acquired the rights to the Flyers and Converse
purchased the Goodrich athletic shoe brand in 1971. When Con-
verse was accused of monopolizing the sneaker market, it sold off
the PF Flyer brand. In 2006, **John Varvatos** designed the Converse
laceless sneaker.

COOPERATIVA DE ALTA COSTURA. The Spanish version of the
Chambre Syndicale founded in Barcelona in 1942.

COPYIST. A copyist is a skilled technician who copies the designs of a particular **designer** or company. Applying the technical disciplines of **draping** and **patternmaking**—and often through the means of a **rub-off**—**couture** items as well as garments worn by television and movie stars are copied and mass produced. Entire businesses have been built on the ability of the fashion copyist to successfully capture the original garment's style lines, drape, movement, and fit, together with a fabrication that is identical or appears to be identical.

See also ASSOCIATION POUR LA DÉFENSE DES ARTS PLASTIQUE ET APPLIQUÉS; COUNTERFEITING; FASHION ORIGINATORS' GUILD OF AMERICA (FOGA); KNOCK-OFF; PROTECTION ARTISTIQUE DES INDUSTRIES SAISONIERES (PAIS); SOCIÉTÉ DES AUTEURS DE LA MODE; WORLD TRADE ORGANIZATION.

CORSET. From the sixteenth through the nineteenth centuries, women in the Western world wore corsets to create the "perfect" hourglass shape, the fashionable body silhouette of the time. Never to be confused with an undergarment created for comfort, the corset has been the cause of health issues and even death. Its origin is from the French word *corse*, which means bodice. Strips of whalebone, wood, and horn were used until the 1850s when steel replaced these materials to provide the rigid structure of the corset. By the early 1920s, women were engaged in sporting activities that required the flexibility offered by brassieres and girdles. This trend in flexibility, combined with the fashion look of the 1920s flapper, saw the end of the corset era. In the 1980s, **Jean-Paul Gaultier** and **Vivienne Westwood** set the stage for the return of the corset as a fashion statement. *See also* INTIMATE APPAREL.

COSTA, FRANCISCO (1966–). Born in Brazil, Costa has family roots in the apparel industry. He arrived in the United States in the early 1990s and studied at the **Fashion Institute of Technology**. He was recruited as a **designer** for **Bill Blass** soon after and then by **Oscar de la Renta** for his signature collection, **Pierre Balmain** Couture, and the de la Renta Pink Label. In 1998, he joined **Tom Ford** at **Gucci** as a senior designer, and afterward, has been with **Calvin Klein** since 2002. Costa has demonstrated his ability to fill Klein's

shoes. As **creative director** for Calvin Klein, Costa has maintained the clean, soft Calvin look. Costa is the recipient of the **Council of Fashion Designers of America (CFDA)** Award for **womenswear** designer of the year for 2006.

COSTING ANALYST. This person prepares a breakdown of cost in regard to garment manufacturing, which is inclusive of production piece rates, material costs, import duties, and quotas, as well as sourcing options.

COSTUME DESIGNER. A person who designs for the actors or players in film or on stage. *See also* ADRIAN, GILBERT; HEAD, EDITH.

COSTUME INSTITUTE OF THE METROPOLITAN MUSEUM OF ART. Located in New York City, the Costume Institute began in 1937 as the Museum of Costume Art. With the assistance of the fashion industry, in 1946, the Museum merged with the Metropolitan Museum of Art. It was in 1959 that the Costume Institute became its own department. **Diana Vreeland** played a significant role in setting the standards for the outstanding costume exhibitions that the Costume Institute is known for. It boasts of more than 5,000 square feet of space, more than 80,000 costumes and **accessories**, and a state-of-the-art conservation laboratory.

COSTUME NATIONALE. Founded in 1987, by Italian **designer** Ennio Capasa and his brother, Carlo, Costume Nationale's name was derived from an antique book about French uniforms. Capasa was a protégé of **Yohji Yamamoto** in the 1980s. The Milan based **ready-to-wear sportswear** company is known for its slim tailoring and attention to detail. Costume Nationale has retail stores in New York, California, Italy, Japan, and China and has **accessories** and **menswear** lines. In 2000, a designer label was added, Costume Nationale Luxe. Capasa regards this line as his way to branch out in the luxury market.

COTTON. One of the most widely used **natural fibers** in the world, cotton plants are native to many areas across the globe and have been

cultivated for more than 7,000 years. With cotton's ease of processing together with an extensive list of attributes such as comfort, durability, and absorbency, one can easily see why it is a much-preferred fiber of choice. It is biodegradable and therefore "green," which adds to its popularity today. High-quality cotton textiles are labeled Egyptian, pima, supima, sea island, and Peruvian. Companies such as **Liberty of London** are known for the quality of cotton used in its textiles. *See also* ORGANIC FASHION.

COTTON INCORPORATED. An organization created in 1970 in recognition by the cotton industry and the U.S. Congress that cotton products and product development, together with consumer awareness, was essential for the future of the cotton industry. By 1973, the Seal of Cotton was introduced and, by 2003, this seal was a key recognized **brand**. In 1994, a research program, the Lifestyle Monitor, was introduced to record and analyze consumer attitudes in regard to fiber preference, fashion views, and related areas. It entered a relationship with Worth Global Style Network (WGSN) to include pertinent information in regard to cotton research and development. In 2005, Cotton Inc. opened its state-of-the-art headquarters and R&D facilities in Cary, North Carolina. Today, Cotton Inc. provides critical information to the fashion industry, as well as development and marketing support.

COTY AWARD. The Coty American Fashion Critics Award was founded in 1942 by cosmetics company Coty as a means to promote and recognize American **designers**. Recipients were selected by a national jury of **fashion editors** from magazines, newspapers, and news services. **Norman Norell** became the first recipient of the Winnie, the name given to the original Coty Award for **womenswear**. The Coty Special Award went to a designer who excelled in a specific area of the fashion industry such as **millinery**, **intimate apparel**, or jewelry. There was also a Coty Award for **menswear** beginning in 1968. Designers who received more than one award were given the Coty Repeat Award; after they won three awards they were placed in the Coty Hall of Fame and were ineligible for future awards. Famous Hall of Famer recipients include **Norman Norell**, **Bill Blass**, **Calvin Klein**, **Ralph Lauren**, and **Mary McFadden**. By 1985, the

Coty Awards had lost their meaning as a result of numerous factors: the same designers receiving awards, increased competition from the **Council of Fashion Designers of America (CFDA)** and **Fashion Group International (FGI)**, and an unsuccessful attempt by Coty to capitalize on the awards with the launch of its Coty Awards Collection of Cosmetics line in 1985.

COUNCIL OF FASHION DESIGNERS OF AMERICA (CFDA). This nonprofit trade organization was founded in 1962 by some of America's foremost fashion and **accessories designers**. Some of its founding members included **Bill Blass, Rudi Gernreich, Norman Norell, Arnold Scaasi**, and **Pauline Trigere**. By 2005, its membership had grown to more than 250 members. One of the organization's missions is to become more involved in educational support at both the high-school and college level and to encourage emerging design talent. In 2004, the CFDA partnered with *Vogue* magazine to present an annual monetary award to a deserving new designer or design firm. **Stan Herman** served as president of the CFDA for more than 15 years. In 2005, the bylaws of the CFDA were changed to limit presidential terms to two years. In 2006, **Diane von Furstenberg** was elected president. *See also* WINTOUR, ANNA.

COUNCIL OF LATIN AMERICAN DESIGNERS. Initiated in 1999 by the Venezuelan-born **designer Carolina Herrera**, this council brings together designers of note of Latin American decent.

COUNTERFEITING. The problem of stealing or illegally taking an idea or product design and passing it off or selling it as your own. Counterfeiting, or product piracy, in 2005 accounted for approximately $600 billion in lost revenue globally. It also accounts for the loss of more than 750,000 American jobs according to U.S. Customs and Border Protection. Designers **Coco Chanel** and **Madeleine Vionnet** were quite successful in bringing **copyists** to justice beginning in the nineteenth century. However, it was not until the twenty-first century that designers, especially those in the luxury category such as **Chanel, Gucci, Hermès, Prada**, and **Louis Vuitton** have aggressively pursued and won huge settlements against counterfeiters. The United States has joined forces with the **European Union** to combat counterfeiting

at their borders by sharing customs data and reporting intellectual property theft violations. They are also calling for cooperation among emerging markets, such as China and Russia, to boost enforcement efforts through the **World Trade Organization (WTO)**. In France, the luxury-goods trade association Comité Colbert continues to advocate for stricter anticounterfeit laws. *See also* ASSOCIATION POUR LA DÉFENSE DES ARTS PLASTIQUES ET APPLIQUÉS; FASHION ORIGINATORS' GUILD OF AMERICA (FOGA); KNOCK-OFF; PROTECTION ARTISTIQUE DES INDUSTRIES SAISONIÈRES (PAIS); SOCIÉTÉ DES AUTEURS DE LA MODE.

COURRÈGES, ANDRÉ (1923–). Best know for **futuristic fashion,** Courrèges brought flat white boots, metallic accents, and geometric cuts to the runway during the early 1960s. Born in France, he studied under **Balenciaga** and created his own look in 1961 by combining the 1960s youth influence with Paris **couture,** particularly in regard to world acceptance of the **miniskirt.** It was in 1961 that Courrèges and Coqueline Barrière (c. 1935–), who would later become his wife, approached fashion with a focus on the future and barely a glance to the past. Courrèges, who was a former civil engineer, projected a look in his salon of a "high-tech lab"; he and Barrière went on to create fashion history when, in 1965, they unveiled to the world a collection inspired by the space age that was spare on decoration and all about the cut, with sleek helmet hats and white **go-go boots** grounding the designs from top to bottom. In 1969, they again created history with their ribbed **knitwear** that became the springboard for leggings, a perfect compliment to the **mini.** Courrèges sold his business in 1985 and immersed himself in painting and sculpture. *See also* HAUTE COUTURE.

COURTS, JOSEPH. He invented the **tape measure** in 1809.

COUTURE. *See* HAUTE COUTURE.

COUTURIER. The French term for a male **designer** in the **haute couture** tradition.

COUTURIÈRE. A French term for a female **designer** in the **haute couture** tradition.

COUTURIÈRES. Members of **haute couture**, who show collections of at least fifty pieces in Paris twice a year. The designs are **custom-made** for each specific client.

CREATIVE DIRECTOR/DESIGN DIRECTOR/HEAD DESIGNER. A highly creative **designer** who heads the design team. He/she must possess a **merchandising** background, strong technical skills, and fabric sourcing knowledge and be able to communicate with sales and merchandising staff.

In the publishing and advertising industries, a creative director is responsible for creative direction for magazines, **catalogs**, or other advertising vehicles. He/she must have strong graphic design skills, catalog/editorial layout know-how, graphic production experience, and a strong artistic understanding specific to the individual **target market**.

CUNNINGHAM, BILL (c. 1930–). Cunningham began his career as a milliner but photographed his first **fashion show** in 1947. It is said that **fashion illustrator Antonio Lopez** gave Cunningham his first camera. Photography serves as the venue for Cunningham to document fashion. In the world of fashion, he is well respected for his clear and direct means of capturing and recording its history. Cunningham is a very private person and does not grant interviews. His photographs of fashion for the *New York Times* illustrate the everyday adaptation of fashion by the rich, the famous, and the ordinary. His many years as a photographer at *Women's Wear Daily* (*WWD*), as well as his runway archives, have made Cunningham one of the most famous **fashion photojournalists** alive today. *See also* FASHION JOURNALISM; FASHION PHOTOGRAPHER/PHOTOJOURNALIST.

CUSTOMER RELATIONS MANAGEMENT (CRM). CRM is software technology that keeps track of customer preferences at the retail level.

CUSTOM-MADE. Made-to-order. The individual client's measurements, as well as design elements, are used in creating each garment.

CUSTOM-MADE PATTERNS. Patterns specifically created for an individual client.

CUT, MAKE, AND QUOTA SOURCING (CMQ). This term describes the method used to calculate the cost of a product when sourcing production offshore. It includes cutting and sewing contractor costs and quota fees.

CUT, MAKE, AND TRIM (CMT). This is the method used to calculate the contractor portion of pricing a product—cutting, sewing, and any trimmings such as **zippers**, buttons, and so on.

CUT, MAKE, PACK, AND QUOTA SOURCING (CMPQ). The CMPQ is the term applied to calculating the cost of a product when sourcing production offshore. It includes contractor costs for cutting and sewing, plus packing and quota fees.

CUTTING ROOM. The area of apparel production where the garment pieces are cut and readied for assembly. *See also* CONTRACTOR; PRODUCTION MANAGER.

CYBERWARE. Incorporated in 1982, Cyberware is a privately owned company that manufactures a line of low-power laser 3-D bodyscanners. The company's Whole Body Color 3D Scanner is used for garment design and fitting, anthropometrics, and ergonomics. Cyberware has worked with the Apparel Research Network to improve military uniform delivery and to automate the process to calculate better fitting clothing through **bodyscanning**.

– D –

DACHÉ, LILY (1904–1989). Born in Bègles, France, Lily Daché began her career as a **millinery designer** in France, then went to New York in 1925 to create not only high-quality hats but also, by 1949, clothing, **accessories**, perfume, and costume jewelry. Daché saw an advantage of the American depression of the 1930s and built upon the concept that women could add fashion to a dated and tired wardrobe with an inexpensive hat. She called this line Dachettes. Her most famous hat style was her turban. Daché was known to study the facial structure of her clients and design hats that would

emphasize the positive; this won her a place of significance with Hollywood starlets.

DAHL-WOLFE, LOUISE (1895–1989). Born Louise Emma Augusta Dahl in San Francisco, to Norwegian parents, she would become one of the foremost female photographers in the industry. She married sculptor Mike Wolfe, who would often help her with her photography. Dahl-Wolfe is best known for her use of natural light and for having worked with **Diana Vreeland** for more than 25 years at *Harper's Bazaar* and then at *Vogue*. She is credited with having discovered actress Lauren Bacall and for her influence on photographers **Irving Penn** and **Richard Avedon**. *See also* FASHION PHOTOGRAPHER.

DAILY NEWS RECORD **(DNR).** A leading **menswear** weekly magazine published every Monday. It is inclusive of apparel and textile design and retail and financial information exclusive to the men's fashion industry. Its parent company is Fairchild Publications.

DALRYMPLE, DAVID. *See* FIELD, PATRICIA.

DARRE, VINCENT. *See* UNGARO, EMANUEL.

DAVISIN, JACOB. He created the first pair of **jeans** in 1873. He and **Levi Strauss** joined to patent the garment. *See also* DENIM.

DE BEERS. In 1888, Cecil Rhodes incorporated his company, De Beers Consolidated Mines, which became the largest, most successful diamond company in the world. De Beers's memorable ad campaign, A Diamond Is Forever, secured its place as one of the top luxury **brands**. In 2004, De Beers pleaded guilty and paid a $10 million fine to settle charges of anticompetitive behavior and price-fixing, which had prevented it from selling its collection in the United States for the previous 10 years. De Beers formed a joint venture with **Moët Hennessey Louis Vuitton (LVMH)** and launched its first store in New York City the same year.

DE LA RENTA, OSCAR (1932–). Born in the Dominican Republic, de la Renta studied in Madrid and began his fashion career sketching

for **Cristòbal Balenciaga.** He founded his own company in New York in 1967 and received worldwide recognition. In 1993, de la Renta was appointed **designer** at **Balmain** in Paris, the first American designer to receive such a prestigious appointment. Combining drama and ethnic tradition is de la Renta's trademark. He has dressed famous film stars and U.S. first ladies. In 2005, de la Renta held his first **trunk show** in Russia. The **department store** Aizel will carry de la Renta cocktail and evening dresses, daywear, and **accessories.** *See also* COUNCIL OF LATIN AMERICAN DESIGNERS; HAUTE COUTURE.

DELAUNAY, SONIA (1885–1979). Born Sonia Turk into a Jewish family in the Ukraine, she studied art in Germany and Paris. She married painter Robert Delaunay in 1910 and went on to become a printmaker, artist, and dress designer who embodied the fashion movement of the 1920s. Along with her contemporary **Madeleine Vionnet,** she was known for creating new ways of thinking about women's identity, the body, and newfound freedoms in women's fashion. She also collaborated with designers **Coco Chanel** and **Jeanne Lanvin.** In 1925, Delaunay featured her fashion designs at the Exposition Internationale des Arts Décoratifs. She is known for her expressive use of color and for her Sorbonne lecture on the influence of painting on clothing. She is also credited with introducing the then-novel idea of prêt-à-porter clothing.

DEMEULEMEESTER, ANN (1959–). Born in Belgium, she is one of the **Antwerp Six.** Demuelemeester is best known for her ability to study form and create a personal design style both built upon and in contrast to the human form. Demeulemeester presented her first collection in Paris in 1987.

DEMOREST PATTERNS. A **pattern** company that sold patterns to the home sewer in 1850. This was the beginning of fashion transcending the social classes. The talented home sewer with a creative eye could now design and construct clothing with the look and quality of **designer** apparel. By the 1950s, pattern companies such as **Butterick, Simplicity,** and **Vogue** brought the ability to dress "like" a socialite or movie star to Middle America.

DENIM. Denim is a **cotton** fabric from France called *serge de Nimes* used in 1849 by **Levi Strauss** to make pants that were worn by thousands of men who traveled West during the Gold Rush. By the twenty-first century, denim had taken on a totally new dimension. No longer relegated to casual wear, it can be found in all categories of fashion from **intimate apparel** to eveningwear.

DEPARTMENT MANAGER. A person who is directly responsible for a department or area of a retail store. He/she reports directly to the store **divisional merchandise manager**. The position can be inclusive of both merchandising and operational responsibilities. Additionally, the manager may be responsible for the training and supervising of **salespeople** as well as fostering target sales.

DEPARTMENT STORE. A large retail company that plans, buys, merchandises, and displays merchandise in groups/departments either by **target market** or by product category such as in a swimwear department, a coat department, a **designer** collection department, and a **junior sportswear** department. In addition to apparel and related items, a department store also includes product inclusive of but not limited to furniture, jewelry, toys, and cosmetics. They are often part of a group of stores that have a national or global presence. Department stores can be further classified as **discount department stores**. Areas between departments are not as clearly defined in a discount department store and front-end checkout areas, as well as shopping carts are part of the profile.

The first department store, **Le Bon Marché**, was founded in Paris by Aristide Boucicaut in 1838, and established departments were in place by 1852. In New York, Alexander Turney Stewart opened the "Marble Palace" on Broadway in downtown Manhattan. This became a department store in 1858 and, by 1862, it was linked with **Macy's**, **B. Altman**, and **Lord & Taylor** forming the "Ladies Mile." Thus it gave birth to numerous department stores throughout the country that would eventually be consolidated and reconfigured over the next two centuries. According to the Census Bureau, a department store is a retail establishment that employs more than fifty people and carries a wide assortment of merchandise. *See also* BERGDORF GOODMAN; BLOOMINDALE'S; FEDERATED DEPARTMENT

STORES, INC.; J. C. PENNEY'S; LORD & TAYLOR; MAY COMPANY; SEARS, ROEBUCK AND CO.

DESIGN DIRECTOR. *See* CREATIVE DIRECTOR/DESIGN DIRECTOR/HEAD DESIGNER.

DESIGNER. A person who conceptualizes and oversees the creation of **accessories, childrenswear, footwear,** jewelry, **menswear, millinery,** and/or **womenswear.** **Costume designers** design clothing specific to the cinema, theatre, or television. In the **haute couture** tradition, a female designer is known as a **couturière** while a male is a **couturier.** The word *designer* is also used to refer to high-end merchandise or clothing such as high-end **ready-to-wear.** *See also* ACTIVEWEAR DESIGNER; APPAREL DESIGNER; BRA DESIGNER; CHILDRENSWEAR DESIGNER; COSTUME DESIGNER; COUTURIER; COUTURIÈRE; CREATIVE DIRECTOR; DESIGNER; FOOTWEAR DESIGNER; INTIMATE APPAREL DESIGNER; JEWELRY DESIGNER; LEATHER APPAREL DESIGNER; MENSWEAR; MILLINERY DESIGNER; OUTERWEAR DESIGNER; PERFORMANCE APPAREL DESIGNER; TEXTILE DESIGNER; WOMENSWEAR DESIGNER.

DESIGN ROOM. The American name given to a designer's work space. In Europe the term used is **atelier.** Beginning in the late 1980s, design rooms have been phased out as more of the **patternmaking** and **samplemaking** process moved offshore to save costs. Today, it is considered a luxury for a designer to have his/her own design room.

DE SOLE, DOMENICO. *See* FORD, TOM; GUCCI.

DIESEL. Celebrating its 25th anniversary in 2003, Diesel was purchased in 1985 by its designer Renzo Russo. Known globally for its **jeans,** Diesel introduced kids **footwear** in 2002 and jewelry in 2003. *See also* BRAND.

DIOR, CHRISTIAN (1905–1957). Born in Normandy, France, as one of five children, Dior exhibited a love of art from his early childhood.

When the family moved to Paris, Dior studied economics and painted for pleasure. Family financial difficulties prompted him to begin designing and selling hat designs. He worked for **couturiers** Robert Piguet and **Lucien Lelong** and, in 1945, he began a business partnership with the wealthy textile industrialist Marcel Boussac. A quiet and polite gentleman, Dior was very superstitious and in fact selected his #28-#30 Montaigne address based on this. Dior opened his own house in 1947 and his first employee was **Pierre Cardin**.

With war restrictions over, Dior embraced the full skirt, cinched waist, and mid-calf length, which was called the **New Look** by **Carmel Snow** of *Harper's Bazaar* magazine. Dior named his lines Corolla and Figure of Eight; skirts could take as much as 50 yards of fabric to construct. The fashion world was desperate to see fashion revert to prewar years and Dior's designs made those dreams a reality. During his reign of eleven years, Dior introduced twenty-two different lines. Dior was the true inventor of **licensing.** As early as 1949 he shared in the profits of copies of his designs and saw opportunities in everything from perfume to shoes.

The house of Dior continued after the designer's death with **Yves Saint Laurent** taking over the helm and even included the design of flight attendant uniforms for Air France in 1962. Saint Laurent was followed by **Marc Bohan, Gianfranco Ferre**, and **John Galliano**. Galliano has been known to shake things up at Dior. Not unlike Dior himself, who had his own moments of excitement, whether they be a demonstration over the dangers of wearing his full Corolla *skirts or receiving the press while in the bath, Galliano often creates over-the-top theatrical performances at Dior and is confident the "Master" approves. The twenty-first century has seen a new Dior customer: young, sexy, drawn to the chemistry of the past Dior foundation and demanding the fresh approach of the present. *See also* COPYIST; HAUTE COUTURE.

DIRECTOR OF PLANNING. This person works in conjunction with the **merchandising** arm of a retail organization to develop and achieve sales, gross margin, and turnover goals. He/she manages basic and promotional in-stock and provides leadership for store suppliers, **buyers,** and logistics, to maintain supplier order fulfillment and supply-chain efficiency.

DIRECT SALES. The term applied to a company that bypasses the **retail** establishment to sell its collection direct to customers. Companies such as **Doncaster**, the Worth Collection, and Carlisle Group are some of the most successful in the United States.

DISCO STYLE. Clothing worn by men and women inspired by the disco music craze of the 1970s. Synthetic fabrics, satin, **polyester, nylon**, and velvet abounded. The movie *Saturday Night Fever* (1977) starring John Travolta immortalized the era, especially for **menswear**, with polyester bell-bottoms, bright floral body shirts with wide butterfly collars, white three-piece suits, and platform shoes.

DISCOUNT DEPARTMENT STORE. These are **department stores** that offer low prices and a wide assortment of merchandise with low profit margins, which in turn generate sales volume. They provide limited services—the result being the ability to keep prices down. These stores are also known as big box stores and include **Target, Wal-Mart**, and **Kmart**. *See also* CHAIN STORE; MASS MARKET.

DIVISIONAL MERCHANDISE MANAGER (DMM). This person works under the **general merchandise manager** and fashion office to ensure that the store's image is maintained in the buying process. DMMs oversee all **vendors**, are responsible for meeting store sales projections, and coordinate the various **buyers** within their division.

DKNY. *See* KARAN, DONNA.

DOC MARTENS. *See* DR. MARTENS.

DOLCE & GABBANA. Domenico Dolce (1958) and Stefano Gabbana (1962) were born in Sicily and Venice, respectively. They founded their company in Milan in 1982 and showed their first collection in Milan in 1986. Known as the "designer of choice" of rock star Madonna, they are credited with turning lingerie into street clothing. In 1990, they presented their first **menswear** line. It is beautifully tailored with a signature Dolce & Gabbana "hot" look. They also have the D&G line, geared to the customer seeking luxury at a price. *See also* INTIMATE APPAREL; STREETWEAR.

DONCASTER. A direct-sales clothing company that began in 1931 as the Doncaster Collar and Shirt Company founded by S.B. (Bobo) Tanner in Rutherfordton, North Carolina. Today, the company has national distribution mainly through sales reps, who continue to sell direct to customers, with the exception of a few outlet stores and a showroom in New York City. Other **direct sales** companies have followed including the Worth Collection and Carlisle Collection.

DONOVAN, CARRIE (1928–2001). A graduate of **Parsons School of Design**, Donovan went on to work for **Jacques Fath** in Paris and returned to New York to design junior dresses. She left the world of design in 1955 and took a position at the *New York Times* as a page reporter and was soon an associate fashion editor. In 1963, she left the *Times* and joined *Vogue* where, under **Diana Vreeland**, she was a senior editor. In 1972, she left to join *Harper's Bazaar* as senior fashion editor. Donovan became the vice president of communications for **Bloomingdale's** in 1976 and returned to the *Times* in 1977. She remained at the *Times* until her retirement in 1995. It was then that she became spokeswoman for Old Navy and joined the *Times* one last time as a contributing editor. She is credited with providing inspiration and guidance to many in the design world including **Donna Karan** and **Ralph Lauren**. *See also* FASHION CRITIC; FASHION JOURNALISM.

DORSEY, HEBE (1925–1987). Born in Tunisia, she moved to Paris and studied chemistry at the Sorbonne before switching to English literature. She married Franck Dorsey in 1950 and, through his connections, began her career as a second-string **fashion reporter** at the *International Herald-Tribune*. It was there that she became the protégé of famous fashion *Tribune* journalist **Eugenia Sheppard** and eventually assumed her spot. While Dorsey had the looks of a femme fatale, some designers considered her an enfant terrible due to her sharp tongue and one-phrase put-downs. In the tradition of Sheppard, she alienated designers **Azzedine Alaïa, Karl Lagerfeld**, and **Yves Saint Laurent** and was even banned from **Givenchy** fashion shows. Dorsey was the author of the book *The Belle Époque in the Paris Herald* (1986).

DOUCET, JACQUES (1853–1929). Born in Paris, Doucet lived in the area of the city where all of the **couture** houses were situated and was a playmate of the **Worth** sons. After taking over his family's fashion business, Doucet became a successful **couturier**. He is also credited with discovering **Paul Poiret** and **Madeleine Vionnet**. *See also* HAUTE COUTURE.

DRAPER. The **assistant designer** assigned to the art of **draping** the designer's muslins.

DRAPING. The art of transforming fabric into a wearable garment or muslin into a garment **pattern**. The design room in postwar America consisted of the **designer, assistant designer, samplemakers**, and **patternmakers**. The designer used draping as the vehicle to transform a design concept into a three-dimensional form. The **design room** at the close of the century, however, saw this art of draping and its related tasks relocated overseas to places including mainland China, India, and Turkey. The twenty-first century is exploring and sharing in the explosion of technology in the form of virtual draping. While the foundational skill sets are paramount to satisfactory design conclusion, traditional means of draping have evolved and are supported by technological advances. *See also* ATELIER; COMPUTER-AIDED DESIGN; DRAPER.

DRESS CODE. A set of rules that dictate what should and should not be worn for a particular situation or event. History has seen significant adaptations and blurring of the dress-code rules. The 1950s dictated hats and gloves as appropriate attire for women in public. Men in the corporate world only wore white business shirts accompanied by neckties that were generic. The 1990s saw the birth of casual business attire as the dress code of the business world for both males and females. Social trends continue to redefine dress codes on all levels whether they be related to gender, age, or business.

DRESS FORM. A replica of a human form made of cloth, padded and mounted on a metal base that is used for **draping** and fitting garments. Dress forms, which are hand-crafted, have been made by the **Wolf**, Royal, and Modern Dress Form companies for the past 100

years. However, since the late 1990s, companies such as **Shapely Shadow** and **Alvanon** use bodyscanners to more accurately create each form. Technology has also advanced the dress form into the virtual arena. Through the use of specific software programs such as Optitex 3D, designers can now fit on a virtual dress form.

DRESSMAKER. A dressmaker is a skilled seamstress who is capable of executing a professionally finished garment. The dressmaker of the late 1800s and the dressmaker of the twenty-first century remain the same in that they must possess the ability to construct and fit a garment. Dressmakers often specialize in specific categories and price ranges. Seamstresses differ from **tailors** in that they are not as skilled in the craft of tailoring. Instead, they utilize their skill in handling softer fabrics with different finishing techniques than those used in tailored garments.

DR. MARTENS. A boot designed with an air-cushioned sole created by Dr. Klaus Maertens in Seeshaupt, Germany, in 1945. The first workboots, with the revolutionary new soles, were made in 1960 and were labeled the "Dr. Martens 1460 boot." These boots became standard **footwear** for the British working class and later became known as "Doc Martens," a fashion icon of the modern subculture as a sign of individualism and rebellion. *See also* GRUNGE LOOK; PUNK STYLE.

– E –

ECKO, MARC (1973–). Founder of Ecko in 1993, this graffiti artist began making **T-shirts** in tune with the **hip-hop** culture. Ecko's rhino **logo** identifies his look. A joint venture with music star 50 Cent lead to the creation of **G-Unit** Clothing Company, part of the Ecko empire. *See also* HIP-HOP LOOK.

ÉCOLE DE LA CHAMBRE SYNDICALE DE LA COUTURE PARISIENNE. *See* L'ÉCOLE DE LA CHAMBRE SYNDICALE DE LA COUTURE PARISIENNE.

E-COMMERCE. The paperless exchange of business information using **electronic data interchange (EDI)**, e-mail, electronic bulletin

boards, fax transmissions, and electronic funds transfer. For the fashion industry it refers to Internet shopping, online transactions, the downloading and selling of "soft merchandise," and business-to-business transactions using the Internet.

ELBAZ, ALBER (1961–). Israeli-born Elbaz studied fashion at Shenkar College of Engineering and Design in Israel before moving to the United States. After a short stint designing bridalwear, Elbaz spent seven years designing alongside **Geoffrey Beene**. Upon leaving Beene, he went to work at Guy Laroche, and then did a short run at **Yves Saint Laurent** before being ousted in 2000 by the new owner, **Gucci**. In 2001, he was hired as **creative director** at the house of **Lanvin**. He is a master of detail and is known for his modern take on couture. *See also* HAUTE COUTURE.

ELECTRONIC DATA INTERCHANGE (EDI). A system of transferring **point of sale** (POS) information to a **retailer**'s or vendor's data system for analysis. It is also used by vendors when shipping boxes in compliance with each individual retailer's mapping specifications. *See also* CHARGEBACK.

ELECTRONIC PRODUCT CODE (EPC). The numbering scheme utilized on **radio frequency identification (RFID)** tags that have the ability to provide a unique ID tag for any product throughout the world; they cost pennies and are smaller than a grain of sand. These tags provide inventory capability, planning, and allocation management of product.

ELIZABETHAN PERIOD (1558–1603). The era in history when court fashion was influenced by both Spanish and French styles although the period is named after the English monarch, Queen Elizabeth. Ruffles at the neck, bodice, and sleeve were of significance for both men and women. Embroidery was embraced as an elaborate detail with gold thread generously interwoven throughout the design. *See also* EMPIRE PERIOD; RENAISSANCE; VICTORIAN ERA.

ELLE **MAGAZINE.** Established in 1945, it was founded by Pierre Lazareff and Hélène Gordon, his spouse. This French magazine

began an American edition in 1983. Later purchased by the Lagardére Group of France, it is published in the United States by Hachette Filipacchi Media U.S. Published monthly, *Elle* developed a niche market as a **fashion magazine** for people, not industry. It hosts the annual style awards ceremony and publishes the winners as a feature article. *See also* FASHION JOURNALISM; FASHION PHOTOGRAPHY.

ELLEN TRACY. Founded by Herbert Gallen as a blouse company in 1949, the name Ellen Tracy was invented by Gallen. The collection eventually evolved into a **bridge market** line and, in 1964, Linda Allard joined the company as design director. In 1984, Allard's name was added to the label. The collection has maintained its classy appeal for the nontrendy yet fashionable customer throughout the years. Designer **Charles Nolan** designed the collection from 1990 to 2001. The company was sold to **Liz Claiborne** in 2002. In 2006, British designer George Sharp took over as vice president of design.

ELLIS, PERRY (1940–1986). A native of the United States, Ellis began his fashion career in retail. In 1975, he launched his own label, Perry Ellis for Portfolio, a division of Manhattan Industries. Perry Ellis Sportswear was introduced in 1978. A recipient of both **Coty Awards** and **Council of Fashion Designers of America (CFDA)** Awards, Ellis continued at the helm of the business until his death. **Marc Jacobs** took over as head of design until the early 1990s. Each year the CFDA presents the Perry Ellis Award for New Design Talent in Ellis's honor.

EMPIRE PERIOD. The period in French history (1804–1814) under the reign of Napoleon Bonaparte and **Empress Josephine**. Women's clothing during this period was characterized by a style known as the empire silhouette: a low neckline, puffed sleeves, high waistline, and long columnar skirt. Neoclassical references for the silhouette came from ancient Greece and Rome, whose democratic governments served as political inspiration during the French Revolution (1789–1799). During this period, the style was known as Regency in England and America. *See also* ELIZABETHAN PERIOD; RENAISSANCE.

EMPRESS JOSEPHINE (1763–1814). She was born Marie Josephe Rose Tascher de la Pagerie in Les Trois-Îlets, Martinique, on a slave plantation. She married an aristocrat, Alexander de Beauharnais in 1779 and produced two children. Her daughter Hortense married Napoleon Bonaparte's brother. Her husband Alexander was guillotined in 1794 during the French Revolution and Josephine became the mistress of several leading political figures before meeting and marrying Napoleon in 1796. In 1804, Josephine and Napoleon became the empress and emperor of France and greatly influenced French fashion. They were divorced in 1810 when Josephine failed to produce an heir. Although she is attributed with having created the Empire style to conceal her pregnancy (a myth), the style's neoclassical reference became quite fashionable throughout history. *See also* EMPIRE PERIOD.

ENTERPRISE RESOURCE PLANNING (ERP). A software system that serves as the backbone of a company's business. ERP tracks company financials, human resources data, and manufacturing information—such as where inventory is kept and what needs to be taken from the parts warehouse to the shop floor.

EOM DATING. EOM is an abbreviation for *end-of-month* dating. This term is used to describe the merchandise contract payment schedule used between retailers and **manufacturers**. Due date and discounts are due at the end of the month when the invoice is dated rather than the invoice date itself.

ERTÉ, ROMAIN DE TIRTOFF (1892–1990). Born into an aristocratic family in St. Petersburg Russia, Erté's interests were art and theatre. He is recognized as one of the most notable **fashion illustrators** and **costume designers**; his work is easily identified by its stylized designs, exotic fabrics, and strands of beads and ornaments, together with towering and dramatic headwear. In 1912, his family moved to Paris. It was there that Erté illustrated for **Paul Poiret** and designed costumes, his most notable being for the famous Dutch-born Mata Hari. Erté left Poiret in 1914 due the great demand for his costume work in places such as Monte Carlo, London, Chicago, and New York. He designed for the Hollywood filmmakers and is said

to have influenced such greats as **Adrian**. He illustrated for many publications, including *Vogue* and *Harper's Bazaar*.

ESCADA. This is a German sportswear company founded in 1976 by Wolfgang Ley, born in Germany (1937), and Margarethe Ley, born in Sweden (1933). The label took its name from a racehorse and the company expanded into the American market in 1982. Known for style, comfort, and superb workmanship, the company trademark is its attention to detail. Margarethe died in 1992 and Michael Stolzenburg became the head **designer**. In 1990, a **leather** line was added and then a **fragrance** was developed. In the mid-1990s, American designer Todd Oldham was hired as a creative partner. By the turn of the century, the company had expanded into successful **accessories**, **childrenswear**, **sportswear**, and eveningwear lines.

ESMOD. Founded in 1841 by Alexis Lavigne in France, it was the first school to offer a fashion education. Lavigne, the inventor of the **couture mannequin**, built a foundation for a school that today has developed a program with depth in both the artistic and technical areas. Esmod competes globally with its international programs.

ESQUIRE. Founded in 1933 by American Arnold Gingrich as a racy men's magazine, today *Esquire* is a highly regarded, refined periodical owned by the Hearst Corporation. Most known for its men's fashion coverage, it is also revered as a literary publication. During the 1940s, the magazine featured the famous "Varga Girls," centerfold illustrations by pinup artist Alberto Vargas. *Esquire* also is known for their "Dubious Achievement Awards," which poke fun at news events of the previous year. A distinguished list of literary contributors, including Ernest Hemingway, F. Scott Fitzgerald, Gay Talese, Tom Wolfe, Norman Mailer, William F. Buckley, and Truman Capote, have been featured, as well as emerging writers often promoted.

E-TAILING. A shortened form of *electronic retailing*, this is the name given to retail selling on the Internet. *See also* E-COMMERCE.

ETRO. Begun in 1967, this Italian fabric **manufacturer** was founded by Gimmo Etro. Although a privately owned company, Etro does not

operate as many family-owned companies do in Italy. At Etro, each family member has a distinct and separate responsibility, thus creating a balanced business environment. Identified by its signature paisley prints, Etro launched its **womenswear** collection in 1991. Its clothing is recognizable by the attention to detail and combination of patterns and colors. A significant portion of the line is timeless in its design; an Etro jacket can be worn forever. Etro also has a **menswear, fragrance**, and **footwear** line. It opened its New York store in 1996 with rollouts planned in Russia and the Middle East. Additionally, the family is considering Etrobranded resorts and a **lifestyle** line of products. *See also* BRAND.

EUROPEAN COMMISSION (EC). This "first pillar" of the **European Union** is the organization's legislative, policymaking branch.

EUROPEAN UNION (EU). The Treaty of European Union, or Maastricht Treaty, which was ratified in November 1993, formed this economic and political confederation of European nations, which grew out of the earlier European community. The EU is responsible especially for economic coordination and harmonization. In addition, it fosters common foreign and security policies and cooperation on justice and home affairs. The most important EU institutions are the Council of the **European Commission (EC)**, the European Parliament, and the European Court of Justice. There are presently twenty-seven member states or countries—Austria, Belgium, Bulgaria, Cyprus, Czech Republic, Denmark, Estonia, Finland, France, Germany, Greece, Hungary, Ireland, Italy, Latvia, Lithuania, Luxembourg, Malta, the Netherlands, Poland, Portugal, Romania, Slovakia, Slovenia, Spain, Sweden, and United Kingdom.

E-ZINE. The resulting product of reworking a seasonal, monthly, or weekly magazine or publication into an electronic format.

– F –

FABRIC BUYER. This person purchases fabrics for production. Additional responsibilities include negotiating costs, monitoring delivery, and managing any problems regarding fabric quality issues.

FACHINETTI, ALLESANDRA. *See* GUCCI.

FACTORING. The business practice of lending money against a company's receivables. From the earliest days of the fashion industry, especially after the **Industrial Revolution**, factoring became crucial. Factoring evolved from the selling agents for European textile mills establishing themselves as agents facilitating the sale of fabrics to the United States. Today **factors** provide expertise in trade finance on a global scale and are not lending against receivables alone but also against property, inventory, and intellectual property.

FACTORS. These are lending institutions—some of which are bank affiliated—that lend money to a company against the company's receivables or assets. Factors are usually compensated based on a percentage formula relative to the company's size and volume. *See also* FACTORING.

FADS. These are short-lived, usually revolutionary styles of dress or items that are embraced by groups or subcultures—the attention-getters. Some notable fads were **go-go boots**, the **miniskirt**, and the **Wonderbra**.

FAIRCHILD PUBLICATIONS. Comprised of four divisions, Fairchild is best known in the fashion industry as the publisher of *Women's Wear Daily*. Fairchild also is significant in its role as a publisher of fashion and fashion-related textbooks. It was begun in 1892 in Chicago by Louis Fairchild and moved to New York approximately eight years later. The company was acquired by Advance Publications in 1999. *See DAILY NEWS RECORD; FOOTWEAR NEWS; W MAGAZINE.*

FAIR LABOR STANDARDS ACT OF 1938 (FLSA). A law administered by the **U.S. Department of Labor** that established a national **minimum wage** for workers and guaranteed time and a half for overtime in certain jobs. It prohibits most employment of minors in "oppressive child labor," which is defined in one of the statutes. While the FLSA conducts audits and workplace inspections, the administrator of the Wage & Hours Division has no enforcement

authority but may bring a lawsuit in federal court, though that is rare. The FLSA does provide for employees to bring federal action against employers, which is more commonplace. In 2004, the George W. Bush administration made controversial changes to the FLSA's overtime regulations, making substantial modifications to the definition of "exempt" status.

FAIR TRADE FASHION. This term describes the industry response to heightened consumer concern as it relates to apparel manufacturing and damage to the environment or the violation of human rights. The early sweatshops of New York, filled with immigrants willing to "pay" any price for the opportunity to work, have moved into other areas of the world. However, the violation of human rights as it relates to products and production worldwide has created awareness and worldwide disapproval to the point of consumers boycotting of products. Consumers have also voiced their commitment to environmental concerns and the industry has responded with "green" fibers being used in everything from denim to **intimate apparel**. Bamboo, for example, has become a desirable sustainable option not only for interior design but as a fabric alternative; designers confirm that it is lightweight and drapes beautifully. Eco-friendly clothing is demanded from both the **mass market** and the **designer** customer. *See also* ORGANIC FASHION; SUSTAINABLE DESIGN; TRADE UNIONS.

FANNY PAC. A purse-like accessory that was made popular in the 1980s, the fanny pac design derived from the pouches worn by bike messengers. *See also* ACCESSORIES.

FARHI, NICOLE (1947–). Born in France, Farhi moved to London in the 1970s to design for **French Connection**. She began her own label in 1983. Farhi is known for her fashion-forward casual **streetwear**.

FASHION ADVERTISING. Fashion advertising can be traced back to **fashion plates**, which were introduced in France and England during the late sixteenth and seventeenth centuries. These **fashion illustrations** were the first advertising vehicles used to sell clothing. Fashion illustrations continued to sell clothing through the eighteenth and nineteenth centuries in **fashion magazines** such as the

Lady's Magazine, Godey's Lady's Book, and the *Gallery of Fashion*. Advertisements became more sophisticated with the introduction of photography in fashion magazines in 1913, notably by **Harper's Bazaar** (1867) and **Vogue** (1892). However, early ads were a combination of image and copy. The growing number of retail establishments and clothing manufacturers found that advertising in newspapers and magazines gave them a competitive advantage. By the 1930s, photography replaced illustration and advertising agencies devised ads that not only sold product but more importantly, projected an image. In the 1950s, fashion's landscape changed with the **baby boom** and 1960s press promotions were selling and marketing an image of "youth." Fashion advertising in the 1970s exploded with a plethora of **jeans** ads. Calvin Klein was the first designer to use the media to his advantage, beginning with his jeans ads featuring Brooke Shields. Throughout the 1980s, 1990s, and 2000s, advertising agencies realized that controversy sold products. A series of print and billboard ads created buzz, such as those from United Colors of Benetton which addressed race, religion, and health issues; Kenneth Cole's shoe ads which made social and political statements; Calvin Klein ads flirted with sex, drugs, and rock 'n' roll; and Dove beauty ads featured plus-size women as the "real beautiful." The use of supermodels, celebrities, and iconic sports figures in the 1990s and 2000s made advertising a powerful tool for the fashion industry and often overshadowed the merchandise itself.

FASHION BLOG. A *blog* (derived from "Web log") is an Internet-based source for people's thoughts on a variety of subjects, and a fashion blog is dedicated to the coverage of clothing and **accessories**. Fashion blog topics range from runaway trends, celebrity fashion, and **streetwear** to fashion items such as handbags, shoes, lingerie, and so on.

FASHION CALENDAR. In existence since the 1950s, the *Fashion Calendar* is *the* fashion planner for all fashion events. Ruth Finley is the founder and is personally credited with the success of this publication.

FASHION COLUMNIST. A person who regularly contributes a fashion column to a newspaper or website. He/she writes his/her point-

of-view on topics relating to fashion such as new trends, celebrities, fashion events, scandals, shopping tips, and anything that is newsworthy. Fashion columnists may write for one publication or have their own syndicated column that appears in many newspapers. They could be a fashion reporter, commentator, or a **fashion critic**.

FASHION CRITIC. A person who is responsible for critiquing fashion either for a newspaper, magazine, television or the Internet. Some of the best-known fashion critics include **Carrie Donovan** (*New York Times*), **Mary Lou Luther** (International Fashion Syndicate), **Hebe Dorsey** and **Suzie Menkes** (*International Herald Tribune*), **Eugenia Sheppard** (*New York-Herald Tribune*) and Pulitzer Prize–winner **Robin Givhan** (*Washington Post*).

FASHION EDITOR. This person is responsible for creating and/or supervising the fashion editorial content of print or electronic media, outlets such as **fashion magazines**, newspapers, television, or Internet sites. Fashion editors possess excellent journalistic vision. They are well versed in all aspects of fashion from historical to present day. Fashion editors must have an excellent taste level, possess fashion-forward thinking, and have the ability to maintain relationships with key fashion industry players. A fashion editor-at-large contributes major fashion editorials to a publication, while an editor-in-chief leads the fashion publication's fashion content and direction. Famous editors-at-large are Andre Leon Talley for U.S. *Vogue* and Hamish Bowles for European *Vogue*. Famous editors-in-chief include, **Carmel Snow** (*Harper's Bazaar*), Jessica Daves, **Diana Vreeland**, and **Anna Wintour** (*Vogue*). *See also* FASHION JOURNALISM.

FASHION FORECAST SERVICE. A company that specializes in predicting fashion trends, color, and silhouette direction to the fashion industry. These predictions, which are made more than a year in advance of products making it to the selling floor, cover multiple areas of the industry including **childrenswear, womenswear, menswear, knitwear, outerwear, activewear**, and **accessories**. The forecasting process starts with panels of color experts, who meet to create a color palette for each season—such as the International Color Authority (ICA) (American, Dutch, and British), the British Textile

Color Group (BTCG), the *Comité Française de la Couleur* (French), and the Color Marketing Group (USA). Fiber and fabric companies purchase this information to develop their seasonal collection of fabrics or yarns. **Designers** and **retailers** use these services in the inspiration process for creating their collections. Forecast services advertise at trade shows and through their own sales channels. Fashion forecasting magazines often support predictions made by fashion forecast services or publish their own predictions.

FASHION GROUP INTERNATIONAL (FGI). A nonprofit organization founded in 1930, originally comprised of women, whose mission was to increase awareness of the American fashion industry and of women's role in that business. Some of the founding members include Eleanor Roosevelt, Elizabeth Arden, **Edith Head, Carmel Snow, Lily Daché,** Helena Rubinstein, **Claire McCardell, Dorothy Shaver,** and **Virginia Pope. Mary Lou Luther,** a **fashion journalist,** is the **creative director.** Today, the organization includes men and has more than 6,000 members worldwide. Each year, FGI honors members of the fashion industry with awards for professional achievement in various areas of the industry, including men's and women's fashion, beauty, architecture, journalism, and humanitarianism and also presents its Rising Star Award.

FASHION HOUSE GROUP OF LONDON. This was an organization founded in England in 1950 by eight major British wholesalers under the leadership of Leslie Carr-Jones. Its mission was to capitalize on the emerging notoriety of British fashion and to arrange promotional events such as the twice-yearly London Fashion Week. Originally named London Model House Group, the name was changed to the Fashion House Group of London in 1958. This group was quite influential in promoting the **Chelsea look** in the 1960s and British designers like **Mary Quant** and the model **Twiggy.**

FASHION ILLUSTRATION. The art of drawing costume images dates back to sixteenth century costume books that depicted regional and ethnic dress. Beginning in France and England during the seventeenth century and continuing through the eighteenth and nineteenth centuries, a multitude of fashion magazines became popular, such as

Lady's Magazine, La Belle Assemblée, Godey's Lady's Book, Acker-man's Repository of the Arts, Le Cabinet des Modes, Le journal des dames et des modes, and the *Gallery of Fashion.* The **fashion plate,** popularized during the eighteenth century, where watercolor illustrations were later engraved, depicted with great technical accuracy fashion trends of the times. Later, designers commissioned artists to illustrate their designs that were featured in fashion magazines such as *Vogue* and *Harper's Bazaar* or in trade publications such as *WWD.* This changed, however, with the introduction of photography, which began in 1913. By the late 1960s, magazines completely favored **fashion photography** over fashion illustration with fashion photographers creating new and interesting ways to sell and advertise clothes. *WWD* broke with the past much later. It was not until well into the 1980s that it began to phase out illustrations in favor of photography. The early twenty-first century saw a renewed interest in illustration, mostly inspired by computer-generated fashion illustration. *See also* FASHION ILLUSTRATOR.

FASHION ILLUSTRATOR. An artist who illustrates a **designer**'s designs. Some of the best known illustrators are Edouard Benito, Francois Berthoud, Rene Bouche, Jean Phillippe Delhommes, **Erté**, Rene Gruau, Mats Gustafson, Paul Iribe, Georges Lepape, **Antonio (Lopez)**, Albert Elia Maning, Kichisaburo Ogawa, Robert Passantino, Barbara Pearlman, Gladys Perrint-Palmer, George Stavrinos, Ruben Toledo, Marcel Vertes, and Michael Vollbracht. *See also* FASHION ILLUSTRATION.

FASHION INSTITUTE OF TECHNOLOGY (FIT). A fashion school founded in New York City in 1944 by Mortimer C. Ritter, a tailor and educator, and Max Meyer, a retired coat and suit **manufacturer** and union organizer. Part of the State of New York's higher education system, SUNY, FIT was created with the help of fifteen apparel industry leaders. They formed the Educational Foundation for the Fashion Industries and obtained a charter from the New York Board of Regents to form an institute of fashion and technology. The original mission of the institution was to establish a career-focused educational institution to directly serve the fashion industry. The college began with ten faculty members who

were **buyers** for retail stores, salespeople in fabric and trimming companies, **designers, patternmakers**, and production people. The startup of the institution was entrepreneurial, creative, and determined to succeed. Initially a community college only, FIT now offers more than thirty majors in fashion and the related industries, awarding the AAS, BFA, BS, MA, and MPS degrees. It maintains a strong global presence with its programs and fosters relationships with Europe and Asia.

Numerous successful entrants in the fashion field have graduated from **FIT** including **Norma Kamali, Calvin Klein, Michael Kors**, and **Ralph Rucci**. It is also the home of the Museum at FIT. The museum was founded in 1967 to support the college's educational programs. Today, it is renowned worldwide for its fashion and textiles collections as well as its exceptional exhibitions and its permanent gallery. The museum has more than 50,000 garments beginning with the eighteenth century and more than 30,000 textiles and 250,000 swatches in its textile collection. In 2002, it was the recipient of the first Richard Martin Award for Excellence in Exhibition of Costume from the Costume Society of America.

FASHIONISTA. Person or persons respected as being "in the know" with regard to what is in and/or out of fashion. *See also* BRUMMELL, GEORGE BRYAN (BEAU).

FASHION JOURNALISM. This type of journalism is mainly defined as the communication of fashion information using a variety of means whether through trend-related reportage or subjective commentary. Fashion journalists can cover fashion shows and events or write dedicated fashion columns; they author fashion books, magazines, articles, and periodicals; or they use the Internet and/or broadcast media for commentary and reporting. Fashion journalism, in order to be successful, must create "an escape" for the reader and pepper the thrust of the article with personal anecdotes and fashion trivia. Additionally, an eye must be kept on the advertising client and the critique of the collection, achieving a balance of information that is truthful, if not too judgmental. *See also* FASHION COLUMNIST; FASHION CRITIC; FASHION EDITOR; FASHION JOURNALIST.

FASHION JOURNALIST. A person who covers fashion through any one of a number of media: magazines, books, periodicals, television, radio, Internet, and broadcast. Some of the most famous fashion journalists include **Bill Cunningham, Carrie Donovan,** Eleanor Lambert, **Mary Lou Luther, Suzie Menkes, Virginia Pope, Eugenia Sheppard, Diana Vreeland,** and **Anna Wintour.** *See also* FASHION CRITIC; FASHION JOURNALISM; FASHION PHOTOGRAPHY; FASHION PRESS.

FASHION MAGAZINES. The first publication to feature fashion was France's *Le Mercure Galant* in 1678. **Fashion illustrations,** in the form of **fashion plates,** depicted the latest in fashion trends and listed suppliers' names. As interest in fashion steadily increased between the seventeenth and nineteenth centuries, other French, English, and German fashion publications emerged, such as *Lady's Magazine, La Belle Assemblée, Godey's Lady's Book, Ackerman's Repository of the Arts, Le Cabinet des Modes, Le journal des dames et des modes,* the *Gallery of Fashion, Journal der Luxus und der Moden,* the *Englishwomen's Domestic Magazine,* the *Queen,* and *Myra's Journal of Dress and Fashion.* By the mid nineteenth century, as literacy levels increased, more women bought magazines, as they now included information articles, poems, stories, and, on occasion, paper **patterns.** In 1867, *Harper's Bazaar* became the first fashion magazine to be printed in the United States, initially in newspaper format but, by 1901, as a monthly magazine. *Vogue* magazine followed, first as a weekly fashion publication and then as a monthly magazine in 1909. By 1913, archrivals *Harper's Bazaar* and *Vogue* began featuring fashion photography. Both magazines catered to an affluent reader and over the years launched numerous careers in the fashion industry, from illustrators, designers, models, and photographers to their own colorful and sometimes controversial, editors-in-chief. **Carmel Snow,** who began her career at *Vogue,* defected to *Bazaar* in 1934 and, as editor-in-chief, was credited with revolutionizing fashion magazines. She made stars of Parisian **designers Cristòbal Balenciaga, Coco Chanel, Christian Dior,** and **Yves Saint Laurent** and **fashion photographers** Cecil Beaton, Edward Steichen, **Louise Dahl-Wolfe,** and **Richard Avedon.** She is also responsible for being the first to promote American designers. *Vogue* on the other hand, represented a more European high-fashion/high-society point of

view. *Vogue* Paris, *Vogue* Italia, and *Vogue* United States are arguably the most influential magazines of the fashion world. As early as the 1930s, *Vogue* created the concept of the **supermodel**. In 1940, they began coverage of American designers. Famous *Vogue* editors, such as **Diana Vreeland** (1963–1971) and its current editor **Anna Wintour**, enjoy colorful, sometimes infamous reputations. Today, Condé Nast publishes sixteen editions of *Vogue* throughout the world with circulation figures estimated at more than 1.2 million. *Harper's Bazaar*, owned by the Hearst Corporation, is published in 18 countries with its circulation in the 750,000 range. Most magazines survive largely on advertising money and therefore it is not uncommon for the September issue of *Vogue* U.S. to contain more than 700 pages, mostly advertisements. Other magazines specializing in women's fashion include *Glamour, Elle, Marie Claire, InStyle,* and *Cosmopolitan.* Magazines for men include **Gentlemen's Quarterly (GQ), Esquire,** and *Men's Vogue.* Fashion magazines aimed at teenagers are *Teen Vogue* (U.S.), *Vogue Girl* (Australia), and *Cosmo Girl* (U.S.). Even babies have their own fashion magazines, such as *Vogue Bambino* (Italy). Today, fashion magazines are more than just aspirational trend sources for fashion and beauty; they provide thoughtful coverage of current social, economic, and health issues, travel information and other useful information for the modern working woman. Magazines such as *Vogue* and *Harper's Bazaar* are going beyond the printed pages, using their influence in a number of ways to help new designers get started, to promote health awareness, and to support philanthropic causes. Thanks to the Internet revolution, fashion magazines are offered online as **e-zines**.

FASHION ORIGINATORS' GUILD OF AMERICA (FOGA). This is an organization that was begun in 1932 by twelve apparel **manufacturers** in response to widespread copying in the ready-to-wear business. By 1941, the organization represented 176 manufacturers. These manufacturers refused to sell to any **retailer** which also sold garments copied from their originals. The organization was disbanded when the U.S. Supreme Court ruled its practices illegal under the terms of the Sherman Clayton Act. *See also* COPYISTS.

FASHION PHOTOGRAPHER/PHOTOJOURNALIST. A person who specializes in taking photographs of fashion for advertising

or editorial purposes to appear in magazines, trade publications, catalogs, press kits, Internet, and elsewhere. Among the best-known fashion photographers are **Richard Avedon, Louise Dahl-Wolfe, Steven Meisel, Helmut Newton, Herb Ritts**, and **Bruce Weber**. Some photographers, in addition to taking the photographs, will also write fashion stories for publication. **Bill Cunningham** of the *New York Times* is an example of a photojournalist. *See also* FASHION PHOTOGRAPHY.

FASHION PHOTOGRAPHY. Since the invention of photography in 1839, clothes have been depicted in portraits. However, it was not until the 1850s that French **couture** houses began using photographs to document their collections, starting with Parisian photographers in the 1880s: Henri Manuel, Maison Reutlinger, and Talbot. The first important fashion photographer is considered to be the American Baron Adolf de Mayer, whose photographs in the early 1900s were more artistic than descriptive. He was followed by Edward Steichen in the 1920s and Horst P. Horst. In the 1930s and 1940s **Bill Cunningham**, Man Ray, **Irving Penn**, and **Louise Dahl-Wolfe** made major contributions followed by **Richard Avedon** in the 1950s. The 1960s saw David Bailey, Bert Stern, and Diane Arbus and the 1970s brought the work of **Helmut Newton**, Guy Bourdin, and Debra Turbeville to the pages of *Vogue* and *Harper's Bazaar*. In the 1980s and 1990s, advertising fashion became highly important as a means to create and market a look and/or sell a lifestyle—and fashion houses sought the help of photographers to capture and project those images. The work of photographers **Herb Ritts, Richard Avedon, Irving Penn, Helmut Newton, Bruce Weber, Steven Meisel**, Dick Nystrom, David Sims, Patrick Demarchelier, Mario Testino, Annie Leibowitz, David La Chapelle, and Ellen von Unwerth could be seen in editorial and advertising pages in magazines and in press kits. New photographers continue to be discovered and have become as important to the hype of a launch as the clothes themselves. *See also* FASHION PHOTOGRAPHER.

FASHION PLATE. A fashion drawing, engraving, or illustration that depicts the newest clothes, shoes, hairstyles, and **accessories** of a particular period in time. Fashion plates were first used in England

and France during the late sixteenth century and were a wonderful way to promote fashion workshops in countries throughout Western Europe. They were also a source for "common folk" to copy what nobility was wearing with, of course, modifications. *Fashion plate* is also a term given to a person who is known to dress well. *See also* FASHION ILLUSTRATION; FASHION ILLUSTRATOR.

FASHION PRESS. Reporters and photographers who write or cover fashion and the fashion industry. *See also* FASHION COLUMNIST; FASHION CRITIC; FASHION EDITOR; FASHION JOURNAL-IST; FASHION PHOTOGRAPHER/PHOTOJOURNALIST; FASH-ION REPORTER.

FASHION PUBLIC RELATIONS (PR). The area of the fashion industry that is involved in creating, maintaining, communicating, and promoting an exciting public image for a company or store. This is accomplished by the PR through interaction with the fashion press, magazines, trade publications, in movies, on television, through special events and fashion shows, or by having celebrities wear the product.

FASHION REPORTER. A person who reports on fashion events as they happen. They attend fashion shows, conduct interviews, or report on events relating to fashion and the fashion industry. Some famous fashion reporters are Elsa Klench, **Isaac Mizrahi**, Hal Rubinstien, and Robert Verdi.

FASHION SEASON. The timing of a collection that coincides with a particular fashion selling season such as Fall, Spring, Summer, Holiday, and Resort.

FASHION SHOW. A venue for **designers** to showcase their new collections to the public that involves fashion **models**, sound, lighting, and a crew of others who help stage the runway show. Industry press and noted **retailers** are invited as well as celebrities and members of society. The first fashion shows can be traced to Paris beginning in the mid-1800s with designers **Charles Frederick Worth**, **Jeanne Paquin**, and **Jean Patou**. In the 1930s, **Elsa Schiaparelli** broke from

the traditional model parade of her contemporaries and staged fashions shows using lights, acrobatics, and music. Designers **Claude Montana** and **Thierry Mugler** staged fashion show "extravaganzas" during the 1970s and 1980s that became media hypes, with fashion models often upstaging the clothes. In the late 1990s and early 2000s, designers **John Galliano** and **Alexander McQueen** continued to create some of the most spectacular shows, often with celebrity guests in attendance and sometimes even on the runway. While most twenty-first-century designers do not veer from the modern runway fashion show formula, others, most notably **Viktor & Rolf**, have transformed the fashion show experience for the new millennium by creating avant-garde conceptual performances.

FASHION SHOW PRODUCER. Designers often hire show producers specific to the fashion industry. The producer is responsible for all aspects of the show production and preparation—from model selection, lighting, and sound to the specific order of garment presentation. See also FASHION SHOW.

FASHION STYLIST. The person hired to project a fashion mood. In film or television, this is a person who interprets trends well in advance and can predict what will be popular with the viewing audience. Additionally, the stylist on a "fashion shoot" will select the **accessories** and coordinate the clothing pieces to best reflect the message the **designer** is imparting in his/her collection. See also FIELD, PATRICIA.

FATH, JACQUES (1912–1954). Grouped with **Pierre Balmain** and **Christian Dior** as one of the top three designers in Paris during the 1950s, French-born Fath began his company in 1937. It was this same year he designed his famous "pencil skirt." He understood the aligning of fantasy and drama with the marketing of clothing. He had a loyal following in Hollywood and designed for both stores and movie stars alike. Fath patented the "basket bustier" and incorporated them for support in his designs with plunging necklines. Fath died at the age of forty-two and his business closed shortly after, though his perfume label continued until 1992. It was shortly after that the house reopened with Tom Van Lingin as head of design. See also HAUTE COUTURE.

FEDERATED DEPARTMENT STORES, INC. The history of Federated Department Stores, Inc., began with John Shillito, when he founded Shillito's Department Store in Cincinnati, Ohio, in 1830. In 1929, Shillito, **F & R Lazarus**, Filene's, and other family-owned stores joined together and formed a holding company, Federated Department Stores, Inc. Fred Lazarus in 1939 convinced President Franklin D. Roosevelt to move the Thanksgiving holiday to create a longer Christmas selling season. It was also in that year that Allied Stores (formed in 1935) joined Federated to offer credit to customers. During the next few decades, various acquisitions took place throughout the retail business. In 1988, Campeau Corporation, which had acquired Allied Stores in 1986, acquired Federated. After filing for bankruptcy in 1990, a new public holding company was formed in 1992, consisting of 220 stores in 26 states in the United States. The world-famous **Bloomingdale's** joined the Federated group and, in 1996, Macy's also became part of the group. By the turn of the century, **department stores** were struggling for identity and began losing market share to the huge **mass-market** chains that developed trendy merchandising teams and joined forces with recognized designers. **Lord & Taylor**—also part of the Federated group, but not necessarily a perfect fit into the Macy's–Bloomingdale's profile mix—eventually felt the brunt of these various competitive market forces, and talk of closing these stores began. In 2005, Federated merged with the **May Company**, creating the largest department store conglomerate in the United States. In 2006, Lord & Taylor was sold to NRDC Equity Partners for $1.195 million. *See also* CHAIN STORE; RETAILER.

FÉDÉRATION FRANÇAISE DE LA COUTURE, DU PRÊT-À-PORTER DES COUTURIERS ET DES CRÉATEURS DE MODE. Begun in France in 1973 and derived from the **Chambre syndicale de la haute couture parisienne** (1868), this organization, also known as the French Couture Federation, is composed of approximately 100 members from the three branches or "houses" of the French fashion industry: the **Chambre syndicale de la haute couture**, the **Chambre Syndicale du prêt-à-porter des couturiers et des créateurs de mode** and the **Chambre syndicale de la mode masculine**. In 1975, the Union National Artisanale de la couture et

des Activites Connexes (National Couture Craft Industry and Related Activities Union), representing couture dressmakers, became a member. Created by the Chambre syndicale de la haute couture in 1928, the **Chambre Syndicale de la couture parisienne** is under the umbrella of the Federation, providing training for the benefit of its members.

The Federation represents companies with famous, worldwide **brands** from **haute couture** to **ready-to-wear**. It provides numerous services for members such as setting the haute couture, men's, and ready-to-wear fashion show schedules and coordinating the press list for those shows; initiating relationships with **buyers**, weavers, and subcontractors; collaborating with the French Ministry of Industry on new technology projects and working to defend intellectual property rights; producing agendas and official guides and maintaining a website with contacts and news about Federation members.

FELLOWES, DAISY. *See* SCHIAPARELLI, ELSA.

FENDI. This company began as a **boutique** and **leather** shop and was opened in Rome in 1918 by Edoardo and Adele Fendi, whose retailing concept was to bring the opportunity to purchase **furs** to a wide variety of social classes. Daughters Paola (1931–), Anna (1933–), Franca (1935–), Carla (1937–), and Alda (1940–) are credited with making the Fendi label known throughout the world. For numerous years **Karl Lagerfeld** had been the **designer** name behind the Fendi **brand** responsible for the leather and fur creations. In 1977, the company introduced a **ready-to-wear** line and, in 1985, it launched a **perfume**. At the turn of the century, the company still maintained its hold in the **accessories** market where it all began.

FERRAGAMO, SALVATORE (1898–1960). Ferragamo lived near Naples, Italy, and was born into a family where shoes were a luxury reserved for special occasions. He created his first shoe as a child and later migrated to the United States in 1923 to learn machinery production methods. His handcraft approach did not translate into mechanical production and he moved to California where he designed **custom-made** shoes for celebrities in his own boot shop in Los Angeles. He later returned to Florence, Italy, in 1927 to secure the

craftsmen and materials of the superior level he required. He married and continued his business in his home country. In 1936, Ferragamo invented the wedge heel. Made of cork or raffia or hollowed out, this heel remained in fashion for a decade. It still enjoys significant resurgent cycles and became prominent again in 2005. After his death, his family continued his **footwear** business and expanded the company to include smaller **leather** goods, apparel, perfume, scarves, and luggage. In 1996, the Ferragamo Company took over the **Emanuel Ungaro** fashion house.

FERRE, GIANFRANCO (1944–2007). An Italian **designer** who studied architecture, Ferre designed belts while studying at college. He spent several years in India and the colors and craftsmanship he discovered there have been a significant influence on his work. He launched his first women's **ready-to-wear** collection in 1978, in part due to the backing of Bolognese industrialist Franco Mattioli. Known for his bold look and luxurious textiles, Ferre is also hailed as *the* creator of the white shirt. In 1989, Ferre was appointed **creative director** at **Dior** where he remained until 1996. Ferre has **menswear, childrenswear, fragrances,** and watches that bear his name. *See also* HAUTE COUTURE.

FETISH FASHION. Pioneered by **Vivienne Westwood** in the 1970s and **Jean-Paul Gaultier** in the 1980s, fetish fashion emphasizes dominatrix in the use of **leather, corsets,** rubber, and shoes that could be classified as extreme.

FIELD, PATRICIA. With more than thirty years as a stylist/designer/ costumer for socialites, film, media, and **fashionistas,** Patricia Field also styled the hit television show *Sex and the City* (1998–2004), for which she received five Emmy nominations and one win. The show is considered by many to be one of the most "fashionable" shows in TV history. Field also has a clothing line, House of Field, which is sold internationally and designed by **David Dalrymple** since 1995 and signed with Candies to do a limited-edition line of apparel, **footwear,** and **accessories**: Vintage Candies by Patricia Field, which launched in spring 2005. Her roots, however, reach back to her own store in New York, which she opened in 1966. Filled with **punk** fashion, hip accessories, and flashy undergarments, it has set the stage

for numerous trends for more than thirty years. *See also* COSTUME DESIGNER; FASHION STYLIST.

FINANCIAL PURCHASING MANAGER. A **buyer** at a large corporate apparel company that oversees the financial purchasing activities for the entire office and supports the executive vice-president in all financial activities. Job responsibilities include the coordination of competitive bidding and price and term negotiations; managing internal budgets and reporting activities; implementing and administering the operational policies and systems within the functional areas; establishing methods and procedures for departmental work activities; and identifying and resolving any operational problems, vendor disputes, and contract compliance issues. He/she works in conjunction with the corporate purchasing office, legal and finance departments, and the vendors to ensure that merchandising programs are fully supported in accordance with corporate business plan initiatives, approved budgetary targets, and contracts compliance.

FIT MODEL. A **model** experienced in assisting the designer to achieve a perfect garment fit. Fit models, unlike runway models, address the "feel" of the garment on the body. As a critical aspect of the design process, designers are very respectful of "fit model" input before releasing their creations for completion. *See also* MODEL.

FLAT PATTERN. *See* PATTERN.

FOB. An acronym for "free on board," it is used as a shipping term and means that the buyer pays the freight charges.

FOGARTY, ANNE (1919–1980). Fogarty began as an actress and became the 1950s "wife-dressing" designer. She had the ability to create clothing to compliment the 1950s **lifestyle** look of the perfect American housewife. Best known for the "paperdoll" dress and her "tea cozy" dress, Fogarty continued to design until her death. *See also* AMERICAN LOOK.

FONTANA SISTERS. Three sisters, Zoe, Micol, and Giovanna, began their Italian design business in 1944 in Rome. They were

inspired by the 1950s films, and so the leading ladies of Hollywood soon became devoted customers. The sisters' evening dresses, wedding gowns, and film costumes were luxurious and dramatic, thus their appeal to the stars. The American public, hungry to escape into the world created by film, followed the design choices of the stars and socialites who chose the Fontana sisters' designs. The "cassock dress," inspired by ecclesiastical dress, was the sisters most famous and controversial.

FOOTWEAR. The original purpose of footwear was for foot protection. And although protection from the elements is still the basis of its existence, many will declare that there is nothing "sexier" than a pair of shoes by any of the current designers, such as **Manolo Blanik.** From the mid-seventeenth century, shoemakers worked for individual fashion houses; in Paris, one of the most famous was Pinet, who became established with **Worth** and continued to sell shoes until the beginning of World War II. In the United States, the first mass production of shoes began in 1750. Once the shoemakers adapted the sewing machine to work with leather, they could make and sell shoes at affordable prices by the late 1700s. Also at this time, shoes began to be sold by shoe stores rather than shoemakers and, by the 1880s, shoes were produced with right and left feet. The twentieth century saw shoemaking as a global enterprise—**mass-market** shoes were produced in Asia and high-end footwear sales centered in Italy.

Footwear consists of numerous categories such as sandals, moccasins, boots, and clogs. The shoe is defined by having a sole that is attached to an upper. In the twelfth century, shoes featured elongated pointed toes. By the fourteenth century, shoes were highly sought-after fashion accessories and the quality of the leather or textiles was a clear distinction of status and wealth. The fifteenth century saw wide toes replace the pointed predecessor and by the sixteenth century platform soles raised the wearer as much as 39 inches from the ground level. During the seventeenth century, both men and women wore raised heels, and buckles became a key symbol of determining the wealth of the wearer. Women of the eighteenth century wore three types of heels; sharp and narrow, mid-height and curved, or low and broad. Shoelaces replaced buckles and, by the end of the century, styles modeled after life in the English countryside became popular.

The nineteenth century saw the birth of the women's ankle boot and the middle class had a variety of affordable styles to choose from. In the twentieth century, shoes became a "fashion collectible" and it seemed as though both women and men could not own enough pairs of shoes. Colors from red to metallic gold, as well as the pairing of white with black or brown, became the rage. The birth of the shoe designer took place in the 1930s. **Claire McCardell** in the war-rationing 1940s requested a hard version of the ballet slipper, due to the fact that it was not part of the war time restrictions. Shoes became light and flat and complemented **Dior's New Look**. The postwar era saw the Italians and the French competing for the spotlight as *the* shoe designers and recognized names such as **Charles Jourdan** and **Roger Vivier** made pointed toes and **stiletto heels** a fashion must-have. The rise of youth fashion in the 1950s saw loafers as the choice of college students, along with basketball shoes and the "desert boot" by Clark. The 1960s was home to the **go-go boot** first introduced by **Courrèges**, as well as Vivier's "Pilgrim" pump. The "hot pants" style of the 1960s included thigh-high boots for women, and **androgyny** in fashion presented platforms for both men and women. **Street** fashion in the 1970s propelled the sneaker/trainer as we now know it and the **Doc Marten** became the shoe of choice for the followers of the **punk look**. The most significant influence on footwear in the 1980s was the fitness rage—and the sneaker took center stage. This, together with **brand** awareness, made names such as **Nike**, **Reebok**, and **Adidas** sought after by consumers of all ages. The **accessory** market for designers exploded in the 1990s and fashion shoes by Gucci, Louis Vuitton, and other designers of note become a fashion necessity across various income levels.

FOOTWEAR DESIGNER. A designer who specializes in the design of shoes, boots, sandals, or **sneakers**. He/she must possess knowledge of mold drawing and the **footwear** development process, be computer proficient in **Adobe Photoshop** and **Adobe Illustrator**, and have a knack for trend-spotting and presentation board skills. *See also* ACCESSORIES; BLAHNIK, MANOLO; CHOO, JIMMY.

FOOTWEAR NEWS (FN). A weekly newspaper launched on October 6, 1945, and published by **Fairchild Publications**, *Footwear News*

covers the shoe industry of the United States. *FN* focuses on all issues relevant to women's, men's, and children's **footwear**.

FORECAST SERVICE. *See* FASHION FORECAST SERVICE.

FORCE OUVRIÈRE (FO). A French **trade union** that was founded in 1948 as an offshoot of the **Confédération Générale du Travail (CGT)** in opposition to French Communist dominance of that organization. Today, the FO is the third-largest union in France behind the **Confédération Française Démocratique du Travail (CFDT)** and the CGT.

FORD, TOM (1962–). Born in Texas, Ford began his specialized education in acting and then studied interior design at **Parsons School of Design** in New York City. He became a recognized **designer** while he headed the design team for **Perry Ellis** under the direction of **Marc Jacobs**. In 1990, he was hired as **creative director** by **Gucci**. During his tenure at Gucci, Ford reinvented the business suit for women. Masculine pinstripes were softened with halter tops and high heels. The look conveyed a secure, competent woman. When the Gucci Group bought the **Yves Saint Laurent ready-to wear brand** in 2000, Ford became the creative head there, as well. He is credited with turning the failing Gucci company around with his keen sense of editing and focusing on his interpretation of the customer. He left Gucci in 2004 to pursue his own line of beauty products in partnership with Estee Lauder. In 2006, Ford signed a deal with the Italian fashion house **Ermenegildo Zegna** to produce a line of men's clothing, shoes, and **accessories**, all under the Ford name and sold initially at Ford's **boutique** in New York before going global. This venture of Ford's speaks to **custom-made** clothing for real people rather than runway drama.

FORMAFIT. The parent company that developed **Clothing Creator**.

FORTUNY, MARIANO (1871–1949). Born in Granada, Spain, Fortuny trained as a painter and set designer. In 1901, he opened a technical studio in Paris and is credited with the invention of indirect lighting. Later in the decade, Fortuny devoted himself to the dyeing

and pleating of **silks**. He is, however, best known for his creation of the "Delphos" evening dress. This 1907 design is one that can never be in or out of fashion; it is an entity unto itself. It is a seamless tunic that neatly coils into a small box. It is created from a single length of fabric and is permanently pleated in a manner that is still today a secret. During the next forty years' time, Fortuny designed numerous variations of this dress. He created sweeping hemlines to compliment the body and added hand-blown Murano glass beads to the hem for weight in order to keep its shape. Ownership of an original Delphos is coveted by women worldwide. Today, the Venice-based Fortuny Company is known for textiles that have a depth and richness, credited to the printing processes developed by Mariano Fortuny.

FRAGRANCE. Fragrance has always been associated with luxury, indulgence, and personal recognition and, even though its full known history is lost in antiquity, it's been shown that the ingredients were once valuable trade items. People in the sixteenth century used scents to mask unpleasant odors. The scent of choice in the seventeenth century was musk, while the women of the eighteenth century preferred floral and fruity scents. By the nineteenth century, Paris became the center of the perfume world. In the early 1900s, **Paul Poiret** was the first designer to market a perfume. However, it was **Chanel** in the 1920s who created the most famous designer fragrance, arguably of all time, with her Chanel No 5. Chanel was followed by **Jeanne Lanvin**, **Jean Patou**, and **Elsa Schiaparelli**. Not only can fragrance make a significant positive impact on many designers' businesses, it also enhances their **brand image** for their customers through advertising and marketing. Additionally, a fragrance permits a larger audience due to the fact it is less expensive to purchase than **couture** clothing. Lalique in the 1940s created perfume bottles that today are highly collectable and, by the 1950s, French perfume was at its height. By the 1970s, perfume was a marketing tool that created "shock value," such as Opium by **Yves Saint Laurent**. **Ralph Lauren** used fragrance to assist in creating and selling his total **lifestyle brand** and **Calvin Klein's** perfume business generates more than $500 million in sales annually. Each fragrance that Klein created reflected the state of his life and/or his clothing collections: Obsession, related to living life for the moment; Eternity, about his new marriage; and CK One,

as **androgynous** as many of his advertising campaigns. **Tom Ford** in the 1990s targeted the younger clientele with his sleek fragrance packaging, as did **Versace**, with multiple fragrances named after various jeans line such as Baby Blue Jeans and Yellow Jeans.

FRANCHISED BOUTIQUES. These stores feature merchandise of a specific **designer**, for example, **Ralph Lauren.** Each store is independently owned as opposed to corporate ownership. Designers are provided the opportunity to merchandise their lines cohesively, unlike **department stores** that may divide garments into several departments. By the year 2000, many corporations were beginning to "buy back" their franchised stores and have complete control over their product at retail. *See also* RETAILER.

FREELANCE DESIGNER. Responsibilities of freelancers are inclusive of all that relate to a **designer**; they often vary with each client. Positions can be based on an hourly, daily, or line commitment.

FRENCH CONNECTION. Identified with its signature label, FCUK, this trendy company was founded in 1969 by Stephen Marks in London. *See also* BRAND; BRAND IMAGE; CARNABY STREET LOOK.

F & R LAZARUS & CO. A **department store** founded in Columbus, Ohio, by Simon Lazarus in 1851. *See also* FEDERATED DEPARTMENT STORES, INC.

FRUIT OF THE LOOM. This company dates back to 1851 when textile mill owner Robert Knight of Rhode Island was inspired by a friend's fruit artwork and trademarked the name. The company made men's and women's underwear initially but later diversified to other product categories. In 1976, Fruit of the Loom bought rival **BVD** and, in 1985, Fruit of the Loom was bought by William F. Farley. It became a vertically integrated, international basic apparel company, which emphasized branded products for consumers ranging from infants to senior citizens. The company manufactures and markets men's and boys' underwear, women's and girls' underwear, printable **activewear**, casualwear and **sportswear**, **childrenswear**, and fam-

ily socks. **Brand** names include Fruit of the Loom, BVD, Best, and Screen Stars. **Licensed** brands include Munsingwear, Wilson, Botany 500, and John Henry. Licensed apparel bearing the **logos** or insignia of major sports leagues, their teams, and certain popular players, and the logos of most major colleges and universities, are marketed under the Fan's Gear brands. In 1999, the company filed for bankruptcy but, in 2001, was sold to Berkshire Hathaway Inc., a company owned by billionaire financier Warren Buffett.

FUR. In addition to foliage and **leather**, fur is among the oldest materials used as clothing. Cro-Magnon-era folks, who lived 50,000 years ago, migrated to colder climates in search of food. Fur provided protection from the elements. Our early ancestors learned how to keep animal skins from rotting by salting them and were therefore able to create fur head coverings and one-piece shawl-like garments. From the fourteenth to seventeenth centuries, certain furs such as marten, fox, grey squirrel, and ermine were reserved for and worn only by royalty as part of "sumptuary legislation," which placed public consumption restrictions on certain items and practices. These furs became symbols of power, wealth, and status. However, fur has not always had a stellar reputation: it was believed that flea-infested furs were responsible for spreading the Black Death across Europe in the fourteenth century, killing more than one-third of the population. By the sixteenth century, however, fur was once again in high demand and even lead to the exploration of North America, where beaver, fox, and raccoon were plentiful.

The fur industry is composed of three areas: (1) trappers and breeders who produce the pelts, (2) fur processors (dressers and dyers) who tan the skin side of the hide, making it soft, and then clean, color, and preserve the natural luster of the fur, and (3) the manufacturer of fur products. Traditionally, the most expensive and desirable furs have been mink and sable, worn mostly by wealthy middle-aged women. Today, however, many different and less-expensive furs such as rabbit, beaver, muskrat, and raccoon are worn by men and women of all ages. International law prohibits trade of endangered species in the United States. The Fur Products and Labeling Act of 1952 requires labeling of the name and origin of the fur pelt, the type of processing and dyeing, whether tail or paws have been used, and whether any

parts are reused fur. Animal-rights activist groups, such as People for the Ethical Treatment of Animals (PETA) and Friends of Animals in the United States and LYNX in England, raise awareness of the mistreatment of ranch-bred animals killed for their pelts. Anti-fur **designer Stella McCartney** and singer Chrissy Hines campaigned against the wearing of fur while other designers shunned the controversy and fearlessly featured fur on the catwalk, often to visible protest. While the goal of anti-fur activists has been to make wearing fur unfashionable, fur trade organizations—like the Fur Information Council of America and the Fur Institute of Canada—work hard to promote fur as fashion and to support animal welfare organizations.

FURLA. A company founded by Aldo Furlanetto as a leathergoods store on Bologna's Via Ugo Bassi in 1927. Known for luxury leather handbags and accessories, Furla made a name for itself in Italy and, through the efforts of son Paolo, expanded the company worldwide. Today the company is run by the founder's daughter, Giovanna Furlanetto, with 255 stores in 73 countries. In 1999, Giovanna set up an art awards program called Furla l'Arte, which supports young artists.

FUTURISTIC FASHION. Inspiration for fashion futurism stemmed from the Italian modernist movement and the writings of Filippo Tommaso Marinetti in his *Manifesti du Futurisme*. Futurism was an oppositional expression to the bourgeois **dress code** of the early 1900s. Speed, movement, and dynamism were the core design elements. In 1913, Parisian **designer**/artist **Sonia Delaunay** created her "simultaneous" dresses—colorfully painted, modern clothing with movement well suited for the dance trends of the time, namely the new foxtrot and tango.

However, it wasn't until the youth movement in the 1960s that designers experimented with new textiles and technologies to create futuristic, space-age fashion. Designers **Paco Rabanne, Rudi Gernreich, André Courrèges,** and **Pierre Cardin** were pioneers of plastic, **vinyl,** metal, and other nontraditional materials used to fashion garments, materials such as laser discs, rhodoid discs, paper, and plastic paillettes. They also created innovative shapes, devised new molding and seaming techniques, and pioneered minimalist

silhouettes such as the monokini, helmet hats, **go-go boots**, micro **miniskirts**, vinyl mini dresses, and the concept of unisex dressing.

– G –

GALANOS, JAMES (1927–). Born in Philadelphia, Galanos is an American designer respected worldwide as a true **couturier**. A perfectionist in regard to workmanship, Galanos received his formal design education at the Traphagen School of Design in New York City and studied for a year in Paris at the house of Piguet. He opened his own business in Los Angeles in 1951 and was the recipient of numerous design awards. Galanos's designs are represented in permanent collections throughout the United States. Nancy Reagan, the former first lady of the United States, often wore Galanos gowns at formal functions.

GALERIES LAFAYETTE. This fashion store began in a small haberdasher's shop in Paris in 1893 by Theopile Bader and his cousin Alphonse Kahn. Today it is Europe's largest **department store**, selling everything from **designer** clothing to gourmet food. *See also* VIONNET, MADELEINE.

GALLERY OF FASHION. An exclusive fashion periodical published from 1794 to 1803 by Nicholaus von Heideloff (German).

GALLIANO, JOHN (1960–). The first British designer since **Charles Frederick Worth** to command the helm of a French **couture** house. Galliano was born in Gibraltar and studied at **Central Saint Martins College of Art and Design** in London, where, upon graduating, he opened his own business in 1984. In 1995, he was hired as designer at **Givenchy** but left one year later. In 1996, he was hired at the house of **Dior**. He is best known for his beautiful evening gowns that are often cut on the bias. In 2001, **Galliano** added eyewear and lingerie and, in 2003, **menswear**. A second women's **ready-to-wear** line will be launched in 2007 with Italy's IT Holding, owner of **Gianfranco Ferre**, **Roberto Cavalli**, and until 2005, **Dolce & Gabbana**. Influenced by film, art, and pop

culture, Galliano collections traditionally cause a "stir" on the runway. *See also* HAUTE COUTURE.

GAP. Founded in 1969 by real estate entrepreneur Donald Fisher, the Gap created a **brand identity** with their merchandising formula—basic **sportswear** items and **accessories**, all displayed in an uncluttered, color-coordinated atmosphere. By the mid-1990s, other retailers had copied the Gap and president and CEO Millard Drexler integrated a strong marketing plan to enhance the Gap **brand**. In 1997, after a decade-long hiatus, Gap returned to TV advertising. Its campaign, Fall into the Gap, set the stage for revitalization of the brand. Drexler ran Gap from 1998 to 2002 and increased annual sales from $4.4 billion to $13.8 billion annually. Located in San Francisco, California, Gap is the largest specialty retailer in the United States; as of 2005, Gap employed 150,000 people and had 3,005 retail establishments worldwide. In 2004, it sold its German operation to its local competitor, **H&M**. The Gap empire has a value retail chain, Old Navy, and an upscale brand—Banana Republic. In 2005, it launched Forth & Towne, a retailer geared to women in their forties and fifties not comfortable with the merchandise of the youth-oriented stores. By 2007, however, all 19 stores were closed. *See also* RETAILER; SPECIALTY STORE.

GAULTIER, JEAN-PAUL (1952–). Born near Paris in the suburb of Arcueil, Gaultier served apprenticeships at **Pierre Cardin** and **Jean Patou**, which provided a solid foundation. He presented his first collection in 1978. In the 1980s, he was known as the **designer** who emphasized broad shoulders and narrow hips. But perhaps he is best known for his obsession with gender—he would put men in skirts and have women wear underwear on the outside, and he was the force behind Madonna's conical bra. He is known by his rebellious antics such as his participation in the TV series *Eurotrash* and poking fun at the Parisian bourgeoisie. In 1997, Gaultier made his couture debut and, in 2003, he was appointed **creative director** at **Hermès**. In 2004, he launched a young **denim** and **sportswear** line. Gaultier's latest innovation is a makeup line for men, which he pioneered in 2004; his eyewear collection launched in 2006. Gaultier also has a **fragrance**. *See also* HAUTE COUTURE.

GENDER BENDERS. The term given to underwear created by **Calvin Klein** in 1983. Women's underwear took on a very masculine look incorporating elastic treatments traditionally only found on men's underwear. Men's underwear went from looking functional to sexy without looking feminine.

GENERAL AGREEMENT ON TARIFFS AND TRADE (GATT). GATT is an international treaty dating from 1947 based on the "unconditional most-favored nation principle," a treaty which was the foundation for the **World Trade Organization (WTO)** in 1993. Since its inception, GATT has spearheaded several roundtables on issues that closely affect the garment and textile industries, such as trade barrier reductions, tariff reductions, quota reduction, anti-dumping agreements, trade-related intellectual property rights (TRIPS), and international trade law.

GENERAL MERCHANDISE MANAGER (GMM). In the retail store, this person is the senior retail manager or vice president, who reports to the store president and is responsible either for an individual store or a chain of stores. The GMM oversees all aspects of the store's merchandising policy and profitability.

GENERATION X. This is the name given to the group of people born between the mid-1960s and the late 1970s. This group, who in 2006 were 29–39 years of age, makes up approximately 48 million people in the United States. *See also* TARGET MARKET.

GENERATION Y. This is the name given to the cohort of people born between the late 1970s to the year 2000, following Generation X. This group totals approximately 76 million people in the United States. *See also* TARGET MARKET.

GENTLEMEN'S QUARTERLY. See GQ.

GERBER TECHNOLOGY. A computer technology company that provides product lifecycle management (PLM), **computer-aided design (CAD)**, and **computer-aided manufacturing (CAM)** solutions to manufacturers and **retailers** in the sewn and flexible goods

industries. In 1968, Joseph Gerber (American) invented the first automated cutting machine, which revolutionized the apparel industry worldwide. Between 1985 and 1987, he introduced the Gerber mover, a device that automatically moved pieces around the sewing floor and launched a more affordable multi-ply cutter. In 1988–1990, Gerber created the first PC-based marker system and Bill Clinton presented Joseph Gerber with the National Medal of Science and Technology for his introduction of the Silhouette pattern drafting table. From 1995 to 1997 Gerber introduced his GERBERsuite software package and, recognizing the shift in manufacturing potential, opened major operations in China and other developing countries. In 2004, Gerber received the Export Achievement Award from the U.S. Congress; the same year, Gerber launched GerberNet, a customer service Web portal. Additionally, Gerber Technology provides products for fashion retailers and manufacturers in other areas, including fashion lifecycle management (FLM), WebPDM, textile design, 3-D pattern visualization, and mass customization.

GERNREICH, RUDI (1922–1985). Best known for shocking the world as the creator of the monokini, Gernreich was born in Vienna and began his career in fashion in California. After several years working for various **manufacturers** and designing **costumes**, he opened his own business in 1960. Gernreich believed in a *total look* and understood the role that hairstyles played in creating this complete package. In 1965, he collaborated with the famous hairstylist Vidal Sassoon. Not timid in regard to color or pattern, Gernreich was part of the antifashion, unisex movement of the 1960s. Gernriech had a direct impact on **intimate apparel** with his "no-bra" look in the mid-1950s. Peggy Moffit, a famous 1960s fashion **model**, complemented his designs with her bold stark look. *See also* LIFESTYLE-DRESSING.

GHESQUIÈRE, NICOLAS (1971–). Born in Provence, France, he entered the fashion industry upon graduation from fashion school by landing a job at **Jean-Paul Gaultier** in Paris. In the mid-1990s, he was hired to design a **licensed** line for **Balenciaga** and, when designer Josephus Thimister left Balenciaga in 1997, Ghesquière assumed the position. His goal is to stay true to the expert **tailoring** that "the master" made famous. *See also* HAUTE COUTURE.

GIANNINI, FRIDA (1955–). Born in Rome, Giannini attended fashion school and then designed **jeans** before moving to **Fendi** in 1995. Hired by **Tom Ford** to design **Gucci accessories** in 2002, she later replaced Alessandra Facchinetti (after only two seasons) as **creative director** for Gucci women in 2005. Giannini's goal is to create clothing for women who have a more balanced life in contrast to the sleek, sexy, chic customer that Tom Ford chose to dress. *See also* BRAND IMAGE; WOMENSWEAR.

GIGLI, ROMEO (1949–). Born in Italy, he started his own business in 1983, consistently marching to the beat of his own drummer. Inspired by romanticism, Gigli incorporated rich colors and fabrics into his collections. He is also the creator of a successful **menswear** line, a young women's line, and a perfume, which received the American Fragrance Foundation Award for best packaging. *See also* READY-TO-WEAR.

GIMEL. Gimel is a globally recognized jewelry company whose head of design, Kay Akihara, is known for her traditional Japanese designs.

GIRBAUD, MARITHÉ AND FRANCOIS. Born in 1942 and 1945, respectively, the Girbauds met in Paris in the early 1960s; this couple shared the dream of becoming American **designers**. They opened their first **boutique** in 1962 and introduced the world to faded **denim** in 1963. Intrigued by textile development, they maintain a proactive approach to exploring new techniques. In 1984, they introduced the cargo pocket, which soon became a design staple.

GIRDLE. The first rubber girdle was marketed by Stanford Mail Order in 1916. Women at the time were demanding bodyshaping with comfort. The girdle became an **intimate apparel** necessity until the 1960s, when the hippie movement and its influence on fashion factored into the girdle becoming less fashionable. *See also* HIPPIE LOOK.

GIVENCHY, HUBERT DE (1927–). Born in Beauvais, France, Givenchy began his career working at the house of **Fath** at the age of seventeen. He then worked for **Lucien Lelong**, Piguet, and **Elsa**

Schiaparelli. In 1952, at the age of twenty-five, he opened his own business in Paris. Givenchy was the youngest of the **haute couture** designers and created significant media attention with a simple white **cotton** blouse. Of course this was no ordinary blouse—it was perfectly crafted; that first collection set the tone for a career that kept Givenchy at the helm of his house for forty-three years. His approach to fashion was made up of **separates** and pieces that could be interchanged, each with attention to line rather than decoration. Actress Audrey Hepburn, whose style was flawless, basically became his muse. It was Hepburn who requested Givenchy to design her wardrobe for the Hollywood movie *Sabrina*. This was the first time that a French **couturier** crossed the Atlantic and bridged the fashion worlds of France and America, resulting in a relationship that continues today. He continued to make his mark with Hepburn and Hollywood; his famous black sheath, that Hepburn wore in the 1961 film *Breakfast at Tiffany's*, went to auction in 2006 with an estimated fetching price of more than $100,000. Givenchy also became the desired choice of designer for First Lady Jackie Onassis, Grace Kelly, and Gloria Guinness.

A dear friend and student of **Balenciaga**, Givenchy today is active in the Balenciaga Foundation in Getaria, Spain. Givenchy realized **licensing** was a business model to be embraced and went on to develop numerous licensed products. In 1988, he sold his company to French conglomerate **Moët Hennessey Louis Vuitton (LVMH)**, while remaining as head designer. Bernard Arnault took over LVMH two years later and, by 1995, Givenchy and Arnault parted company when Givenchy retired. Givenchy was first replaced by **John Galliano**, then **Alexander McQueen**, followed by designer **Julien McDonald**. By 2005, Riccardo Tisci was the creative force behind the Givenchy name.

GIVHAN, ROBIN (1965–). Born in Detroit, Michigan, Givhan graduated Princeton University and obtained a master's degree in journalism from the University of Michigan. Her career as a journalist included the *Detroit Free Press*, the *San Francisco Chronicle*, and *Vogue* magazine. She joined the *Washington Post* in 1996 and won the Pulitzer Prize for criticism in 2006 for her witty essays that "transform fashion criticism into cultural criticism."

GLOBALIZATION. Globalization, in a fashion sense, is the unification of the fashion world as it relates to trends, branding, and manufacturing. The fashion industry saw the implementation of globalization in the 1980s when the Western world discovered the financial advantages of overseas production. Today, the Internet serves as the ideal venue for fashion global communication for both the consumer and manufacturing worlds. Additionally, a sense of sensitivity and attention is being focused on the cultural component of fashion that spans the globe, specifically in relationship to color, sizing, silhouette, and **brand** identification. *See* GENERAL AGREEMENT ON TARIFFS AND TRADE.

GLOBAL SOURCING DIRECTOR. This person's duties include overseeing and creating strategies and buying plans; developing and maintaining relationships with overseas suppliers; managing aggressive sourcing policies and procedures; managing liaison offices; and motivating and developing staff. The global source director should possess expertise in foreign trade to excel in this position.

GO-GO BOOTS. A thigh-high, white boot created by **André Courrèges** in 1966. While the boot was a **fad**, it also translated across all levels of fashion, from **designer** to **mass market**. Even the **childrenswear** market immediately jumped on board, since, in that era, the traditional **footwear** styles had become influenced by adult fashion.

GOTHIC STYLE. A subculture of the **punk** look, gothic style for both sexes exudes somber fetish features such as black corsets, PVC skirts, facial piercing, dyed hair, combat boots, and tattoos. Begun in the 1980s, gothic style evolved into "cyber goth" in the 1990s. This look is inclusive of clothing that is sensitive to ultraviolet light and makeup that is fluorescent.

GOVERNMENT UTILITY SCHEME. Under the **British Civilian Clothing Order CC41** that went into effect in 1941, severe rationing of cloth and other embellishments were necessary during World War II. The United States passed similar enforcements. The British laws that were introduced made it illegal for a **manufacturer** or **designer** to use unnecessary buttons, stitches, pockets, pleats, or any

embellishment that was not functional to the garment. The Incorporated Society of London Fashion Designers was called upon to design clothes to help enforce the law and to boost morale during the war years. The government issued women a limited number of coupons with which they could buy clothes.

GQ. This American men's fashion quarterly magazine was founded in 1931 as *Apparel Arts*. For many years it was published in association with *Esquire* magazine but in 1967 changed its name from *Gentlemen's Quarterly* to *GQ* and, in 1970, became a monthly magazine. Condé Nast Publications bought the magazine in 1983 and, in addition to its coverage of **menswear**, it began featuring articles on food, movies, sex, and books.

GRADER. The person who is responsible for the process of grading **patterns**, that is, creating a size range of a particular pattern. Today, grading is almost always executed by a computer-based design system (**PDS**), which performs many functions of importance to the fashion industry, such as **pattern** drafting, pattern grading, and **marker** making.

GRAFF. A noted jewelry company, Graff is based in London and New York. It is known as the **haute couture** of diamond jewelry.

GRAPHIC DESIGNER. This is a person who is hired to create graphic design images for apparel, **accessories**, and/or fashion-related industries. This person must be proficient in **Adobe Photoshop**, Quark, and **Adobe Illustrator.**

GRÈS, ALIX (MADAME) (1903–1994). Born Germaine Emilie Krebs in Paris, she later changed her name to Alix Grès. In 1933, she first apprenticed at the **couture** house of Premet before moving to assist another **couturière** named Julie Barton. She opened her own house from 1941 to 1944 but closed for a short time due to the German occupation of Paris. When she reopened in late 1944, her business prospered and continued to do so through the 1950s and 1960s, which included the launch of a **fragrance**, Cabochard, released in 1959. Grès is best known for donning a beige turban and for designing the most

exquisitely **draped** goddesslike **silk** jersey gowns, sometimes using up to 30–70 yards each. It was not until the house was on the brink of bankruptcy that the company offered a **ready-to-wear** line, designed by Marc Audibet; in 1984, the company was sold to businessman Bernard Tapie. Two years later, it was resold to the French group Estorel and went bankrupt in 1987. The **brand** was eventually acquired by a Japanese investment group Yagi in 1988. In 2003, the shop on Rue St. Honorè was revamped and Japanese **designer** Koji Tatsuno (1965–) was hired to reinvent the Grès style. Today, Madame Grès is regarded as one of the most influential designers of the twentieth century. *See also* HAUTE COUTURE.

GRUNGE LOOK. Born out of the 1980s "grungers" from Seattle, Washington, this nonfashion look was influenced by a lack of fashion interest. Functional cargo pants (loose-fitting pants with numerous utility pockets) and **Dr. Martens** shoes are paired with finds at the local thrift store and untraditionally layered and mixed to create the look. **Marc Jacobs** brought grunge to the runway with his 1993 collection for **Perry Ellis**. *See also* PUNK STYLE.

GUCCI. Guccio Gucci founded this fashion house in 1904. Its roots are in the production of exclusive **leather** goods. During his years working in exclusive hotels in Paris and London and observing the quality of the luggage carried by guests, Gucci decided to open a fine leather shop in Florence, Italy. He was later joined by his three sons and expanded the family business. Changing from leather to canvas during World War II due to leather shortages, the situation gave creative birth to the famous double-G **logo**, which became the Gucci signature. The famous snaffle-bit clasp was introduced in 1966. Watches, apparel, and men's ties expanded the company's product line. The company enjoyed prosperity until the 1980s when family friction nearly destroyed the company.

 Tom Ford was named **creative director** in 1990 and is credited with being key in the positive recreation of the Gucci fashion house. Ford and his business partner, Domenico de Sole, left the Gucci Company in 2004. It was also during this time period that the Gucci **brand** joined other sought-after fashion names in the saturated **counterfeit** market. Major cities around the world had street vendors

promoting Gucci look-alikes in everything from handbags to scarves and **T-shirts**. Today the brand is owned by French conglomerate **Pinault-Printemps-Redouté**. Designer **Frida Giannini** was hired as creative director in 2005. In 2006, Gucci opened the Gucci Tower in the Ginza shopping district of Tokyo, Japan. Giannini has placed her mark on the interior and moved away from the cool look of Tom Ford into a lighter and warmer atmosphere. Eyewear, fine jewelry, and watches are fast-growing categories for the brand and the 11,000-square-foot retail space allows for a creative division of product.

GUESS. Launched in 1981 by the Marciano Brothers, this hip **jeans**-driven company creates women's, men's, and children's apparel lines. Recognizing that in the twenty-first century its customers had grown up, Guess began to add a more sophisticated dimension to its **womenswear** and **menswear** lines. *See also* DENIM.

GUILDS. Trade guilds date back to India (circa 2000 B.C.) and shoemakers' artisan guilds developed during the Roman Empire. Most guilds required long apprenticeships before achieving master status and had strict rules in order to maintain quality and control production. Medieval guilds protected and developed their members' jobs by controlling their education and progression of skill levels from apprentice to craftsman to journeyman and, eventually, to master and grandmaster of their craft.

Guilds began to spring up in major European cities and specialized in trades such as **millinery**, textile **manufacturing, footwear**, **dressmaking**, and tailoring. These early guilds were elitist, mostly male-dominated groups that placed many restrictions on their members based on their skills. Some guilds became extremely powerful. Of particular note was the French tailors' guild, Maitres Tailleurs d'Habits. Government policies favored guilds, which in turn often impeded technological progress and maintained a sense of government control. One example is **Barthélemy Thimmonier's** sewing machine, created in the early 1800s, which was destroyed by journeymen tailors who felt that the machine threatened their livelihood.

Functions of guilds were to oversee pay scales and to set work standards. Many guilds adhered to restrictions including the number of

apprentices that could be trained, the quantity of a particular item that could be made, and the prices at which items could be sold. These and other restrictions, coupled with industrialization and modernization, led to the demise of guilds. However, modern-day **trade unions** and trade associations are somewhat reminiscent of the guild concept.

G-UNIT. A division of Ecko Unlimited, this **hip-hop** clothing line is represented by music rapper 50 Cent and was launched in 2005. *See* ECKO, MARC; HIP-HOP LOOK.

– H –

HALSTON (1932–1990). Roy Halston Frowich was born in Iowa and studied fashion illustration at the Art Institute of Chicago. His fashion career began as a **milliner** designing hats for **Lilly Daché**. Halston is the **designer** of the pillbox hat worn by Jacqueline Kennedy at U.S. President John F. Kennedy's inaugural. In 1966, he designed his first **womenswear** collection for **Bergdorf Goodman** and launched the first Halston collection in 1968. Making Ultrasuede a must-have fabric, Halston is best known for his ability to marry exquisitely cut simple silhouettes with luxury fabrics. **Elsa Peretti** designed the bottle of his very successful eponymous perfume. Halston was the first designer to sign a partnership with a mass merchant, **J. C. Penney's**, in 1983, which some say led to his company's demise. After Halston's death in 1990, the company was reopened in 1995 by Tropic Tex. However, it was later sold to Catterton Partners in 1998, who hired Randolph Duke to revive the collection, but was again sold to Newco LLC in 1999. The collection has had a succession of designer names pass through it since 1999—Kevan Hall, Craig Notiello, Piyawat Pattanapuckdee, and, in 2002, Bradley Bayou. Bayou left in 2005 to start his own business.

HAMNETT, KATHARINE (1948–). Born to a British military family, Hamnett attended **Central Saint Martins College of Art and Design** in London. She and a friend opened a store in 1969, but she went bankrupt after a nasty divorce settlement. After years of **freelance designing**, she started her own company in 1979; in 1986, she received

backing from Danish fashion entrepreneur, Peder Bertlesen, to open her flagship store on Brompton Road. Known for her strong political views and controversial slogans on **T-shirts**, Hamnett was also one of the first designers to support the Green Movement in fashion. In 1989, Hamnett signed one deal with Italian **manufacturer** Zamasport for her men's and women's collection and another with CGA for Hamnett II, her secondary line. Hamnett, who began showing her collections in London, became critical of the British fashion industry and moved her show to Paris and her manufacturing facility to Italy. After the September 11, 2001, terror attacks, Hamnett stopped showing her collection and was forced into liquidation. She has since restructured and downsized her business and still actively campaigns for environmentally friendly **cotton** production and other ecological causes. *See also* FAIR TRADE FASHION; FREELANCE DESIGNER.

HANES. In 1901, P. H. Hanes of North Carolina founded the P. H. Hanes Knitting Company and began manufacturing men's underwear. In 1972, Hanes launched L'eggs, stockings that were packaged in an egg-shaped container. In 1979, Sara Lee Branded Apparel bought Hanes and was instrumental is making it the most successful **hosiery brand** in U.S. fashion history. In addition, Hanes is rated number one in male and female underwear and socks. *See also* GENDER BENDERS; INTIMATE APPAREL.

HANNANT, DOUGLAS (1965–). Hannant presented his first collection in 1995. Known for his unique approach to men's evening apparel, he also has received recognition for his design work with supple **leathers**.

HARGREAVES, JAMES (c. 1776). He invented the spinning jenny, a hand-operated device to spin **cotton** faster. Later, water power (and then steam power) would propel the spinning frames to even faster speeds.

HARPER'S BAZAAR. The oldest continuously published fashion magazine, *Harper's* was first published in New York and Paris in 1867. It is also where **Diana Vreeland** began her career. The **fashion illustrator Romain de Tirtoff Erté** is best known for his

work at *Harper's*. Erté had an exclusive contract with *Harper's* that began in 1916 and ended in 1937. The magazine was home to Erté's original designs and illustrations, which were unlike that of most fashion illustrators. In 1947, **Carmel Snow** was the editor-in-chief of *Harper's*, who announced **Christian Dior**'s **New Look** to America. Owned and operated by the Hearst Corporation, *Harper's* provides readers with insight on a sophisticated level in regard to beauty, fashion, and pop culture. It is published in eighteen countries. *See also* FASHION JOURNALISM, FASHION MAGAZINES, FASHION PHOTOGRAPHY.

HARRODS OF LONDON. Begun by Charles Henry Harrod in a poor area of London in 1835, Harrods Department Store moved near Knightsbridge London in 1949, and set the stage to become Europe's largest **department store**. With one million square feet of selling space, and known worldwide for quality and quantity, Harrods has a depth of product from apparel to gourmet foods. The Harrods Group, owner of Harrods, is comprised of H Bank, H Estates, H Casino, H Aviation, and Air Harrods.

In 1883, a fire destroyed the establishment and the Harrods family rebuilt on a much grander scale. Although the family gave up control of the store in 1889, it was not until 1985 and the purchase of Harrods by the Al-Fayed brothers that significant renovations occurred.

Due to pressure from animal rights groups in the 1980s, Harrods ceased selling furs and did not resume the sale of furs until 2000. In 2006, addressing the consumer demand for apparel for "furry four-legged" creatures, Harrods held a fashion event showcasing the latest in pet attire. *See also* RETAILER.

HART, SCHAFNER & MARX (HSM). Established in 1887, Hart, Schafner & Marx dressed corporate America. When casual Friday became the **dress code** of business in the 1990s, HSM redefined itself by focusing on a younger customer. It expanded its line to include casual apparel, as well as traditional business attire.

HARTNELL, NORMAN (1901–1979). Born in England, he opened his business in 1930. Known as the **couturier** of royalty, he designed the wedding gown of Queen Elizabeth II and received worldwide

recognition for the design due to the televised broadcast of the ceremony. Hartnell was the first British couturier to be knighted. *See also* GOVERNMENT UTILITY SCHEME; HAUTE COUTURE; INCORPORATED SOCIETY OF LONDON FASHION DESIGNERS.

HARVEY NICHOLS. Originally founded as a **linen** shop in London in 1813 by Benjamin Harvey, it grew to become an upscale **department store** owned by Dickson Concepts. With five locations worldwide, the store is known for selling high-end clothing, cosmetics, **accessories**, and home furnishings.

HASKELL, MIRIAM (1899–c. 1950). Born in Indiana to parents who were local merchants, Miriam Haskell later attended the University of Chicago for a brief period, made her way to New York City, and opened a gift shop in midtown Manhattan. Frank Hess, who began his career as a window dresser for **Macy's**, joined Haskell as a designer shortly after the opening of her shop. Each had their specific strengths: Hess as an artisan and Haskell with her keen sense of business. By the 1930s, Haskell had established herself in the industry as the owner of a costume jewelry company with a clientele of society women, movie stars, and royalty. Influenced by nature and incorporating exquisitely handmade beads from Czechoslovakia, France, Germany, Italy, and Russia, Haskell jewelry was built upon craftsmanship incorporating unusual metal findings and stamps. In the 1940s, Hess entered the military and Haskell continued to run the company. Due to her health, she sold the company in 1950 to her brother Joseph Haskell. The company took numerous turns over the next several decades and, in 1990, the owner for thirty-two years, Sanford Moss, sold the company to Frank Fialkoff. Today, the Haskell Company produces M. Haskell, Jewels of Haskell, Haskell, and several **private label** lines including the **JLo** line.

HAUTE COUTURE. The craft known as *haute couture* emerged in seventeenth-century France, with luxury textiles as its base. However, it was **Charles Frederick Worth**, the father of couture, who opened the first couture house in 1856. Worth initiated the organization **Chambre Syndicale de la confection et de la couture pour dames and fillettes** in 1868, whose name changed in 1910 to the

Chambre Syndicale de la couture parisienne. In 1928, an affiliate school was started under the French Ministry of National Education called **L'École de la Chambre Syndicale de la couture parisienne** which became the training ground for Paris **ateliers.** By 1945, the Chambre Syndicale clearly defined the **made-to-order** couture business with criteria that fashion houses had to adhere to in order to qualify to use the name *couture.* The term *haute couture* is protected by French law and according to the Chambre Syndicale, "only those companies mentioned on the list that is drawn up each year by a commission domiciled at the Ministry for Industry are entitled to avail themselves thereof."

In 1992, couture rules were updated to include the following: the house must present a collection of 35 pieces consisting of day and eveningwear twice each year, for spring/summer collection (January) and autumn/winter (August); they must design fashions that are made-to-measure for private clients that require one or more fittings; and the house must have a workroom in Paris with a minimum of fifteen full-time workers. In the couture tradition, a female designer is known as a **couturière,** while a male designer is a **couturier.** Described as the authority in regard to clothing that was luxurious and original in concept, **couturières** began receiving name recognition in the mid-nineteenth century. A couturier will hire a *modelliste,* who assists with the creation of the design, fabric, and **trims.** A **toile** is created by **draping** either on a live **model** or on a **dress form.** It is then fitted on a **mannequin** who will wear the garment during the showings. The garments are sewn and overseen in the designer's workroom (**atelier**) by carefully constructed layers of skilled workers called *midinettes* consisting of a *première* (female head of workroom) or a *premier* (male head), who is responsible for putting the design into three-dimensional form; a *seconde* (assistant of the premier); *petits mains* (sewers); and *arpettes* (apprentices). The skilled sewers are divided into two areas: the *flou,* where dresses and gowns are made and the *tailleur,* for jackets and suits. While sewing machines and irons are used for primary seams, the buttons and buttonholes, pleats, **zippers,** and embroideries are all done by hand. Couture garments can require three to ten fittings and can take anywhere from 100 to 1,000 hours to make, depending on the complexity of the garment. In the 1990s, couture garments ranged from $15,000 to $150,000 each, depending on the fabric and amount of beading, embroidery, and

other details. A specially trained salesperson, known as a **vendeuse**, works with clients, catering to his/her every whim.

In 1973, the Chambre Syndicale de la couture parisienne merged with the Prêt-à-Porter federation and became the **Fédération française de la couture, du prêt-à-porter des couturiers et des créateurs de mode**. In 1975, the Fédération de l'union nationale des artisanale de la couture et des activites connexes merged with the Fédération.

In 1939, there were 70 haute couture houses; in 1996, only 18; and, in 2006 that number dwindled to 10 official haute couture members' houses, namely Adeline Andé, **Chanel, Christian Dior, Christian Lacroix**, Dominique Sirop, **Emanuel Ungaro**, Franck Sorbier, **Givenchy, Jean-Paul Gaultier**, and Louis Scherrer. Correspondent members for 2006 include Elie Saab, **Giorgio Armani**, and **Valentino**. Guest members are Adam Jones, Anne-Valérie Hash, Boudicca, Carven, Cathy Pill, Christophe Josse, Eymeric Francois, Felipe Oliveiera Baptista, Gustav Lins, Lefranc Ferrant, Maison Martin Margiela, Marc Le Bihan, Maurizio Galante, Nicolas Le Cauchois, On Aura Tout Vu, **Ralph Rucci**, Richard Rene, and Gerald Watelet.

Today, couture houses serve as true design labs and assist the houses in maintaining press relations, as well as add prestige to their ready-to-wear and perfume collections. Saint Catherine, the guardian saint of unmarried girls, is considered the patron saint of haute couture. Saint Catherine's day is celebrated in November.

HAWES, ELIZABETH (1901–1971). A graduate of Vassar College, Hawes pursued a love of fashion and studied in Paris for three years after receiving her degree in economics. She began a dressmaking business in the United States in 1928 and was promoted by **Lord & Taylor** department store as an American talent. Able to recognize the power of publicity, Hawes creatively named each of her collections. She eventually closed Hawes and Company in 1940 and, except for a short revival in fashion, she devoted her life to writing. Drawn to controversial topics, Hawes is credited with publishing nine books on fashion and culture.

HEAD, EDITH (1898–1981). Head began her career as an assistant **costume designer** at Paramount Studios. Throughout her career she received thirty-five Academy Award nominations and won eight of

them for her costumes. Gifted with the ability to accentuate the positive and conceal the negative, Head is credited with assisting several stars and films with their success.

HEAD DESIGNER. *See* CREATIVE DIRECTOR/DESIGN DIRECTOR/HEAD DESIGNER.

HEAD MERCHANDISER/DESIGN/SALES. This person is responsible for leading the design and sales team. He/she works with the sales staff, design director, **designer**/s, production managers, and advertising and public relations staff. One must have technical knowledge and expertise in design, merchandising, sales, production and the ability to identify new and upcoming trends. He/she must also be well organized, able to lead the design team, work with large accounts on special projects, and possess fabric sourcing, importing, and costing knowledge.

HEAD OF STOCK. This is the person whose responsibility it is to maintain merchandise in the stockroom and on the selling floor and to monitor inventory in a large retail store.

HEATHERETTE. Begun in 1999 by Traver Rains and Richie Rich, the "glitz" of this company's designs attracted trendy Hollywood stars. Rains and Rich are best known for their glittery tees.

HENRI BENDEL. This unique store was started by Henri Bendel in 1896 as a **specialty store** and **custom-made** import house that sold original designs and adaptations of European designs according to the customers' directions. A group of investors and Geraldine Stutz, who had been with the store as president since the 1960s, bought Bendel from fashion conglomerate Genesco in 1980. Stutz is credited with turning the store into the most unique **retail** experience of the times and a breeding ground for new, upcoming design talent. In 1985, the store was sold to Limited Brands.

HERE. *See* UNITE HERE.

HERMAN, STAN (1930–). Born in a small town in New Jersey, Herman entered the fashion industry as **designer** and later the president

of Mr. Mort, a women's clothing company that popularized "fashion at a price." He is a three-time winner of the **Coty Award** who went on to design loungewear and more recently is known as a leading "uniform designer." He has designed uniforms for McDonalds, United Airlines, Amtrak, Federal Express, TWA, Avis, and several cruise ship lines. Herman served as president of the **Council of Fashion Designers of America (CFDA)** and Seventh on Sixth from 1992 until 2006.

HERMÈS. Thierry Hermès started this company in Paris in 1837 as an establishment that made harnesses. The company, sensing changes in the transportation industry in the early twentieth century, began manufacturing luggage and related travel items. Internationally recognized as the creator of the Kelly and Birkin handbags, Hermès is also famous for its scarves and men's neckties. *See also* ACCESSORIES.

HERNANDEZ, LAZARO. *See* PROENZA SCHOULER.

HERRERA, CAROLINA (1939–). Born in Venezuela, Herrera founded her company in New York in 1981 and launched her **fragrance** line in 1988. Her signature is clothing that is classic and sophisticated. In 2004, she was the recipient of the **Council of Fashion Designers of America (CFDA)** Women's Designer of the Year Award. Carolina Herrera is owned by Barcelona-based beauty and fashion conglomerate Puig.

HILFIGER, TOMMY (1952–). Born in Elmira, New York, his entry into the fashion industry was through his retail store in 1969. He showed his first collection in 1984, which was initially launched by Murjani International and later backed by Noval enterprises. Best known as the **designer** whose marketing took center stage instead of design, Hilfiger is a **lifestyle** designer. He has numerous **licensing** agreements that promote **womenswear, menswear, childrenswear,** home décor, **fragrances,** and **accessories.** Recognizing the potential of the influence of music, especially **hip-hop,** Hilfiger enlisted rappers and musicians such as the Rolling Stones, Britney Spears, Jewel, and Lenny Kravitz to promote his product. In 1995, Hilfiger was the

recipient of the **Council of Fashion Designers of America (CFDA)** Award as Menswear Designer of the Year. In 2005, he produced a reality TV show called *The Cut* and bought the trademark to the **Karl Lagerfeld** portfolio. In 2006, Tommy Hilfiger Corp was sold to Apex Partners. Hilfiger signed a lifetime contract and plans to remain as principal designer and chairman of the strategy and design board.

HIMATION. A wrap garment invented by the Ancient Greeks during the Archaic Period (750–480 B.C.E.). A square piece of fabric is folded diagonally and worn by either a man or women as a shawl. This invention would continue as an important item of clothing throughout the ages.

HIP-HOP LOOK. This look is an extension of hip-hop music, which is a form of storytelling of the everyday events in the African oral tradition. The look had its roots in the South Bronx during the 1970s and was originally known as "old school." Its style was grounded in DJing (spinning and scratching records), breakdancing, early rap music, graffiti, and the need to differentiate from disco and ghetto-gang life. The clothing, while consisting of basic American **jeans, T-shirts**, baseball caps, **sneakers**, and boxer shorts, is transformed when worn in a hip-hop style. Jeans, which are oversized and slung low on the hip, gather in deep folds at the ankles and hang low on the waist to reveal the **designer** label on the boxer shorts. Designer **logo accessories** accent the look. Several rappers have successful fashion apparel companies that create hip-hop fashion collections. *See also* DENIM; PHAT FARM; ROCAWEAR; SEAN JOHN.

HIPPIE LOOK. A fashion trend born in San Francisco, California, in the mid-1960s, the hippie look was in direct contrast to fashion as it had been known. It emanated from the "flower child generation" whose philosophy of free love, drugs, peace, multiculturism and international inclusion, and going back to nature affected fashion worldwide. It celebrated freedom of choice in all forms—clothing being the most visual. **Vintage** was "in," individualism was "in," and having a male **designer** dictate what a woman should wear was "out." Peasant looks, embroideries, tent shapes, and tie-dye were definable elements of this individualist look. Marijuana leaves, psy-

chedelic patterns and colors, and the peace symbol were clear fashion statements of a pop culture whose tentacles deeply affected music, politics, and moral values on a global scale.

Vintage dressing crossed all social classes. It was no longer a statement of nonaffordability. It created an equal playing field in the world of fashion for the first time in history. And as vintage stores became a shopping destination, designers sought creative solutions to their lost customer base. One couture designer up for the challenge was **Yves Saint Laurent**, who in 1960 created the **Beat look** for the house of Dior. The fashion world was becoming more and more connected to the various forces that deeply influenced its inner core; by the turn of the century, multiculturalism, ethnic identity, environmental commitment, and a society secure in who it was shaped fashion and the business of fashion as never before. *See also* DIOR, CHRISTIAN; HAUTE COUTURE.

H&M. A retail establishment begun in 1847 by Earl Persson in Sweden. By 2005, H&M (Hennes & Mauritz) was Europe's largest **retailer** with 1,193 stores worldwide and its niche was fashion at a price. In 2004, H&M signed a deal with **Karl Lagerfeld** to design an inexpensive line for its stores and, in 2005, launched a limited edition collection with British designer **Stella McCartney**. H&M attributes its success as a fashion retail leader in part to these limited-edition designer collaborations. H&M has discovered that such one-time designer partnerships are a key venue to stimulate consumer interest in physically visiting the retail establishment. In 2006, H&M continued with this marketing strategy by teaming up with **Viktor & Rolf** to create a price-conscience designer wedding gown. The company also recognizes the draw of celebrity connections. It collaborated with music icon Madonna for tracksuits sold in stores, which she wore on and off of the stage. In the world of twenty-first-century online buying, H&M has tapped into a successful venue for customer connection. It also has been proactive on the Internet front and opened its first online boutique in the Netherlands in 2006. Its main competition is Spanish retailer **Zara**. *See also* CHAIN STORE; MASS MARKET.

HOME SHOPPING NETWORK (HSN). HSN's history stems from the first regional home-shopping cable television show known as *The*

Home Shopping Club created by Lowell "Bud" Paxon and Roy Speer in Tampa, Florida, in 1981. The show went national in 1985 and the name changed to the Home Shopping Network. Today, HSN reaches 144 million viewers in four countries: United States, Great Britain, Japan, and Germany.

HOSIERY. Knitted and fitting snugly to the leg and/or foot, hosiery was knitted by hand until 1589. It was at this time that William Lee invented the first knitting machine in England. Hosiery was, and to this day still is, produced in **silk**, **wool**, and **cotton**. The invention of **nylon**, elastic fibers, and **Lycra** spandex had a dramatic impact on the cost, the production, and the fit and look of hosiery. *See also* KNITWEAR; LEGWEAR.

HOUSE OF DERÈON. A women's clothing line launched by music artist Beyoncé Knowles and her mother Tina Knowles in 2005 under license by the Tarrant Apparel Group, a design and sourcing company for **private label** and private **brand** casual apparel.

HOWE, ELIAS (1819–1867). Born in the United States in the countryside of Massachusetts, Howe led the life of a typical farmer's son. Seeking to secure a better life, Howe worked in a machine shop and, realizing the demand for a mechanical sewing device, began his exploration of such a machine. He designed a crude lockstitch machine and soon thereafter created a second version perfecting his original design. In 1846, he made his way to Washington, D.C., and was issued a patent for his design. When his machine did not attract buyers, Howe and his family emigrated to London where Howe, unfortunately, did not receive the success he had anticipated. Desperate, he sold off his last model and pawned his patent rights so that his family would have the necessary finances to return to America. At this point, the sewing machine was experiencing significant interest on the part of the public. Howe and several other sewing machine inventors were vying for sole patent rights and, in 1856, the leading inventors joined together and created a fixed license fee for the group. Howe and an inventor named **Isaac Singer** were part of the license pool. The majority of the patents that were part of this pool expired in 1877.

HYPERMARKET. A combination of a **department store** and supermarket all under one roof. *See also* WAL-MART.

– I –

IMITATION OF CHRIST. Launched in 2000 in an East Village funeral home in New York City, Tara Subkoff is the creator of this line. Its foundation is to reinvent old discards into beautiful new fashions.

IMPORT COORDINATOR. An import coordinator coordinates and monitors overseas production and shipments. This person is also responsible for adhering to production schedules and interfacing with design, merchandising, and warehousing.

IMPORT/EXPORT SPECIALIST. This industry specialist must be an expert on trade law for various countries, as well as have the ability to know where to source supplies specific to a particular apparel production need for cost-efficiency.

INCORPORATED SOCIETY OF LONDON FASHION DESIGNERS. This was an organization founded in 1942 by British **couture** designers and then-editor-in-chief of *British Vogue*, Audrey Withers. Initially the goal was to attract buyers, press, and clients and it was modeled after the Parisian **Chambre Syndicale**, but the group became an important vehicle during World War II to boost morale—especially when asked to create smart utility clothing designs, as a result of the **British Civilian Clothing Order CC41**, which rationed cloth, fancy **trims**, and unnecessary buttons, pleats, and pockets unless they were necessary and functional. The thirty-four designs were also used to raise money from their sales to clients and stores in the Americas. One of the most popular suits selected was known in America as the victory suit. Among the most notable members were **Norman Hartnell, Molyneux,** and **Hardy Amies**. *See* GOVERNMENT UTILITY SCHEME.

INDUSTRIAL REVOLUTION. The Industrial Revolution took place during the mid to late nineteenth century and saw significant social,

technological, and economic progress. For the fashion industry, it began with advances in the mass production of textiles due to earlier innovations such as the steam-driven power loom of **James Watts** (1785), the **cotton** gin of **Eli Whitney** (1793), and the jacquard loom of **Joseph Marie Jacquard** (1804). However, it was the first foot-treadle sewing machine of **Elias Howe** (1846), and later the electric sewing machine of **Isaac Merritt Singer** (1889), that moved the fashion industry from handmade, home-based manufacturing to large-scale, factory-based production. During the reign of Queen Victoria, known as the **Victorian Era**, the **Industrial Revolution** was at its peak.

IN-STOCK. A retail term describing that a particular stock keeping unit (SKU) item is available.

INTELLIFIT. A patented radiowave technology originally developed by a U.S. Department of Energy research facility, Pacific Northwest National Labs (PNNL), as a security scanning technology. Intellifit was founded in 2000 when Albert Charpentier and a group of investors purchased proprietary software that converted personal body measurements into **custom-made patterns**. Their patterns and specs helped improve **manufacturers**' sizing problems. In 2002, Charpentier and Ed Gribbin began the Intellifit System, which combined their software with a license for PNNL's patented radiowave-based **bodyscanning** technology. Intellifit received the prestigious R&D 100 Editor's Choice Award as the "most compelling new technology of 2004." In 2005, it unveiled its "search engine for clothing" to help consumers find clothes that fit and it rolled out bodyscanning units in shopping malls around the United States. *See also* BODYMETRICS; CYBERWEAR; [TC]².

INTERNATIONAL CHAMBER OF COMMERCE (ICC). An organization founded in 1919 to promote world business, trade, and investment and to create open markets for goods and services. Today the organization is headquartered in Paris and has thousands of members from more than 130 countries with headquarters. The ICC works in cooperation with the United Nations and advocate on behalf of the international business community in matters relating to arbitration, multilateral trading systems, fighting commercial crime, and other business services. *See also* COUNTERFEITING.

INTERNATIONAL CONFEDERATION OF FREE TRADE UNIONS (ICFTU). An international **trade union** formed in 1949 following a split within the World Federation of Trade Unions (WFTU) as a result of alleged Communist domination. Members included the major unions from the United States, Great Britain, France, Italy, and Spain. New members from developing countries in Asia, Africa, and, after the fall of Communism, Eastern block nations were recruited as production in these regions increased while developed countries were experiencing a decrease. In 2006, the ICFTU was dissolved when it merged with the **International Trade Union Confederation (ITUC).**

INTERNATIONAL LADIES' GARMENT WORKERS' UNION (ILGWU). A **trade union** that was formed in the United States in 1900 due to appalling working conditions in garment factories known as **sweatshops.** It was chartered by the American Federation of Labor (AFL) and started with approximately 2,000 members. In 1909, the union conducted a strike of 20,000 shirtwaist workers known as the Big Strike and, in 1910, held a strike of 60,000 cloakmakers called the Great Revolt. The strikes ended in a settlement known as the Protocol of Peace granting workers a fifty-hour work week, higher wages, double pay for overtime, better working conditions, and the closed-shop concept whereby employers could only hire union members. The ILGWU merged in 1995 with the Amalgamated Clothing and Textile Workers' Union (ACTWU) to form the group UNITE and, in 2004, merged with the Hotel Employees and Restaurant Employees International Union (HERE) to form **UNITE HERE.**

INTERNATIONAL TRADE UNION CONFEDERATION (ITUC). A **trade union** formed in 2006 when the **International Confederation of Free Trade Unions (ICFTU)** merged with the **World Confederation of Labor (WCL).**

INTERNET SALES. *See* E-COMMERCE.

INTIMATE APPAREL. During the nineteenth century, women traditionally wore a chemise, which was a straight unadorned **linen** garment, as their sleeping apparel. Hence the origin of intimate apparel

or lingerie derived from the French word *linge*, or linen. By 1830, **empire period** sleep gowns adorned with lace began the transition into sleeping and personal apparel that was visually pleasing. In this way, women had the ability to remain privately feminine while outwardly exerting their independence. In the 1920s, Theodore Baer combined a chemise with panties and created the teddy. It was also the beginning of drastic transformations of bras, which initiated their progress into using boning and cup sizes. Additionally, intimate apparel as a market segment began to take shape; women's nightgowns were created and women of means were able to purchase intimate apparel made of **silk** and fine European laces. The development of synthetic silk-like fabrics, such as **nylon**, opened the door for the creation of intimate apparel for the **mass market**. With the influence of men's pajamas, the 1930s saw the creation of women's pajamas. The 1950s also brought an explosion of synthetic peignoir sets (nightgowns with matching cover-ups) and babydoll pajamas, the desired bedroom attire of the 1950s housewife of moderate means while her wealthy counterpart worn peignoir sets and babydolls of silk.

The 1960s and the birth of the **miniskirt** and pantyhose together with the women's liberation movement created radical changes in the intimate apparel industry. Wearing or not wearing a bra became a focal point of demonstrated feminine independence. **Girdles** were out. Sleepshirts replaced peignoir sets and character and sports-licensed products were introduced at the high and moderate markets in both juniors and misses. **Armani** in the 1980s can be credited with moving the market toward the acceptance and incorporation of femininity while maintaining the strength of masculinity in women's business and personal dress. The **Victoria's Secret** catalog became an industry icon and women embraced their ultra-feminine undergarments peeking through their **power suits**. The 1990s witnessed the **Wonderbra** rage and the direct influence of intimate apparel in all areas of fashion. By the turn of the century, intimate apparel was being recognized as a powerful component of the fashion industry. Designers saw intimates as an extension of their **brand** and not merely as a **licensing** opportunity as it had been viewed in the past.

INTIMATE APPAREL DESIGNER. This is a type of designer who specializes in the design of **intimate apparel** that is, lingerie (bras,

corsets, panties, slips, teddys, thongs, and undergarments) and sleeping apparel (nightgowns, pajamas, peignoir sets, and sleepshirts). Usually, a company will hire a **bra designer** who has experience in fit and shapewear for this area of the intimate apparel market. Sleepwear is traditionally designed by someone with experience in lace and embroidery design, as well as in cut-and-sew knits.

INVENTORY PLANNER. An inventory planner is a person working in the retail side of the industry who sets monetary limitations on the retail **buyer**'s purchasing power.

ISO TAPE. An electronic measuring device that can output measurement data into a computer system. It is a multi-functional tool that, similar to a **tape measure**, can measure **patterns**, garments, and people.

ITALIAN FASHION. Italian **haute couture** began after World War II in Rome. Affectionately referred to as *Alta Moda*, haute couture was embraced by tourists and starlets alike, especially when the demand for quality was supplied by **designers** such as **Guccio Gucci** and **Salvatore Ferragamo**. The first Alta Moda show was held in Florence at the Pitti Palace. Nine high fashion houses and sixteen **sportswear** and **boutique** houses participated. It seemed that just as Florence had established itself as the center of Italian fashion, several designers defected back to Rome. An agreement was eventually worked out with Alta Moda remaining in Rome and **accessories** and boutique shows being held in Florence. Paris and Italy synchronized their calendars and the Italians founded the Camera Nazionale d'Alta Moda. "Made in Italy" translated into extravagant fashion scooped up by wealthy Americans. Rising designers such as **Giorgio Armani**, Domenico Dolce and Stefano Gabbana, **Gianfranco Ferre**, **Franco Moschino**, and **Gianni Versace** joined with established ones like Ferragamo and **Garavani Valentino** to promote Italian fashion. In 1979, Milanese businessman Beppe Modenese organized the first fashion show to be held in Milan with more than forty designers participating. During the 1980s, Milan reinforced Italy as an established center of fashion, maintained by strong design and a commitment to market its product.

– J –

JACOBS, MARC (1963–). Born and educated in New York City, Jacobs began his affair with fashion, when, at the age of fifteen, he managed to gain entrance into the hip nightclub Studio 54. It was the stomping ground of the fashion world and Jacobs was hooked. He received his first break while presenting his senior collection as a **Parsons School of Design** student in 1984. His first **ready-to-wear** collection in 1986 was produced by Rubin Thomas Inc. and, in 1989, Jacobs became head of design at **Perry Ellis** and brought the "**grunge look**" to the runway. It was his promotion of this look that got him fired from Perry Ellis. In 1994, he showed under his own name and, in 1997, became artistic director at **Louis Vuitton**. Jacobs gave new life to the **logo** and, starting with one handbag on the runway in 1998, celebrated the end of a successful show in spring 2004 with every model carrying a different Vuitton bag. Jacobs succeeded in making the Louis Vuitton bag, once feared to become a fashion has-been, a fashion must-have. It was this same year that Jacobs and his business partner Robert Duffy signed a ten-year contract with **Moët Hennessey Louis Vuitton (LVMH)**, keeping Jacobs and the LVMH chairman Bernard Arnault in a continuous business partnership. Both parties committed to growing Marc Jacobs into a global fashion market force. The designer **bridge** line, Marc by Marc Jacobs, was launched in 2000` and Little Marc, a collection of **childrenswear** for ages two to seven, was launched in 2005. Jacobs has always had an affinity with **vintage** and has successfully incorporated the vintage details he finds attractive into his collections. He is the recipient of numerous **Council of Fashion Designers of America (CFDA)** and other design awards, and his apparel includes **womenswear**, **menswear**, **accessories**, **fragrances**, home items, eyewear, and a watch line.

JACOBS, MARY. An American, who in 1914, patented the first bra. *See* HIPPIE LOOK; INTIMATE APPAREL.

JACQUARD, JOSEPH MARIE. A Frenchman who invented a loom attachment in 1804 that made it possible to weave complex figured patterns in cloth, his namesake.

JAMES, CHARLES (1906–1978). Born in England, James's family relocated to Chicago where he began designing **millinery** before eventually moving to New York. He is credited as being America's first highly respected **designer** to work in the tradition of **haute couture**. To be dressed by Charles James indicated both wealth and a taste for the nontraditional dress. His greatest years of designing were between the late 1920s and late 1950s. In 1933, he reopened his business after going bankrupt and produced some of the most intriguing pieces, which earned him the respect of his peers, such as **Coco Chanel**, **Cristòbal Balenciaga**, **Christian Dior**, and **Paul Poiret**. In 1937, James designed down-filled evening jackets creating a soft sculpture, as so described by artist Salvador Dali. An international childhood and a passion for the arts served as the foundation for James to spend his life drawn to fashion. Unfortunately, his business decisions often impacted negatively on his success. By 1958, his professional career as a designer came to an end.

J. C. PENNEY'S. James Cash Penney founded a small dry goods store in 1902 in a 900-member mining town in Wyoming. Penney practiced a retail philosophy that was customer-driven. He is also credited with being one of the first to set prices and not barter with customers. Penney's gained a reputation of providing quality merchandise at low prices. In the 1920s, Penney opened **chain stores** throughout the country. In 1954, James Cash Penney was the recipient of the Tobe award, the highest honor given by the National Retail Dry Goods Association. In 1962, Penney was the first American **retailer** to purchase merchandise from a new cutting-edge designer named **Mary Quant** of Great Britain. J. C. Penney's launched its **catalog** in 1963 and together with **Sears, Roebuck and Co.** and **Montgomery Wards** brought soft goods as well as hard goods to millions of Americans who did not live in close proximity to any major **department store**. James Cash Penney died in 1971. In 2005, J. C. Penney's had sales of $18.7 billion. It is aggressively marketing to Middle America with **lifestyle** categories that address consumer needs. In 2007, Penney's will expand its traditional lifestyle area with the addition of Liz & Co. by **Liz Claiborne**. Penney's also recognizes the benefit of off-mall locations, dedicating 90 percent of its expansion in the upcoming few years to this category. *See also* MASS MARKET.

J. CREW. Drawing on the **catalog** experience he gained in the founding of *The Popular Club Plan* in 1947, founder Arthur Cinader launched J. Crew in 1983 as a catalog company. Cinader went on to expand the concept into a **retail** establishment of more than 150 stores by the twenty-first century. Identified with a classic and relaxed but fashionable look, J. Crew sells **menswear, womenswear**, and home goods.

JEANS. Jacob Davisin created jeans in Nevada in 1873. He and **Levi Strauss** joined to patent the garment. In the 1970s, **designer** jeans became a "must have" and **Gloria Vanderbilt** began the association of jeans to glamour. **Calvin Klein**, in 1980, launched an ad campaign with actress and model Brooke Shields that made Calvin and his jeans a household name. By the 1990s, with the popularity of **hip-hop**-promoted baggy and loose jeans, companies such as **Phat Farm** and **ECKO** were naturally associated with this look. The turn of the century saw companies such as **Diesel** and Paper Denim competing in the jeans category, a forever-reinventing itself product. *See also* DENIM.

JEFFREY'S. *See* KALINSKY, JEFFREY.

JEWELRY DESIGNER. The creation of jewelry dates back to ancient Greece. Medieval Europe dictated that only nobility be permitted to wear this **accessory**. During the **Empire Period** jewelry took on a significant role in fashion. Coordinated pieces comprised of necklaces, bracelets, earrings, pins, and rings kept the jewelry artisans extremely busy. Film, television, and fashion **designers** have all had and continue to have an impact on jewelry design. **Coco Chanel** made costume jewelry an acceptable couture accessory in the 1920s, and the 1930s saw the creation of costume jewelry as a means to inexpensively personalize and update fashion. **Jewelry designers**, therefore, acquire skill sets in a specific medium or in several media; designer **Elsa Peretti** is known for her extensive line of silver jewelry; another notable is **Miriam Haskell** for her costume jewelry of the 1930s. *See also* HAUTE COUTURE.

JLO. Music star Jennifer Lopez launched this **brand** in 2001. Lopez has created sexy, casual **sportswear** for **generation Y**. The JLo label also appears on swimwear and **intimate apparel** lines and includes a line

called Sweetface. This line is indicative of the changing role of celebrities in the fashion world. Previously just the fashion influencers and **trendsetters**, celebrities became, by the turn of the century, actively involved in the world of design. Lopez has the social following, media attention, and financial capabilities to support her company.

J. MENDEL. This is a family-owned fur business founded by Joseph Breitman in 1833. Giles Mendel, great-grandson to Breitman, took over the helm in 1981. Mendel increased the business after arriving in America and opening a **retail** establishment for his family under the J. Mendel name; he ended up clinching a deal with Elizabeth Arden to open fur-selling **boutiques** in twelve Arden salons. His continued determination to open a retail fur establishment of his own in New York resulted in Mendel designing sheath dresses as a counter-balance to the fur revolt of the 1990s. His "fur store" was overshadowed by customer demand for his elegant dresses. His first collection was shown during Fashion Week in 2004. Giles has brought a new dimension to "fur" and infused beautiful cloth garments into the J. Mendel line.

JOBBER. A middleman or intermediary in the fashion industry who buys from a wholesaler to sell to a retailer or manufacturer. Textile jobbers carry inventory and then sell their fabric to manufacturers. An apparel jobber expedites the apparel production process but contracts out the cutting and sewing tasks.

JOHNSON, BETSEY (1942–). Bold, brash, and playful describe Johnson's design sense; astute, intuitive, and focused describe her business sense. She began her career selling designs to the hip New York City store Paraphernalia in the 1960s, which became the springboard to the famous Betsey Johnson label started in 1978. She was presented with the **Council of Fashion Designers of America (CFDA)** Timeless Award in 1999. As popular today as in the 1970s, she is the creator of a distinctive look very much her own. She has more than forty stores worldwide and designs two collections. Her garment hangtags are an extension of her personality and creativity — they are snapshots taken by Betsey with personal notes, and stylistic doodles. Never one to follow trends, Betsey consistently reinvents **minis**, **corsets**, and **bloomers**. And while she is cartwheeling down

the runway in fishnets and spiked hair as playful as ever, Betsey has a very keen eye for fit as well as a savvy business sense. Very much a part of the rock 'n' roll world, Betsey lived in the Chelsea Hotel in New York City in the late 1960s and maintains her 1960s energy.

JONES APPAREL GROUP. A *Fortune* 500 company that is a **brand** conglomerate, Jones's present chairman and director, Sidney Kimmel, began the group more than thirty years ago. Jones Apparel Group is a **designer**, marketer, and wholesaler of **branded accessories** and apparel. Jones has its own chain of **specialty retail** establishments and, in 2004, entered into a merger agreement with luxury retailer **Barneys**. National brands include Albert Nipon, **Anne Klein**, Bandolino, Easy Spirit, Energie, Enzo Angiolini, Erika, Evan-Picone, l.e.i., **Gloria Vanderbilt**, Joan & David, Jones New York, Judith Jack, Kasper, Le Suit, Mootsies Tootsies, Napier, **Nine West**, Norton McNaughton, and Sam & Libby. Jones also markets apparel under the Polo **Jeans** Company brand, **licensed** from Polo **Ralph Lauren**, and **Givenchy** from the Givenchy Corporation.

Jones entered the **footwear** business in 1999 with the purchase of Nine West. In 2005, Jones succeeded in a $346-million takeover of Maxwell Shoe. A major competitive player in the **department store** arena, Jones is making inroads to the moderate market as well. In 2006, it launched Jeanstar brand **denim**, targeted at a moderate price point. This will provide the Jones Apparel Group with depth and balance across all markets. Jones had affiliations in more than sixty foreign countries as of 2006. *See also* CHAIN STORE.

JORDAN MARSH. A Boston **department store** that was opened in 1841 by Eben Jordan and Benjamin L. Marsh. *See also* FEDERATED DEPARTMENT STORES, INC.

JOURDAN, CHARLES (1883–1976). Born in France, Jourdan trained as a shoemaker before opening a shop in 1919. He was the first shoe designer to advertise in magazines in the 1930s and was joined by his sons in 1947. **Christian Dior** granted the company a **license** to design and manufacture Dior shoes in 1959, though the company is best known for its provocative advertising in the 1960s, using famous surrealist photographer Guy Bourdin. Jourdan's four famous shoe

styles, the Maxim, the Ruby, the Line, and the Amazone, continue to be reissued. Today, designer Josephus Thimister is its director of design. *See also* ACCESSORIES; FOOTWEAR.

JUICY COUTURE. Often referred to as a cult following because of its appeal to daughters, mothers, and grandmothers alike, Juicy Couture was launched in 1996 by Pamela Skaist-Levy and Gela Taylor. They started a Juicy **jeans** line in 1999 and the company was purchased by **Liz Claiborne** in 2003 for $47 million. In 2006, it was a $300 million **brand**. *See also* LIFESTYLE-DRESSING.

JUNIOR SPORTSWEAR. A term that applies to the sizing of **sportswear** for young girls. This market category was conceived by Helen Valentine when she was the editor-in-chief of *Seventeen* magazine. At that time, she recognized the need for garments sized between the children's and misses market **body types**.

JUST-IN-TIME (JIT). Introduced originally in Japan, just-in-time is a business philosophy that describes a more efficient way of doing business by eliminating unnecessary costs and steps. The lowest possible inventory is maintained according to the company business cycle.

– K –

KALINSKY, JEFFREY (1962–). Kalinsky is the founder of Jeffrey's specialty store in the hip Meatpacking district of New York City and in Atlanta, Georgia. He recognized the allure of the district and the opening of several **designer boutiques** soon followed. Kalinsky's keen eye for fashion gained him the position of director of design and merchandising for Nordstrom's Department Stores. In 2006, he partnered with Gant to design a **menswear** collection. *See also* SPECIALTY STORE.

KAMALI, NORMA (1945–). Kamali, a native New Yorker, began making fashion statements as a teenager with her very personal innovative style of dress. Kamali, a graduate of the **Fashion Institute of Technology**, opened a **boutique** in New York City in 1968 with her

husband. The merchandise was a combination of Kamali's overseas finds, supplemented with her own designs that spoke to the mood of fashion in the 1960s. In 1977, Kamali went through a divorce, which prompted the launch of her OMO line (On My Own). She is credited with revolutionizing how the world viewed **sweatshirt** goods. Additionally, Kamali challenged the fashion world's opinion at this time of quilted-down fabric and parachute cloth for cutting-edge apparel. Her swimsuit collections are an ingenious incorporation of retro and fresh innovation.

KARAN, DONNA (1948–). Born in New York City, Karan was first hired by the designer **Anne Klein** and quickly fired. She was rehired two years later and upon the death of Anne Klein took over the reigns as head of design. Karan developed the concept of **bridge sportswear** and achieved quick success with the line called Anne Klein II. In 1984, she launched her own collection and again stimulated the fashion world with her easy day-to-evening dressing pieces. Thus gave birth to Donna Karan New York (**DKNY**), which also sold **childrenswear, fragrances, menswear**, and home products. DKNY was launched in 1989 and, while being more competitively priced than Donna Karan, also carried numerous **licenses**. The company went public in 2001 and was acquired by **Moët Hennessey Louis Vuitton (LVMH)**.

KAWAKUBO, REI (1942–). She is the Japanese designer who "is" **Comme des Garçons**. Kawakubo's view of the human form differed drastically from her contemporaries, which gave birth to a view of fashion the Western world had never dreamed of. Referred to in Japan as "Garcons" and in France as "Comme des," Comme des Garçons (which means "like boys") spoke to the very essence of Kawakubo's criticism of society's view of women and fashion. She presented her first collection in 1975. In 1981, Kawakubo made fashion history with her **knitwear** that used holes and tears as a fashion statement. By the close of the decade, she had developed a furniture line, a magazine, and opened a flagship store in Tokyo. Kawakubo's ability to master line and form transforms her garments into works of art. She is credited with the prompt of Japanese **designers** gaining acceptance in the French fashion world. In 1997, she was awarded an honorary degree by the Royal College of Art, London.

KEDS. *See* SNEAKERS.

KÉLIAN, STÉPHANE. Kélian is a French shoe designer who started in the shoe business along with his two brothers but opened his own shoe store in 1978. He is most known for his colorful braided shoes made of high quality **leather**. The company filed for bankruptcy in 2005 and was acquired by French conglomerate France Luxury Group. *See also* FOOTWEAR.

KENZO (1939–). Kenzo Takada was born in Japan and was the first Japanese designer to open a house in Paris in 1970. His interpretation of the traditional kimono brought him instant global success in the **womenswear** arena. Known for his unique mix of patterns, Kenzo also designs **childrenswear**, **menswear**, and home products. *See also* BRAND.

KEYSTONE MARK-UP. *See* MARK-UP.

KIESELSTEIN-CORD, BARRY (1945–). Born in New York City, Kieselstein-Cord was introduced to jewelry design when he took a jewelry class with a girlfriend. He started his own jewelry business in 1972. In 1973, George Jensen was the first to introduce Kieselstein-Cord's exquisitely crafted fine jewelry and belt buckles that had mythological, equestrian, and animal themes. He is a two-time **Coty Award** winner and is also the recipient of a **Council of Fashion Designers of America (CFDA)** award. In addition to jewelry, his range includes handbags, luggage, home furnishings, tabletop **accessories**, lamps, a limited-edition humidor, and furniture. He also **licenses** scarves, ties, and eyewear. In 2005, Kieselstein-Cord launched Crocodile Hall, a collection of affordable totes and handbags based on his signature crocodile inspiration.

KLEIN, ANNE (1921–1974). Born Hannah Golofski in Brooklyn, New York, she attended the Traphagen School of Fashion and started in the industry as a **sketcher** at the age of fifteen. She changed her name to Anne Klein and, in 1939, began designing for Vardin Petites as a junior designer. In 1948, Klein launched her own company, Junior Sophisticates, and, in 1968, formed Anne Klein the company

with her second husband Matthew Rubinstein. A true American designer, Anne had the talent to create practical as well as fashionable **separates** that the American **lifestyle** demanded. In 1967, Klein addressed the needs of the popular **miniskirt** by patenting a **girdle** specific to the constraints of the short skirt. Klein is the only designer to be a two-time recipient of the **Neiman Marcus** Award for fashion leadership. She was inducted into the **Coty** Fashion Hall of Fame in 1971. **Donna Karan** and Louis Dell'Olio, designers for Anne Klein at the time of her death, took over the creative direction of the company until the departure of Karan, when she broke out on her own. *See also* AMERICAN LOOK; SPORTSWEAR.

KLEIN, CALVIN (1942–). Born in the Bronx, New York, Klein first learned fashion at the **Fashion Institute of Technology** and, after a few design positions in the moderate-priced market, opened his own business with his friend Barry Schwartz in 1968. Klein developed a line of coats and suits. He impressed a **buyer** at Bonwit Teller with the fine **tailoring** of his garments together with his refreshing approach to color. This provided an entrance to the then-president of Bonwit's and Calvin Klein Limited received the support necessary to gain a position in the industry. Klein became a client of the great fashion publicist, Eleanor Lambert, whose guidance helped shape his early career. Classic lines, uncluttered looks—these are elements that contribute to a design being a true Calvin. He gave American fashion significant definition. He integrated elements of active **sportswear** into his collections, yet at the same time kept them soft. He is most famous for his advertising shock appeal, his business savvy, and his intuitiveness in creating American sportswear.

Klein was the first **designer** to include **jeans** on the runway. He also became a household name in the 1970s with his famous jeans ad campaign featuring **model** and actress Brooke Shields, who stated "nothing came between her and her Calvins." In the 1980s, Klein blurred genders with his line of underwear that had his name embroidered into the elastic waistband and the line's accompanying ad campaign that appealed to jocks, gays, and women. He jumpstarted his **fragrance** line with the introduction of Obsession and again seized the power of advertising with the great photographer **Richard Avedon** to put this fragrance on the map. Klein received his first **Coty Award** in 1973.

The **Council of Fashion Designers of America (CFDA)** honored Klein with awards in 1982, 1983, and 1986. In the 1990s, Klein expanded to include distribution of his products to Asia, Europe, and the Middle East. The company was sold in 2003 to **Phillips-Van Heusen**, which is one of the world's largest apparel companies. It is now the owner and marketer of the Calvin Klein **brand** worldwide.

In 2004, Klein turned his attention to the **outerwear** market, an area that he had addressed only sporadically over his years in business. He signed a **licensing** agreement with Marvin Richards to manufacture and distribute this line. In 2005, Calvin Klein, Inc., entered into an agreement with Fingen S.p.A. to manufacture and distribute the Calvin Klein Collection brand women's and men's designer collection and **accessories. Tod's** S.p.A. is presently the licensee for Calvin Klein jeans in Europe and Asia and CK (Calvin Klein Bridge) in Europe. Additionally, Klein signed a licensing agreement with G-III Apparel to manufacture and distribute women's better suits under the Calvin Klein label. Brazilian-born **Francisco Costa** holds the role of **creative director** for the women's collection and Italo Zucchelli for the men's. Klein's vast empire in fashion encompasses apparel and a range of product that is manufactured and marketed through myriad license agreements. *See also* AMERICAN LOOK; BRAND IDENTITY; BRAND IMAGE; GENDER BENDERS.

KLENSCH, ELSA (c. 1940–). Fashion journalist Elsa Klensch arrived in the United States in 1966. Born in Australia, she worked in Sydney, London, and Hong Kong and then at *Women's Wear Daily* in New York. In 1980, she changed the way the world viewed fashion with her CNN television show, *Style with Elsa Klensch*. She is noted for her ability to understand the designers' concept and its direct relationship to the clothes. The show ended in 2000 and Klensch broke with the fashion world and went on to write murder novels. *See also* FASHION JOURNALISM; FASHION REPORTER.

KMART. Originally called S.S. Kresge Co., it was founded by Sebastian S. Kresge in 1899 in Detroit, Michigan. In 1962 the company opened its first Kmart discount store in a Detroit suburb and, in 1977, changed its name from Kresge to Kmart. By 1981, there were 2,055 Kmart stores in the United States, Canada, and Puerto Rico. In

1987, Kmart retained Martha Stewart as a consultant and, in 1997, produced a home collection and paint line. The company faced serious competition from Wal-Mart. Kmart, who was known as a tightly managed corporation, lost its focus and filed for bankruptcy in 2002. In 2004, it combined with **Sears, Roebuck and Co.** and concentrated on creating fashion at a moderate price. *See also* CHAIN STORE; DISCOUNT DEPARTMENT STORE; MASS MARKET.

KNITWEAR. History confirms that the early beginnings of knitwear started somewhere around 250 C.E. in Asia and in Europe at about 712 C.E. By the ninth century, patterned knitwear was in use and in the 1300s the Knitters Guild was in place in Paris. From the 1300s through the 1900s, luxury goods included knitted **silks** and **wools.** The invention of the first knitting machine in England in 1589 saw **hosiery** move into **mass production** and, by the late 1600s, England was a key exporter of knitted stockings. It was in the sixteenth century that Italy, England, Wales, and Scotland look to the knitted cap as a stylish component of a man's wardrobe. The eighteenth and nineteenth centuries were times of significant development in knitting technology; by 1863, William Cotton had invented machinery that could knit an entire garment with shape. It was **Chanel** in the 1920s who first made jersey knit fabric acceptable at the **couture** level. In 1930, the Pringle Company in England introduced the twin sweater set. It became a staple of the middle-class women's wardrobe and variations remain popular today. In the 1940s and 1950s, the varsity sweater was an essential component of the young man's wardrobe, girl's sweaters were often lavishly embellished for special occasions, and women's evening attire often included elegant beaded sweaters. The 1960s can be defined by the poor-boy sweater, a tight-fitting, wide-ribbed sweater. By the 1970s, high-quality **designer** knits were being produced in Italy. By the 1980s, knitted fabrics equaled woven fabrics in production. The twentieth century saw dramatic technology changes in knitting machinery. Computerized knitting machines allowed for the replication of skills that in the past could only be achieved by hand.

Knitting is separated into two distinct categories. Weft knitting, which includes circular knitting, is when the yarn loops are joined to one another horizontally. Sweater bodies, stockings, and both single

and double knits are examples of weft knitting. In warp knitting, the loops are formed vertically. Tricot is the generic name for all warp knit fabrics and is traditionally used in **intimate apparel, outerwear,** and **activewear.**

KNITWEAR DESIGNER. A designer who is responsible for the inspiration and design of a **knitwear** collection is a knitwear designer. Knowledge of various sweater yarns and gauges, stitches and patterns, and color is mandatory. This designer must also be familiar with computer technologies such as seamless and whole garment machinery, as well as the **CAD** software programs used in the knitwear industry, including Primavision and U4ia.

KNOCK-OFF. The term that refers to copying, adapting, or modifying the design of another **designer** or **manufacturer.** In the fashion industry, especially in the less-expensive clothing categories, knocking-off is common practice yet in the designer market it is rare. Most designers who are copied accept it as a form of flattery and taking legal action is time-consuming and expensive. However, in 1994, **Yves Saint Laurent** accused **Ralph Lauren** of knocking-off his sleeveless tuxedo gown. Although tuxedo gowns were selling from other companies for years, a French judge fined Ralph Lauren $411,000 and ordered him to advertise the court decision in ten publications. This incident was ironic especially since Saint Laurent himself was fined in 1985 for knocking-off a design from designer Jacques Esterel. *See also* COPYIST; COUNTERFEITING.

KOHL'S DEPARTMENT STORE. This **retailer,** which found its niche in the moderate price range, is not a discounter like **Target,** nor is it upscale like **Nordstrom.** Kohl's has captured the mid-market customers and supplied them with wide aisles for easy stroller navigation and plenty of merchandise to choose from, with a significant number of name **brands.** This small family-owned business was sold in 1972 and, in 1980, was purchased by management in a leveraged buyout. In 1992, the company went public and launched its expansion plan. By 2004, Kohl's was operating 637 stores. *See also* CHAIN STORE; DEPARTMENT STORE; DISCOUNT DEPARTMENT STORE.

KOLOBUS. A rectangular piece of fabric joined at the shoulders and down the sides leaving slit openings for the arms and head. Invented by the Ancient Greeks during the Archaic Period (750–480 B.C.E.), this style has influenced and inspired designers to the present day.

KORS, MICHAEL (1959–). Born in New York, Kors graduated from the **Fashion Institute of Technology**. He first achieved success and recognition designing and merchandising for a New York City **boutique**. In 1981, Kors started his own label with a collection of **womenswear**. A true believer in the value of firsthand customer input, Kors loves the **trunk show** experience for the valuable feedback it provides. In 2003, Kors sold an interest in his company, Michael Kors LLC, to Sportswear Holdings Ltd., in an effort to turn the Kors label into a **megabrand**. The launch of Michael Kors, an affordable luxury label, is one venue for capturing additional market share. By 2004, Kors collections included **accessories**, fragrance, furnishings, **menswear**, and **footwear**. In the same year, he also signed a **licensing** agreement with Warnaco to manufacture, distribute, and market swimwear and related accessories. By 2005, the parent company announced its plans to drop its Michael Kors menswear line; key industry figures noted that the line did not meet a Kors label expectation and that Michael Kors was not a recognized enough **brand** to carry itself in a market other than the top luxury tier. A key figure on the hit television series *Project Runway*, Kors shared his industry experience as a critic and judge on the show. He was a recipient of his first **Council of Fashion Designers of America (CFDA)** Award in 1999. *See also* BRAND IDENTITY.

KRETCHMER, STEVEN. Kretchmer is a recognized **jewelry designer** and metal smith, known for his famous "tension setting" of precious stones. He received the 1992 Jewelers of America Award.

– L –

LA BELLE ASSEMBLEE. A publication that communicated the latest in contemporary fashion during the 1800s in the United States.

LA BELLE ÉPOQUE. The era known in France as the years of luxury and beautiful dress that lasted from 1890–1914.

LACOSTE, JEAN RENÉ (1904–1996). French tennis legend René Lacoste revolutionized men's **sportswear** with a short-sleeved collared shirt in 1927 that featured a crocodile on the left breast. The company was run for more than four decades by René's son, Bernard, who is credited with building the company into a global sports **brand**. In 2005, the year Bernard retired, forty-eight million Lacoste-branded articles were sold. Leadership was passed to his younger brother, Michael. In 1933, Lacoste created a business selling the shirts called La Société Chemise Lacoste. In 1951, David Crystal Inc. imported them from France to sell under the Izod label. In 1993, the Izod affiliation ended and Lacoste reentered the U.S. market on its own in 1996. In 2003, the France-based company gave exclusive rights to Idea Workshop, an apparel marketing firm, to bring Lacoste Sportswear to the U.S market. Paris **designer** Christophe Lemarire succeeded Gilles Rossier as **creative director** at Lacoste and presented his first runway show in 2003. Lacoste operates more than forty **boutiques** and outlets in the United States, with expansion plans in the works. The far-reaching collection consists of luxury sportswear for men, women, and children, as well as **footwear, fragrances**, and a $100 limited-edition polo shirt with a silver alligator especially for **Barneys New York**. *See also* LACOSTE SHIRT.

LACOSTE SHIRT. A short-sleeved **cotton** sport shirt sporting an embroidered alligator **logo** on the right breast, inspired by French tennis legend **René Lacoste**. This shirt marked the first time that a logo was ever worn on the outside of a garment. The alligator logo is really a crocodile, which was Lacoste's nickname. When President Dwight D. Eisenhower wore one while playing golf, they became extremely popular and knit polo shirt copies soon appeared.

LACROIX, CHRISTIAN (1951–). Born in Arles, France, Lacroix never studied fashion; rather he pursued a degree in art history at the Sorbonne. He began his career as a design assistant in **accessories** for the house of **Hermès** in 1978. In 1982, he moved to the

house of **Jean Patou** after a female friend "won over" the Patou president, Jean de Mouy, with a private showing of several of Lacroix's samples. Lacroix opened his own house in 1987 with the financial backing of Bernard Arnault of **Moët Hennessey Louis Vuitton (LVMH)**. Lacroix made the pouf skirt a must-have item of the 1980s. In 2002, Lacroix became artistic director of the house of **Emilio Pucci**. In 2005, Lacroix designed flight attendant uniforms for Air France. An admirer of **Claire McCardell**, Lacroix, who is known never to shy away from fashion statements, is a calm, quiet man who is often observed traveling on the metro wearing chinos and tennis shoes.

THE LADY'S MAGAZINE. This magazine published its first fashion edition in England in 1770 and kept men and women current on new fashion trends.

LAGERFELD, KARL (1938–). Born in Hamburg, Germany, Lagerfeld began his career as a design assistant at **Pierre Balmain** and later as an art director at the house of **Jean Patou**. Unlike his contemporaries, Lagerfeld chose to freelance design rather than acquire his own house, until he formed his own company in 1975. From 1963 to 1983, he designed for **Chloé** and, in 1965, began designing furs for **Fendi**. Lagerfeld is best known for revamping and reenergizing the house of **Chanel**, where he continues as artistic director, since taking the post in 1983. In 2004, he signed a deal with **H&M** to design an inexpensive line for its stores and, in 2005, sold the global Karl Lagerfeld trademark portfolio and related companies and collections, including Lagerfeld Gallery, to the **Tommy Hilfiger** Corporation. In 2006, Lagerfeld gave his vote of approval to Apex Partners to purchase Tommy Hilfiger Corporation. This coincided with a Lagerfeld showing in the United States in Bryant Park in 2006. In the same year, Lagerfeld signed a **licensing** agreement with Spanish bridal **manufacturer** Rosa Clara to create a Lagerfeld Collection of bridalwear.

LANG, HELMUT (1956–). Born in Austria, Lang studied fashion design at a local trade academy. He presented his first runway show in Paris in 1986. Known for his utilitarian approach to avant-guard

minimalist design, Lang entered into a collaborative relationship with **Prada**.

LANVIN, JEANNE (1867–1946). As a young girl, Lanvin worked as a **milliner**. After the birth of her daughter, she was inspired to design **childrenswear**. She later added a **womenswear** collection and thus her couture business began. Lanvin had numerous **boutiques** throughout Europe, as well as in Spain and Buenos Aires. Known for exquisite beading and embellishments as well as her signature color, Lanvin blue, she is also credited with the dress design known as the *robe de style*, a silhouette that was flattering on all figure types. The Lanvin name employed 800 people by 1925. In 1926, Lanvin began to create **menswear** and was the first couture house to design for all members of the family. Lanvin is the oldest couture house still in existence. *See also* HAUTE COUTURE.

LASTEX. This is a trademarked product of the U.S. Rubber Company, named for its synthetic rubber core yarn that is covered in **cotton, silk, wool,** or **man-made fibers**. Lastex is used in a variety of items including foundation garments, socks, leggings, and swimwear. *See also* ACTIVEWEAR; INTIMATE APPAREL.

LAUREN, RALPH (1939–). A native New Yorker, Ralph Lauren is best known for his ability to create **lifestyle-dressing**. He was born Ralph Lifshitz, the son of Jewish refugees from Eastern Europe. As a young child, he exhibited a sense of style. Ralph and his brother could often be found thrift-shop hunting; it was here that Ralph discovered fashion as a means of identity transformation. Lauren began his design career with his tie collection, Polo, a division of Beau Brummel Company in 1967. The line was adopted by **Bloomingdale's Department Store**. In 1968, Lauren and the name Polo joined forces with Norman Hilton, a suit maker. Never timid to expand, Lauren created full lines of men's and women's apparel. Possessing a keen sense of marketing, Lauren understood the power of **branding** early in his career and his polo player emblem is one of the most recognized **logos** throughout the world. Inspired by the colors of M&M candies, Lauren dyed his famous polo shirt in the same vibrant colors. Today, a visitor to his New York headquarters on Madison Avenue will find

bowls of mounded M&M candies, a nostalgic reminder of the company past. In the 1970s, Lauren presented to the world through print advertisement his products as a total image in which clothes were a means of recreating oneself. In the 1980s, Lauren made retail history with the opening of his flagship Polo **retail** store in New York, in a historical Madison Avenue mansion, which exudes the projected lifestyle of the Polo customer.

While the fashion world has not been generous in the recognition of Lauren as a creative force in the industry, he has been the recipient of numerous awards and his company went public in 1997. Lauren's name adorns successful **accessories, childrenswear,** eyewear, **fragrances,** and home products. His style for creating and marketing the "American blueblood image" is the core of his success. Lauren is also credited with grooming many notable industry successes. **Joseph Abboud** and **John Varvatos** are two of the many **menswear** designers to train with the king of lifestyle design and merchandising. His former students credit him with an exceptional business sense, as well as a clear vision for the total design process and marketing strategy. *See also* BRAND IDENTITY; BRAND IMAGE; SPORTSWEAR.

LEAD ASSISTANT DESIGNER. This is a person who is responsible for managing a team of **assistant designers.** The position requires a minimum of three to five years of managerial experience. Additionally, strong **Adobe Photoshop** and **Adobe Illustrator** skills are necessary. The position consists of assisting head designers with tasks including, but not limited to, scanning art, data entry, and trend sourcing.

LEATHER. One of the oldest materials used by man to fashion clothing, leather dates back 50,000 years to Cro-Magnon man. The invention of preserving and then softening animal skins, known as tanning, provided warmth as early man migrated to cold climates. Animal skins were also used to create footwear, furniture, and utensils and provide shelter. Innovations in the tanning process during the nineteenth century, by American Augustus Schultz, revolutionized and streamlined the tanning process through the use of chromium salts. Other technological advances included the use of sulfuric acid, fat liquors, and chemical tannins and new machinery that made skins softer and thinner. While these advances increased production, they

also added to the high cost of processing leather, thus making it a luxury commodity. Today, hides (large animal skins such as buffalo, cow, deer, horse, and pig) and skins (smaller animal skins such as goat, sheep, and lamb) come in myriad colors, finishes, and textures. Leather products have ranged from gazelle skin loincloths and ceremonial tribesmen garb to World War II aviator jackets, and tough-guy 1950s motorcycle jackets to **Claude Montana** voluminous leather coats circa 1980. Wearing leather is synonymous with status, sex appeal, and bravado. It creates an allure like no other material and even after continued attacks by the animal rights group PETA, the leather industry is still a thriving multibillion-dollar global industry. Today, the leather industry is supported by trade associations such as Leather Industries of America (LIA) and the Leather Apparel Association (LAA) with new, more environmentally friendly tanning methods on the horizon.

LEATHER APPAREL DESIGNER. This type of designer specializes in **leather** apparel or **accessories** design. Knowledge of the various types of animal skins and the tanning process and technical expertise in fashioning leather clothing and/or accessories is necessary. **Designers** must be able to source tanneries for specific kinds of skins.

LE BON MARCHÉ. Founded in Paris in 1838 as a drapery and dry goods outlet, Le Bon Marché was turned into a true **department store** in 1850 and is considered the world's first department store. The store was the simple but brilliant concept of Aristide and Marguerite Boucicaut, the husband-and-wife team credited with the vision of successful retailing that holds true today—that customers should be treated fairly and respectfully thereby ensuring a loyal following with the result being a booming business. *See also* BON MARCHÉ.

L'ÉCOLE DE LA CHAMBRE SYNDICALE DE LA COUTURE PARISIENNE. This school was established in Paris in 1928 by the **Chambre Syndicale de la couture parisienne** under the French Ministry of National Education. The school continues today and provides training for **haute couture** salons in the areas of sewing, construction, and **made-to-measure** design. In 2004, a partnership

agreement was signed with L'École National Superieure des arts Decoratifs whereby host companies work with students to develop highly creative design projects.

LECTRA. A software company specializing in **CAD/CAM** equipment and related services used by companies in the fashion industry, spanning the entire product lifecycle up to retailing. The company was formed in 1973 by engineers Jean and Bernard Etcheparre (French) and, in 1976, they launched their first apparel patternmaking and pattern-grading system. By 1986, the company became a world leader in computer-aided design (CAD) systems and computer-aided manufacturing (CAM). However, in 1990, Lectra faced financial difficulties and was recapitalized by Daniel and André Harari. In 1993, they had a technological breakthrough with *Vector*, a new generation of fabric-cutting systems which quickly became the global industry standard. By 2002, Lectra offered products including the most advanced design software, mass-customization solutions, laser-cutting systems, and an Internet platform. In 2006, Lectra launched its **product lifecycle management (PLM)**, dedicated to the management of the collections and product lifecycles. Lectra has established twenty-eight foreign subsidiaries and operates in one hundred countries.

LE FAY, MORGANE. Born in Argentina, Liliana Orcas Casabal is a self-taught **designer** who left a law career to pursue a career in fashion. Together with her husband, Carlos Garcia Casabal, in 1982, they opened Morgane Le Fay, a shop in the SoHo district of New York City named after King Arthur's half-sister from *Camelot*. Best known for beautifully feminine dresses, wedding dress, and eveningwear, Casabal also designs **sportswear** for the collection. In 1998, it launched a **fragrance**; today, it operates a wholesale business and two stores in New York and one in Santa Monica, California.

LEGWEAR. The legwear category of fashion includes socks, pads, sheer **hosiery**, legwarmers, leggings, pantyhose, tights, and footless tights. Legwear is a multibillion-dollar industry and one of the most technologically advanced, utilizing state-of-the-art knitting technology.

LEIBER, JUDITH (1921–). Born in Budapest as Judith Petro, she married a U.S. soldier from New York in 1946. After working in hand-bag factories for years in various positions, Leiber and her husband founded Judith Leiber, Inc., in 1963. The company's minaudière bags are easily identifiable due to their heavily jeweled surfaces. Leiber's bags are often inspired by animals, fruits, or trompe l'oeil objects. Her bags are considered collectors' items. Lieber also creates traditional style bags made from luxury skins as well as velvet and **silk**. In 1993, the British watch company, Time Products, acquired the Leiber name and, in 1998, Judith Leiber retired. The company was taken over by the private equity firm of Pegasus Capitol Advisors in 2002. By 2006, the Judith Leiber company realized that its bags were no longer a must-have of the young and chic social scene. The company began using young socialites in its promotional pieces in an effort to capture its present and future **target market**. *See also* ACCESSORIES.

LELONG, LUCIEN (1918–1948). Born in Paris, Lelong was the son of parents who owned a small couture house. Their trademark was their unique ability in designing with fur. Lelong took over the fam-ily business after World War I and transformed the house into one that focused on the simplicity of a silhouette, luxurious fabrics, and superb workmanship. Noted for his early recognition of the impor-tance of marketing, Lelong used his double-L **logo** to influence his designs as well as refining the packaging design of his perfumes and cosmetics. He was a master of the use of knits and bias to shape the body in the most complementary fashion. An active member of high society, Lelong socialized with the women he dressed and did not miss the opportunity to capitalize on his name. Lelong was the first Paris couturier to launch a **ready-to-wear** line. A true leader, Lelong negotiated with the Germans and was successful in **haute couture** remaining in Paris rather than being moved to Berlin. It was during this time that **Pierre Balmain** and **Christian Dior** headed a design team for the house of Lelong. Believing that only he had the ability to carry out the vision of the house, Lelong closed its doors in 1948.

LEMARIE HOUSE. This is a French feather company founded in Paris in 1898 by Madame Lemarie, the grandmother of the current owner, André. The last of its kind, this company creates the finest

feathers, which are used in **haute couture** houses throughout the world. **Chanel** bought Lemarie House in 1993 in order to keep the company in business.

LEOTARD. A form-fitted, one-piece knitted garment with either a high or low back, which can be sleeveless or have short or long sleeves, that ends in a pantie leg. It was named after **Jules Léotard**, a French aerial gymnast who invented the flying trapeze in 1859.

LÉOTARD, JULES. He was a gymnast who created the **leotard** in 1943. The garment is in one piece, covering the torso from the shoulder to pantie line. It is made of a stretch fabric that is form fitting to the body. The uniform of dancers and gymnasts, it is often accompanied by tights. The leotard became a fashion item in the 1950s when designers such as **Claire McCardell** discovered the freedom of movement they possessed. By the 1970s, technology assisted designers in expanding the leotard into fashionable **activewear**, as well as inspiring the bodysuit, catsuit, maillot, and unitard.

LEPORE, NANETTE (c. 1972–). Lepore was born in Ohio and educated at the **Fashion Institute of Technology** before opening her business in 1992. Together, she and her artist husband, John Savage, have built a wholesale business for **womenswear** and opened stores in Boston and Las Vegas and stores in London and Oyster Bay, New York. They launched a **fragrance** and **footwear** line in 2006. Lepore is best known for designing whimsical, fun clothing with an attention to fine detailing at a price.

LESAGE, FRANCOIS (1929–). Born in Chaville, France, Francois eventually took over the family's embroidery business, the House of Lesage, which was founded in 1922. The "House" supplied **couturières** with magnificent hand embroideries. Francois continued with the family tradition and expanded the traditional embroidery applications. His client list included **Balenciaga**, **Saint Laurent**, **Givenchy**, and **Dior** as well as American designers like **Geoffrey Beene** and **Oscar de la Renta**. Each creation can take from a dozen to hundreds of hours and everything is done entirely by hand. A collection can consume as much as 25,000 hours of work.

LESER, TINA (1910–1986). Born in Philadelphia and educated in the United States and Europe, Leser owned and operated her own retail store in Hawaii from 1936 to 1942 where she designed hand-blocked floral printed playclothes. She returned to New York to show her Hawaiian-inspired clothing in 1942 and partnered with Edwin H. Foreman, Inc., from 1943 to 1952. She opened her own company in 1952, retired in 1964, and then returned to design from 1966 to 1982. Leser is best known for her fun, playful clothes and is one of the pioneers of the **American Look**. *See also* CHUN, ELLERY; LIFESTYLE-DRESSING.

LHUILLER, MONIQUE (c. 1970–). Born in Cebu, Philippines, Lhuiller attended the Fashion Institute of Design and Merchandising in Los Angeles and aspired to design wedding dresses. She showed her first bridal collection in 1996. With her husband, Tom Bugbee, as company president, the collection expanded and, in 2001, they launched an eveningwear collection. Best known for her exquisite evening gowns and bridal gowns, she presented an entire collection during New York Fashion Week in 2003, which put her on the fashion map.

LIBERTY OF LONDON. A shop founded in 1875 by Arthur Lasenby Liberty on London's Regent Street, Liberty of London specializes in exotic Middle Eastern and Asian items with a handicraft feeling. The company is best known for its distinctive small floral prints.

LICENSING. A legally binding agreement between two parties, a **designer** (licensor) and a **manufacturer** (licensee), a license "loans" the name of the designer for the purpose of using that name on the label to manufacture and sell merchandise. The designer receives monetary compensation usually in the form of royalties and guarantees from the manufacturer. Royalties can range anywhere from 3 to 10 percent, depending on the designer, celebrity, or commodity being licensed. Clothing designers have been licensing their names to perfume as early as the mid-nineteenth century, as well to products such as cosmetics, eyewear, ties, shoes, **accessories**, jewelry, home products, and even food. Celebrity licensing deals, which began in the mid-1900s, are one of the fastest-growing segments in the fashion industry. Ce-

lebrities include sports icons, musicians, actors, and even cartoon and movie characters (such as Mickey Mouse and *Star Wars*). *License Magazine* estimated that worldwide retail sales for licensed merchandise in the fashion category reached a total of $37.3 billion in 2004. Of that, according to the International Licensing Industry Merchandisers' Association (LIMA), celebrity merchandise retail sales totaled $3.16 billion. The licensing trend continues to grow, becoming a major factor for market share within the fashion industry.

LIFESTYLE-DRESSING. A manner of dressing that reflects a specific style or attitude. Designers such as **Ralph Lauren** and **Calvin Klein** are examples of highly successful lifestyle designers who have created clothing, accessories, and home goods that evoke the perception of a particular social class or lifestyle. Retailers, as well as designers, recognize the value of creating a customer **brand** to gain customer loyalty. Consumers identify with brands that project the lifestyle they already lead or that emulate a lifestyle they desire to lead. The customer can rightfully assume that the brand they identify with will have depth across numerous categories of clothing. Silhouettes, colors, fabrication, and garment details will reflect this lifestyle identification.

LINEN (FLAX). One the oldest textiles, linen can be traced back to 8,000 B.C.E. It was used for curtains in Tutankhamen's tomb and it was the Phoenicians who introduced linen to the Romans and thus continued the spread throughout Europe. The process of producing a fiber to be woven is expensive; however, the list of attributes of this natural **plant fiber** is lengthy: comfort, strength, moisture absorption, and a beautiful luster. Today, the best-quality linen comes from Belgium, France, Ireland, and the Netherlands, with Ireland as the leader. Linen is frequently blended with other fibers to take advantage of its positive qualities and reduce issues such as wrinkling and difficulties in dyeing.

L.L. BEAN. Leon Bean of Freeport, Maine, founded the company in 1912. Bean, an outdoorsman, invented the Maine Hunting Boot out of personal necessity. He decided to start a mail-order company with this boot as its product and customer service as its motto. Today, the company continues catering to customers who are both nature enthusiasts and are looking for quality traditional clothing and accessories.

L.L. Bean continues with its original establishment and **catalog** business, along with an impressive Internet business and **retail** stores both in the United States and Japan.

LOGO. The emblem or insignia of a specific company or designer. Often the logo is comprised of company or designer initials. However, companies such as **Lacoste** with the alligator appliqué and Polo with an embroidered polo player have had significant success with logo or **brand** recognition. Many designer labels have used and continue to use double-lettered logos and double logos as their **brand identity**.

LOPEZ, ANTONIO (1943–1987). Born in Puerto Rico and raised in New York City, Antonio Lopez graduated from the **Fashion Institute of Technology**. It was there that he met his lifelong creative and business partner Juan Ramos, and together they made fashion history, through their reaction to the youth culture of the 1960s and the emergence of **street style**. A friend of **Karl Lagerfeld**, Antonio is credited with discovering the famous model Jerry Hall when she was fifteen. An artist of many dimensions, Antonio is best known as an illustrator for the *New York Times*. See also FASHION ILLUSTRATOR.

LORD & TAYLOR. This **department store** opened in New York City by Samuel Lord and George Washington Taylor in 1826. The store has a rich history of promoting American **designers**, beginning in 1932 with their president, **Dorothy Shaver**. Lord & Taylor eventually merged with the May Company group and was therefore included in the 2005 **Federated** buyout of the **May Company**. In 2006, Federated sold Lord & Taylor to NRDC Equity Partners for $1.195 billion.

LOUBOUTIN, CHRISTIAN (1964–). Born in France, Louboutin interned at **Charles Jourdan** and **Roger Vivier**. He spent time designing shoes for a number of couture and **ready-to-wear** houses in France and Italy and, in 1989, opened his own shoe company. He is best known for a signature collection of pumps called *inseparables*— shoes that go together as pairs, such as the Love Shoe, which has the letters "LO" on the one heel and "VE" on the other. He is also known for his famous red-soled stilettos, which are celebrity favorites. *See also* FOOTWEAR DESIGNER.

LOUIS VUITTON. *See* VUITTON, LOUIS.

LOUIS VUITTON MOËT-HENNESSEY. *See* MOËT HENNESSEY LOUIS VUITTON (LVMH).

LUCA LUCA. Born in Italy, Luca Orlando moved to New York in 1987 and began his design career working for a moderate-priced **sportswear** company, He-Ro. In 1990, he opened his own company producing a beautiful collection of clothes using exquisite fabrics. He is best known for chic, understated yet sexy collections. Luca first showed his collection at Seventh on Sixth in 2000, to rave reviews. He currently operates seven stores: two each in New York and Florida and one each in Las Vegas, Chicago, and Dallas. In addition, Luca also produces an **accessories** and **footwear** collection.

LUTHER, MARY LOU (c. 1940–). A graduate of the University of Nebraska, Luther is former **fashion editor** of the *Los Angeles Times*, *Chicago Tribune*, and *Des Moines Register*. She is the **creative director** for **Fashion Group International**, reporting on fashion and beauty trends twice-yearly. Luther is also the editor of the *International Fashion Syndicate* and writes the award-winning syndicated column Clotheslines, which is read weekly by five million readers. Her essays have appeared in *The Rudi Gernreich Book, Thierry Mugler: Fashion, Fetish and Fantasy, The Oldham Without Borders, The Color of Fashion*, and *Yeohlee: Work*. She has also published a book with the late **Geoffrey Beene**, *Beene by Beene*. Luther is the recipient of the **Council of Fashion Designers of America** lifetime achievement award for **fashion journalism** and each year an award for journalism is given in her name. *See* FASHION GROUP INTERNATIONAL; FASHION CRITIC; FASHION JOURNALIST.

LYCRA. The INVISTA Company trademarked this name for the synthetic fiber invented by DuPont in 1959. Stronger than rubber, it is generically refereed to as spandex in the United States and elastane in Europe. The fiber can stretch up to 600 percent and spring back to its original length. Xtra Life Lycra was introduced to the public in 2005. The fiber resists chlorine and holds its shape five to ten times longer than unprotected spandex. Lycra, as its advertising

campaigns have stated, is woven into all aspects of clothing design. Traditional **wools** and **cottons** take advantage of the added design flexibility of stretch. Lycra has been used in the **activewear**, swimwear, **hosiery**, and **intimate apparel** markets for more than thirty-five years. In 2000, Brazilian designer Carlos Miele introduced natural **leather** with Lycra.

– M –

MACINTOSH, CHARLES (1766–1843). Charles Macintosh was born in Glasgow, Scotland. His father had a successful dyeing business, which is where Macintosh first became interested in science. In 1797, he opened a chemical factory and invented a series of processes and products (for example, a conversion process that used carbon gases to turn iron to steel; a hot blast process; and an easy-to-carry bleaching powder). While amassing a considerable fortune as a result of these inventions, he also found a use for one of the waste products from one of his inventions, naptha, a rubber solvent. He used it to bond two pieces of cloth together and thus created the first waterproof textile, which he patented in 1823 and named "India rubber cloth." By 1836, a coat known as a "macintosh" or "mac" was being produced. The original coat, designed for women, was single-breasted and loose-fitting and had a detachable cape, and waterproof seams. The coating process could be applied to the inside, the outside, or between two layers of cloth. Macintosh's process was the precursor to the invention of **vinyl** (1926) and other plasticizers that would eventually dominate not only the rainwear business but other areas such as **sportswear**, **footwear**, and handbags, as well as the home furnishings industry. In 1823, Macintosh was elected a fellow of the Royal Society, a prestigious group of Scotland's best scientists and entrepreneurs. *See also* SEMON, WALDO L.

MACKIE, BOB (1940–). Born Robert Gordon Mackie in Monterey Park, California, he studied art and design at Choinard Art Institute in Los Angeles and Pasadena City College. Mackie started his career as a sketcher for Paramount Pictures, then later for 20th Century Fox

and Universal Studios. He sketched for **costume** designers **Edith Head** and Jean Louis before gaining the attention of another costume designer, Ray Aghayan, who hired Mackie as his assistant to work on costumes for *The Judy Garland Show* in 1963. Thus began a lifelong partnership between the two that resulted in projects ranging from television specials and films to the opening of the MGM Grand Hotel in Las Vegas where they were responsible for designing 940 costumes. Mackie is perhaps most famous for his work on television shows such as *The Carol Burnett Show* (1967–1978) and the *Sonny & Cher Comedy Hour* (1971–1974). Both hit shows owed much of their success to Mackie's wonderfully creative and inventive costumes. His penchant for showgirl fashion included the use of furs, beads, and feathers, which earned him the nicknames the Sultan of Sequins and the Rajah of Rhinestones.

Cher was the perfect muse for Mackie as she never shied away from wearing his outrageous, body-revealing clothing, which flattered her incredibly fit body. Mackie has been quoted as saying, "A woman who wears my clothes is not afraid to be noticed," which was why his Hollywood client list was so long. These clients included Lucille Ball, Carol Burnett, Diahann Carol, Carol Channing, Cher, Marlene Dietrich, Judy Garland, Mitzi Gaynor, Whoopi Goldberg, Debbie Harry, Teri Hatcher, Anjelica Huston, Elton John, Madonna, Ann Margaret, Bette Midler, Liza Minnelli, Diana Ross, Sharon Stone, Barbra Streisand, Kathleen Turner, Tina Turner, Oprah Winfrey, and Raquel Welch, as well as drag queens RuPaul, Brandywine, and Lypsinka. Mackie's Mohawk Warrior costume, designed for Cher's appearance at the 1986 Academy Awards, exposed her tattooed derriere and caused a national sensation.

In 1982, Mackie launched a high-end **ready-to-wear** line and a succession of **licensing** deals for bridalwear, eyeglasses, belts, **fragrances**, a bath line, **sportswear**, watches, **furs**, men's formalwear, dress shirts, and neckwear. In 1989, Mackie licensed his name to a line of lower-priced sportswear with the He-Ro Group but the line was discontinued 1994. In 1993, Mackie closed his signature high-end collection but returned in 1995 for a joint venture with business partner Ray Aghayan and **manufacturer** United Designers, creating a line of special occasion dresses. During his three-year hiatus from **Seventh Avenue**, he continued to design costumes for theatrical

productions in Los Angeles and for the Broadway production of *Moon Over Buffalo*. Mackie even tried his hand at acting in a made-for-television movie, *Tales of the City*. In addition to his numerous licensed products, Mackie has sold **accessories**, blouses, and costume jewelry on **QVC** and has also designed jewelry and porcelain for the Franklin Mint. He is the recipient of eight Emmys, thirty-one Emmy nominations, three Academy Award nominations, and in 2001, the **Council of Fashion Designers of America (CFDA)** gave him a special award for fashion exuberance. Mackie, in 2003, was the first designer to be inducted into the Academy of Arts and Sciences Hall of Fame.

MACY'S. This industry giant was founded as a dry goods store in downtown Haverhill, Massachusetts, in 1851 by Rowland Hussey Macy. In 1858, Macy moved to New York City, where he set up a new store called R.H. Macy and Company on 14th Street and Sixth Avenue. He moved again to 18th Street and Broadway, an area which was known as the "Ladies Mile" during the nineteenth century, an elite shopping area similar to what Madison Avenue is today. In 1896, Isidor Straus and his brother, Nathan, bought the store and, in 1902, moved it to its present location in Herald Square (34th Street and Broadway). Over the years, the store expanded and eventually encompassed the entire block. Although other stores in Russia and Tokyo claim to be larger, Macy's flagship store in Herald Square advertises itself as the world's largest **department store**. In 1922, Macy's went public and experienced growth during the 1920s and 1930s, opening branch stores and acquiring other stores throughout the country. In 1986, Ed Finkelstein, Macy's chairman and CEO, attempted a leveraged buy-out of Macy's and a takeover bid for the **Federated Department Stores, Inc.** Both efforts failed. Later, Canada's Campeau Corporation succeeded in buying the company.

In 1992, Macy's filed for bankruptcy and, in 1994, Federated succeeded in merging with Macy's and shutting down I. Magnin department store in the process. Federated continued to gain a dominant position in the **retail** sector during the 1990s by acquiring stores and changing them to the Macy's nameplate. By 2005, Macy's had approximately 400 stores when Federated Department Stores, Inc., made an $11 billion bid for the **May Company** and succeeded, cre-

ating the largest department store chain in the world with more than 1,000 stores. The famous Macy's Thanksgiving Day Parade was first held in Haverhill in 1854 and has been a holiday tradition in New York City for more than 75 years.

MADDEN, STEVE (1958–). Born in Queens, New York, Steve Madden entered the shoe business during the 1970s at age sixteen as a stockboy at a local shoe store, Toulouse. After another sales position at Jildor, in Great Neck, he landed his first job working for shoe **manufacturer** L. J. Simone during the 1980s, where he learned how to build a shoe collection. With a keen eye for spotting trends coupled with his skill for turning product around quickly, Madden and a partner formed Souliers, which soon failed. However, in 1990, he struck out on his own forming Steve Madden, Inc., and opened a hip shoe store in New York City's trendy SoHo district, where he retailed his own collection in addition to other hot brands like Caterpillar, **Puma**, and Sperry. Madden's reputation as a **copyist** was overcome with the introduction of one of his own creations known as the "logger boot." Not only were these boots all the rage among teenagers in the 1990s, but they too were widely copied. His shoes could best be characterized as high chunky platforms. He attracted a cult-like following.

In 1993, the company went public and, by 1997, Madden extended his product line into **T-shirts**, hats, and other accessories. His T-shirt was merchandised in a box called the "Ice-Tee." In 2000, he partnered with Atlantic Records and launched a cross-marketing campaign called Rock N'Sole: The Girl Band Search, which provided support for aspiring female recording artists. His enfant terrible personality worked in synergy with his "cutting-edge" brand image. However, in 2000, Madden was arrested on charges of conspiracy to commit money laundering and securities fraud. He pleaded guilty to those charges in 2001, paid $7 million in fines, relinquished his CEO status, and spent thirty-one months in a minimum security prison in Florida before returning to his company in 2005. The company continues to **license** its **brand** name for handbags, eyewear, hosiery, and belts. It is also the licensee for L.E.I. **footwear**, Candies Footwear, and Unionbay men's footwear, as well as for 100 freestanding Steve Madden stores worldwide.

MADE-TO-MEASURE. Clothing that is made to an individual's body shape by creating and fitting on a **custom-made** dress form, from body measurements, or from a bodyscanned image. Made-to-measure clothing had been very popular until the introduction of **ready-to-wear** in the mid-nineteenth century. At that time, made-to-measure had been considered a luxury, reserved for only those who could afford couture clothing or the expert tailoring of suits from **Savile Row.** However, recent advances in **bodyscanning** technology have begun to offer made-to-measure to the masses. Companies such as **Levi's, Brooks Brothers,** Land's End, and numerous bridal companies offer customization options to increase product visibility and to provide their customers with better solutions to fittings. *See also* HAUTE COUTURE.

MAINBOCHER (1890–1976). Born Main Rousseau Bocher in Chicago, Illinois, he studied at the Academy of Fine Arts, Chicago, and later at the Art Student's League in New York. While an interest in music brought him to Munich and Paris for voice training, he also dabbled in fashion by sketching clothing for several **designers,** earning him some notoriety at Paris's Salon des artistes décorateurs. At the onset of World War I, he returned to New York to study vocals, financed by selling sketches to **ready-to-wear manufacturer** Edward L. Mayer. Bocher enlisted in the Army during this period and once again landed in France where, after a failed attempt at a singing career, he pursued a career as an illustrator at *Harper's Bazaar.* In 1923, he joined French *Vogue* as fashion editor and was promoted to editor-in-chief in 1927. Bocher left *Vogue* in 1929 to open his own fashion house, Mainbocher. For an American in Paris, he enjoyed a great deal of international renown with an impressive list of clients that included socialites and royalty alike. Mainbocher's wedding dress for Wallis Simpson, wife of the Duke of Windsor, created a stir on both sides of the Atlantic. In 1939, at the onset of World War II, Mainbocher returned stateside and reopened his salon in New York. During his forty years in the business, Mainbocher was responsible for creating some of the most beautiful couture dresses, suits, and eveningwear. "Wallis blue" and "Venus pink" were names associated with his collections, as was the first strapless evening dress. Mainbocher was commissioned to

design uniforms for the WAVES (a group for women in the naval reserves; an acronym for Women Accepted for Volunteer Emergency Service), the American Red Cross, and, in 1948, the Girl Scouts. In 1971, Mainbocher closed his business and returned to Europe until his death.

MALANDRINO, CATHERINE (c. 1970–). Born in Grenoble, France, Malandrino began her career after graduating from **Esmod**. Before moving to the United States, her work experience included Dorothèe Bis, **Emanuel Ungaro**, and the French label, Et Vous. In 1998, she met her husband and business partner, Bernard Aidan, and helped relaunch the **Diane von Furstenberg** collection before opening her own collection in 1998. Best known for naming her collections with simple, evocative words such as Collage, Flag, or Hallelujah, Malandrino produced beautiful clothes with star appeal. Her clothes have appeared on Madonna, Halle Berry, and Julia Roberts, as well as on Sarah Jessica Parker while *Sex and the City* was being filmed at Malandrino's store.

MAN-MADE FIBERS. Man-made fibers can be created by synthetic means, by extruding material through holes, called spinnerets, into the air to form thread. Some of the most popular man-made fibers used in the fashion industry include acetate (1924), acrylic (1950), modacrylic (1949), **nylon** (1939), **polyester** (1953), the artificial, but not truly synthetic, fiber **rayon** (1910), and spandex (1959).

MANNEQUIN. A word with two meanings in the fashion industry: one describes an inanimate model of the human body used in store displays, and the other refers to a live **model** such as those used in **haute couture**.

MANUFACTURER. In reference to the fashion industry, this is a company that is in the business of manufacturing apparel or accessories. The systemized manufacture of garments and accessories began once the sewing machine was invented in 1846.

MARII. A unique **silk** pleating technique patented by American designer **Mary McFadden** in 1975.

MARKDOWN. Markdown refers to the amount of money that a **buyer** is given in order to mark down items to clear them out of their stock. Sometimes the buyer will ask the **manufacturer** for markdown money to clear out stock of that particular vendor's merchandise. *See also* CHARGEBACK; MARK-UP.

MARKER. A marker is a type of schematic plan that places various **pattern** pieces of a garment or other item in the best possible position for cutting and to achieve the best possible yield. Various sizes are integrated according to the quantity needed. A person can do this by hand on paper or by computer. The marker is then placed on top of several layers of fabric and then cut. *See also* GERBER; LECTRA; PAD; PDS.

MARKETING ACCOUNT MANAGER. A highly skilled and creative manager who directs and manages the development and implementation of in-store marketing programs, the marketing account manager carries many responsibilities. The manger's projects include marketing communications strategies and programs, seasonal campaigns, window presentations, item promotions, sponsorship tie-ins, and testing new concepts.

MARKS & SPENCER. In 1884, Michael Marks, a Russian-born Polish refugee, opened a stall at Leeds Kirkland market in England. In 1894, he formed a partnership with Tom Spencer. By 1907, upon the founders' deaths, Marks & Spencer stores were run by son Simon Marks for the next fifty-six years. Today, it is the number-one retailer in Europe with 375 stores in 29 countries, retailing such diverse commodities as clothing, foods, home goods, and financial services.

MARK-UP. The amount that a **manufacturer**, supplier, or retailer adds to the cost of a product or service. The mark-up percentage is calculated based on each company's own formula, taking into account factors such as overhead, operating expenses, advertising budget, and other such considerations. *Keystone mark-up* or *keystoning* are terms which indicate that an item has been marked up to double the cost. *See also* MARKDOWN.

MARMOT. In 1973, as students at the University of California Santa Cruz, Eric Reynolds and Dave Huntley went into business making down parkas, vests, sleeping bags, and sweaters. In 1974, they founded Marmot Mountain Works in Grand Junction, Colorado. In 1976, Marmot was the first to promote Gore-Tex, a new fabric with extraordinary waterproofing capabilities. Throughout the years, they have worked in conjunction with well-known performance athletes to create top-of-the-line outdoor products for the serious sports enthusiast. In 1993, there was a management buyout of the company and, in 2004, Marmot was acquired by K2, Inc., a premier branded consumer products company with a portfolio consisting of leading **brands** in the sports and performance industries. In 2004, Marmot launched its Phenomenon EL, a jacket with built-in lights for skiers and boarders to be able to see in the dark or inclement weather. The Marmot brand consists of clothing, **sportswear**, base layer, gloves, packs, bags, tents, and **accessories**. *See also* PERFORMANCE APPAREL.

MARNI. This company was founded in 1994 by the Castigliani family of Milan. The company was originally known for supplying furs to major **designers**. Under the design direction of Consuelo Castigliani, it presented its own collection to rave reviews. The collection was eclectic with bright colors, bold graphics, elaborate fantasy prints, and expert tailoring while retaining a hip, relaxed aesthetic. **Accessories** (shoes and bags) were added in 1998. In 2000, Marni signed a 50 percent partnership with Onward Kashyama to open three in-store shops in Japan's top **department stores** and shopping centers: Ginza Matsuia, Isetan, and Movida. By 2002, Marni launched a men's line and had stores in New York, London, Milan, and Paris and, in 2005, opened a store in Los Angeles. The collection was also sold in better department and specialty stores and has been a favorite among Hollywood celebrities.

MASS MARKET. Clothing and products sold to a very broad range of customers are said to appeal to the masses. Retailers such as **Wal-Mart, Kmart, Target**, and **H&M** are examples of large mass-market **chain stores**. Price point and mass appeal are key components to this classification.

MASS MERCHANDISE. Mass merchandise is produced in great quantities to appeal to a very broad audience. *See also* CHAIN STORE; DEPARTMENT STORES; MASS MARKET.

MASS PRODUCTION. This refers to the capability to produce vast amounts of a particular item for consumption. During the **Industrial Revolution**, the invention of the **sewing machine** and other machines—together with the concepts of **standardized sizing, separates**, and **ready-to-wear**—resulted in a major leap from **made-to-measure/bespoke tailoring** to the mass-production of apparel and accessories.

MATRIX BUYING. A **retailer**'s list of preferred vendors, often further described by a specific merchandise classification. As department store business began to decrease in the early 1990s due to "**commoditization**," **department store** retailers became increasingly cautious about taking risks. Key manufacturers such as **Ralph Lauren, Tommy Hilfiger, Ellen Tracy**, and other large companies like them, invested in computer software that could interface with that of the major department stores. This made it easy for both the retailer and the vendor to track sales. If a style wasn't selling or needed to be reordered, the **manufacturer** would not have to wait for the **buyer**'s report to find out, but could react appropriately by sending replenishing stock or taking merchandise off the selling floor. This made the buyer's job easier and store operations more efficient.

MAX MARA. This company was founded in 1951 by Italian born Dr. Achille Maramotti (1927–2005). Although trained as a lawyer, his mother's influence from owning a **patternmaking** school inspired him to enter the fashion business. His company started in coats and suits. It expanded over the years with the hiring of such notable designers as Jean-Charles de Castelbajac (1975) and with the Sportmax line designed for Anne-Marie Beretta, **Karl Lagerfeld**, and **Dolce & Gabbana**. Max Mara was best known for its camel coat introduced in 1982. The coat was included in each collection and was widely copied. In 2001, Max Mara opened an architecturally exquisite store in New York's SoHo district that added to its roster of 1,790 stores worldwide. Today, the house of Max Mara is still family-run with son

Luigi Maramotti as chairman. The company produces a full range of **sportswear** and coats under the Max Mara label, a **plus-size** division, Marino Rinaldi, named after Achille's mother, and a contemporary line called Max & Co. A **fragrance** and an eyewear collection also bear the Max Mara name.

MAXWELL, VERA (1903–1995). Born in New York, Maxwell started out wanting to be a ballet dancer. She landed her first job as a "showroom girl" at Linker and Klein on **Seventh Avenue.** Although she had no formal fashion training, she began sketching and producing clothing designs that she sold to **Lord & Taylor,** which at the time was promoting American contemporaries **Bonnie Cashin, Tina Leser,** and **Claire McCardell.** In the 1940s, Maxwell was the creator of the Rosie the Riveter coveralls that were made for women working for the war effort in the United States. In 1947, she opened her own **sportswear** company, Vera Maxwell Originals. She was one of the first designers to work in ultrasuede and the synthetic fabric, Arnel. She is best known for her "six-piece ensemble" that was designed in 1975 to fit into one carry-on bag, ideal for air travel. Maxwell's clothes were designed for ease and comfort. A retrospective of her work was held at the Smithsonian Institute (1970) and another at the Museum of the City of New York (1980). She retired in 1985 but returned in 1986 to design a collection for Peter Lynne.

MAY COMPANY. David May founded this **department store** in Leadville, Colorado, in 1877. In 1905, he moved the headquarters to St. Louis, Missouri, later incorporating the company in 1910 and going public with it in 1911. In the same year, the company acquired the William Barr Dry Goods Company and combined it with Famous Clothing Store to become Famous-Barr. In 1951, David's son, Morton, became the chairman and headed the company for sixteen years. The company became May Merchandising in 1969. In 2005, May was acquired by **Federated Department Stores, Inc.,** making it the second-largest department store chain with more than 1,000 stores and $30 billion in sales annually. From 1923, until just before the Federated acquisition, the company had acquired a long list of other department stores: the Jones Store, Famous-Barr, Marshall Field's, A. Hamburger and Sons, Kaufman's, the Daniel & Fischer Stores

Company, Hecht's, G. Fox, Meier & Frank, Associated Dry Goods, **Lord & Taylor**, Strouss, the Denver Dry Goods Company, Foley's, Filene's, Thalhimers, Robinson's, Hess's, Wanamakers, Woodward and Lothrop, Strawbridge & Clothiers, L.S. Ayres & Co., ZCMI, David's Bridal, After Hours Formalwear, and Priscilla of Boston. Federated's strategy was to divest many of the stores and consolidate the nameplates of these stores under the **Macy's** and **Bloomingdale's** mastheads. Mergers of this type highlighted the changing landscape of **retailing** in the twenty-first century as it adapted to new socioeconomic factors, the Internet, lifestyle shifts, and world events.

MCCALL'S PATTERN CO. McCall's was a **pattern** company founded in 1873 by (American) James McCall that sold full-scale paper patterns to the home sewer. Unlike his competitors at the time, McCall's offered a full range of sizes. As the home sewing market grew, better methods of communicating garment cutting and construction procedures were sought after. McCall's responded with its own patent in 1921 by Francis Hotter called the "Printo Gravure," the first printed-pattern process (patent expired in 1938) and instruction panel. Up until then, patterns were done manually and lacked instructional materials. In 1984, Reginald F. Lewis purchased the floundering McCall's Pattern Company and three years later sold it for a $70 million profit to Crowther Group. Under Crowther, the company filed for chapter 11 bankruptcy and, in 1990, was sold to MP Holdings Inc. In 2001, McCall's acquired Butterick and **Vogue** although all three retain their own signature names.

MCCARDELL, CLAIRE (1906–1958). Born in Frederick, Maryland, Claire McCardell attended Hood College before pursuing a career in fashion that began at the **Parsons School of Design**, followed by a one-year stint in Paris. Upon graduation in 1928, McCardell held several jobs ranging from **fit model** to sales assistant before landing a job as a **designer** for **knitwear manufacturer** Sol Pollack. In 1929, she met Robert Turk and became his assistant at Townley Frocks, until his tragic death in 1932. After his death, McCardell was named chief designer where she stayed for most of her career, later becoming a partner in the company. McCardell's design philosophy pioneered the concept known as the **American Look**, that is, uncomplicated,

comfortable clothing for the casual American lifestyle. Her design philosophy was in sharp contrast to her European counterparts of the 1940s, whose clothes were fitted, fussy, decorated, and tailored. Having spent a year in Paris, McCardell gained firsthand experience about French fashion, **haute couture**, and the complexity of garment construction which is why she chose to rebel and to create clothes that were affordable, relaxed, and had mass-market appeal.

McCardell took an innovative approach to fashion and was the originator of **lifestyle-dressing**. She is known for using worker and farmer uniforms as inspiration and was also famous for her wrap and tie styles. She created the timeless and highly copied Monastic dress, a bias cut shift dress. Her "five easy pieces" concept was the foundation for today's mix-and-match **sportswear** category and her "**popover** dress" was the chic precursor to the "housedress." Perhaps her most remembered designs were those in **wool** jersey which were seasonless, casually chic and easy-care. However, other fabric choices such as **denim**, gingham and **cotton** calico demonstrated her unpretentious approach to fashion, yet were considered quite stylish. Before, during, and immediately following World War II, McCardell and other American designers such as **Tina Leser** and **Bonnie Cashin** were promoted by **Lord & Taylor's** then-president, **Dorothy Shaver**. The American Look began to receive international acclaim after the war and eventually became the catalyst for the sportswear industry as we know it today. Before her death in 1958, McCardell was featured on the cover of *Time* magazine and authored a book, *What Shall I Wear? See also* SEPARATES.

MCCARTNEY, STELLA (1972–). Born in England, McCartney graduated from the fashion program at **Central Saint Martins College of Art and Design** in London in 1995. Amid much controversy, due to her famous father, the former Beatle Sir Paul McCartney, she was hired as chief designer at the house of Chloe directly out of school. Her collections at then-ailing Chloe were well received and boosted sales. However, McCartney left in 2001 to design under her own label as part of the **Gucci** Group. She was best known for combining tomboy tailoring with frilly rock-star glamour. Like her mother, Linda, she was a staunch animal-rights activist. In 2005, she unveiled a limited-edition capsule collection in partnership with

MCFADDEN, MARY • 157

H&M that sold out within hours and, elsewhere, a line of **performance sportswear** for **Adidas**. In 2006, an organic skin care line was launched.

MCCOLLOUGH, JACK. See PROENZA SCHOULER.

MCDONALD, JULIEN (1972–). Born in Merthyr Tydfyl, Wales, he was originally interested in becoming a dancer but became fascinated in college with **knitwear** design. McDonald furthered that desire by attending the master's program at London's Royal College of Art. He began designing knitwear for **Chanel** under **Karl Lagerfeld** but he ultimately created his own line and presented it during London Fashion Week, 1997. In 2000, he was named head designer at **Givenchy** and stayed there until 2004. McDonald continued after that with his own collection, known for its razzle-dazzle vibe and appeal to the celebrities and stars of the film and music industry.

MCFADDEN, MARY (1938–). Although she was born in New York City, Mary McFadden grew up on a **cotton** plantation in Memphis, Tennessee. McFadden was educated at the Sorbonne in Paris, the Traphagen School of Design, Columbia University, and the New School for Social Research in New York City. Her educational background and extensive travels contributed to her eclectic taste level. While working as the director of public relations for **Dior** New York in 1965, McFadden married a De Beers diamond merchant and moved to South Africa, where she became a journalist for *Vogue* South Africa. In 1970, she became a special projects editor for American *Vogue* and, through an article written about her eclectic style, she caught the attention of Gerry Stutz, president of **Henri Bendel** in New York. During the 1970s and early 1980s, Henri Bendel was famous for promoting new design talent and helped launch the careers of many new **designers**, such as **Stephen Burrows**, **Zoran**, McFadden and countless others. In 1976, she opened Mary McFadden Inc., featuring pleated clothing in a technique similar to that created by **Fortuny**, which she called Marii and patented in 1975.

McFadden is best known for drawing on ethnic costume and ancient cultures for inspiration in combination with embellishment and passementerie. Her beautifully crafted evening dresses soon caught

the attention of wealthy women everywhere and were widely copied. In the late 1970s, McFadden spun off a less expensive line and later **licensed** her name on a range of products such as eyewear, neckwear, home furnishings, sleepwear, and **footwear**. She even sold her accessories on **QVC**, a cable TV home-shopping network, in 1994.

Her personal life was as colorful as her clothes. She claimed to have been married at least eleven times, although she described some of these "marriages" as being "only spiritual." In 1997, McFadden became an advocate of cancer awareness for women. She abruptly closed her high-end ready-to-wear line in 2002, but she remained active thereafter licensing her moderate-priced suit line, the Mary McFadden Collection. Her contributions to the fashion industry have earned her two **Coty Awards** and a place in the Coty Hall of Fame as well as a Lifetime Achievement Award from Fashion Week of the Americas.

MCQUEEN, ALEXANDER (1969–). Born Lee McQueen to a London cabbie and a genealogist, he was one of six children who grew up in London's East End. At the age of sixteen, McQueen entered the fashion industry as an apprentice to **tailors** Anderson & Shepherd of **Savile Row**. After two years, he moved to Gieves & Hawkes and furthered his knowledge of **bespoke menswear**. After a short stint at a theatrical costume house and with avant-garde designer Koji Tatsuno, he went to work in Milan for **designer Romeo Gigli** in 1989. He returned to London in 1990, seeking a job as a **pattern** cutter at the fashion college **Central Saint Martins College of Art and Design**, but instead enrolled there as a student in its master's program. McQueen's senior collection was discovered by a *Vogue* fashion editor, Isabella Blow, and she set out to be his patron, muse, and PR agent. While working at Gigli, McQueen learned the power of the media and cleverly used his outrageous fashion shows to hype himself and his clothes. His famous "bumster" pants and sharp-edge tailoring, which he learned on Savile Row, are among his trademarks. In 1996, he signed a pact with Gibo, the Italian subsidiary of Onward Kashiyama of Japan (a promoter of emerging fashion talent), to make and distribute his men's and women's collection.

Also in 1996, with only eight collections under his belt, he accepted the job as chief designer at **Givenchy** but insisted on keeping his own company independent from the parent company, **Moët**

Hennessey Louis Vuitton (LVMH). His four-year term at Givenchy was a rocky one. However, he continued to impress the bourgeois French fashion establishment with his elaborate theatrical fashion productions that featured basketball players, robots, maggots, pirates, amputees, cult heroes, and powerful female imagery with a dark romantic edge. In 2000, while still at Givenchy, he sold a 51 percent share of his own company to the **Gucci** Group, the archrival of LVMH. In the same year he launched an expensive range of **childrenswear** as well as **licensing** his name to eyewear, **leather** goods, watches, neckwear, scarves, handkerchiefs, and umbrellas. In 2001, he left Givenchy, opened a store in New York City, launched a **custom-made menswear** collection in collaboration with Huntsman of Savile Row and continued to show his collection in Paris. In 2003, he opened two more stores, one in London and the other in Milan, and launched a **fragrance** called Kingdom. He is a three-time British Designer of the Year award winner and, in 2003, was named International Designer of the Year by the **Council of Fashion Designers of America (CFDA)** and was awarded a CBE (Commander of the British Empire) for his services to the British fashion industry. In 2005, McQueen created his famous Novak bag, unveiled a **footwear** line for **Puma**, and launched a second **ready-to-wear** line called McQ–Alexander McQueen, a **denim**-based collection that included **accessories**.

MEGABRAND. A term given to a brand that has achieved worldwide recognition and sales in the high millions or billions of dollars. Examples are **Nike, Liz Claiborne, Prada, Gucci,** and **Ralph Lauren.**

MEGASTORE. The name given to a large chain of stores such as **Target, Kmart,** and **Wal-Mart.**

MEISEL, STEVEN (1954–). A New York **fashion photographer** who began his career as an illustrator upon graduation from the **Parsons School of Design.** After brief stints at **Halston** and *Women's Wear Daily,* he fulfilled his lifelong dream of becoming a photographer and was discovered by editors at *Seventeen* magazine. He went on to produce work that was featured in *Vogue* magazine—the French, American and Italian versions—and is credited with launching the

careers of top models Linda Evangelista, Guinevere Van Seenus, Elsa Benitez, Karen Elson, Maggie Rizer, Iman, Kristin McMenamy, Naomi Campbell, and Alek Dek. He rose to fame in the 1980s and today is considered one of the most influential fashion photographers of his generation by fashion designers and editors alike. Meisel is one of the "Blue Chip" photographers who commands upward of $15,000–$30,000 a day. His body of work is impressive beginning with his 30-plus page spreads for Italian *Vogue*, his 1995 "teen porn" **jeans** ads for **Calvin Klein**, and his banned-in-Britain ad for Opium perfume in 1999. He was also the shutterbug behind Madonna's infamous 1992 *Sex* book and has shot numerous ad campaigns for **Anne Klein, Max Mara, Prada, Dolce & Gabbana, Yves St. Laurent, Valentino, Gap, Escada**, and, in 2000, his highly acclaimed **Versace** ad campaign, Four Days in L.A. In 2004, he produced a 38-page exploration of erotic male–female gender roles, published in *W* magazine, which once again caused controversy.

MENICHETTI, ROBERTO (1967–). Italian-born Menichetti began his career at Claude Montana. He moved to Jil Sander as its **menswear** designer from 1993 to 1997. In 1997, Rose Marie Bravo hired him to revive the high-end **Burberry** Prorsum collection and together they turned the company into a successful luxury **brand**. Known for innovative fabrics and motocross inspirations, his look is both modern and chic. Menichetti left Burberry in 2001 to become **creative director** at **Celine**, but left after only two seasons. He went into business for himself in 2004.

MENKES, SUZIE (c. 1940–). Menkes was a British **fashion journalist** who was schooled as a fashion designer but became a fashion journalist for the *International Herald Tribune*. In 2002, she was blacklisted from attending all of French conglomerate **Moët Hennessey Louis Vuitton (LVMH)** designers' runway shows for writing an unfavorable review of the **John Galliano** show. Menkes had a reputation for writing scorching reviews and did not worry much about alienating her publisher's advertising clients. *See also* FASHION CRITIC.

MENSWEAR. *Menswear* describes the category of men's clothing and accessories that includes men's **sportswear**, suits, shirts, neck-

ties, hosiery, shoes, hats, **outerwear**, sleepwear, underwear, athleticwear, and **performance apparel**. Trends in men's clothing have historically moved much slower than for women's clothing and can be traced back to as early as the Greek and Roman **himations** and **togas**. Medieval mantles, tunics, and leggings for men lasted until the cotehardie (tight-fitting bodice, full sleeves, and short skirt) and houppelande (long voluminous outerwear garment) took over in the fourteenth century and lasted for the next 100 years. Inspired by increased trade between the Far East and Europe, men's fashion became extravagant during the Italian **Renaissance** and, by the late fifteenth century, men were wearing knee breeches with knee-length stockings and doublets with shirts made from exquisite **silks** and brocades. In 1633, Louis XIV of France issued an edict requiring simplified dress at the French court; ruffs, paned sleeves, and ribbons were outlawed in favor of plain **linen** collars and cuffs. With the end of the Thirty Years' War, men's fashions of the 1650s and early 1660s imitated the new peaceful and more relaxed feeling in Europe. In 1666, Charles II of England decreed that, at court, men were to wear a long coat, a vest or waistcoat, a cravat, a periwig or wig, and breeches gathered at the knee, as well as a hat for outdoor wear.

A big shift in menswear followed the American (1775–1783) and French (1789–1799) Revolutions, when fashion became understated and "undress" was the popular opposition to the abundant adornments that defined aristocracy. While men continued to wear the waistcoat, coat, and breeches of the previous period for both full dress and undress, they were now made of the same fabric, signaling the birth of the three-piece suit. The early 1800s saw the final abandonment of lace, embroidery, and other embellishment from serious men's clothing and it became gauche to dress like an aristocrat. In Britain, **Beau Brummell**, a **trendsetter** of the time, is credited with introducing and making the modern man's suit and necktie fashionable. The Row, as it is commonly termed, became the center of traditional **bespoke tailoring**, primarily for men. This trend led to the trousers that are popular in menswear today as they have been for the past 200 years. What Paris was to women's fashion, London was to men's. After the U.S. Civil War (1861–1865), standardized sizing in men's clothing introduced the concept of **mass production** with less individual tailoring and the necktie was introduced by 1880.

During the early 1900s in the United States, menswear took a less formal approach than in Europe with a trend toward brightly colored sportswear. The Norfolk jacket remained fashionable for shooting and rugged outdoor pursuits but, in the United States, the fashion was the Norfolk suit worn with knickerbockers, knee-length stockings, and low shoes for bicycling or golf and, for hunting, the same but with sturdy boots or shoes with **leather** gaiters. In the 1920s, students at Oxford and Cambridge violated, for the first time ever, the Edwardian practice of different types of dress for different times of the day wearing flannel trousers, tweed jackets, "Oxford Bags" (khaki trousers), and soft collar shirts. Jazz clothing consisting of tight-fitting suits was considered an expression of passion for jazz music. **Phillips-Van Heusen** introduced the first-ever collar-attached shirt, called Collarite. Also at this time in the United States, men's **fashion magazines** often featured styles and trends from London.

The crash of the American stock market in 1929 marked a change in the worldwide economic situation and had a drastic effect on men's clothing. By 1931, eight million people were out of work in the United States. The garment industry suffered and the Edwardian tradition of successive clothing changes throughout the day finally died. **Tailors** responded by offering more moderately priced styles. In 1935, President Roosevelt's New Deal rebounded the economy and thus created a demand to redesign the business suit to signify new success. This new look was designed by London tailor Frederick Scholte and was known as the "London cut." Blazers also became popular for summer wear. Blazers are descendants of the jackets worn by English university students on cricket, tennis, and rowing teams during the late nineteenth century. The name may derive from the "blazing" colors the original jackets were made in, which distinguished the different sports teams. The zoot suit became popularized in Harlem nightclubs. It was an exaggerated look comprised of an oversized jacket, wide lapels and shoulders, with baggy low-crotched trousers that narrowed dramatically at the ankle. This 1930s "gangster influence" bore the image of a businessman because of the suits they wore; this did not include typical business colors and styles and, in fact, they took every detail to the extreme, featuring wider stripes, bolder glen plaids, more colorful ties, pronounced shoulders, narrower waists, and wider trouser bottoms. In 1931, *Apparel Arts*

was founded as a men's fashion magazine for the trade and became the fashion bible for middle-class American men, later known as *Esquire* magazine. America began to successfully compete with long-established English and French tailors. However, the eruption of war at the end of the decade brought an abrupt halt to the development of fashion all over the world.

In 1942, the U.S. Government War Production Board issued regulation L-85, which regulated every aspect of clothing and restricted the use of **natural fibers**. In particular, **wool** supplies for civilian use were cut from 204,000 to 136,000 tons in order to meet military requirements. All countries turned to the production of **man-made fibers**. Viscose and **rayon** (derived from wood pulp) were the most common. Stanley Marcus, the apparel consultant to the War Production Board, said it was the designer's patriotic duty to design fashions that lasted for multiple seasons and used a minimum of fabric. Men's suits were made minus vests and pocket flaps and trousers lost their multiple pleats and cuffs. **McCall's** produced **patterns** for transforming men's suits into ladies suits, since the men were at war and not wearing the garments. The end of the war and rationing brought a dramatic change in fashion. Men's style after the war favored full-cut, long clothing as a reaction to wartime shortages. Long coats and full-cut trousers were a sign of opulence and luxury, available in a full spectrum of colors. One of the most extreme changes in postwar men's fashion was the adoption of the casual shirt. In 1946 and 1947, Hawaiian shirts were first worn on the beaches in California and Florida. In 1949, *Esquire* magazine promoted a new look by labeling it "the bold look." Its characteristics were a loose-fitting jacket with pronounced shoulders.

By the 1950s, Europe looked to the United States for trends as American designers left their mark on the world with the concept of sportswear. In 1953, the gray flannel suit began its reign and fashion trends were being set by younger people. California surf culture spawned **streetwear**, the surfer look consisting of faded **Levis**, huarache sandals, Pendleton shirts, and baggie surf trunks. The **preppy look** was also fashionable—a look adapted from clothes worn by students in private or prep schools, such as Ivy League shirts, chino pants, loafers, and crew-cut hairdos. Other trendsetters were American singer Elvis Presley and the British Teddy Boys.

The early 1960s saw a renaissance in the refinement of men's fashion, influenced by such Italian designers as Brioni, **Nino Cerruti**, and **Ermenegildo Zegna**. The "British invasion" and the Beatles also had a sweeping influence on menswear when, in 1962, the Beatles pioneered the **mod look** of **Pierre Cardin** with tight-fitting suits, Nehru jackets, tight and hip-hugging trousers, turtleneck sweaters, long hair, and sideburns. The mods proved that men could care about the clothes they wore. This attitude allowed for changes in men's fashion as the decade progressed. Narrow pants were worn by the fashionable young with "winkle picker" shoes (long, pointed-toe shoes). In 1967, the Beatles adopted the **psychedelic look** wearing flower-patterned shirts, epaulette jackets, and flared bell-bottomed trousers. Jewelry collections were also launched for men. Burton, the largest tailoring franchise in England, actually introduced a line of clothes called 007 during actor Sean Connery's heyday as James Bond.

The 1970s introduced **unisex dressing** with both sexes wearing tie-dyed shirts, "unisex" bell-bottoms, and secondhand military attire—an ironic-yet-stylish comment on the Vietnam War. The movie *Saturday Night Fever* popularized **disco style** throughout the world and had a huge impact on men's clothing. The mid-1970s saw **punk style** popularized with chains, piercings, crazy-colored spiked "Mohawk" haircuts, ripped **T-shirts**, bondage trousers, and **Doc Martens** workboots as the uniform. By the end of the decade, the fitness craze took shape in the form of jogging suits, **sneakers**, and message T-shirts.

By the 1980s, **baby boomers** were into adulthood and enjoying financial success. Consequently, the 1980s was the decade of excess. The marketing term **YUPPIE** (Young Upwardly Mobile Professional Person) defined the time when the economy moved from cash to credit, giving more spending power to consumers. The movie *American Gigolo* (1982) brought **Giorgio Armani**'s relaxed elegance to the masses and **designer** labels and **branding** gained force. Brand names became status symbols for sports gear and sportswear, perfumes, electrical equipment, cars, and fashion designer goods such as clothing, bags, luggage, scarves, and spectacles. The television show *Miami Vice* created the look of pastel T-shirts under dinner jackets with loafers and no socks. Break-dance fashion became mainstream with flat-soled **Adidas**, **Puma**, or Fila shoes with thick, elaborately patterned laces and colorful **nylon** track suits.

Almost as a backlash to the seemingly bad taste of the 1980s, the next decade represented the clean, pared-down era, and a time when menswear returned to beautifully tailored suits in classic colors from **Helmut Lang, Ermenegildo Zegna, Hugo Boss, Nino Cerruti, Giorgio Armani,** and **Ralph Lauren.** The term **metrosexual** was coined by British journalist Mark Simpson as the trait of an urban male of any sexual orientation (usually heterosexual) who has a strong aesthetic sense and spends a great amount of time and money on his appearance and lifestyle. Italian suits were the basis for luxury and high-quality dressing. The Armani suit dressed the businessman throughout the decade until "business casual" took over in the mid and late 1990s. Other trends went in and out of fashion during this decade including **grunge style,** a return to punk—although this time it was known as cyberpunk—and **hip-hop style,** inspired by **street** youth culture. In an ironic move, the preppy look made a comeback in the late 1990s, closely associated with the **Tommy Hilfiger** clothing line, which emulated the more expensive preppy look pioneered almost a decade earlier by Ralph Lauren.

The new millennium began with a retro influence, a mixture of the best elements of all previous fashion eras. Once the first major American corporation, Alcoa, sanctioned casual office attire in 1991, it wasn't long before "casual Friday" was replaced with "casual everyday" as most companies loosened their **dress code** restrictions with the exception of the legal and financial professions and those requiring uniforms. Sports and performance apparel continue to play a major role in men's clothing, as do men's **designer** labels.

MERCHANDISE COORDINATOR/SELLING SPECIALIST. This is the person who drives sales by providing all necessary selling assistance, develops and maintains customer contact lists, educates other sales associates on the product, accompanies the **buyer** to showroom appointments, and assists in assortment planning. The other tasks of this function include maintaining and merchandising the store area on a regular basis, preparing and sending weekly selling reports, participating in the planning and execution of special events, providing timely consumer feedback to account executives, and maintaining timely **markdowns.**

MERCHANDISING. The term *merchandising* refers to the stages of planning, creating, and selling: identifying a particular market segment and designing, planning, and producing or selecting a collection of merchandise that appeals to that market in terms of color, style, fit, materials, price, sizing, and timing. Merchandisers are hired to work either in the design/wholesale side of the industry or on the retail end. On the retail end, they are part of the retail management team consisting of **general merchandise manager, divisional merchandise manager, director of planning, buyer,** and **associate** and **assistant buyer.**

MERCURE GALANT. This was the first French fashion magazine, published in 1672.

METROSEXUAL. A word coined by Mark Simpson, in a 1994 British magazine article, *metrosexual* describes an urban male with a strong esthetic sense who spends a great deal of time and money on his appearance and lifestyle, whether gay or straight.

MIELE, CARLOS (1964–). Born in Brazil of Italian parents, Meile found himself in fashion but would rather have been an artist or musician. He combines his art with a desire to help the handicapped by employing women in Brazilian cooperatives to embroider, crochet, and create the most amazing clothes. He opened his collection and store in New York in 2002 in the trendy Meatpacking district, although he had previously shown in London. He operates a total of 93 stores in Brazil and is considered one of its biggest designers. He aimed to open his first store in Paris in 2007.

MILLENIALS. This is the name given to the cohort of people born after the year 2000. They are also referred to as the "Net Generation," since they are the first group to grow up immersed in an Internet-driven world. *See also* TARGET MARKET.

MILLER, NICOLE (1952–). Born in Lenox, Massachusetts, Miller attended the Rhode Island School of Design and the **Chambre Syndicale de la haute couture** in Paris. She began designing under her own label in 1982 creating her "hip smock dress," which was an

instant sellout. She and her partner Bud Konheim opened the first Nicole Miller store on Madison Avenue in New York City in 1986. Miller is best known for her evening dresses and dramatic graphics and prints. While her theater ticket print was a bomb as a **silk** dress, it was an instant hit as a tie and was the accidental start of her very popular neckwear collection. She pioneered the use of actresses as runway **models** and has a diversified range of products that bear her name: **womenswear, menswear,** golfwear, **outerwear, accessories,** cosmetics, **fragrances,** and a Bed, Bath, and Beyond home line. In 2003, during L.A. Fashion Week, she launched "millergirl," a contemporary line. In 2004, Miller partnered with Donkenny Apparel, Inc., to produce three new lines: women's suits, sweaters/knits, and better **sportswear.** In 2005, she launched Signature, a red-carpet collection, and Nicole by Nicole Miller, a line of affordable clothes sold exclusively at **J. C. Penney's.** She also launched a lingerie line where she chose strippers as models and staged the show at a Manhattan Strip Club. Together with partner Konheim, they own and operate thirty freestanding Nicole Miller **boutiques** and sell to upscale **retailers** such as **Saks Fifth Avenue** and **Neiman Marcus.** Miller is an active fundraiser for multiple charities and was named a celebrity cabinet member of the American Red Cross.

MILLINERY. The word *millinery* is used to describe women's hats. A person who makes women's hats is known as a *milliner*; the term *hat-maker* refers to a person who makes men's hats. The derivation of the word comes from sixteenth-century Italy: merchants traveling from Milan who sold their fashion wares were known as "Millaners." In France, **Rose Bertin** (1744–1813), the **designer** to **Marie Antoinette,** was known as "Marchande de Mode" or "modiste." Bertin created perhaps the most extravagant hats; in fact, one of her "poufs" actually featured a ship in full sail. Millinery thrived especially in the eighteenth and early nineteenth centuries. No outfit was complete without the proper hat and France, with its prolific "modistes," took center stage up until the 1960s. Names such as Madame Guerin, Madame Herbault, and Madame Victorine set the tone and were routinely copied. In the United States, Betsy Metcalf of Providence, Rhode Island, created straw bonnets made of oat straw and is considered the founder of American millinery.

During the 1930s and 1940s, most couture houses had their own millinery atelier staffed with a "première" (designer), a "seconde" (workroom head), and "petits mains" (workers). Several designers started their careers as milliners such as **Coco Chanel** (creator of the cloche hat), **Elsa Schiaparelli** (creator of surreal hats), **Lilly Daché** (creator of the toque, snood, and profile hat), and **Halston** (creator of the pillbox). In the mid-1950s, males dominated the mostly female millinery scene, beginning with Aage Thaarup, a Danish **milliner** who created hats for Queen **Elizabeth** and the Queen Mother of England. He was followed by Otto Lucas, who established a wholesale hat business in London that employed Madame Paulette (creator of the soft draped turban), the last of the famous French milliners.

By the mid to late 1960s, millinery was in sharp decline due to the youth movement and an emerging casual **dress code**. Britain held on to tradition thanks to Princess Diana, the royal family, and the British love of horse-racing events such as Royal Ascot. Milliners Frederick Fox, Graham Smith, and Philip Somerville kept the craft alive and maintained highly successful businesses during the 1970s. In the 1980s, a new group of milliners emerged that created "hat art": David Schilling (British), Patricia Underwood (American), Stephen Jones (British), and Philip Treacy (Irish). These milliners are dedicated to creating show-stopping headwear, often featured on the runways of top designers and which have become status symbols. Many of them are now collectors' items and are treasured by museums around the world. *See also* RENAISSANCE.

MILLINERY DESIGNER. This is a person who designs and creates hats for women. Knowledge of **patternmaking**, cutting, fabrics, trimmings, sourcing, sketching, and hat construction techniques is a must. *See also* MILLINERY.

MINERAL FIBER. Mineral fibers are any fiber made from either a **natural fiber** such as asbestos or slightly modified fibers such as ceramic and metal fibers.

MINIMUM WAGE. The minimum rate that an employee can be legally paid is referred to as the minimum wage. The minimum wage law was first introduced in the United States in 1938 (at $.25 per

hour), although the state of Massachusetts had declared a minimum wage for women and children as early as 1912. Other countries followed (France in 1950, Great Britain in 1999) and in Latin America, minimum wage laws were introduced in the 1960s as part of the Alliance for Progress. Each country determines its own minimum wage and establishes its own arbitration board to deal with enforcing the laws. In the United States, a federal minimum wage was set during the Clinton administration; individual states were allowed to set their own minimum wage above the federal level. In 2006, the current minimum wage in the U.S. was $5.15 per hour, a level that had not increased since 1998. In Britain, the minimum wage for workers between 18 and 21 years of age in 2006 was £4.45 per hour and for adults 22 and older, £5.35. In France, the 2006 minimum wage was 8.03€ per hour. *See also* U.S. DEPARTMENT OF LABOR; FAIR LABOR STANDARDS ACT OF 1938.

MINISKIRT. A short skirt trademarked in 1960 by British designer **Mary Quant**. The miniskirt was a symbol of sexual freedom for women during the **mod** period in fashion. They were offered in lengths ranging from 18 inches below the waist, or mid-thigh, to less than 12 inches below the waist, which were called micro miniskirts. The mini dress, derived from the miniskirt, was revived in the 1980s and both the dress and the skirt continue today as fashion staples, either worn with boots, leggings, or on their own. *See also* MOD LOOK.

MISSONI. Octavio (Tai) Missoni (1921) and Rosita Torrani (1932) grew up in Italy and were both exposed to fashion at an early age. Tai, an Olympic athlete, had a trainer who owned a small knitting factory in Trieste, which created **wool** tracksuits. Rosita's grandmother produced a line of high-quality nightgowns and robes. When the couple met and later married in 1953, they set up their **knitwear** business called Maglificio Jolly with four knitting machines in Varese, Italy. In 1965, they changed the name to Missoni and were selling striped knit shirtwaist dresses to Italian department stores for $5 each. In the early 1960s, the couple teamed up with designer Emmanuelle Khanh and developed a joint collection called Missoni Emmanuelle Khanh. In 1967, Rosita sent braless models down the runway so that their

white bras would not show through the knit clothing, causing such a scandal that they were banned from showing at the Palazzo Pitti for several seasons. However, the company catapulted to fame in 1968 when **Diana Vreeland**, editor-in-chief of American *Vogue,* went head-over-heels for the collection presented at the Plaza Hotel. Missoni's signature consists of knit **separates** in unusual color combinations and intricate jacquard patterns, which include their often copied stripes, wave, zigzag and flame-patterns. They got their first in-store **boutique** at **Bloomingdale's** in 1970, received the Neiman Marcus Fashion Award in 1973, and opened their first boutique in Milan in 1976.

Tai and Rosita eventually passed control of their company to their three children: Angela, Vittorio, and Luca. Angela dabbled in her own collection for five years but, in 1998, assumed complete creative control of the Missoni collection, which includes the men's and women's collections, company image, stores and the company's eleven **licenses**. In 1999, the company launched M Missoni, a less expensive collection, and added a woven collection to complement the knit line. In 2006, in partnership with Valentino Fashion Group, Missoni launched an M Missoni Boutique in SoHo, New York, and plans to open more stores in Asia and the Middle East.

MIU MIU. This collection was launched by Italian **manufacturer Prada** in 1992, named after designer **Miuccia Bianca Prada**'s nickname. The line is aimed at a hip, younger customer and is slightly less expensive that the Prada line. Creative aspects of the Miu Miu are overseen by Miuccia Prada and the collection is sold in their own freestanding stores, as well as in **department** and **specialty stores** worldwide. In 1996, a Miu Miu store opened in New York's SoHo and, in 2005, actress Kim Bassinger was retained for the **brand**'s advertising campaign.

MIYAKE, ISSEY (1938–). Born in Hiroshima, Japan, Miyake graduated in 1964 with a degree in graphic design from Tama Art University, Tokyo. Before graduation he showed a clothing collection in a multimedia theatrical event, *Poem in Cloth and Stone,* solidifying his reputation as an artist and clothing **designer**. Upon graduation, he moved to Paris and studied at the **École de la Chambre Syndicale de la Couture**. In 1966, he apprenticed with Guy Laroche

and two years later with **Givenchy**, where he mastered his craft in the high fashion world of the **haute couture**. In 1969, Miyake left Paris for New York where he worked for **Geoffrey Beene**, another creative genius. In 1970, he returned to Tokyo and opened Miyake Design Studio. In rebellion against the staid fashions of the time, Miyake began experimenting with fabric and the concept of creating clothes from a single piece of cloth, which he would later perfect. As a result of a friend's effort, some of his pieces were shown to *Vogue* **magazine** and to **Bloomingdale's**. Both were quick to acknowledge his talent. Miyake was soon featured in *Vogue* magazine and given a small in-store shop at Bloomingdale's in 1971. He was the first Japanese **designer** to be invited to show at the newly formed Paris prêt-à-porter show in 1973, and later was invited to become an official member of the French prêt-à-porter organization. During the 1960s and 1970s, his "downtown unisex" look was popular and portended an exploration of an early anti-Western dress era.

Miyake is considered the founding father of the Japanese avant-garde movement, which began in the early 1980s. Other Japanese contemporaries supported the movement such as **Rei Kawakubo**, with her **Comme des Garçons** line, and **Yohji Yamamoto**, though it was never a formal or organized movement. Miyake's unconventional approach to Western style and his collaboration with textile designer Makiko Minagawa resulted in some of the most innovative textiles of the twentieth century. His oversized, bag-lady look of the 1980s was a welcome change from the tight-fitting fashion which was popular at that time. In 1983, Miyake launched a collection, Plantation, which was a commercial success and introduced the world to his unique design philosophy. In 1988, his solo show at the Musée des Arts Décoratifs solidified his title as artist/designer. In 1993, Miyake again collaborated with Makiko Minagawa and created perhaps his most commercially successful collection, Pleats Please (unique pleated pieces), which reversed the Western close-to-the-body style of dressing to a loose, less-constructed aesthetic. Garments were pleated *after* they were constructed, which differed from previous pleating techniques popularized by **Mariano Fortuny** and **Mary McFadden**, who pleated the cloth first. Miyake collaborated with other artists for this project, such as Yasamasa Mori, Nobuyoshi Araki, Tim Hawkinson, and Cai Guo-Qiang.

In 1999, Miyake once again challenged the status quo with his A-POC (A Piece Of Cloth) collection—a concept whereby clothes were made out of a single piece of jersey, giving creative control to the wearer rather than the designer while at the same time minimizing waste by utilizing all of the cloth. He featured the concept in a gallery show called *Making Things* at the Foundation Cartier in Paris, during that same year. In 1994 and 1999, respectively, Miyake passed the torch for his women's and men's line to Naoki Takizawa and spent most his time on his A-POC line and research. Miyake has stores in Tokyo, Paris, and London and his flagship store, in Tribeca, was designed by famous architect Frank Gehry. In 2004, he launched a follow-up **fragrance** to L'Eau d'Issy and L'Eau d'Issy Pour Homme, called L'Eau Bleue D'Issy Pour Homme for younger men.

MIZRAHI, ISAAC (1961–). Born in Brooklyn, New York, and educated at **Parsons School of Design,** Mizrahi worked for **Perry Ellis,** Jeffrey Banks, and **Calvin Klein** before opening his small Holiday collection at the age of twenty-seven in 1987. He was in business for only two years when he won the **Council of Fashion Designers of America (CFDA)** award for new talent. The following year he earned their Designer of the Year Award and, in 1992, won it again. In a push to promote and capitalize on American design talent, **Chanel** entered into a partnership with Mizrahi in 1992. In 1994, Mizrahi hosted his own talk show on the cable channel Oxygen and, in 1995, along with his lover Douglas Keeves, made a hit movie documentary about the life of a fashion designer, *Unzipped*, distributed by Miramax. That same year, Mizrahi launched a secondary line called Isaac (a less expensive **bridge** collection), licensed his name to an **outerwear** collection, and, in 1996, designed a line of clothing that he sold on the cable TV network Nickelodeon. Due to mounting losses, Chanel pulled the plug and closed Mizrahi's bridge line Isaac in 1997 and the signature line in 1998. Mizrahi sued Chanel in 2001 for breach of their partnership agreement and for the rights to use his own name, which he won.

Mizrahi's passion for the entertainment industry prompted him to form a production company called Baby in 1998 with his vice president of public relations, Nina Santisi, and he played a small part in Woody Allen's film *Celebrity*. Mizrahi has licensed his name to eye-

wear, **footwear**, handbags, **leather accessories**, and fine jewelry. He has also dabbled in theatrical costume design for the Broadway play *The Women*, staged a one-man off-Broadway cabaret show (*Les Mizrahi*), penned a series of comic books (*The Adventures of Sandee the Supermodel*), and won two more CFDA awards, all while continuing to design a line of inexpensive clothes for **Target** since 2003. In 2005, he launched a collection of **made-to-measure** clothes in partnership with **Bergdorf Goodman** and began production on *Isaac*, a talk show on cable television. In 2006, Mizrahi inked a **licensing** deal for two footwear collections, a couture line, and a bridge collection, designed aprons for workers at the Smithsonian Institute Conservation Center, and caused controversy for his bold behavior as a red carpet commentator for the E! Network.

MME. DEMOREST. Founded by the American Ellen Curtis in 1853, this company was the first commercial **pattern** company in the United States. Demorest's patterns were initially only offered in one size for women, men, and children, with no instructions on how to grade up or down. The periodicals *Frank Leslie's Gazette of Fashions* and *Godey's Lady's Book* were the first to sell these full-scale patterns in 1854, either through mail order or at retail as foldout inserts in the magazines. Demorest was the first company to offer its own publication in 1860, *Quarterly Mirror of Fashion*, and later as *Demorest's Monthly Magazine*, which was the precursor to today's pattern **catalog** books, which feature a wide range of patterns shown on fashion **models**. Demorest was also the first pattern company to market patterns in envelopes by 1872. Mme. Demorest closed after Curtis's retirement in 1887. *See also* PETERSEN'S MAGAZINE.

MODEL. A model is a person who is paid to wear a garment or product for promotional purposes such as in a fashion show or photo shoot. The historical origins of formal "showings" of clothing began with the House of **Worth** in 1858. Wealthy women would be invited to watch as "models" would present a **designer**'s designs each season. As more designers opened their **couture houses**, competition increased the need for publicity, which in turn prompted the need for more fashion models. **Model agencies** were established to recruit

women. In the early days, women were chosen from well-to-do families as the images they portrayed evoked a sophisticated, genteel aura. While the invention of photography came in 1839, **fashion photography** was not fully realized until the late 1850s when it was used to document the increasing number of designers' works and replaced the **fashion plate**. The invention of the halftone printing process made it possible to reproduce photographs and sell them to the burgeoning magazine industry beginning with *Harper's Bazaar* (1867) and *Vogue* (1892). The first successful black model was Dorothea Towles Church (1922–2006) who broke the color barrier in the 1950s by modeling on the runways of **Elsa Schiaparelli** and **Christian Dior** in Paris. During the 1950s, models such as Suzy Parker and Dorian Leigh became famous not only for their modeling careers but also for their extravagant lifestyles. By the 1960s, the modeling profession would be turned upside down with the entrance of **Twiggy** in 1966. Twiggy, with her waif-like look, opened the door to alternative forms of beauty and paved the way for other models to come. In the early 1990s, at the height of supermodel mania, models Niki Taylor, Christy Turlington, Naomi Campbell, Cindy Crawford, Claudia Schiffer, Karen Mulder, Stephanie Seymour, and Tatjana Patiz—and later Kate Moss, Tyra Banks, and Iman—were earning upward of $10,000 per day, with some models asking as much as $25,000 a day.

In 1995, the same designers that helped catapult these models to fame (**Calvin Klein, Karl Lagerfeld, Gianni Versace**, etc.), reacted to their overinflated prices and overexposure by ditching them for a new crop of less-expensive models. Once the designers realized that the models were getting more attention than the clothes, the era of the supermodel ended. Today, models are discovered by fashion photographers and models agencies and through worldwide model open calls. In 2005, the reality TV series *America's Next Top Model*, hosted by supermodel Tyra Banks, attempted to revive the supermodel phenomenon.

Recently some models have gone into the fashion business with their own product lines. Examples include Christy Turlington, who designs a line of yoga clothes for **Puma** called Nuala, and Kate Moss, who signed with **Topshop** to design a line specifically for the **retailer**. *See also* MODEL AGENCY.

MODEL AGENCY. A company that is in the business of finding jobs for **models** and handling the business end of a model's career. As early as 1930, beginning with the Conover Agency in New York City, model agencies have been searching for the next great *girl*, the term the fashion industry uses to describe models. The Conover Agency launched the modeling career of Anita Colby, possibly the first *supermodel*, who later went on to a career in Hollywood. Agencies work on a commission basis, finding the best girls for fashion **design** houses, **retailer** establishments, and their advertising agencies. Prospective models are screened by the agency by a "dry call" (sending a comp card to an agency unsolicited), on a walk-in (an on-site interview), or via an "open call" (agencies advertise that, on a designated day, models can come for an interview). Models are booked for print, media, Internet, and runway shows. The best agencies train their models, set up test shoots, give "walking lessons," and help compile their "book" (head shots and editorial/print work) and "comp cards" (the leave-behind composition photo cards).

People known as booking agents make contacts for their models with photographers and agencies and earn a 10–35 percent fee for each booking. Among the twenty-five top model agencies, Ford Models is the oldest existing agency in the United States, established in 1946 by Eileen and Jerry Ford, in England. They founded modeling schools such as Lucie Clayton's Modeling and Grooming School in Mayfair that recruited models from middle-class backgrounds. Other agencies include CAPE London Model Management, 2PM Model Management, Action Model Management, Boss, Elite, IMG, Look Model Management, Madison Models, Major Model Management, Models 1, Next, Premier, Storm, Trump, VMH, Wilhelmina, Fimnesse, and Wicked Talent. *See also* MODEL.

MOD LOOK. Mod is the term given to a look that appealed to the youth culture that, by the early 1960s, represented more than half of the world's population. The mods were a subculture in England whose love of Italian tailoring and neat dress was inspiration for the modernistic designs of **André Courrèges**, **Rudi Gernreich**, and **Paco Rabanne,** as well as looks from London's **Carnaby** Street designer **Mary Quant**. The look involved **miniskirts, go-go-boots,**

and an overall futuristic aesthetic. The Beatles were among the music groups to promote the look.

MOËT HENNESSEY LOUIS VUITTON (LVMH). This French fashion luxury goods conglomerate was formed in 1987 between the Louis Vuitton SA holding company, Moët-Hennessey (the world's largest producer of cognac and champagne), and the **Christian Dior** Group. Henry Recamier, a former steel executive who married into the Vuitton family, was named to run the **Louis Vuitton** business in 1977. In an attempt to fund increased expansion, Vuitton initiated a merger with Moët-Hennessey. A partnership formed in 1971 between the Mercier and Hennessey families. However, by 1989, Bernard Arnault, the financial genius, chairman, and CEO of the Christian Dior empire, in a hostile takeover, took 51 percent majority control of LVMH. In 2001, **De Beers**, the diamond company, launched a joint venture with LVMH. Today, there are more than fifty subsidiaries of LVMH including wines and spirits (most notable: Moët et Chandon, Dom Pérignon, Hennessey, and Veuve Clicquot), watches and jewelry (TAG Heuer, Dior Watches, Chaumet, Zenith, OMAS, and FRED), fashion and **leather** goods (Berluti, **Celine**, **Christian Lacroix**, **Donna Karan**, eLUXURY, **Emilio Pucci**, **Fendi**, **Givenchy**, **Kenzo**, Loewe, Louis Vuitton, **Marc Jacobs**, Stefano Bi, and Thomas Pink), retail establishments (DFS, La Samaritaine, **Bon Marché**, Sephora, and Starboard Cruise services), and perfumes (Acqua di Parma, Guerlain, Parfums **Kenzo**, Christian Dior, Givenchy, and Loewe).

MOHAIR. Mohair is an **animal fiber** derived from the hair of the **Angora** goat, which originated in Turkey several thousands of years ago and today is also farmed in Texas and South Africa. Mohair fiber, which is a long and lustrous fiber, is much smoother in texture than **wool**. It is used in men's, women's, and children's apparel and accessories.

MOLYNEUX (1891–1974). An Irish-born aristocrat who was an officer in the Duke of Wellington's regiment, Molyneux studied art with the hope of becoming a painter but his drawings led him into the fashion world. He started his career at age seventeen as an illustrator in New York, Chicago, and London. He moved to Paris and, in 1919, opened his salon. While fashion during the 1920s often depicted

women wearing fringed flapper dresses for evening, Molyneux and his French contemporaries, **Madeleine Vionnet, Paul Poiret,** and **Jeanne Lanvin** were creating some of the most beautiful evening gowns for **couture.** Molyneux was very connected to Paris society. His client list included many international café society types such as Countess Mona Bismarck, who was the wife of Harrison Williams, the richest man in America. He also designed the trousseau and wedding dress for Princess Marina of Greece for her marriage to the Duke of Kent. Molyneux lived a very lush lifestyle, owning villas in France and even opening a Paris nightclub with American columnist, Elsa Maxwell, in 1921.

During the Nazi occupation of France, Molyneux returned to England in 1939. He headed the Fashion Group of Great Britain's war effort to create designs in response to the rationing of cloth and trims—the **British Civilian Clothing Order CC41**—along with contemporaries **Norman Hartnell** and **Hardy Amies.** Molyneux returned to Paris in 1949 and is most known for his printed **silk** suits with pleated skirts. He broadened his collection to include **millinery, furs,** lingerie, and **fragrances.** Due to ill health, he turned his company over to Jacques Griffe in 1950. In 1965, Molyneux returned to Paris and opened a **ready-to-wear** collection called Studio Molyneux. However, the collection was unsuccessful and he retired soon thereafter. *See also* GOVERNMENT UTILITY SCHEME; INCORPORATED SOCIETY OF LONDON FASHION DESIGNERS.

MOM-AND-POP STORES. *Mom-and-pop* describes a small proprietor-owned store employing only a few workers. Historically, these stores are operated by a husband and wife, typically with no branch stores or maybe just one, and located in large and small communities. In the 1980s, during a wave of large **retail store** consolidations, many mom-and-pop stores closed. As large **retailers** turned to **private label** merchandise to boost profitability, the 1990s ushered in the **commoditization** of fashion which was the demise of "fashion-oriented" merchandise. Today, the Internet has created a new version called the "online mom-and-pop."

MONTANA, CLAUDE (1949–). Born in Paris to a German mother and a Spanish father, Montana had no formal fashion training. He

moved to London in 1971 and began designing jewelry made out of papier-mâchè and rhinestones. Returning to Paris in 1972, he worked as an assistant designer for MacDouglas **leathers**. Leather was a medium with which Montana would become synonymous, especially after featuring it in his first eponymous collection in 1976 to rave reviews.

In 1979, Montana officially opened his **ready-to-wear** company and two years later designed his first men's collection, Montana Hommes. From 1982 to 1987, he designed the Complice collection and, from 1990–1992, the **haute couture** collection for **Lanvin**. Although he won two Golden Thimble awards for his work at Lanvin, he was fired after only two collections when his designs proved too bold for the Lanvin couture customer.

Montana is known for his use of strong color, monochromatic fabrics, razor-sharp tailoring, and broad shoulders. His love of leather has placed him in the "fetish" category, alongside his contemporary **Thierry Mugler**. During the 1980s, both designers were at the top of their game. Their shows were fashion extravaganzas and their clothes were avant-garde. However, by the 1990s, neither designer had changed with the times, which were trending toward a minimal approach to fashion. Consequently, their businesses struggled. Montana eventually sold his house to French entrepreneur Jean-Jacques Layani while continuing to serve as a consultant to the design team. Product **licenses** include handbags, eyewear, shoes, and men's ties.

MONTANO, MARK (1973–). Born in La Junta, Colorado, Montano graduated from Colorado State University with a bachelor's degree in business. He continued his education at the **Fashion Institute of Technology**, earning a master's degree in costume history. Montano interned at **Oscar de la Renta** before opening his signature shop in New York's trendy East Village in the late 1990s. He is best known for his edgy, downtown couture look in vibrant colors and luxurious fabrics. In 1999, Montano joined *Cosmo Girl!* magazine as a contributing editor, after a few editors at the magazine discovered his boutique's quirky décor. He found instant success with his creative room makeovers column, "Cool Room." As a result of his column, he published a book in 2002, *Super-Suite* and followed it up with his second and third books in 2005, *Dollar Store Décor*

and *The Dummies Guide to Window Treatments and Slip Covers.* In 2004, he became a feature columnist in the *New York Post*'s Home Section where his column "Mark Your Territory" tackled city living problems. He currently writes a weekly syndicated column in more than seventy newspapers across the country titled "Make Your Mark" and answers readers' questions with do-it-yourself advice, as well as supplying them with gift certificates from major retailers to complete their projects. In 2003, the Learning Channel recruited him to collaborate in the hit decorating show *While You Were Out.* He was also signed to host another show entitled *Ten Years Younger*, a daily half-hour makeover show with an empowering message for the viewer. Starting in early 2006, he was tapped by the Style network to head up the design team for its new show *My Celebrity Home.* Montano was the youngest member ever to be inducted into the **Council of Fashion Designers of America.** In 2006, The World Gold Council sponsored his fashion show at Seventh on Sixth in New York.

MONTGOMERY WARDS. Born in New Jersey, Aaron Montgomery Ward (1844–1913) created the first mail-order business in Chicago, Illinois, in 1872, selling dry goods to people living in rural areas in the United States. As a traveling salesman, Ward discovered that people in rural areas had a hard time getting products that people living in cities could get readily. He devised a plan so that people could buy quality items by mail and then have them delivered to the nearest train station. Ward started the business with two partners and offered 163 items for sale. However, his first inventory was destroyed by the Great Chicago Fire. After his partners left, his brother-in-law, Richard Thorne, joined the company. At first, local **retailers** were threatened by the new business model of "satisfaction guaranteed or your money back" and actually took to burning Wards **catalogs.** However as customer demand grew, Wards became a serious competitive threat to small stores. By 1883, the catalog had become known as the *Wish Book* and had grown to 10,000 items including pianos, bathtubs, sewing machines, books, bicycles, stoves, chairs, jewelry, and thousands of other items.

In 1896, Richard W. Sears began his catalog company and for decades to come would prove to be a formidable competitor. In 1913,

Ward died but the company continued with sales of more than $8.7 million. By then the company had affectionately become known as "Monkey Ward's" and, in 1926, it opened its first retail store in Plymouth, Indiana. Two years later there were 244 stores and, by 1929, 531 outlets. At its peak, Wards was the largest retailer in the United States and, in 1930, declined an offer to merge with **Sears, Roebuck.** In 1949, Gene Autry, a famous American folk hero, recorded the song "Rudolph the Red-Nosed Reindeer," written by a Wards copyrighter, Robert L. May. But after the 1950s, Sears and **J. C. Penney's** made the move to suburban neighborhoods while Wards did not and, as a result, lost market share. In 1960, it merged with Container Corp. of America and became Marcor, Inc.; in 1976, it was bought by Mobil Oil. In 1985, it closed its catalog business and, in 1988, its management pulled off a leveraged buyout of the company. Repositioning itself as an electronics store, it bought out the Lechmere retail chain in 1994 and sold branded items instead of its own **private label** brands.

In 1997, Wards filed for chapter 11 bankruptcy and became a subsidiary of General Electric company. By 2000, all of its stores were closed, making it the largest retail bankruptcy liquidation in U.S. history. In 2004, Montgomery Ward was resurrected as an Internet catalog-based retailer selling apparel, home products, furniture, jewelry, and electronics. *See also* CATALOG COMPANIES; E-COMMERCE.

MORI, HANAE (1926–). Born in Shimane, Japan, as Hanae Fujii, she was educated at Tokyo Women's Christian University. Upon graduation in 1947, she married Ken Mori, an executive in a textile firm, which led her to enroll in a school for dressmaking. In 1951, she opened her first shop in Tokyo and was approached by a famous Japanese director, Sotojiro Kuromoto, to design costumes for his films. Mori designed **costumes** for operas in Milan, Paris, and Vienna, as well as for Japanese kabuki theater. She is most known for bringing the beauty and culture of Japan to the West with her exquisite fabrics, calligraphic prints, and use of traditional Japanese motifs such as butterflies and cherry blossoms applied to Western-style clothing, giving her the nickname Madame Butterfly. By 1977, she was the first internationally known Japanese designer and the first Asian **couturière** to be admitted to the **Chambre Syndicale de**

la haute couture parisienne. She designed flight attendant uniforms in 1970 as well as uniforms for the Japanese Olympic team in 1994. She was awarded the Croix de chevalier des artes et lettres in 1984 and, in 1989, she received the chevalier of the Légion d'honneur and was awarded the Japanese Person of Cultural Merit award. After her husband's death in 1996, the company was sold to the British firm Rothschild and the Japanese trading company Mitsui. Mori continued to design the couture collection. In 2004, she showed her last collection in Paris and then closed the couture business and her Paris store. The Mori **ready-to-wear** and **accessories** line, owned by Mitsui & Co. Ltd. since 2002, continues to operate.

MORRIS, ROBERT LEE (c. 1940–). During the 1970s, Morris and contemporary **Elsa Peretti** greatly influenced costume jewelry. Morris opened his company called Art Wear and achieved fame for his handmade gold bead necklaces, gladiator cuffs, metal breastplates, and heavy metal belt buckles. **Donna Karan** featured his work in her shows for several seasons.

MOSCHINO, FRANCO (1950–1994). Born in Abbiategrasso, Italy, Moschino studied art at Milan's Academia di Belle Arti di Brera. In 1971, he worked as a sketcher for **Versace** and from there went on to design for other Italian **manufacturers**: Blumarine, Aspesi, Cadette, and Cassoli. In 1983, he started his own company under his own name, renamed it Moonshadow and then reverted back to Moschino. He created some of the most hilarious clothes, while maintaining a concern for social justice. His fashion shows were media events and his store windows were provocative. In 1986, he launched a men's line called Uomo, then launched a secondary line, called Cheap & Chic, in 1988. He went on to launch a **jeans** line in 1986 and his Diffusion line in 1989. Moschino died from AIDS in 1994. Aeffe S.p.A. took over ownership of the company. The **creative director** and Moschino's best friend, Rossalla Jardini, then took responsibility for continuing the company's growth and direction.

MOULAGE. As it relates to fashion, *moulage* is a form-fitting pattern that duplicates the human figure with no added ease. The term is derived from the French word for "mold," *moule.*

MUGLER, THIERRY (1948–). Born in Strasbourg, France, Mugler studied dance at Lycée Fustel de Coulange at the age of fourteen and photography at nineteen at the École des Arts Decoratifs. As a dancer, he performed with the Rhine Opera Dance Company in 1965; he also worked as a professional photographer and window dresser for "Gudule" in Strasbourg, while simultaneously freelancing for **designers** in Paris, Milan, and London. In 1973, in partnership with Alain Cardeuc, he presented his first **ready-to-wear** under the label Café de Paris and officially opened Thierry Mugler in Paris in 1974. Designer **Azzedine Aläia** helped him with design until the late 1970s. With financial backing in 1977 from Didier Grumbach and Umberto Ginochetti, Mugler was the first to produce the "fashion show extravaganza." His background as a dancer inspired him to orchestrate every detail of his fashion show production, with some of his shows becoming public events. In 1984, he showed at the Zenith nightclub in Paris where he sold tickets to 6,000 people in celebration of his 10th year anniversary in business. Mugler, along with designer Claude Montana, helped keep French fashion in the forefront for more than a decade. They were both also known as the "bad boys of fashion" due to their rock-star lifestyle and volatile personalities.

Mugler is known for his identifiable style that features the feminine shape and curve. He also has a penchant for fetish fashion which has been a theme throughout many of his collections. Although he was a favorite of France's first lady, Danielle Mitterand, his legacy is based on power-dressing, along with his Glamazon silhouette inspired by 1930s costumers **Adrian** and **Edith Head**, in combination with S & M, catwomen, and dominatrixes. His structured suits and jumpsuits, however, were at the core of his retail popularity and, by 1990, his business peaked with sales of $90 million. In 1992, Mugler presented an **haute couture** collection featuring a different corset for each of the sixty pieces shown. In the same year, in partnership with Groupe Clarins, he launched his highly successful **fragrance**, Angel, which was to outsell the very popular Chanel No. 5 and become one of the top ten fragrances of all time. In 1999, he launched the fragrance Angel Innocent.

As fashion in the 1990s shifted to a more casual, pared-down look, Mugler did not respond and consequently his fashion business steadily declined. Clarins, who by 1997 was the majority shareholder,

had a hard time dealing with Mugler's volatile personality and, in 2000, Mugler showed his last couture runway collection. In 2001, Mugler and Clarins released the men's fragrance, Cologne, but in 2003, Clarins closed the fashion house altogether. Although Mugler holds **licenses** for handbags, jewelry, and women's apparel, he lost interest in fashion. Instead, he designed the costumes for a Cirque de Soleil spectacle in Las Vegas, and devoted more time to his fragrance business. In 2004, the men's fragrance BMen was introduced, brother to AMen, which was launched in 1997 and was based on Mugler's vision of the superhero with an accompanying illustrated comic book. In 2005, Mugler launched his women's fragrance, Alien. *See also* FRAGRANCE; POWER SUIT.

MUIR, JEAN (1928–1995). Born in Bedford, England, of Scottish roots, Muir entered the fashion industry in sales and as a sketcher for Liberty on Regent Street. From 1956 to 1962, she worked as the **designer** for Jaeger, Ltd., before moving to David Barnes, where her collection of jersey garments was such a hit that he created a division just for her, called Jane & Jane. Miss Muir (as she preferred to be called) ventured out on her own in 1966 with her husband Harry Leuckert. She is best known for designing timeless clothes using matte jersey, **wool** crepe, and soft **leather** and **suede**, usually decorated with discreet punch holes, topstitching, pleats, tucks shirring, or smocking. Muir's collection was prominently displayed in its own shop at **Henri Bendel** in New York in 1967 and was later given its own area in **Bergdorf Goodman** and **Neiman Marcus**.

Muir's own signature style was to wear only navy or black and she preferred the moniker "**dressmaker**" to designer when referring to her craft. Through the years, she launched several line extensions beginning in 1978 with her JM in **Cotton** and JM in Wool. In 1985, she presented lower-priced collections, Jean Muir Studio and Jean Muir Essentials. Muir received many awards during her career, including the Ambassador Award of Achievement and the *Harper's Bazaar* trophy (1965), Fellow of the Royal Society of Arts (1973), Fellow of the Chartered Society of Designers (1978), Member of the Design Council (1983), Commander of the Order of the British Empire (1984), and British Fashion Council Award for Services to Industry (1985) and she was inducted into the British Fashion Council's

Hall of Fame in 1994. Since her death in 1995, creative control of the signature and studio collections has been handled by her former assistants, Caroline Angell, Sinty Stemp, Joyce Fenton, and Angela Gill. In 2005, a Jean Muir freestanding store was opened in London's West End and, in 2006, her husband donated the entire Jean Muir personal design collection to the National Museum of Scotland. The company closed in 2007.

– N –

NATURAL FIBERS. Any fiber made from a **plant, animal,** or **mineral** resource. Natural fibers from plants include **cotton, linen,** jute, ramie, sisal, and hemp. Fibers from animals include **silk, wool, angora, mohair,** and **alpaca.** Fruit fiber is collected from the coconut, stalk fiber is culled from bamboo and grass, and straw comes from from wheat, barley and rice.

NAUTICA (1953–). Taiwanese-born **David Chu** found his way into the fashion business via his architecture studies where one of his teachers at the **Fashion Institute of Technology** saw his potential as a fashion designer. In 1993, after an unsuccessful export business venture in Taipei and a stint at a large conglomerate in the United States, Chu began designing nautical inspired **menswear** and sold them to **Barneys** and **Bloomingdale's.** Within ten years, the company went from sales of $700,000 to $1 billion. In 2003, Nautica merged with the **VF Corporation** and is now a wholly owned subsidiary of that corporation. In 2005, David Chu launched a new company called DC Design International, his own high-end collection of menswear.

NEIMAN MARCUS. This **specialty store was** established in 1907 by Herbert Marcus, his sister, Carrie Marcus, and her husband, Abraham L. (Al) Neiman, in Dallas, Texas. All three of the founders had retail experience: Herbert had been a **buyer** for Sanger Brothers, Carrie was an **assistant buyer** for A. Harris and Co. (Sanger and Harris were the two leading department stores in Dallas at the time), and Al worked at Harris in sales. Naming the store Neiman Marcus, the founders set out to create a specialty store featuring high-end women's **outerwear** and

millinery. After a fire destroyed the first store in 1913, they reopened within seventeen days at another Dallas location and developed a reputation for high prices and high quality. The clientele consisted of wealthy **cotton** aristocrats and, later, oil-rich Texans.

In 1926, Herbert's son Stanley entered the business and, in 1928, Neiman sold his interest in the business for $250,000 when his marriage to Carrie ended in divorce. In 1930, the discovery of the East Texas oilfield brought a new group of millionaires to the store and despite the effects of the Great Depression elsewhere in the country, Neiman Marcus's business boomed. In 1934, the store was the first retailer outside of New York City to advertise in *Vogue* and *Harper's Bazaar* and, in 1938, it created the Neiman Marcus Award for Distinguished Service in the Field of Fashion, the "Oscar" of fashion. In 1939, Stanley Marcus created the famous Christmas **catalog** tradition, another of his marketing ploys to bring visibility to the store.

After World War II, the store began to add branches. Another store was opened in Dallas and then in Ft. Worth and Houston. Upon Herbert's death in 1950, son Stanley became president. After a devastating fire in 1964 at one of the Dallas stores, Neiman's merged with California-based Broadway-Hale stores in 1969 and, shortly after, with another group to form Carter Hawley Hale Incorporated. Stanley became a top executive at Carter Hawley Hale, while his son Richard was appointed president of Neiman Marcus. After 1971, stores opened in over thirty cities across the United States. In 1987, General Cinema became the majority shareholder and Allen I. Questron succeeded Richard Marcus as president.

Neiman Marcus's reputation in the **retail** community is unparalleled with its number of innovations. It was the first to mount a national ad campaign; the first to produce a luxury direct mail **catalog** featuring items such as his-and-hers airplanes and private yachts; the first to establish an annual fashion award; the first to begin its "fortnights" concept in 1957 featuring merchandise and cultural exhibitions from other nations (which **Bloomingdale's** and other stores later copied) and the concept of "selling the store"; and the first to explore a real **branding** of a retail store. In 1984, Neiman's introduced the InCircle program, offering an array of extraordinary gifts for its most-valued customers and, in 1988, the Horchow Collection became part of Neiman Marcus. In 1999, neimanmarcus.com

debuted, becoming the first luxury online retail website and, in 2002, the fashion industry mourned the death of Stanley Marcus. While the company passed through several hands during the last twenty years, the headquarters are still located in Dallas. The Neiman Marcus Group is comprised of the specialty-retail-stores division, which includes Neiman Marcus Stores, **Bergdorf Goodman**, and the direct marketing division, Neiman Marcus Direct. The company operates two Bergdorf Goodman stores in New York City and thirty-seven Neiman Marcus stores across the country. The company is also known for its "chocolate chip cookie urban legend," whereby a woman was supposedly charged a substantial amount on her credit card for the recipe (proven to be false) and in retaliation posted the recipe for all to see. In an effort to capitalize on the legend, Neiman's lists the recipe on its website, another example of its marketing savvy. By 1996, Neiman Marcus Group revenues topped $2 billion, and by 2004, $3.44 billion. In 1998, Neiman's bought a 51 percent interest in Laura Mercier cosmetics and, in 1999, a 56 percent share of **accessories** designer **Kate Spade**, another first for a retail organization. In 2005, the Neiman Marcus Group was sold to Texas Pacific Group and Warburg Pincus. *See also* DEPARTMENT STORE.

NEW LOOK. A silhouette that was created in 1947 by **Christian Dior** in Paris after World War II. The New Look was soft and feminine utilizing many yards of fabric, which was a sharp contrast from wartime fashion where fabric and **trims** were rationed and silhouettes were masculine and functional. *See also* BRITISH CIVILIAN CLOTHING ORDER CC41; GOVERNMENT UTILITY SCHEME.

NEWTON, HELMUT (1920–2004). This photographer was born Helmet Neustädter in Berlin, son to a Jewish garment factory owner and an American mother. Newton was schooled at Werner von Trotschke Gymnasium and the American School in Berlin. His interest in photography can be traced to his childhood when he worked as an assistant for German photographer Else Simon, also known as Yva. In 1938, he left Germany to escape Nazi persecution as a Jew and worked for a short time as a photographer for the *Straits Times* in Singapore. During World War II, he served with the Australian Army (1940–1945). After the war, he married actress June Browne and

worked as a freelance photographer for *Playboy* magazine. By 1950, he had moved to **fashion photography** and settled in Paris in 1961 to work extensively for French *Vogue*.

In 1970, while on a New York street, Newton suffered a heart attack which was a life-altering experience resulting in a creative surge that produced some of his best work. He is most known for pushing the limits of conventional photography with his erotic style and sado-masochistic overtones. During the 1980s, his celebrity portraits were often featured in *Vanity Fair* magazine. He also caused a sensation with his witty erotic work for *Oui* and *Playboy* magazines and for his series called *Big Nudes*. In 1975, Newton staged a one-man show in Paris and, in 1976, published his first book, *White Women*. During the next twenty-five years, Newton, with his wife June at his side, produced a series of books and exhibitions including a major installment at the Neue National Galerie in Berlin in 2000. Newton donated his extensive photo collection to the Foundation of Prussian Cultural Heritage in Berlin in 2003, before his tragic death in 2004. *See also* FASHION PHOTOGRAPHER.

NIKE. In 1964, Phil Knight, a former distance runner for the University of Oregon, teamed up with his ex–track coach Bill Bowerman to form Blue Ribbon Sports, the precursor to Nike, Inc., which was later formed in 1972. In 1979, the first "air-cushioned" sports shoe was created in collaboration with a former NASA employee, Frank Rudy. After losing market share to **Reebok** in the early 1980s, Nike rebounded by securing famous sports pro Michael Jordan in 1985 and recouped with their massive ad campaign Just Do It in 1988. An integral part of Nike's success has been the Nike Sports Research Lab at the Nike World campus in Beaverton, Oregon. This is a facility comprised of **designers**, trainers, athletes, and podiatrists who study the science of shoes for each sport to create more useful, innovative, new products. By 1991, Nike was back on top, not only with a broad range of sport shoes, but also with a line of fitness and sports apparel for men and women. In 2005, Nike employed 24,300 people and acquired companies such as **Converse**, Cole Haan, freedom of choice, Hurley, Exeter Brands, and Bauer. Nike is the largest sports shoe **manufacturer** and, in 2005, posted annual revenues of $13.7 billion. *See also* ADIDAS; FOOTWEAR; PF FLYERS; PUMA; SNEAKERS.

NINE WEST. This shoe company, started in 1978 by partners Jack Fisher and Vince Camuto, was named after their address at 9 West 57th Street in New York City. It is a top **designer** and marketer of women's shoes, clothing, and **accessories**. Nine West sells through 600 of its own stores, as well as through **department stores**, **specialty stores**, and independent shoe stores in the United States. Further, it **licenses** its name outside the United States. In 1992, Nine West went public and sales were posted at $373 million. In 1995, Nine West bought the **footwear** division of the United States Shoe Corporation for $600 million. In 1996, it acquired the handbag and accessories firm LJS Accessory Collections and signed a partnership deal with **Calvin Klein** to jointly produce and distribute a new line of footwear and accessories under the CK **brand** name. In 1997, Nine West licensed its name for **outerwear** to G-III Apparel. Jones Apparel purchased Nine West in March 1999 for about $1.4 billion. By 1999, Nine West had licensed its name to eyewear and watch companies. In 2000, it was one of the first companies to roll out an e-mail marketing strategy that provided a targeted one-on-one communication with the customer, which proved to be more successful than direct-mail efforts of the past. Nine West brands include Nine West, Easy Spirit, Bandolino, Enzo Angliolini, and Calico. In 2006, Nine West collaborated with designers Thakoon Panichgul, Sohia Kokosalaki, and **Vivienne Westwood** to produce a limited-edition **ready-to-wear** collection. *See also* E-COMMERCE.

NOLAN, CHARLES (c. 1950–). Born in New York and educated at the **Fashion Institute of Technology,** Nolan apprenticed at **Bill Blass** and **Christian Dior** before joining **Ellen Tracy** in 1990 as chief designer. He left Ellen Tracy in 2001 to help pull the **Anne Klein** label out of bankruptcy. Nolan left Anne Klein in 2003 and opened his own **boutique** in the Meatpacking district in New York City, designing and selling an eclectic range of merchandise—from his own women's designer high-end clothing to antique furniture, jewelry, books, and handbags.

NORDSTROM. Founded as a Seattle shoe store in 1901 by John W. Nordstrom (Swedish immigrant) and Carl Wallin, who met during the Klondike Gold Rush, the store was originally known as Wallin & Nordstrom. In 1929, upon the founders' retirement, the company

passed to Nordstrom's sons, Everett and Elmer. In 1963, the company moved into apparel with the purchase of Best Apparel and, in 1966, the name changed to Nordstrom Best. In 1971, the company went public and, in 1973, dropped the word "Best" from the name. Nordstrom's commitment to outstanding customer service is legendary and it is one of the leading fashion **retailers** in the United States today. A massive expansion plan began in the late 1970s. Nordstrom's competes with, and is below the price level of, **Neiman Marcus** and **Saks Fifth Avenue** but above that of **Macy's** and **J. C. Penney's**. It sells apparel, **footwear**, furniture, bedding, beauty products, and housewares. The company's corporate headquarters is still located in Seattle, Washington. Nordstrom operates 156 U.S. stores in 27 states—including 99 full-line stores, 49 Nordstrom Rack stores, 5 Façonnable **boutiques**, 1 free-standing shoe store and 2 clearance stores. Nordstrom also operates 32 international Façonnable boutiques, primarily in Europe.

NORELL, NORMAN (1900–1972). Norell was born in Noblesville, Indiana, the son of a haberdashery store owner. In 1919, he attended the **Parsons School of Design** and began his career designing costumes for the theater and film. From 1928 to 1940, Norell designed for Charles Armour and for **Hattie Carnegie**. From 1941 until 1960, Norell formed a partnership with **designer** Teal Traina and designed a collection of dresses, suits, and eveningwear under the label Traina-Norell. In 1961, upon Traina's death, he opened his own business and was known for his attention to quality and craftsmanship in the French **couture** tradition. In fact, he was often called the American **Balenciaga**. Signature looks of Norell include his eveningwear "mermaid dresses," his use of polka dots, sailor collars, and oversized bows, and his expertly tailored trouser suits. He was the first recipient of the **Coty** American Fashion Critic's Award in 1943 and was the first president of the **Council of Fashion Designers of America (CFDA)** in 1965. The company continued after Norell's death with designs by the American designer Gustave Tassel, but it closed four years later.

NORTH AMERICAN FREE TRADE AGREEMENT (NAFTA). This is a free-trade agreement that went into effect on January 1, 1994 between the United States, Canada, and Mexico. NAFTA called for the immediate elimination of duties on half of all goods shipped

to Mexico and the gradual phasing out of other tariffs over a span of fourteen years.

NORTH AMERICAN INDUSTRY CLASSIFICATION SYSTEM (NAICS). In 1997, this system replaced the Standard Industrial Classification (SIC), a division of the U.S. Department of Commerce. Its function is to analyze the economic changes in technology, growth, and diversification of services across the three **North American Free Trade Agreement** partners: Canada, Mexico, and the United States.

THE NORTH FACE. An outdoor-products manufacturing company that was founded in San Francisco's North Beach district as a small mountaineering shop in 1966 by American Doug Tompkins. Initially it offered only backpacking and climbing equipment but, in 1968, Tomkins and his wife, Susie, sold the company to the **VF Corporation** and the product line expanded to include a line of **performance apparel**. By the 1980s, the company added skiwear and it designed, manufactured, and wholesaled its own products to stores worldwide. The North Face wear-tests its newest innovations using some of the world's most famous athletes. It sponsors major events within the performance-apparel industry—ranging from climbing expeditions and extreme ski, snowboard, and cross-country events, to bicycle treks and dog-sled expeditions. The North Face has been firmly committed to environmental causes, beginning in 1975 when it inaugurated the Ice-9 Award, a prize for the entity that contributed most to the ecological destruction of the earth (the first recipient: the Atomic Energy Commission). In 1989, it cofounded the Outdoor Industry Conservation Alliance. In 2001, it introduced the Met5 Jacket, utilizing Intelligent Garment Technology; the company is known for identifying and satisfying the clothing needs of the serious outdoor sports enthusiast. Its **logo** consists of its name plus an image of the famous half Dome Rock formation at Yosemite National Park. The North Face **brand** logo is highly **counterfeited** throughout the world.

NYLON. This is the first commercial petroleum-based synthetic fiber; it was invented by DuPont scientists **Gerald Berchet** and **Wallace Carothers** (Americans) in 1935. Commercial production of nylon **hosiery** began in 1939 by the DuPont Company in America. Nylon

stockings were all the rage, especially after World War II, as they were stronger and cheaper than **silk** stockings. By the late 1950s, nylon became a significant fiber of the **intimate apparel** business. "Penior Sets," as the matching robe and nightgown ensembles were named, consisted of yards of sheer and opaque nylon. In the late 1960s and early 1970s, the warp-knit nylon was given a shiny surface and it gave the appearance of silk or satin. This allowed the **mass-market** manufactures and **retailers** in the United States to design and produce **knock-offs** of high-end intimate apparel. The 1980s saw a return of the demand for comfort, namely **cotton**; while nylon was no longer front and center, it remained a significant component of the intimate as well as **sportswear** industry.

– O –

OLD NAVY. *See* GAP.

ONLINE MARKETING MANAGER. This person's responsibilities include developing and executing a marketing strategy to increase online sales and traffic, and improving key metrics such as the visitor conversion rate and shopping cart abandonment, among others. He/she works to establish marketing strategies, build an online marketing team, and implement and manage affiliates, e-mail blasts, and search-engine marketing programs and campaigns. This person must also collaborate on the integration of marketing and advertising between stores and online sites to develop multichannel strategies and increase **brand** awareness, as well as build and maintain strategic partnerships. He/she works with internal teams to develop database marketing efforts and to create and implement promotional offers. Keeping current with the latest **e-commerce** trends and technology and keeping the website competitive in the online arena are musts. He/she is responsible for driving consumer research and analysis in order to increase sales and improve the customer's experience.

OPEN-TO-BUY. This term is used by retailers to describe how much money is allocated to a **buyer** to purchase product for a particular season.

OPERATIONS MANAGER. This manager is a person who manages all nonselling areas of the store, inclusive of analysis budgeting, maintenance, and human resources.

OPERATOR. An operator sews one or more of the steps in the construction of a garment. The term is most often used when referring to a **sewing machine** operator at the factory level.

ORGANIC FASHION. Clothing and **accessories** can be considered organic when they are made from fibers produced without the use of synthetic chemicals, such as conventional pesticides; without fertilizers made with synthetic ingredients or sewage sludge; and without bioengineering or ionizing radiation. Organic fashion emphasizes the use of renewable resources to conserve soil and water to enhance environmental quality for future generations. In the United States, organic products originate from certified farms and production plants that meet the United States Department of Agriculture's (USDA) organic standards. Organic farming focuses on ecology, soil science, crop diversity, decoy crops, beneficial bugs, increased human labor, and renewable fertilizers. Farming organically is more labor intensive because of higher labor, management, and certification costs. It is widely believed that reducing chemicals prevents serious and ultimately more costly, long-term problems for the environment and human health. Ground-water pollution, soil erosion, loss of biodiversity, and human health problems (mainly cancers and asthmas) caused by chemical residues are serious effects of conventional agriculture. The increased cost of organic farming creates a struggle for many farmers in the global economy since they can't compete with countries that can produce crops cheaper; however, organic farming has helped some farmers carve out a niche market. Although developing countries can produce goods for less, **fair trade** practices are a major concern.

Organic agriculture was the only option for farmers until the twentieth century. Synthetic chemicals, developed for farming in the 1920s, were not widely used until after World War II when farmers learned to increase productivity through mechanization and homogenization of farming. "Factory farms" developed and used synthetic fertilizers, pesticides, herbicides, and mass-rearing techniques to

increase yield without more land. This resulted in a lack of crop diversity, diminished the soil (when crops aren't rotated), and allowed pests to flourish.

During this agricultural industrial revolution, pioneers of the organic movement called for a return to traditional methods. Prior to 2002, no consistent definition of *organic* existed. Effective October 2002, *certified organic* refers to produce/livestock from farms, ensured by a third-party certifier, that complies with National Organic Standards set by the USDA. To qualify, farmers must abstain from using prohibited materials (including synthetic fertilizers, pesticides, herbicides, fumigants, and sewage sludge) for three years prior to certification and then continually thereafter. They are prohibited from using genetically modified organisms (GMOs) and irradiation. They must employ positive soil building, conservation, manure management, and crop-rotation practices.

In the case of livestock, they must provide outdoor access and pasture for livestock, refrain from antibiotic and hormone use, and sustain animals on organic feed. The use of synthetic hormones, antibiotics, and genetic engineering is prohibited, as is the use of synthetic pesticides (internal, external, and on pastures). In addition, organic livestock management for fibers includes a regulation that animals cannot be dipped in parasiticides (insecticides) to control external parasites such as ticks and lice. Farmers must also meet specific requirements for labeling and record-keeping. Organic **wool** must be produced in accordance with federal standards for organic livestock production. Livestock feed, from the last third of gestation, must be certified organic and natural carrying capacity on grazing land cannot be exceeded. In 2005, 19,152 pounds (8,705 kilos) of organic wool were grown in the United States and Canada. New Mexico is the second-largest producer with 15,200 pounds, then comes Montana (2,400 lb.), Maine (520 lb.), Colorado (300 lb.), Vermont (200 lb.), New Jersey (132 lb.), and Ontario, Canada (300 lb.). The organic wool industry is very small relative to the overall wool industry and does not have the economies of scale.

Cotton provides about half of all global fiber needs. The six biggest producers of cotton are the United States, China, India, Pakistan, Uzbekistan, and Turkey. However, cotton is produced in more than sixty countries and represents an essential component of foreign ex-

change earnings for more than fifty of them. Cotton is an important source of income for millions of small farmers and contributes significantly to the national economy of many developing countries. The cotton-growing land areas of conventionally grown (using pesticides) have not changed much since the 1930s but average yields have increased threefold through the intensive use of synthetic chemicals, irrigation, and the use of higher-yielding plant varieties. Conventional cotton is very prone to insect attacks and large quantities of the most toxic insecticides are used in its production. According to the Pesticide Action Network of the United Kingdom and the Organic Trade Association (OTA), organic cotton farming is on the rise with Turkey and the United States as the leading producers, followed by India, Peru, Uganda, Tanzania, Egypt, Senegal, Israel, Greece, Benin, and Brazil. Based on OTA's 2005 survey of U.S. organic cotton producers, funded by Cotton Incorporated, farmers in four states harvested 6,814 bales (3,270,720 pounds) of organic cotton from 5,550 acres during 2004. This is an increase from the 4,628 bales harvested from 4,060 acres in 2003. Texas continues to lead the United States in organic cotton production, with limited acreage also planted in California, New Mexico, and Missouri. Other fibers that are organically farmed are hemp, soybean, corn, and bamboo.

One of the first **manufacturers** to promote the use of organic cotton was California-based Espirit de Corps in the early 1980s. **Patagonia** joined the cause in 1992, along with Nike in 1998 and Eileen Fisher in 2001. The organic movement, which started out as a grassroots movement, is now attracting companies worldwide including Coop Schweiz (Switzerland), EDUN (England), and Otto and Hess Natur (Germany). *See also* SUSTAINABLE DESIGN.

OSCAR DE LA RENTA. *See* DE LA RENTA, OSCAR.

OUTERWEAR. The outerwear category of clothing includes jackets, coats, wraps, capes, rainwear, and furs for men, women, and children. Although **fur** and **leather** is included in this category, they are each their own industries. Outerwear consists of jackets and coats made of **wool**, wool blends, synthetics, and leather; they can be knitted, fur-trimmed, microfiber, down-filled, and quilted garments. Throughout history, many types of jackets and coats have been popularized and,

as is the case with most trends, certain styles go in and out of fashion while others remain constant. Some of the most popular types of outerwear include the anorak, balmacaan, baseball jacket, bomber jacket, car coat, cape, chesterfield coat, chubby, clutch coat, barn or field coat, coachman's coat, **denim** jacket, down jacket, duffle coat, duster coat, Eisenhower or battle jacket, flight jacket, frock coat, golf jacket, mackinaw jacket and coat, Macintosh, maxi-coat, military coat, motorcycle jacket, raincoat, riding coat, Nehru coat, officer's coat, parka, pea jacket, polo coat, reefer, safari coat/bush jacket, shearling jacket and coat, ski jacket, stadium coat, topcoat, topper coat, trenchcoat, walking coat, windbreaker, and Soave or wrapper coat.

OUTERWEAR DESIGNER. An outwear designer specializes in and is responsible for the inspiration and design of capes, jackets, wraps, shawls, coats, and rainwear. Knowledge of **outerwear** fabrics, **furs**, and **trims** is mandatory.

OVERALLS. This trouser and bib combination article of clothing was created by Lee Mercantile in 1911 and is often associated with attire worn by farmers.

OWENS, ROD (1962–). Born and raised in California, Owens studied at the **Parsons School of Design** before taking a job as a **pattern-maker** for his **designer**-girlfriend, Michele Lamy. He opened his own business in 1994, designing deconstructed **punk**-rock style clothing. He got his big break in 2001 when **Anna Wintour** and *Vogue* magazine sponsored his first fashion show in New York and he received the prestigious **Council of Fashion Designers of America (CFDA)** Perry Ellis Award for Emerging Talent the same year. Owens moved to Paris in 2003 and, in addition to designing his own collection, he was named artistic director for Revillon, the French **fur** company.

– P –

PAD SYSTEM. PAD stands for pattern-aided design. The PAD System is a computer software company which was founded in 1988 in Montreal that offers **CAD/CAM** solutions to the apparel, textile, and

leather industry from virtual design to integrated production. *See also* PATTERN DESIGN SYSTEM (PDS).

PANTALETS. This garment became the choice of dress in children's clothing in 1857. *See also* CHILDRENSWEAR.

PANTIE GIRDLE. In 1934, this garment revolutionized the women's underwear market. An amount of **Lycra** adds control, resulting in an overall slimming effect. *See also* INTIMATE APPAREL.

PAQUIN, JEANNE (1869–1936). Born Jeanne Marie Charlotte Beckers outside of Paris, she started her career as a seamstress at the French firm Maison Rouff. In 1891, together with her banker-businessman husband, Isidore Rene Jacob, they opened the House of Paquin. The couple built one of the largest international **haute couture** houses of their time. The clientele included royals, actresses, and wives of American tycoons such as the Rockefellers, **Vanderbilts,** Wannamakers, and Astors. By 1907, its volume surpassed that of the House of **Worth.** However, upon the death of Isidore in 1907, Paquin operated the business with her family until her retirement in 1920. After a series of **designers** had been hired to continue the house, it eventually merged with the House of Worth in 1954. Two years later, Worth-Paquin closed.

Paquin was known for her extremely artistic design sense and her creative use of color and fabric combinations. Her **fashion shows** were rich with theatrics. She was one of the first designers to understand fashion marketing and promotion, as was evidenced by her all-white ballet fashion show finales and her parade of tango dresses. She was the first to take her collection on tour to major cities in the United States, the precursor to today's "**trunk shows.**" Paquin was her own muse. She wore her own designs and was the best publicist for her work. Her awards included being chosen by fellow couturiers to head the Paris Universal Exposition in 1900, the Order of Leopold II of Belgium award in 1910, the Légion d'honneur in the field of commerce in 1913, and elected president of the Chambre syndicale des couturiers in 1917. Paquin is considered the first great **couturière** and was the first fashion house to have foreign branches in London, Buenos Aires, Madrid, and New York.

PARKA. The parka is a loose and hooded **outerwear** garment that originated in the cold climate of the Arctic. Today it is made in various fabrics and worn as a fashion item, as well as a functional item for skiing and for cold-climate militaries. *See also* PERFORMANCE APPAREL.

PARSONS SCHOOL OF DESIGN. Parsons was founded in 1896 by American Impressionist painter William Merritt Chase and originally named the Chase School. In 1898, the name was changed to the New York School of Art. In 1904, Frank Alvah Parsons (ca. 1880–1938) joined the faculty and, in 1907, became an administrator. Under his direction, the school broadened its curriculum offering the first interior design, graphic design, and advertising programs in the United States. In 1909, the school was again renamed, to the New York School of Fine and Applied Arts, and in 1911 Parsons became president, a position he held until his death in 1930. Parsons's successor, William Odom, established the school's Paris Atelier in 1921 and, in 1941, renamed the school as the Parsons School of Design, in recognition of his predecessor's contributions. In 1970, the school was incorporated into the New School for Social Research and, in 2005, when its parent school was renamed, Parsons was again renamed, Parsons the New School for Design. Today, the school's fashion program is highly regarded in the fashion community.

Parsons has produced many famous designers, among them **Donna Karan, Isaac Mizrahi, Anna Sui, Tom Ford, Marc Jacobs, Jack McCollough,** and **Lazaro Hernandez.** Parsons has independent affiliate schools in France, South Korea, Japan, and the Dominican Republic. There are approximately 30 full-time faculty and more than 675 adjunct faculty members, with an enrollment of approximately 2,400 undergraduates and 400 postgraduate students. The school offers continuing education courses, certificate programs, and weekend and summer pre-college programs for high-school students. Parsons has been the setting for the popular *Project Runway* competition show on cable television since 2004.

PATAGONIA. At age fourteen, Yvon Chouinard got his start as a mountain climber in 1953 at the Southern California Falconry Club. His love of climbing led him to create metal pitons (mountain climbing

spikes), which he made in his Burbank, California, backyard and sold from his car to climbers from Big Sur and San Diego to Yosemite, Wyoming, and Canada. In 1965, he began a nine-year partnership with Tom Frost and, by 1970, Chouinard Equipment was the largest supplier of climbing hardware in the United States. In 1972, as an alternative to the environmentally unfriendly metal pitons, Chouinard invented an alternative, the aluminum chock, which could be wedged instead of hammered in and out of rock. Chouinard also realized that until that time, no one was making clothing specifically for climbers. He began importing garments from Scotland, England, Argentina, New Zealand, and Austria under the name Patagonia and soon thereafter began textile collaboration with Malden Mills (American) to produce fleece garments. By the 1980s, Patagonia was addressing the needs of the serious performance sports enthusiast and attracted other consumers who wanted to look like them.

From base layer underwear that wicks moisture and insulates the body, to outer shell garments that offer wind and water protection and can adjust to weather conditions (their R1.5 "biomap design"), Patagonia is considered a pioneer and industry leader. In 1986, it committed to donate 1 percent of sales or 10 percent of profits, whichever was greater, to groups whose mission it was to restore degraded habitat around the world. In 1994, Patagonia committed to using only organic **cotton** in its cotton-based products and achieved that goal within two years. Today it manufactures outdoor clothing and gear consisting of organic cotton **sportswear**, travel clothing, technical fleece, Synchilla fleece, and Capilene underwear for those sports of alpine climbing, backcountry skiing and snowboarding, paddling, hiking, and backpacking. It also sells Lotus Designs paddling gear and Water Girl women's surf clothing. *See also* PERFORMANCE APPAREL.

PATOU, JEAN (1880–1936). The French **couturier** Jean Patou was born in Normandy to a father who was a successful **leather** tanner and an uncle who owned his own **fur** business. Patou entered the fashion industry by first working for his uncle. In 1910, he opened his own **dressmaking** shop, and although his work received international praise, his company failed due to undercapitalization. However, in 1914, he opened a **couture** house but soon closed when he served

in the French regiment during World War I. Patou is best known for his use of the color beige, his love of geometric patterns and, together with **Chanel**, the "garçonne look." He is also known for his contributions to the design of sports clothing. He even partnered with textile companies to create new fabrics to be worn during various sports activities. In 1925, he opened a special division of his couture business dedicated to different sports such as golf, tennis, horseback riding, and fishing and called it "le coin des sports." Patou was the first designer to place his "JP" monogram on clothing, which was the precursor to the subsequent **logo** craze. In 1924, his sweaters, inspired by the cubist works of Picasso and Braque, were all the rage and extremely popular on an international level. Perhaps the house of Patou is most known for **fragrances**, especially the perfume, Joy, which was launched in 1929 and is still considered one of the top ten fragrances in the world. Patou died unexpectedly in 1936 but the company continued with several designers at the helm, including **Marc Bohan** (1953–1957), **Karl Lagerfeld** (1958–1963), Michel Goma and his assistant **Jean-Paul Gaultier** (1963–1974), Angelo Tarlazzi (1973–1976), Gonzales (1977–1981), and **Christian Lacroix** (1981–1987). In 1976, the house of Patou designed flight attendant uniforms for the Concorde but, in 1987, it showed its last collection. Upon Lacroix's exit, a legal battle ensued between Lacroix and Patou. Lacroix opened his own company and, by 2002, the fashion side of Patou closed officially. In 2001, Clarins sold the company to Procter and Gamble, where the company's main focus was on fragrances. In 2006, Patou launched a new fragrance, Sira des Indes, to add to its stable of women's fragrances: Joy, 1000, Sublime, and Enjoy.

PATTERN. A pattern is a two-dimensional diagram of a garment drafted by a **patternmaker** that is subsequently cut and sewn in fabric. The history of patternmaking can be traced as far back as the thirteenth century with the introduction of form-fitting clothing. **Tailors** and **dressmakers** authored guides on how to cut and sew men's, women's, and children's clothing and **guilds** were formed during the Middle Ages that offered apprentices the opportunity to learn techniques of the trade. By the late 1770s, publications such as Garasault's *Descriptions des arts et métiers* and Diderot's *Encyclopédie Diderot et D'Alembert: arts de l'habillement* contained pattern drafts for the professional tailor

as well as, in 1809, the American publication *The Tailor's Instructor* by Queen and Lapsley. The home dressmaker was soon able to access full-size patterns designed for charitable women whose time was spent sewing for the poor in the early 1800s. During the early 1850s, *Godey's Lady's Book* and **Petersen's magazine** began promoting small pattern diagrams of new clothing styles and later offered **Mme. Demorest**'s full-scale patterns through mail order. **Butterick & Company**, incorporated in 1863, offered its patterns in a full range of sizes and was eventually followed by **McCall's**, **Vogue**, and **Simplicity** pattern companies. Patents were issued that included solutions for properly identifying pattern pieces (Robert S. O'Laughlin, 1899, and George M. Laub, 1907), conveying the order of garment assembly with numerical symbols (William P. Ahnelt, 1907, and Alice Audrey Maxwell, 1908), and the most comprehensive solution patented by Hannah G. Millard in 1920—her "Dressmaker's Pattern Outfit" instructed pattern users in garment cutting and construction procedures with an accompanying step-by-step instruction sheet and diagram. Her patent was secured as proprietary by competitor **Butterick** and called the "Deltor" after Butterick's magazine the *Delineator*. The "Pictograph," patented by Max Herzberg for the Excella Corporation in 1925, printed all of the instructions on the pattern pieces themselves, eliminating the need for a separate reference sheet. Between the 1930s and 1950s, the home sewing industry, dominated by women, flourished. However, after World War II as more and more women entered the workforce, they had less leisure time. By the 1960s, the home sewing market began to wane as women, with increasing amounts of disposable income, found that buying clothes instead of making them satisfied their need for immediate gratification. Although pattern companies resorted to various marketing strategies, such as using top **models** for their **catalogs** and **licensing** designer names, the industry continued to diminish. Today, patterns are either drafted manually or by computer.

PATTERN DESIGN SYSTEM (PDS). *See* PATTERN.

PATTERNMAKER. *See* PATTERN.

PDS. PDS is an acronym for pattern design system. *See also* PATTERN.

PEASANT DRESS. This dress style is characterized by its use of eighteenth-century peasant styling, popularized by **Yves Saint Laurent** in Paris in 1972.

PENN, IRVING (1917–). Born in Plainfield, New Jersey, Penn studied under Alexey Brodovitch (art director of *Harper's Bazaar*) at the Philadelphia Museum School, and he graduated in 1938. Although he would go on to make his name as a photographer, it was his drawings and paintings that first caught the attention of *Harper's Bazaar*, which led to freelance work as an assistant art director at **Saks Fifth Avenue** in 1937. He was hired in 1943 by *Vogue* magazine where his photography career blossomed and continues even today. Penn has had more than 170 *Vogue* covers and has taken hundreds of portraits of celebrities such as Marlene Dietrich, Igor Stravinsky, Georgia O'Keefe, Martha Graham, Salvador Dali, and Hubert Humphrey. He is most famous for his austere backgrounds, usually a simple grey or white. The simplicity of the backdrop allows the subject to become the focal point of the picture. Positioning his subjects into corners was another way for him to capture their essence and to direct the viewer's eye to the subject's expression. This technique became known as Penn's "corner portraits" (1948–1949). Penn's style is characterized by his careful use of light and his clarity of composition and form. This style was to prevail consistently in his **fashion photography** and portrait and ethnographic work.

In 1950, Penn married his favorite **model**, Lisa Fonssagrives (1911–1992), with whom he would open a studio and collaborate. In 1960, Penn published his first book, *Moments Preserved*, which documented the best ten years of his fashion photography and, in 1961, Penn created a series of photographic essays for *Life* magazine. In 1964, he refined new photographic processes utilizing precious metals, iridium, platinum, and palladium. The results produced exhibition quality photographs that were shown in a solo exhibition at the Metropolitan Museum of Art in 2002 and at the National Gallery of Art in Washington, D.C., in 2005. Penn's other published works include *Irving Penn Regards the Work of Issey Miyake* (1999), *Still Life* (2001), *Drawings* (1999), *A Notebook at Random* (2004), and *Photographs at Dahomey* (2004). He resides in New York City and is a regular contributor to *Vogue* magazine.

PERETTI, ELSA (1940–). Born in Florence, Italy, to a well-to-do family, Peretti studied interior design at Volbicela School in Rome. She moved to New York in the 1960s and began designing jewelry for **designers Oscar de la Renta, Halston,** and Georgio Di Sant'Angelo. In addition, she designed the containers for **Halston's fragrance** and cosmetics lines. In 1974, Peretti partnered with **Tiffany & Co.** and produced some of the most sought-after jewelry of the time. A trip to Jaipur, India, inspired her gold bra and scarf designs in metal mesh that she did for Halston in 1975. Other revolutionary designs for which she received fame are her "Diamonds by the Yard," her sculptural "Open Hearts" pendants, her "Bone Cuffs," and her "Wave and Sevillana" collections. Another inspirational reference is the traditional craft of *urushi* (Japanese lacquer) with which she has created the most extraordinary bangles and pendants. Peretti's awards include the 1971 **Coty Award** for Jewelry, the 1994 Divine Design Award for Jewelry, and the **Council of Fashion Designers of America (CFDA)** Award in 1996 for **Accessory Designer** of the Year.

PERFORMANCE APPAREL. This category of clothing is designed specifically for activities that relate to performance and extreme sports such as skiing, snowboarding, mountaineering, hiking, and fishing. Perhaps the first example of a performance garment was the creation of protective armor dating back to the Greco-Roman period. The present equivalent is the spacesuit developed in the late 1950s, with its collective layers of materials which can withstand life-threatening temperatures ranging from –250° F to 250° F. Textile technology, at the advent of the Space Age, has been the inspiration for the $3 billion performance-apparel industry that we know today. The National Aeronautics & Space Administration (NASA) was formed in 1958, the same year the United States passed the Space Age Act of 1958. This Act required NASA to make inventions and discoveries available to private industry. This legislation led to more than 700 laboratories being placed under the umbrella of the National Technology Transfer Center and resulted in numerous collective collaborations, an increase in competition, and the development of new technologies that, in turn, affected the **sporting goods** industries as well as the performance-apparel industry.

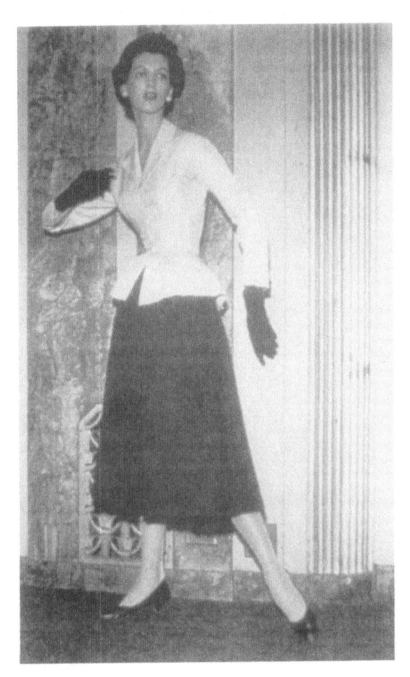

Christian Dior, 1947.

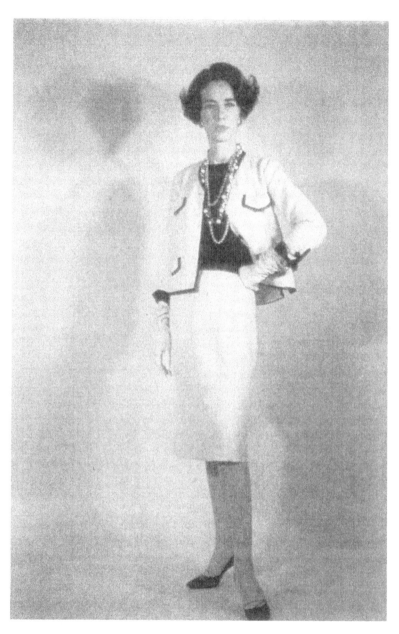

Coco Channel, 1959.

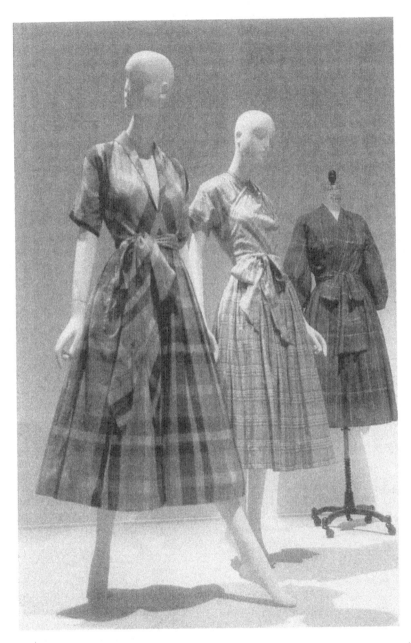

Claire McCardell, late 1940s–1950s.

Andre Courrèges, 1964.

Yves St. Laurent, 1982 (center), 1985 (left), and 1986 (right).

Calvin Klein, 1990.

Sean John, 2002.

Marc Jacobs, 2005.

NASA's spacesuit technology inspired performance textiles such as Teflon (1938), Kevlar (1971), Nomex, and Gore-Tex (1976). Another spinoff of spacesuit technology was UV-blocking (protective coatings against the sun's harmful rays) and cooling vests (which cooled the body when it could not do it fast enough itself, such as with burn victims). By the 1970s, leisure-time sports such as skiing, hiking, camping, and mountain climbing were becoming increasingly popular. Companies such as **The North Face**, **Patagonia**, and **Marmot** are at the cutting edge of emerging technologies and not only design comfortable and functional performance clothing, but also are instrumental in creating and pioneering textile innovations.

PERFUME. *See* FRAGRANCE.

PETERSEN'S **MAGAZINE.** A fashion periodical that offered trends and **patterns** in the United States during the 1800s. *See also* MME. DEMOREST.

PF FLYERS. In 1909, Benjamin Franklin Goodrich (American), looking for another use for rubber other than tires, created a line of rubber-soled canvas shoes. By 1928, they were producing 28,000 pairs a day. In 1933, Hyman Whitman patented his arch-support invention. Goodrich used this invention to create the first **sneaker** with arch support, the "PF Flyer," which stands for "posture foundation." It was a canvas-duck high-top sneaker with a rubber ankle patch that read "PF Flyer."

Throughout the 1960s, the PF Flyer was *the* sneaker; however, between 1970 and 1990, they fell out of favor due to increased competition from other athletic shoe companies such as **Adidas**. In 1972, Goodrich sold the brand to **Converse**. To settle a Department of Justice complaint that Converse was monopolizing the sneaker market, the PF Flyer brand was spun off and from 1991–2001, **LJO** Inc. owned the **brand** until 2001when New Balance acquired the rights. In 2003, the PF Flyer was resurrected and increased in popularity.

PFISTER, ANDREA (1942–). Born in Pesaro, Italy, Pfister moved to Paris after studying shoe design at the Ars Sutoria Institute of **Footwear** Design in Milan. He designed shoes for the **haute**

couture collections of **Jeanne Lanvin** and **Jean Patou** and, in 1967, he opened his own shop in Paris. Pfister designed shoes for royals and celebrities such as Elizabeth Taylor and Madonna and is best known for his feminine and sexy heels.

PFR. This is an acronym for a term used in the retail segment of the industry, "planning, forecasting, and replenishment."

PHAT FARM. A **hip-hop** young men's clothing company founded in 1992 by Rap mogul Russell Simmons (1957–) as a division of his media company, Rush Communications. In 1999, Phat Farm signed an agreement with Aris Industries, Inc., for worldwide **licensing** rights for its **Baby Phat** children's line designed by Simmons's ex-wife, former model Kimora Lee Simmons. In 2004, Phat Farm was sold to Kellwood for $140 million and, by 2006, the Phat empire grew to include clothing and accessories for men, women, and children (Phat Farm kids and Baby Phat) and a partnership with Motorola for cell phones. Originally known for its urban fashion appeal, its broken flag **logo** (political statement), and "American Flava" moniker, the company has expanded into a global American **lifestyle brand**, with flagship stores located in the United States, Canada, European countries, and the United Arab Emirates.

PHILLIPS-VAN HEUSEN (PVH). This company was started in 1881 by Moses and Endel Phillips, selling handmade men's shirts to coal miners from their pushcart in Pottsville, Pennsylvania. After advertising their shirts in New York's *Saturday Evening Post*, business boomed. In 1919, their son Seymour partnered with Dutchman John Manning Van Heusen to open a clothing outlet and called themselves the Phillips-Van Heusen Corporation. In 1919, John Van Heusen patented his process of weaving fabric on a curve which was the basis for his self-folding collar, an immediate hit. In 1922, Van Heusen created the "Collarite Shirt," the first collar-attached shirt.

By 1974, the company was awarded the Royal Warrant as Shirtmakers to Queen Elizabeth II and, in 1991, was the number-one dress shirt **brand** in the world. PVH continued to expand throughout the years by acquiring businesses including Bass (1982), Izod (1995), and **Calvin Klein** (2002). In 2006, PVH agreed to provide Warnaco

with worldwide rights for Calvin Klein **Jeans** to produce CK Calvin Klein Bridge sportswear and accessories in Europe and Calvin Klein Jeans and **accessories** in Europe and Asia. PVH's Dress Shirt Group maintains dress shirt licenses for the brand names **Geoffrey Beene, DKNY, Kenneth Cole,** Arrow, **Michael Kors, BCBG Max Azaria,** BCBG Attitude, **Sean John,** Chaps, and Donald J. Trump Signature. The PVH range includes apparel and **accessories,** jeans, underwear, **fragrances,** eyewear, men's tailored clothing, ties, **footwear,** swimwear, jewelry, watches, **leather** goods, coats, handbags, home furnishings, and men's knit and woven sport shirts, sweaters, bottoms, swimwear, boxers, and underwear. As of 2006, the company operates 700 retail stores under the names Geoffrey Beene outlet, Calvin Klein outlet, Bass Factory outlet, and Van Heusen outlet stores.

PHOTOJOURNALIST. *See* FASHION PHOTOGRAPHER/PHOTO-JOURNALIST.

PHOTOSHOP. *See* ADOBE PHOTOSHOP.

PHOTO STYLIST. The job of the photo stylist is to coordinate photographic shootings for advertisements and **catalogs,** create appropriate settings, and manage accessories coordination. Other duties may include sourcing clothes, **model** booking, shoot location, garment fittings, presentation, and alterations.

PILATI, STEPHANO (1966–). Born in Milan, Pilati interned at Nino Cerruti before designing at the famous fashion houses **Armani** and **Prada.** In 2000, Pilati moved to Paris and became the design director for YSL ready-to-wear under **Tom Ford.** In 2004, upon Ford's departure, Pilati was named **creative director.** His goal is to pay respect to the famous YSL archive and rich **brand** heritage by creating young, free-spirited clothes. *See also* SAINT LAURENT, YVES.

PINAULT-PRINTEMPS-REDOUTÉ (PPR). This company, founded as a timber trading company in 1963 by François Pinault, was first known as the Pinault Group. In 1992, the company took over the French **department store** Au Printemps and the company's name changed to Groupe Pinault Printemps. By 1994, the company acquired

La Redouté, the biggest mail-order house in France (and third largest in the world) and was renamed Pinault-Printemps-Redouté. From 2001 until 2004, the company engaged in a highly publicized battle with the **Gucci** Group, and it eventually succeeded in acquiring control of the company. In 2005, François-Henri Pinault, at age forty-two, took the helm (which is controlled by his family's holding company, Artemis) and renamed the company PPR. The company is headquartered in Paris and includes the following subsidiaries: Gucci (which owns the luxury brands **Yves Saint Laurent**, Sergio Rossi, Boucheron, **Bottega Veneta**, Bédat & Co., **Alexander McQueen, Stella McCartney**, and **Balenciaga**), Redcats mail-order retailer (which operates La Redouté, Ellos, Empire, Brylane, Cyrillus, Vertbaudet, Somewhere, Daxon, Edmée, Celaia, and La Maison de Valérie), FNAC (book and CD retailer in France, Belgium, Spain, and Portugal), and Conforama (household furnishings retailer). PPR sold Printemps to Italy's La Rinascente department stores in 2006. PPR's chief competitors are luxury goods conglomerates **Moët Hennessey Louis Vuitton (LVMH)** and **Prada**.

PLANNER/DISTRIBUTOR. A planner projects sales and inventory based on an analysis of sales history, current market trends, and the retail organization's performance objectives. He/she must possess strong analytical and computer skills and serves as the key link between corporate merchandising and the stores.

PLANNING, FORECASTING, AND REPLENISHMENT (PFR). PFR is a term used by the retail segment of the fashion industry.

PLANT FIBER. Natural fiber made from fruit or vegetable plants. Vegetable fibers include **cotton, linen,** flax, jute, ramie, sisal, and hemp. An example of a fruit fiber is coconut, which is not only durable but has inherent wicking properties. Stalks of wheat, rice, and barley are made into straw, bamboo, and grass fibers.

PLANT MANAGER. This person is in charge of the total operation of running a factory. Responsibilities may include maintaining production schedules, overseeing production flow, garment and textile examination, and garment compliance in regard to flammability standards, as well as overall plant operations.

PLINER, DONALD J. (1944–). Born in Chicago, Pliner opened his own shoe business in 1989 and is best known for designing elastic **leather** shoes. He has added leather clothing and **accessories** to his collection. *See also* FOOTWEAR.

PLUS SIZE. The women's size range that caters to women who wear sizes 14 to 28. This segment of the women's clothing market accounts for only 19 percent of sales, while recent **bodyscanning** data and other surveys indicate that approximately two-thirds of American women are size 14 and up. In the early 1980s, **manufacturers** and **retailers** finally realized the plus-size market was significantly underserved, leading it to soon become the fastest-growing market segment. Historically, many **designers** have shied away from the plus-size market for fear of losing **brand image**. However, customers have pressured retailers and they in turn pressured designers to start offering fashionable plus-size clothing.

Beginning in the 1990s, companies like **Liz Claiborne** (Liz), **Givenchy** (Givenchy En Plus), **Tommy Hilfiger**, Old Navy, **Wal-Mart**, and **Target**, as well as some manufacturers have either spun-off new plus-size divisions or increased their size assortment. Lane Bryant, now a division of Charming Shoppes, is the leading retailer of women's plus-size clothing in the United States and Fashion Addition is the largest plus-size clothing and accessories retailer in Canada. In 2001, two retailers addressed the newest segment of the plus-size category, the junior plus size. Specialty retail chain Hot Topics launched Torrids and a new direct retailer known as Turnstylz offered trendy fashion for the tween-to-preteen age range.

POINT OF SALE (POS). This system of tracking customer information includes gathering such data as their buying habits, address, phone number, email, and so on. *See also* ELECTRONIC DATA INTERCHANGE; UNIVERSAL PRODUCT CODE (UPC).

POIRET, PAUL (1879–1944). Born in Paris to a cloth merchant, Poiret was educated at a Catholic lycée. He apprenticed to an umbrella maker and sold sketches to **couturière** Mme. Chéruit before landing a job in 1896 working for **Jacques Doucet**, a leading **couturier** at the time. His designs were quite successful and he was soon promoted.

In 1900, he entered the military and a year later went to work for the famous **haute couture** house **Worth**, designing the casual line and not the glamorous evening clothes. This experience would be the inspiration for revolutionizing the way he thought women really wanted to be dressed. In 1903, Poiret opened his own couture house and, in 1906, married Denise Boulet, daughter of a textile **manufacturer**; she would eventually become his muse.

Poiret is credited as being the first designer to do away with the corset and petticoat and pioneered the move away from the hourglass silhouette, in favor of the highwaisted column. Poiret was also the first to bring the art and fashion worlds together, often in collaboration with prominent artists of his time, including Georges Barbier, Raoul Duffy, **Erté**, Paul Iribe, and Georges Lepage. Together, they created inventive fashion albums depicting Poiret's collections such as *Les Robes de Paul Poiret*, *Les Choses de Paul Poiret*, and other collaborations.

His famous jupe-culottes (tunic over harem pants) paved the way for it to be socially acceptable for women to wear trousers. Another first from Poiret was his perfume Rosine, launched in 1911 and named after his daughter. Designers such as **Coco Chanel**, the **Callot Sisters**, and **Jean Patou** later followed suit. Also in 1911, Poiret opened a school in Paris called Martine, dedicated to the decorative arts. In 1912, he opened a Martine store where student work was sold, such as wallpaper, textiles, rugs, and china. Just as his contemporaries had their own signature flower (**Dior** had the lily-of-the-valley, and Chanel had the camellia), Poiret had Paul Iribe design his signature rose label. During the war, Poiret worked as a military tailor and relaunched his business in 1919 when the war ended. He continued up until 1929, but then sold the business and lost the rights to the name in the process. In 1931, he made an unsuccessful comeback in the couture, but closed in 1932 to write an autobiography, *King of Fashion*.

POLYESTER. This **man-made** fiber was invented in 1941 by two British chemists, John Rex Whinfield and James Tennant Dickson, while working together at the Calico Printer's Association of Manchester. Whinfield and Dickson furthered the research done by DuPont scientist **Wallace Carothers** while researching **nylon**.

However, when polyester was introduced to the United States in 1951, it gained popularity because of its resistance to wrinkling, stretching, and shrinking. Polyester also washes well, is colorfast, and dries quickly. It was advertised as a miracle fiber that could be worn for 68 days straight without ironing and still look presentable. Polyester experienced constant growth until the 1970s—sales drastically declined due to the negative public image that emerged in the late 1960s when it was suddenly regarded as cheap and uncomfortable.

In 1993, Dyersburg Corporation began efforts to recycle materials made of 100% man-made materials (nylon, polyester), to minimize the volume of chemical fiber clothing on the earth.

POLYVINYL CHLORIDE (PVC). A group of synthetic textile fibers that, when woven into cloth, provide performance characteristics mostly used by the fashion industry in rainwear. PVC was first created by Eugen Bauman, a German scientist, in 1872. However, it was not patented until 1913, when Frederich Heinrich August Klatte (German) invented the polymerization process of combining **vinyl** chloride with sunlight. Later, in 1926, **Waldo S. Semon** plasticized PVC and thus invented vinyl. While both of these textiles are not breathable, they continue to hold a unique place within the fashion industry. From its very early use in raingear and umbrellas, to the trendy **mod** 1960 fashions created by designers **André Courrèges, Paco Rabanne, Pierre Cardin**, and **Mary Quant**, these fabrics continue their "futuristic" appeal.

POPE, VIRGINIA (1885–1978). Considered by many in the fashion world as the first serious **fashion journalist**, Pope was a fashion editor for the *New York Times* (1925–1955). In 1934, she began covering the Paris **haute couture** collections and in addition to her fashion column, produced the first live fashion presentation in 1942 called *The Fashion of the Times*, specifically aimed at showcasing American fashion. Her coverage featured the business of fashion and Pope regularly reported on the growth of the wholesale and retail marketplaces. In 1955, she joined *Parade* magazine as fashion editor. She was also known as the grand dame of American fashion. *See also* AMERICAN LOOK.

POPOVER. The popover denim wrapdress was designed by **Claire McCardell** (American) in 1940.

POSEN, ZAC (1980–). Born in Brooklyn, New York, Posen studied fashion design at the **Parsons School of Design** and at **Central Saint Martins College of Art and Design**. After internships at the Metropolitan Museum of Art and **Nicole Miller**, as well as an **assistant designer**'s position at Tocca, Posen won the prestigious Gen Art 2001 Fresh Faces in Fashion contest in 2001. Together with his mother, Susan, they opened the Zac Posen collection in New York, in 2001. He won the **Council of Fashion Designers of America (CFDA)** Perry Ellis Award for Ready-to-Wear after his first runway show in 2004 and was backed by Sean "Puffy" Combs the same year. He is known for his timeless **couture** style pieces with a nostalgic flare and for his young celebrity-style evening pieces.

POTTER, CLARE (c. 1925–). After graduating from Pratt Institute with a degree in painting, Potter entered the fashion industry designing embroidery. She founded her own company in 1940 called Clarepotter, specializing in sportswear and eveningwear. In 1960, she formed Potter Designs, Inc., and Timbertop, Inc. She is best known for her unusual color combinations and, together with contemporaries **Bonnie Cashin** and **Clare McCardell**, for creating the **American Look**, which was promoted during the 1940s and 1950s by **Dorothy Shaver**, the president of **Lord & Taylor**, and **Virginia Pope**, the *New York Times* **fashion journalist**.

POWER SUIT. *See* ADRIAN, GILBERT; ARMANI, GIORGIO; MUGLER, THIERRY; INTIMATE APPAREL.

PRADA. Founded in Milan in 1913 by Mario Prada and his brother, the company was originally called Fratelli Prada (Prada Brothers). In their opulent **boutique**, Galleria Vittorio Emmanuelle, they sold such luxury items as Austrian crystal, silver from London, Hartman **leather** goods, and their own shoes, leather handbags, and trunks made out of durable walrus skin. With the advent of air travel, Prada began manufacturing luxurious lighter-weight leather suitcases and handbags, which were sold to rich Americans and European aristocrats.

After Mario's death in 1978, the company was run by his daughter and went into decline until his granddaughter, Miuccia Bianca Prada, took over. Miuccia, who holds a doctorate in political science, spent five years studying mime at Milan's Teatro di Piccolo. In her thirties, she was a registered Communist and seemed an unlikely candidate to move the company forward. However, her unique fashion sense, based on nonconformity, was the secret to her success. During the 1970s, she started making black nylon backpacks but it was not until 1985, when she created her famous high-priced, black nylon waterproof handbag (made out of a material known as "Pocone") with its silver triangle **logo**, that Miuccia catapulted to fame. She and her husband Patrizio Bertelli transformed the company by creating younger, hipper bags and shoes and, in 1989, **ready-to-wear**.

Her collection was in sharp contrast to her contemporaries in that it was not sleek nor sexy à la **Gucci** but rather intelligent, eclectic, and in her own words "Prada Ugly." In 1992, Prada launched a less expensive line, **Miu Miu** (Miuccia's nickname). In 1993, Prada won the **Council of Fashion Designers of America** International Award for Accessories and, in 1995, the Designer of the Year Award. By the end of the 1990s Prada had become a fashion empire rivaling **Moët Hennessey Louis Vuitton (LVMH)** and **Pinault-Printemps-Redouté (PPR)**, with a stable of acquisitions: Church Shoes, Helmut Lang, **Azzedine Alaïa**, Byblos, Jil Sander, and **Fendi** (with whom they partnered with LVMH to acquire). However, by 2006, due to rising debt, Prada Holding was forced to sell off Byblos, Jil Sander, Helmut Lang, Church's, and Fendi. Today the Prada and Miu Miu collections are highly regarded in the fashion community for their innovation and originality as evidenced by their "epicenter" store designed by famed intellectual architect Rem Koolhaus in New York's SoHo district, replete with **radio frequency identification (RFID)** technology designed by IDEO (a "cool" Silicon Valley industrial design firm). The *Wall Street Journal* has named Miuccia Prada one of the thirty most powerful women in Europe.

PREPPY LOOK. This trend in men's and women's fashion popularized in the 1950s in the United States was borrowed from clothing worn by students in private or prep schools consisting of chino pants or a-line skirts, Ivy League shirts, **cashmere** or **wool** sweaters, penny

loafers, and pony tails for women and crew-cut hair for men. It was synonymous with elitism, traditional Americana, and high quality.

PRINTEMPS. A **department store** founded in 1865, in Paris by Jules Jaluzot. In 1991, the **Pinault-Printemps-Redouté (PPR)** group bought Printemps and divided it into five universes: Beauty, Art of Living, Fashion, Accessories, and Men. The store's façade and Art Nouveau Cupola are classified as historical monuments. In 2006, PPR sold Printemps to Italy's La Rinascente department store group.

PRIVATE LABEL. Beginning in the mid-1980s, in an effort to improve margins, reduce prices, and achieve product differentiation, retailers began to assume the role of **manufacturer** or **jobber** by offering apparel under their own "private" label. The downsides for retailers are that **markdown money** is not there and they have inventory ownership and management issues to deal with, which in turn can drag down their bottom lines. However, opening their own retail **outlet stores** has solved that problem.

In the early days, there were several techniques used by **department stores** to create private-label merchandise. The first involved store **buyers** visiting overseas factories and creating **knock-offs** of styles already being produced for specific manufacturers, sometimes only changing a fabric or detail, then bringing it in under an "especially made for . . ." label or under their own "created" label. Another way was to knock-off a "big seller" from a national **brand** the following season. Or, retail buyers could make shopping trips to Europe, buy original store merchandise, and then have a contractor, a private-label contractor, or a manufacturer copy it for them, under their own label. In the mid-1990s, some department and **specialty store** chains realized how lucrative the private-label business could be and invested in the research and development process by creating their own **product development** teams equipped with a **product development manager, designer or product developer, products buyer, technical designer,** specification writer, and **production manager.**

Having recognized the value of creating **brand image,** many stores invented their own brand names for their private-label merchandise.

Examples of successful store brands are **Macy's** I.N.C. and Alfani labels; **J. C. Penney's** Arizona **Jeans** and Worthington lines; **Target's** Xhileration, Merona, and Cherokee brands; Marshall Field's Field Gear clothing; and Jacobson's Take Five, Take Five Sport, and Leyla Mitra labels. Even high-end stores offer private-label merchandise such as **Barneys New York** and **Saks Fifth Avenue** with The Works, Real Clothes, and Saks Fifth Avenue Collection. Some stores **license** designers' names to promote their private-label merchandise, such as Target's **Isaac Mizrahi** and Luella Bartley collections and **J. C. Penney's** Nicole by **Nicole Miller**.

Private-label merchandise has helped shift power to the **retailer** in the industry and store brands are perceived as major threats to national brand manufacturers and private-label manufacturers alike. Kellwood, founded in 1961 as a private-label firm to **Sears**, has had to diversify and is now a $2.4 billion volume private-label producer and licensor of numerous national brands. Cyne Design, which began manufacturing private-label merchandise for Ann Taylor, The Limited, Express, and Casual Corner also has diversified as retailers are cutting out the middleman and going vertical, that is, going from manufacturing to retail. Private-label brands are priced some 15–20 percent lower than national brands and, in 2006, private-label merchandise accounted for between 15–50 percent of the merchandise mix at major American department and specialty chain stores. The future of fashion is most definitely in the hands of the retailer.

PRIVATE LABEL PRODUCT DEVELOPMENT MERCHANDISE MANAGER. While mostly a sales-driven position, this person must possess the ability to solicit new accounts and service existing accounts. He/she works directly with **retail** and/or **catalog** companies developing product for their **private label** business and follows up on private label programs from concept to shipping.

PRODUCT DATA MANAGEMENT (PDM). PDM is software technology designed to manage data associated with developing a product, such as testing and specifications, as well as a garment's measurements, fabrics, **trims**, and construction details. *See also* GERBER TECHNOLOGY; LECTRA.

PRODUCT DEVELOPER. Developers are responsible for working directly with stores or with the design staff on conceptualizing the item or line. They conduct buy meetings, manage the sample approval process, store communication, and order follow-up. *See* PRIVATE LABEL; PRODUCT DEVELOPMENT.

PRODUCT DEVELOPMENT. Product development is the process of producing product from concept to creation. While the term *product development* refers to the procedure that **retailers** adhere to in creating product or **private label** merchandise, the process is somewhat the same for **designers** in the design and manufacturing side of the fashion industry. The process begins approximately one year in advance of the season for which the merchandise will be sold at retail (or "on the floor"). The larger the store or company, the bigger the volume, therefore the more lead time is needed to manufacture product. **Designers, design directors, merchandisers,** and **textile** and **color specialists** will begin by researching what the predicted colors, textiles, prints, and trends will be for that particular season using available color and **forecast services.** The team will also attend trade shows for color, fabric, yarn, and trend directions from Europe, America, and Asia. Once this information is gathered, concept or theme boards are created establishing the design direction for that season. The design team then makes a presentation to the product merchandisers (in the case of a retail organization) or to the sales team (in a wholesale manufacturing scenario). Samples of the collection are made either in a design room or **"tech packs"** are compiled and sent to factories where first samples are made. Tech packs include the original sketch with a technical drawing, which provides specific fabric, color, **trims,** size specifications, and any other pertinent design details. Target prices are agreed to before the product sourcing team chooses the appropriate fabric mill and sewing contractor. Once the first samples are sewn, they are reviewed and fit on a **fit model** for any necessary changes or adjustments. The editing process takes place before production patterns are executed, then labor and material prices are finalized, fabric and manufacturing contracts are signed, and cutting tickets are written. Once the product goes into production, it is delivered in the fastest turnaround time possible. **Production managers** are responsible for production scheduling and flow, quality control, and meeting delivery due dates.

PRODUCT DEVELOPMENT MANAGER. The product development manager oversees the development of products from conceptual stages to market introduction. He oversees **product development**, explores opportunities for product extensions, works with the sales force and key customers, and manages and monitors inventory.

PRODUCTION MANAGER. The production manager oversees the entire process and scheduling of all garment manufacturing operations. He or she also directs production assistants in the purchasing of **trims** and piece goods, monitors inventory, prepares cutting tickets, and maintains production records.

PRODUCT LIFECYCLE MANAGEMENT (PLM). This is computer software designed to manage the product lifecycle process of garments from **product development** through to production. PLM builds on a related category of software, **product data management (PDM)**, which preceded it.

PRODUCTS BUYER. This person's duties include product sourcing and research, **product development**, tracking of sales and inventory, and **private label** negotiations. He/she must possess strong negotiation tactics, conceptual knowledge of inventory level projection and control, and strong communication as well as computer skills.

PROENZA SCHOULER. Lazaro Hernandez (born in Miami of Spanish/Cuban parents in 1978) and Jack McCollough (born in Tokyo in 1978 and raised in New Jersey) met at the **Parsons School of Design** in 1999. After internships at **Michael Kors** (Hernandez) and **Marc Jacobs** (McCollough), the pair were discovered at their senior school show when the then-president of the **Council of Fashion Designers of America (CFDA)**, Peter Arnold, introduced them to **Barneys New York**. They had their first professional runway show in 2003, with backing from German venture capitalists, and received rave reviews. Their clothes are inspired by **designers** of the past such as **Coco Chanel, Cristòbal Balenciaga,** and **Christian Dior** and are refined and well constructed. In 2003, they won the CFDA Perry Ellis Award for new talent and launched a shoe line under **license** with

Iris, an Italian **manufacturer**. In 2004, they won top honors from the CFDA/Vogue Fashion Fund and, in 2005, they launched a limited watch collection for Movado.

PROJECT ALABAMA. Founder Natalie Chanin, born in Florence, Alabama, founded the company in 2001 after a stint as a stylist in the film industry. Manufacturing is done using women who are expert in handicrafts. Best known for layered **T-shirts**, patchwork and appliqués, and affordable clothing, the collection was first shown on the runway in New York with the help of the Ecco Domani Fashion Foundation. The company formed a partnership with Italian **manufacturer** Gibo, in 2004.

PROMOTION DIRECTOR. This person is in charge of the **sales promotion** and marketing division of a retail store or chain of stores. This division includes advertising, **visual merchandising**, and public relations.

PROTECTION ARTISTIQUE DES INDUSTRIES SAISONIÈRES (PAIS). This anticopying group, headed by Armand Trouyet of **Vionnet** et Cie, formed in Paris in 1930. The organization succeeded in conducting **counterfeiting** raids and bringing about laws that pertained to the illegal copying of designs from the **couture**. A landmark case involving **Vionnet** and **Chanel** against **copyist** Suzanne Laneil ruled that **couturières** were entitled to the same copyright protection in France as artists and writers. *See also* ASSOCIATION POUR LA DÉFENSE DES ARTS PLASTIQUES ET APPLIQUÉS; SOCIÉTÉ DES AUTEURS DE LA MODE.

PSYCHEDELIC FASHION. This clothing during the 1960s was influenced by **hippie** pop culture and the use of the drug lysergic acid diethylamide, or LSD, also referred to as acid. The heightened awareness of color and texture while on the drug resulted in surrealistic, optical, oscillating, and pulsating designs and patterns, which included tie-dye. **Designers** jumped on the trend and created some of the most avant-garde creations such as Diana Dew's **vinyl** dress that "turned-on" (a popular **hippie** term) in sync with music and was quite popular with the disco set. The trend, which started as a grass-

roots movement, eventually made its way into the top echelons of the fashion chain with **Yves Saint Laurent**, **Pucci**, and **Halston** creating prints and expensive clothing with psychedelic overtones. The trend ebbed in the early 1970s but resurged in the 1980s when the look appealed to a new youth culture group.

PUCCI, EMILIO (1914–1992). Pucci was born the Marchese di Barsento a Cavallo in Naples, Italy, to an aristocratic family. Pucci was educated first at the University of Georgia in Athens, Georgia, and then at Reed College in Portland, Oregon, where he went on a skiing scholarship. He then completed his doctorate in political science at the University of Florence, graduating in 1941. Pucci's fashion career arose out of his love of skiing as he had been a member of the Italian Olympic Ski Team in 1934 and designed his own ski clothes. In 1947, Toni Frissel, a *Harper's Bazaar* photographer, took pictures of Pucci wearing his own skiwear while skiing in Zermatt, Switzerland. The photos were shown to the head **buyer** at **Lord & Taylor**, Marjorie Griswold, who asked him to design them for the store, and to *Harper's Bazaar* fashion editor, **Diana Vreeland**, who featured them in the magazine in 1948.

Pucci opened a **boutique** in 1950 on the Isle of Capri and is credited with creation of the Capri pants. He is best known for his colorful engineered prints that offer multicolor swirling, often geometric, kaleidoscopic patterns. Pucci has been dubbed the "Prince of Prints." His participation in the first Italian Designers fashion show in 1951, at the Pitti Palace in Florence, gained him the attention of high-end retailers **Neiman Marcus** and **Saks Fifth Avenue**, who not only loved his fitted **silk** jersey shirts and Capri pants, but his aristocratic roots. Pucci won the coveted Neiman Marcus Award, once in 1954 and again in 1967. At the insistence of Marjorie Griswold, Pucci signed his name, Emilio, to all of his print designs to differentiate his work from the numerous copies. In addition to his fashion career, Pucci was also a well-known fascist and was elected to the Italian Parliament in 1965.

Between 1965 and 1977, Pucci created flight attendant uniforms for Braniff Airways and in 1974, for Quantas Airways. Pucci's signature style was easily recognizable and was sought after by famous women including Marilyn Monroe, who was actually buried in a

Pucci. By the early 1970s, the Pucci look began to fade but came back into style in the early 1990s. Upon Pucci's death in 1992, his daughter, Laudomia, and his wife, Cristina, took the helm. In 2000, the French conglomerate **Moët Hennessey Louis Vuitton (LVMH)** acquired the rights and hired **designer** Julio Espada and later **Christian Lacroix**. In the same year, Pucci was awarded the Fashion Excellence award from the International Apparel Mart in Dallas. In 2006, British designer **Matthew Williamson** took over as **creative director** with Laudomia as image director.

PULITZER, LILY (1931–). Lillian Lee Kim was born in Old Westbury, Long Island, and married publishing icon Peter Pulitzer. She became famous when one of her dresses was worn by First Lady Jackie Kennedy in the early 1960s. The company grew to consist of a chain of stores in the 1960s and 1970s. The stores closed in 1984 but, due to a resurgence of all things 1960s, Lilly Pulitzer was revived in 1993. Today there are more than 77 stores nationwide. She is best known for her Palm Beach look consisting of vividly patterned prints and resortwear.

PUMA. Adi and Rudolf Dassler began making sports shoes in Herzogenaurach, Germany, in the 1920s. They tapped the advice of coaches, trainers, athletes, and doctors to create shoes for running, football, and tennis. Throughout the years their shoes were worn by many prominent athletes but, in 1948, the brothers severed their partnership. Adi went on to form **Adidas** while Rudolf started **Puma**. Today, Puma is one of the top ten sport shoe **manufacturers** and in the rush to keep up with the competitive **sneaker** industry, has hired top designer Philippe Starck to create a line of high-end sneakers. *See also* FOOTWEAR.

PUNK STYLE. A fashion movement that had its roots in the music world and, although it was believed to have started in New York City in the 1970s, historians now agree that it began sooner. Andy Warhol's Factory in the mid-1960s, the pop art movement, and the hippie movement that followed were incubators that set the stage for the next **baby boomers'** rebellion, punk. The Lower East Side in Manhattan was the hub of the music scene at the time with clubs

like Max's Kansas City, CBGB, and Mother's, where bands like the Velvet Underground, the Stooges, the New York Dolls, and Patti Smith performed.

Later, punk appeared in Great Britain with groups like the Sex Pistols, with band member names like Johnny Rotten and Sid Vicious, and the Ramones, as part of the punk antiestablishment, working-class aesthetic. At first clothing was influenced by the American musicians who adopted black as their uniform. However, once British "glam rock" crossed the Atlantic, and Malcolm McClaren became the manager for the New York Dolls, he and his designer wife **Vivienne Westwood** defined the punk **dress code**. Their first shop on Kings Road, called Let it Rock, was followed by Too Fast To Live, then Sex, then Seditionaries, and the last one was called World's End. Westwood's punk style involved the use of bricolage, such as safety pins, ripped **T-shirts**, bondage trousers, and antiestablishment sloganed T-shirts and jackets. Black **leather** motorcycle jackets, black pants, **Doc Marten** work boots, body and facial piercing, crazy colored spiked hair, and mohawk haircuts were trademarks of "high-punk." By the late 1970s, punk was overly commercialized, resulting in its demise. However, the core belief of the punk movement lived on in all of the youth culture movements that followed, namely **grunge** and **hip-hop**. *See also* RHODES, ZANDRA.

– Q –

QUALITY ASSURANCE MANAGER. This person controls all aspects of production quality for a manufacturer or retail establishment. His/her responsibilities may include any or all of the following: garment specing, spec sheet creation and distribution, garment and fabric examination, and garment assembly issues, as well as compliance of industry standards. Significant travel is required for this position.

QUANT, MARY (1934–). Born to Welsh parents in London, Quant was educated at Goldsmith's College where she studied illustration. Her first job was as a milliner's assistant. After her marriage to Alexander Plunket Greene in 1955, they, together with their accountant, Archie McNair, opened a store on Kings Road called Bazaar. With

only a few evening pattern-cutting classes under her belt and no formal training as a **designer**, Quant began making clothing for her shop in 1958, specifically short skirts, which she named after her car, the Mini. Although there is disagreement as to who actually invented the **miniskirt**, Quant or **André Courrèges**, Quant was the first to trademark it. Similarly, she is also credited with being the first to offer colored pantyhose to match her clothing designs; however, this is also attributed to **Cristòbal Balenciaga**. No matter who was the first, Quant was known for her interest in the **mod** youth subculture of the early 1960s and for her shop that was the hub of the "Chelsea Set" of "Swinging London."

Quant created a black, five-petal daisy **logo** that would be her worldwide trademark She was the first designer to use **polyvinyl chloride (PVC)** for clothing and, in 1962, partnered with **J. C. Penney's** to create a less expensive line called the Ginger Group. By 1965, she was exporting her mod fashions to the United States; she opened a second store in Knightsbridge, a cosmetics line in 1966, and a third store on New Bond Street in 1967. In the late 1960s, she created her last big fashion statement, "hot pants." During the 1970s and 1980s, she concentrated on her makeup and household goods line. Quant's publications include *Color by Quant* (1984), *Quant on Make-up* (1986), and *Classic Make-Up and Beauty Book* (1996). Her awards include the Order of the British Empire in 1966, the Annual Design Medal of the Royal Society of Arts in 1967, the Hall of Fame Award for Outstanding Contribution to British Fashion by the British Fashion Council in 1969, and the British Council's Award for Contribution to British Industry in 1990; she became a fellow of the Society of Industrial Artists and Designers in 1993. In 2000, Quant sold her cosmetics firm to a Japanese company, which sells the line in more than 200 Mary Quant shops throughout Japan, as well as in New York, London, and Paris.

QUICK RESPONSE (QR). This is the term given to the ability to shorten the time frame from product concept to consumer. This is accomplished by making decisions based on up-to-the-minute information provided by business software systems designed for this purpose.

QVC. Joseph Segal founded QVC in 1986 as a home shopping network that originally aired on fifty-eight national cable television systems

in twenty states. The name is an acronym for "Quality, Value, Convenience." Today QVC broadcasts in four different countries to approximately 141 million viewers in the United States, Japan, Germany, and Great Britain. It also operates its own website, sales, and a series of retail stores in the United States and Britain.

– R –

RABANNE, PACO (1934–). Born Francisco Rabaneda y Cuervo in San Sebastian, Spain, he and his mother fled to France in 1939, during the Spanish Civil War, after his father was executed by Francisco Franco's regime. Rabanne studied architecture at the École nationale supérieure des Beaux-arts and, in 1963, won an award for his garden sculpture, which was exhibited in the Museé d'art moderne de la ville de Paris. As a student in the 1950s and 1960s, Rabanne sold drawings of handbags to Roger Model and drawings of shoes to **Charles Jourdan**. He designed dresses under the name Franck Rabanne, which were published in 1959 in *Women's Wear Daily*. Rabanne and his mother, a former seamstress at the house of **Balenciaga** in Spain, had a small business producing unusual buttons and embroideries for **couture** houses in Paris until 1966. In 1965, Rabanne created oversized jewelry in bright colors using untraditional materials that was featured in the collections of **Givenchy**, **Dior**, and Balenciaga, which gained him media attention. In 1966, he showed his first collection in Paris, Twelve Unwearable Dresses in Contemporary Materials, and his reputation as France's enfant terrible was sealed.

Rabanne was famous for the use of unconventional materials such as coconuts, rhodöid discs, paper, plastic paillettes, wood, laser discs, the patented Giffo process of molding buttons and pockets into a garment block, and his signature metal ring seaming techniques. His designs were in great demand for their artistic and innovative character and for their space-age **futuristic** look. He was also a favorite **costume designer** of the theater, ballet, and cinema. His costumes for the movie *Barbarella*, in 1968, are legendary as were his chain mail dresses for the film *Who Are You, Molly Magoo?* As is the case with most **designers** of his stature, Rabanne created a line of **fragrances** beginning in 1969 with Calandre.

In 1991, Rabanne published a book on paranormal phenomena called *Trajectoire*, a subject that he would often write about. His other books are *El Fin de Los Tiempos* (1995), *La Iluminación del Budismo* (1997), *Dawn of the Golden Age: A Spiritual Design For Living* (1999), and *Journey: From One Life to Another* (1999). Rabanne closed his couture and unisex Paco business in 1999 but continued his many **licenses** and fragrances. The Puig Group, a Barcelona-based beauty and fashion conglomerate, reopened the **ready-to-wear** collection in 2000 with Rabanne and Spanish designer Rosemary Rodriquez. In 2006, American designer Patrick Robinson replaced Rodriquez as **creative director**.

RADIO FREQUENCY IDENTIFICATION (RFID). This is the term for a technology that uses radiowaves to automatically track or identify objects or people. A microchip containing a serial number is attached to an antenna that transmits identification information to a reader, which in turn digitally passes it on to a computer. Retailers such as **Wal-Mart** use this technology to track goods within their supply chain to manage inventory and stock-outs.

RATIONAL DRESS SOCIETY. This was a group founded in London in 1881 whose goal was to protest and seek reform against the introduction of any fashion in dress that either deformed the figure, impeded the movements of the body, or in any way tended to injure health. It protested against the wearing of tightly-fitting corsets, high-heeled shoes, and heavily weighted skirts that impeded the movements of the arms and render exercise impossible. Their mission raised women's awareness to dress healthily, comfortably, and beautifully, as a duty to themselves and each other.

RAYON. Rayon is a fiber made from regenerated cellulose fibers obtained from **natural** materials. Created in 1855 by the Swiss chemist Georges Audemars, it was known as "artificial **silk**."

READY-TO-WEAR (RTW). This is the term given to clothing that, unlike **made-to-measure**, is designed either for commissioned consumption (as in uniforms) or speculative sale at the **retail** level. When pertaining to retail consumption, another common term is

"off-the-rack" or "off-the-peg." Evidence of speculative production can be traced as far back as ancient Babylonia. **Guilds** in the Middle Ages and during the **Renaissance** tried to restrict **mass production** but, by the late 1600s, their power ebbed. Records of preindustrial commissioned consumption exist throughout England, France, Italy, Belgium, and Spain, with one of the earliest being the British Navy's commission of uniforms in 1666. As preindustrial international trade flourished during the 1700s, merchant houses traded ready-made clothing between the United States, China, and Europe. The American Civil War provided statistics for men's sizing and the invention of the tape measure (1820) helped in **standardizing sizing** measurements. However, the invention of the **sewing machine** by **Elias Howe** (1846) and the electric sewing machine by **Isaac Singer** (1889) not only made mass production possible but provided unskilled workers with the chance to work in a factory production line, sewing a piece of the garment (known as piecework) rather than the whole garment, which required much more skill in **tailoring** and/or **dressmaking**.

By the end of the nineteenth century, New York City was the hub of ready-to-wear in the United States, especially fueled by the number of **department stores** and mail-order **catalogs** that sprung up in the mid-1800s. After World War II, the European **haute couture** houses **Christian Dior**, **Hubert de Givenchy**, and **Jacques Fath** recognized that ready-to-wear was the future of the industry. Rather than continue being copied, they signed lucrative **licensing** deals with American **manufacturers** to produce less expensive lines. Other **designers** followed suit and the first prêt-à-porter show was held in Paris in 1973. Designer's ready-to-wear collections bring a much bigger return on investment than their couture collections. Most companies that manufacture ready-to-wear present their collections twice a year during *fashion week*, namely, in February, they show their Fall merchandise and, in September, they show their Spring merchandise. Couture is shown in January for Fall collections and July for Spring.

REARD, LOUIS (1897–1984). A French mechanical engineer who designed the **bikini** bathing suit in Paris, in 1946. While two-piece bathing suits had been invented prior to Reard's, his was exceptionally skimpy and it was he who called it the "bikini."

REEBOK. Joseph William Foster of Great Britain made a business of creating handmade running shoes in 1895 that were later worn in the Olympics of 1924. In 1939, he founded the company known as J.W. Foster & Sons. In 1958, two of the owner's grandsons started a companion company they called Reebok, named after an African gazelle. In 1979, Paul Fireman negotiated the **license** for North American distribution; three years later Reebok came out with the Freestyle, a women's athletic shoe, to satisfy the fitness craze. In the late 1980s, the Reebok Pump line was introduced and the company expanded to include the rights to manufacture sideline apparel for the National Football League, National Basketball Association, National Hockey League, Canadian Football League, and Major League Baseball. Reebok's successful marketing and innovation ranked it as the number three **brand** in the athletic **footwear** industry—that is, until Paul Fireman sold Reebok to **Adidas** in 2005, making it the number two brand, with **Nike** as number one. *See also* PUMA; SNEAKERS.

REESE, TRACY (1963–). Born in Detroit, Michigan, Reese began her career as assistant designer for Martine Sitbon, after graduating from the **Parsons School of Design** in 1984. From 1987 to 1989, she designed her own collection of contemporary women's clothing but closed it in 1990 to design a **bridge** collection for Magaschoni. In 1992, she launched her own collection, Tracy Reese for Magaschoni, and had her first runway show. Her collection was considered feminine and romantic with **vintage** overtones. In addition to the Tracy Reese line, she also produced "Plenty" by Tracy Reese and a home collection.

REGIONAL SALES REPRESENTATIVE. A sales representative hired by a manufacturer to sell their collection to retail stores within that region or territory is known as a regional sales rep. Many manufacturers have regional sales reps in different cities who help increase the amount of sales outside of their own showroom in places like Dallas, Los Angeles, and Chicago. Regional sales representatives work on a commission basis, often requiring showroom participation fees from each of the manufacturers that they represent.

RENAISSANCE. This time in history is known as the *rebirth* of art and science (French). The movement is believed to have originated

in Florence, Italy, at the end of the Middle Ages, during the mid-1300s, and spread in the late fifteenth century to France, Poland, and Hungary, and finally to England, Germany, Scandinavia, and Central Europe by the late sixteenth century. The Italian Renaissance was an age when a prosperous society reconnected to its ancient past and, through rediscovery, applied knowledge to intellectual activities in the arts and sciences. This knowledge resulted in an explosion of inventions in printing technology and in new techniques in art, architecture, and poetry, which were disseminated throughout Europe by way of commerce. The Italian Renaissance is referred to by historians as the beginning of the Modern epoch or the Early Modern period, since the focus shifted from spirituality, popular in the Middle Ages, to humanism. Artists and artisans worked in collaboration, many under patronage of the rising wealthy class.

Renaissance fashion is clearly recorded in the number of artists' paintings of the period depicting rich velvets, ornate brocades, and elaborate embellishments that were used in both men's and women's clothing. In the Early Renaissance, due to Italy's proximity to the Middle East, clothing styles were heavily influence by their Eastern neighbors. When Catherine de Medici (Italian) became Queen of France (1547–1559), she had an impact not only on gastronomy, but is credited with commissioning the first pair of high-heeled shoes and with the invention of lip gloss, and, perhaps her most famous edict, of enforcing a ban on "thick waists" worn at court, so that for the next 350 years women wore laced-up corsets made of whalebone or metal that cinched in their waists to 17 inches or less.

The English Renaissance, known as the **Elizabethan Period**, brought the flowering of English art, poetry, literature, and William Shakespeare, among others. In terms of fashion, the reign of Queen Elizabeth I (1558–1603) was more influenced by the Spanish and French Renaissance than the Italian. The farthingale (a supporting device worn under skirts), square necklines, and ruffs worn at the neck (by both men and women) were fashionable items of that period which were passed to the English from Queen Isabella of Spain. The Renaissance was followed by the period known as the Enlightenment in the seventeenth century.

RESIDENT BUYING OFFICE. A resident **buying office** works with a number of individual specialty stores and their **buyers** and acts

in an advisory capacity, although they may buy directly for a store. Their primary responsibility is trend prediction and merchandising. They are either private buying offices or independent buying offices. *See also* CENTRAL BUYING OFFICE.

RETAILER. A retailer is a person or group that owns and/or operates a retail store or stores. The earliest retailers were those who sold their merchandise from their small store or **catalog**. Today's retailers run the gamut from **mom-and-pop** stores to **department stores, specialty stores, chain stores**, off-price stores, and **mass-market** stores. Some are large corporations with hundreds of stores worldwide and huge buying power. Retailers such as **Target, Gap, Macy's, Kmart, Wal-Mart**, and **H&M** dominate the market and have even entered the world of **e-tailing**. It has become harder for the small retailer to exist in such a competitive environment.

RETRO STYLES. *Retro* is the term given to a design or style that has its roots or inspiration in the past. **Designers'** collections are often referred to as having a "**vintage** look" if they rely too heavily on styles of an earlier time period for inspiration.

RETURN-TO-VENDOR (RTV). This is the term used when a retailer sends merchandise back to the vendor for reasons such as inferior quality, poor fit, poor sell-through, or late shipment.

R.H. MACY'S. *See* MACYS.

RHODES, ZANDRA (1940–). She was born Zandra Lindsey Rhodes in Kent, England, to a mother who was a fitter for the House of **Worth**, who later became a teacher at Medway College of Art where Zandra would later study textiles. Rhodes continued her studies at the Royal College of Art and graduated in 1964, before opening her own print studio. Since her print designs were a bit avant-garde for most British **manufacturers**, she and fellow graduate Sylvia Ayton established their own clothing store in trendy West London on Fulham Road (backed in part by actress Vanessa Redgrave). They were known for their tattoo transfer prints and paper dresses. After closing the store after only one year in business, Rhodes began **freelance**

designing and, in 1969, caught the attention of **Henri Bendel**, *Vogue*, and ***Women's Wear Daily***. Soon her signature, avant-garde printed clothes were favored by Natalie Wood, Liza Minnelli, Bianca Jagger, Tina Chow, Jackie Onassis, Princess Anne, and Princess Margaret.

Rhodes's Conceptual Chic collection of 1977, in which she created clothing with inside-out seams, torn effects, and jeweled safety pin embellishments, earned her the name of the Queen of **Punk**. She is most known, however, for her loose, almost monastic clothing shapes and extravagant prints, which are often embellished with embroideries, beads, feathers, and sequins. Her pink hair and face paint were also part of her look. As style in the 1980s became suit driven and the 1990s was more about sleek and chic, Rhodes's clothing fell out of favor and she was forced to close her business. However, she diversified her business by branching out into home products, textiles, glassware, and terazzo. Her terazzo designs won her the National Terazzo and Mosaic Association Award in 1998. Among her other awards and honors are honorary doctorates from the Royal College of Art and other universities and she was named a Commander of the British Empire in 1997. In 2001, she designed costumes for the San Diego Opera and, in 2003, opened the Fashion and Textile Museum in London.

RICCI, NINA (1883–1970). Born in Turin, Maria Adelaide Nieli (nicknamed Nina), left Italy for Paris and at the age of sixteen became a seamstress at the **couture** house Maison Raffin. In 1899, she married Luigi Ricci, a Florentine jeweler, and two years later was promoted to a "première d'atelier." Upon the death of the company's founder in 1929, she left the house and, with the encouragement of her son Robert Ricci, she opened her own house in 1932. Known as the architect of gowns, she occupied eleven floors and had 450 women working at her **atelier** before the outbreak of World War II. After the war, her son Robert, the vice-president of the **Chambre Syndicale**, organized an exhibition of dolls from fifty-three designers, known as the Théâtre de la Mode, which helped promote French fashion and **accessories**, and which later toured New York, London, and Los Angeles. In 1940, Ricci launched her first **fragrance**, Coeur Jolie, packaged in a Laliqué bottle. More than ten fragrance and beauty lines followed through the years, but none as popular as L'Air du Temps, which was created in 1950 and remains one of the best-selling fragrances in the world.

Designer Jules Francois Cahay took the helm at Ricci in 1954, and, in 1960, it was the first couture house to sign a **licensing** agreement in Asia. In 1964, Gerard Pipart was hired as **creative director** and, in 1970, Nina Ricci died at the age of eight-seven. The house continued to prosper, adding a women's **ready-to-wear** collection in 1979 and a **menswear** line in 1986. However, most of the revenue was generated by the fragrance business. In 1988, upon son Robert's death, the house was bought by French pharmaceutical giant Sanofi. In 1998, it was sold to the Barcelona-based beauty and fashion conglomerate, the Puig Group. Designer Lars Nilsson was hired as creative director for the collection in 2003 but was replaced in 2006 with Belgian designer Olivier Theyskens.

RITTS, HERB (1952–2002). Born in Los Angeles to a wealthy family in the furniture business, Ritts attended Bard College in upstate New York and graduated in 1974 with an economics degree. He returned to Los Angeles and worked as a sales representative at the family business while taking evening classes in photography. His first photographic assignment came in 1978 when he made stills on the set of *The Champ*; his big break came in 1979, when a friend introduced him to then-unknown actor Richard Gere, for whom he did a series of portraits in the desert. When Gere rose to stardom a year later, it was in part due to the sensual and gritty photos taken by Ritts which were used as publicity shots and then appeared on numerous national magazine covers. During the 1980s and 1990s, Ritts worked with *Harper's Bazaar*, *Rolling Stone*, *Vogue*, and *Vanity Fair*. His photography appealed to the young media-conscious audience of the 1980s. Edgy ads for the **Gap** and other clients such as **Guess**, Revlon, **Cartier**, **Calvin Klein**, **Ralph Lauren**, **Versace**, and **Donna Karan** made him a much sought-after advertising photographer. In addition to fashion, Ritts photographed numerous celebrities, including the Dalai Lama, Cindy Crawford, Jack Nicholson, Elizabeth Taylor, and Ben Affleck. He is credited with creating Madonna's image on her album covers *True Blue* and *Papa Don't Preach* as well as her "Cherish"(1989) music video. In 1991, he won an MTV Video Music Award for Janet Jackson's "Love Will Never Do (Without You)" and Chris Isaak's "Wicked Game." Ritts's work has appeared in several museum exhibitions and in numerous publications. His books include *Africa Vol. 0*, *Notorious*,

Duo, Men and Women, Herb Ritts, Herb Ritts: Work, Herb Ritts: Pictures, Kaz, and *Stern Portfolio: Body Art and Work.* He is best known for his black-and-white glamour photography, with its roots in classical Greek sculpture, and for his sensual male and female nudes.

ROCAWEAR. This **hip-hop** sportswear company was founded in New York in 1999 by rap star Shawn "Jay-Z" Carter, music producer Damon Dash (Roca-A-Fella recording label), and Norton Cher. Rocawear began as a men's clothing company but later added women's and two spin-offs: State Property, a workwear and military-inspired label that was formed with rapper Beanie Seigel and Dash, and Team Roc, an athletic-inspired label. In 2004, Rocawear signed a **licensing** deal with Stride-Rite to revive Pro-Keds **sneakers.** In 2005, Dash severed his ties with Rocawear and took the State Property and Team Roc lines with him.

ROI, ALICE (1976–). A native New Yorker, Roi studied fashion at the **Parsons School of Design.** After graduation, she worked as an **assistant designer,** then did a short stint at the **Fashion Group** archives and worked as an intern at *Elle* magazine. She opened her own company in 1999 and showed her collection in New York as part of the designers chosen by Moët & Chandon. Roi is known for her hip design style and was nominated for the **CFDA**'s Perry Ellis Award for **womenswear** in 2001.

ROWLEY, CYNTHIA (1968–). Born in Barrington, Illinois, Rowley graduated from the Art Institute of Chicago before starting her own company in 1983. She is known for her fun, nostalgic dress designs often done in plaids and colorful prints. Rowley operates shops in New York's SoHo, Chicago, Los Angeles, and Tokyo and has licenses for sunglasses and a **knitwear** line. She is a recipient of the **CFDA**'s 1995 Perry Ellis Award for New Fashion Talent. Rowley added to her quirky fashion sensibility by partnering, in 2005, with the Tupperware Corporation, a leading direct-sales food-storage company, to produce a line of **accessories.**

RUB-OFF. This is the act of extracting and copying the pattern of a particular garment or item. Some manufacturers will purchase a gar-

ment at retail and, using chalk and muslin, "rub-off" the seams onto the muslin in order to steal the pattern of that garment. This process is much faster than trying to make the pattern from scratch. Manufacturers will often return the garment to the store for a refund after they have stolen the design/pattern. *See also* COPYIST; KNOCK-OFF.

RUCCI, RALPH (1957–). Born in South Philadelphia and trained at the **Fashion Institute of Technology**, Rucci began his career working for **Halston** in 1980. After producing his first show in 1981, which failed to solicit orders, he closed his business but then reopened in 1993 under the name Chado. Ralph Rucci is the first American designer, since **Mainbocher**, to show **couture** in Paris as part of the **Chambre Syndicale**. In 2006, Rucci was awarded the first Couture Council Award presented by the Couture Council of the Museum at the **Fashion Institute of Technology**.

RYKIEL, SONIA (1930–). Born in Paris as Sonia Flis, this woman of Polish Jewish heritage grew up aspiring to be a writer. However, after marrying Sam Rykiel in 1953, and with no formal fashion training, she began designing maternity wear while pregnant with her first child, selling them in her husband's clothing store in 1962. By 1964, her trendy poor boy–signature black striped sweaters were selling to hip New York retailers **Henri Bendel** and **Bloomingdale's**. In 1968, she opened her own Left Bank **boutique**, catering to a youthful, bohemian customer and she pioneered the boutique movement in Paris that spread throughout Europe from London. Dubbed the "Queen of Knits" by *Women's Wear Daily*, Rykiel expanded the collection to include eveningwear, **sportswear**, and **accessories**, always with a hint of wit. For example, her rhinestone "messages" plastered on jackets, dresses, and belts, and her reversed or raw-edge seaming details were considered rebellious yet were extremely popular. By 1975, she expanded her business to include household items and, in 1978, tried her hand as an interior designer, creating decoration for the Hotel Crillon on the place Vendome. With her signature red hair, high cheekbones, and regal expression, in 1980, she was chosen as one of the world's most elegant women. By 1993, Rykiel added **childrenswear**, **menswear**, shoes, **fragrances**, and lingerie to her empire.

The company is 100 percent family-owned with Sonia designing collection, her sister designing accessories, and her daughter, Nathalie, acting as **creative director** for the company and operating Rykiel Women, a store that has been selling intimate sexual toys and **streetwear** since 2002. Among Rykiel's honors are the medal of Chevalier de la Légion d'Honneur in 1985 and her 30th anniversary show at the Bibliothèque nationale de France in 1998. Rykiel served as vice-president of the **Chambre Syndicale**, sang a duet with Malcolm McClaren, and has authored seven books to date.

– S –

SACK DRESS. The "sack" dress shape was created by **Balenciaga** in 1959 based on **Norman Norell**'s chemise.

SAINT LAURENT, YVES (1936–). Born Yves Henri Donat Mathieu Saint Laurent, in Oran, Algeria, to a socialite mother and an insurance-company-manager father. He was schooled at the Collège du Sacre-Coeur, graduating in 1954, but moved to Paris to continue his education at the **École de la Chambre Syndicale de la Couture**. His interest in theatrical costume as a young boy prompted him to enter design contests, of which he won several prizes. He eventually made it to Paris. At his mother's insistence, he was introduced to the editor of French *Vogue*, Michel de Brunhoff, in 1953, who in turn introduced him to **Christian Dior**, where he landed a job as an intern in 1955. Upon the sudden death of Dior in 1957, Saint Laurent was named successor, the youngest **couturier** in the world at age twenty-one. His first collection in 1958 was not only a huge success, but reaped him the prestigious **Neiman Marcus** Award for his creation of the "trapeze silhouette." Before being drafted into the Algerian army in 1960, Saint Laurent met Pierre Bergé, his future companion and business partner. After suffering a nervous breakdown as a result of severe hazing in the military, he was declared unfit for military service.

During his military absence, the house of Dior replaced Saint Laurent with **Marc Bohan**, but upon his return and after a few unsuccessful collections, he was unceremoniously fired. He then sued and won for breach of contract and opened his own **couture** house

in 1961 with Bergé, partially financed by American businessman Jesse Mack Robinson. He showed his first collection in 1962, which was met with rave reviews, and created his first signature look, the "peacoat." Thus began Saint Laurent's fascination with gender dressing. Also during this period, the famous YSL **logo** was created by the graphic designer Cassandre; Saint Laurent also befriended dancer Rudolph Nureyev for whom he would design costumes and with whom he maintained a long-term friendship. In 1965, Richard Salomon of Charles of the Ritz bought all of the stock from Brunhoff and, the same year, Saint Laurent began producing theme-based collections. Some of the most famous are the Mondrian Collection (1965), the Pop Art Collection (1966), the Ballets Russes Collection (1976), the Chinoises Collection (1977), and the African Look Collection (1985). Saint Laurent opened his first **ready-to-wear** store, Saint Laurent Rive Gauche, with French actress Catherine Deneuve, for whom he had designed costumes for the film, *Belle de jour*.

Throughout his forty-four years in business, he is best known for dressing the modern woman with his classic blazer, peacoat, tuxedo suit ("Le Smoking"), pantsuits, raincoats, smock, and dinner and safari jackets; he is also known for pioneering his "nude look," use of cross-cultural references, and his exploration of high fantasy, gender play, and **street style**. In 1971, he shocked the world by posing nude for an ad for his men's **fragrance** Pour Homme. In 1972, Bergé bought back all of the stock from Charles of the Ritz (then a subsidiary of the pharmaceutical giant Squibb). Bergé built a **licensing** empire (200 at its height) while Saint Laurent continued designing for films, theater, the ballet, and a steady stream of ready-to-wear and **haute couture** collections. In 1982, the **Council of Fashion Designers of America** presented Saint Laurent with the International Fashion Award, the same year he celebrated the 20th anniversary of the founding of his **couture** house. His fragrance **brands** include Y (1964), Rive Gauche and Pour Homme (1971), Opium (1977), Kouros (1981), Paris (1983), Jazz (1988), Cinema (1989), Yvresse (1993), Champagne (1994), In Love Again and Live Jazz (1998), Baby Doll (1999), Nu (2001), and M7 (2002). Museum presentations include *Yves Saint Laurent 25 Years of Design* at the Metropolitan Museum of Art (the first living designer retrospective), an exhibition of his work at the Fine Art Museum of Beijing (1983), and a retrospective shown at the Musée des Arts de la

Mode (1986). He was presented the medal of Chevalier de la Légion d'Honneur (1985) and Paris Opera's Best Couturier Award (1985).

In 1986, Bergé and Saint Laurent, together with Cerus, bought Yves Saint Laurent perfumes from Charles of the Ritz for $630 million and, in 1993, the company merged with the Elf-Sanofi company. In 1998, Saint Laurent announced that he would concentrate on the couture line, while designer Albert Albaz would design the women's ready-to-wear line, and Hedi Slimane would head the men's collection. A year later, Francois Pinault bought Yves Saint Laurent from Elf-Sanofi and named the **Gucci** Group as the parent company, with **Tom Ford** as **creative director**. Ford's collection for YSL debuted in 2000 but was not well received. In 2002, Saint Laurent announced his retirement from couture and, in 2004, Ford was replaced at YSL by designer **Stephano Pilati**. Also in 2004, Bergé and Saint Laurent turned their headquarters at 5 Avenue Marceau into the "Foundation Pierre Bergé, Yves Saint Laurent," a museum open to the public, for those interested in fashion and who wish to study the life and work of Yves Saint Laurent.

SAKS FIFTH AVENUE. Begun in 1867 and incorporated in New York as Saks & Company in 1902, founder Horace Saks joined forces in 1924 with Bernard Gimbel of Gimbels to open their upscale specialty store called Saks Fifth Avenue. In 1926, when Adam Gimbel became president, the store began their national expansion plan by opening stores in resort areas such as Palm Beach, Florida (1926), and Southampton, New York (1928). Stores in Chicago and Miami Beach (1929) followed and by 1938 Saks had ten branch stores in high-profile areas such as Sun Valley, Beverly Hills, Mount Stowe, and Newport Beach.

BATUS Industries PLC acquired Saks in 1973 and sold it in 1990 to Investicorp S.A. In 1998, Saks merged with Profitt's Inc., a retail conglomerate of stores which included more than thirty-two McRae stores and the company was renamed Saks Incorporated. The first Saks outlet store opened in Franklin Mills, Pennsylvania, under the name Clearinghouse and, in 1995, as more outlet stores were opened, the name was changed to Off 5th.

In 2005, Saks was implicated in a **chargeback** dispute which resulted in having to pay back vendors. In an effort to reduce debt, Saks Incorporated sold off several of their business holdings in 2005 including the Profitt's and McRae's businesses to Belk, Inc.,

and their Northern Department Store Group to the Bon-Ton Stores, Inc., in 2006.

Saks Fifth Avenue remains one of the world's preeminent fashion retailers, known for its extraordinary assortment of international and American designer collections. There are 55 full-line stores in 26 states, 2 stores in the Middle East (Dubai and Riyadh), and 50 Off 5th Outlet Stores.

SALESPEOPLE. In a retail store, people are hired to assist customers, sell product, and maintain merchandise on the selling floor. In the absence of a **head of stock**, salespeople will also monitor and report inventory levels to the **department manager** or **buyer**.

SALES PROMOTION. This is a retail store division that deals with advertising, public relations, and **visual merchandising**. It is headed by a **promotion director** whose job function is to influence the sale of merchandise or services for a store or chain of stores. These activities may include **fashion shows**, special events, personal appearances, advertisements (print, TV, radio, and Internet), store displays, and creating an overall image for the store.

SALES REPRESENTATIVE. This is a person or firm hired by a **manufacturer** to sell their collection to retail **buyers**. A "sales rep" has his/her own showroom where they may also sell merchandise created by other manufacturers.

SAMPLE CUTTER. A person whose chief responsibility is to cut first samples into fabric using the first **pattern** created for a particular design. This person must be familiar with fabric cutting techniques, terms, and standard tools—including grain, pinning, using weights, scissors, rotary cutter and board, **tape measure**, and ruler. He/she reports either directly to the **designer**, the **assistant designer**, or to a **production manager** if she is cutting preproduction samples.

SAMPLEMAKER. A samplemaker is a person who is adroit at sewing first samples of a particular product, such as clothing or accessories. He/she must be able to sew the entire prototype and be familiar with a variety of sewing and pressing equipment.

SANDER, JIL (1943–). Born in Germany, Sander studied textile engineering before beginning her own label in 1973. Her designs reflect clean lines and she is best known for her attention to well-coordinated pieces. Sander sold the company to **Prada** and is no longer designing her namesake label. The Belgian **designer** Raf Simmons took over as **creative director** as of 2005.

SARAFPOUR, BEHNAZ (1970–). Born in Iran but raised in Philadelphia, Sarafpour graduated from the **Parsons School of Design** and went to work for **Isaac Mizrahi** before his company closed in 1998. Before opening her own business in 2001, she designed **private label** merchandise for **Barneys New York**. Her collection is best described as classic **sportswear** with a feminine touch.

SAVILE ROW. Originally part of the Burlington Estate in 1695, it was given its name for Lord Burlington's wife, Lady Dorothy Savile. At first, the Row was home to military officers and their wives but, by 1740, expert **tailors** set up shop in and around Savile Row on Cork Street, St. James Street, and Jermyn Street and serviced the clothing needs of English gentlemen. **Beau Brummel** (1778–1840), the epitome of the well-dressed man, patronized these shops and thus made English **bespoke tailoring** famous. The area is mostly known as the center for men's tailoring, however, women have also been accommodated. Tailors on Savile Row include Gieves and Hawkes (No. 1), Kilgor (No. 8), Jasper Littman (No. 9), Dege & Skinner (No. 10), Huntsman (No. 11), Darren Beamon (No. 12), Henry Poole & Co. (No.15), Maurice Sedwell (No. 19), Welsh & Jeffries (No. 20), Thomas Mahon (No. 20), Stephen Hitchkock, Davies and Son (No. 38), and James & James (No. 38). Tailors that are just off Savile Row include Anderson & Shepherd (32 Old Burlington Street) and the oldest company, Ede and Ravenscroft (8 Burlington Gardens), established in 1689. Savile Row was also home to the Beatles' record company, Apple Corps. (No. 3), and the location of their famous "Rooftop Concert," their last live performance in 1969.

SCAASI, ARNOLD (1931–). He was born Arnold Isaacs in Montreal, Canada, the son of a Jewish furrier. Although he never finished high school, he studied the trade at the **Chambre Syndicale de la haute**

couture parisienne and apprenticed at the house of **Paquin** before returning to Montreal to study at the Cotnoir-Capponi School of Design. He moved to New York in 1951 and worked for **Charles James** for two years, before opening his own business in 1956. He changed his last name by reversing the letters and is known to be one of the first American **designers** to do **trunk shows**. By 1959, Scaasi was designing three **ready-to-wear** collections a year, a **fur** collection, a **childrenswear** collection, and a jewelry collection. Scaasi is best known for his **tailored** suits and glamorous eveningwear, which are often embellished with feathers and beads. His celebrity clients included Joan Crawford, Arlene Francis, Dina Merrill, Diahann Carroll, Sophia Loren, Lauren Bacall, Elizabeth Taylor, Joan Rivers, Mary Tyler Moore, and Aretha Franklin. He has also dressed First Ladies Mamie Eisenhower, Barbara Bush (inaugural gown), and Laura Bush.

In 1964, Scaasi opened his couture collection and, in 1969, caused a scandal when Barbara Streisand accepted her Oscar for *Funny Girl*, all while wearing a see-through pantsuit created by Scaasi. The 1980s were Scaasi's heyday. He launched his Scaasi **Boutique** Collection in 1984, and over the years signed a series of **licensing** agreements for **fragrance**, furs, jewelry, sleepwear, porcelain dolls, **accessories**, **sportswear**, bridalwear, and a lower-priced evening-wear collection. In 1993, Scaasi signed a five-year agreement with the home shopping network **QVC**, selling dresses and jewelry. His clothes are also a favorite among society ladies such as Nan Kempner, Ivana Trump, Blaine Trump, Pat Kluge, Irma Schlesinger, Anne Bass, Nina Griscom, Gayfryd Steinberg, Libet Johnson, and Patty Davis Raynes. Scaasi's professional honors include a **Coty Award** in 1958, the **Council of Fashion Designers of America (CFDA)** Creative Excellence Award in 1987, along with its Lifetime Achievement Award in 1997, and Pratt Institute's Award for 25 Years of Couture Design in 1989. There have been three retrospectives of his work by the Museum of the City of New York in 1999, Kent State University in 2001, and the Museum at FIT in 2002. Scaasi received the Canadian government's Lifetime of Creativity Award in 2002 and his tell-all book, *Women I Have Dressed (and Undressed)*, was published in 2004. Scaasi continues his **made-to-measure** business by appointment only.

SCAVULLO, FRANCESCO (1921–2004). Born on Staten Island, New York, to a wealthy family in the catering business, Scavullo was one of five children. He knew at an early age that he loved all things glamorous and, by the time he was sixteen, he was working as an assistant to Horst B. Horst, a famous *Vogue* photographer. He moved on to *Harper's Bazaar* for a short time and then shot a cover for *Seventeen* magazine (1948), after which he opened his own studio. However, his big break came in 1965 when he met *Cosmopolitan* magazine's editor-in-chief, Helen Gurley Brown. Together with Brown and stylist Sean Byrnes (who later became his life partner), they revolutionized the magazine's covers by featuring some of the sexiest models in the most sensual poses, known as Cosmo Girls. He directly affected the birth of the **supermodel** and turned girls like Patti Hansen, Cindy Crawford, Christy Turlington, Iman, Naomi Campbell, Linda Evangelista, and Rene Russo into household names during the 1980s and 1990s. Scavullo shot covers for *Cosmopolitan* for thirty years. His books include *Scavullo on Men* (1977), *Scavullo on Beauty* (1979), *Scavullo Women* (1982), *Scavullo: Francesco Scavullo Photographs*, 1948–1984 (1987), *Scavullo Photographs: 50 Years* (1997), and *Scavullo Nudes* (2000). *See also* FASHION PHOTOGRAPHY; MODELS.

SCHIAPARELLI, ELSA (1890–1973). Born in Rome to a distinguished family (her uncle was the astronomer who discovered the Martian canals), she spent her childhood rebelling against her intellectually staid, yet artistic, family. She left Italy in 1913 to travel to Paris and then London, where she married Count Wilhelm Went de Kerlor, who traveled in artistic circles. Her marriage failed and, in 1920, she returned to Paris where she met designer **Paul Poiret**, who encouraged her career in fashion. After designing for Maison Lambal, Schiaparelli opened her first salon "stupidir le Sport" in 1927, specializing in **sportswear** and trompe l'oeil sweaters. Of particular note was a black-and-white "bow-knot" sweater which was an instant success on both continents. She introduced her perfume, S, in 1928 and, in 1931, designed a divided tennis skirt, worn by tennis star Lili de Alvarez at Wimbledon, which caused a sensation.

"Schiap," as she is often referred to, was known for innovative, avant-garde ideas and boasted a long list of "firsts." She was the first to use shoulder pads, animal prints, trompe l'oeil prints, and

embroidery in clothing. She made dyed-to-match **zippers**. She was the first **designer** to issue press releases. In fact, she printed her press clippings on fabric and made them into clothes. She liberally used hot pink (which she termed "shocking pink" in 1937). And, finally, she was known for her friendships and collaborations with the Surreal artists Salvatore Dali, Jean Cocteau, and Alberto Giacometti. One of her muses was Daisy Fellowes, one of the most daring **fashion plates** of the twentieth century, erstwhile *Harper's Bazaar* editor, and granddaughter of **Isaac Merritt Singer**, the inventor of the electric sewing machine.

Schiaparelli's whimsical, "tongue-in cheek" approach to fashion was reflected in her theme-based collections beginning in 1935 with "Stop, Look and Listen," the "Music Collection" (1937), the "Circus Collection," the "Pagan Collection," the "Zodiac Collection" (1938), the "Commedia dell'Arte Collection" (1939), and her "Cash and Carry Collection" (1940). Schiaparelli's presentations would inspire future designers since they were not the model parade, typical of contemporaries **Coco Chanel** and **Madeleine Vionnet**, but rather extravaganzas, with music, acrobatics and light shows. In 1937, her second **fragrance**, "Shocking," was launched, in a bottle shaped after the voluptuous body of film star Mae West. Her fashion whimsy enabled her to become a huge commercial success on both continents, signing **licensing** deals with many American companies.

Schiaparelli took surrealism and made it commercial with her hat that looked like a shoe, a handbag that looked like a telephone, a hat with a complete bird's nest on top and a lobster printed on the front of a white **silk** dress. At the core of the fierce rivalry between Chanel and Schiaparelli was the fact that Schiaparelli was born into money (Chanel, an orphan) and, although she lacked formal design training, she was skilled at marketing herself and, for a time, even surpassed Chanel in renown. However, in 1954, her couture house declared bankruptcy and Schiaparelli relocated to the United States. Her autobiography, *Shocking Life*, was published in 1954 and her legacy as a true original was forever recorded. Schiaparelli's showmanship and work as a modern designer has inspired many of today's fashion giants such as **Yves Saint Laurent, Alexander McQueen, John Galliano, Christian Lacroix** and **Jean-Paul Gaultier**. Her influence in print design can be seen in the work of designer **Nicole Miller** among

others. In 2003, the Philadelphia Museum of Art featured her work and, in 2004, the Musèe de la Mode et du Textile in Paris presented a major Elsa Schiaparelli retrospective exhibition.

SCOTT, JEREMY (1974–). Born in Kansas City, Missouri, Scott was trained in fashion at Pratt Institute in New York. Although he opened his collection in Paris in 1995, he now shows in New York. He is best known for his outrageous designs and theatrical fashion shows.

SEAN JOHN. This company was launched in 1998 by Sean "Puffy" Combs (1971–), a rap artist and music executive (Bad Boy Entertainment). Capitalizing on the urban **hip-hop** apparel trend, Combs initially focused on **menswear** and boyswear but expanded the collection through the years with the help of a $100 million injection of capital in 2003 by billionaire Ron Burkle. The empire consists of more sophisticated clothing through **licensing** deals which include men's suits, dress shirts, neckwear, **outerwear**, **accessories**, and **fragrances**. In 2004, Combs won the **Council of Fashion Designers of America (CFDA)** Menswear Award. In 2005, he created a line of shaving products, launched a women's collection, and opened his own flagship store on Fifth Avenue in New York City.

SEARS, ROEBUCK AND CO. Richard Sears, a railroad station agent, sold (for a profit) a local jeweler's unwanted shipment of watches in North Redwood, a rural area of Minnesota, and thus began a small watch business. After moving to Chicago, Sears met Alvah C. Roebuck, a watch repairman, who joined him in the business in 1893. Recognizing the need for people in rural areas to find reasonably priced supplies and merchandise, Sears and Roebuck created a **catalog** of merchandise featuring sewing machines, sporting goods, bicycles, and clothing. In 1895, Julie Rosenwald, a clothing **manufacturer**, became part owner and, a year later, the Sears catalog grew to more than 532 pages, including shoes, women's clothing and millinery, wagons, fishing tackle, furniture, china, musical instruments, buggies, baby carriages, glassware, refrigerators, dolls, stoves, and groceries. The company's reputation for quality products and customer satisfaction was the key to their success. The catalog was known as the "Consumers' Bible" and the Christmas catalog

was called the *Wish Book* because of the many toys it displayed on its pages. In 1908, they began selling house construction kits and, by 1940, more than 100,000 houses had been sold.

The first Sears retail store opened in 1925 in Evansville, Indiana, thanks to the effort of then–vice president Robert E. Woods, who realized that with the invention of the car and modern roads, the catalog business would decline as people made more frequent jaunts into the nearest city. By the end of 1927, 27 stores were in operation and, by 1929, there were 319 stores. As the company grew, Sears began to develop its own **brands**, including Craftsman (tools), Kenmore (appliances), Allstate (tires), and Diehard (batteries). In 1931, Sears launched Allstate Insurance Co., a subsidiary that sold automobile insurance. After World War II, shopping mall sprawl was under way with Sears stores filling many of them. In 1973, the new headquarters opened in downtown Chicago, making the Sears Tower the tallest building in the world. Up until 1980, Sears was the largest **retailer** in the United States with stores in Canada, Central and South America, and Europe. However, during the 1980s, Sears also went through a major restructuring. It acquired the Dean Witter Financial Services Group and the Caldwell Banker Real Estate Group and closed many underperforming retail stores. It then sold its real estate and financial services business in the mid-1990s, returning to its retailing roots. By 2000, Sears operated 863 mall-based retail stores and 1,200 hardware/battery stores and, in Canada, 176 retail stores and 1,500 catalog stores. In 2004, Sears merged with **Kmart** stores to become the Sears Holdings Corporation. *See also* MONTGOMERY WARDS.

SELFRIDGES. Gordon Selfridges opened his eponymous **department store** on Oxford Street in London in 1909. It was acquired by the Sears Group in 1965 and, in 1998, it de-merged and listed itself on the London Stock Exchange. In 2004, it was reregistered as a private company known as Selfridges & Co. Today it operates four locations in Great Britain, selling **menswear, womenswear, childrenswear,** health and beauty, home, leisure, and food.

SEMON, WALDO L. While working for the B. F. Goodrich Company in the United States, Semon (American) was boiling **polyvinyl chloride (PVC)** in a high-temperature solvent in an effort to extract an

unsaturated polymer that might bond rubber to metal. The result was the creation of **vinyl**, a process and product that he patented in 1926. This synthetic rubberlike composition had many end uses, mostly in the area of waterproofing for such items as coated electrical wires, shower curtains, raincoats, boots, and umbrellas. During World War II, the bulk of vinyl production went for the war effort. However, during the 1950s and especially the 1960s, the textile became sensationalized in the **mod** and **futuristic** designs of **Paco Rabanne, Pierre Cardin, André Courrèges**, and **Mary Quant**. Vinyl's appeal continues with innovations ranging from synthetic **leather** looks to printed, texturized, matte, or clear, in full range of colors and patterns. New backings, which allow for breathability, are also being offered. Vinyl's popularity is no longer limited to rainwear sectors but reaches all areas of the fashion industry.

SEPARATES. Clothing that can be mixed and matched are termed *separates*. The concept first appeared during the Italian **Renaissance**, when women would interchange their skirts on certain occasions. However, fashionable dress through the ages consisted mainly of dresses and ensemble dressing until the **Industrial Revolution**, when the introduction of separate blouses and skirts made it easier to manufacture such items en masse. It also brought the advent of the **bloomer** and dress reform. With the invention of the **sewing machine** in 1846, mass production made it possible for working and middle-class women to afford clothing. Purchasing a ready-made blouse was less expensive than buying a dress. Additionally, the practicality of separates allowed for the mixing of sizes for better fit, which is not the case with dresses, which have to sometimes struggle with potential differences between bust and hip measurements.

In 1890, Charles Dana Gibson illustrated the new functional style of separates in his famous "Gibson Girl" drawings. He depicted women in puffed-sleeved blouses paired with long simple skirts, the basis for the casual American style of dressing called **sportswear**. In the 1920s, the American Berthe Holley came up with the concept of interchangeable coordinated separates to expand the wardrobe. In France, designers **Jeanne Paquin** (1869–1936), **Paul Poiret** (1879–1944), and **Coco Chanel** (1883–1971) each promoted separates in their collections in the early and mid-1930s. Arguably the

biggest influence came after World War II when the trend exploded with American designers **Claire McCardell** (1906–1958), **Bonnie Cashin** (1908–2000), **Tina Leser** (1910–1986), **Clare Potter** (1925–), and **Anne Klein** (1923–1974). Today, the wearing of separates has become a universally accepted way to dress, in just about every culture throughout the world.

SEVENTH AVENUE. The fashion marketplace in New York City that encompasses the area from 30th to 42nd Streets and from 6th to 9th Avenues is generally referred to as Seventh Avenue. While once a thriving "garment center" for both design and manufacturing beginning in the mid-1800s, it has since changed due to the shift to offshore production of textiles and garment **manufacturing**. Today, Seventh Avenue is spoken of more in terms of a place where **buyers** visit showrooms of fashion houses both big and small. Some small factories and trimmings houses still exist but only to serve the few remaining design rooms.

SEWING MACHINE. The earliest known sewing machine was created in France by **Barthélemy Thimmonier** in 1830, however, mounting pressure from tailors' guilds at the time thwarted its success. In 1846, American **Elias Howe** perfected and patented the lockstitch machine, first developed in 1834 by Walter Hunt (American). Even though the lockstitch sewing machine could only sew straight stitches, not curves, it radically reduced sewing time compared to hand-sewn garments. In 1850, **Isaac Merritt Singer** (American) created an improved version that not only could sew curved seams but was operated by a foot treadle. This innovation left the hands free and therefore drastically sped up the sewing process by 500 percent. By 1856, other inventors sought to patent their improved machines, which led Howe to sue for patent infringement. This action resulted in the first patent pool whereby every sewing machine inventor paid a license fee for each machine they sold. In 1877, that patent expired.

Singer and his lawyer, Edward Clark, recognized the market need for the first home sewing machine and in 1889, Singer invented the first electric sewing machine. By the 1930s, factories and homes converted to motor-powered sewing machines equipped with special features. The first computer-controlled sewing machine was introduced

by Singer in 1978, around the same time that foreign-made sewing machines began to flood the market, such as Bernina, Brother, Juki, Necchi, and Pfaff. Today, the sewing machine does much more than sew; it is capable of zig-zagging and embroidering and can overlock seam edges and make buttonholes.

SHAPELY SHADOW INC. Shapley Shadow is a **dress form** company founded in 1997 by Ilona Foyer in Malibu, California. Utilizing 3-D **bodyscanning** technology to capture a particular body image, it makes a dress form that is perfectly symmetrical for use by designers, **manufacturers**, and retailers alike.

SHAVER, DOROTHY (1893–1959). Born in Arkansas, Shaver entered the world of **retailing** in the 1920s with her sister by creating dolls known as "Little Shavers." The dolls' popularity prompted the then-president of **Lord & Taylor** to hire her. In 1932, she established a fashion program known as the **American Look** to promote the work of American designers. Because of her vision and foresight, she was elected president of Lord & Taylor (1946–1959). Shaver was also one of the founders of the Costume Institute at the Metropolitan Museum of Art in New York.

SHEPPARD, EUGENIA (1903–1984). Born in Columbus, Ohio, to a banker/food broker father, she attended Bryn Mawr College in Pennsylvania. She began writing a women's column for the *Columbus Dispatch*, which was owned by her second husband's father, H. P. Wolfe. After her divorce in 1937, Sheppard moved to New York and began writing for *WWD*. In 1938, she landed a job at the *New York Herald-Tribune* as assistant editor of the women's page. By 1947, she was the *Tribune's* fashion editor and created journalistic history when she combined fashion reportage and New York gossip with pictures of society's most fashionable. In 1956, Sheppard's syndicated column "Inside Fashion" appeared in one hundred newspapers around the country, making her one of the most powerful fashion columnists in the country. Covering the European collections with **fashion illustrator** Joe Eula in tow, together they would go head-to-head against *WWD*, their biggest competitor. Sheppard's pen was so mighty that she was actually banned from the showrooms of designers **Cristòbal Balenciaga,**

Yves Saint Laurent, and **Hubert de Givenchy** for writing unfavorable reviews of their collections. In collaboration with Earl Blackwell, Sheppard wrote two books, *Crystal Clear* (1978) and *Skyrocket* (1980). Sheppard's career spanned more than forty years and, in her memory, the **Council of Fashion Designers of America** each year presents the Eugenia Sheppard Award to a deserving **fashion journalist**.

SHIMADA, JUNKO (1950–). Japanese-born Shimada founded her clothing business in Japan in 1991. Known for avant-garde but wearable styling, she also sold well in Paris. The house has several **licenses** from sunglasses, handbags, shoes, and home products. In 2001, French designers Alexandre Morgando and Matthieu Bureau were hired to design and revitalize the collection.

SHOWROOM SALES ASSOCIATE. This is a salesperson who works in the manufacturer's showroom, sells the clothing line, and acts as the intermediary between the manufacturer and the retail establishment.

SILK. The use of this **natural fiber** dates back to the third millennium B.C.E. in China and is derived from the dried saliva of the silkworm during the cocooning process. Sericulture, or the process of cultivating and ultimately weaving silk cloth, was for many centuries a coveted secret. Throughout history, silk was used as a form of currency with traders exchanging silk fabric for other goods. The famous Silk Road eventually led to silk production moving to other countries such as India, Korea, Japan, France, and Italy. Silk's long staple, brilliant luster, and extremely complex processing make it one of the most expensive luxury fibers in the world and maintains a high-status appeal.

SIMMONS, RAF (1968–). Born in Neerpelt, Belgium, Simmons began his career as a furniture designer. He launched his own fashion collection in 1995 and is known for his innovative and modern approach to proportion. In 2005, Simmons was hired to design the **Jil Sander** line.

SIMPLICITY PATTERN COMPANY. In 1927, American Joseph M. Shapiro formed the Simplicity Pattern Company. The company competed with established **pattern** companies **McCall's** and **Butterick**.

Shapiro's aim was to sell his patterns cheaper than his competition at 15 cents instead of the going rate of 25 cents. He later partnered with F.W. Woolworth Company and sold patterns for 10 cents. In addition to offering contemporary fashion, Simplicity also offered a Historical Costume Collection. In 1936, Shapiro acquired Pictorial Review and the pattern company Excella. In 1998, Simplicity joined Conso Products Company, the world's largest **manufacturer** of trimming and decorative hardware for the international home furnishings industry.

SIMPSON, JESSICA (1980–). The American singer Jessica Simpson launched a fashion **brand** that capitalized on her success and fan following. **Licensing** rights for her contemporary line, handbags, and shoes were sold to the Camuto Group for $15 million in 2005. Simpson also has a licensing deal for **jeans** and a junior collection called Princy, with Tarrant Apparel Group.

SINGER, ISAAC MERRITT (1811–1875). Singer was born in Pittstown, New York, the son of a Saxon immigrant. At age thirteen, Singer became an apprentice in a machine shop but soon left to pursue acting. He married in 1830 and moved to New York and, in 1837, received a patent for his invention, a rock drilling machine. In 1850, while trying to sell his second patented invention, a metal and wood cutting machine, he met Orson C. Phelps who asked his advice on perfecting a **sewing machine** by Lerow and Blodgett. Together with Phelps and with financial backing from George B. Zeiber, the three formed the Jenny Lind Sewing Machine Company. Singer perfected the lockstitch sewing machine first created by Walter Hunt in 1839, and received a patent in 1851. However, **Elias Howe** patented his sewing machine earlier, in 1846. But, when Howe tried to sue Singer for patent infringement, the courts established the first patent pool, which allowed all involved parties to earn royalties from the sewing machine's future sales. In 1856, the I.M. Singer Co. manufactured 2,564 machines for $100 each. Sales were hot and the company made 13,000 in 1860. In 1863, the original company was dissolved but continued as the Singer Manufacturing Company. Singer's sales jumped to 170,000 in 1870, thanks to its new installment payment-plan promotion. By 1880, Singer was selling 500,000 machines a year.

In 1889, Singer introduced the first electric sewing machine and, by 1900, produced 40 different sewing machine models. In 1921, the first portable, electric, motor-powered sewing machine model (the 99K) was sold and the first Singer Sewing Center opened in New York City. By 1951, the centers grew and trained an estimated 400,000 housewives. The company changed its name in 1963 to the Singer Company and, in 1978, the company launched the first computer-controlled machine. Singer's personal life was more colorful than any present day soap opera. Multiple wives, infidelity, polygamy, lawsuits, and some eighteen children later, Singer spent the rest of his life living in Paris and then England. Upon his death in 1875, Singer's estate was worth $14 million, the equivalent of hundreds of millions of dollars in today's economy.

SIZES. Clothes and accessories are sold to consumers in a size range based on specific body measurements. Clothing and **accessories** are usually sized according to each **manufacturer**'s customer base. Guidelines for clothing size ranges are Infants, Children (girls/boys), Boys, Juniors, Women's (Misses, Petite, Tall, **Plus Size**), and Men's (Regular, Big, Tall). (See appendix 8 for other product sizes ranges.) *See also* SIZE UK; SIZE USA; STANDARDIZED SIZING.

SIZE UK. In 2001, a National Sizing Survey was conducted in collaboration with the British government, seventeen major British **retailers**, and leading academic institutions and technology companies. An anthropometrics research study, the first of its kind since 1950, utilized whole body scanners from [TC]². The purpose of the study was to improve product for better fit and increase customer satisfaction. Over 11,000 body measurements in three regions of Great Britain were collected and evaluated. One of the results of the study revealed that 60 percent of people have trouble with the fit of their clothes and, among other things, people in Britain are taller and larger than they were in 1950s. The data is for sale and is posted on a secure website hosted by **Bodymetrics**. *See also* BODYSCANNING.

SIZE USA. In 2002, the first major study of the size and shape of Americans was conducted by [TC]² as a followup to **ASTM**'s study during World War II. Using **bodyscanning** technology, 10,000 Americans were scanned for this study in 2002. Subjects scanned were

grouped into divisions of gender, six age groups, and four ethnicities. Information including ZIP code, annual household income, marital status, lifestyle, education, employment status, and apparel shopping preferences were obtained. The results of the study, released in 2003, concluded that, among other things, the U.S. population has grown heavier versus taller, that sizing rules of the past were obsolete, and that new sizing standards need to be developed. The results of this study are available to the public.

SKECHERS USA. Robert Greenberg started this shoe company after he left L.A. Gear in 1992. His four sons helped to build one of the top **footwear brands** in the United States. Skechers is known for great marketing and for producing trendy, affordable **sneakers** sold in **department stores**, as well as in its own stores, throughout the world.

SKETCHER. A person who possesses strong illustration and flat-sketching skills. His/her responsibilities include assisting the **designer** and designing and illustrating presentation boards for sales meetings and showroom display. **CAD** skills are mandatory.

SMARTLABEL. SmartLabel is a merchandise-return tracking system developed by the Newgistics company, which speeds up the often time-consuming returns process. A high-tech barcode links return packages to customer invoices. Merchandise returns are swift and require little effort with this system.

SMITH, SIR PAUL (1947–). A true English gentleman, he was born in Nottingham, England, and opened a men's clothing store there in 1970. Smith opened a second store in London in 1976 and showed his own collection in Paris the same year. He became famous for designing traditional English **tailored** suits with a twist. His signature "naked lady" design, which is hidden inside cuffs and collars, is part of the allure of his clothing. Smith's empire consists of stores worldwide that carry his full line of clothing for men, women, and children, as well as **accessories** and **fragrances**. He is known as the most successful of all British designers and was awarded knighthood by the queen in 2001. In 2006, Smith sold a 40 percent stake in the company to Japanese **licensee** Itochu.

SMITH, WILLI (1948–1987). Born in Philadelphia, Pennsylvania, Smith started his career as a designer of casual **sportswear** for companies such as Digits and Bobbi Brooks in the late 1960s and early 1970s. He opened WilliWear Limited in 1976 and was one of the first successful African American designers.

SNEAKERS. The first soft shoe dates back to Mesopotamia; it was made of leaves and twine and was worn for hunting and combat games. As competitive sports gained in popularity, people wore soft shoes made of **cotton** uppers and rope soles for greater flexibility. In 1830, the "sand shoe" was invented, which had a cotton canvas upper and a vulcanized rubber sole, originally intended as a beach shoe. By 1868, this casual shoe was the preferred choice for aristocratic lawn games. In 1870, the British Dunlop rubber company created its version of the sand shoe, the "Plimsoll," at the same time that the Americans created the "sneaker." Although there are many variations of the origin of the term *sneaker*, the most popular definition cites the noiseless characteristic of one who could "sneak" around in them. Sneakers were so popular among athletes that soon their design was based on a specific end use, depending on the sport. In the 1880s, rubber tips were added to keep the toenail from poking through the tip. Englishman Joseph William Foster created handmade running shoes in 1895 that were worn in the Olympics in 1924. Later, in 1958, his grandsons started a sneaker company called **Reebok**, which later sold to **Adidas** in 2005, making them the second largest sneaker company behind **Nike**. In 1905, the BF Goodrich rubber company (American) produced its version of rubber-soled canvas shoes and, in 1937, using new Posture Foundation Technology, introduced the first sneakers with arch support, the **PF Flyers**. In 1906, American William J. Riley began making arch supports for people with troubled feet. He later founded the company New Balance, making running shoes in a variety of widths and in 1961 launched the Trackster, a high-performance running shoe. In 1917, U.S. Rubber marketed **Keds**, which became the first **mass-marketed** sneaker in the United States. In 1918, **Converse** launched the All-Star high-top basketball sneaker, known as the Chuck, along with a low-cut version, the Oxford. Adi and Rudolf Dassler (Germany), founded **Adidas** in the 1920s but Rudolf split to form his own sneaker company, **Puma**, in 1948.

Advancements in sneaker design evolved as different sports required different performance demands, such as better traction, different arch support, lighter weight, and better soles and insoles. Technological advances moved the sneaker from the cloth tops and uppers with rubber soles version into the "athletic shoe" or "trainer," made of **leather** or waterproof synthetic leather that was breathable and fashionable. Trainers were designed with subparts to enhance performance for athletic endeavors such as basketball, tennis, cross-training, jogging, and walking. Athletic shoes quickly became the **footwear** of choice, not only worn for a broad range of sports but also as casualwear. In 1964, Blue Ribbon Sports was founded and, in 1972, was renamed **Nike** from the Greek god of victory. Nike became famous with the first "air-cushioned" shoe in 1979 and, after losing market share to Reebok in the early 1980s, rebounded with a massive advertising campaign featuring sports icon Michael Jordan in 1988. Throughout the 1990s, athletic shoe companies pumped millions of dollars into advertising and signed iconic sports celebrities to endorse their products. Keeping ahead of the curve and the competition has lead to expensive research and development labs such as the Nike Sports Research Lab, where athletes, **designers**, and podiatrists come up with new and innovative products. In 2004, Adidas created the "thinking sneaker" that contained a microchip that could modulate as-needed cushioning. In 2006, the Traquer sneaker was created by American scientist Isaac Daniel for Fele Footwear. These sneakers contained a Global Positioning System (GPS), which could be linked to a laptop, cell phone, or emergency services, designed to be able to track your child.

SNOW, CARMEL WHITE (1887–1961). Born Carmel White in Dublin, she was raised along with her six siblings by her widowed mother who eventually moved the family to New York. It was her mother's job at an upscale store, TM & JM Fox, that inspired Carmel to pursue a career in fashion. In 1921, while accompanying her mother on a buying trip to Paris, she was introduced to Edna Wollman Chase, the editor of *Vogue*, who offered her a job as assistant **fashion editor**. At age thirty-four, Snow joined *Vogue*, where she remained for eleven years, during which time she married George Palen Snow. In 1934, Snow defected to arch rival *Harper's Bazaar*

and within a few months was promoted to editor-in-chief, where she made sweeping changes and built her reputation as "a little Irish firecracker." Snow is credited with revolutionizing fashion magazines and made stars of Parisian **designers Cristòbal Balenciaga, Coco Chanel, Christian Dior, Yves Saint Laurent** and **fashion photographers** Cecil Beaton, Edward Steichen, **Louise Dahl-Wolfe,** and **Richard Avedon.** She also promoted the work of American designers, especially **Bonnie Cashin.** In addition, Snow was responsible for hiring **Diana Vreeland** as a fashion editor. Snow's reputation for being impeccably groomed (she always wore a hat) and consistently named to the International Best-Dressed List is coupled with her reputation as a "brilliant, alcoholic, mother superior." Snow was ultimately fired from *Bazaar* in 1958 after twenty-five years of service when an embarrassing public incident occurred, owing to her alcoholism. Anecdotes surrounding the life and times of Carmel Snow were documented in a book, *A Dash of Daring: Carmel Snow and Her Life in Fashion, Art and Letters*, by Penelope Rowlands.

SOCIÉTÉ DES AUTEURS DE LA MODE. This anticopyist society was founded in Paris in 1928 to curb the rising trend of copying French fashion designs principally by American **department stores.** *See also* COPYIST.

SOM, PETER (1972–). Born in San Francisco, California, Som presented his first collection in 1999. He became a selected **designer** for the hit TV show *Sex and the City* in 2004. Of Chinese decent, Som is associated with the new wave of notable Asian designers.

SPADE, KATE (1964–). Born in Kansas City, Missouri, Spade worked as an **accessories** editor at *Mademoiselle* magazine in 1986 before starting her own handbag company with husband Andy in 1993. Known first for her satin-finished nylon bags, she expanded the collection to include shoes, baby items, sunglasses, books, stationery, and home and beauty products. Spade is the recipient of several awards including the **Council of Fashion Designers of America** new talent award in 1996. As of 2006, the $200 million business was majority-owned by **Neiman Marcus.**

SPECIAL OCCASION. *Special occasion* is the market category within the fashion industry that encompasses the more formal side of attire, including after-five dresses and suits, formal attire, and evening-wear. It also includes the bridal industry, which consists of clothing worn by the bride, bride's maids, grooms, ushers, ring bearers, flower girls, and the father and the mother of the bride and groom.

SPECIALTY STORE. This type of retail store specializes in one category of merchandise or a specific market segment. Some smaller specialty stores cater to affluent consumers, while larger specialty **chain stores** such as the **Gap** and **Banana Republic** appeal to the more price-conscious consumer. Examples of specialty chains are **Abercrombie & Fitch**, Aeropostale, American Eagle, Ann Taylor, Banana Republic, Bebe, Caché, Chico's, Gap, **Guess, Old Navy**, Talbots, **Victoria's Secret**, and Wet Seal. Examples of smaller specialty stores are **Barneys New York, Henri Bendel**, and **Jeffrey's**.

SPECIFICATION TECHNICIAN. A person responsible for creating technical measurements for **tech packs**, which are sent to overseas factories from the designers' initial sketches. They must have a strong technical background in **patternmaking** and garment construction and be extremely detail-oriented. Flat-sketching, **computer-aided design (CAD)**, and garment specification knowledge is mandatory. *See also* PRIVATE LABEL; PRODUCT DEVELOPMENT.

SPEEDO. In 1910, the Scottish immigrant Alexander MacRae (1888–circa 1930) moved to Australia and, in 1914, opened MacRae Knitting Mills, a hosiery factory on Bondi Beach. He expanded his product line to include swimwear in 1928 and the name *speedo* was given to a racerback swimsuit—first coined from a competition slogan "Speed on in your Speedos." During World War II, MacRae's production was dedicated to the war effort but resumed afterwards as Speedo Knitting Mills (Holdings) Ltd. It became a publicly traded company in 1951. Speedo introduced its new **nylon** swimsuit "brief" for men at the 1956 Olympics in Melbourne. The company quickly rose to international fame when it claimed that 70 percent of swimming medals were won by athletes wearing Speedos during the 1968 and 1971 Olympics. By the 1976 Olympics, 52 out of 54 countries wore Speedo swimsuits. **Ly-**

cra was first introduced in the 1970s and by the 1990s, the company's research and development department began experimenting with aquablade and fastskin product technology, which are scientifically based on shark's skin which reduces drag and airflow.

In 1991, Speedo was sold to the British company, Pentland Group Plc., although Speedo Australia remained a separate company. In 2004, Speedo announced a sponsorship agreement with the International Federation of Swimming (FINA) and a partnership with MTV. Speedo's Fastskin FSII Ice, worn by athletes at the 2006 Winter Olympics in Turin, was created after five years of extensive research and provides aerodynamic "second skin" technology that extended into sports other than swimming, such as skeleton, bobsledding, and luge. Speedo is the world's top-selling swimwear **brand** consisting of women's, children's, and men's fashion and fitness swimwear, and also includes a complete collection of aquatic and fitness equipment. Speedo sponsors many top athletes who collaborate with its research and development team to actualize its three basic principles, "Fit, Fast, and Free." *See also* ACTIVEWEAR.

SPORTSWEAR. Having its roots in attire specific to English hunting sports during the mid-nineteenth century, it soon became fashionable to wear garments associated with leisure-time sports such as golf, tennis, ice skating, polo, horseback riding, bicycling, and lawn sports. The wearing of riding coats, blazers, trousers, divided skirts, and separate shirts by both men and women soon traveled to America as more Europeans began to migrate. The **Rational Dress Society**, founded in 1881, pioneered the wearing of trousers for sport, emulating Amelia Jenks Bloomer, who in the early nineteenth century, promoted the first daytime-wear trouser-suit for women. With the advent of the **Industrial Revolution** and advances in **manufacturing** came a preference for a more casual way to dress, especially for the working and middle classes. Clothing known as **separates** evolved and grew to make up the largest category of merchandise in retail today. Mix-and-match separates consisting of shirts, skirts, jackets, pants, and sweaters were color coordinated and were marketed as a way to increase a wardrobe.

During the 1920s and 1930s **designers Paul Poiret** (1879–1944), **Coco Chanel** (1883–1971), and **Jean Patou** (1880–1936) vigorously

promoted the sportswear look. Patou's specialty **boutique**, Le coin des sports, was the first division of a **couture** house to specialize in all types of sports apparel. **Elsa Schiaparelli** (1890–1973) founded her company and shop, stupidir le Sport, in 1927, specializing in sportswear and trompe l'oeil sweaters. It was a fact that women buying these clothes were not always sports-inclined, yet preferred this more casual style of dress over the stricter European alternative. Americans embraced the sportswear concept more readily than their European counterparts, which is why they are most often given credit as its originators. American designers **Bonnie Cashin, Claire Mc-Cardell, Clare Potter, Vera Maxwell**, and **Tina Leser** were sportswear pioneers after World War II and their work filled the pages of newspapers, magazines, and store racks. The look was endorsed and promoted with the help of people like **Virginia Pope** (*New York Times* fashion editor, 1925–1955), **Carmel Snow** (*Harper's Bazaar* editor, 1934–1958), and **Dorothy Shaver** (**Lord & Taylor** president, 1946–1959).

The sportswear category became internationally acceptable with the unique design and marketing talents of designers including McCardell's "five easy pieces" concept (1940s), Vera Maxwell's "six-piece ensemble in a travel bag" concept (1975), and **Donna Karan's** twist on the mix-and-match concept, "seven easy pieces" (1990), consisting of a bodysuit, tights, dress, skirt, jacket, pants, and accessories. Today, designers on both continents design sportswear and the original concept of "sports apparel" is now broken down into **activewear** and **performance apparel**.

STANDARDIZED SIZING. With the introduction of the **tape measure** in 1820 and the growing market for selling **ready-to-wear** clothing to the masses, a system of standardized sizing was created. Measurements, taken in inches, were obtained from Civil War soldiers and helped standardize the male population. In 1863, **Butterick**, a paper pattern company, patented size specifications for women. An organization known as the **American Society for Testing and Materials (ASTM)** began issuing body-sizing standards in 1941 and has continued to update these standards, in addition to other initiatives, such as **SizeUSA** and **SizeUK**. (See appendix 8 for sizes ranges.) *See also* SIZES; [TC]².

STEFANI, GWEN (1969–). Born in the United States, Stefani was a music celebrity before entering the fashion world. She began her **ready-to-wear** company, L.A.M.B., in 2003. Stefani selected the name in memory of her childhood dog; it is also an acronym for love, angel, music, and baby. She is inspired by old Hollywood and creates hip, wearable clothing. In 2006, Stefani **licensed** her name to **accessories** and watches.

STEFFE, CYNTHIA (1958–). A graduate of the **Parsons School of Design** and the recipient of both the Designer of the Year Award and the Donna Karan Gold Thimble Award, Steffe launched her first line in 1989. In 2000, she became part of Leslie Fay Brands. In 2001, Steffe launched Cynthia Steffe Black Label, a step above her Cynthia Steffe contemporary market **sportswear** line. In 2004, the Cynthia Steffe company was sold to Chaus.

STEIGER, WALTER (1942–). Born in Geneva, Switzerland, Steiger was introduced to the shoe business while working for Bally. In 1967, he designed his first shoe collection in a studio on Bond Street in London. Today, the company operates more than twenty stores worldwide and sells to only the best **department** and **specialty stores**. Steiger is known for elegant shoes, especially his signature sculpted curved heel and his one-piece **Lycra** boot. *See also* FOOTWEAR.

STILETTO HEELS. These were introduced in 1950 by Italian designer **Ferragamo** and in 1954 by **Roger Vivier**. The stiletto is a shoe whose heel is 4–5 inches in height. *See also* FOOTWEAR.

STOCKOUT. This retail term describes when an item is not in stock.

STORE BRAND. This is another name for **private-label** merchandise or a **brand** that is specific to a particular retail store under its own label or rebranded under another name. *See also* PRODUCT DEVELOPMENT.

STORE MANAGER. This person heads the operations division of a retail store. Responsibilities include store maintenance, merchandise

delivery, and marking and warehousing of merchandise, as well as customer service, supervision of sales staff, and store security. People that report to the store manager include the **merchandise coordinator/selling specialist**, **salespeople**, head of stock, warehouse, maintenance, security, and customer services areas of the store.

STRAUSS, LEVI (1829–1902). Born in Bavaria, Strauss immigrated to San Francisco at twenty years of age by way of New York, where, in 1849, he opened a dry goods store at the height of the California Gold Rush. He soon began manufacturing pants made of a **cotton** fabric from France called *serge de Nimes* (later called *denim*). In 1873, his company, Levi Strauss & Co., created a stitching design on the back pockets and in 1886 created the now famous "two-horse" design. In 1936, it added a red tab on the left pocket as a way to identify the **brand** at a distance, all of which are registered trademarks. *See also* JEANS.

STREET STYLE. This term refers to trends that are inspired by pop culture which in turn inspire a fashion movement. Examples of trends inspired by people on the street are London's Teddy Boys and the **beat look** of the 1950s, **hippies** of the 1960s, **punk style** of the 1970s, **goth style** of the 1980s, the fitness craze and **grunge** of the 1990s, and the **hip-hop** style of 2000. Many big-name designers such as **Mary Quant**, **Vivienne Westwood**, **Yves Saint Laurent**, **Dolce & Gabbana**, **Sonia Rykiel**, and **Calvin Klein** have been known to get fashion direction and inspiration from observing street culture. Street style is the exact opposite of the trickle-down effect, which dates back to the Middle Ages when fashion was handed down from the noble class to the peasants. While replication of clothing worn by the wealthy elite continues, it is in direct opposition to this trend that inspiration for street style comes from "middle or lower class heroes." Biker jackets worn by the beat generation, denim jeans worn by hippies, and oversized hip-hop clothing worn by inner-city breakdancing kids are all examples of trends that emulated from the bottom up.

STREETWEAR. While **street style** refers to trends, streetwear refers to clothing inspired by a particular subculture of society. The earliest examples of streetwear were born out the youth movement in the 1960s and 1970s, particularly the **hippie** and surf cultures. Los Angeles surf

board **designer** Shawn Stussy created a trend of screen printing his logo on **T-shirts** and it wasn't long before surf clothing was adopted by nonsurfers. The hippie culture was fueled by the antiwar and antiestablishment movement with clothing such as **denim** bell-bottom **jeans** and fringed **suede** jackets as the uniform. Another example of streetwear took its inspiration in the 1980s from sports franchises: basketball **sneakers** bearing iconic player names such as Michael Jordan and LeBron James for **Nike**; Chicago Bulls and L.A. Raiders baseball caps worn backwards; and oversized sports jerseys were all popularized by **hip-hop** culture. By the turn of the century, as rap artists got rich, the term *bling* was introduced, which not only referred to the wearing of oversized, expensive jewelry but also launched the luxury fad. Rap artists wore expensive clothes and jewelry and drove expensive cars, which they featured in their music videos, and eventually they further capitalized on their success by opening their own fashion houses. Sean Combs of Bad Boy opened **Sean John**, Russell Simmons of Def Jam opened **Phat Farm**, Jay-Z and Damon Dash of Roc-a-Fella launched **Rocawear**, and 50 Cent opened **G-Unit**. As each new generation of youth seeks to establish its cultural footprint on society, the masses will create clothing that will define them.

SUEDE. *See* LEATHER.

SUI, ANNA (1955–). Born in Dearborn, Michigan, Sui received her training at the **Parsons School of Design** and, upon graduation, worked for several **sportswear** companies on **Seventh Avenue** before going on her own with her first runway show in 1991. Sui is known for her reasonably priced eclectic collection of **vintage**-inspired clothing. Today she operates a wholesale business and four stores—one in New York, two in Tokyo, and one in Osaka, Japan.

SUPERMODELS. This is the term coined in the early 1980s that refers to highly paid, highly sought-after fashion **models**, many of which achieved celebrity status. Examples of supermodels who were at the peak of supermodel mania were Patti Hansen, Cindy Crawford, Christy Turlington, Iman, Naomi Campbell, Linda Evangelista, Rene Russo, and later Kate Moss. **Francesco Scavullo**, a *Cosmopolitan* magazine **fashion photographer** for thirty years, is believed to have

originated the supermodel concept by featuring these and other celebrities on the cover of the magazine in sexy, sensual poses. Today, the frenzy has died down but every so often a few models such as Heidi Klum and Gisele Bundchen reach the rank. *See also* MODEL AGENCY; TWIGGY.

SUSTAINABLE DESIGN. Within the fashion industry, sustainable design refers to environmental stewardship, such as products that are ecological, **organic,** or recycled. Sustainable products are those products providing environmental, social, and economic benefit while protecting public health, welfare, and the environment over their full commercial cycle, from the extraction of raw materials to final disposition. Sustainable products cause little or no damage to the environment and are therefore able to continue for a long time. Organically grown **natural fibers** are produced with little or no chemical fertilizers, pesticides, or other artificial chemicals.

Sustainable agriculture is an integrated system of plant and animal production practices having a site-specific application that, over the long term, satisfy human food and fiber needs but also enhance environmental quality and the natural resource base upon which the agricultural economy depends. Fibers are derived from a variety of sources including plants (**cotton,** kapok, cotton **rayon,** flax, hemp, china grass, Manila hemp, New Zealand hemp, west saar hemp, fine jade hemp, and phenix leaf), fruits and vegetables (coconut and corn), wood (straw, culm, and wick grass), and animals (**wool, cashmere,** camel's wool, **mohair, alpaca,** ox hair, and **angora**); fibers from insects (Chinese silkworm, Japanese silkworm, and European silkworm) are grown or cultivated using organic methods.

Recycling, or the act of collecting and treating rubbish to produce useful materials that can be used again, is another part of sustainable design. The recycling of soda bottles to produce polar fleece garments began in the 1993 by Dyersburg Corporation. Currently, a movement is underway to recycle clothing made of 100% **man-made** materials (**nylon, polyester**) to minimize the volume of chemical fiber clothing on the earth. Antique clothing, which has mostly been a fashion trend, has a new meaning in the sustainable movement. Designers recycle clothing to create new garments and **accessories** with ecological purpose.

The sustainability paradigm shift suggests structural, economic, and social change. According to the World Commission on Environment and Development, there are seven rules to follow to be considered "sustainable": (1) efficiency and cost internalization, (2) environmental integrity, (3) equity (concerning whether developing trade regimes contribute to social justice), (4) international cooperation, (5) openness (examining how developing trade regimes can be negotiated in a transparent, open, and participatory way), (6) science and precaution (of whether developing trade regimes respect the precautionary principle), and (7) subsidiarity (developing trade regimes must contribute to decision-making on the best possible level). Numerous trade organizations are the backbone of the sustainable movement, such as the Sustainable Cotton Project, which works with farmers to develop chemical-free cotton; the Organic Trade Association (OTA), which has hundreds of worldwide companies producing organic fabrics or clothing; and the Fairtrade Labelling Organizations International (FLO), which is part of a worldwide network of **Fair Trade** organizations actively involved in supporting producers, raising awareness, and campaigning for changes in the rules and practices of conventional international trade. Major manufacturers such as **Nike**, **Patagonia**, Eileen Fisher, and mass retailer **Wal-Mart** are promoting organic fashion and sustainability, not only in their products but also in the building of their stores and offices.

SWAROVSKI. In 1892, Austrian David Swarovski (1862–) patented his crystal-cutting machine. In 1895, together with his brothers-in-law, Franz Weis and Armand Kosmann, they founded Swarovski in the Austrian Alps town of Wattens. In 1908, Swarovski's sons Wilhelm, Friedrich, and Alfred joined the company and began experimenting with the production of crystal and, by 1913, were producing their own crystal. Soon, their flawless, brilliantly cut jewelry stones were coveted everywhere and sold to Parisian fashion houses and jewelers. **Coco Chanel** was one of their first customers who enjoyed using crystal in brooches and embroidery. In the 1920s, "dancing dresses" embroidered with pearls and crystals were all the rage and, in 1931, Swarovski registered his invention for patent: a crystal-set fabric ribbon, which could be applied directly to textiles, shoes, and **accessories**. In 1975, Swarovski introduced its "Hot-Fix" technol-

ogy, a molten glue with which crystal motifs could be applied to the most diverse materials with the use of heat and pressure—this technique was used on **jeans**, **T-shirts**, bathing suits, and **hosiery**. In 1977, Swarovski America introduced its own line of jewelry called Swarovski Jeweler's Collection. In 1986, it launched a moderately priced line called Savvy, formed a joint venture with People's Group of Toronto, and acquired 1,300 Zales stores. In 1989, the company commissioned a limited edition of avant-garde evening handbags, jewelry, and belts from the leading Italian architects and designers Alessandro Mendini, Ettore Scottsass, and Stefano Ricci. Another first for the company was the launch in 1992 of its Scent Stone, stones that could be filled with perfume. In 1992, it created Crystal Mesh, used by **Dolce & Gabbana**, Chanel, and **Louis Vuitton** and, in 1999, launched Crystal Tattoos. Swarovski launched Crystal Fabric in 2003, fusing fabric and crystal into a second skin. It is a transparent Hotfix-foil, the surface of which is set with tiny full-cut and round crystals, which can be ironed, sewn, or glued onto materials such as lace, velvet, **silk**, jeans, **leather**, and synthetic fabrics. Swarovski is now a $2 billion, privately held company, selling crystal jewelry, figurines, chandeliers, picture frames, high-end optical equipment, and cutting tools for the construction industry. It operates 430 stores worldwide with 63 in the United States.

SWATCH WATCH. The Swatch Watch was created and popularized in 1983 by the Swatch Group Ltd., the world's largest watch producer and distributor. During the 1960s and 1970s, the Swiss watch industry lost much of its dominance to Japanese competitors. In an attempt to recapture lost market share, The Swatch Group created twelve new, inexpensive "disposable watches"—the word *swatch* is derived from the contraction of "second watch." These fun watches, offered in many different colors, were instantly successful and, by the mid-1980s, there were more than 2.5 million sold. In the late 1980s, Swatch created a limited edition artist series with Keith Haring and other artists which were sold in Swatch stores. Swatch diversified over the years and acquired numerous Swiss and other luxury **brands** including **Pierre Balmain**, Blancpain, Breguet, Certina, Jaquet Droz, Endura, Flik-Flak, Glashutte-Original, Hamilton, Leon Hatot, **Calvin Klein**, Omega, Mido, Rado, and Tissot. Swatch continues to reinvent itself

with its marketing and promotion campaigns. Beginning in 1999, it launched an e-mail watch. In 2005, it created the "smart watch," known as Paparazzi, that can access MSN Direct service to receive personalized information such as news, sports, weather, horoscopes, and more. Its ad campaign prompted people to wear their Swatch on their right wrist instead of the left. The Swatch Group was chosen as the official timekeeper of the Olympic Games in Athens, Turin, and Beijing and of the Ski/Snowboard World Cup Competitions.

SWEATSHIRT. A collarless, long-sleeved pullover, originally made of a fleeced **cotton** was introduced in 1925 by underwear manufacturer Russell Athletics as a lightweight alternative to men's **wool** football practice jerseys. In the 1930s, Champion added a front **zipper** and varsity lettering, a style later known as a *hoodie*. Universities began placing their logo on the front of sweatshirts in the 1960s and by the 1970s, Champion added sweatpants and the *sweatsuit* became the uniform for the jogging craze. In 1983, American **designer Norma Kamali** created her famous Sweatshirt Collection using sweatshirt fabric for a line of nonathletic **womenswear**. The oversized sweatshirt was adopted as part of the **hip-hop** look by the 1990s and continues to be part of the subculture of the fashion industry in all of its iterations.

SWEATSHOP. This name is given to a factory or workplace that operates under unsafe and/or unlawful working conditions and/or employs minors. The name is derived from the hot rooms in which the employed unskilled laborers performed piecework. The name "sweater" was given to the middleman who directed operations for the factory and who often subcontracted to other sweatshops. The "sweating system" was often associated with low pay, long hours, and overcrowded, rat-infested working conditions, which sometimes included child labor. In 1850–1900, immigrants from many countries ended up working in sweatshops in places like New York's Lower East Side and England's East London. Anti-sweatshop campaigns began in the late eighteenth century with the abolition of slavery in France in 1794, Britain in 1834 (Factory Act of 1833), and in the United States in 1865. In 1884, the **U.S. Department of Labor** was founded. A strike in the United States by 60,000 cloak makers,

known as the Great Revolt, resulted in the Protocol of Peace, a settlement whereby workers received a fifty-hour work week, double pay for overtime, and higher wages. It also initiated the "closed shop" concept, whereby employers could only hire union employees. However, in 1911, the world came to know the dangers of sweatshops when the Triangle Shirtwaist Factory Fire killed 146 workers and ultimately resulted in the first workplace health and safety laws in the United States. In the early 1900s, the **International Ladies' Garment Workers' Union (ILGWU)** and the **Women's Trade Union League (WTUL)** lobbied for passage of the **Fair Labor Standards Act of 1938**, which created minimum wage laws and other laws protecting workers from unsafe working conditions.

However, neither trade unions nor labor laws have been completely successful in eliminating sweatshops worldwide. As of 1994, there were still thousands of sweatshops operating in the United States, centered mostly in New York's Chinatown and surrounding boroughs, and in Los Angeles, as well as in other cities with large immigrant populations. In developing countries such as India, Honduras, Pakistan, China, and Vietnam, the problem is even greater. Indeed, due to globalization, there are millions of people—mainly women and children—heavily concentrated in the garment and textile industries. Anti-globalization activists—including the group United Students Against Sweatshops and labor unions **UNITE HERE** and the AFL-CIO—exposed companies such as **Gap, Wal-Mart**, and **Nike**, among others, which used sweatshops in developing countries. They sought legislation to hold these companies accountable for abuse violations and for the increase in domestic sweatshops that arise from having to compete with overseas sweatshops. While proponents of sweatshops argue that sweatshop-produced goods are a way of raising the standard of living, few would argue that the shops benefit workers at all. *See also* MINIMUM WAGE; TRADE UNIONS.

– T –

TAILOR. A person who is trained in the craft of designing, pattern drafting, cutting, fitting, and sewing garments, specifically suits and coats. Male dominated tailor's **guilds** were in existence as early as

the Middle Ages. Today, the British **bespoke tailors** of **Savile Row** and the tailors of Italy are some of the best experts at the craft.

TAM, VIVIENNE (1958–). Born in Canton, China, and raised in Hong Kong, Tam eventually settled in New York in 1983. She had her first runway show in 1994 and became famous for her irreverent **T-shirts** of Mao Zedong. In 2004, she opened two stores in Shanghai. In 2005, she launched Vivienne Tam Dress and, in 2006, opened a freestanding store in Beijing.

TAPE MEASURE. This flexible tool was introduced in 1820 by Joseph Courts and is designed to accurately figure body measurements. Initially the British and Americans favored inches, while the French used the metric system. Today most tape measures contain both. *See also* BODYSCANNING; ISO TAPE; SIZES; STANDARDIZED SIZING.

TARGET. In 1962, the Dayton Corporation entered the discount merchandising business with its first Target store in Minneapolis. In 1969, the Dayton Corporation merged with the J. L. Hudson Company to form the Dayton Hudson Corporation. Target introduced "plan-o-grams," which were designed to give a certain image to all of the stores and, by 1975, the stores were Dayton's largest revenue producer. In 1990, the first Target Greatland opened and offered a wide range of products for sale to consumers; in 1995, its first Super Store in Omaha, Nebraska, opened. In 2000, the Dayton Hudson Corp. changed its name to Target and it began to enlist name **designers** to create product exclusively for them such as housewares by Michael Graves, decorative touches by designers **Cynthia Rowley** and Ilene Rosenzweig, home furnishings by Philippe Starck, and maternity clothing by Liz Lange. In 2003, **Isaac Mizrahi** signed on to design a line of affordable clothing. The store has a new and modern approach that has been a model for other **retailers**. By 2005, Target operated more than 1,300 stores in 47 states. In 2006, Target's Go International program signed on British designer **Luella Bartley** to design a capsule collection. In 2006, in its ongoing pursuit to bring design to the masses, Target opened the Target National Design Center at the Cooper-Hewitt National Design Museum in New York City. It also

supported the Minneapolis Design Institute and the Museum of Modern Art, as well as sponsoring the Cooper-Hewitt National Design Awards and other museum special shows and events.

TARGET MARKET. In the United States, designers and retailers create merchandise to appeal to the lifestyle of specific age groups, such as the G.I. Generation (born 1900–1924), Silent Generation (born 1925–1942), **Baby Boomers** (born 1943–1960), **Generation X** (born 1961–1981), **Generation Y** (born 1982–2000), and **Millennials** (born 2000–2010). By understanding customer demographics, **designers** and **retailers** market to and satisfy the needs of each market segment. Other considerations such as race, religion, and socioeconomic issues are also considerations when defining a particular market category.

[TC]². This company sprang to life as the Tailored Clothing Technology Corporation in 1981 from a concept generated from a 1979 National Science Foundation Study conducted by John T. Dunlop and Fred Abernathy of Harvard University. The mission was to expand technology and educational programs and, in 1999, its first three-dimensional body measurement systems (**bodyscanning**) were made commercially available to four groups—**Levi Strauss**, the U.S. Navy, North Carolina State College of Textiles, and Clarity Fit Technologies of Minneapolis. Land's End and **Brooks Brothers** followed in 2000 and 2001, respectively. In 2001, **[TC]²** was selected for an anthropometric research study in 2002 using its 3-D measurement system to scan more than 10,000 men and women. The system utilizes four strategically placed white light sensors to extract more than 200 data points from the body in less than a minute. The results of **SizeUK** in 2003 and **SizeUSA** in 2004 yielded important information about the changing shape of British and American men and women. In 2003, [TC]² was selected for SizeMX, a national survey for Mexico.

TECHNICAL DESIGNER. This person's responsibilities include executing detailed flat drawings and garment specifications, communicating **pattern** corrections with domestic and overseas factories, and creating **technical packages**. He/she must have strong

patternmaking, pattern grading, and garment construction skills, as well as the ability to conduct fittings on a **dress form** or live **model**.

TECHNICAL PACKAGE. Also known as a *tech pack*, a technical package provides a complete composite of a product's size specifications, illustration, construction details, **patterns**, **trims**, fabrics, and **markers**.

TECHNICAL SERVICES MANAGER. This manager oversees both the **patternmaking** and **pattern** grading departments. He/she must have experience in a management capacity and be proficient with computer patternmaking/grading systems **PDM** and Web PDM.

TEXTILE AND MATERIALS PLANNER. This person creates and manages a materials strategy for an apparel company. He/she must have strong global textile and materials development experience.

TEXTILE DESIGNER. A textile designer creates a textile palette for designers to choose from for each collection/season. A strong sense of color and **pattern** design is mandatory. Textile designers create plaids, patterns, and checks, as well as various combinations of textures, yarns, and textile design surfaces. Computer software programs, such as U4ia, are often used to help illustrate the designer's designs.

TEXTILE WORKERS UNION OF AMERICA (TWUA). A union formed in the United States in 1939 by Southern textile workers. It later merged, in 1976, with the **Amalgamated Clothing Workers of America (ACWA)** to form the Amalgamated Clothing and Textiles Workers Union (ACTWU). In 1995, the ACTWU merged with the **International Ladies' Garment Workers' Union (ILGW)** to form the **Union of Needletrades, Industrial and Textile Employees (UNITE)**. In 2004, UNITE merged with the Hotel Employees and Restaurant Employees International Union (HERE) to create **UNITE HERE**.

THIMMONIER, BARTHÉLEMY. In 1830, he invented a chain-stitch **sewing machine** to make uniforms for the French army. It was later destroyed by French **tailors** who were afraid of losing work.

THREEASFOUR. *See* AS FOUR/THREEASFOUR.

TIFFANY & CO. Established 1837 in downtown New York City as Tiffany & Young, a stationery and fancy goods emporium by Charles Lewis Tiffany and John B. Young. In 1845, the company published its first **catalog** known as the Blue Book, a tradition that continues today. In 1886, the famous "Tiffany setting" was introduced (a six-prong solitaire diamond engagement ring), and, in 1853, the company name was changed to Tiffany & Co. Tiffany was the first to use the 925/1000 sterling standard, later adopted as the United States Sterling Standard and, in 1926, Tiffany's standard of purity for platinum became the official standard for platinum for the United States. In 1902, Louis Comfort Tiffany launched the Tiffany Art Jewelry department and, upon his father's death, assumed the role of artistic director. In 1940, Tiffany moved to its present headquarters on Fifth Avenue and 57th Street, which was immortalized by Truman Capote's novel, *Breakfast at Tiffany's*, which was made into a film in 1961 starring Audrey Hepburn.

Tiffany's collaborations with artists, designers, and architects began in 1956 with Parisian master jeweler, Jean Schlumberger, then **Elsa Peretti** in 1974, Paloma Picasso in 1980, and famous architect Frank Gehry in 2006. Trophies, handcrafted by Tiffany artisans, include the National Football League's Vince Lombardi Trophy (Super Bowl trophy beginning in 1967); the National Basketball Association's Larry O'Brien Championship Trophy; NASCAR's Nextel Cup Trophy (2004), which takes more than 135 hours to create; the U.S. Open Tennis Championship Trophy; and the Major League Baseball's World Series Trophy. Tiffany has been traded on the New York Stock Exchange since 1987. In 2001, the Tiffany & Co. Foundation was established in support of nonprofit groups dedicated to preserving the arts and environmental conservation. **FIT** was one of the first recipients in recognition of Elsa Peretti's 25th Anniversary with Tiffany and her contribution in the development of FIT's jewelry program. Jewelry and other products are still presented in the classic "Tiffany Blue Box," just as they were in 1837.

TOD'S. *See* VALLE, DIEGO DELLA.

TOGA. A toga is a large rectangular piece of fabric that is wrapped around the body and crosses over one shoulder. Although this garment was made popular by the early Romans in the period of 509–27 B.C.E., it was actually the Etruscans (750–200 B.C.E) who created the fashion look. Designers throughout the world often refer to this design concept for their collection.

TOILE. This is a French term for the sample garment that is usually made out of muslin, as a trial step to check the cut and fit before making it in the actual fabric.

TOLEDO, ISABEL AND RUBEN. Isabel is a fashion designer and Ruben is a fashion artist. Together they opened a fashion house in 1985. She is best known for her architectural silhouette targeting a sophisticated "downtown" customer. He is famous for his **fashion illustrations** that have appeared in major **department store** windows, advertisements, and as fashion **mannequins**.

TOPSHOP. A British **specialty store** chain that was considered a budget "rip-off merchant" in the 1980s until it was bought, in 2002, by Phillip Green of the Arcadia Group (who also owns Dorothy Perkins, Burton, Miss **Selfridge**, and British Home Stores). Topshop, under the **brand** directorship of Jane Sheperdson, has been transformed into a fast-moving fashion powerhouse. Topshop's **target market** is comprised of young, fashion-conscious females (Topshop) and males (Topman). The company operates 290 Topshop stores and 165 Topman stores throughout Great Britain, Ireland, and Europe, with its flagship store on Oxford Street being the largest clothing shop in the world. A New York City location is planned to open in 2007. The Arcadia Group has underwritten the British Fashion Council's New Generation Award since 2001 and has given many new young **designers** their start (such as Sophie Kokosalaki). In 2005, Topshop presented its Unique label during London's Fashion Week.

TRADES UNION CONGRESS (TUC). This British national **trade union** was founded in 1868. Three other trade unions are related, namely the Scottish Trades Union Congress, the Irish Congress of Trade Unions, and the Wales Council. Since 1979, membership in

the TUC has steadily diminished due to restrictions placed on trade unions by Prime Minister Margaret Thatcher's Conservative Party and the reduction in the amount of garment and textiles' domestic production. The TUC helped form the **International Confederation of Free Trade Unions (ICFTU)** in 1949.

TRADE UNIONS. An association of workers recognized by law, who join together to protect their rights and to influence working conditions in the workplace. **Guilds**, it could be argued, were the early ancestor to today's modern unions. Guild restrictions became so oppressive that by the end of the French Revolution (1799) they all but ceased to exist. In their place, trade unions were established whose focus was on workers' rights, pay, and working conditions, rather than skill hierarchy and production control. Unions strove to unite the "laboring man" instead and, in 1776, British economist Adam Smith, author of *The Wealth of Nations*, noted the imbalance in the rights of workers in regard to owners. Unions were illegal for many years in most countries with penalties as severe as execution for attempting to organize. The Reform Act of 1832 made unions legal in Great Britain where it was considered a human rights abuse to prohibit a person from forming a union, joining a union, or forcing them to join a union. In France, Germany, and other European countries, socialist parties and anarchists played a prominent role in forming and building up trade unions, especially from the 1870s onwards.

The primary function of most unions is the process of negotiation, which results in a union contract known as the collective bargaining agreement. This contract, between management and labor union, usually involves the following: salary ranges, job descriptions, seniority, wages, hours, benefits, grievances, and disciplinary procedures. At the heart of a union contract are how many hours an employee must work to earn a certain income, overtime pay, pay raises, and work responsibilities. Union contracts define tasks employees in different job titles cannot be asked to do; this helps avoid the "cannibalization" of jobs. Seniority is another contract concern, helping long-term employees retain their jobs during periods of budget cuts, layoffs, or other employee cutbacks, over newer employees who have fewer years on the job. Seniority provisions also determine who will have the first opportunity to apply for job openings. In addition to employee benefits,

the collective bargaining agreement's grievance procedure allows employees to file complaints, alleging violations of the contract.

In 1868, the British Trades Union Congress (TUC) was founded. However, diminishing production of clothing in developed nations over the years forced unions to consolidate. The TUC helped, along with French, Italian, and Spanish unions to form the **International Confederation of Free Trade Unions (ICFTU)** in 1949 following a split within the **World Federation of Trade Unions (WFTU)**. However the ICFTU was dissolved in 2006 when it merged with the **World Confederation of Labor (WCL)** and formed the **International Trade Union Confederation (ITUC)**. Early European trade unions included the formation of the French **Confédération Générale du Travail (CGT)** or General Confederation of Labor in 1895 and the **Confédération Française des Travailleurs Chrétiens** (French Confederation of Christian Workers) founded by Roman Catholic workers in 1919, which later became the **Confédération Française Démocratique du Travail (CFDT)**. The **Force Ouvrière (FO)** was founded in 1948 by former members of the CGT who opposed Communist dominance within that organization. Italy's largest trade union, **Confederazione Generale Italiana Del Lavoro (CGIL)**, was originally founded in 1944; however, this group later merged with the Federazione Italiana del Lavoro (Italian Federation of Labour) and now calls itself the **Confederazione Italiana dei Sindacati Lavoratori (CISL)**.

In the United States, the **International Ladies' Garment Workers' Union (ILGWU)** was formed in 1900. In 1903, the **Women's Trade Union League (WTUL)** became the first American national trade union dedicated to women; however, it dissolved in 1950. These unions helped bring about government legislation, such as the **Fair Trade Labor Standards Act of 1938**, but offshore manufacturing weakened their strength and by the 1990s more that half of all apparel and most textile production was nondomestic. The ILGWU merged with the Amalgamated Clothing and Textile Workers' Union (ACTWU) in 1995 to form the **Union of Needletrades, Industrial and Textile Employees (UNITE)**; in 2004, the group merged with the Hotel Employees and Restaurant Employees International Union (HERE) to form **UNITE HERE**.

As the production of garments and accessories continued to move offshore to less-developed nations, numerous activist groups began

fighting for workers' rights in those countries. The International Trade Union Federation linked together national unions from a particular industry on an international level. Today, issues including freedom of association (the right to unionize); monitoring and abolishing child labor; eliminating discrimination based on race, religion, sex, or origin; and establishing "core labour standards" are the groups' main focus.

Trade unions, however, have not been completely successful in eliminating worker abuse neither in developed nor undeveloped countries. **Sweatshops** are still being reported in cities like Los Angeles and New York. The worst cases of worker abuse are in countries like Bangladesh, Cambodia, China, India, the Philippines, and South Korea. The right to unionize in regions of Africa, Asia, Central and South America, the Middle East, and Haiti is often met with violence, torture, and death. The International Trade Union Confederation as well as grassroots organizations—such as the Workers Rights Consortium, a factory-monitoring organization founded by a national activist group; United Students Against Sweatshops; and the Fair Labor Association (FLA), an anti-sweatshop group including apparel manufacturers—continue to lobby governments and fight for sweat-free products. These organizations and others like them such as Global Exchange, Co-op America, United Students for **Fair Trade**, Sweatshop Watch, and the National Labor Committee, report abuses to the media who in turn expose companies like **Wal-Mart** and **Nike** to the public to highlight their manufacturing practices in sweatshops.

TRAFFIC MANAGER. This person is responsible for managing all in-store marketing projects including signage, point of purchase displays, packaging, collateral, and so on, from start to finish within the graphic arts studio. He/she also acts as a liaison between account management, creative, and production sections.

TRAPEZE. This silhouette is one that **Yves Saint Laurent** is credited with creating in 1958 for the House of **Dior**. It is best described as narrow shouldered and wide at the hem.

TREACY, PHILIP (1967–). Born in Ireland, Treacy opened his own hat shop in London in 1994. His hat designs have graced the runways

of some of the most important **designers** of the time, such as **Gianni Versace, Valentino, Alexander McQueen,** and **Karl Lagerfeld.** Best known for his surrealist, whimsical hats such as the "birdcage," Treacy was honored by the **Chambre Syndicale de la haute couture parisienne** in 2000, to show his collection during the **haute couture** shows in Paris.

TRENCHCOAT. A water resistant raincoat designed by Thomas **Burberry** during World War I for officers working in the trenches.

TRENDSETTERS. Trendsetters are those people known for their ability to attract a fan following that desires to emulate them in dress and/or **lifestyle.** Historically speaking, famous fashion trendsetters have been aristocrats, who set the standards of dress for nobility, the social elite, the demimonde, and society at large. Today's trendsetters include actors, musicians, models, sports celebrities, and celebrity **designers.** *See also* FASHIONISTA.

TRIANGLE SHIRTWAIST FACTORY FIRE. *See* SWEATSHOP.

TRICKLE-DOWN. In the fashion industry, this term refers to the phenomena of how a trend starts in an upscale market and then filters down to the masses. The psychology of differentiation and imitation is at the core of why members of the lower classes want to have what the upper classes have, especially in terms of clothing if they cannot have the lifestyle. The average lifecycle of a trend, from **haute couture** to **mass merchandise**, before the advent of television and the Internet, could take from one to two years. Now, as designers' runway shows air for all to see virtually immediately, styles are not only quick-changing but also being copied—and, in some cases, the **knock-offs** make it to the stores faster than the originals.

TRIGERE, PAULINE (1908–2002). Born in Paris to Russian Jewish parents, she learned the trade as a child; her mother was a dressmaker and her father owned his own **tailoring** shop and manufactured military uniforms. In 1937, as Adolf Hitler rose to power, Trigere, her two children and husband, Lazar Radley, moved to New York City. She went to work for her brother's tailoring business and, after divorcing

her husband in the mid-1940s, began building a name for herself with the launch of a line of beautifully tailored dresses. However, Trigere is best known for her impeccably tailored coats and suits, which she achieved by actually draping them in cloth rather than designing them from a sketch. She has often been quoted as saying "you can't wear a sketch" and would frequently demonstrate her draping technique to students throughout the years. Her accomplishments include three **Coty Awards** (beginning in 1949), a Lifetime Achievement Award from the **Council of Fashion Designers of America**, and France's Legion d' Honneur. Her list of clients included the Duchess of Windsor, Josephine Baker, Claudette Colbert, Bette Davis, Lena Horne, Grace Kelley, Angela Lansbury, and Audrey Meadows. In addition to her clothing, Trigere designed scarves, jewelry, men's ties, and a perfume. Before she died, she worked with a website and **catalog** company creating styles for fashion-savvy senior citizens.

TRIM BUYER. This person is knowledgeable in sourcing suppliers and the purchasing of buttons, **zippers**, braid, ribbon, hooks, toggles, beads, or any other type of trimming or other miscellaneous pieces needed to complete a garment.

TRIMS. Trims consist of many types; the most common are tassels, braids, ribbons, buttons, lace, and beads. They can serve a function, such as a button, but more often are strictly nonessential decorative elements. They can convey rank (as in military braids) or position due to their expense. Trims run the gamut from prosaic to ostentatious. As early as the thirteenth century, guilds existed for buttonmakers in Italy and France. Convents were often centers of production of high-quality trims, including braids and embroidered boarders. During the sixteenth to eighteenth centuries, knitting frames were used to make trims such as ribbons, braids, yarns, and tapes. It was during this time period that *passementerie* ("trimming bands") were produced in France. This process required such skill that an apprenticeship typically lasted for five years. By the seventeenth century, small hand-powered devices created tie cloths. It was during the nineteenth century, however, that power machines made tassels and the house of **Lesage** began beading for clients such as **Worth**, **Poiret**, and **Paquin**. René Béque, known as Rébé, was a competitor of Les-

age and had both **Dior** and **Hartnell** as costumers. Anea Tonegatti had **Mainbocher** and **Norell** as customers. All of these great trim houses produced master pieces of beading and embroideries for their **couture** house clients. A $15,000 couture gown could have $10,000 worth of embroidery on it. In the twentieth century, the **ready-to-wear** market moved **mass production** to places like China, India, and Turkey—and even Lesage opened a production facility in India.

TRUNK SHOW. The name given to a **designer**'s or designer sales associate's personal appearance at a store to preview the designer's latest collection and to sell merchandise. Begun in the late 1800s, designers including **Charles Frederick Worth** and **Jean Patou** would travel with their collections to promote business. More recently, **Arnold Scaasi, Bill Blass,** and **Michael Kors** became well known for the number of trunk shows they held. Trunk shows can create publicity for designers, as well as generate revenue. **Giorgio Armani** and **Karl Lagerfeld** trunk shows have set records, often bringing in millions of dollars in sales per show.

TSE. This sweater company began in Hong Kong in 1986, founded by Augustine Tse, who originally called the company Cashmere House. It began as a **private label** business but eventually developed into a women's, children's, men's, and home products collection. Tse operates many in-store shops and freestanding stores worldwide.

T-SHIRT. The T-shirt originated as a garment of utilitarian purposes, first serving as a piece of men's underwear. Today, it is extremely complex and remains a functional underwear component for men, women, and children and a staple of their **sportswear** wardrobe. With sales in the billions each year, T-shirts are offered in a variety of price points and fabrics. They also serve as a means of advertisement, through promotion of products, political opinion, or shock value. Images and decorations are applied in a variety of processes including silk screening, heat transfer, embroidery, or textured printing. The T-shirt has progressed from first protecting the body from exterior weight and roughness, such as in body armor, to protecting delicate fabrics from the wearer's body. In the late 1800s, circular-knitting machines allowed for the manufacture of close fitting knitted undergarments.

By 1901, P.H. **Hanes** Knitting Company was founded and by 1910, **Fruit of the Loom** dominated the market. The 1930s saw T-shirts as a staple of the college wardrobe and also saw the use of the **logo** on the shirt. World War II saw the T-shirt as an integral part of the U.S. soldier's uniform; photos of soldiers in magazines, newspapers, and newsreels familiarized the public with the T-shirt. While returning soldiers, laborers, and athletes broadened the T-shirt's use, it was not until the 1950s that Hollywood made it a fashion statement. Film stars such as Marlon Brando and James Dean eroticized the T-shirt. Teamed with blue **jeans** and **leather** motorcycle jackets, the T-shirt spoke to a rebellious attitude against a conservative society. In 1962, **Dior** showed a T-shirt in his summer collection and other designers created them in **silk** for eveningwear. The youth of the 1960s tie-dyed T-shirts and they became synonymous with the **hippie look**. T-Shirts became necessary components of a well-rounded wardrobe and by the 1980s the polo T-shirt by **Ralph Lauren** and **Lacoste** were fashion must-haves. Black T-shirts were worn by hip **trendsetters** and became an identifying statement of designers, specifically **Armani** and **Gaultier**. T-shirts have been paired in recent years with a tuxedo or skirt for eveningwear or constructed out of **cashmere** or silk for office attire. The **counterfeit** market moved into the twenty-first century using the T-shirt as its backdrop to countless **designer** names. *See also* KNITWEAR.

TWIGGY (1949–). Born Lesley Hornsby in North London, she was discovered at age sixteen and went on to become the face of the 1960s. Her waif-like body and baby face completely revolutionized the **modeling** industry and catapulted her to celebrity status. *See also* MOD LOOK.

TYLER, RICHARD (1948–). Australian-born designer Richard Tyler began his career by opening a **boutique** at age eighteen. He designed a men's collection in 1987 and a women's collection in 1989. He was hired to design for the **Anne Klein** collection in 1993 but soon left to concentrate on his own line. He is best known for his impeccable **tailoring** and hand-finishes. His **couture** collection is a favorite among Hollywood stars. In 2004, Tyler created flight attendant uniforms for Delta Air Lines. Richard Tyler has won three **Council of Fashion**

Designers of America (CFDA) awards and a Michelangelo Shoe Award for his debut **footwear** collection.

– U –

UNGARO, EMANUEL (1934–). Ungaro's family had fled to France to escape the fascist Italian government and he was born in Aix-en-Provence. He learned to sew from his father, a **tailor**, and became a tailor's apprentice as a young boy. He landed a job at **Balenciaga** (1958–1963) and worked for six years as his assistant before moving to **Courrèges** for two years. Ungaro opened his own **couture** house in 1965 with partner Sonia Knapp, who also designed his prints. His first collection consisted of only seventeen dresses but his use of bold color and expert tailoring quickly caught the eye of the **fashion press** and two famous **haute couture** connoisseurs, Jackie Kennedy and Marie-Hélène de Rothschild. Ungaro is famous for beautifully sensual clothes done in brightly colored floral prints. He is among the group of famous designers — **Madame Grès, Balenciaga, Pauline Trigere**, and others — who believe that working on a **model** or living body, as opposed to a sketch, is the best way to be truly creative.

In 1968, Ungaro created his first **ready-to-wear** collection, Parallèle, and, in 1973, his first **menswear** collection, Ungaro Uomo. Fragrances followed with Diva (1983), Senso (1987), Ungaro (1991), and Emanuel Ungaro for Men (1991). In 1988, Ungaro married Laura Bernabei. Over the years, the company expanded to include **boutiques** and numerous **licensing** deals. In 1996, Ungaro sold the company to **Salvatore Ferragamo** Italia SpA; in 1997, Ferragamo and **Bulgari** formed Emanuel Ungaro Parfums. The new perfumes launched were Fleur de Diva (1997), Desnuda (2001), and Apparition (2004). In 2002, Ungaro launched a less expensive line, Ungaro Fushia, while he continued to market his **sportswear** line, Fever, and his **ready-to-wear** Ungaro collection. Also that year, Ungaro announced that he would continue to design the couture line but that the ready-to-wear, Fever, and **accessories** collections would be under the design direction of Italian **designer** Giambattista Valli.

The 35th anniversary in 2002 saw a rebirth at Ungaro with a new wave of celebrity interest from stars such as Sarah Jessica Parker, Jennifer Lopez, Whitney Houston, and Britney Spears. In 2005, Ungaro was sold to Asim Abdullah, a U.S. entrepreneur of Pakistani decent, and the collection is now designed by the Frenchman Vincent Darre. The Ungaro empire consists of **womenswear**, **menswear**, accessories, perfume, and thirteen stores worldwide.

UNION OF NEEDLETRADES, INDUSTRIAL AND TEXTILE EMPLOYEES. *See* INTERNATIONAL LADIES' GARMENT WORKERS' UNION; UNITE.

UNISEX CLOTHING. The term originated in the 1960s and refers to clothing specifically designed to be worn by both sexes. The trend arose in response to the youth revolution and the **hippie** movement of the 1960s and the women's liberation movement of the early 1970s. Designers such as **Pierre Cardin** and especially **Rudi Gernreich** designed clothes that challenged the clichés of male and female dress that later gave way to the **androgynous look**.

UNITE. An acronym for the union which was formed in 1995 from the merger of the **International Ladies' Garment Workers' Union (ILGWU)** and the Amalgamated Clothing and Textile Workers Union (ACTWU).

UNITED COLORS OF BENETTON. Founded in 1965 by Luciano Benetton and his family in Veneto, Italy, the company is known for its "shock" appeal in its choice of ad campaigns as well as savvy business practices. Beginning in the early 1990s, however, the company struggled with its **brand identity** and began losing market share. Luciano, who was seventy-one years old in 2006, was grooming his son, Alessandro, to succeed him and is committed to creating a classic well-made line of clothing. Its European competition consists of **H&M** and **Zara**, both of which are hailed as trendy **retailers**. Benetton plans to again secure a strong market share in Italy, as well as China and India. In 2000, Oliviero Toscani, Benetton's **creative director** of eighteen years, departed the company. Toscani is credited with the company's attention-grabbing advertising campaigns. And

while many believed this assisted the **brand**, business relationships were also severed because of them. In 1993, **Sears, Roebuck and Company** dropped the Benetton USA line and it was estimated that Benetton lost upwards of $100 million in sales. Fabrica, a think tank formed by Benetton and comprised of creative individuals, is now considered the key in developing a strong **brand identity**. The company plans extensive store rollouts in China, with the aim to have 200 stores there by the year 2008.

UNITE HERE. This super union resulted from the merger of two trade unions, **UNITE** (Union of Needletrades, Industrial and Textile Employees) and **HERE** (Hotel Employees and Restaurant Employees International Union), which, in 2006, represented more than 440,000 active members and more than 400,000 retirees throughout North America.

UNIVERSAL PRODUCT CODE. A 12-digit code attached to an item that, when scanned, collects data about a product's style, color, and size. This data provides "real time," **point-of-sale (POS)** information that is relayed to a vendor's data system via **electronic data exchange**. Retailers use the information for reorders and other business analysis tasks.

U.S. CENSUS BUREAU. A U.S. government institution dating from the first population census taken in the early 1600s. In 1810, the census expanded to include statistics on manufacturing, quantity and value of products, and, in 1902, the Census Bureau became a permanent institution by an act of Congress. Today the U.S. Census Bureau, through its surveys, reports statistical data not only on the fashion industry but many other areas of goods and services.

U.S. DEPARTMENT OF LABOR. A department within the cabinet of the United States government that is responsible for occupational safety, wage and hour standards, unemployment insurance benefits, reemployment services, and some economic statistics. It was first established by the U.S. Congress in 1884 and has been responsible for initiating numerous pieces of legislation passed throughout the years, including the **Fair Labor Standards Act of 1938**, which sets **minimum wage** rates for workers.

– V –

VALENTINO. Valentino Garavani (1932–) was born in Voghera, Italy, to an electrical engineer father. While in high school, Valentino apprenticed under Vogherese designer Ernestina Salvadeo. Upon graduation he moved to Paris to study at L'École des beaux arts and **Chambre Syndicale de la haute couture parisienne** and went to work for Jean Desse and Guy Laroche. Valentino moved to Rome in 1960 and set up his own **couture house**, the same year that he met his future business partner, Giancarlo Giammetti. His first show, in 1962, was a huge success and, in 1967, he launched his famous "V" **logo**, when he premiered the Valentino White Collection. His client list is extensive and includes Jackie Kennedy, who wore a Valentino dress for her wedding to Aristotle Onassis. Valentino's **menswear** is worn by Tom Cruise, Mikhail Baryshnikov, Alexander Gudunov, and Mathew Modine. He is best known for the clothing line Valentino Red, with its lively prints, feminine silhouettes, expert craftsmanship, and dramatic drop-dead eveningwear.

Valentino's vast empire includes men's and women's couture collections, **fragrance**, makeup, **accessories**, **jeans**, and leatherwear; altogether he has more than forty **licenses**. His wealth and jetsetter **lifestyle** boasts an 84-foot yacht and homes in Rome, Gstaad, Capri, New York, and London.

In 1984, Valentino presented his **ready-to-wear** in Paris under the French Couture Federation as well as showing in Rome. In 1990, he cofounded with Giammetti an association that supports victims of AIDS known as the L.I.F.E. Foundation. In 1998, Valentino was sold to Italy's Holding di Partecipazion Industriali in a move that was intended to create a rival luxury group to **Moët Hennessey Louis Vuitton**. However, in 2002, Valentino was sold to Marzotto Apparel, a company whose portfolio consists of **Hugo Boss**, Marlboro Classic, **Gianfranco Ferre**, and M **Missoni**. The company was restructured and now appeals to a younger customer with Valentino Red, its less expensive contemporary line, and Valentino Roma, an evening and daywear diffusion line. Young Hollywood stars Kate Hudson, Kate Beckinsale, and Cate Blanchett have discovered Valentino. In 2005, Valentino launched the **fragrance** V with Procter & Gamble and expanded its stores to twenty in Japan

and five in the United States. In 2006, Valentino received France's distinguished Légion d'Honneur.

VALLE, DIEGO DELLA. The store known as Tod's has its roots as an Italian shoe company founded in the early 1900s by Filippo Della Valle. It was not until the 1970s when the founder's grandson, Diego, entered the firm that **Tod's** S.p.A. became a leading luxury shoe and **leather** goods company. Tod's is best known for its iconic Driving Shoe, a hand-crafted, high-quality, soft-leather moccasin with 133 rubber studs on its sole, which was introduced in the late 1970s. Tod's shoes and bags are bought by some of the most affluent people in the world, are favorites among celebrities, and are strategically placed in films. Tod's has identified a niche **target market**, that is, a chic customer with a casual lifestyle. In addition to its 150 Tod's stores worldwide, Tod's launched a limited-edition women's **ready-to-wear** collection in 2006 and hired Derek Lam as **creative director**. Della Valle is also the owner of the Italian football team Fiorentina, which he bought in 2002.

VALVO, CARMEN MARC (1954–). Born in Westchester County, New York, to a Spanish/Italian family, Valvo received a degree in Fine Arts from Manhattanville College and later studied fashion at **Parsons School of Design**. He began his career as a **designer** at **Nina Ricci** followed by a stint at **Christian Dior**. In 1989, he launched his own label of **sportswear** and eveningwear, and his eveningwear is what catapulted him to fame. In 1998, he launched Carmen Marc Valvo Couture to rave reviews during New York Fashion Week and immediately became highly sought-after by Hollywood celebrities including **Beyoncé**, Kim Cattrall, Lucy Liu, Oprah Winfrey, and Catherine Zeta-Jones. Valvo is most known for his extraordinary craftsmanship, painstaking hand-detailing, masterful fit, and luxurious fabrics, many of which are inspired by his love of world travel. In addition to his evening collection, he also designs a sportswear collection, a suit collection, custom-made **furs**, shoes, limited-edition jewelry, and a swimwear collection.

VAN BEIRENDONCK, WALTER (1957–). Born in Belgium, he opened his own company in 1988 and was one of the **Antwerp Six**.

In 1992–1996 he produced a line called W. & L. T., which is an acronym for Wild and Lethal Trash. His designs are often considered avant-garde and he was one of the first designers to incorporate the Internet and CD-ROMs in the marketing of his collection.

VANDERBILT, GLORIA (1924–). Vanderbilt was born in New York and was the daughter of the American railroad heir, Reginald Claypoole Cooper. She became heiress to a $4 million trust fund upon her father's death in 1925. A custody battle ensued and the name Gloria Vanderbilt made headlines. She studied at the Art Student's League in New York City and pursued a career in art with shows that featured her oil paintings, pastels, and watercolors. In 1968, Vanderbilt began designing cards for Hallmark and textiles for Bloomcraft. She eventually branched out, designing home products including linens, glassware, china, and flatware. Vanderbilt's numerous marriages made headlines beginning with her first husband, Hollywood agent Pasquale DiCicco, whom she married in 1941 but divorced in 1945, the same year she married and divorced her second husband, conductor Leopold Stokowski. Her third husband was director Sidney Lumet, to whom she was married from 1946 to 1963. Her fourth and final marriage was to the author Wyatt Emory Cooper, who died in 1978.

Considered American royalty, her foray into the fashion industry was secured when Vanderbilt agreed to put her name on a line of blouses produced by the Murjani Corporation. In 1979, Murjani launched a line of designer **jeans** and chose Vanderbilt's signature for the back pocket, thus creating the designer-jeans craze that followed. Vanderbilt's swan **logo** began to appear on moderately priced merchandise such as stationery, scarves, textiles, a home collection, watches, sunglasses, **footwear**, and a line of **fragrances**. Vanderbilt wrote several books including *Once Upon a Time: A True Story, A Mother's Story*, and *It Seemed Important at the Time*. The sale of her name was like a tennis match with **licensors** selling her name to other large companies such as Murjani, Gitano, Echo Design Group, and ending up with **Jones Apparel Group**. The Vanderbilt name is still considered a widely recognizable **brand** name, though Gloria no longer receives royalties from it. In 2003, the Vanderbilt/Jones Apparel Group signed a licensing agreement with Amerex for a line

of **outerwear** and, in 2004, expanded with a home products line for **Kohl's department store**.

VAN NOTEN, DRIES (1958–). Born in Antwerp, Belgium, Van Noten showed his first collection shortly after graduating from fashion school in 1986. He is part of the **Antwerp Six**.

VAN SAENE, DIRK (1959–). He graduated from the Academy of Antwerp in 1981 and he is one of the **designers** known as the **Antwerp Six**.

VARVATOS, JOHN (1955–). Born in Detroit, Michigan, Varvatos was born to a Greek American father and an Italian American mother. He began his design career in 1983 working for Polo **Ralph Lauren**. He left Lauren in 1990 to become the head of **menswear** design at the **Calvin Klein** Collection and later helped launch the CK line. In 1994, he returned to Ralph Lauren as vice president of **menswear** design for all Ralph Lauren **brands** (he launched Polo **Jeans**) until 2000 when he partnered with **Nautica** to open his own menswear collection. Varvatos is known for his luxurious fabrics, mixed in an eclectic way, for the casual modern man. He is a three-time winner of the coveted **Council of Fashion Designers of America** Perry Ellis Award for Menswear (2000) and Menswear Designer of the Year Award (2000 and 2005). His men's collection is a favorite among Hollywood celebrities including Tom Cruise, Adrien Brody, Brad Pitt, and Bruce Springsteen. In 2004, he launched a women's line, just as Nautica was sold to the **VF Corporation** (2003). In 2005, VF agreed to form John Varvatos Enterprises, with Varvatos maintaining a 20 percent stake in the company. The same year, he partnered with **Converse** and debuted his laceless Chuck Taylor **sneakers**. Adding to his popular John Varvatos **fragrance** (launched in 2004), he created a line of men's skin care called Skin and a new fragrance, Vintage, both launched in 2006. In addition to his skin care, fragrance, and menswear collection, Varvatos operates five retail stores and manages an eyewear **license**.

VENDEUSE. The French word *vendeuse* describes a salesperson employed at a **couture** house. These employees are carefully trained to

be able to cater to each individual client's needs. One might be hired to deal with clients with classical tastes, while another might specialize in those customers with eccentric tastes. Vendeuses are required to speak several foreign languages and have a refined sense of the social graces as they are selling clothing priced in the thousands of dollars, usually to an elite group of wealthy women. *See also* HAUTE COUTURE.

VENDOR. The name that refers to a manufacturer in the retail segment of the fashion industry.

VERSACE, DONATELLA (1955–). Born in Reggio di Calabria, Italy, she is one of one of four children. Her father was a businessman to Italian aristocrats and her mother was a seamstress. She attended Florence University and studied languages but soon assumed the role of public relations manager, muse, and collaborator with her brother, **Gianni Versace**, when he opened his clothing business in 1978. She designed the Versus line and, in 1993, she launched Versace Young, a line of **designer childrenswear** clothing. Upon her brother's death in 1997, Donatella went on to continue the tradition of designing for the modern, sexy woman and maintained a celebrity following. She is credited with being the first designer to use celebrities as the "face" of Versace, including Madonna, Demi Moore, Britney Spears, Christina Aguilera, and, in 2006, Halle Berry. Today the Versace empire consists of luxury men's, women's, and children's clothing, **accessories**, perfumes, cosmetics, home furnishings, and a luxury hotel chain. Chief designer Donatella and brother Santo, operating as the company's CEO, expanded the Versace empire to include the Palazzo Versace Resort in Gold Coast, Australia, an ultra-luxurious resort, with plans to expand to a new location in Dubai, United Arab Emirates, in 2008. Versace **brands** include Atelier Versace (**haute couture**), Gianni Versace Couture (**ready-to-wear**), Versus Versace, Versace **Jeans** Couture, Versace Ceramics Designs, Versace Sport, Versace Collection, Versace Precious Items, Versace Intensive, and Versace Young. In 2004, Allegra Versace, the daughter of Donatella and ex-husband Paul Beck, inherited $700 million from Gianni Versace's estate and today is the majority shareholder in the company. There are approximately 240 **boutiques**, 150 in-store shops in major

department stores and duty-free shops, and selective multi-brand boutiques in 60 countries. *See also* VERSACE, GIANNI.

VERSACE, GIANNI (1946–1997). Born in Reggio di Calabria, Italy, Versace grew up playing at his mother's couture business. Although he studied architecture and music, his true passion was for fashion. During the 1960s, Versace opened two shops (one for men, one for women) in his hometown, which is where the president of Genny Group saw his work; he moved him to Milan to design the Genny line and later Complice. In 1978, Versace opened Versace Atelier Collection, his signature company, catering to the celebrities and highly successful modern women and men. In 1989, he launched Versus, which was designed by his sister **Donatella Versace**. Versace is best known for his drop-dead eveningwear, elegant **ready-to-wear**, his Medusa **logo**, and a flair for all things Baroque. In addition to clothing, he created **accessories**, eyewear, home products, and, in 1995, launched his perfume, Blonde, named after his sister/muse, Donatella. Among Versace's awards and exhibitions include a show in 1985 at the Victoria and Albert Museum in London, and the **Council of Fashion Designers of America** award for his contribution to fashion in 1993. Versace also designed costumes for *Salome* at the La Scala Opera house and the 1991 production of *Capriccio* at the Royal Opera House. Tragically in 1997, Versace was shot dead in front of his Miami home, which left Donatella with creative responsibility and his brother, Santo, the company's CEO, to run the business. Immediately following his death, the Metropolitan Museum of Art paid tribute to him with one of the largest exhibitions of a designer's work. In 2002, a major retrospective of his work was presented at the Victoria and Albert Museum, *The Art and Craft of Gianni Versace*. Pieces from his collections included Elizabeth Hurley's 1994 "Medusa-headed safety pin dress," his signature gold metal mesh evening gowns, his fantastically sexy **leather** pieces, and his signature prints. In 2004, when Donatella's daughter Allegra turned eighteen, she inherited $700 million and assumed majority control of the vast Versace empire. *See also* VERSACE, DONATELLA.

VF CORPORATION. VF is the largest American apparel company and a leader in offering high-quality, high-value branded apparel. VF's

brands include jeanswear, **intimate apparel**, outdoor, and specialty apparel. Established as the Reading Glove and Mitten Manufacturing Company in Pennsylvania in 1899 by John Barbey and a group of investors, it began manufacturing undergarments in 1919 and changed its name to Vanity Fair Mills. The company went public in 1951 and, in 1969, after acquiring the H. D. Lee Company, the company changed its name to the VF Corporation. Once Blue Bell Inc. was acquired, VF Corp. became the largest publicly held apparel company with annual revenues of $6 billion in 2004. Its principal brands include Britannia, Gitano, JanSport, Kipling, Lee, Lily of France, **Nautica**, **The North Face**, Riders, **Tommy Hilfiger** Intimates, Vanity Fair, Vans, **John Varvatos**, Vassarette, and Wrangler.

VICTORIAN ERA. Alexandrina Victoria (1819–1901), daughter of the fourth son of King George III, was born in Kensington Palace, London. She became the queen at age eighteen, produced nine children with her husband Prince Albert, was monarch of Great Britain and Ireland from 1837–1901, and was the Empress of India from 1877 to her death in 1901. During her reign of more than sixty-three years, the longest monarchy in British history, Great Britain became a superpower. The Victorian Era, as it came to be known, was at the height of the **Industrial Revolution** and a time of significant social, technological, and economic change. By 1837, cloth was being **mass produced** in mills in Northern England and, with the invention of the lock-stitch machine, home sewing flourished as did factory-made product. In 1851, the first World's Fair was held; known as the Great Exhibition of 1851 and organized by Prince Albert, it did much to promote British fashion and the concept of a rational dress.

Queen Victoria of England acceded to the throne in 1837. The Victorian Era in fashion is broken down into three periods: Early Victorian (1837–1856), also known as the Crinoline era; Mid-Victorian (1860–1882), called the First Bustle Era; and Late Victorian Period (1883–1901), which covers the Second Bustle Era and the period of Gibson Girls and **tailor**-made suits. The Victorian Era produced a broad range of styles: Orientalism, Gothic revival, the Pre-Raphaelites, Artistic Dress, the Scottish Highlands, and Aestheticism. However, reaction to the extravagant excesses of **Charles Frederick Worth**'s designs resulted in a dress reform movement in Britain. The

Victorian period became known for sexual repression and prudery that transcended into fashion. Fussy collars, corsets, tight lacing, **bloomers**, and a prim-and-proper ladylike look prevailed. Even the showing of an ankle was scandalous. In fact, *Harper's Bazaar* printed a chart in 1868 dictating the proper length of a little girl's skirt based on her age.

VICTORIA'S SECRET. Established in San Francisco in the early 1970s by Roy Raymond, this lingerie shop captured a Victorian boudoir atmosphere, which in time would become highly successful. Victoria's Secret, consisting of three stores and a **catalog** business, was acquired by Limited Brands and, in 2006, was the leading specialty retailer of lingerie in the United States, operating more than 1,000 stores across the nation. Victoria's Secret **fashion shows**, catalogs, and **models** have been somewhat controversial and have brought the **retailer** unprecedented revenue and growth. *See also* INTIMATE APPAREL.

VIKTOR & ROLF. Viktor Horsting (1968) and Rolf Snoeren (1969) were born in southern Holland and met at the Arnhem Academy design school in 1988. Their first collection won the grand prize in the competition *Salon européen des jeunes stylistes* in Hyères, France, in 1993—their designs were conceptually oriented, with a focus on poking fun at fashion rather than creating wearable fashion. Their 1996 collection was shown entirely on Barbie-size dolls. In 1998, the Groniger Museum in northern Holland not only gave them an art show and funded their first **couture** show (inspired by the atomic bomb) but also launched a retrospective of their first five seasons. They were among an elite group of **designers** to be invited by the prestigious Fédération Française de la Couture to show their fall/winter 1999–2000 collection in France. Their fashion presentations often have been media hyped, such as their couture show in 1999, the Russian Doll Collection, where they placed a model on a turntable and dressed her in nine layers of crystal-studded clothes until she could not move. In 2000, they **licensed** their **ready-to-wear**, handbags, and **footwear** lines to Gibo, the Italian subsidiary of Japanese conglomerate Onward Kashiyama and, in 2001, the duo was hired to design Kashiyama's **bridge sportswear** line, International Concept Brand (ICB).

They exhibited a ten-year retrospective at the Museum of Fashion and Textiles at the Louvre in 2003, the same year that they launched their **menswear** line. In 2003, Viktor & Rolf initiated a creative collaboration with actress Tilda Swinton, who not only had become their muse but had also been featured in their runway presentation *One Woman Show*. In 2004, Viktor & Rolf partnered with L'Oreal and launched their first **fragrance**, Flowerbomb, which was packaged as a pink hand grenade. In 2005, they opened their first store in Milan with an upside-down concept: chandeliers came up from the floor and a floor of oak parquet was on the ceiling. In 2006, they signed with Allegri to design a line of men's and women's **outerwear** and with **H&M** to design a one-time line of menswear, **womenswear**, and **accessories**. They continue to explore the world of avant-garde fashion in their ready-to-wear and **haute couture** collections and are definitely on the radar screens of both the art and fashion worlds.

VINTAGE FASHION. Popularized during the 1960s, the trend to wear, collect, or use vintage clothing for inspiration has become big business. *Vintage clothing* refers to any item whose origin is from an earlier period in time. Today vintage clothes are collected for various reasons: they are worn by celebrities, auctioned or sold on eBay, collected by fashion historians, used by fashion **designers** as references, and bought and worn by people who have an individualistic approach to dressing themselves. The latest trend in vintage clothing stems from two diametrically opposed perspectives: one is an ecological viewpoint that professes to "save the planet" through reusing materials, and the other is a status symbol as a show of wealth and/or individualism.

VINYL. *See* POLYVINYL CHLORIDE (PVC); SEMON, WALDO L.

VIONNET, MADELEINE (1876–1975). Born in Chilleurs-aux-Bois, Loiret, France, to a poor family, Vionnet was a dressmaker's apprentice at age eleven for Madame Bourgeuil. In 1863, when she was seventeen, she moved to Paris and worked at the house of Vincent, where she later became a première, at the age of nineteen. She married at eighteen, but after the death of her infant daughter, divorced her husband and moved to London; there, she was employed at Mme.

Kate Reilly and learned to copy the work of top Parisienne couturiers. In 1900, she returned to Paris where she worked with Madame Gerber, at the house of the **Callot Sisters**. It was here that she gained an understanding of the female form, was exposed to sumptuous fabric, and acquired her passion for cutting and draping, which were to become hallmarks of her career as a designer. In 1907, Vionnet moved to the house of **Doucet**, where she met many celebrities of the time such as Cécile Sorel, diva Mary Garden, and the notorious Marquise de Casati. Inspired by an American dancer, Isadora Duncan, and her braless, barefooted performance, Vionnet's first collection for Doucet was a collection of *déshabillé,* lingerie-inspired dresses, which were presented on braless, barefooted models. In protest, the powerful **vendeuses** at Doucet refused to sell the clothes. Shortly after this rebellion, designer **Paul Poiret** showed his uncorseted collection and was ultimately given credit for having eliminated the corset.

In 1912, Vionnet opened her own house on rue de Rivoli, with financial help from M. Lillas owner of the Bazar de l'Hôtel de Ville, but closed in 1914, at the onset of World War I. She moved to Rome and after the war, there were great bursts of creativity in the industry, especially in textiles and in the arts, which would inspire Vionnet. Two inspirations were the method of piece-dying cloth, which stabilized yarn twist, allowing for stretchier bias grain, and the artistic movement called Cubism, which used simple geometric shapes inspired by African art. Vionnet also studied ancient Greek and Roman dress, specifically the rectangular and kimono silhouette. These all became inspirations for many of her collections, such as her famous bias cut, twists, cowl necklines, zig-zag cut waist seams, chiffon handkerchief dresses, and Asian-inspired body-wrapping methods. Her association with artist Thayaht (Italian-Ernesto Michelles) not only helped produce some of the most creative **fashion illustrations** of the 1920s but also were an inspiration for drawn-on printed patterns and a new aesthetic to the art of clothing.

In 1918, Vionnet reopened her rue de Rivoli shop, again with the help of M. Villas and a new backer, the Argentinean Martinez de Hoz, whose wife was one of her best-known clients. Between 1924 and 1929, Vionnet created some of the most exquisite embroideries in partnership with the house of **Lesage**. In 1922, Théophile Bader, owner of the **Galeries Lafayette department store**, invested in the

house of Vionnet. The company's name was changed to Vionnet et Cie and, in 1923, moved to luxurious quarters on Avenue Montaigne. In an effort to teach the secrets of the bias cut, Vionnet set up a school on the premises in 1927, where interns got to study for three years before apprenticing at one of the **ateliers**. With the expanding American economy, Vionnet's work received enthusiastic acceptance and her clothes were copied and commissioned. In 1924, Vionnet's business manager Armand Trouyet, opened Madeleine Vionnet, Inc., in the United States and negotiated the first "royalty deal," whereby an American store would have exclusive rights to manufacture certain of Vionnet's couture styles and market them as "one-size-fits-all" **ready-to-wear**. The agreement, however, ended within six months. In 1926, Vionnet announced that it would manufacture its own ready-to-wear line and the first store to buy the collection was John Wanamakers.

In 1923, Vionnet introduced a fingerprinted label to authenticate models and discourage **copyists** and was married the same year to "Captain Hetch," a shoe **manufacturer**. Up until Vionnet's retirement in 1945, she continually filed lawsuits against copyists and won. Together with her business manager Louis Dangel, two anti-copyist organizations were formed: in 1923, the **Association pour la Défense des Arts Plastiques et Appliqués** and, in 1928, the **Société des Auteurs de la Mode**. In 1929, Vionnet received the Order of the Chevalier of the Legion of Honor for her achievement and public service. The day known as Black Tuesday, October 29, 1929, marked the end of an era for many **couturiers**; French exports crashed as wealthy American families lost their fortunes during the Great Depression. Still through the 1930s, Vionnet continued to explore **dressmaker** details such as pleats, tucks, scarf dresses, and her signature rose motifs, as well as to create some of the most exquisite **fur**-trimmed suits and coats.

Vionnet's client list included society women and women from the courts of Belgium, Italy, and Spain, as well as a Russian princess and the Countess of Chavaignac. After winning her lawsuit against Bader of Galéries Lafayette for **copying**, she showed her last collection in August 1939. At the end of World War II, Vionnet was too old to restart her company. In her retirement, she was known to give lectures in her home to teachers of the L'École de Chambre Syndicale. In

1991, a book on Vionnet's life and techniques was published by costume historian Betty Kirke. In 1995, the house of Vionnet reopened and, in 1996, the **fragrance** Haute Couture was launched.

VIRTUAL MODEL. A company founded by Louise Guay in 1999 that uses software to create a virtual model, so that shoppers can easily select, on the Internet, the best size that fits them. *See also* ARCHETYPE; GERBER TECHNOLOGY.

VISUAL MERCHANDISER DIRECTOR. This person heads the visual merchandising division for a store or group of stores. He/she must possess knowledge from concept to completion of visual presentations for store layouts, window dressing, signs and posters, color and lighting, merchandising and marketing, and arrangement of merchandise and fixtures within the store.

VISUAL MERCHANDISING. This practice entails the creation of window and store displays to attract shoppers to a store and to keep them interested once they enter. Understanding the psychology of customer buying habits, designing store layouts and fixtures, creating window dressings, and effectively using color, lighting, and accessories to stimulate purchasing are the key requirements for this function. Visual merchandising is part of the **sales promotion** division of a retail store.

VIVIER, ROGER (1913–1998). Born in Paris, he first opened his shoe company in 1937 but later closed it to serve during World War II. Vivier designed shoes for Delman and had a brief stint designing **millinery** before designing shoes for **Christian Dior** in 1953. In 1963, he reopened his own salon in Paris. He is best known for his heel shapes: the comma, ball, needle, pilgrim, spool, pyramid, thorn, and escargot. His shoes are described as the "Fabergé of **footwear**," and he is also credited with the invention of the **stiletto** in 1954. The company was bought by **Diego Della Valle** of **Tod's** in 2000 with designer Bruno Frisoni appointed as **creative director**.

VOGUE **MAGAZINE.** This magazine began as a weekly fashion publication in New York in 1892 and was bought by Condé Nast

(1873–1942, American), a poor Louisiana boy. He transformed it, along with his editor, Edna Woolman Chase, into a monthly magazine in 1909. In 1959, S.I. Newhouse acquired a controlling share and eventually became its sole owner. *Vogue* is considered to be the "fashion bible" and owes its success to several creative editors-in-chief, most notably Chase (1914–1952), whose tenure lasted thirty-eight years. Although she favored European designers, Edna began giving American designers coverage in the late 1940s. **Diana Vreeland** (1963–1971), undoubtedly the magazine's most colorful editor, came to *Vogue* by way of *Harper's Bazaar*. It was during Vreeland's term that the fashion world was rocked in the 1960s by the "youthquake" movement. Vreeland promoted trends that emerged from **street styles**, including the **mod look**, **hippie** fashion, **futuristic**/space-age, and **psychedelic fashion**. She helped launch many **designers'** careers and has been immortalized in numerous books about her life and in a Broadway play, "Full Gallop." When Vreeland was fired in 1971, Grace Mirabella (1971–1988) took the helm. Her style was much less flamboyant than her predecessor's, being more lifestyle driven and catering to the working woman, as evidenced in the feature column "More Dash Than Cash."

Vogue's current editor-in-chief, **Anna Wintour** (1988–), is an amalgam of both Vreeland and Mirabella. Her vision for mixing **lifestyle brands** with high-brow couture has positioned *Vogue* as a leader in the fast-paced world of fashion in the twenty-first century.

Vogue has launched the careers of some of the most famous **fashion illustrators**, **fashion photographers**, **creative directors**, **models**, and designers. They include fashion illustrators **Antonio**, Christian Berard, Rene Gruau, George Hoyningen-Huene, and Eric Stemp; creative directors M. F. Agha and Alexander Liberman; fashion photographers **Richard Avedon**, David Bailey, Cecil Beaton, Guy Bourdin, **Louise Dahl-Wolfe**, Patrick Demarchelier, Arthur Elgort, Horst, Annie Leibowitz, **Steven Meisel**, Baron Adolph de Meyer, **Irving Penn**, **Herb Ritts**, Edward Steichen, Mario Testino, Deborah Turbeville, and **Bruce Weber**; models Naomi Campbell, Patti Hansen, Lauren Hutton, Iman, Kate Moss, Paulina Porikova, Claudia Schiffer, Stephanie Seymour, and Christy Turlington; and designers from **Paul Poiret** and **Yves Saint Laurent** to **Proenza Schouler**. Beginning in the 1930s, *Vogue* began to replace **fashion illustrators**

with **fashion photographers** (the first photo cover was published in 1932). However, illustration saw a rebirth in 2000 with the work of Jason Brooks, Natalie Ferstendik, Natasha Law, Liselotte, David Remfry, Julie Verhoeven, and Daisy De Villeneuve. Today there are sixteen editions of *Vogue* throughout the world (Australia, Brazil, China, France, Germany, Great Britain, Greece, Italy, Japan, Korea, Mexico, Portugal, Russia, Spain, Taiwan, and the United States). Each has its own distinct personality owing to the fact that each has its own editor-in-chief. In 2003, Condé Nast launched *Teen Vogue* and, in 2005, *Men's Vogue*. *See also* FASHION PHOTOGRAPHY.

VOGUE PATTERNS. The Condé Nast company established a home-sewing paper **pattern** company in 1932 under the name Vogue Patterns. From 1932 to 1947, it offered Hollywood patterns appealing to home sewers who wanted to dress like their favorite movie stars; in 1961, it was purchased by **Butterick** Publishing. A program called Vogue Individualist, which started in 1984, offered **designer** patterns from **Issey Miyake** and **Claude Montana** and continued through the 1980s to include Betty Jackson, Patrick Kelly, and **Isaac Mizrahi**. In 1990, a new division called Vogue Attitudes was launched, focusing on emerging designers that included Barbara Bui, Nathalie Garcon, Jennifer George, Gordon Henderson, Odile Lancon, Rebecca Moses, Tom and Linda Platt, Carmelo Pomodoro, and Myrene de Premonville. In 2001, **McCall's Pattern Company** bought Butterick and Vogue. However, each continued to be marketed under its own name.

VON FURSTENBERG, DIANE (1946–). She was born in Brussels, Belgium, as Diane Simone Michelle Halpin to a Jewish upper-middle-class Russian father and Greek mother. Educated at the University of Madrid and the University of Geneva, her introduction into fashion came as a photographer's assistant and later as a filmmaker's agent in Paris. She married jet-setter Prince Egon von Furstenberg (descendant of Empress Josephine) in 1969 and moved with him to New York, where they divorced after the birth of her second child. She opened Diane von Furstenberg Studio in 1970 and is best known for her "wrap dress," which she created in 1973. In 1975, she launched the **fragrance** Tatiana, named after her daughter, and partnered with **Sears** to create the Diane von Furstenberg Style for Living Collection.

By the late 1970s, von Furstenberg had **licensed** her name to clothing **accessories**, cosmetics, and jewelry. She closed the business in 1988 but reopened in 1997 after a successful run on the home shopping network **QVC**, selling her famous wrap dress. In 1998, she published her memoirs, *Diane: A Signature Life*, and, in 2000, launched her website and online magazine. In 2001, she married American media mogul Barry Diller and, in 2003, received Dallas Market Center's Fashion Excellence Award. In 2006, von Furstenberg opened her first freestanding store in her native Belguim, and another in St. Tropez. Her empire consists of a comprehensive luxury **lifestyle brand** that includes clothing, cosmetics, fragrances, jewelry, and swimwear, sold in her own nine stores as well as in stores in more than 50 countries.

VREELAND, DIANA (1903–1989). Diana Vreeland was a fashion legend who was born in Paris to a socially prominent family. She married Thomas Reed Vreeland in 1924 and the couple moved to New York in 1935. Vreeland worked under *Harper's Bazaar's* editor-in-chief, **Carmel Snow**, from 1939 until 1962, when she moved on to *Vogue* magazine where she quickly became editor-in-chief in 1963. While at *Vogue*, Vreeland transformed the magazine during a time when the fashion world was undergoing a renaissance. **Street fashion**, never before popular in fashion magazines, filled *Vogue's* pages in Vreeland's distinctive style combining fantasy with glamour. The "youthquake" movement of the 1960s saw the **mod look**, featuring unisex models such as **Twiggy** and Penelope Tree, and the **hippie** and futuristic movement, with bare-breasted **Rudi Gernreich** fashions and **Paco Rabanne**'s modernistic looks. Vreeland worked with some of the most famous fashion photographers of her time, namely **Louise Dahl-Wolfe** and **Richard Avedon**. She helped launch many careers. She was fired from *Vogue* in 1971, due to the publisher claim that her editorial style was too costly.

In 1972, Vreeland assumed the role of **creative director** for the Metropolitan Museum of Art in New York and produced twelve exhibitions before she left in 1985. She created a new concept of how to present costume in the context of the paintings, sculptures, and music of the period. Her first show was *The World of Balenciaga* in 1973 followed by *The Tens, Twenties and Thirties—Inventive Clothes:*

1909–1939, featuring forty-one magnificent **Vionnet** dresses. Her shows set a new standard for costume museums and Vreeland will be remembered for her flamboyant style and extravagant personality.

VUITTON, LOUIS (1821–1892). Born in Anchay, Jura, France, Vuitton set up his luggage-making business, Louis Vuitton Malletier (*trunk maker*), in 1854. By initially making trunks for Empress Eugénie, he established himself as a luxury resource. One of his first innovations was a waterproof canvas trunk (Treason), which had a flat top that allowed for stacking and stowing under beds, which was a milestone from the dome shaped trunks that preceded them. Upon the suggestion of designer **Charles Frederick Worth**, Vuitton created personalized drawers and hanging spaces within each trunk. In 1867, Vuitton won the bronze medal at the Universal Exhibition at the World's Fair in Paris and the gold medal in 1889. In 1872, Vuitton created the red-and-beige striped canvas and, in 1888, the Dummier canvas (checkerboard) pattern. In 1896, his son George created the famous "LV" monogram and the Japanese-inspired flower design, to prevent further copying of their designs. However, even today, it is still the most copied **brand**—even though it spends more than $18 million a year protecting its trademark.

By 1900, the company expanded its product line to make car trunks and small **leather** goods like the steamer bag, a small handbag designed to fit inside steamer trunks. The company's product line continued to grow under George until his death in 1936 and, prior to World War I, Vuitton stores had opened in New York, Washington, London, Alexandria, Buenos Aires, and Bombay. George's son Gaston took the helm and expanded the company's product line to include wallets, handbags, and other small leather goods until his death in 1969. In 1977, Henry Recamier, a former steel executive who married into the Vuitton family, was named to run the business and formed the Louis Vuitton SA holding company. In 1987, Recamier forged the merger between Vuitton and drinks company Moët Hennessey. However, by 1989, Bernard Arnault, the financial genius behind the **Christian Dior** empire, took majority control of **Moët Hennessey Louis Vuitton (LVMH)**, forming the largest luxury goods conglomerate. In addition to its fashion presence, Louis Vuitton initiated the America's Cup Louis Vuitton Cup for Sailing in 1983

and the Louis Vuitton Classic Annual Automobile Race in 1988. In 1996, designer Hedi Slimane organized new bag shapes designed by **Helmut Lang**, **Azzedine Aläia**, **Vivienne Westwood**, and **Manolo Blahnik.**

In a move to increase Vuitton's presence in North America, in 1997, LVMH's head, Arnault, signed American **Marc Jacobs** to become the artistic director for all leather goods and to design a new men's and women's **ready-to-wear** collection. His collections have been pivotal in catapulting the house into "cool" status. The Vuitton business accounts for more than half of the revenues of the LVMH conglomerate. Collaboration on handbags with artists including Stephen Sprouse, Julie Verhoeven, and Takashi Murakami has resulted in a tweaking of tradition **logo** stereotyping and given the label a **street-style** credibility. As a result, young celebrities are now fans, such as Sarah Jessica Parker, Madonna, and Jennifer Lopez. Today, there are more than 300 Louis Vuitton stores in fifty countries. The product lines include watches, clothing, key chains, wallets, pens, jewelry, diaries, scarves, and shoes. Asnières-sur-Seine, France, is home to both the private Louis Vuitton Museum and Patrick-Louis Vuitton, a direct descendant of Louis, who works in the Vuitton luggage factory and handles all of the made-to-order pieces. *See also* COUNTERFEITING.

– **W** –

WAL-MART (1918–1992). The founder of Wal-Mart, Sam Walton, was born in Oklahoma and entered retailing as a management trainee for **J. C. Penney's.** After his World War II discharge and with the help of his father-in-law, he opened his own department store in 1945. Soon, Walton opened larger stores called Walton's Family Centers with his brother Bud, and by 1962 they owned a total of sixteen variety stores. The first Wal-Mart store was opened in Rogers, Arkansas, in 1962. Walton would continue to expand his retail empire through acquisitions of other stores and by his extraordinary leadership and vision. Wal-Mart became the nation's number-one retailer in 1990 and the first U.S. retailer to expand globally. Sam Walton's contributions to the retail world were honored in March

1992 when he received the Medal of Freedom from President George H. W. Bush. In 2006, its subsidiary Asda launched a new line called Must Haves as a spin-off from its George product line, which is run by Global George division.

WANG, VERA (1949–). Born to an affluent Chinese American family, she was schooled at the Chapin School, the Sorbonne in Paris, and Sarah Lawrence College, where she graduated with a degree in art history. At the 1968 U.S. Figure Skating Championships, she competed but lost out to Peggy Fleming for a spot on the U.S. Olympic team, so she turned her attention to fashion. Wang began her career as a fashion editor at *Vogue,* where she worked for sixteen years before moving to **Ralph Lauren** as **designer**. Within two years she was promoted to design director. She married financier Arthur Becker in 1989 and, as a result of her own frustration in finding a modern wedding dress, she went to her father for financial backing and started a wedding gown business. She and her business partner, Chet Hazzard, opened a **boutique** in 1990 at the Carlyle Hotel in New York. Wang is the first luxury designer to make her name on wedding gowns and is best known for her exquisitely modern, minimal gowns with architectural lines. Her gowns have been worn by celebrities Victoria Beckham, Mariah Carey, Jennifer Garner, Kate Hudson, Holly Hunter, Jennifer Lopez (**JLo**), Jessica Simpson, Sharon Stone, and Uma Thurman. She has also designed figure skating costumes for Nancy Kerrigan and Michelle Kwan.

In 2001, Wang published a book, *Vera Wang on Weddings.* In 2002, she launched her **fragrance**, Vera Wang, and signed **licensing** deals for **footwear**, eyewear, china, crystal, and fine jewelry. In 2003, she launched a men's fragrance. In 2004, she launched a **ready-to-wear** collection. In 2005, she signed a license for lingerie and, in 2006, she expanded her product line with Wedgewood to include sterling silver, flatware, and gift items. Wang designed a suite at the Halekulani Hotel and licensed her name to mattresses and fine paper products. The **Council of Fashion Designers of America** honored Wang, in 2005, with its Women's Designer of the Year Award.

WATTS, JAMES (c. 1750-?). Watts patented his steam engine in England, based on improvements made to Thomas Newcomen's engine.

His invention was applied to many different uses, such as power machinery in **cotton** factories as early as 1780.

WEARABLE ART. As far back as the Pre-Raphaelite Brotherhood in 1848, artists have created clothing in deference to the prevailing fashion of the time. In the 1960s, when individualism and anti-establishment philosophies flourished, clothes that expressed an artistic flair became popular. Today, wearable art runs the gamut in clothing and **accessories** from historically inspired, one-of-a-kind extreme designs crafted with labor-intensive hand treatments (such as embroidery, tooling, knitting, crocheting, hand dyeing, and weaving) to more mainstream artistic dress (such as **street**-inspired clothing and technology-inspired pieces).

WEBER, BRUCE (1949–). Weber was born in Greensburg, Pennsylvania, to a well-to-do businessman father, who was also an amateur photographer. He began his career in 1978 with a two-page spread of water polo player Jeff Aquilon, a nonprofessional **model**, who Weber photographed half naked with his hands down his boxer shorts. This new erotic photographic style was later used in 1982 by **Calvin Klein**, featuring Olympic pole-vaulter Tom Hintnaus, to sell underwear on billboards in Times Square. Weber's work, which is mostly black and white, was regularly featured throughout the 1980s in *GQ*, *Vogue*, *British Vogue*, *Vanity Fair*, and *L'Uomo Vogue*. He has shot major ad campaigns for **Ralph Lauren, Versace**, and **Abercrombie & Fitch** and won the International Center of Photography's Lifetime Achievement Award. Other achievements include sixteen published books, music videos for the Pet Shop Boys, and several documentary films; he is also credited with launching the modeling career of Isabella Rosselini. In 2006, Weber was commissioned to photograph the Ralph Lauren fall collection ad campaign. He is considered one of the top ten **fashion photographers** of the last century.

WEB PDM. Web PDM is Web-based software technology designed to manage all of the data associated with developing a product, such as testing and specifications, as well as a garment's measurements, fabrics, **trims**, and construction details.

WESTWOOD, VIVIENNE (1941–). Born Vivienne Isabel Swire in Glossop, Derbyshire, England, her father was a cobbler and her mother worked in the local **cotton** mill. Westwood studied art for one term at the Harrow School of Art. Upon graduating from a teacher training college, she became a North London primary school teacher. She married Derek Westwood in 1962 and had a son. After only three years of marriage, she met impresario Malcolm McClaren, with whom she had another son and began a creative partnership. In 1971, Westwood left teaching and started designing clothes for the store McClaren named Let It Rock, featuring anti-establishment clothing with shock value inspired by the music band the Seditionaries. Though the punk movement actually began in the Lower East Side of New York City in the late 1960s, Westwood and McClaren epitomized **punk style** both in their store and in the clothes designed by Westwood for the British band the Sex Pistols, whom McClaren managed. The look consisted of bondage gear, safety pins, bicycle and lavatory chains dangling on clothing, and razor blades and spiked dog collars worn as jewelry. Mohawk or crazy colored hair and makeup were also part of the look. In 1981, Westwood staged her first runway collection in London known as the Pirate Collection, ushering in a new romantic movement. This was followed in 1982 by the Savage Collection, which pioneered asymmetric layering, followed by the Buffalo Girls Collection, inspired by Latin American Indians. Subsequent collections would combine **street style** with tongue-in-cheek historical references, all done with an irreverent flair, until her split with McClaren in 1985.

Although Westwood's post-McClaren collections still challenged bourgeois standards, they were steeped in historical, political, and literary tradition. Her collections were more refined, even glamorous, and offered better fabrics and quality. Westwood's 1993–1994 collection Anglomania was a huge success and prompted her to diversify her business. She created a **ready-to-wear** line called Red, a couture label under the name Gold Label, and in 1998, a secondary line called Anglomania. In 1996, she designed the costumes for the *Three Penny Opera* in Vienna and launched her **menswear** line. By the late 1990s, Westwood had signed a partnership deal with Itochu and opened a showroom and a store in New York's SoHo. However, after the attack on September 11, 2001, business suffered and the store closed.

Westwood has taught fashion since 1993 at Berliner Hochschuleder Kunts. Her awards include an Order of the British Empire Award (1992), the British Designer of the Year Award (twice) from the **British Fashion Council**, and, in 2004–2005, the Victoria and Albert Museum, London, and the National Gallery, Australia, held a major retrospective of her work. In 2006, Westwood was named a dame of the British Empire by Queen Elizabeth II.

In that same year, she also signed a manufacturing agreement and revealed plans to reenter the U.S. market with her Anglomania line. In addition to clothing, Westwood launched a series of tea sets with the Wedgewood pottery company in 2003 and, in 2005, created a jewelry line featuring gold safety pins with a diamond dangle. In 2005, Westwood announced plans to open retail stores in China. She also partnered with the British civil rights group Liberty to launch a limited line of **T-shirts** and **childrenswear** with the message "I am not a terrorist, please don't arrest me." Her collection is sold in twenty-two countries throughout the world and in her two flagship stores in London and Tokyo. Her empire consists of men's and women's clothing and shoes, bags, jewelry, and her **fragrance**, Boudoir. She remarried in 1989 to Andreas Kronthaler and is still known as the "High Priestess of Punk."

WHITNEY, ELI (1765–1825). Born in Westborough, Massachusetts, the son of a farmer, Whitney graduated Phi Beta Kappa from Yale College in 1792. In 1793, he invented a mechanical device that separated seeds from **cotton**—until his invention, this was an arduous process. Known as a cotton gin, it automated the processing of cotton and was responsible for the economic development of the Southern United States and also helped to lower the cost of cotton textiles, which were in high demand during the **Industrial Revolution**. Whitney's concept of interchangeable rifle parts went on to surpass his cotton gin invention, which was so widely copied that he was forced out of business by 1797.

WILLHELM, BERNARD (1972–). Willhelm attended the Royal Academy of Art in Antwerp and presented his first collection in Paris in 1999. Known for his whimsical approach to fashion, Willhelm often incorporates handcrafts into his untraditional designs. His signature label, in the shape of a mitten that has his initials cross-stitched,

speaks to this design trademark. Willhelm joined the Italian design firm Roberto Capucci as **head designer** to launch the company's first **ready-to-wear** collection in 2003.

WILLIAMSON, MATTHEW (1972–). Born in Manchester, United Kingdom, Williamson was educated at **Central Saint Martins College of Art and Design** in London. He debuted his collection Electric Angels, in 1997, during London Fashion Week and managed to get Kate Moss, Helena Christensen, and Jade Jagger to model for him. Known for exquisite embroideries and beading, Williamson designed **womenswear, menswear**, babywear, and **lifestyle** collections. He maintains two stores in London and launched a **fragrance** called Matthew Williamson, in 2005. Williamson replaced **Christian Lacroix** as artistic director at **Emilio Pucci** and showed his first collection for it in 2006.

WINSTON, HARRY (1978–1896). Born the son of a New York jeweler, Harry Winston began collecting and selling stones at a young age. He opened his own company at age nineteen, buying estate-sale jewelry, resetting them in modern settings and then selling them to wealthy clients. Probably his most famous purchase was the Hope Diamond, a 45.52 carat dark-blue diamond dating from 1642, which was smuggled out of India and later sold to King Louis XIV in 1668. Winston gained possession of the Hope in 1949 and donated it to the Smithsonian Institute in 1958. He also took possession of the Lesotho Diamond (originally 601 carats and discovered in 1967) which was eventually cleaved into eighteen pieces, one of which he sold to Aristotle Onassis as his 40-carat diamond engagement ring for Jackie Kennedy. Other famous diamonds that Winston bought and sold are The Jonker (726 carats), the Star of Independence (204 carats), the Deal Sweetner (181 carats), The Lal Qila (72.76 carats), The Taylor–Burton (69.42 carats), and the Mabel Boll (46.57 carats). Known as the jeweler to the stars and the King of Diamonds, Winston has provided Hollywood stars with more then $200 million of precious gems to be worn at the Oscar Awards.

WINTOUR, ANNA (1949–). Born to a prominent British newspaper editor of the *Evening Standard* and an American heiress, Wintour was educated at the prestigious North London Collegiate School.

Foregoing college for the swinging world of London in the 1960s, she held several jobs ranging from a sales position at the trendy shop Biba to a short stint at a British ladies magazine, before moving to New York in 1975. There she worked as a junior fashion editor at *Harper's Bazaar*, an editor at *Viva* magazine, and in 1980 as a freelance fashion editor for *Savvy* magazine. In 1981, Wintour moved to *New York* magazine, in charge of the fashion and home décor pages. In 1984, she married David Shaeffer, a child psychiatrist. Wintour returned to London in 1986 to become editor-in-chief of *British Vogue* and, in 1987, went back to New York to run *House & Garden*. In 1988, S.I. Newhouse was eager to replace the *Vogue* editor at the time, Grace Mirabella, with a younger, hipper, more modern-thinking editor and Wintour was selected.

Wintour transformed the magazine within the first few years with her mantra of "Mass with Class" and became the single most influential person in the fashion industry. She made stars of **Marc Jacobs, John Galliano, Proenza Schouler**, and **Alexander McQueen**, to name a few, as well as bolstering the careers of numerous **models** and **fashion photographers**. She was one of the first to place celebrities on the cover, as well as a first lady (Hillary Clinton). Wintour's famous Louise Brooks bob hairdo (which she has donned since age fifteen), her signature wearing of sunglasses, and her infamous icy demeanor have been the subject of books and a movie, including *The Devil Wears Prada* and *Anna Wintour: The Cool Life and Hot Times of Vogue's Editor-in-Chief.* Her philanthropy included initiating the **Council of Fashion Designers of America**/Vogue Fund, which promoted new, unknown fashion **designers** with seed money; contributions as a trustee of the Metropolitan Museum of Art; and her work in training women to run beauty salons in Afghanistan. Wintour has been the target of animal rights organizations for endorsing **fur** yet remains firm on her position that people have the right to wear what they want. She is the mother of two children and has been married twice.

W MAGAZINE. *W* is a monthly fashion publication that began in 1972 as an offshoot of *Women's Wear Daily*.

WOLF DRESS FORM. This **manufacturer** of standard and custom-made hand-crafted **dress forms** has made them extensively for **de-**

signers, manufactures, fashion schools, and private individuals for more than 100 years.

WOMEN'S TRADE UNION LEAGUE (WTUL). The WTUL is the first American national trade union dedicated to women workers. Due to the fact that the American Federation of Labor (AFL) would not include women workers into its unions, settlement workers Lillian Wald and Jane Addams, together with labor leaders Mary Kenney O'Sullivan and Leonora O'Reilly, formed the WTUL in 1903. Branches in New York City, Chicago, and Boston helped to improve working conditions, establish a **minimum wage** and working hours, and abolish child labor. In 1909–1911, a series of garment worker strikes occurred. The WTUL set up strike funds for workers in need. After the 1911 Triangle Shirtwaist Company fire in New York City, the WTUL conducted an investigation and was influential in establishing new factory safety regulations. In 1950, the WTUL was dissolved. *See also* INTERNATIONAL LADIES' GARMENT WORKERS' UNION; TRADE UNIONS.

WOMENSWEAR. The category of women's fashion that includes bras, panties, lingerie, sleepwear, **sportswear**, dresses, **activewear**, **outerwear**, **performance apparel**, **special occasion**, and **accessories.** Although **menswear** and womenswear traditionally have been influenced by historical events, women's fashion trends progress at a much faster rate than those of men. A major shift in female dress occurred when Western European women of the twelfth century moved away from the Greco-Roman **himation** and **chiton**, in favor of clothing that emphasized, rather than concealed, their bodies. With the melding of cultural influences between the East and West beginning during the Byzantine period, trends in women's fashion really flourished in the **Renaissance**. Some trends were not always the most practical, however. Some examples are tight-fitting **corsets** (eleventh century), awkwardly oversized skirts with panniers, and long trains such as the robe à l'anglaise (eighteenth century), bustles and restricting hobble skirts (late 1800s and early 1900s) and torturous **stiletto heels** (twentieth century). As women's role in society changed, so did their clothing needs. While **Charles Frederick Worth**, fashion's first **couturier**, was dictating fashion

from Paris (mid 1800s), women in the United States were initiating dress reform, introducing clothing that was more functional and comfortable. The **Rational Dress Society** (London 1881), founded in reaction to the excessively harmful nature of the corset, high-heeled shoes, and heavily-weighted skirts, resulted in popularity of informal clothing. The concepts of **standardized sizing, mass production, separates, ready-to-wear**, and the introduction of American coordinated sportswear created new womenswear product categories such as activewear, athletic **footwear**, office attire, **performance apparel**, and **sportswear**.

WOMEN'S WEAR DAILY (WWD). A publication founded by Edmund Wade and his brother, Louis E. Fairchild, in 1910 as a supplement to their industry publication the *Daily News Record*. Originally called *Women's Wear*, the word *Daily* was added in 1927. The paper was published every day except Sunday. Recognizing Paris as the hub of the fashion industry, the Fairchild brothers opened a Paris office in 1911. It was not until a nephew of the originators, John B. Fairchild, took over in 1960, that the publication began covering not only industry events but also society events, the Hollywood scene, and world events, since they all impacted the booming fashion industry. The paper continued to cover the fashion industry over the years. In 1968, Fairchild Publications was sold to Capital Cities Broadcasting. John Fairchild retired in 1997 and was succeeded by Patrick McCarthy as chairman and director of Fairchild Publications. In 1999, the company was acquired by Advance Publications Inc., which is owned by the Newhouse Family. *WWD* is still considered the "bible of the fashion industry."

WONDERBRA. The original push-up bra was created by designer Louise Poirier in 1964. In 1994, the Wonderbra Push-Up bra took the country by storm—the garment was sold at the rate of one every fifteen seconds. While there have been many imitators since then, the Wonderbra continues to be the top selling push-up due to its superior design and comfort. *See also* INTIMATE APPAREL.

WOOL. This **animal fiber** is derived from the hair of sheep or lamb. Wool fiber dates back 10,000 years when early man in Central Asia

discovered that the hair from animal skins, which were already being used to provide warmth, could be formed into yarn and then woven to form fabric. The technique spread and ancient Egyptians were known to have popularized its use as early as 4000 B.C.E.

The processing of wool yarn involves cleaning or scouring the wool to extract impurities and then carding it, which produces a continuous strand of yarn before it is twisted. The combing process yields a smoother more lustrous yarn such as those used to make worsted wool fabric. The yarn is then spun and twisted to create the desired thinness before it is dyed to the desired color. Once wool yarn is woven it must be finished to control shrinkage and smooth out the wrinkles.

Wool fiber is measured in microns, with 1 micron measuring the equivalent of 1/20,000th of an inch in diameter. The finest wool yarns, such as those used in underwear, measure between 10–20 microns in diameter and are taken from fleece taken from the animal's shoulders and sides.

Wool is one of the most popular fabrics in the industry today because of its warmth, resiliency, comfort, and flame resistance.

WOOLRICH. This is a woolen mill founded by John Rich in Plum Run, Pennsylvania, in 1830 and later moved to Woolrich, Pennsylvania, in 1845. The company has a rich history from supplying blankets to the Union Army during the Civil War (1861–1865) to servicing soldiers during World War I (1914–1918) with blankets, coats, and stockings, and again during World War II (1942–1945).

WORLD CONFEDERATION OF LABOR (WCL). A trade union founded in 1920 under the name of the International Federation of Christian Trade Unions. The WCL was a confederation of trade unions associated with the Christian Democratic parties of Europe. Its members consisted of Eastern Europe countries as well as Austria, Germany, and Italy. Although it remained independent of the International Confederation of Free Trade Unions (**ICFTU**) and the World Federation of Trade Unions (**WFTU**), in 1968 the IFCTU changed its name to the WCL. The WCL was formally dissolved on October 31, 2006, when it merged with the **ICFTU** to form the International Trade Union Confederation (**ITUC**).

WORLD FEDERATION OF TRADE UNIONS (WFTU). This was a conglomeration of trade unions that included Communist and non-Communist labor unions from around the world representing fifty-three countries. In 1949, claiming Communist domination in the union, the United States AFL-CIO, the British TUC, the French FO, the Italian CISL, and the Spanish UGT seceded from the WFTU and created the **International Confederation of Free Trade Unions (ICFTU)**. In 2006, the ICFTU merged with the **World Confederation of Labor (WCL)** to form the **International Trade Union Confederation (ITUC)**.

WORLD TRADE ORGANIZATION (WTO). The WTO is an international multilateral trade system formed in 1995 (during the Uruguay Round negotiations 1986–1994) as the successor to the **General Agreement on Tariffs and Trade (GATT)** that was first established after World War II. While it began as a forum for negotiating lower customs duties and other trade barriers, it has become the umbrella organization for international trade issues that deal with specific sectors such as agriculture, textiles, and services; or specific problems like state trading, subsidies, actions against dumping, intellectual property, dispute settlement, and trade policy reviews. The services area is a recent addition to the topics covered. In addition, the WTO assists developing countries in trade policy through technical assistance and training programs and interfaces with other international organizations. The WTO is based in Geneva and maintains a membership of 150 countries.

WORTH, CHARLES FREDERICK (1826–1895). Born in Bourne, Lincolnshire, England, he started his career working in a dry goods store in London before moving to Paris in 1846, where he worked at a prominent dry goods and **dressmaking** firm, Gagelin et Opigez. He not only gained experience with fine fabrics and **trims** but he also met his future business partner, Otto Bobergh, and future wife, Marie Vernet. In 1856, they opened Worth and Bobergh. However, the partnership dissolved in 1870 due to Bobergh's retirement and the Franco-Prussian War. Worth reopened in 1871 as the House of Worth. Acting as his muse, Worth's wife attracted the attention of the French aristocracy and, in 1860, Worth became the official court

couturier under Empress Eugénie. Soon, women came from as far as the United States to be fitted for dresses at the house. Throughout the years, his client list consisted of royals such as Queen Victoria and members of the royal families of Spain, Russia, Italy, and Germany. He also dressed film and opera celebrities including Sarah Bernhardt, Lillie Langtry, Cora Pearl, and Eleanora Duse. American society women Mrs. J. P. Morgan and the Vanderbilts, Stanfords, Hewitts, Astors, and Palmers were devoted fans of Worth. Even courtesans were devotees.

Known as the first couturier and the "father of the couture," Worth earned that name because he did not let his customers dictate design, which had been the practice until then. Rather, he was the first to design and display, via a **fashion show** on live models, his own creations for women to choose from, four times a year. He would allow the client to select the style, fabrics, and **trim** and, using the highest standards of sewing, would **tailor** the clothing as **made-to-measure** to fit each customer's figure. Worth dressed like an artist, with a beret and oversized smock, and revolutionized the business of dressmaking because he considered himself an artist rather than an artisan/dressmaker and, because of his popularity, he was able to turn clients away, which only added to his *éclat*. Worth is credited with the creation of the tailor-made suit, the puffed sleeve known as the Polonaise, and voluminous skirts that not only defined the Gilded Age of the French Second Empire but kept the French textile industry economically sound. In 1868, Worth's sons, Jean-Philippe and Gaston, entered the business and founded the **Chambre Syndicale de la haute couture**. The company flourished over the span of four generations making it the longest-running **couture** house to date. However, after World War II, the house merged with the house of **Paquin**, although both closed in 1956, leaving only the Worth **fragrance** on the market today. *See also* HAUTE COUTURE.

– Y –

YAMAMOTO, YOHJI (1943–). Born in Tokyo, Yamamoto's father died during World War II. As a result, he was primarily raised by his **dressmaker** mother. Although he graduated with a law degree

from Keio University in 1966, he pursued a career in fashion and studied at the prestigious Bunka-fukuso Gakuin fashion school in Tokyo. After designing anonymously for several years, Yamamoto launched his own collection, called Y, in 1972. In 1981, he created fashion history when he showed his collection of Japanese-inspired worker uniforms on models with bald heads and white face paint in Paris. He chose mostly black, distressed fabrics covered in holes for the collection, which were shown on beautiful **models** wearing flat shoes. Yamamoto's anti-fashion statement marked a new era in the fashion world, known as shabby chic. Throughout his career, Yamamoto worked with longtime collaborator Madame Shimosaka and experimented with ancient Japanese traditions such as *shibori* (a tie-dye technique) and *wabi-sabi* (the beauty aesthetic of imperfection). He and compatriot **Rei Kawakubo** were known for their deconstructivist philosophy and for pioneering the cross-gender movement; hallmarks of their individual style.

In 1984, Yamamoto introduced a men's line that built on this philosophy and, in 1996, he marketed an eponymous **fragrance**. In partnership with **Adidas** in 2001, he launched a line of athletic shoes and, in 2003, a less expensive men's and women's line of clothing under the Y-3 label. Convinced that his clothes were more **couture** than **ready-to-wear**, Yamamoto shocked the industry by showing his 2002 ready-to-wear collection during couture week in Paris. Yamamoto has published two books, *Talking to Myself* (2002) and *A Magazine 2* (2005). In 2005, he was honored with a retrospective at Paris's Musée de la Mode et du Textile in a show entitled *Juste des Vêtements* (just clothes). Yamamoto operates 160 stores in Japan and 6 stores outside of Japan and sells to 200 stores worldwide.

YEE, MARINA. *See* ANTWERP SIX.

YEOHLEE (1955–). Born in Georgetown, Malaysia, of Chinese/Muslim background, she attended the **Parsons School of Design** and eventually opened her own company in 1981. Her unique use of fabric, concentrating on architectural form (inspired by her brothers, both of whom are architects) is one of her trademarks. Yeohlee's cape design, a mainstay in all of her collections, has earned her the moniker of "designing for the urban nomad" (from her 1997 Urban Nomad

Collection)—one who is confident, sophisticated, and seeks uncomplicated functional clothing. She is unusual among fashion **designers** in that she is known for intelligent design and does not follow fashion trends. Her use of architectural and geometrical elements, minimal cutting and seaming details, conservation of textiles, one-size-fits-all sizing, and pioneering of high-tech textiles are all hallmarks of her unique design philosophy. Exhibitions of her work include *Intimate Architecture: Contemporary Clothing Design* at the Hayden Gallery at the Massachusetts Institute of Technology (1982), *Fashion in Motion* at the Victoria & Albert Museum (2000), and *Yeohlee: Supermodern Style* at the Museum at the Fashion Institute of Technology (2001). Her book, *Yeohlee: Work Material Architecture*, was published in 2003. In 2004, Yeohlee won the prestigious National Design Award from the Smithsonian's Cooper-Hewitt National Design Museum.

YUPPIE. An acronym for Young Upwardly Mobile Professional Person, the *yuppie* term, coined in the 1980s, refers to a new generation of consumer with big spending power.

YURMAN, DAVID (1942–). Born in Great Neck, Long Island, New York, Yurman began his career as a sculptor who hung out with Beat artists of the 1960s: painter Franz Kline, sculptor Ron Boise, and writer Norman Mailer. In the 1970s, Yurman created two jewelry collections for **Cartier** and together with his girlfriend, Sybil, started their company, Putnam Art Works. The couple married in 1979 and, in 1980, created a new company called David Yurman, designing jewelry that combined precious stones in silver settings. In 1981, Yurman won the Designer of the Year Award from the Cultured Pearl Associations of America and Japan and, in 1982, he created his most often copied signature piece, his cable bracelet design. In 1983, Yurman won the Intergold Award and, in 1994, launched a line of watches. His cable jewelry is trademarked, copyrighted, and stamped with his **designer** hallmark and is the core of most of his designs. He and his wife are responsible for creating a relaxed, more modern approach to wearing elegant jewelry which, up until that time, was either too dressy or too costumey. In 1999, he created his famous Angel pin, inspired by one of his earlier sculptures, and also opened his first retail store on Madison Avenue.

Yurman's collections are a favorite among Hollywood celebrities—Gwyneth Paltrow, Steven Spielberg, Barbra Streisand, Jay-Z, and Damon Dash, to name a few—and are advertised on some of the world's top **models** including Heidi Klum, Naomi Campbell, Naomi Watts, and Kate Moss.

The **brand**'s empire consists of its iconic Cable Collection, numerous limited editions, Silver Ice, Pearls, fine timepieces, men's, and Cable Kids. Yurman is one of the few designers who actively pursues **copyists** and wins millions of dollars from settlements of copyright and trade infringement lawsuits each year.

The Yurman collection is sold to more than 450 fine **department stores** worldwide as well as in its ten signature stores. In 2004, David and Sybil Yurman received the Lifetime Achievement Award at the Jewelry Information Center's annual GEM awards. Their son, Evan, is now involved in the business. They are active philanthropists and have raised money for numerous causes. In 2001, they formed the David and Sybil Yurman Humanitarian and Arts Foundation, which cites individuals who fund and give of their time to charitable causes, most notably Elton John and Steven Spielberg. And, in 2005 they partnered with the American Red Cross to auction fifty lots of jewelry to raise funds for victims of Hurricanes Katrina and Rita.

– Z –

ZARA. A **specialty store** chain that was launched in 1975 (the same year that Spain's dictator General Francisco Franco died) by reclusive businessman Amancio Ortega (1936–) in Coruña, Galicia, Spain. Ortega was owner of the Inditex textile empire and Zara is part of the Spanish Inditex Group, which also owns **brands** Massimo Dutti, Pull and Bear, Bershka, Stradivarius, Oysho, Zara Home, and Kiddy's Class. The conglomerate boasts 2,858 stores in sixty-four countries and of that total, Zara stores number 912 stores in sixty-four countries. Zara not only delivers fashion at a price but is Europe's largest fashion **retailer**, competing with industry giants such as **Gap**, **Benetton**, and **H&M**. Zara embraced computerized technology that resulted in the ability to bring product to market in a two-week turnaround time as compared to the usual nine-month

industry average. Zara merchandise competes with branded merchandise yet it has a zero-advertising policy, which enables it to pass those savings along to its customers. Zara is best known for noticing stylish catwalk trends, responding quickly to consumer demand, producing product in record speed, and delivering creativity and quality design at affordable prices. Most of the 10,000 new styles offered each year are made in Europe—in their own high-tech factories located in Arteixo, Spain, which is one of the keys to the turnaround time record.

ZEGNA, ERMENEGILDO (1892–1966). Ermenegildo Zegna began his family-owned business as a textile-manufacturing company in 1910 with one small weaving mill in the town of Trivero, Italy. During the 1930s, the company expanded, selling expensive **made-to-measure** men's **wool** suits throughout Europe and the United States. In 1942, Ermenegildo's sons, Aldo and Angelo, entered the business and, by 1954, Zegna had pioneered Italy's foray into the world of finely tailored men's suits, a segment of the market that had, up until then, been monopolized by the British **tailors** of **Savile Row**. Most Zegna suits cost in the $2,000–$3,000 range. However, in 1968, it launched a line of ready-made suits that were priced in the $900 range. In the 1980s, Aldo and Angelo's children, Gilda and Paolo, entered the business and are at the helm today. They expanded the company beginning in 2000 by adding Angina, a women's line, and in 2002, signed an exclusive partnership with a private jet aircraft company. In 2003, a **fragrance** (Essenza di Zegna) was added and, in 2006, the company signed a manufacturing deal with **Tom Ford** to manufacture his signature men's collection. Zegna operates more than 300 retail locations worldwide, including China, selling fabrics, suits, ties, **knitwear**, shirts, **accessories**, and **sportswear**.

ZIPPER. Although **Elias Howe** had patented the "automatic and continuous closure device" in 1851, and Whitcomb L. Judson invented and patented the "clasp locker" in 1891, it was Gideon Sunback, a Swedish-born Canadian immigrant, who invented the concept of interlocking teeth called the "hookless fastener" in 1913. Although the Hookless Fastener Company opened in Meadeville, Pennsylvania, in 1914, the clothing industry was slow to accept the invention. In 1920, the B.F. Goodrich Company used the fastener on its rubber

boots and coined the word *zipper*. But, in 1928, the Hookless Fastener Company trademarked the word *talon* and, in 1938, changed the company name to Talon, Inc. It was during the mid to late 1930s that the zipper gained acceptance in men's, women's, and children's clothing. Today, zippers are not only the fastener of choice for all areas of the apparel industry, but are offered in various materials and styles, including coil or classic, invisible, metal or plastic, separating, and closed-ended zippers. **Designers** have promoted their use in such trends as the **punk style** and to evoke sexual provocation.

ZORAN (1947–). Born in Yugoslavia, Zoran opened his design house in 1976. Known for his minimalist approach to design, Zoran named his collections "jet packs," designed to be packable and wearable without **zippers**, buttons, and embellishments. His designs appeal to women who prefer luxurious fabrics in basic silhouettes.

Appendix 1

Fashion Magazines

Allure (United States)
Another Magazine (United Kingdom)
Apparel (China, United States)
BiBi Magazine (United States)
Book Moda (Italy)
Book Moda Sposa (Italy)
Book Moda Uomo (Italy)
Brides (United States)
Cadena (Germany)
Children's Business (United States)
Collections Men (Germany)
Collections Women (Germany)
Collezioni Accessories (Italy)
Collezioni Baby (Italy)
Collezioni Bambini (Italy)
Collezioni Beachwear (Italy)
Collezioni Donna Complete (Italy)
Collezioni H.C. (Italy)
Collezioni P. à P. (Germany)
Collezioni Sports & Street (Italy)
Collezioni Sposa (Italy)
Collezioni Uomo (Italy)
Commons & Sense (Japan)
Cosmopolitan (Australia, Chile, Taiwan, France, Italy, the Netherlands, South Africa, Spain, United Kingdom, United States)
Creation Lingerie (France)
Dazed and Confused (United States)
Detour (United States)
Die Linie (Germany)
Diva-Moda Intima (Germany)

Divos (Spain)
Doingbird (Australia)
Drapers Record (United Kingdom)
Earnshaws (United States)
Elegante (Italy)
Elle (Australia, Brazil, Canada, Taiwan, Czech Republic, France, Germany, India, Italy, Japan, South Korea, the Netherlands, Quebec, South Africa, Spain, Sweden, United States)
Esquire (Taiwan, Korea, United Kingdom, United States)
Event Alta Costura (Spain)
Event Pasarelas (Spain)
Fantastic Man Magazine (the Netherlands)
FashionClick (Spain)
Fashion Planet (United States)
Fashion Show (Italy)
Fashmod (United States)
Fjords (Norway)
Flare (Canada)
Focus On Style (United States)
Footwear News (*FN*) (United States)
GAP Press Collections Complete (Canada)
GAP Press Men (Canada)
Glamour (France, Germany, Italy, Spain, United Kingdom, United States)
Gotham (Australia)
Gothic Beauty Magazine (United States)
GQ (Australia, Germany, Japan, Korea, Spain, United Kingdom, United States)
Harper's Bazaar (Australia, Taiwan, Czech Republic, Russia, United Kingdom, United States)
Honey (United States)
Impressions (United States)
IMPULS Internazionale La Moda delle (Italy)
In Fashion
InStyle (Australia, United States)
International Textiles-Bodywear (United Kingdom)
Kid's Wear (Germany)
La Piel (Italy)
L'Officiel 1000 Models (France)

L'Officiel 1000 Models Accessories (France)
L'Officiel 1000 Models Men (France)
L'Officiel de la Couture et de la Mode (France)
Lucire (New Zealand, Romania)
Lucky (United States)
Lumière (France)
L'Uomo Vogue (Italy)
Marfy (Italy)
Marie Claire (Australia, Austria, Belgium, Brazil, China/Hong Kong/
 Taiwan, Colombia, France, Germany, Greece, India, Italy, Japan,
 South Korea, Malaysia, Mexico, the Netherlands, Philippines,
 Puerto Rico, Russia, South Africa, Spain, Switzerland, Thailand,
 Turkey, United Kingdom, United States, Venezuela)
Men's Fashion International (Germany)
Men's Vogue (United States)
Moda Linea Maglia (Italy)
Moda Linea Maglia Hosiery/Calze (Italy)
Modern Bride (United States)
Nylon (United States)
032c (Germany)
Outdoor Business (United States)
Outerwear Magazine (United States)
Oyster Magazine (Australia)
Papermag's Stylin' (United States)
Pelle (Vogue Pelle Italy)
Purple (France)
Rendez-vous de la Mode (France)
Rundchau Damen (Germany)
Rundschau Herreb (Germany)
SAZ-Sportfashion (Germany)
Self Service (France)
Sous-Fashion in Lingerie (Germany)
Sportswear International (France, Germany, Italy, United States)
Sposabella (Spain)
Style (Canada, Japan, United States)
Totem Fashion (France)
Town & Country (United States)
Vanity Fair (Italy, United Kingdom, United States)
V Magazine (United States)

V Man (United States)
Vogue (Australia, Brazil, China, France, Germany, Great Britain, Greece, Italy, Japan, Korea, the Netherlands, Spain, Taiwan, United States)
Vogue Bambino (Italy)
W Magazine (United States)
Zoom (United Kingdom)

Appendix 2
Trend and Forecasting Magazines and Services

A + A c (Italy)
A + A Concept Colour Trends (Italy)
A + A Knit to Wear (Italy)
A + A Men's Fashion Trends (Italy)
A + A Touch (Italy)
A + A Vision Print Trends (Italy)
A + A Women's Trends (Italy)
Anteprima Shoes Collezioni Trends (Italy)
Bebissimo (Germany)
Chiron Tendenze Intreccio (Italy)
Chiron Tendenze Ricerca (Italy)
European Color Summary (Germany)
Fashion Box Knitwear Men (Italy)
Fashion Box Knitwear Women (Italy)
Fashion Box T-Shirt (Italy)
Fashion Trends Forecast (United States)
Fashion Trends Sports & Leisurewear (Germany)
Here & There CD Collection (United States)
Here & There Color Cubicle (United States)
Here & There Fabric Package (United States)
Here & There Forecasting Package (United States)
Here & There Full Package + CD (United States)
Here & There Part I Fabrics (United States)
Here & There Part II Silhouettes (United States)
Here & There Reporting Package (United States)
Huepoint Spring/Fall Color (United States)
Huepoint Summer/Winter Color (United States)
Huepoint Youth Spring/Fall Color (United States)
I.C.A. Fashion Compendium Edition (United Kingdom)
Infantimo (Italy)

International Color Authority (United Kingdom)
International Textiles (United Kingdom)
Kids Planet (Germany)
Kidz Trendbook (Switzerland)
Kjaer Global Influences (United Kingdom)
Kjaer Global Women's Antennae (High Street Report) (United Kingdom)
Kjaer Global Women's Trend & Concept (United Kingdom)
Knit! Alert (France)
Knit Point (Italy)
Milk (France)
Orrizonti Color (Italy)
Orrizonti Pui (Italy)
Pantone Color Guide (United States)
Pantone View Colour Planner (United States)
Promostyl (France)
Ready-Made Color The Mix Fashion (Germany)
Ready-Made Pattern (Germany)
Ready-Made Weaves (Germany)
Sacha Pacha Girls Junior Codes (France)
Sacha Pacha Men's Casual Outerwear (France)
Sacha Pacha Womens' Casual Outerwear (France)
Sacha Pacha Womens' Citywear (France)
Sacha Pacha Womenswear (France)
ShoePoint (Italy)
Texitura (Canada)
Textile Report (France)
ViewPoint (The Netherlands)
View Textile (The Netherlands)
WeAR (Germany)
WGSN (London, New York, Los Angeles, Madrid, Frankfurt, Tokyo)
Where to Wear Shopping Guide (London, Los Angeles, New York, Paris, San Francisco)
Zoom on Fashion Trends (Italy)

Appendix 3

Periodicals, Newsletters, and Directories

AATCC Review (United States)
American Apparel Producers' Network (United States)
American Demographics (United States)
Apparel Magazine (United States)
Apparel News (United States)
California Apparel News (United States)
Children's Business (United States)
Consumer Reports (United States)
Daily News Record (*DNR*)
Drapers Records (United Kingdom)
Fashiondex (United States)
Fashion Italia (Italy)
Fashion Theory Journal (United Kingdom, United States)
Fashion Week Daily (United States)
Footwear News (United States)
It News (United States)
Journal du Textile (France)
Journal of International Consumer Marketing (United States)
Leathernet: World Wide Leather Industry (United States)
Licensing Letter (United States)
Made-to-Measure (United States)
Marketing News (United States)
Metro (United States)
Sales and Marketing Management (United States)
TextilMitteilungen European Edition (Germany)
TextilWirtschaft (Germany)
Women's Wear Daily (*WWD*) (United States)

Appendix 4
Trade Shows

ABC Salon (Munich, Germany)
Accessories Circuit (New York)
Accessories Market Week (New York)
Air New Zealand Fashion Week (Auckland)
Alberta Fashion Market (Edmonton, Canada)
All China Leather Exhibition (Shanghai)
Altaromaltamoda (Rome)
American International Designers (New York)
ASAP Global Sourcing Show (Las Vegas)
Asia Pacific Leather Fair Fashion Access (Hong Kong)
Asia's Fashion Jewelry & Accessories Fair (Hong Kong)
Atelier Designers (New York)
Atmosphère d'Été (Paris)
Australian Fashion Week
Baltic Textile + Leather (Lithuania)
Bangkok International Leather Fair
Bangkok Jems & Jewelry Manufacturers Fair (Thailand)
Beijing International Jewelry Fair (China)
Bijorha Eclat de Mode (Paris)
B-in-Berlin (Germany)
Body Look International Apparel Fair (Leipzig, Germany)
Bread and Butter Barcelona (Spain)
Bread and Butter Berlin (Germany)
Brideworld Expo (California)
Casabo Homme and Casabo Femme (Paris)
Chibimart (Milan)
Children's Club (New York)
China Fur (Dalian, China)
China International Footwear Fair (Shanghai)
China International Gold, Jewelry & Gem Fair (Guangzhou, China)

China Textile & Apparel Trade Show (New York)
CISMA (Shanghai)
Cloudnine (Milan)
Collection Premiere Moscow
Collective (New York)
Comocrea (Cernobbio, Italy)
Copenhagen International Fashion Fair
CPD Global Fashion (Düsseldorf, Germany)
CPD woman_man_kidz (Düsseldorf, Germany)
CPH Vision (Copenhagen, Denmark)
Dalian International Garment Fair (Dalian, China)
Designers & Agents (New York, Tokyo, Los Angeles)
Designers at the Essex House (New York)
District-A Five Star International Trade Event for New Luxury Brands
DNR Menswear (Miami)
Eurofashionweek (Berlin)
European Preview (New York)
Exit-Exportilia (Bologna, Italy)
Expofil (Paris)
Fabric@Magic (Las Vegas)
FAME (Fashion Avenue Market Expo) (New York)
Fashion Access (Hong Kong)
Fashion China (Shanghai)
Fashion Coterie (New York)
Fashion Exposed (Melbourne)
Fashion First (Brussels)
Fashion Market of San Francisco (California)
Fashion North Menswear Show (Canada)
Fashion Rio (Rio de Janiero)
Fashion Shoe (Modena, Italy)
Fashion Week (New York)
Fatex (Paris)
FFANY: New York Shoe Expo (New York)
Filo (Milan)
Frontier (Tokyo, Japan)
GDS International Shoe Fair (Düsseldorf)
Great Bridal Expo (Boston)
H & S (Hosiery & Seamless) (Montichiari, Italy)
Hong Kong Fashion Week

Hong Kong Jewelry & Watch Fair
Hong Kong Mega Showcase
Hong Kong Optical Fair
Ideacomo (Milan)
IF International Ready-to-Wear Fair (Istanbul, Turkey)
Igedo (Düsseldorf, Germany)
IMB (Germany)
India International Leather Fair (Chennai)
Indigo (Paris)
Interfilière Lyon (Lyon, France)
Intermezzo Collections (New York)
International Bead Show (California)
International Fashion Fabric Exhibition (IFFE)
International Fashion Fair (Tokyo, Japan)
International Gift & Jewelry Week (Madrid)
International Lingerie Show
International Shoe & Accessories Fair (Montreal)
International Vision Expo (New York)
Interséléction (Paris)
Interstoff Asia (Hong Kong)
Interstoff Rossija (Moscow)
Intertex (Milan)
Intertextile Shanghai (China)
Intimate Apparel Market Week (New York)
Intimate Apparel Salon (New York)
Ispo International Fair for Sporting Goods & Sports Fashion (Munich, Germany)
Ispovision Russia (Moscow)
Japan Jewelry Fair (Tokyo)
Journées Fournisseurs (France)
KidsShow (Las Vegas)
Le Cuir à Paris
Le Showroom (Paris)
Licensing International Trade Show (New York)
Lineapelle (Bologna, Italy)
Los Angeles International Textile Show (California)
Los Angeles Kids' Summer Market (California)
Los Angeles Mercedes-Benz Fashion Week at Smashbox Studios (California)

Luxury Asia 2005 (Brunei)
Lyon Mode City (Lyon, France)
Madrid International Fashion Week (Spain)
MAGIC (Las Vegas)
Magic Kids (Las Vegas)
Malaysia International Jewelex (Kuala Lumpur)
Material World (New York)
Melbourne Bride Wedding Expo (Australia)
Melbourne Fashion Week (Australia)
Men's Fashion Collections (Paris)
Micam (Milan)
Midec International Shoe Fair (Paris)
Milano Moda Donna (Milan)
Milano Moda Uomo (Milan)
MilanoVendeModa (Milan)
Mipel (Milan)
Mocap (Porto, Portugal)
Moda Made in Italy (Munich)
Moda Manhattan (New York)
Mod'Amont (Paris)
Moda Prima (Milan)
Moda Shanghai (China)
Moda-tex Budapest (Hungary)
Mode Accessories Show (Toronto)
Mode et Mariage (Paris)
Montreal Fashion Week (Canada)
Montreal Gift Show (Canada)
Montreal International Fashion Mart (Canada)
Montreal International Shoe and Accessories Fair (Canada)
Munich Fabric Start (Germany)
Munich Fashion Fair Men (Germany)
Munich Fashion Fair Women (Germany)
National Retail Federation (New York)
Neozone (Milan)
New York Fashion Week (New York)
New York Shoe Expo (New York)
New York Women's Fall I Apparel Market (New York)
Nouveau Collective Lifestyle Show (New York)
Off-Price Specialist Show (Las Vegas)

Ontario Fashion Exhibitors Market (Canada)
Orogemma (Vicenza, Italy)
Outdoor Retailer Show (Salt Lake City)
Paris Haute Couture Collections
Paris Ready-to-Wear Collections
Paris Sur Mode
Pasarela Cibeles (Madrid)
Pirmasenser International Leather Week/Salon Euro-shoe design
(Pirmasens, Germany)
Pitti Immagine Bimbo (Italy)
Pitti Immagine Filati (Florence)
Pitti Immagine Uomo (Florence)
Portojoia (Porto, Portugal)
Pozan Fashion Week (Pozan, Poland)
Prato Expo (Prato, Italy)
Première Classe (Paris)
Première Vision (Paris)
Premium (Berlin)
Premium Plus (Berlin)
Prêt-à-Porter (Paris)
Printsource (New York)
Project Las Vegas (Nevada)
Pulse (Chicago)
Pure London (Olympia, London)
Ready to Show (Milan)
Retail Industry Leaders Association's Logistics 2005 (San Diego)
Salon de la Maroquinerie (Paris)
São Paolo Fashion Week (Brazil)
Semana Internacional de la Piel (Madrid)
Sewn Products Equipment & Suppliers of the Americas (SPESA)
(Florida)
Shangaitex (Shanghai)
Shenzhen International Jewelry Fair (China)
Shoes & Leather Vietnam (Ho Chi Min City, Vietnam)
SIA SnowSports Show (Las Vegas)
Silmo Paris (France)
SIMM—Semana Internacional de la Moda de Madrid (Spain)
Singapore Fashion Week (Singapore)
Si Sposaitalia Collezioni (Milan)

SPESA Expo (Miami Beach)
Spinexpo Shanghai (China)
Spotlight on New Styles (Milan, sponsored by *Italian Vogue*)
Stoff München (Munich)
Super Show & World of Sports Innovation (Florida)
Surf Expo (Florida)
Swim Show (Miami Beach)
Sydney JAA Australian Jewelry Fair (Australia)
Taipei Innovative Textile Application Show (TITAS) (Taiwan)
Technology Solutions (at Material World Show)
Texbrasil Fenit International Textile Industry and Fashion Fair (São
 Paolo, Brazil)
Textilmoda (Madrid)
Texworld (Paris)
Tissu Premier (Lille, France)
Toronto Fashion Week (Canada)
Tranoi Femme (Paris)
Trends the Apparel Show (Edmonton, Canada)
Vancouver Fashion Fair (British Columbia, Canada)
Vietnam Fashion & Fabric Fair (Vietnam)
Western Apparel Market (Vancouver, Canada)
White (Milan)
Who's Next (Paris)
Women's & Men's Wear Brussels + Poodle + Frank + Fashion In-
 spiration Lab (Brussels)
Workshop Paris (France)
Workshop Tokyo (Japan)
WWDMagic (Las Vegas)
YIWU International Exhibition on Hosiery & Garment Industries
 (Zhejiang, China)

Appendix 5
Major Trade Associations and Organizations

American Apparel & Footwear Association (United States)
American Fiber Manufacturers Association (United States)
American Manufacturing Trade Action Coalition (United States)
American Marketing Association (United States)
Apparel International (United States)
Association for Retail Technology Standards (United States)
Association of Textile, Clothing and Leather Industry (Czech Republic)
Bobbin Show (United States)
British Clothing Industry Association (Great Britain)
British Fashion Council (Great Britain)
British Fur Trade Association (Great Britain)
British Hat Guild (Great Britain)
Camera Nacional de la Industria Textil (Mexico)
Canadian Apparel Federation (Canada)
Children's Apparel Manufacturing Association (Canada)
Clothing Manufacturers Association of the U.S.A. (United States)
Coalition for Equitable Retailer Practices (United States)
Color Association of the United States (United States)
Comité Colbert (French Luxury Goods Trade Assoc.)
Consumer Federation of America (United States)
Consumer Products Safety Commission (United States)
Costume Society of America (United States)
Costume Society of Scotland (Scotland)
Cotton Incorporated (United States)
Council of Fashion Designers of America (United States)
Couture Council of the Museum at the Fashion Institute of Technology (United States)
Direct Marketing Association (United States)
Drapers-Drapers Record and Menswear (Great Britain)
Embroidery Trade Association (United States)

European Apparel and Textile Organization (Belgium)
Fashion Center Business Improvement District (New York)
Fashion Design Council of Canada (Canada)
Fashion Design Council of India (India)
Fashion Footwear Association of New York (United States)
Fashion Group International (United States)
Fashion Industry News (United States)
Fédération Française de la Couture, du Prêt-à-Porter des Couturiers et des Créateurs de Mode (France)
Fiber Society (United States)
Fur Council of Canada (Canada)
Hong Kong Trade Development Council (Hong Kong)
Hosiery Association (United States)
International Apparel Federation (Great Britian)
International Fabrics Association International (United States)
International Licensing Industry Merchandisers' Association (United States)
International Mass Retail Association (United States)
International Textile and Apparel Association (United States)
International Textile, Garment & Leather Workers Federation (Belgium)
International Textile Manufacturers Federation (Germany)
Intimate Apparel Council (United States)
Israel Export Institute (Israel)
Italian Trade Commission (Italy)
IWA: Wool Bureau (United States)
Japan Apparel Industry Council (Japan)
MAGIC International (United States)
Menswear of Canada (Canada)
Menswear Retailing (United States)
Mohair Council of America (United States)
National Academy of Needle Arts (United States)
National Association of Display Industries (United States)
National Association of Retail Merchandising Services (United States)
National Association of Store Fixture Manufacturers (United States)
National Childrenswear Association (Great Britain)
National Council of Textile Organizations (United States)
National Retail Federation (United States)
National Textile Association (United States)

Northern Society of Costume and Textiles
Organic Fiber Council (United States)
Organic Trade Association (United States)
Professional Apparel Association (United States)
Retail Advertising & Marketing Association (United States)
Retail Industry Leaders of America (United States)
Sporting Goods Manufacturers Association (United States)
Turkish Clothing Manufacturers Association (Turkey)
Wool Bureau (Australia)

Appendix 6
Fashion and Textile Museums

Australia

Powerhouse Museum (Sydney)
Rose Grainger Costume Collection (Melbourne)

Austria

Kunsthistorisches Museum Wien (Vienna)

Belguim

ModeMuseum (Antwerp)
Museum of Costume and Lace (Brussels)

Canada

Bata Shoe Museum (Toronto)
Costume Museum of Canada (Winnipeg)
Musée McCord Museum (Montreal)
Société du Musée canadien des civilizations (Quebec)
Textile Museum of Canada (Toronto)

Croatia

Ethnographic Museum (Zagreb)
Museum of Arts and Crafts (Zagreb)

Czech Republic

Museum of Southeast Moravia (Zlín)

Denmark

Costume Group of Danish Museums (twenty-four museums nationwide)

France

Atelier-Musée du Chapeau (Chazelles-sur-Lyon)
Foundation Pierre Bergé, Yves Saint Laurent (Paris)
Le Musée du Textile (Ventron)
Musée de la Mode et du Textile (Paris)
Musée de l'Impression sur Etoffes (Mulhouse)
Musée des Tissus et des Arts Decoratifs (Lyon)
Musée Galliera (Paris)
Musée national du Moyen Age (Paris)

Germany

Badisches Landemuseum (Karlsruhe)
Bayerisches Nationalmuseum (Munich)
Deutsches Historisches Museum (DHM) (Berlin)
Germanisches Nationalmuseum (GNM) (Nürnberg)

Great Britain

Allhallows Museum of Lace and Antiquities (Honiton)
Berkely Costume & Toy Museum (Wexford)
British Museum (London)
Costume & Textiles, Penlee House Gallery and Museum (Cornwall)
Costume Museum (Bath)
Fan Museum (Greenwich)
Fashion & Textile Museum (London)
Gallery of Antique Costume and Textiles (London)
Gallery of Costume (Manchester)
Museum of Costume (Bath)
Museum of London (London)
National Trust Costumes (Moneymore)
Northampton Museum Boot & Shoe Collection (Northampton)
Northern Society of Costume & Textiles (West Yorkshire)

Platt Hall, Gallery of English Costume (Manchester)
Royal Marines Museum of Costume & Textiles (Hampshire)
Shambellie House Museum of Costume (Scotland)
Victoria & Albert Museum (London)
Wakefield Museum: Bridal Costume (Wakefield)

Greece

Silk Museum (Soufli)

Italy

Galleria del Costume (Florence)
Museo del costume (Palermo)
Museo del Tessuto (Prato)
Museo Stibbert (Florence)

Japan

Bunka Gakuen Costume Museum (Tokyo)
Costume Museum (Kyoto)
Kyoto Costume Institute (KCI) (Kyoto)
Sugino Costume Museum (Tokyo)

Russia

Costume Collections of St. Petersburg (St. Petersburg)
Hermitage Museum (St. Petersburg)
Russian Ethnographic Museum (St. Petersburg)

South Africa

Bernberg Museum of Costume (Johannesburg)

Spain

Museo del Calzado (Arnedo)
Museu Tèxtil I d'Indumentaria (Barcelona)

United States

Beverly Burks Couture Collection (New York, NY)
Black Fashion Museum (Washington, DC)
Celebrity Lingerie Hall of Fame (Los Angeles, CA)
Cornell Costume and Textiles Collection (Itaca, NY)
Costume Institute at the Metropolitan Museum of Art (New York, NY)
De Young Fine Arts Museum of San Francisco (San Francisco, CA)
Drexel Historical Costume Collection (Philadelphia, PA)
Elizabeth Sage Historic Costume Collection (Bloomington, IN)
Fashion Institute of Design & Merchandising (San Francisco, CA)
Garren Collection of Historic Dress at University of Virginia (Charlottesville, VA)
Goldstein Gallery at the University of Minnesota (St. Paul, MN)
Helen Louise Allen Textile Collection (Madison, WI)
Historic Costume Collection (University of Akron, OH)
House of Victorian Visions Bridal Museum (Orange, CA)
Lace Museum (Sunnyvale, CA)
Metropolitan Museum of Art: Costume Institute (New York, NY)
Museum at the Fashion Institute of Technology (New York, NY)
Museum of the City of New York (New York, NY)
OSU Historic Costume and Textiles Collection (Columbus, OH)
Philadelphia Museum of Art Costume Collection (Philadelphia, PA)
Texas Fashion Collection (Denton, TX)
Textile Museum (Washington, DC)
University of Hawaii Costume Collection (Honolulu, HI)
Valentine Museum (Richmond, VA)
Victorian Bridal Museum (San Jacinto, CA)
Women's Museum Costume Collection (Fort Lee, VA)

Appendix 7
Top Fashion Schools

Australia

Royal Melbourne Institute of Technology (Melbourne)

Belguim

Académie Royale des Beaux-Arts s'Anvers (Antwerp)
Antwerp Academy (Antwerp)
Atelier de Stylisme et Création de Mode de la Cambre (Brussels)
Royal Academy of Fine Arts (Antwerp)

China

Central Academy of Fine Arts (Beijing)
Dong Hua University (Shanghai)
Hong Kong Polytechnic University (Hong Kong)
Zhejiang Institute (Hanzhou)

Great Britain

Central Saint Martins College of Art and Design (London)
Kingston University (Kingston)
London College of Fashion (London)
Manchester Metropolitan University (Manchester)
Royal College of Art (London)

France

École de la Chambre Syndicale de la couture parisienne (ECSCP)
(Paris)

École Supérieure des Arts Appliqués Duperre (Paris)
ESMOD (Paris)
Institut Francais de la Mode (IFM) (Paris)
Paris Fashion Institute (Paris)
Studio Bercot (Paris)

India

National Institute of Fashion Technology (NIFT) (New Delhi)

Israel

Shenkar College of Textile Technology & Fashion (Ramat-Gan)

Italy

Accademia Altieri, Moda Altieri (Rome)
Domus Academy (Milan)
Ent-Art Polimoda Firenze (Florence)
IFD/Polimoda, Fashion Institute of Technology (Florence)
Istituto Artistico Dell Abbigliamento Marangoni (Milan)

Netherlands

Fashion Institute Arnhem (Amsterdam)

Japan

Osaka Bunka College (Osaka)
Tokyo Bunka College (Tokyo)

Spain

Felicidad Duce (Barcelona)

Switzerland

University of Applied Arts of Basel (Basel)

Turkey

Istanbul Technical University (Istanbul)

United States

Academy of Art University (San Francisco, CA)
Drexel University (Philadelphia, PA)
Fashion Institute of Design & Merchandising (Los Angeles/San Francisco, CA)
Fashion Institute of Technology (New York, NY)
Kent State University (Kent, OH)
Laboratory Institute of Merchandising (New York, NY)
Otis College of Art & Design (Los Angeles, CA)
Parsons School of Design (New York, NY)
Pratt Institute (Brooklyn, NY)
Rhode Island School of Design (Providence, RI)
Savannah College of Art & Design (Savannah, GA)
University of Cincinnati (Cincinnati, OH)
Virginia Commonwealth University (Richmond, VA)

Appendix 8
Size Ranges

Apparel

Size Category	Size Range (United States)	Size Range (British)	Size Range (European)
Newborn	0–9 months (0–3, 3–6, 6–9)		
Infants	9–24 months (9, 12, 18, 24)		
Toddler	2T–4T (2T, 3T, 4T)	92–104 (92, 98, 104)	
Children's (Boys & Girls)	4–7 and 4–6X (4, 5, 6, 6X/7)	110–122 (110,116,122)	
Pre-Teen Girls	7–16 (7, 8, 10, 12, 14,16)	128–158 (128, 134, 146, 158)	
Pre-Teen Boys	8–20 (8, 10, 12,14,16,18, 20)	128–158 (128, 134, 146, 158)	
Junior (female)	1–15 (1, 3, 5, 7, 9, 11, 13, 15)		
Petite (female)	4P–14P(4P, 6P, 8P, 10P, 12P, 14P)		
Misses'	4–14 (4, 6, 8, 10, 12, 14)	8–18 (8, 10, 12, 14, 16)	36–46 (36, 38, 40, 42, 18)
Misses'	16–20 (16, 18, 20)		
Misses' Tall	2–14 (2, 4, 6, 8, 10, 12, 14)		
Plus Size (female)	16W–26W (16W, 18W, 20W, 22W, 24W, 26W)		
Men's (regular)	34R–48R (34R, 36R, 38R, 40R, 42R, 44R, 46R, 48R)	34–48 (34, 36, 38, 40, 42, 44, 46, 48)	44–58 (44, 46, 48, 50, 52, 54, 56, 58)

Men's (large)	46B–56B (46B, 48B, 50B, 52B, 54B, 56B)		
Men's (tall)	38L–52L (38L, 40L, 42L, 44L, 46L, 48L, 50L, 52L)		
Men's Shirts	14–18.5 (14, 14.5, 15, 15.5, 16, 16.5, 17, 17.5, 18, 18.5)	14–18.5 (14, 14.5, 15, 15.5, 16, 16.5, 17, 17.5, 18, 18.5)	36–47 (36, 37, 38, 39/40, 41, 42, 43, 44/45, 46, 47)

Millinery

	32	34	36	38	40	42	44	46	48	50	52	54
	S	M	L	XL	XXL							
U.S.	6.625	6.75	6.875	7	7.125	7.25	7.375	7.5	7.625	7.75	7.875	8
UK	6.5	6.625	6.75	6.875	7	7.125	7.25	7.375	7.5	7.625	7.75	7.875
CM	53	54	55	56	57	58	59	60	61	62	63	64
inches	20.75	21.25	21.625	22	22.5	22.75	23.25	23.125	24	24.5	24.75	25.25

Women's Gloves

	inches	CM
X-small	6	15
Small	6.5	17
Medium	7	18
Large	7.5	19
X-large	8	20

Men's Gloves

	inches	CM
Small	7	18
Medium	7.5–8	20
Large	8.5–9	23
x-large	9.5–10	25
xx-large	10.5–11	30

Infant/Toddler Sock Sizes

U.S.	European
3–5	18/20
6.5–7	22/23
8–8.5	24/25

Children Sock Sizes

U.S.	European
9–10	26/27
10.5–11.5	28/29
12–12.5	30–31

Children/Adult Women Sock Sizes

U.S.	European
13–1	26/27
2–3	34/35
4–5	36/37
6–7	38/39
8–9	40/41
10–11	42/43

Adult Men Sock Sizes

U.S.	European
8–9	42/43
10–11	44/45
14	—

Bibliography

Contents

INTRODUCTION

The strength of the literature noted below is in its content, both the descriptive written words and the vivid visual references that coalesce to relay the fundamental nature of fashion. There are many excellent resources available for scholars and students alike. Numerous books, journals, exhibition catalogs and periodicals have been published on a wide variety of fashion-related topics. Costume collections, whether housed at major art or anthropological museums or local historic houses can be an invaluable resource to experience and learn about historic costume firsthand.

With the tremendous popularity of the World Wide Web, a surplus of costume-related sites now exist. Approach enthusiastically, but judiciously when relying on them for information. Sites associated with museums, universities and colleges, and professional organizations consistently offer well researched information, though other sites can also be informative.

An excellent resource for studying the evolution of fashion is the *Encyclopedia of Fashion* edited by Valerie Steele and published in 2004. Steele's book offers a variety of designer biographies, histories of inventions that shaped fashion design, and key factors that influenced clothing and fashion. Steele is also the author of numerous books on fashion. Chief curator of the Museum at the Fashion Institute of Technology, Steele provides accurate historical information while sharing her own intuitive and experienced interpretations with the reader. Of particular note are *Fifty Years of Fashion*, *Women of Fashion*, and *Twentieth Century Designers*.

Fairchild's Dictionary of Fashion together with *Fairchild's Dictionary of Textiles* provide a basic fashion vocabulary that serves as a firm foundation for expressing one's thoughts on a variety of costume-related topics from pure fashion verbiage to the specifics of fibers.

Francois Baudot, a leading French author on design and editor at *Elle Decor* writes knowingly on a variety of style-related topics. The designer biographies (Chanel, Poiret) that he has authored for the Universe of Fashion series are insightful and provide clear and direct information.

For a British perspective on fashion history, James Laver, past Keeper of the Robes at the Victoria and Albert Museum in London, is an impeccable source, as is Natalie Rothman. In particular is Rothman's book, *Four Hundred Years of Fashion* (written with Madeleine Ginsburg, Avril Hart, and Valerie Mendes), which utilizes examples of men's and women's clothing, as well as accessories, from the world famous Victoria and Albert Museum dress collection. Laver's *Costume and Fashion: A Concise History* explores the history of dress and its relationship to society.

Historical Fashion in Detail: The Seventeenth and Eighteenth Centuries by Avril Hart, Susan North, and Richard Davis provides detailed photographs of the trimmings, textiles, and the intricacies of construction for men's and women's fashion during this time period.

For readers interested in the unique elements that are specific to couture clothing, Victor Skrebneski and Laura Jacobs's *The Art of Couture* provides beautifully detailed photographs essential to the foundation of understanding and appreciating this art form.

John Peacock's *Twentieth Century Fashion Complete Sourcebook* together with his *Men's Fashion Sourcebook* and *Fashion Accessories Sourcebook* contain comprehensive bibliographies that are clearly separated by decade with helpful sketches. Peacock is also the author of *Costume: 1066 to the Present.*

Visionaire magazine founder and creative director of *Harper's Bazaar*, Stephen Gan has a lucid understanding of modern fashion. *Visionaire's Fashion 2000 Designers at the Turn of the Millennium* and *Visionaire's Fashion 2001: Designers of the New Avant-Garde* offer the reader constructive insight into today's fashion influencers as well as fashion's revolutionary designers.

For the definitive look at American fashion, Caroline Rennolds Milbank's *New York Fashion: The Evolution of Style*, examines the development of clothing and designers from the early nineteenth century to the late twentieth century.

A. GENERAL

1. Dictionaries and Directories

Calasibetta, Charlotte Mankey. *Fairchild's Dictionary of Fashion*. 2nd ed. New York: Fairchild, 1985.

Callan, G. O. *Dictionary of Fashion and Fashion Designers*. New York: Thames and Hudson, 1998.

Cox, J. S. *An Illustrated Dictionary of Hairdressing and Wigmaking*. New York: Drama, 1984.

Cunnington, C. W. *A Dictionary of English Costume*. London: 1960.

Cunnington, C. W., P. E. Cunnington, and C. Beard. *A Dictionary of English Costume, 900–1900*. London: Adam and Charles Black, 1972.

Edelman, A. *The Fashion Resource Directory*. 2nd ed. New York: Fairchild, 1990.

Guida internazionale ai musei e alle collezioni pubbliche di costumi e di tessuti. Venice: Centro Internazionale delle arti e del Costume, 1970.

Humphries, Mary. *Fabric Reference*. 2nd ed. Upper Saddle River, N.J.: Prentice Hall, 2000.

Mason, A., and D. Packer. *An Illustrated Dictionary of Jewellery*. New York: Harper and Row, 1974.

McDowell, Colin. *McDowell's Directory of Twentieth Century Fashion*. London: Frederick Muller, 1984.

O'Hara Callan, Georgina. *Dictionary of Fashion and Fashion Designers*. London: Thames and Hudson, 1998.

Ostrow, R., and S. Smith. *The Dictionary of Marketing*. New York: Fairchild, 1987.

Picken, Mary Brooks. *A Dictionary of Costume and Fashion*. New York: Dover, 1999.

Remaury, Bruno, ed. *Dictionnaire de la mode au xx siècle*. Rev. ed. Paris: Editions du Regard, 1996.

Stegemeyer, Anne. *Who's Who in Fashion*. 3rd ed. New York: Fairchild, 1996.

Tortora, Phyllis G., and Robert S. Merkel. *Fairchild's Dictionary of Textiles*. 7th ed. New York: Fairchild, 2005.

Watkins, Josephine Ellis. *Who's Who in Fashion*. New York: Fairchild, 1975.

2. Encyclopedias

Jerde, Judith. *Encyclopedia of Textiles*. New York: Facts on File, 1992.

Martin, Richard. *The St. James Fashion Encyclopedia*. Detroit, Mich.: Visible Ink, 1997.

———. *The Encyclopedia of Fashion*. London: 1986.

Planché, V. R. *A Cyclopedia of Costume*. 2 vols. London: 1876, 1879.

Schoeffler, O. E., and W. Gale. *Esquire's Encyclopedia of Twentieth Century Men's Fashions*. New York: McGraw-Hill, 1973: 35.

Steele, Valerie. *Encyclopedia of Clothing and Fashion*. Farmington Hills, Mich.: Charles Scribner's Sons, 2004.

3. General Information and Interdisciplinary Studies

American Women of Style. New York: Metropolitan Museum of Art Exhibition Catalog, 1975.

Adler, J. "The Rise of the Overclass." *Newsweek*, 31 July 1995: 32–45.

Balfour, Victoria. *Rock Wives*. New York: Beech Tree, 1986.

"Beyond the Fringe." *Independent* (London), 30 October 2005.

"Books." The Sinclair Consultancy. www.sinclair-consultancy.sagenet.co.uk/resources.htm [accessed 23 June 2005].

Browne, Alix. "Flight Patterns." *Harper's Bazaar*, June 1995.

———. "Moonstruck." *Harper's Bazaar*, December 1994.

————. "Revival of the Fittest." *Harper's Bazaar*, September 1994.

————. "Eastern Exposure." *Harper's Bazaar*, August 1994.

"A Businessman, a Thinker and a Succeeder." *Philadelphia Tribune*, 11 February 1997.

Cameron, Julia. *The Artist's Way*. New York: Putnam, 1992.

Carlson, Janet. "Designer of Dreams." *Town & Country*, February 2002.

Catton, Bruce. *The Coming Fury*. New York: Washington Square, 1961.

"Centuries Old, But with an Update." *New York Times*, 19 February 1995.

Chapsal, Madeleine. *La Chair de la Robe*. Paris: Fayard, 1989.

Clark, Grahame. *Symbols of Excellence*. New York: Cambridge University Press, 1986.

Collins, Amy Fine. "JKO." *Harper's Bazaar*, August 1994.

————. "Romeo." *Mirabella*, July 1989.

Conti, Samantha. "George's Must Haves." *Women's Wear Daily*, 4 April 2006.

Copage, Eric V. "African Cloth Is Making Its Mark." *Boston Herald*, 15 February 1994.

Cope, Nigel. "Stars and Stripes." *The Independent* (London), 6 June 2001.

Culbet, Steven John. *Colorgenics*. New York: Dell, 1988.

"Daisy Fellowes." From Wikipedia, the Free Encyclopedia. http://en.wikipedia.org/wiki/Daisy_Fellowes [accessed 5 May 2006].

DiPaolo, N. Quotation in *Daily News Record*, citation information unknown. 1 March 1995.

"Does This Make My Butt Look Big? Full Fashioned Clothing E-tailer." PR Newswire, 22 March 2002.

Dunn, B. "Canada: Heading South." *Women's Wear Daily*, January 2000: 22–23.

Du Roselle, Bruno. *La Mode*. Paris: Imprimerie Nationale, 1980.

"The Empire Expands." *Mirabella,* July 1989.

Fairchild, John. *Chic Savages*. New York: Simon and Schuster, 1989.

————. *The Fashionable Savages*. New York: Doubleday, 1965.

"Famous Scots—Charles Macintosh (1766–1843)." www.rampantscotland.com/famous/blfammac.htm [accessed 11 March 2006].

Feibleman, Peter. "What Is This Thing Called Glamour?" *Town & Country*, November 1993.

Foulkes, Caroline. "Why Art is Back in Vogue." *Birmingham* (England) *Post*, 11 May 2005.

————. "Back to the Fuchsia." *Birmingham* (England) *Post*, 2 February 2005.

Frankel, Susannah. "Planet Fashion: A Style Bible in Any Language." *Independent* (London), vol. 23 (July 2005).

Franzen, Monica, and Nancy Ethiel. *Make Way! 200 Years of American Women in Cartoons*. Chicago: Chicago Review Press, 1987.

Friedan, Betty. *The Feminine Mystique*. New York: W. W. Norton, 1963.

Froncek, Thomas. *The Northmen*. New York: Time Life Books, 1974.

Harper's Bazaar, 2 November 1989.

Harper's Bazaar, 19 October 1989.

Harper's Bazaar, 2 July 1981.

Harper's Bazaar, 14 May 1892.

Harper's Weekly, 7 February 1980.

Harper's Weekly, 21 February 1980.

Harth, Eric. *The Creative Loop*. New York: Addison-Wesley, 1993: 75, 90.

Head, Edith, and Joe Hymas. *How to Dress for Success*. New York: Random House, 1967.

Head, Edith, and Jane Ardmore Kesmore. *The Dress Doctor*. Boston: Little Brown, 1959.

Hochswender, Woody. "Pins and Needles." *Harper's Bazaar*, November 1995.

————."Pins and Needles." *Harper's Bazaar*, March 1993.

Hooper, Joseph. "Finally Cowgirls Get Their Due: New Thoughts on the Old West." *Harper's Bazaar*, August 1993.

Horn, Marilyn J. *The Second Skin: An Interdisciplinary Study of Clothing*. New York: Houghton Mifflin, 1975.

Huckbody, Jamie. "Fashion: Emperor of the Senses." *Independent* (London), 6 March 2004.

————. "Fashion: Starship Trooper." *Independent* (London), 8 March 2003.

Huntington, Patty. "Staying with the Homeland." *Women's Wear Daily*, 18 July 2003.

"Innocence and Experience." *Women's Wear Daily*, 28 September 2004.

"International Best Dressed List." From Wikipedia, the Free Encyclopedia. http://en.wikipedia.org/wiki/International_Best_Dressed_List [accessed 5 May 2006].

"Italian Vogue Highlights New Talent." *Women's Wear Daily*, 16 February 2006.

Iverson, Annemarie. "The Big Fashion Face-Off: Frilly vs. Edgy." *Harper's Bazaar*, February 1997.

Jackson, Jennifer. "Modern Dance." *Harper's Bazaar*, February 1997.

————. "Sentimental Journey." *Harper's Bazaar*, September 1994.

————. "Highland Fling." *Harper's Bazaar*, August 1994.

James, Laurie. "Let's Work." *Harper's Bazaar*, May 1993.

————. "Sheer Nerve." *Harper's Bazaar*, February 1993.

Joan Rivers Show. "Images, Images, Images." 14 July 1993.

Kantrowitz, B., and P. Wingert. "The Truth about Tweens." *Newsweek*, 18 October 1999: 62–67.

Kaye, Elizabeth. "So Weak, So Powerful." *New York Times*, 6 June 1993.

Kerwin, Jessica. "Joie de Vivier." *W*, March 2005.

Khornak, Lucille. *Fashion 2001*. New York: Viking, 1982.

Kletter, Melanie. "Putting Pizzazz in Plus-Sizes." *Women's Wear Daily*, 15 March 2001.

Kling, Cynthia. "Seeing Red." *Vogue*, August 1995.

Koski, Lorna. "Keeping the Faith." *Women's Wear Daily*, 4 January 2005.

Kramer, Louise. "New Executive: Wedded to Ready-to-Wear," *Crain's New York Business*, 13 September 2004.

Kroll, Betsy. "Artistic Renderings." *Time*, Fall 2004.

Kryston, Courtney. "Deconstructing Fashion." *Women's Wear Daily*, 24 January 2006.

Kuchta, David M. "Comely, Virile and Useful: Gender in the Origins of the Three Piece Suit." In *Appearance and Gender Identity*. Edited by Louise Wehrle, Costume Society of America Symposium Abstracts, 1990.

"Ladies Man." *Town & Country*, September 2004.

Langer, Suzanne K. *Feeling and Form*. New York: Charles Scribner's Sons, 1953.

Lehmann-Haupt, Rachel. "China Wear." *Vogue*, April 1998.

London, Liz E., and Anne H. Adams. *Color Right, Dress Right*. New York: Crown, 1985.

Longino, C. *Retirement Migration in America*. Houston, Tex.: Vacation, 1995.

Lopes, Hedy. "Not Just For Texans-Locals Lassoed by the Wild Look." *Minuteman Chronicle* (Lexington, Mass.), 8 July 1993.

Lurie, Alison. *The Language of Clothes*. London: Hamlyn, 1982.

Lyons, Beverley. "No Girls Allowed Wed." *Daily Record* (Glasgow), 1 May 2006.

"Making Do: Fishnet Fashions." *Yankee Magazine*, July 1995.

Malossi, Giannino. *The Style Engine*. New York: Monacelli, 1998: 78.

"Marriage à Trios." *Vogue*. January 2005.

Menkes, Suzy. "Priestess of the Modern Glossy." *International Herald Tribune*, 4 April 2006.

———. "Something Familiar to Slip Into: Glamour." *New York Times*, 28 August 1994.

Middleton, William. "Cutting Edge Classics." *Harper's Bazaar*, 1 October 2003.

Molloy, John T. *Dress for Success*. New York: P. H. Wyden, 1975.

———. *The Woman's Dress for Success Book*. New York: Warner, 1975.

Moments de Mode. Paris: Musée des Arts de la Mode and Hercher, 1986.

Moore, Allison. "Pilgrim's Progress" *New York Times*, 1 August 1993.

Morishita, Hiromo. *Inventive Clothes*. Kyoto: Chamber of Commerce, 1975.

Morris, Bernadine. "The Line That Helps To Define Fashion." *New York Times*, 1 April 1994.

Morris, Bob. "Glowing, Growing and Going Strong." *New York Times*, 22 October 1995.

Morton, David Lawrence. *Traveler's Guide to the Great Art Treasures of Europe*. Boston: G. K. Hall, 1987.

Mower, Sara. "New Chemistry." *Harper's Bazaar*, September 1995.

Muir, Robin. "All is Finally Revealed." *Independent* (London), 31 March 2002.

Murphy, Robert. "The Artistry in Fashion." *Women's Wear Daily*, 27 February 2004.

Murray, Maggie Pexton. *Changing Styles in Fashion: Who, What, Why*. New York: Fairchild, 1989.

Nash, Elizabeth. "Dressed for Success." *Independent* (London), 31 March 2006.

Parker, Geoffrey. "Introduction." in Parker and Smith, *The General Crisis*.

Parola, R. "MFA at 35." *Daily News Record*, 30 April 1991.

Parrot, André. *Summer*. London: Thames and Hudson, 1960.

Rattray, Fiona. "The Broader Picture." *Independent* (London), 8 July 2001.

"Readers' Choice Poll." *Financial News*, 26 December 2005.

Regenold, Stephen. "The New Wearing of the Green." *New York Times*, 17 November 2005.

Richards, Kristina. "It Looks Great Again." *Harper's Bazaar*, March 2002.

Riley, Robert. *The Fashion Makers*. New York: Crown, 1968.

Robinson, John. "What Will the Simple Folks Wear?" *Boston Globe*, 16 March 1993.

———. "The Fashioning of a First Lady." *Boston Globe*, 19 January 1993.

Robinson, Pamela. "Don't Tell Me What to Wear!" *Boston Globe*, 22 August 1995.

Roger-Miles, L. *Les Créateurs de la Mode*. Paris: Eggimann, 1910.

Rosner, Stanley, and Lawrence E. Abt, eds. *The Creative Experience*. New York: Dell, 1972.

Rousseau, Jean Jacques. *Èmile or On Education*. Trans. Allan Bloom. New York: Basic, 1979.

Rushton, Susie. "Fashion: The Queen of Paris." *Independent* (London), 5 November 2005.

———. "Fashion and Style: Still Leader of the Pack." *Independent* (London), 16 December 2004.

———. "Monogram Man." *Independent* (London), 8 February 2003.

Sarkisian-Miller, Nola. "A Wider Niche." *Women's Wear Daily*, 16 February 2006.

Schiro, Ann-Marie. "Broadening the Appeal of Resort Wear." *New York Times*, 24 June 1997.

——. "Chic Scales the Heights, or Walks the Dog." *New York Times*, 3 December 1996.

——. "The Designer's Starting Point." *New York Times*, 18 April 1995.

——. "From Chinese Traditions, Up-to-the-Minute Clothes." *New York Times*, 17 January 1995.

——. "For Resort Wear, Shine, Shape, Color." *New York Times*, 3 January 1995.

——. "Citified Suits Are the Focus of Resort Collections." *New York Times*, 3 January 1994.

Scully, James. "Mover and Shaper." *Time*, 23 September 2005.

"Search for Next Hot Female Band Announced." *Business Wire*, 12 April 2000.

Shaw, Dan. "The Upstaging of High Society." *New York Times*, 9 April 1995.

Sherwood, James. "Fashion and Style." *Independent* (London), 13 February 2003.

Silvano, Arieti. *Creativity*. New York: Basic, 1976: 54.

Skrebneski, Victor, and Laura Jacobs. *The Art of the Couture*. New York: Abbeville, 1995.

Smith, Laura C. "Web Wear." *People*, 22 April 1996.

——. "The Designer Jeans Craze." *Entertainment Weekly*, 23 June 1995.

Socha, Miles. "Questions Still Abound." *Women's Wear Daily*, 5 January 2005.

——. "Tragedy of Two Titans." *Women's Wear Daily*, 21 January 2003.

"Somewhere East of Laramie." *New York Times*, 5 December 1993.

Spindler, Amy M. "Designers Put Their Minds to Uniformity." *New York Times*, 14 May 1996.

——. "Taking Fashion to the Extremes." *New York Times*, 9 January 1996.

——. "By Design." *New York Times*, 24 January 1995.

——. "Looking Back: All the Bustle over Retro." *New York Times*, 15 November 1994.

——. "Coming Apart." *New York Times*, 25 July 1993.

Stainiland, Kay. "Book Review." *Costume*, volume 22, 1988.

Stanley, T. *Networking with the Affluent and Their Advisors*. Burr Ridge, Ill.: Irwin Professional,1993.

Stuever, Hank. "The Flash of Fame." *Washington Post*, 28 December 2002.

Stukin, Stacie. "A Romance with Style." *Advocate*, 6 November 2001.

Tannen, Deborah. "Richard Nixon Didn't Wear Khakis." *Boston Globe*, 13 November 1994.

——. "Wears Jump Suit, Sensible Shoes, Uses Husband's Last Name." *New York Times*, 20 June 1993.

"The Tanner History: A Legacy of Personal Style." Don Caster. www.doncaster.com/home/doncaster/legacy.asp [accessed 30 April 30 2005].

Tate, Sharon Lee. *Inside Fashion Design*. New York: Harper and Row, 1984.

Templeton, J. *The Focus Group*. Chicago: Probus, 1994.

Theroux, Alexander. *Primary Colors*. New York: Henry Holt and Co., 1994.

Thomas, Dana. "Behind the Seams." *New York Times*, 1 April 1995.

Thomas, Vanessa. "Truth in Fashion." *Glamour*, June 1995.

Tran, Khanh T. L. "Vincent Commits to Cyn." *Women's Wear Daily*, 1 December 2005.

Updike, J. "The Seriousness Gap." *New Yorker*, 7 November 1994.

Varley, Helen, ed. *Color*. Los Angeles: Knapp, 1980.

Vincent-Richard, Francoise. *Les Objects de la Mode*. Paris: Editions du May, 1989.

———. *Clefs pour la Mode*. Paris: Seghers, 1987.

Vreeland, Diana. *Allure*. New York: Doubleday, 1980.

Wadyka, Sally. "Bosom Buddies." *Vogue*, August 1994.

"When Women Got the Vote." *Good Housekeeping*, March 1995.

"Whippersnappers vs. the Supersnappers." *St. Louis Post-Dispatch* via *Women's Wear Daily*, 9 December 1993.

White, Constance C. R. "Retro Prices by Young Designers." *New York Times*, 2 January 1996.

Williamson, Rusty. "Dallas Fashion Awards: A History Lesson." *Women's Wear Daily*, 31 October 2000.

Wilson, Elizabeth. *Adorned in Dreams. Fashion and Modernity*. London: Virago, 1985.

Witzel, Morgen. "The Democratization of Luxury." *European Business Forum*, 22 September 2003.

Wolinsky, Cary. "The Quest for Color." *National Geographic*, July 1999.

Worthington, Christa. *Chic Simple Clothes*. New York: Alfred A. Knopf, 1993: 40–41.

Yarwood, Doreen. *Costume of the Western World*. New York: St. Martin's, 1983.

B. HISTORY

1. General

Arnold, Janet. *Patterns of Fashion I: Englishwomen's Dresses and Their Construction c. 1660–1860*. New York: Drama, 1977.

———. *Patterns of Fashion II. Englishwomen's Dresses and Their Construction c. 1860–1940*. New York: Drama, 1977.

———. *A Handbook of Costume*. London: Macmillan, 1973.

Ash, Juliette, and Elizabeth Wilson. *Chic Thrills: A Fashion Reader*. London: Pandora, 1992.

Beaton, Cecil. *The Best of Boston*. New York: Macmillan, 1968.

Benaim, Laurence. *Pants: A History Afoot*. Paris: Vilo, 2001.

Boucher, Francois. *A History of Costume in the West*. rev. ed. London: Thames and Hudson, 1996.

———. *20,000 Years of Fashion*. London: Thames and Hudson, 1987.

———. *Historie du Costume en Occident de L'Antiquité à Nos Jours*. Paris: Flammarion, 1965.

Boucher, Francois. w/a new chapter by Yvonne Deslandres. *20,000 Years of Fashion, Expanded Edition*. New York: Harry N. Abrams, 1987.

Bradfield, Nancy. *Costume in Detail: Women's Dress 1730–1930*. London: 1969.

———. *Historical Costumes of England*. London: 1938.

Bradley, C. G. *Western World Costume*. New York: 1954.

Brain, Robert. *The Decorated Body*. New York: Harper and Row, 1979.

Brockman, Helen L. *The Theory of Fashion Design*. New York: John Wiley and Sons, 1965.

Brooke, Iris. *English Costume*. 6 vols. London: 1946.

Carr, William. *A History of Germany, 1815–1985*. 3rd ed. London: Edward Arnold, 1987.

Cawthorne, Nigel, et al. *Key Moments in Fashion*. London: Hamlyn, 1998.

"China Charges On." *Women's Wear Daily*, 28 September 2004.

Colavita, Courtney. "The Rainmakers." *Daily News Record*, 9 January 2006.

Costume. London: The Costume Society, 1967–present.

Cray, E. *Levis*. New York: Houghton Mifflin, 1979.

Davenport, Millia. *The Book of Costume*. New York: Crown, 1976.

Daves, Jessica. *Ready-Made Miracle*. New York: G.P. Putnam's Sons, 1967.

Delbourg-Delphis, Maryléne. *Le Chic et le Look: Histoire de la Mode Féminine et des Moeurs de 1850 à nos Jours*. Paris: Hatchett, 1981.

De Marly, Diana. *Working Dress: A History of Occupational Clothing*. London: B.T. Batsford, 1986.

Dobson, John M. *A History of American Enterprise*. Englewood Cliffs, N.J.: Prentice Hall, 1988: 129–36.

Dorfles, Gillo. *Kitsch: The World of Bad Taste*. New York: Universe, 1979.

Dorner, Jane. *The Changing Shape of Fashion through the Years*. London: Octopus, 1974.

Dress. Earleville, Md.: The Costume Society of America, 1975–present.

Duffy, Martha. "Fashion's Fall." *Time*, 25 April 1994.

Elwood, Mark. "Fashion Special." *Independent* (London), 23 March 2003.

Evans, Mary. *Costume Throughout the Ages*. Philadelphia: Lippincott, 1930.

Fairholt, F. W. *Costume in England.* 2 vols. London: 1885.

Ferrier, R. W. *The Arts of Persia.* New Haven, Conn.: Yale University Press, 1989.

Garnier, Guillaume et al. *Paris.* Paris: Musée de la Mode et du Costume, Editions Paris–Musées, 1987.

Goldstein, L. "What We Wore." *Fortune,* 12 November 1999: 156–60.

Grumbach, Didier. *Histoire de la Mode.* Paris: Le Seuil, 1993.

Hannisett, Jean. *Period Costume for Stage and Screen.* London: Player, 2002.

Hart, Avril, and Susan North. *Fashion in Detail.* New York: Rizzoli, 2000.

"The Haute Couture Houses." From Toffsworld. http://womens-mens-haute-couture-fashion-designers-wear.toffsworld.com/haute_couture_houses.php [accessed 16 December 2006].

Herald Wire Services (Fashion). *Boston Herald,* 9 August 1996.

"History of Fashion Designers." From History of Fashion and Costume. www .designerhistory.com/historyofashion//fashiondesignersintroduction.html [accessed on 16 December 2006].

"The History of Haute Couture Houses." From Toffsworld. http://womens -mens-haute-couture-fashion-designers-wear.toffsworld.com/history_of _haute_couture.php [accessed 16 December 2006].

Holland, Vyvyan. *Hand Coloured Fashion Plates, 1770–1899.* Boston: Boston Book and Art Shop, 1955.

Hollander, Anne. *Sex and Suits.* New York: Random House, 1994.

Honor, Hugh. *The Image of the Black in Western Art: From the American Revolution to World War I.* Vol. 4. Cambridge, Mass: Harvard University Press, 1989.

Johnson, Paul. *A History of the Jews.* New York: Harper and Row, 1987: 227.

Joselit, Jenna Weissman. *A Perfect Fit: Clothes, Character and the Promise of America.* New York: Henry Holt and Company, 2001.

Kelly, F. M., and R. Schwabe. *A Short History of Costume and Armour.* London: 1931.

———. *Historic Costume.* London: 1925.

Kempner, Rachel H. *Costume.* New York: Newsweek Books, 1979.

Kidwell, Claudia Brush, and Margaret C. Christman. *Suiting Everyone: The Democratization of Clothing in America.* Washington, D.C.: Smithsonian Institution Press, 1974.

Kohler, Carl. *A History of Costume.* (an unabridged republication of the English translation first published by George G. Harrap and Company Limited in 1928). New York: Dover, 1963.

Koike, Kazuko, ed. *East Meets West.* Tokyo: Heibonsha, 1978.

Langer, William L. "Immunization Against Smallpox Before Jenner." *Scientific American* 234. January 1976: 112–17.

Laver, James A. *Costume and Fashion: A Concise History*. London: Thames and Hudson, 2002.

———. *Dress*. London: J. Murray, 1966.

———. *Costume*. London: 1963.

———. *Taste and Fashion from the French Revolution to the Present Day*. London: Harrap, 1945.

———. *Fashion and Fashion Plates*. London: 1943.

———. *Taste and Fashion: From the French Revolution until Today*. New York: Dodd, Mead, 1938.

Laver, James A., and Amy De La Haye. *Costume and Fashion: A Concise History*. rev. ed. London: Thames and Hudson, 1995.

Lebergott, Stanley. *The Americans: An Economic Record*. New York: W.W. Norton, 1984.

Leloir, Maurice. *Histoire du Costume*. Paris: 1933.

Lencek, Lena, and Gideon Bosker. *Making Waves: Swimsuits and the Undressing of America*. San Francisco: Chronicle, 1989.

Leonard, Mary. "Where Feminism Began." *Boston Globe*, 16 July 1998.

Lerner, M. *America as a Civilization*. New York: Simon and Schuster, 1957.

Lester, K. M. *Historic Costume*. London, 1942.

Lyman Ruth, ed. *Paris Fashion*. London: Michael Joseph, 1972.

Martin, Richard, and Harold Koda. *Splash: A History of Swimwear*. New York: Rizzoli, 1990.

McGrath, C. *The Suit Doctor*. *New Yorker*, 7 November 1994: 91, 96.

McKay, John P., et al. *A History of Western Society, vol. 2: From Absolutism to the Present*. 3rd ed. Boston: Houghton Mifflin, 1987.

Milbank, Caroline Rennolds. *New York Fashion: The Evolution of American Style*. New York: Harry N. Abrams, 1989.

La Mode et ses Métiers du xviii siécle à nos Jours. Paris: Musée de la Mode et du Costume, Éditions Paris-Musées, 1981.

Le Monde Selon ses Créateurs. Paris: Musée de la Mode et du Costume, Editions Paris-Musées, 1991.

Norris, H. *Costume and Fashion*. 6 vols. London: 1927–33.

Nunn, Joan. *Fashion in Costume, 1200–2000*. 2nd ed. Chicago: New Amsterdam, 2000.

Nuzzi, Christina. *Parisian Fashion Designers*. New York: Rizzoli, 1980.

Payne, Blanche., et al. *The History of Costume*. 2nd ed. New York: HarperCollins, 1992.

Power, Susan. "National Museum of the American Indian." *Bazaar*, February 1995.

Randall, Richard H., Jr. *Masterpieces of Ivory from the Walters Art Gallery*. New York: Hudson Hills, 1985.

Rothstein, Natalie, ed. *Four Hundred Years of Fashion*. London: Victoria and Albert Museum, 1984.

Schnurnberger, Lynn. *Let There Be Clothes: Forty Thousand Years of Fashion*. New York: Workman, 1991.

"Sewing Machine." From Wikipedia, the Free Encyclopedia. http://en.wikipedia .org/wiki/Sewing_machine [accessed 13 December 2006].

Smith, D. "Changing U.S. Demographics: Implications for Professional Preparation." *Journal of Home Economics*.

Steele, Valerie. *Paris Fashion: A Cultural History*. Oxford: Oxford University Press, 1988.

Tortora, P., and K. Eubank. *Survey of Historic Costume*. New York: Fairchild, 1998.

Weltge, Sigrid Wortmann. *Women's Work: The First 20,000 Years*. San Francisco: Chronicle, 1993.

Wilcox, R. Turner. *Five Centuries of American Costume*. New York: Charles Scribner's Sons, 1963.

———. *The Mode in Costume*. New York: Charles Scribner's Sons, 1942.

2. Pre-History

Dennell, Robin. "Needles and Spearthrowers." *Natural History*, volume 95 (October 1986): 70–78.

Leroi-Gourhan, André. *Treasures of Prehistoric Art*. New York: Harry N. Abrams, 1967: 130–31.

Sandars, N. K. *Prehistoric Art in Europe*. 2nd ed. New York: Viking-Penguin, 1985.

3. Antiquity

Adred, Cyril. *Akhnaten: King of Egypt*. London: Thames and Hudson, 1989.

Andrea, Bernard. *The Art of Rome*. Trans. Robert Erich Wolf. New York: Harry N. Abrams, 1977.

Andronikos, Manolis. "The Royal Tombs at Vergina." In *The Search for Alexander: An Exhibition*. Boston: New York Graphic Society, 1980.

Baines, John, and Jaromir Malek. *Atlas of Ancient Egypt*. Oxford: Phaidon, 1980.

Bieber, Margarete. *Ancient Copies: Contributions to the History of Greek and Roman Art*. New York: New York University Press, 1977.

Boardman, John. *Greek Art*. New York: Frederick A. Praeger, 1964.

Bonfante, Larissa. *Etruscan Dress*. Baltimore: Johns Hopkins University Press, 1975.

Bonfante, Larissa, and Eva Jaunzens. "Greece and Rome, 1385–1413." In *Civilization of the Ancient Mediterranean*, vol. 3, eds. Michael Grant and Rachel Kitzinger. New York: Charles Scribner's Sons, 1988.

Brendel, Otto. *Etruscan Art*. New York: Penguin, 1978.

Browning, Robert. *The Byzantine Empire*. London: Weidenfeld and Nicolson, 1980.

Cockburn, Aidan, et al. "The Autopsy of an Egyptian Mummy." *Science*, vol. 187 (28 March 1975): 1158–59.

Connolly, Peter. *Greece and Rome at War*. Englewood Cliffs, N.J.: Prentice Hall, 1981.

Cook, J. M. *The Persian Empire*. London: J. M. Dent and Sons, 1983.

Cormak, Robin. *Writing in Gold*. London: George Philips, 1985.

Crawford, Michael. "Early Rome and Italy." In *The Oxford History of the Classical World*, eds. John Boardman, Jasper Griffin and Oswyn Murray. Oxford: Oxford University Press, 1986: 402–3.

Cristofani, Mauro. *The Etruscans: A New Investigation*. Trans. Brian Phillips. New York: Galahad, 1979.

Devisse, Jean, and Michel Mollat. *The Image of the Black in Western Art: From the Early Christian Era to the "Age of Discovery."* Vol. 2. New York: William Morrow, 1979.

Doumas, Christos G. *Thera: Pompeii of the Ancient Aegean*. London: Thames and Hudson, 1983.

El Mallakh, K., and A. C. Brackman. *The Gold of Tutankhamen*. New York: Newsweek Books, 1978.

Forrest, George. "Greece: The History of the Archaic Period." In *The Oxford History of the Classical World*, eds. John Boardman, Jasper Griffin and Oswyn Murray. Oxford: Oxford University Press, 1986.

Fowler, Brenda. "Forgotten Riches of King Tut: His Wardrobe." *Science Times*, 25 July 1995.

Ghirshman, Roman, et al. *The Arts of Ancient Iran*. New York: Golden, 1964.

Grant, Michael. *The Etruscans*. London: Weidenfeld and Nicolson, 1980.

Graves, Michael, ed. *The Birth of Western Civilization: Greece and Rome*. New York: McGraw-Hill, 1964: 135.

Greene, Kevin. *The Archaeology of the Roman Economy*. London: B. T. Batsford, 1986.

Harding, A. F. *The Mycenaeans and Europe*. London: Academic, 1984: 68–86.

Heichelheim, Fritz M., et al. *A History of the Roman People*. 2nd ed. Englewood Cliffs, N.J.: Prentice Hall, 1984: 23–24, 79–81, 131–34.

Hornblower, Simon. "Greece: The History of the Classical Period." *The Oxford History of the Classical World*, eds. John Boardman, Jasper Griffin, and Oswyn Murray. Oxford: Oxford University Press, 1986.

Houser, Caroline. *Greek Monumental Bronze Sculpture*. New York: Vendome, 1983.

Houston, Mary G., and Florence S. Hornblower. *Ancient Egyptian, Assyrian and Persian Costumes and Decoration*. 2nd ed. London: A. and C. Black, 1954.

Kagen, Botsford. *Robinson's Hellenistic History*. 5th ed. New York: Macmillan, 1969.

Laver, James A. *Costume in Antiquity*. New York: Clarkson N. Potter, 1964.

Mallowan, M. E. L. *Nimrud and Its Remains*, Vol. 1. London: Collins, 1966.

Massa, Aldo. *The World of the Etruscans*. New York: Tudor, 1974: 49.

Morrow, Katherine Dohan. *Greek Footwear and the Dating of Sculpture*. Madison: The University of Wisconsin Press, 1985.

Moscati, Sabatino. *The Phoenicians*. New York: Abbeville, 1988.

Murray, Oswyn. "Life and Society in Classical Greece." In *The Oxford History of the Classical World*, eds. John Boardman, Jasper Griffin, and Oswyn Murray. Oxford: Oxford University Press, 1986.

Mylonas, George E. "The Middle Helladic Period," in *Hellenic: Prehistory and Protohistory*. Athens: Ekdotike Athenon S.A., 1974.

Oates, Joan. *Babylon*. London: Thames and Hudson, 1979.

Oppenheim, Leo A. *Ancient Mesopotamia: Portrait of a Dead Civilization*. 2nd ed. Chicago: University of Chicago Press, 1977.

Phylactopoulos, George, ed. *History of the Hellenic World*. Vol. 2, The Archaic Period. Athens: Ekdotike Athenon S.A., 1974.

Phylactopoulos, George, and Christos Doumas. *Thera: Pompeii of the Ancient Aegean*, London: Thames and Hudson, 1983.

Platon, Nicholas E. "The Final Catastrophe." Trans. Philip Sherrard in *History of the Hellenic World: Prehistory and Protohistory*. Athens: Ekdotike Athenon S.A., 1974.

———. "The Minoan Period," "The Old-Palace Minoan Period," and "During the New Palace Period." In *History of the Hellenic World: Prehistory and Protohistory*. Athens: Ekdotike Athenon S.A., 1974.

———. "The Origins of Mycenaean Power" with Spyridon E. Iakovides. "The Centuries of Achaian Sovereignty: Expansion." In *History of the Hellenic World: Prehistory and Protohistory*. Athens: Ekdotike Athenon S.A., 1974.

Price, Simon. "The History of the Hellenistic Period." *The Oxford History of the Classical World*, eds. John Boardman, Jasper Griffin, and Oswyn Murray. Oxford: Oxford University Press, 1986.

Reich, John. *Italy Before Rome*. Oxford: Elsevier-Phaidon, 1979.

Rolley, Claude. *Greek Bronzes*. Trans. Roger Howell. London: Sotheby's, 1986.

Roux, George. *Ancient Iraq*. 2nd ed. New York: Penguin, 1980.

Russman, Edna R. *Egyptian Sculpture: Cairo and Luxor*. Austin: University of Texas Press, 1989.

Saleh, Mohamed, and Hourig Sourouzian. *Official Catalogue of The Egyptian Museum Cairo*. Munich: Prestel-Verlag, 1987.

Sebesta, J. L., and L. Bonfante. *The World of Roman Costume*. Madison: University of Wisconsin Press, 1994.

Shetelig, Haakon, and Hjalmar Falk. *Scandinavian Archaeology*. Translated by E. V. Gordon. New York: Hacker Art, 1978.

Speake, Graham, ed. *Atlas of Ancient Egypt*. Oxford: Phaidon, 1980.

Spyridon, N. Marinatos. "Minoan Thera." In *History of the Hellenic World: Prehistory and Protohistory*. Athens: Ekdotike Athenon S.A., 1974.

Turfo, Jean Macintosh. "International Contacts: Commerce, Trade and Foreign Affairs," in *Etruscan Life and Afterlife*, ed. Larissa Bonfante. Detroit: Wayne State University Press, 1986.

Vercoutter, Jean., et al. *The Image of the Black in Western Art: From the Pharaohs to the Fall of the Roman Empire*. Vol. 1. New York: William Morrow, 1976.

Vogelsang-Eastwood, G. *Pharaonic Egyptian Clothing*. Leiden, Netherlands: E. J. Brill, 1924.

Weiss, Harvey, ed. *Elba to Damascus: Art and Archaeology of Ancient Syria*. Washington, D.C.: Smithsonian Institution Traveling Exhibition Service, 1985.

Wilber, Donald N. *Persepolis: The Archaeology of Parsa, Seat of the Persian Kings*. Rev. ed. Princeton, N.J.: Darwin, 1989.

Wilford, John Noble. "Mummies, Textiles Offer Evidence of Europeans in Far East." *New York Times*, 7 May 1996.

———. "Site in Turkey Yields Oldest Cloth Ever Found." *New York Times*, 13 July 1993.

Wilson, John A. *The Culture of Ancient Egypt*. Chicago: University of Chicago Press, 1951.

Wilson, Lillian M. *The Clothing of the Ancient Romans*. Baltimore: Johns Hopkins University Press, 1938.

———. *The Roman Toga*. Baltimore: Johns Hopkins Press, 1924.

Wilson, R. J. A. "Roman Art and Architecture." *The Oxford History of the Classical World.*, eds. John Boardman, Jasper Griffin and Oswyn Murray. Oxford: Oxford University Press, 1986.

Woolley, Sir Leonard, and P. R. S. Moorey. *Ur of the Chaldees*. 2nd ed. New York: Penguin, 1980.

———. *Excavations*. London: Oxford University Press, 1934.

4. Pre–Nineteenth Century

Adam, R. J. *A Conquest of England*. London: Hodder and Stoughton, 1965.

Anderson, Ruth Matilda. *Hispanic Costume, 1480–1530.* New York: Hispanic Society of America, 1979.

Andres, Glenn., et al. *The Art of Florence,* 2 vols. New York: Abbeville, 1988.

Arnold, Janet, ed. *Queen Elizabeth's Wardrobe Unlock'd.* Leeds: W. S. Maney and Son, 1988.

———. *Patterns of Fashion: The Cut and Construction of Clothes for Men and Women c. 1560–1620.* New York: Drama, 1985.

Ashelford, Jane. *Dress in the Age of Elizabeth.* New York: Holmes and Meier, 1988.

———. *A Visual History of Costume: The Sixteenth Century.* London: B. T. Batsford, 1983.

Bailyn, Bernard. *Voyagers to the West.* New York: Alfred A. Knopf, 1986.

Barber, Richard, and Juliette Barker. *Tournaments: Jousts, Chivalry and Pageants in the Middle Ages.* Woodbridge, England: Boydell, 1989.

Basing, Patricia. *Trade and Crafts in Medieval Manuscripts.* London: The British Library, 1990.

Baxandall, Michael. *The Limewood Sculptors of Renaissance Germany.* New Haven, Conn.: Yale University Press, 1980.

Birbari, Elizabeth. *Dress in Italian Painting, 1460–1500.* London: John Murray, 1975.

Bishop, Morris. *The Middle Ages.* New York: American Heritage, 1968.

Blair, C. *European Armour.* London: B. T. Batsford, 1972.

Bologna, Giulia. *Illuminated Manuscripts: The Book Before Gutenberg.* London: Thames and Hudson, 1988.

Buck, Anne. *Dress in Eighteenth Century England.* New York: Holmes and Meier. Calthrop, D. C. *English Costume.* 4 vols. London: 1946.

Campbell, Lorne. *Renaissance Portraits: European Portrait-Painting in the Fourteenth, Fifteenth and Sixteenth Centuries.* New Haven, Conn: Yale University Press, 1990.

"Catherine de' Medici." From Wikipedia, the Free Encyclopedia. http://en.wikipedia.org/wiki/Catherine_de_Medici [accessed 1 May 2006].

Christiansen, Keith., et al. *Painting in Renaissance Siena, 1420–1500.* New York: Metropolitan Museum of Art and Harry N. Abrams, 1988.

Cowie, Leonard W. *Sixteenth-Century Europe.* Edinburgh: Oliver and Boyd, 1977.

Cumming, Valerie. *A Visual History of Costume of the Seventeenth Century.* New York: Drama, 1984.

Cunningham, Patricia A. "Eighteenth Century Nightgowns: The Gentleman's Robe in Art and Fashion." *Dress* 10, 1984.

Cunnington, C. W. *Handbook of English Costume in the Eighteenth Century.* London: 1957.

——. *Handbook of English Costume in the Seventeenth Century*. London: 1955.

——. *Handbook of English Costume in the Sixteenth Century*. London: 1954.

——. *Handbook of English Medieval Costume*. London: 1952.

De Marly, Diana. *Louis XVI and Versailles*. New York: Holmes and Meier, 1987.

Demus, Otto. *The Mosaics of San Marco in Venice*. Chicago: University of Chicago Press, 1984.

Devisse, Jean, and Michel Mollat. *The Image of the Black in Western Art: From the Early Christian Era to the "Age of Discovery."* Vol. 2. New York: William Morrow, 1979.

Druitt, H. *A Manual of Costume as Illustrated by Monumental Brasses*. London: 1906.

Dunn, Richard S. *The Age of Religious Wars, 1559–1715*. 2nd ed. New York: W.W. Norton, 1979.

Eales, Jacqueline. *Puritans and Roundheads: The Harleys of Brampton Bryan and the Outbreak of the English Civil War*. New York: Cambridge University Press, 1990.

Edwards, Lesley. "'Dres't Like a May-pole': A Study of Two Suits of ca. 1660–62." *Costume* 19, 1985: 86.

"Elizabethan Era." From Wikipedia, the Free Encyclopedia. http://en.wikipedia .org/wiki/Elizabethan_Period [accessed 1 May 2006].

Fraser, Antonia. *The Weaker Vessel: Woman's Lot in Seventeenth-Century England*. London: Weidenfeld and Nicolson, 1984.

Freeman, Margaret B. *The Unicorn Tapestries*. New York: The Metropolitan Museum of Art, 1976.

Freida, Leonie. *Catherine de Medici: Renaissance Queen of France*. New York: Harpers Collins, 2003.

"French Revolution." From Wikipedia, the Free Encyclopedia. http://en .wikipedia.org/wiki/French_Revolution [accessed 8 April 2006].

Geanakoplos, Deno John. *Interaction of the "Sibling" Byzantine and Western Cultures in the Middle Ages and Italian Renaissance (330–1600)*. New Haven, Conn.: Yale University Press, 1976.

Gordon, Alden R. *Masterpieces from Versailles: Three Centuries of French Portraiture*. Washington, D.C.: National Portrait Gallery, Smithsonian Institution, 1983.

Green, Charles. *Sutton Hoo: The Excavation of a Royal Ship-Burial*. London: Merlin, 1988.

Hagg, Inga. "Viking Women's Dress at Birka: A Reconstruction by Archaeological Methods." In *Cloth and Clothing in Medieval Europe*, eds. Harte and Ponting: 116–50.

Haines, Frank, and Elizabeth Haines. *Early American Brides*. Grantsville, Md.: Hobby House, 1982.

Hartley, D. *Medieval Costume and Life*. London: 1931.

Herald, J. *Renaissance Dress in Italy 1400–1500*. Atlantic Highlands, N.J.: Humanities, 1981.

Houston, Mary G. *Medieval Costume in England and France*. London: 1939.

Humble, Richard. *The Saxon Kings*. London: Weidenfeld and Nicolson, 1980.

Jackson-Stops, Gervase, ed. *Treasure Houses of Britain: Five Hundred Years of Private Patronage and Art Collecting*. Washington, D.C.: National Gallery of Art; New Haven, Conn.: Yale University Press, 1985.

"Joséphine de Beauharnais." From Wikipedia, the Free Encyclopedia. http://en.wikipedia.org/wiki/Empress_Josephine [accessed 8 April 2006].

Kleinman, Ruth. *Ann of Austria, Queen of France*. Columbus, Ohio: Ohio State University Press, 1985.

Koch, H. W. *Medieval Warfare*. Greenwich, Conn.: Bison, 1978.

Koenigsberger, H. G. *Medieval Europe, 400–1500*. Essex, England: Longman, 1987.

"Madeleine Vionnet." From Wikipedia, the Free Encyclopedia. http://en.wikipedia.org/wiki/Madeleine_Vionnet [accessed 12 May 2006].

Mango, Cyril. *Byzantium: The Empire of New Rome*. London: Weidenfeld and Nicolson, 1980.

Mansel, Philip. *The Court of France, 1789–1830*. New York: Cambridge University Press, 1988.

"Marie Antoinette." from Wikipedia, the Free Encyclopedia. http://en.wikipedia.org/wiki/Marie_Antoinette [accessed 8 April 2006].

Matthew, Donald. *The Norman Conquest*. New York: Schocken, 1966.

McKay, Derek, and H. M. Scott. *The Rise of the Great Powers, 1648–1815*. New York: Longman, 1983.

Megaw, Ruth, and Vincent Megaw. *Celtic Art*. London: Thames and Hudson, 1989.

Metzger, Thérése, and Mendel Metzger. *Jewish Life in the Middle Ages: Illuminated Hebrew Manuscripts of the Thirteenth to Sixteenth Centuries*. New York: Alpine Fine Arts Collection, 1982.

Mobius, Helga. *Woman of the Baroque Age*. Trans. Barbara Chruscik Beedham. Montclair, N.J.: Abner Schram, 1982.

Munro, John H. "The Medieval Scarlet and the Economics of Sartorial Splendour," In *Cloth and Clothing in Medieval Europe*, eds. Harte and Pontin": 13–70.

Neville, William. "The Tudors." In *The Courts of Europe*, ed. A. G. Dickens. New York: McGraw-Hill, 1977.

Newman, Peter C. *Company of Adventurers: The Story of the Hudson Bay Company*, vol. 1. New York: Viking-Penguin, 1985.

Newton, Stella Mary. *The Dress of the Venetians, 1495–1525*. Brookfield, Vt.: Gower, 1988.

Nicolle, David C. *Arms and Armour of the Crusading Era, 1050–1350.* 2 vols. White Plains, N.Y.: Kraus International, 1988.

Norris, Malcolm. *Monumental Brasses: The Memorials.* 2 vols. London: Phillips and Page, 1977.

Norwich, John Julius. *Byzantium: The Early Centuries.* New York: Alfred A. Knopf, 1989.

Owen-Crocker, Gale R. *Dress in Anglo-Saxon England.* Manchester, England: Manchester University Press, 1986.

Paggetti, Maria. "King of Bohemia." *Independent* (London), 15 May 2005.

Paolucci, Antonio. *Ravenna.* London: Constable, 1978.

Parker, Geoffrey. *The Thirty Years' War.* Boston: Routledge and Kegan Paul, 1984.

Prevenier, Walter, and Wim Blockmans. *The Burgundian Netherlands.* Cambridge, Mass.: Cambridge University Press, 1986.

Randsborg, Klavs. *The Viking Age in Denmark: The Formation of a State.* London: Duckworth, 1980.

Reade, Brian. "The Dominance of Spain." In *Fashions of the Renaissance in England, France, Spain and Holland,* ed. James Laver. New York: Harper and Brothers, 1951.

"Renaissance." From Wikipedia, the Free Encyclopedia. http://en.wikiedia .org/wiki/Renaissance [accessed 27 April 2006].

Ribeiro, Aileen. *Fashion in the French Revolution.* New York: Holmes and Meier, 1988.

———. *Dress in Eighteenth-Century Europe, 1715–1789.* London: B. T. Batsford, 1984.

———. *The Dress Worn at Masquerades in England, 1730 to 1790, and Its Relation to Fancy Dress in Portraiture.* New York: Garland, 1984.

———. *A Visual History of Costume: The Eighteenth Century.* New York: Drama, 1983.

Rice, Tamara Talbot. *Everyday Life in Byzantium.* New York: G.P. Putnam's Sons, 1967.

Rowley, Trevor. *The High Middle Ages: 1200–1550.* Boston: Routledge and Kegan Paul, 1986.

Saunders, Richard H., and Ellen G. Miles. *American Colonial Portraits: 1700– 1776.* Washington, D.C.: Smithsonian Institution Press, 1987.

Schoffer, Ivo. "Did Holland's Golden Age Coincide with a Period of Crisis?" *The General Crisis of the Seventeenth Century,* eds. Geoffrey Parker and Lesley M. Smith. London: Routledge and Kegan Paul, 1978: 91.

Scofield, John. "Christopher Columbus and the New World He Found." *National Geographic,* vol. 148, no. 5 (November 1975): 595–616.

Scott, M. *A Visual History of Costume: The Fourteenth and Fifteenth Centuries.* London: B. T. Batsford, 1986.

————. *Late Gothic Europe, 1400–1500*. London: 1981.

Snyder, James. *Medieval Art*. New York: Harry N. Abrams, 1989.

Storr, Anthony. *The Dynamics of Creation*. New York: Random House, 1981.

Strong, Roy. *The English Renaissance Miniature*. London: Thames and Hudson, 1983.

————. *Tudor and Jacobean Portraits*. vols. 1, 2. London: Her Majesty's Stationery Office, 1969.

Tierney, Brian, and Sidney Painter. *Western Europe in the Middle Ages, 300–1475*. New York: Alfred A. Knopf, 1970.

Treadgold, Warren. *The Byzantine Revival: 780–842*. Stanford, Calif.: Stanford University Press, 1988.

Van Thienen, F. *The Great Age of Holland* (Costume of the Western World). London: 1951.

Wilson, David M. *The Bayeux Tapestry*. London: Thames and Hudson, 1985.

5. Nineteenth Century

Anscombe, Isabelle. *A Women's Touch: Women in Design from 1860 to the Present Day*. New York: Viking, 1984.

Barwick, Sandra. *A Century of Style*. London: Allen and Unwin, 1984.

Bohen, Max Von. *Modes and Manners*. 4 vols. London: 1932.

"Charles Frederick Worth." From Wikipedia, the Free Encyclopedia. http://en.wikipedia.org/wiki/Charles_Frederick_Worth [accessed 12 May 2006].

Coleman, Elizabeth Ann. *The Opulent Era: Fashions of Worth, Doucet and Pingat*. New York: Thames and Hudson and the Brooklyn Museum, 1989.

Cunnington, C. W. *English Women's Clothing in the Nineteenth Century*. London: 1937.

Cunnington, C. W., and Phillis Cunnington. *Handbook of English Costume in the Nineteenth Century*. London: Faber and Faber, 1959.

De Marly, Diana. *Worth: Father of Haute Couture*. New York: Holmes and Meier, 1980.

Foster, Vanda. *A Visual History of Costume of the Nineteenth Century*. New York: Drama, 1984.

Ginsburg, Madeleine. *Victorian Dress in Photographs*. London: B. T. Batsford, 1982.

Godey's Lady's Book. July 1864.

Gordon, Beverly. "Textiles and Clothing in the Civil War: A Portrait for Contemporary Understanding." *Clothing and Textiles Research Journal* 5, Spring 1987: 41–47.

Hildey, Michael. *Victorian Working Women: Portraits from Life*. London: Gordon Fraser Gallery, 1979.

Morra, Marisa. "Silent Informers: Men's Coats from a Nineteenth Century Period of Transition." *Dress* 11, 1988.

Noun, Louise. "Amelia Bloomer, A Biography: Part I, The Lily of Seneca Falls." *The Annals of Iowa* 47, Winter 1985.

Ormond, Richard, and Carol Blackett-Ord. *Franz Xaver Winterhalter and the Courts of Europe, 1830–70*. London: National Portrait Gallery, 1987.

Pope, J. *The Clothing Industry in New York*. New York: Burt Franklin (Original work published in 1905), 1970.

"Victorian Era." From Wikipedia, the Free Encyclopedia. http://en.wikipeda .org/wiki/Victorian_era.

"Victorian Fashion." From Wikipedia, the Free Encyclopedia. http:// en.wikipedia.org/wiki/Victoria_fashion [accessed 27 April 2006].

"Victoria of the United Kingdom." From Wikipedia, the Free Encyclopedia. http://en.wikipedia.org/wiki/Queen_Victoria [accessed 27 April 2006, 12 May 2006].

Walkely, Christina. *Dressed to Impress: 1840–1914*. London: B. T. Batsford, 1989.

———. *The Way to Wear 'em: 150 Years of Punch on Fashion*. London: Peter Owen, 1985.

———. *The Ghost in the Looking Glass: The Victorian Seamstress*. London: Peter Owen, 1981.

Wood, Christopher. *The Pre-Raphaelites*. London: Weidenfeld and Nicolson, 1981.

6. Twentieth Century/Post–Twentieth Century

"1965–1995: The Designer Decades." *Daily News Record*, 18 January 1995.

Agins, Terri. *The End of Fashion: The Mass Marketing of the Clothing Business*. New York: William Morrow, 1999.

"Award-Winning Designer Pauline Trigere, 93, Dies." *Washington Post*, 15 February 2002.

Balmain, Pierre. *40 Annés de Creation*. Paris: Musée de la Mode et du Costume, 1985.

Barker, Barbara. "Lagerfeld, Rosa Clará Sign Licensing Deal." *Women's Wear Daily*, 3 April 2006.

Batterberry, Michael, and Ariane Batterberry. *Fashion, the Mirror of History*. New York: Greenwich House, distributed by Crown, 1977.

Battersby, Martin. *Art Deco Fashion*. London: Academy Editions, 1974.

Baudot, Francois. *Fashion: The Twentieth Century*. New York: Universe, 1999.

Benbow-Pfalzaraf, Taryn, ed. *Contemporary Fashion*. 2nd ed. Farmington Hills, Mich.: St. James, 2002.

Bercovici, Jeff. "Made in the U.S.A.: Evans on Pioneers." *Women's Wear Daily*, 1 October 2004.

Betts, Katherine. "The Best and Worst of '96." *Vogue*, January 1997.

Blum, Eva. *Design by Erté*. New York: Dover, 1978.

Buxbaum, Gerda, ed. *Icons of Fashion: The Twentieth Century*. Munich: Prestel, 2000.

Carter, Ernestine. *Magic Names of Fashion*. Englewood Cliffs, N.J.: Prentice Hall, 1980.

———. *The Changing World of Fashion*. London: Weidenfeld and Nicolson, 1977.

Carter, Ernestine, and The London Museum. *Mary Quant*. London: The London Museum 1973.

Coleman, Elizabeth Ann. *The Genius of Charles James*. New York: The Brooklyn Museum and Holt Rinehart and Winston, 1982.

Core, Philip. *The Original Eye: Arbiters of Twentieth Century Taste*. London: Quartet, 1984.

"Costume National's Big Plans." *Women's Wear Daily*, 28 March 2000.

Cunnington, C. W. *English Women's Clothing in the Present Century*. London: 1952.

Deeny, Godfrey. "Ricci's Pipart: Staying Power." *Women's Wear Daily*, 26 January 1995.

———. "Appeals Court: Lacroix's Exit at Patou Unfair." *Women's Wear Daily*, 2 July 1990.

DeGraw, I. G. *25 Years / 25 Couturiers*. Denver: Art, 1975.

De La Haye, Amy. *The Cutting Edge: 50 Years of British Fashion, 1947–1997*. New York: Overlook, 1997.

De La Haye, Amy, and C. Dingwall. *Surfers, Soulies, Skinheads and Skaters: Subcultural Style from the Forties to the Nineties*. Woodstock, N.Y: Overlook, 1996.

Delbourg-Delphis, Maryléne, and Florence Müller. *Histoire de la Mode au xx Siécle*. Paris: Somogy, 1986.

"Designers Grumble But Fashion Goes On." *Women's Wear Daily*, 26 July 1976.

Diamondstein, Barbaralee. *Fashion: The Inside Story*. New York: Rizzoli, 1985.

Dietz, Paula. "The Undershirt Comes Out." *New York Times: Fashions of The Times*, Spring 1994.

Doody, Richard. "The World at War, France Between the Wars 1918–39." www.worldatwar.net/nations/france/timeline18-39.html [accessed 6 April 2006].

Dychtwald, K., and G. Gable. *The Shifting American Marketplace*. Emeryville, Calif.: Age Wave, 1990.

"The Eighties in Fashion: The Highs and Lows." *Mirabella*, February 1990.

Esquivel, J. "Theme for 1990s: Dress for Survival." *America's Textiles International*, K/A 2-K/A, 10 January 1995.

Evans, Caroline, and Minna Thornton. *Women and Fashion: A New Look.* London: Quartet, 1989.

Evans, Matthew W. "Varvatos: A New Vintage." *Women's Wear Daily*, 31 March 2006.

Ewing, Elizabeth. *History of Twentieth Century Fashion.* London: B. T. Batsford, 1974.

Feitelberg, Rosemary. "FIT Exhibit to Feature Lucien Lelong, Couturier 1918–1948." *Women's Wear Daily*, 18 January 2006.

Feldman, E. *Fashions of a Decade: The 1990s.* New York: Facts on File, 1992.

Frankel, Susannah. "And Long May She Reign . . ." *Independent* (London), 15 March 2004.

———. "The IoS Profile: Alexander McQueen." *Independent* (London), 16 March 2003.

———. "Fashion: Vive Yves!" *Independent* (London), 24 January 2002.

Fraser, Kennedy. *The Fashionable Mind: Reflections on Fashions, 1970–1982.* New York: Alfred A. Knopf, 1981.

"Furla's Women Take Center Stage." *Women's Wear Daily*, 28 December 2005.

Gan, Stephen. *Visionaire's Fashion 2000: Designers at the Turn of the Millennium.* London: Laurence King, 1997.

Garnier, Guillaume, et al. *Paul Poiret et Nicole Groult.* Paris: Musée de la Mode et du Costume, Editions Paris-Musées, 1986.

———. *40 Années de Creation, Pierre Balmain.* Paris: Musée de la Mode et du Costume, Editions Paris-Musées, 1985.

Gellers, Stan. "The Big Brand Era." *1965–1995: The Designer Decades Daily News Record*, 18 January 1995: 30, 62–63.

Glave, Judie. "Designer Pauline Trigere, Known for Her Functional Fashion for Women, Dead at 93." *AP Worldstream*, 15 February 2002.

Glynn, Prudence. *In Fashion: Dress in the Twentieth Century.* London: Allen and Unwin, 1978.

Golbin, Pamela. *Fashion Designers.* New York: Watson-Guptill, 2001.

Gross, Elaine, and Fred Rottman. *Halston: An American Original.* New York: HarperCollins, 1999.

Hommage à Elsa Schiaparelli. Paris: Musée de la Mode et du Costume, Editions Paris Musée, 1974.

Howe, Marvine. "Irene Sharaff, Designer, 83 Dies: Costumes Won Tony and Oscars." *New York Times*, 17 August 1993.

Howell, Georgina. *Dior in Vogue*. London: 1981.

Hulanicki, Barbara. *From A to Biba*. London: Hutchinson, 1983.

"In the Running. International Award: Alexander McQueen." *Women's Wear Daily*, 2 June 2003.

Jouve, Marie-Andree, and Jacqueline Demornex. *Balenciaga*. New York: Assouline, 1997.

Kamitsis, Lydia. *Paco Rabanne*. London: Thames and Hudson, 1999.

———. *"Paco Rabanne: Le Sens de la recherché."* Paris: Michel Lafon, 1996.

———. *Vionnet*. London: Thames and Hudson: 1996.

Kaplan, Fred. "Hiroshima's Legacy." *Boston Globe*, 1 August 1995.

Koren, Leonard. *New Fashion Japan*. Tokyo: Kodansha International, 1984.

Law, Lisa. *Flashing on the Sixties*. San Francisco: Chronicle, 1988.

Lee, Sarah Tomerlin. *American Fashion: The Life and Lines of Adrian, Mainbocher, McCardell, Norell and Trigere*. New York: Quadrangle, 1975.

Lee-Potter, Charlie. *Sportswear in Vogue Since 1910*. New York: Abbeville, 1984.

Lobenthal, Joel. *Radical Rags: Fashions of the Sixties*. New York: Abbeville, 1990.

Lomas, C. *Twentieth Century Fashion: The Eighties and Nineties*. Milwaukee: Gareth Stevens, 2000.

Marion, Rick. "She's Still in *Vogue*." *Newsweek*, 23 November 1998.

"Market Basket: MOMA Digs Yeohlee . . . Body of Work . . . Going to the Dogs." *Women's Wear Daily*, 16 November 2004.

Martin, Richard, ed. *Contemporary Fashion*. Detroit: St. James, 1995.

———. *Fashion and Surrealism*. New York: Rizzoli, 1987.

Martin, Richard, and Harold Koda. *American Ingenuity: Sportswear, 1930s to 1970s*. New York: Metropolitan Museum of Art Exhibition Catalog, 1998.

———. *Three Women: Madeleine Vionnet, Claire McCardell, and Rei Kawakubo*. New York: Fashion Institute of Technology, 1987.

Mendes, Valerie D., ed. *Pierre Cardin: Past, Present and Future*. London and Berlin: Dirk Nishen, 1990.

———. *Twentieth Century Fashion: An Introduction to Women's Fashionable Dress, 1900 to 1980*. London: Victoria and Albert Museum, 1981.

Mendes, Valerie D., and Amy De La Haye. *Twentieth Century Fashion*. London: Thames and Hudson, 1999.

Menkes, Suzy. "Fashion Legends: Elsa Schiaparelli." *Architectural Digest*, October 1994.

Middleton, W. "French Fashion Now." *Women's Wear Daily*, 21 August 1995.

Middleton, William. "The Rise of Ralph Rucci." *Harper's Bazaar*, March 2004.

"Milestones (Died, René Lacoste)." *Time*, 28 October 1996.

Mistry, Meenal. "Four and Three as Four." *Women's Wear Daily*, 4 February 2006.

Moda Italiana, "1946–1986: 40 Anni di Stile Italiano." Rome: Palazzo Braschi, 1987.

Moreno, Elizabeth. *The Fashion Makers: An Inside Look at America's Leading Designers*. New York: Random House, 1978.

Mower, Sara. "Sixty-four / Ninety-five Mod." *Harper's Bazaar*, June 1995.

Mulvagh, J. *Vogue: History of 20th Century Fashion*. London: 1988.

"Obituary: Jeakins, Dorothy." *New York Times*, 30 November 1995.

Ozzard, Janet. "Vera Maxwell Remembered." *Women's Wear Daily*, 23 January 1995.

Paquin: Une Retrospective de Soixante ans de Haute Couture. Lyons: Musée Historique des Tissus, 1989.

Penn, Irving. *Issey Miyake by Irving Penn, 1989; 1990; 1993; 1994; 1995*. Tokyo Miyake Design Studio, 1989, 1990, 1993, 1994, 1995.

Polhemus, Ted. *Style Surfing: What to Wear in the 3rd Millennium*. London: Thames and Hudson, 1996.

———. "Fall Comes In Many Modes of Mod." *Boston Globe*, 6 September 1995.

———. "How Fashion Stole Dress Down Day." *Boston Globe*, 30 May 1995.

———. *Street Style: From Sidewalk to Catwalk*. London: Thames and Hudson, 1994.

———. *Pop Styles*. London: Vermilion, 1984.

Richards, Melissa. *Chanel: Key Collections*. London: Welcome Rain, 2000.

Riley, Robert. *The Fashion Makers*. New York: Crown, 1968.

Robinson, Julian. *Fashion in the Thirties*. London: Oresko, 1978.

———. *The Golden Age of Style: Art Deco Fashion Illustration*. London: Orbis, 1976.

———. *Fashion in the Forties*. New York: Harcourt Brace Jovanovich, 1976.

"Scassi: An American Icon." http://dept.kent.edu/museum/exhibit/scaasi/scaasi .html [accessed 4 May 2006].

Seeling, Charlotte. *Fashion: The Century of the Designer*. Cologne: Konemann, 1999.

Severo, Richard, and Ruth LaFerla. "Oleg Cassini, Designer for the Stars and Jacqueline Kennedy, Dies at 92." *New York Times*, March 2006.

Sheinman, Mort. "Oleg Cassini: Iconic and Enduring." *Women's Wear Daily*, 20 March 2006.

Steele, Valerie. *Fifty Years of Fashion: New Look to Now*. New Haven, Conn.: Yale University Press, 2000.

———. *Women of Fashion: Twentieth Century Designers*. New York: Rizzoli, 1991.

Stern, Jane, and Michael Stern. *Sixties People*. New York: Alfred A. Knopf, 1990.

U.S. Census Bureau. "How We're Changing-Demographic State of the Nation: 1995." Current Population Reports (Special Studies, Series P-23, No. 188), Washington, D.C.: U.S. Department of Commerce, 1995.

U.S. Department of Commerce, Bureau of the Census. "1973–2005."

Van Dorssen, Sacha. *Dior: Christian Dior, 1905–1957*. New York: Rizzoli, 1987.

Veillon, Dominique. *La Mode sous L'occupation*. Paris: Payout, 1990.

"Vionnet, Madeleine." *Columbia Encyclopedia*. 6th ed. Edited by Paul Legassé. New York: Columbia University Press, 2006.

"*Vogue*'s Tribute to the Twentieth Century in Fashion." *PR Newswire*, 25 October 1999.

Vreeland, Diana, and Irving Penn. *Inventive Paris Clothes: 1900–1939*. New York: Viking, 1997.

Vreeland, Diana, et al. *Issey Miyake, Body Works*. Tokyo: Shozo Tsurumoto, 1983.

Watson, Linda. *Vogue: Twentieth Century Fashion*. London: Carlton, 1999.

White, Palmer. *Elsa Schiaparelli: Empress of Paris Fashion*. New York: Rizzoli, 1986.

———. *Poiret*. New York: Clarkson N. Potter, 1973.

Wolf, Roberta, and Trudy Schlachter. *Millennium Mode*. New York: Rizzoli, 1999: 28.

Wiser, William. *The Crazy Years: Paris in the Twenties*. New York: Atheneum, 1983.

Woodham, Jonathan M. *Twentieth Century Ornament*. New York: Rizzoli, 1990.

Zaletova, Lidya, et al. *Revolutionary Costume: Soviet Clothing and Textiles of the 1920s*. London: Trefoil Books: 1989.

C. INFLUENCES

1. Movements

"About Fair Trade." From Fair Trade Certified. www.transfairusa.org/content/about/index.php [accessed November 2006].

Black, P. "Firms Capitalizing on 'Echo-Boomers' Come Out Ahead." *Bobbin*: 54.

Brookman, F. "Aging Boomer, Booming Sales." *Women's Wear Daily*, 8 June 1998.

Choi, Amy S. "Mom, Pop and Wal-Mart Go Green." *Women's Wear Daily*, 27 November 2006.

Chouinard, Yvon. *Let My People Go Surfing*. New York: Penguin, 2005.

"Definition of Organics." From the Organic Trade Association. www.ota.com /organic/definition.html [accessed November 2006].

Douglas, Ann. "City Where the Beats Were Moved to Howl." *New York Times*, 26 December 1997.

Dunn, W. *The Baby Bust: A Generation Comes of Age*. Ithaca, N.Y.: American Demographics, 1993.

"Fair Trade." From Wikipedia, the Free Encyclopedia. http://en.wikipedia .org/wiki/Fair_trade [accessed November 2006].

"Fair Trade Labelling Organizations International." From Fairtrade.net. http:// www.fairtrade.net/ [accessed November 2006].

Frazer, Ronald, ed. *A Student Generation in Revolt: An International Oral History*. New York: Pantheon, 1988.

"Generation X." From Wikipedia, the Free Encyclopedia. http://en.wikipedia .org/wiki/Generation X [accessed 20 July 2006].

"Generation Y." From Wikipedia, the Free Encyclopedia. http://en.wikipedia.org /wiki/Generation Y [accessed 20 July 2006].

McRobbie, Angela, ed. *Zoot Suits and Second-Hand Dresses*. Boston: Unwin Hyman, 1988.

Neuborne, E., and K. Kerwin. "Generation Y." *Business Week*, 15 February 1999: 80–88.

"Organic Certification." From Earthbound Farm. www.ebfarm.com/Organic /OrganicCertification.aspx [accessed November 2006].

"Organic Cotton Background." From Organic Cotton Directory. www .organiccottondirectory.net/ [accessed November 2006].

"Organic Cotton Facts." From the Organic Trade Association. www.ota.com /organic/mt/organic_cotton.html [accessed November 2006].

"Organic Farming." From Wikipedia, the Free Encyclopedia. http://en.wikipedia .org/wiki/Organic_farming [accessed November 2006].

"Organic Farming 101." From Earthbound Farm. www.ebfarm.com/Organic /Organic101.aspx [accessed November 2006].

"Organic Wool Fact Sheet." From the Organic Trade Association. www.ota .com/organic/woolfactsheet.html [accessed November 2006].

Popcorn, Faith. *Clicking*. New York: Harper Business, 1995.

———. *The Popcorn Report*. New York: Bantam Doubleday Dell, 1991.

Reda, S. "Reaching the Aging Boomers." *Stores*, March 1998.

Ritchie, K. *Marketing to Generation X*. Greenwich, Conn.: Lexington, 1995.

Romero, E. "Dressing Things that Go 'Echo Boom.'" *Daily News Record*, 8 October 1997.

"Select Developers Protect the Environment—and Profits." *Women's Wear Daily*, 27 November 2006.

"Sustainable Cotton Project." From the Sustainable Cotton Project. www .sustainablecotton.org/html/cotton.html [accessed November 2006].

"Sustainable Design." From Wikipedia, the Free Encyclopedia. http:// en.wikipedia.org/wiki/Sustainable_design [accessed 5 November 2006].

"Trade Union." From Wikipedia, the Free Encyclopedia. http://en.wikipedia .org/wiki/Trade_union [accessed November 2006].

"USDA Organic Standards Fact Sheet." From Earthbound Farm. www.ebfarm .com/Organic/USDA_facts.aspx [accessed November 2006].

Zinn, L. "Move over Boomers." *Business Week*, 14 December 1992.

2. Sociology and Fashion

Banner, Lois. *American Beauty*. New York: Alfred A. Knopf, 1983.

Barthes, Roland. *The Fashion System*. London: Jonathan Cape, 1985.

———."Histoire et Sociologie du Vétement." *Annales*, no. 3 (July–September 1957).

Baudrillard, Jean. "La Mode ou la féérie du code." *Traverse*, no. 3 (1984).

Bell, Quentin. *On Human Finery*. London: Allison and Busby, 1992.

Bourdieu, Pierre. *La Distinction. Critique Sociale du Jugement*. Paris: Èditions de Minuit, 1979.

———."Le Couturier et sa griffe: contribution à une théorie de la Mode." Paris: Actes de la recherché en science sociale, no. 1 (September 1974).

Chafe, William. *The American Woman: Her Changing Social, Economic, Political Roles, 1920–1970*. Oxford: Oxford University Press, 1972.

Descamps, Marc-Alain. *Psychosociologie de la Mode*. Paris: PUF, 1984.

Evans, Sara. *Personal Politics: The Roots of Women's Liberation in the Civil Rights Movement and the New Left*. New York: Alfred A. Knopf, 1979.

Flügel, J. C. *The Psychology of Clothes*. London: Hogarth, 1930.

Fred, David. *Fashion, Culture, and Identity*. Chicago: University of Chicago Press, 1992.

Hebdige, Dick. *Subculture: The Meaning of Style*. London: Methuen, 1979.

Hollander, Anne. *Seeing Through Clothes*. New York: Viking, 1978.

König, René. *Sociologie de la Mode*. Paris: Payot, 1969.

Melinkoff, Ellin. *What We Wore: An Offbeat Social History of Women's Clothing, 1950–1980*. New York: Quill, 1984.

Ribeiro, Aileen. *Dress and Morality*. London: B. T. Batsford, 1986.

Roach, Mary Ellen, and Joanne Eicher Bubolz. *Dress, Adornment and the Social Order*. New York: John Wiley and Sons, 1965.

Shapiro, H. *Man, Culture and Society*. London: Oxford University Press, 1956.

Weiner, Annette B., and Jane Schneider. *Cloth and Human Experience*. Washington, D.C.: Smithsonian Institution Press, 1989.

3. Styles

Baily, Margaret J. *Those Glorious Glamour Years of Hollywood.* Secaucus, N.J.: Citadel, 1982: 373.

Baines, Barbara. *Fashion Revivals.* London: B. T. Batsford, 1981.

Basinger, Janine. *American Cinema.* New York: Rizzoli, 1994.

Bellafante, Gina. "Knowing What Designers Want Before They Want It." *New York Times*, 21 March 2000.

Bender, Marylin. *The Beautiful People.* New York: Coward-McCann, 1967: 181.

Brown, C. "Dressing Down." *Forbes*, 5 December 1994: 155–60.

Brunel, Charlotte. *The T-Shirt Book.* New York: Assouline Publishing Co., 2002.

Cohen, Meg. "Unforgettable Audrey." *Harper's Bazaar*, April 1993.

Engelmeier, R., and P. W. Engelmeier. *Fashion in Film.* New York: Prestel, 1997.

Gan, Stephen. "It's a Rockabilly Thing." *Harper's Bazaar*, August 1994.

Goldman, D. "'Dressing Down' is Just the New Form of Moving Up." *ADWeek*, 17 April 2000: 16, 19.

"Grannies with Dash." *New York Times*, 6 June 1993.

Greenberg, Cara. "Where the Clothes Match the Music." *New York Times*, 6 June 1993.

Hatfield, Julie. "All That Glitters Isn't Clothes." *Boston Globe*, 7 November 1994.

Head, Edith, and Paddy Callistro. *Edith Head's Hollywood.* New York: E. P. Dutton, 1983.

McCardell, Claire. *What Shall I Wear?* New York: Simon & Schuster, 1956.

McConathy, Dale, and Diana Vreeland. *Hollywood Costume.* New York: Harry N. Abrams, 1976.

McDermott, Catherine. *Street Style: British Design in the 80s.* New York: Rizzoli, 1987.

Melly, George. *Revolt into Style.* London: Allen Lane, 1970.

Munk, N. "Girl Power." *Fortune*, 8 December 1997: 132–40.

"Ready, Sweats, Go." *Women's Wear Daily*, 3 October 2006.

Reynolds, Pamela. "Coming Down a Runway Near You: Audrey Hepburn." *Boston Globe*, 28 September 1995.

Sewell, Dennita. "T-shirt," in *Encyclopedia of Clothing and Fashion*, ed. Valerie Steel. Detroit: Gale, 2005. Vol. 3, 341–43.

Spindler, Amy M. "Designing to a Latin Beat." *New York Times*, 13 September 1994.

———. "Bringing Hollywood Home." *New York Times*, 24 October 1993.

"Streetwear." From Wikipedia, the Free Encyclopedia. http://en.wikipedia .org/wiki/Streetwear [accessed 15 December 2006].

Szabo, Julia. "Think Punk." *Harper's Bazaar*, November 1993.

Taylor, Allyson Rowen. "Gender Bender." *W* , December 2004.

Thomas, Dana. "The Sole of Sexiness." *Newsweek International*, 24 February 2003.

Tierney, Tom. *Diaghilev's Ballets Russes*. New York: Dover, 1986.

Trebay, Guy. "FTV." *Harper's Bazaar*, August 1994.

Van Der Post, Lucia. "Jean Genius." *Daily Mail* (London), 13 March 2005.

Weiner, Garen. "Geek or Chic?" *Entertainment Weekly*, 11 April 1997.

White, Constance C. R. "Bra Straps as Fashion. Don't Tell Your Mom." *New York Times*, 10 August 1997.

Winnick, C. *The New People: Desexualization in American Life*. New York: Pegasus, 1968.

4. Non-Western Cultures

Hansen, Karen Tranberg. "The World in Dress: Anththropologial Perspectives on Clothing, Fashion, and Culture." In *Annual Review of Anthropology*, 2004. 33: 369–92.

Steele, Valerie, and John S. Major. *China Chic: East Meets West*. New Haven, Conn.: Yale University Press, 1999.

D. DESIGNERS AND BRANDS

1. American

"About Kate." Kate Spade, New York. www.katespade.com/corp/index .jsp?page=aboutkate [accessed 2 December 2005].

Apodaca, Rose. "DVF Sizzles in Los Angeles." *Women's Wear Daily*, 3 October 2005.

Baily, Pierre. "On the Marc." *Harper's Bazaar*, 1 February 2004. www .highbeam.com/library/doc3.asp?DOCID=1G1:112801076andnum=1 3andctrlInfo-Round20%3A [accessed 20 May 2006].

Bernstein, Jacob. "Phat Farm." *Women's Wear Daily*, 3 April 2006.

"Bill Blass." www.oralcancerfoundation.org/people/bill_blass.htm [accessed 29 April 2006].

"Bob Mackie." NNDB. Soylent Communications 2005. www.nndb.com /people/174/000024102/ [accessed 17 March 2006].

"Bob Mackie Designs New Collection for Plus-Size Women." *PR Newswire*, 25 September 2003.

Bradley, Barry W. *Galanos*. Ohio: Western World Historical Society, 1996.

Campbell, Roy H. "Fashion Designer Mary McFadden Works to Promote Cancer Awareness for Women." *Knight Ridder/Tribune*, 2 October 1997.

Cassini, Igor, with Jeanne Molli. *I'd Do It All Over Again*. New York: G.P. Putnam's Sons, 1977.

Cassini, Oleg. *A Thousand Days of Magic*. New York: Rizzoli, 1995, 15.

———. *In My Own Fashion: An Autobiography*. New York: Pocket, 1987.

"Charles James to Be Subject of F.I.T. Show." *Women's Wear Daily*, 16 March 1993.

Chocano, Carina. "Betsey Johnson." http://archive.salon.com/people/bc/2001/04/24/betsey_johnson/index.html [accessed 22 June 2006].

Colavita, Courtney. "Tom Ford Said Near Deal With Zegna." *Women's Wear Daily*, 27 February 2006.

Daria, Irene. *The Fashion Cycle: A Behind-the-Scenes Look at a Year with Bill Blass, Liz Claiborne, Donna Karen, Arnold Scaasi, and Adrienne Vittadini*. New York: Simon & Schuster, 1990.

Daria, Irene. "Benetton: 'Between Armani and Coca-Cola.'" *Women's Wear Daily*, 26 June 1985.

"Diane von Furstenberg." From Wikipedia, the Free Encyclopedia http://en.wikipedia.org/wiki/Diane_von_Furstenberg [accessed 18 May 2006].

"Fashion Scoops: Designs on Derek." *Women's Wear Daily*, 14 November 2006.

Elliott, Mary. "Remembering Adrian." *Threads*, May 2001.

Feitelberg, Rosemary. "Ralph Rucci Feted for Couture Honor." *Women's Wear Daily*, 8 May 2006.

———. "Olsen's New Badgley Mischka Faces." *Women's Wear Daily*, 15 February 2006.

———. "Vera Seeking Ways and Means to Grow." *Women's Wear Daily*, 8 February 2005.

Foley, Bridget. "Isaac Mizrahi: His American Way." *Women's Wear Daily*, 30 July 1990.

Ford, Tom, and Bridget Foley. *Tom Ford*. New York: Rizzoli, 2004.

Givhan, Robin. "Relaxed Fit: John Varvato's Subtle Designs are a Cinch Inside the Beltway." *Washington Post*, 23 January 2005.

"Gloria Vanderbilt." From Wikipedia, the Free Encyclopedia. http://en.wikipedia.org/wiki/Gloria_Vanderbilt [accessed 12 May 2006].

Glueck, Grace. "Adrian, Whose Elegant Styles Were Movie Scene-Stealers." *New York Times*, 17 May 2002.

Haber, Holly. "Diane Von Furstenberg to be Honored in Dallas." *Women's Wear Daily*, 18 July 2003.

———. "Sant'Angelo, A Master of Fantasy, Dies." *Women's Wear Daily*, 31 August 1989.

"John Varvatos." www.johnvarvatos.com/about_jv_biography.html [accessed 15 May 2006].

"Jones Apparel Group, Inc. Signs License Agreement with Amerex Group, Inc. for Gloria Vanderbilt Outerwear." *PR Newswire*, 17 March 2003.

"Jones Apparel Group Lays Off 129 Workers." *Women's Wear Daily*, 21 October 2005.

Kaplan, Fred. "Beene Seeks Growth with Licensing Deals." *Women's Wear Daily*, 9 January 2006.

———. "Anna Sui Opens Up with Larger Store." *Women's Wear Daily*, 2005.

———. "Michael's Many Moves." *Women's Wear Daily*, 16 March 2004.

Karimzadeh, Marc. "Proenza Schouler's Next Step." *Women's Wear Daily*, 4 April 2006.

———. "Von Furstenberg Opens Back Home in Belgium." *Women's Wear Daily*, 21 March 2006.

Kerwin, Jessica. "Mackie is Backie." *Women's Wear Daily*, 28 February 1996.

"Kors Exits Better Men's Line." *Women's Wear Daily*, 21 October 2005.

Koski, Lorna. "Arnold Scaasi's Wonderful World." *Women's Wear Daily*, 19 January 1989.

"The Lady of the House: Betsey Johnson Proves Her Brand to Be a . . ." www.highbeam.com/librarydoc3.asp?DOCID=1G1:140833128andnum=4andctrlInfo=R [accessed 4 June 2006].

Larson, Kristin. "Boneparth's Campaign Plan at Jones: Double-Digit Growth." www.highbeam.com/library/doc3.asp?DOCID=1G1:91043660andnum=9andctrlInfo=R [accessed 10 June 2006].

"Levi Strauss." From Wikipedia, the Free Encyclopedia. http://en.wikipedia .org/wiki/Levi_Strauss [accessed 6 May 2006].

"Levi Strauss and Co." *NewsWatch*. San Francisco, 1995.

"Levi Strauss and Co." www.levistrauss.com/about/ [accessed 6 May 2006].

Lipke, David. "Kors, Stroll Rev Their Engines." *Women's Wear Daily*, 17 November 2003.

Lockwood, Lisa. "Lafayette 148: A Company." *Women's Wear Daily*, 7 February 2006.

———. "Tommy, Apax Chart Course." *Women's Wear Daily*, 27 December 2005.

———. "Aghayan Appointed VP by Bob Mackie Originals." *Women's Wear Daily*, 26 November 1986.

"Mackie Plans to Do His Own Bridal Dresses for Spring '92." *Women's Wear Daily*, 1 October 1991.

McCants, Leonard. "Bob Mackie." *Women's Wear Daily*, 5 June 2001.

Monget, Karyn. "Vera Wang Inks Lingerie License." *Women's Wear Daily*, 14 March 2005.

Naughton, Julie. "Kimora Lee Simmons: Independent's Day." *Women's Wear Daily*, 10 March 2006.

———. "Wang Says 'I Do' to Men's Market." *Women's Wear Daily*, 7 November 2003.

Nygaard, Sandra. "Michael's Misfire: What Went Wrong." *Daily New Record*, 31 October 2005.

———. "Varvatos and VF Exchange Vows." *Daily News Record*, 25 April 2005.

Ozzard, Janet. "Scaasi Inks 5-year QVC Deal." *Women's Wear Daily*, 29 March 1993.

Pearson, Mike. "Mounting Gloria Fashion Queen Vanderbilt Keeps a Lid on Hot Stuff in Tepid Romantic Memoir." *Denver Rocky Mountain News*, 15 October 2004.

"Phat City." *Women's Wear Daily*, 21 April 1993.

"Phat Farm." From Wikipedia, the Free Encyclopedia. http://en.wikipedia.org/wiki/Phat_Farm [accessed 23 April 2006].

"Phat Farm and Motorola Unveil the Russell Simmons Phat Farm II Signature Motorola i733 Mobile Phone." *PR Newswire*, 1 December 2003.

"Phat Fashions Opens Phat Farm and Baby Phat Stores in Dubai and Abu Dhabi." *PR Newswire*, 19 April 2006.

Pogoda, Dianne M. "Bob Mackie, Carol Burnett to Get Dallas Apparel Awards." *Women's Wear Daily*, 16 September 1996.

———. "Mackie Returning to Seventh Ave." *Women's Wear Daily*, 27 October 1995.

"Ray Aghayan (1934–)." Biography *ATAS—Emmy Magazine*. www.theoscarsite.com/whoswho5agahyan_r.htm [accessed 17 March 2006].

Reed, Julia. "Calvin's Clean Sweep." *Vogue*, August 1994.

"Richard Tyler." *New York*. www.printthis.clickbility.com/pt/cpt?action=cptand title=Richard+Tyler+-+New+York [accessed 4 November 2005].

Riedman, Patricia. "Phat Farm; Russell Simmons, Founder, Chairman-CEO." *Advertising Age*, 17 November 2003.

Sabga, Patricia, and Jan Hopkins. "Vera Wang Profile." *Business Unusual* (CNNfn), 2 July 2001.

Sauer, Georgia. "Isaac Mizrahi Unzips His New Line." *St. Louis Post-Dispatch*, 14 January 1996.

Schou, Solvej. "Isaac Mizrahi Defends Red Carpet Behavior." *AP Online*, 18 February 2006.

Sischy, Ingrid. *The Journey of a Woman, Twenty Years of Donna Karan*. New York: Assouline, 2004.

Sison, Mary. "Coach Plans a Line of Women's Knitwear." *New York Business*, 23 February 2006.

"The Smell of Success." *Time*. Copyright 1992 Time, Inc. www.highbeam.com/library/doc.asp?DOCID=1G1:12406379andnum=4andctrlInfo=Round18%3Apr [accessed 4 December 2005].

Snavely, Brent. "Lilly Pulitzer Dress Store Opens in Chelsea." *Crain's Detroit Business*, 20 June 2005.

Socha, Miles. "Isaac Mizrahi Shuts Down." *Women's Wear Daily*, 2 October 1998.

Sturrock, Staci. "Fifteen Minutes with the Ever Quotable Michael Kors." *Palm Beach Post*, 8 February 2006.

"Urban-Inspired Apparel Line Phat Farm Sold to Industry Giant Kellwood." *Daily News*, 9 January 2004.

"Vera Wang." From Wikipedia, the Free Encyclopedia. http://en.wikipedia.org/wiki/Vera_Wang [accessed 20 May 2006].

Weil, Jennifer. "Marc Jacobs Finally Signs on LVMH's Dotted Line." *Women's Wear Daily*, 9 January 1997.

"Who's Who, Designers, Nicole Miller, Fashion Designer." Infomat. www.infomt.com/whoswho/nicolemiller.html [accessed 31 March 2006].

Wilson, Eric. "Through the Ages with Mary McFadden." *Women's Wear Daily*, 3 June 2004.

———. "Robinson Unleashed at Paco Rabanne." *Women's Wear Daily*, 15 December 2004.

———. "John Varvatos: Opportunity Knocks." *Women's Wear Daily*, 7 February 2004.

———. "Mary McFadden Still Contrary." *Women's Wear Daily*, 25 September 2002.

———. "Bill Blass Receives a Retrospective." *Women's Wear Daily*, 16 May 2000.

———. "Mackie's Take on Custom-made Makes." *Women's Wear Daily*, 30 June 1996.

Woller, Barbara. "Coach Inc. Is Having a Smooth Ride." *Journal News*, 23 May 2005.

2. Asian

Calliaway, N. *Issey Miyake*. New York: New York Graphic Society, 1988.

"The Fashion House That Yeohlee Built." *Women's Wear Daily*, 20 November 2001.

Frankel, Susannah. "Fashion and Style: Yohji Back to the Front." *Independent* (London), 14 April 2005.

Givhan, Robin. "Museum Quality: Yeohlee Teng, Emphasizing the Design in Designer Fashion." *Washington Post*, 3 October 2005.

Greene, Joshua. "Yeohlee's Latest 'Work' of Art." *Women's Wear Daily*, 26 August 2003.

"Issey Miyake." From Wikipedia, the Free Encyclopedia. http://en.wikipedia .org/wiki/Issey_Miyake [accessed 3 April 2006].

"Japan Designer Hanae Mori Bids Farewell to Fashion World at Last Show in Paris." *Kyodo News International*, 8 July 2004.

"Japanese Designer Hanae Mori Bids Farewell to Haute Couture." *Agence France Presse English*, 23 June 2004.

Menkes, Suzy. "Yohji Yamamoto: 'Just Clothes' From the Inside Out." *International Herald Tribune*, 19 April 2005.

"Miyake Cancels Show in Paris Because of War." *Daily News Tribune*, 25 January 1991.

"Miyake, Issey." *Columbia Encyclopedia*. 6th ed. Ed. by Paul Legassé. New York: Columbia University Press, 2006.

Peterson, Holly. "Doo-Ri Chung." *Newsweek*, December 2005/January 2006.

Sainderichin, Ginette. *Kenzo*. Paris: Éditions du May, 1989.

Sudjic, Deyan. *Rei Kawakubo and Comme des Garcons*. London: Fourth Estate, and New York: Rizzoli, 1990.

"Yohji Yamamoto." From Wikipedia, the Free Encyclopedia. http://en.wikipedia .org/wiki/Yohji_Yamamoto [accessed 12 May 2006].

"Yohji Yamamoto." *Women's Wear Daily*, 8 July 2002.

3. European

"Azzedine Alaia." From History of Fashion and Costume. www.designerhistory .com/historyofashion//azz.html [accessed 16 December 2006].

Baillen, Claude. *Chanel Solitaire*. Translated by Barbara Bray. New York: Quadrangle/*New York Times*, 1974: 62, 74.

Barille, Elisabeth. *Lanvin*. London: Thames and Hudson, 1997.

Baudot, Francois. *Alaïa (Fashion Memoire)*. Paris: Assouline Press, 2006.

———. *Thierry Mugler*. London: Thames and Hudson, 1998.

———. *Alaïa (Universe of Fashion)*.Vendome Press for Universe, 1997.

———. *Elsa Schiaparelli*. London: Thames and Hudson, 1997.

———. *Paul Poiret*. London: Thames and Hudson, 1997.

———. *Alaïa*. London: Thames and Hudson, 1996.

———. *Chanel*. London: Thames and Hudson, 1996.

"Bernard Arnault." From Wikipedia, the Free Encyclopedia. http://en.wikipedia .org/wiki/Bernard_Arnault [accessed 20 May 2006].

Browne, Alix. "Absolute Armani." *Harper's Bazaar*, November 1994.

Chandler, Barbara. "Truly, Madly, Missoni." *Evening Standard* (London), 15 June 2005.

Chapon, Francois. *Mystéres et Splendeurs de Jacques Doucet, 1853–1929.* Paris: Jean-Claude Lattés, 1984.

Chapsal, Madeleine, et al. *Rykiel par Rykiel.* Paris: Herscher, 1985.

Charles Roux, Edmonde. *Chanel: Her Life, Her World, and the Woman Behind the Legend She Herself Created.* New York: Alfred A. Knopf, 1975.

Charlie Rose Program, "Karl Lagerfeld," WGBH Channel 2, Boston, Mass, 9 November 1994.

Chenoune, Farid. *Jean-Paul Gaultier.* London: Thames and Hudson, 1996.

"Coco Chanel." From Wikipedia, the Free Encyclopedia. http://en.wikipedia .org/wiki/Coco_Chanel [accessed 5 May 2006].

Conti, Samantha. "Alexander McQueen Sets New RTW Line." *Women's Wear Daily,* 7 November 2005.

———. "McQueen's Fashion Lab." *Women's Wear Daily,* 7 April 2003.

———. "Here's Gianni." *W,* December 2002.

Degan, Pener. "Italian Lessons: Giorgio Armani's Design for Living." *Elle,* March 1993.

De La Haye, Amy, and Shelley Tobin. *Chanel: The Couturiere at Work.* New York: Overlook, 1994: 185.

De Osma, Guillermo. *Mariano Fortuny: His Life and Work.* New York: Rizzoli, 1980.

De Rethy, Esmeralda, and Jean-Louis Perreau. *Christian Dior: The Early Years, 1947–1957.* New York: Vendome, 2002.

Demasse, Jacques. *Sonia Delaunay: Fashion and Fabrics.* London: Thames and Hudson, 1991.

Derycke, Luc, and Sandra Van De Veire, eds. *Belgian Fashion Design.* Ghent: Ludion, 1999.

Deslandres, Yvonne. *Paul Poiret.* London: Thames and Hudson, 1987.

Desvaux, Delphine. *Fortuny.* London: Thames and Hudson, 1998.

Dieterle, Catherine. *Givenchy—Forty Years of Creation.* France: Paris-Musees, Paris: 1991.

DiMaria, Eugene. "Moët-Vuitton: A Luxe Combo." *Women's Wear Daily,* 10 July 1987.

Dior, Christian. *Christian Dior and I.* New York: E.P. Dutton, 1957.

———. *Dior by Dior.* London: Weidenfeld and Nicolson, 1957.

———. *Talking About Fashion.* New York: Putnam, 1954.

"Donatella Versace." From Wikipedia, the Free Encyclopedia. http:// en.wikipedia.org/wiki/Donatella_Versace [accessed 12 May 2006].

Duras, Marguerite. *Yves St. Laurent: Images of Design 1958–1988.* New York: Alfred Knopf, 1988.

"Elsa Schiaparelli." From Wikipedia, the Free Encyclopedia. http://en.wikipedia .org/wiki/Elsa_Schiaparelli [accessed 4 May 2006].

"Emanuel Ungaro." From Wikipedia, the Free Encyclopedia (redirected from Ungaro). http://en.wikipedia.org/wiki/Ungaro [accessed 10 May 2006].

"Emilio Pucci." From Wikipedia, the Free Encyclopedia. http://en.wikipedia .org/wiki/Pucci [accessed 27 April 2006].

"Ermenegildo Zegna." From Wikipedia, the Free Encyclopedia (redirected from Zegna). http://en.wikipedia.org/wiki/Pucci [accessed 12 May 2006].

Etherington-Smith, Meredith. *Patou*. London: Hutchinson, 1984.

Fallon, James. "Alexander McQueen." *Women's Wear Daily*, 5 June 2001.

———. "Burberry Picks Bailey as Design Director." *Daily News Record*, 4 May 2001.

———. "McQueen's New Deal." *Women's Wear Daily*, 23 February 2001.

———. "Deal for Church Uncovers Prada." *Women's Wear Daily*, 15 October 1999.

———. "Prorsum from Burberry." *Daily News Record*, 21 June 1999.

———. "McQueen Signs Pact with Gibo." *Women's Wear Daily*, 14 May 1996.

———. "UK Designer Jean Muir Dead at 66." *Women's Wear Daily*, 30 May 1995.

"Fashion Remains a Family Affair at Sonia Rykiel." *Agence France Presse*, 23 September 2004.

Foley, Bridget. "YSL Bows Out." *W*, March 2002.

Forden, Sara Gay. "Missoni: Passing the Torch." *Women's Wear Daily*, 30 July 1997.

Frankel, Susannah. "Bailey's Dream." *Independent* (London), 5 December 2004.

Frey, Nadine. "Robert Ricci Dead at 83." *Women's Wear Daily*, 10 August 1988.

Giroud, Francoise, and Sacha Van Dorssen. *Dior: Christian Dior*. London: Thames and Hudson, 1987.

Greene, Lucie. "Queen's Honor for Punk Princess." *Women's Wear Daily*, 4 January 2006.

Guillame, Valérie. *Courrèges*. London: Thames and Hudson, 1998.

———. *Jacques Fath*. Paris: Editions Paris-Musées, 1993.

Haedrich, Marcel. *Coco Channel: Her Life, Her Secrets*. London: Robert Hale, 1972.

Harper's Bazaar, June 2005. "What Hubert de Givenchy Can Teach You About Fashion." www.highbeam.com/library/doc3.asp?DOCID=1G1:132968734a ndnum=6andctrlInfo= [accessed 26 May 2006].

Hayes, David. "Guess Who's Coming for Dinner with Viktor and Rolf." *Evening Standard* (London), 28 February 2006.

"The History of Prada." www.lifeinitaly.com/fashion/prada.asp [accessed 24 April 2006].

"Jean Muir to Open Free Standing Shop." *Women's Wear Daily*, 7 June 1990.

Kaiser, Amanda. "Another Deal for Prada: Sale of Helmut Lang Brand Imminent." *Women's Wear Daily*, 1 March 2006.

———. "Benetton at Forty: Challenges and Change." *Women's Wear Daily*, 16 May 2005.

———. "Benetton's Transformation." *Women's Wear Daily*, 11 December 2003.

Kaplan, Fred. "Gucci America Taps President." *Women's Wear Daily*, 11 January 2006.

Karimzadeh, Marc. "Westwood Plots U.S. Return." *Women's Wear Daily*, 16 March 2006.

Keenan, B. *Dior in Vogue*. London and New York: 1981.

Kirke, Betty. *Madeleine Vionnet*. San Francisco, Calif.: Chronicle, 1998.

Kletter, Melanie. "Emilio Pucci Returns to Ski Roots." *Women's Wear Daily*, 20 October 2004.

Krell, Gene. *Vivienne Westwood*. London: Thames and Hudson, and New York: Universe, 1997.

Lacroix, Christian. *Pieces of a Pattern: Lacroix by Lacroix*. London: Thames and Hudson, 1992.

"Lacroix: The New Paris Star." *Women's Wear Daily*, 31 July 1986.

Leymarie, J. *Chanel*. New York: Skira/Rizzoli, 1987.

Llari, Alessandra. "Missioni's Golden Moment." *Women's Wear Daily*, 22 September 2003.

———. "Biagiotti's Little Girl Luxe." *Women's Wear Daily*, 30 December 2002.

———. "Marzotto and Valentino Team Up at Last, But What Comes Now?" *Women's Wear Daily*, 28 March 2002.

———. "Marni's Controlling Interest." *Women's Wear Daily*, 2 October 2000.

Lockwood, Lisa. "Valentino's Full-Court Press." *Women's Wear Daily*, 10 January 2005.

"Louis Vuitton." From Wikipedia, the Free Encyclopedia. http://en.wikipedia.org/wii/Louis_vuitton [accessed 12 May 2006].

"LVMH Moët Hennessy Louis Vuitton S.A." From Wikipedia, the Free Encyclopedia. http://en.wikipedia.org/wiki/LVMH [accessed 20 May 2006].

Madsen, Axel. *Chanel: A Woman of Her Own*. New York: Henry Holt, 1990.

———. *The Yves Saint Laurent Story*. New York: Delacorte, 1979.

"Marni." www.marni.com/ [accessed 1 April 2006].

Maurois, Patrick. *Sonia Rykiel*. Paris: Assouline, 1997.

Menkes, Suzy. "Lacroix's Arriverderci to Pucci." *International Herald Tribune*, 28 September 2005.

Moore, Allison. "The YSL Revolution." *Harper's Bazaar*, September 1994.

Morais, Richard. *Pierre Cardin: The Man Who Became a Label.* London: Bantam, 1991.

Morand, Paul. *L'Allure de Chanel.* Paris: Hermann, 1976.

Morrison, Jenny. "Dedicated to Followers of High Fashion: Priceless Personal Collection of Designer Jean Muir is Given to National Museum of Scotland." *Daily Mail* (London), 12 February 2006.

Mower, Sara. "Hubert de Givenchy." *Harper's Bazaar,* December 1995.

"Muir's Name Lives on in Boutique." *Journal Newcastle* (England), 1 September 2004.

Murphy, Robert. "Pierre Cardin Museum Chronicles a Legend." *Women's Wear Daily,* 15 November 2006.

———. "Lagerfeld Gets Behind Apax-Hilfiger Deal." *Women's Wear Daily,* 29 December 2005.

———. "The Evolution of Ungaro." *W,* January 2002.

"Nina Ricci Plans Runway Return." *Women's Wear Daily,* 24 May 2002.

"Nino Cerrutti." From History of Fashion and Costume. www.designerhistory .com/historyofashion/cerruti.html [accessed 16 December 2006].

"Nino Cerrutti Biography." From Infomat Fashion Industry Search Engine. www.infomat.com/whoswho/ninocerrutti.html [accessed 16 December 2006].

"Paco Rabanne." From Sixties Central. 1 June 2003. www.geocities.com/Fashion Avenue/Catwalk/1038/rabanne.html?200627 [accessed April 27, 2006].

"Paco Rabanne." From Wikipedia, the Free Encyclopedia. http://en.wikipedia .org/wiki/Paco_Rabanne [accessed 27 April 2006].

Palmer, White Jack. *Elsa Schiaparelli.* London: Aurum, 1986.

———. *Poiret.* London: Studio Vista, 1973.

"Patou Aims for Younger Set this Spring with Enjoy." *Women's Wear Daily,* 17 January 2003.

"Patou Judgment Goes Against Gaultier." *Women's Wear Daily,* 30 November 1994.

"Paul Poiret." From Wikipedia, the Free Encyclopedia. http://en.wikipedia .org/wiki/Paul_Poiret [accessed 23 April 2006].

"Paul Smith (fashion designer)." From Wikipedia, the Free Encyclopedia. http://en.wikipedia.org/wiki/Sir_Paul_Smith [accessed 5 May 2006].

Pelle, Marie-Paule, and Patrick Mauriés. *Valentino: Thirty Years of Magic.* New York: Abbeville, 1990.

Plunket, Robert. "In the Bag: Once You Fall for Louis Vuitton, You Know It's Forever." *Sarasota,* February 2006.

Pochna, Marie-France. *Christian Dior.* Paris: Flammarion, 1994.

Poiret, Paul. *King of Fashion: The Autobiography of Paul Poiret.* Philadelphia: J. B. Lippincott, 1931.

———. *My First Fifty Years.* London: Victor Gollancz, 1931.

"PPR (company)." From Wikipedia, the Free Encyclopedia. http://en.wikipedia .org/wiki/Pinault-Printemps-Redoute [accessed 23 April 2006].

"PPR." www.ppr.com/front_sectionId-49_Changelang-en.html [accessed 23 April 2006].

"Prada." *Fashion Monitor* (Toronto). www.toronto.fashion-monitor.com /designers.php/prada [accessed 24 April 2006].

"Prada." From Wikipedia, the Free Encyclopedia. http://en.wikipedia.org/wiki /Prada [accessed 24 April 2006].

Quant, Mary. *Colour by Quant.* London: Octopus, 1984.

———. *Quant by Quant.* New York: Putnam, 1966.

Raper, Sarah. "Nina Ricci: Staying Family Affair." *Women's Wear Daily,* 20 July 1992.

Rhodes, Zandra, and Anne Knight. *The Art of Zandra Rhodes.* London: Jonathan Cape, 1984.

Riley, Robert. *Givenchy: Thirty Years.* New York: Fashion Institute of Technology, 1982.

Ronnick, Michele Valerie. "Versace's Medusa." *Helios,* 22 September 2005.

Ross, Lillian. "Coco Chanel." *New Yorker,* 7 November 1994.

Rushton, Susie. "Muir's Successors Serve up Sugary Confection." *Independent,* (London), 24 September 2004.

Rykiel, Sonia. *Rykiel.* Paris: Herscher, 1985.

———. *Et je la voudrais nue. . . .* Paris: Bernard Grasset, 1979.

Saint Laurent, Yves. *Yves St. Laurent.* New York: Metropolitan Museum of Art and Clarkson N. Potter, 1983.

Sanderson, Elizabeth, and Gill Martin. "Fashion King of Outrage, Alexander McQueen." *Daily Mail* (London), 7 January 2001.

Sauer, Georgia. "Isaac Mizrahi Unzips His New Line." *St. Louis Post-Dispatch,* 14 January 1996.

Saunders, Edith. *The Age of Worth, Couturier to the Empress Eugénie.* Bloomington: Indiana University Press, 1955.

Schiaparelli, E. *Sourcing without Surprises.* Arlington, Va.: American Apparel Manufacturers Association, 1998.

Schiaparelli, Elsa. *Shocking Life.* London: J.M. Dent, 1954.

Seckler, Valerie. "Benetton's Global Game Plan." *Women's Wear Daily,* 1 July 1999.

Sharkey, Alix. "Elsa Schiaparelli Didn't Know One End of a Tape Measure from the Other." *Independent* (London), 13 March 2004.

Sirop, Dominique. *Paquin.* Paris: Adam Biro, 1989.

Socha, Miles. "Galliano Unveils Name of New Line." *Women's Wear Daily,* 1 June 2006.

———. "Arnault Lauds Brands at LVMH Annual." *Women's Wear Daily,* 12 May 2006.

————. "Lacroix's Friendly Skies." *Women's Wear Daily*, 13 April 2005.

————. "Museum Quality: Mona Lisa, Move Over, Viktor and Rolf is at the Louvre, Part of a New Craze for Fashion at Museums." *W*, November 2003.

————. "Ungaro's Vision of Fuchsia." *Women's Wear Daily*, 20 August 2002.

————. "Thierry Mugler on the Move." *Women's Wear Daily*, 26 February 2001.

————. "The Versace Legacy: Bold and Baroque; the Designer Built a $1 Billion Fashion Empire." *Daily News Record*, 16 July 1997.

"Sonia Rykiel." From Wikipedia, the Free Encyclopedia. http://en.wikipedia.org/wiki/Sonia_Rykiel [accessed 3 May 2006].

Spindler, Amy M. "Galliano Is Named Designer For House of Givenchy." *New York Times*, 12 July 1995.

————. *"Chanel's Message: Dress to Seduce."* *New York Times*, 18 October 1994.

————. "Ungaro's Latest: His Own Boutique." *New York Times*, 13 September 1994.

————. "Valentino." *Daily News Record*, 13 July 1992.

Teboul, David. *Yves St. Laurent: 5 Avenue Marceau, 75116 Paris, France*. New York: Harry Abrams, 2002.

Thierry Mugler: Photographer. London: Thames and Hudson, 1988.

Thim, Dennis. "Valentino to Show Couture in Paris." *Women's Wear Daily*, 16 January 1989.

————. "Patou Suing Lacroix, Agache for $14M." *Women's Wear Daily*, 24 February 1987.

Thomas, Dana. "YSL: The Man, the Myth, the Legend." *Harper's Bazaar*, March 2004.

Tournier, Michel. *Alaïa*. Steidl, 2000.

"Valentino." From Wikipedia, the Free Encyclopedia. http://en.wikipedia.org/wiki/Valentino [accessed 12 May 2006].

Van Dorssen, Sacha, and Giroud Francoise. *Dior*. Paris: Ëditions du Regard, 1987.

Vermorel, Fred. *Fashion and Perversity: A Life of Vivienne Westwood and the Sixties Laid Bare*. London: Bloomsbury, 1996.

"Versace." From Wikipedia, the Free Encyclopedia. http://en.wikipedia.org/wiki/Versace [accessed 12 May 2006].

"Vivienne Westwood." From Wikipedia, the Free Encyclopedia. http://en.wikipedia.org/wiki/Vivian_westwood [accessed 12 May 2006].

"Vivienne Westwood to Promote China Sales." *COMTEX, AsianInfo Services*, 14 June 2005.

Vreeland, Diana. *Yves Saint Laurent*. London: Thames and Hudson, 1984.

Weil, Jennifer. "Thierry Mugler: Angels to Aliens." *Women's Wear Daily*, 27 May 2005.

"Who's Who Miuccia Prada." *Vogue*, www.Vogue.co.uk/whos_who/Miuccia _Prada/ [accessed 24 April 2006].

Wilson, Eric. "Viktor and Rolf to ICB." *Women's Wear Daily*, 5 September 2001.

The World of Balenciaga. Metropolitan Museum of Art Exhibition Catalog, 1973.

Yves Saint Laurent: Images of Design 1958–1988. New York: Alfred A. Knopf, 1988.

"Yves Saint-Laurent." From Wikipedia, the Free Encyclopedia. http:// en.wikipedia.org/wiki/Yves_Saint_Laurent [accessed 3 May 2006].

"Zandra Rhodes." Wikipedia, the Free Encyclopedia. http://en.wikipedia.org/ wiki/Zandra_Rhodes [accessed 27 April 2006].

Zargani, Luisa. "M Missoni on Growth Track." *Women's Wear Daily*, 30 January 2006.

———. "Viktor and Rolf Turn Retailing on Its Head." *Women's Wear Daily*, 8 April 2005.

———. "The Good Humor Man." *Women's Wear Daily*, 9 April 2003.

4. Latin

Zaretskaya, Olga. "Oscar de la Renta a Hit in Moscow." *Women's Wear Daily*, 28 December 2005.

E. BUSINESS

1. Education, Training, and Careers

Diamond, Jay, and Ellen Diamond. *The World of Fashion.* 3rd ed. New York: Fairchild, 2002.

———. *Fashion Advertising and Promotion.* New York: Fairchild, 1999.

Dickerson, Kitty G. *Inside the Fashion Business.* 7th ed. Upper Saddle River, N.J.: Pearson Education, 2003.

Dolber, R. *Opportunities in Fashion Careers.* Lincolnwood, Ill.: NTC, 1993.

"Frank Alvah Parsons Collection." www.newschool.edu/library/parcoll.htm [accessed 16 November 2004].

Goworek, Helen. *Careers in Fashion and Textiles.* Oxford, U.K.: Blackwell Publishing, 2006.

Johnson, Maurice J., and Evelyn C. Moore. *So You Want to Work in the Fashion Business?* Englewood Cliffs, N.J.: Prentice Hall, 1998.

Jones, Sue Jenkyn. *Fashion Design*. New York: Watson-Guptill, 2002.

McDermott, Irene E., and Jeanne L. Norris. *Opportunities in Clothing*. Peoria, Ill: Charles A. Bennett, 1968, 1972.

Mittelhauser, Mark. "Job Loss and Survival Strategies in the Textile and Apparel Industries." *Occupational Outlook Quarterly*, vol. 40, no. 3 (Fall 1996): 18–27.

"Parsons: The New School for Design." From Wikipedia, the Free Encyclopedia. http://en.wikipedia.org/wiki/Parsons_The_New_School for _Design [accessed 14 April 2006].

Perna, R. *Fashion Forecasting*. New York: Fairchild, 1987.

Terzian, Makrouhi. *Understanding Fashion Design*. Lexington, Mass.: Marca, 2003.

2. Production

Balkwell, C., and K. Dickerson. "Apparel Production in the Caribbean: A Classic Case of the New International Division of Labor." *Clothing and Textiles Research Journal*, vol. 12, no. 3 (1994): 6–15.

Benaim, Laurence. *L'Année de la mode 1988–89*. Paris: La Manufacture, 1989.

———. *L'Année de la Mode 1987–88*. Paris: La Manufacture, 1988.

Bonacich, E., et al., eds. *Global Production: The Apparel Industry in the Pacific Rim*. Philadelphia: Temple University Press, 1994.

Brand, Madeleine. "Profile: Fashion Industry Responds to a Heavier American Public with Plus-Size Clothing Market." *National Public Radio*, 8 July 2004.

Des Marteau, K. "Labor Conditions—Not Someone Else's Problem." *Bobbin*, August 2000.

Dickerson, K., C. Hooper, and R. Boyle. "A New Approach for Manufacturers." *America's Textiles International* 1995: 28–32.

Durack, Katherine T. "Patterns for Success: A Lesson in Usable Design from U.S. Patent Records." *Technical Communication*, 1 February 1997.

Egan, S., and D. Steinhoff. "China's WTO Entry: Who Wins? Who Loses?" *Apparel Industry Magazine*, March 2000: 8–10.

"Eli Whitney." From Wikipedia, the Free Encyclopedia. http://en.wikipedia .org/wiki/Eli_Whitney [accessed 12 May 2006].

Ellis Kristi. "Safeguard Showdown." "CAFTA Date Passes without Implementation." *Financial News*, 9 January 2006.

———. "CAFTA Progress Seen." *Women's Wear Daily*, 14 April 2005.

———. "Industry Job Losses Mount." *Women's Wear Daily*, 7 March 2005.

———. *Women's Wear Daily*, 28 September 2004.

Everett, J., and K. Swanson. *Guide to Producing a Fashion Show*. New York: Fairchild, 1995.

"Exports: Finding the Funding." *Women's Wear Daily*, 1994.

"Fair Labor Standards Act." From Wikipedia, the Free Encyclopedia. http://en.wikipedia.org/wiki/Fair_Labor_Standards_Act [accessed 7 June 2006].

Fashiondex. *The Apparel Design and Production Handbook*. New York: Fashiondex, 2004.

Gash, Barbara. "Turning Points in Sewing History." *Knight Ridder Tribune*, 30 December 1999.

Gruau, Francois-Marie. *Les Industries de l'habillement*. Paris: PUF, Que Sais-Je? Collection, 1996.

Grunwald, J., and K. Flamm. *The Global Factory*. Washington, D.C.: The Brookings Institution, 1985.

Hines, J., and G. O'Neal. "Underlying Determinants of Clothing Quality: The Consumers' Perspective." *Clothing and Textiles Research Journal*, vol. 13, no. 4 (1995): 227–33.

"K2 Inc. Announces Closing the Acquisition of Marmot Mountain and the Closing of Three Financing Transactions." *Business Wire*, 1 July 2004.

Kessler, J. "New NAFTA Alliances Reshape Sourcing Scene." *Bobbin*, November 1999: 54–62.

Kidwell, Claudia Brush. *Cutting a Fashionable Fit: Dressmakers' Drafting Systems in the United States*. Washington, D.C.: Smithsonian Institution Press, 1979.

Kincaid, D. "Quick Response Management System for the Apparel Industry: Definition through Technologies." *Clothing and Textiles Research Journal*, vol. 13, no. 4: 245–51.

Kopp, E., et al. *Designing Apparel Through the Flat Pattern*. 6th ed. New York: Fairchild, 1992.

Kotler, P., and G. Armstrong. *Principles of Marketing*. 6th ed. Upper Saddle River, N.J.: Merrill/Prentice Hall, 1994.

Kunz, G. *Merchandising: Theory, Principles, and Practice*. New York: Fairchild, 1998.

Kurt Salmon Associates. *Vision for the New Millennium . . . Evolving to Consumer Response*. New York, 1995.

Levaux, J. "Adapting Products and Services for Global Commerce." *World Trade*, January 2001: 52–54.

Morgan, C., and D. Levy. *Segmenting the Mature Market*. Chicago: Probus, 1993.

Murphy, Robert. "Carrefour Profits Fall 15.6 Percent." *Women's Wear Daily*, 10 March 2006.

———. "Taking the Driver's Seat: Francois-Henri Pinault Claims CEO Slot at PPR." *Women's Wear Daily*, 3 February 2005.

———. "Global Trade Boost PPR Sales 4.8% in Quarter." *Women's Wear Daily*, 20 October 2004.

———. "Europe's Measured Approach." *Women's Wear Daily*, 28 September 2004.

———. "Mizrahi Sues Chanel." *Women's Wear Daily*, 18 July 2002.

Nystrom, P. *Economics of Consumption*. New York: Ronald, 1929.

Ostroff, J. "U.S.-Canada Free Trade Pact Great for Friends, Not for Foes." *Women's Wear Daily*, 21 August 1995.

"P and G Transforms." *Women's Wear Daily*, 15 February 2005.

Porter, M. *Competitive Advantage of Nations*. New York: Free Press, 1990.

Rundles, J. "Made to Order Heralds an Industry Revolution." *Wearables Business*, January 2000.

"Sportswear and Jean Guru Arnold Simon Signs Licensing Agreement with Rap Mogul and Phat Farm Founder Russell Simmons." *Business Wire*, 9 August 1999.

Steele, P. *Hong Kong Clothing: Waiting for China*. London: The Economist Intelligence Unit, 1990.

———. *The Caribbean Clothing Industry: The U.S. and Far East Connections*. London: The Economist Intelligence Unit, 1988.

"Sweatshop." From Wikipedia, the Free Encyclopedia. http://en.wikipedia.org/wiki/sweatshop [accessed 9 June 2006].

"U.S. Department of Labor." From Wikipedia, the Free Encyclopedia. http://en.wikipedia.org/wiki/U.S._Department_of_Labor [accessed 7 June 2006].

U.S. Executive Office of the President, Office of Management and Budget. *Standard Industrial Classification Manual*. Washington, D.C., 1987.

"U.S. Makers Told to Jump on Export Biz." *Daily News Record*, 1987. www.highbeam.com/library/doc3.asp?DOCID=1G1:5214954andnum=12anDCtrlInfo [accessed 12 November 2005].

"Waterford Wedgwood USA, Inc. Expands Global Tabletop License with Vera Wang," *PR Newswire*, 9 May 2006.

Weil, Jennifer. "Angel Still Soars." *Women's Wear Daily*, 21 January 2003.

Weinstein, A. *Market Segmentation*. Chicago: Probus, 1994.

Weisman, K. "Interstoff to Split Shows." *Women's Wear Daily*, 12 September 1995.

Young, V., and V. Seckler. "House Gets Bankruptcy Bill." *Women's Wear Daily*, 4 February 1998.

3. Retail/Merchandising

"Amazon Services and Diane Von Furstenberg Studio Announce E-Commerce Alliance for Online Apparel Offering." *Business Wire*, 18 January 2005.

American Apparel Manufacturers Association (annual, 1987–2001). "Focus: Economic Profile of the Apparel Industry." Arlington, Va.

Anderson, W. "Retailing in the Year 2000: Quixotic Consumers? Exotic Markets? Neurotic Retailers?" In *The Future of U.S. Retailing: An Agenda for the Twenty-First Century*, ed. R. A. Peterson. New York: Quorum Books, 1992: 27–84.

Anthony, Clifford. "J.C. Penney Workers Still Follow Founding Philosophy." www.highbeam.com/library/doc3.asp?DOCID=1G1:120429220and num=3anDCtrlInfo [accessed 26 May 2006].

Baker, S., and K. Baker. *Desktop Direct Marketing*. Hightstown, N.J.: McGraw-Hill, 1995.

Barrett, J. "Market Research Wins in the Marketplace." *Textile World*, October 1999: 57–61.

Bendersky, Ari. "Isaac Hits the Target." *Advocate*, 2 September 2003.

Bird, L. "Department Stores Target Top Customers." *Wall Street Journal*, March 1995: B1, B4, 8.

Boutilier, R. *Targeting Families: Marketing To and Through the New Family*. Ithaca, N.Y.: American Demographics, 1993.

Buckner, Michael. "Grand Opening of Marni's Los Angeles Boutique— Inside." Getty Images, 22 March 2005.

Burns, L. D., and N. O. Bryant. *The Business of Fashion*. 2nd ed. New York: Fairchild, 2002.

———. *The Business of Fashion*. New York: Fairchild Publications, 1999.

Butler, Elisabeth. "Wal-Mart Tags Designers." *Crain's NY Business*, 6 February 2006.

Canadian Corporate News. "Spartacus Capital Announces Fashion Addition— The West's Largest Plus-Size Women's Clothing and Accessory Retailer Joins." 14 March 2000.

"Caribbean High Tech Dreams." *Business Week*, 14 August 2000: 38.

"Carrefour." From Wikipedia, the Free Encyclopedia. http://en.wikipedia.org /wiki/Carrefour [accessed 7 May 2006].

Carter, Ernestine. "Knockoffs' Suburban Sprawl Worries Vendors." *Women's Wear Daily*, 5 December 2005.

———. "Origins of Factoring Come Full Circle." *Women's Wear Daily*, 19 September 2005.

Celente, G., and T. Milton. *Trend Tracking*. New York: Warner, 1991.

Clark, Evan. "Kellwood's New Beat: Apparel Giant Snaps Up Phat Fashions." *Women's Wear Daily*, 9 January 2004.

Conti, Samantha. "Itochu Buys a 40% Stake in Paul Smith." *Women's Wear Daily*, 6 February 2006.

———. "Valentino Said to Be Exploring a Buyback of House from HDP." *Women's Wear Daily*, 18 April 2001.

————. "Zegna Focusing on Small Details to Woo, Win Customers." *Daily News Record*, 20 June 1997.

Corcoran, Cate. "Wal-Mart's Mandate." *Women's Wear Daily*, 12 January 2005.

Courter, E. "Dressing Down Drives Some Stores Out of Biz." *Daily News Record*, 1 March 1995.

"Department Store." From Wikipedia, the Free Encyclopedia. http://en.wikipedia.org/wiki/Department_Stores [accessed 3 June 2006].

Derby, Meredith. "March Same-Store Sales." *Women's Wear Daily*, 7 April 2006.

D'Innocenzio, Anne. "Private Label Powers Up." *Women's Wear Daily*, 30 March 1995.

Dunn, Brian. "Gildan Activewear Plots Expansion." *Women's Wear Daily*, 2 March 2006.

Edelson, Sharon. "Anthropologie's Rock Center Debut." *Women's Wear Daily*, 5 May 2006.

Feather, F. *The Future Consumer*. Buffalo, N.Y.: Warwick, 1994.

"Federated Might Scale Down Land." *Women's Wear Daily*, 11 January 2006.

Feitelberg, Rosemary. "Target Sets Up Camp at Cooper-Hewitt." *Women's Wear Daily*, 4 April 2006.

Frings, Gini Stephens. *Fashion: From Concept to Consumer*. 7th ed. Englewood Cliffs, N.J.: Prentice Hall, 2002.

Gale, B. *Managing Customer Value*. New York: Free Press, 1994.

Gellers, Stan. "Better Private Label." *Daily News Record*, 1 October 1997.

Greenberg, Julee. "The Change Agent." *Women's Wear Daily*, 27 March 2006.

————. "Claiborne's Expansion Heads for Middle East." *Women's Wear Daily*, 7 February 2006.

————. "Boneparth: Product Is King in '06." *Women's Wear Daily*, 7 December 2005.

"Federated Closes the Deal." *Home Textiles Today*, 5 September 2005.

"Hoovers." www.hoovers.com/barneys/—ID_43296—/free-co-factsheet.xhtml [accessed 27 November 2005].

Hughes, A. *Strategic Database Marketing*. Chicago: Probus, 1994.

————. *The Complete Database Marketer*. Chicago: Probus, 1991.

"Industries." Occupational Outlook Quarterly, 22 September 1996. www.highbeam.com/library/docfreeprint.asp?docid=1G1:18928220anDCtrlInfo=Rou [accessed 12 November 2005].

Jerigan, Marian H., and Cynthia Easterling. *Fashion Merchandising and Marketing*. New York: MacMillian Publishing Co., 1997.

Leeming, E., and C. Trip. *Segmenting the Women's Market: Using Niche Marketing to Understand and Meet the Diverse Needs*. Chicago: Probus, 1994.

Levy, Melissa. "Field's Launches 'Private Labels.'" *Star Tribune* (Minneapolis), 13 March 2004.

"Macy's." From Wikipedia, the Free Encyclopedia. http://en.wikipedia.org /wiki/Macy%E2%80%99s [accessed 27 April 2006].

Mallory, C. *Direct Mail Magic*. Menlo Park, CA: Crisp, 1991.

Mallory, M., and S. Forest. "Waking Up to a Major Market." *Business Week*, 23 March 1992: 70–71.

"May Department Stores." From Wikipedia, the Free Encyclopedia. http:// en.wikipedia.org/wiki/May_Department_Stores_Company [accessed 1 April 2006].

"May Department Stores Company." www.scripophily.net/mayecomdepsto .html [accessed 1 April 2006].

"The May Department Stores Company Announces Intent to Divest Thirty-two Lord & Taylor Stores as Part of Its Strategic Repositioning." *PR Newswire*, 30 July 2003.

"The May Department Stores Company Report Twenty-five of Thirty-two Planned Lord & Taylor Store Closings are Complete." *PR Newswire*, 4 January 2005.

"The May Department Stores Company to Acquire All Thirteen Strawbridge and Clothier Department Stores." *PR Newswire*, 4 April 1996.

"May Department Stores Company to Invest $3.4 Billion to Open 100 New Stores." *PR Newswire*, 23 May 1997.

McKendrick, Neil, et al. *The Birth of a Consumer Society*. Bloomington: Indiana University Press, 1982: 43–46.

Mergenhagen, P. *Targeting Transitions: Marketing to Consumers During Life Changes*. Ithaca, N.Y.: American Demographics, 1994.

Meyers, G. *Targeting the New Professional Woman: How to Market and Sell to Today's 57 Million Working Women*. Chicago: Probus, 1993.

"Michael Kors Announces License Agreement with Warnaco." *PR Newswire*, 21 June 2004.

Millstein, Marc. "Banking on Optimization." *Women's Wear Daily*, 12 January 2005.

"Minimum Wage." From Wikipedia, the Free Encyclopedia. http://en.wikipedia .org/wiki/Minimum_wage [accessed 7 June 2006].

Moen, David. "Deborah Fine Exits Pink." *Women's Wear Daily*, 16 March 2006.

———. "Federated to Sell 10 Units to Boscov's." *Women's Wear Daily*, 7 February 2006.

———. "Big, Bigger, Biggest: More Retail Mergers Seen in Mega Era." *Women's Wear Daily*, 1 December 2004.

"Montgomery Ward." From Wikipedia, the Free Encyclopedia. http:// en.wikipedia.org/wiki/Montgomery_Ward [accessed 6 April 2006].

Mowen, J. *Consumer Behavior*. 4th ed. Upper Saddle River, N.J.: Merrill/Prentice Hall, 1992.

"Muir Plans Shop in San Francisco." *Women's Wear Daily*, 29 October 1986.

Nash, Elizabeth. "Focus: Zara Gives Style to the Public." *Independent* (London), 23 May 2001.

"Neiman Marcus." Company Overview. www.neimanmarcus.com/store/service /company_overview.jhtml:jsessionid=D15RK [accessed 15 April 2006].

"Neiman Marcus." The Handbook of Texas Online. www.tsha.utexas.edu/ handbook/online/articles/NN/dhn1.html [accessed 15 April 2006].

"Neiman Marcus." From Wikipedia, the Free Encyclopedia. http://en.wikipedia .org/wiki/Neiman_Marcus [accessed 14 April 2006].

"Nordstrom." From Wikipedia, the Free Encyclopedia. http://en.wikipedia .org/wiki/Nordstrom [accessed 14 April 2006].

Pegler, Martin M. *Visual Merchandising and Display*. 4th ed. New York: Fairchild, 1998.

Peterson, R. "A Context for Retailing Predictions," in *The Future of U.S. Retailing: An Agenda for the 21st Century*. Ed. R. A. Peterson. New York: Quorum, 1991, 1–25.

Phillips, S., et al. "King Customer." *Business Week*, 12 March 1990.

"Ready-to-Wear." From Wikipedia, the Free Encyclopedia. http://en.wikipedia .org/wiki/Ready-to-wear (accessed 27 April 2006).

"The Rise and Fall of Montgomery Ward." *Bellingham Business Journal*, 1 December 2001.

Rossman, M. *Multicultural Marketing: Selling to a Diverse America*. Saranac Lake, N.Y.: AMACOM Books, 1994.

"Saks Fifth Avenue." From Wikipedia, the Free Encyclopedia. http:// en.wikipedia.org/wiki/Saks_Fifth_Avenue [accessed 3 March 2007].

"Saks Fifth Avenue: About Us." www.saksincorportated.com/aboutus/ [accessed 3 March 2007].

"Saks Fifth Avenue Unveils WANT IT." *PR Newswire*, 5 September 2006.

"Sears History—1890s; Early 1900s; 1925; 1930; 1940s to 1970s; 1980s to Today." www.searsarchives.com/history/history1890s.htm [accessed 4 May 2006].

"Sears, Roebuck and Company." From Wikipedia, the Free Encyclopedia. http://en.wikipedia.org/wiki/Sears_Roebuck_%26_Co [accessed 4 May 2006].

"Store Brand." From Wikipedia, the Free Encyclopedia. http://en.wikipedia .org/wiki/Private_label_brand [accessed 26 April 2006].

"Topshop Kisses Kate: U.K. Retailer to Launch Fashion Line by Moss." *Women's Wear Daily*, 20 September 2006.

Underhill, P. *Why We Buy: The Science of Shopping*. New York: Simon & Schuster, 1999.

Vavra, T. *After-Marketing: How to Keep Customers for Life Through Relationship Marketing*. Burr Ridge, Ill.: Irwin Professional, 1992.

Visual Merchandising and Store Design. Great Retail Displays. Rockport, Mass.: Rockport, 1995.

Visual Merchandising and Store Design. Great Store Design. Rockport, Mass.: Rockport, 1994.

Winters, A., and S. Goodman. *Fashion Advertising and Promotion*. New York: Fairchild, 1984.

Winters, A., and S. Milton. *The Creative Connection: Advertising Copywriting and Idea Visualization*. New York: Fairchild, 1982.

"Zara." www.zara.com/v06/index.html [accessed 4 June 2006].

"Zara (clothing)." From Wikipedia, the Free Encyclopedia. http://en.wikipedia.org/wiki/Zara_%28clothing%29 [accessed 2 June 2006].

4. Technology

"About Gerber Technology." Gerbertechnology.com. www.gerbertechnology.com/downloads/pdf/html/1view/index.asp?name=FastFacts06HiRes[accessed 3 March 2007].

"About Lectra." Lectra.com. www.lectra.com/en/index.html [accessed 3 March 2007].

"Archetype Solutions, Inc. Announces Issuance of Patent Relating to the Custom-made Fitting of Apparel." Archetype. www.archetypesolutions.com/index.cfm?fuseaction=news.showarticleandarticle=new [accessed 2 November 2005].

Bellis, Mary. "Vinyl Invention Waldo L. Semon." www.inventors.about.com/library/inventors/blpvc.htm [accessed 11 March 2006].

"Body Type." From Wikipedia, the Free Encyclopedia. http://en.wikipedia.org/wiki/Body_type [accessed 16 December 2006].

Bowers, Katherine. "DVF Relaunches Site, Gets Ready for E-Tail." *Women's Wear Daily*, 29 September 2000.

Cooklin, G. *Pattern Grading for Men's Clothes: The Technology of Sizing*. London: Blackwell Science, 1992.

Coper, Grace Rogers. *The Sewing Machine: Its Invention and Development*, 2nd ed. Washington, D.C.: Smithsonian Institution Press for the National Museum of History and Technology, Smithsonian Institution, 1976.

Corcoran, Cate. "Future Tech: More Connected." *Women's Wear Daily*, 7 September 2005.

———. "Tech Revs Up Warehouse OP." *Women's Wear Daily*, 10 August 2005.

———. "Rocket Science? Not Quite Yet." *Women's Wear Daily*, 15 June 2005.

———. "The 2nd Coming of E-Commerce." *Women's Wear Daily*, 1 September 2004.

Donnellan, J. *Merchandise Buying and Management*. New York: Fairchild, 1996.

"Elliot Abravanel." From Wikipedia, the Free Encyclopedia. http://en.wikipedia .org/wiki/Elliot_Abravanel [accessed 16 December 2006].

Godfrey, Frank P. *An International History of the Sewing Machine*. London: Robert Hale, 1982.

"Isaac Singer." From Wikipedia, the Free Encyclopedia. http://en.wikipedia .org/wiki/Isaac_Singer [accessed 5 May 2006].

Levy, Clifford J. "Cyberflakes." *New York Times*, Styles, 20 February 1994.

Marsh, Emilie. "Scanning the Perfect Fit." *Women's Wear Daily*, 1 December 2005.

Romero, E. "Curtain Falls on NAMSB, Replaced by Vibe Style." *Daily News Record*, 22 July 1998.

"Sewing Machine." From Wikipedia, the Free Encyclopedia. http://en.wikipedia .org/wiki/History_of_the_sewing_machine [accessed 5 May 2006].

"Singer." www.singerco.com/company/history_pf.html [accessed 5 May 2006].

"Singer Corporation." From Wikipedia, the Free Encyclopedia. http:// en.wikipedia.org/wiki/Singer_Sewing_Machine_Company [accessed 5 May 2006].

"Zipper." From Wikipedia, the Free Encyclopedia. http://en.wikipedia.org /wiki/Zipper [accessed 2 June 2006].

F. RELATED AREAS

1. Advertising, Marketing, and Promotion

Agins, Teri. *The End of Fashion*. New York: William Morrow, 1999.

British Apparel and Textile Confederation. "TRENDATA: Key Statistics of the UK Apparel and Textile Industry." Executive Summary. Unpublished Report, 1999.

Cotto, William. "International Trade Show Calendar." *Women's Wear Daily*, 25 May 2005: 24–28.

"Cotton Incorporated." Company History. www.cottoninc.com/AboutCotton/ CompanyHistory/?S=AboutCottonandSort=0 [accessed 3 May 2006].

Easex, Mike. *Fashion Marketing*. 2nd ed. Oxford, U.K.: Blackwell Publishing, 2003.

Evans, C. *Marketing Channels: Infomercials and the Future of Televised Marketing*. Upper Saddle River, N.J.: Prentice Hall, 1993.

"Fashion Blog." From Wikipedia, the Free Encyclopedia. http://en.wikipedia.org/wiki/Fashion_blog [accessed 18 December 2006].

Giacomoni, Silvia. *L'Italia della Moda*. Milan: Mazzotta, 1984.

Gross, Michael. "Fashion Shows and Tell." *Town & Country*, November 1994.

"Group Pinault Printemps to Buy All of LeRedoute." *Women's Wear Daily*, 22 February 1994.

Groves, Ellen. "Fair Trade Fashion Takes Off in Europe." *Women's Wear Daily*, 3 May 2006.

Guber, S., and J. Berry. *Marketing To and Through Kids*. New York: McGraw-Hill, 1993.

Hales, Linda. "Surprises in Store: Architect Rem Koolhaas Redefined the Fashion Boutique for Prada." *Washington Post*, 29 December 2001.

Halkias, Maria. "Private Label Clothing Enhances Penney Profit." *Dallas Morning News* (via Knight-Ridder/Tribune Business News), 18 May 2005.

Hills, S. "I See a Tall, Dark Man in Wal-Mart, Looking for Wide-leg Jeans . . ." *Apparel Industry Magazine*, August 1998: 78–81.

Hirshlag, Jennifer. "Multicategory Master." *Women's Wear Daily*, 27 March 2006.

Wilson, Eric. "CFDA: And the Nominees Are . . ." *Women's Wear Daily*, 9 April 2002.

2. Associations, Organizations, and Trade Unions

Canadian Apparel Federation. "Canadian Apparel Federation." (information packet). Ottawa.

"CFDA Fashion Awards." From Council of Fashion Designers of America. www.cfda.com/flash.html [accessed 18 December 2006].

"The Confédération Française Démocratique du Travail." From Wikipedia, the Free Encyclopedia. http://en.wikipedia.org/wiki/Confédération_Française_Démocratique_du_Travail [accessed 16 December 2006].

"Confédération Générale du Travail." From Wikipedia, the Free Encyclopedia. http://en.wikipedia.org/wiki/Confédération_générale_du_travail [accessed 16 December 2006].

"The Costume Society." www.costumesociety.org.uk/newstuff/Links/links.html [accessed 12 November 2005].

"Fashion Show Schedule- Fédération Française de la Couture." From Mode à Paris. www.modeaparis.com/va/collections/index.html [accessed 17 December 2006].

"Fédération Française de la Couture." From Mode à Paris. www.modeaparis.com/va/toutsavoir/index.html [accessed 17 December 2006].

Fédération Francaise de la Couture de Prêt-à-Porter des Couturiers et des Createúrs de Mode. L' haute couture et le prêt-à-porter des couturiers et

des creatéurs de mode. (Unpublished informational piece, translated by L. Divita.)

"The FGI Mission, Goals and Foundation." From the Fashion Group International. www.fgi.org/index.php?news=645 [accessed 18 December 2006].

"Force Ouvrière." From Wikipedia, the Free Encyclopedia. http://en.wikipedia.org/wiki/Force_ouvrière [accessed 16 December 2006].

"Guild." From Wikipedia, the Free Encyclopedia. http://en.wikipedia.org/wiki/Guild [accessed 14 December 2006].

"The International Confederation of Free Trade Unions." From Wikipedia, the Free Encyclopedia. http://en.wikipedia.org/wiki/International_Confederation_of_Free_Trade_Unions [accessed 15 December 2006].

Kaplan, Fred. "Kolb Says CFDA Is a 'Dream Job.'" *Women's Wear Daily*, 7 December 2005.

"Night of Stars." From the Fashion Group International. www.fgi.org/index.php?news=507 [accessed 18 December 2006].

"Philanthropy." From Council of Fashion Designers of America. www.cfda.com/flash.html [accessed 18 December 2006].

Russell, J., ed. *National Trade and Professional Associations of the United States*. Washington, D.C.: Columbia University, Annual.

"Senate Approves Membership in Two Anti-Sweatshop Organizations." From Columbia University Record. www.columbia.edu/cu/record/archives/vol25/19/2519_CU_Sweatshop.html [accessed 15 December 2006].

"Socially Responsible Shopping and Action Guide." From Global Exchange. www.globalexchange.org/ [accessed 15 December 2006].

"Trade Union Congress." *Encyclopedia Britannica*. Premium Service. www.britannica.com/eb/article-9073141 [retrieved 19 July 2006].

Trade Unions of the World, 6th London, UK.: John Harper. ICTUR et al., 2005. www.wikipedia.org/wiki/CGIL [accessed 18 July 2006].

"Women's Trade Union League." *Encyclopedia Britannica*. Premium Service. www.britannica.com/eb/article-9125097 [retrieved 19 July 2006].

"The World Confederation of Labour." From Wikipedia, the Free Encyclopedia. http://en.wikipedia.org/wiki/World_Confederation_of_Labor [accessed 15 December 2006].

3. Beauty

Askin, Ellen. "Varvatos Launching Skin Care Line." *Daily News Record*, 23 August 2004.

Corbin, Alain. *The Foul and the Fragrant*. Cambridge, Mass.: Harvard University Press, 1986.

Costello, Brid. "McCartney's New Design: Skin Care." *Women's Wear Daily,* 10 November 2006.
————. "Thierry Mugler Fashions a Superhero of a Scent." *Women's Wear Daily,* 30 April 2004.
Costello, Brid, and Miles Socha. "Just Add Flower." *Women's Wear Daily,* 7 October 2004.
Fragrance and Fashion. New York: TODTRI Book Publishers, 2002.
"The French Brand Jean Patou Has Announced That the Fashion Side of Its Business is to Close—Though a Future Resurgence Has Not Been Ruled Out." *Cosmetics International,* 10 February 2002.
Friedman, Vanessa. "Beauty That Works." *Vogue,* August 1994.
Naughton, Julie. "DVF Beauty: Coming Around Again." *Women's Wear Daily,* 10 September 2004.
"Nina Ricci Flies High." *Cosmetics International,* 24 February 2006.
"Patou Latest Jus Inspired by India." *Cosmetics International,* 10 February 2006.
Pavia, Fabienne. *The World of Perfume.* New York: Knickerbocker Press, 1995.

4. Illustration

Baudot, Francois. *Gruau.* Paris: Assouline, 1998.
Brady, James. "Vet Who Brought Feisty Style to His Fashion Illustration." *Crain's New York Business,* 15 November 2004.
Bryant, Michele Wesen. *Women's Wear Daily Illustrated: 1960s–1990s.* New York: Fairchild, 2004.
Ginsburg, Madeleine. *An Introduction to Fashion Illustration.* London: Victoria and Albert Museum, 1980.
Horyn, Cathy. "Joe Eula, Seventy-nine, Fashion Illustrator with Joi de Vivre." *International Herald Tribune,* 29 October 2004.

5. Journalism

"Anna Wintour." Wikipedia, the Free Encyclopedia. http://en.wikipedia.org/wiki/Anna_Wintour [accessed 12 May 2006].
"Anna Wintour Gets Powdered at Fashion Week." *M2 Presswire,* 23 February 2006.
"Apparel and Fashion Journals and Magazines Throughout the World." From Penrose Press. www.penrose-press.com/idd/search_db.php?REGION=NONE&SUBJECT=SUB10006&TYPE=journal [accessed 11 August 2006].
Ballard, Bettina. *In My Fashion.* New York: David McKay, 1967.

"Conde Nast to Launch Teen *Vogue* in Spring 2003." *PR Newswire*, 6 June 2002.

"Diana Vreeland." From Wikipedia, the Free Encyclopedia. http://en.wikipedia.org/wiki/Diana_Vreeland [accessed 5 May 2006].

Dwight, Eleanor. *Diana Vreeland*. New York: HarperCollins, 2002.

"*Esquire* (Magazine)." From Wikipedia, the Free Encyclopedia. http://en.wikipedia.org/wiki/Esquire_magazine [accessed 11 December 2006].

"*GQ* (Magazine)." From Wikipedia, the Free Encyclopedia. http://en.wikipedia.org/wiki/GQ_magazine [accessed 11 December 2006].

"*Harper's Bazaar*." From Wikipedia, the Free Encyclopedia. http://en.wikipedia.org/wiki/Harper's_Bazaar [accessed 5 May 2006].

"Fashion and Beauty Magazines." www.dir.yahoo.com/Arts?Design_Arts/Fashion_and_Beauty/News_and_Media/Magazines/ [accessed 13 October 2005].

"Fashion Columnist Eugenia Sheppard Dead." *Women's Wear Daily*, 12 November 1984.

"Fashion Writing." www.middlebury.edu/okeefe/discuss/msgReader$44 [accessed 14 April 2006].

Jackson, Donald. *The Story of Writing*. London: Cassell, 1981.

Kelly, Kitty. *The Wonderful World of* Women's Wear Daily. New York: Saturday Review, 1972.

Larson, Christina. "From Venus to Minerva: Most Fashion Magazines Play on Women's Insecurities." *Washington Monthly*, April 2005.

"Mary Louise Booth." From Wikipedia, the Free Encyclopedia. http://en.wikipedia.org/wiki/Mary_Louise_Booth [accessed 5 May 2006].

Mirabella, Grace, with Judith Warner. *In and Out of Vogue*. New York: Doubleday, 1995.

Rowlands, Penelope. *Bazaar Life of a True Fashion Star*. New York: Simon & Schuster, 2005.

Seebohm, Caroline. *The Man Who Was* Vogue*: The Life and Times of Condé Nast*. New York: Viking, 1982.

Snow, Carmel. *The World of Carmel Snow*. New York: McGraw-Hill, 1962.

Tiberis, Liz. "Editor's Note." *Harper's Bazaar*, October 1994.

"Vargas." From Pin-Up Page. www.btinternet.com/~brmerc/vargas/Vargas.html [accessed 12 December 2006].

"*Vogue* (magazine)." From Wikipedia, the Free Encyclopedia. http://en.wikipedia.org/wiki/Vogue_magazine [accessed 5 May 2006].

Vreeland, Diana. *D.V.* New York: Alfred A. Knopf, 1984; New York: Random House, 1985.

Wilson, Eric. "Carrie Donovan Dies at Seventy-three." *Women's Wear Daily*, 13 November 2001. www.highbeam.com/library/doc3.asp?DOCID=1G1:80610344andnum=1anDCtrlInfo=Ro [accessed 3 June 2006].

Witchel, Alex. "A Not So Wild and Crazy Writer." *New York Times*, 22 October 1995.

"Women's Wear Daily." From Wikipedia, the Free Encyclopedia. http://en.wikipedia.org/wiki/Womens_Wear_Daily [accessed 12 May 2006].

6. Modeling

"About Us." *Boss Model Management*. 2003. www.bossmodelmanagement.co.uk/misc/aboutboss.htm [accessed 19 April 2006].

"Cape London Model Management." From Wikipedia, the Free Encyclopedia. http://en.wikipedia.org/wiki/CAPE_London_Model_Management [accessed 19 April 2006].

"Elite Model Management." From Wikipedia, the Free Encyclopedia. http://en.wikipedia.org/wiki/Elite Model_Management [accessed 19 April 2006].

"Ford Models." From Wikipedia, the Free Encyclopedia. http://en.wikipedia.org/wiki/Ford_Models [accessed 19 April 2006].

"Modeling Agency." From Wikipedia, the Free Encyclopedia. http://en.wikipedia.org/wiki/Modeling_agency [accessed 19 April 2006].

"Models 1." From Wikipedia, the Free Encyclopedia. http://en.wikipedia.org/wiki/Models_1 [accessed 19 April 2006].

Thurlow, Valerie. *Model in Paris*. London: Robert Hale, 1975.

7. Photography

"Antonio Lopez Fashion Drawings and Photographs." *Art in Context*, 26 April 2006. www.artincontext.org/listings/pages/exhib/g/bll8dv9g/press.htm [accessed 30 March 2006].

Avedon, Richard, and Doon Arbus. *The Sixties*. New York: Random House, 1999.

Avedon, Richard, and Truman Capote. *Observations*. New York: Simon & Schuster, 1959.

Bagley, Christopher. "Bruce Weber: The Wonder Years." *W*, January 2000.

"Biography for Steven Meisel." www.imdb.com/name/nm1071373/bio [accessed 13 April 2006].

"Bruce Weber (photographer)." From Wikipedia, the Free Encyclopedia. http://en.wikipedia.org/wiki/Bruce_Weber [accessed 21 May 2006].

"Francesco Scavullo." From Wikipedia, the Free Encyclopedia. http://en.wikipedia.org/wiki/Francesco_Scavullo [accessed 5 May 2006].

"Helmut Newton." From Wikipedia, the Free Encyclopedia. http://en.wikipedia.org/wiki/Helmut_Newton [accessed 14 April 2006].

"Henri Cartier-Bresson." From Wikipedia, the Free Encyclopedia. http:// en.wikipedia.org/wiki/Henri_Cartier-Bresson [accessed 5 May 2006].

"Herb Ritts." From Wikipedia, the Free Encyclopedia. http://en.wikipedia .org/wiki/Herb_Ritts [accessed 1 May 2006].

"Herb Ritts, Photographer, Fifty." *Women's Wear Daily*, 27 December 2002.

"Irving Penn." From Wikipedia, the Free Encyclopedia. http://en.wikipedia .org/wiki/Irving_Penn [accessed 19 April 2006].

Lipke, David. "Bruce Weber's Ode to Fashion." *Daily News Record*, 9 January 2006.

Lockwood, Lisa. "Fashions Top Photogs." *Women's Wear Daily*, 27 March 1992.

"Louise Dahl-Wolfe." From Wikipedia, the Free Encyclopedia. http:// en.wikipedia.org/wiki/Louise_Dahl-Wolfe [accessed 5 May 2006].

Meredith, Roy. *Mathew Brady's Portrait of an Era*. New York: W.W. Norton, 1982.

"Steven Meisel." www.modernamuseet.se/v4/templates/template3.asp?lang= Engandid=23 84andbhcp=1[accessed 13 April 2006].

Thurman, Judith, and Richard Avedon. *Richard Avedon: Mode in France*. San Francisco: Frankel Gallery, 2001.

Trebay, Guy. "Style Hound: On the Street with Bill Cunningham. *Artforum International*, March 1996.

Williams, Val. "Obituary: Francesco Scavullo." *Independent* (London), 13 January 2004.

———. "Obituary: Herb Ritts." *Independent* (London), 30 December 2002. www.highbeam.com/library/docfreeprint.asp?docid=1G1:18403698anDCt rlInfo=Roun [accessed 13 March 2006].

8. Textiles and Trimmings

a. Business

Buzzaccarini, Vittoria de, and Isabella Zotti Minicci. *Buttons and Sundries*. Modena: Zanfi Editori, 1990.

Crabtree, Caroline, and Pam Stallebrass. *Beadwork: A World Guide*. New York: Rissoli/Thames and Hudson, 2002.

Dickerson, Kitty G. *Textiles and Apparel in the Global Economy*. Upper Saddle River, N.J: Prentice Hall, 1999.

———. *Textiles and Apparel in the International Economy*. Upper Saddle River, N.J.: Merrill/Prentice Hall, 1991.

Espen, Hal. "Fleeced." *New York Times Magazine*, 15 February 1998.

Finnerty, A. *Textiles and Clothing in Southeast Asia*. London: The Economist Intelligence Unit, 1991.

Jayaraman, S. "Logistics: The Invisible Driver." *America's Textiles International*, October 1998: 67–70.

Remarry, Bruno., ed. *Repéres Mode and Textile 96. Visages d'un secteur*. Paris: Institut Francais de la Mode 1996.

"Research and Markets: World Textile and Apparel Trade Production Trends 2004: US Domestic Clothing Sales Picked up Mid-2003." *Business Wire*, 19 May 2004. www.highbeam.com/library/docfreeprint.asp?docid=1G1:11677 9437ctrlInfo=Ro [accessed 12 November 2005].

Rodie, Janet Bealer. "[TC]2 to Conduct U.S. Sizing Survey." *Textile World*, July 2002.

Roscho, Bernard. *The Rag Race*. New York: Funk and Wagnalls, 1963.

Ryder, Michael J. "The Evolution of the Fleece." *Scientific American*, January 1987: 118.

Schneider, Paul. "The Cotton Brief." *New York Times*, 20 June 1993.

Smith, T. "Marketing in 2004." *Textile Asia*, January 1995.

Textiles and Clothing in Eastern Europe. London: The Economist Intelligence Unit, 1991.

Toyne, B., J. Arpan, A. Barett, D. Ricks, and T. Shimp. *The Global Textile Industry*. London: George Allen and Unwin, 1984.

Tucker, J. *Apparel and Fabricated Textile Products. U.S. Industry and Trade Outlook*. Washington, D.C.: U.S. Department of Commerce, 2000.

"U.S. Textile-Apparel Export Program Moving, But in a Lower Gear." *Women's Wear Daily*, www.highbeam.com/library/doc3.asp?DOCID=1G1:4028478% num=5anDCtrlInfo [accessed 12 November 2005].

Walker, A. "West European Textiles to 2000: Markets and Trends." London: *Financial Times*, 1995.

Werbeloff, A. *Textiles in Africa: A Trade and Investment Guide*. London: Alain Charles, 1987.

White, Palmer. *The Master Touch of Lesage*. Paris: Chene, 1987.

"Who Are Tomorrow's Consumers?" *Textile Horizon*, vol. 12, no. 10 (1992): 3.

Wingate, Elizabeth. *Textile Fabrics*. New York: Prentice Hall, 1952.

b. History

Allen, Thomas B. "The Silk Road's Lost World." *National Geographic*, no. 3 (March 1996).

Baroque and Rococo Silks. New York: Taplinger, 1985.

Campbell, Thomas. *Textiles in the Metropolitan Museum of Art*. New York: The Metropolitan Museum of Art, 1995.

Dickens, Susan. *The Art of Tassel Making*. St. Leonards, NSW Australia: Allen & Irwin, 1994.

Geijer, Agnes. *A History of Textile Art*. London: Pasold Research Fund, 1979, 217–25.

"History of Polyester." From About: Inventors. http://inventors.about.com /library/inventors/blpolyester.htm [accessed 3 March 2007].

Hoover, Doris, and Nancy Welch. *Tassels*. Self published, 1978.

Laval, June D. *Antique French Textiles for Designers*. Atglen, Pa.: Schiffer Publishing Ltd., 2004.

Lebeau, Caroline. *Fabrics—The Decorative Art of Textiles*. New York: Clarkson Potter, 1994.

"Natural Fiber." From Wikipedia, the Free Encyclopedia. http://en.wikipedia .org/wiki/Natural_fiber [accessed 3 March 2007].

Parker, Rozsika. *The Subversive Stitch: Embroidery and the Making of the Feminine*. New York: Routledge, 1989.

Paton, Kathleen. "Trimmings" in *Encyclopedia of Clothing and Fashion*, ed. Valerie Steele. Detroit: Gale, 2005, 337–39.

Quilleriet, Ann Laure. *The Leather Book*. New York: Assouline, 2004.

Reif, Rita. "Dazzling Treasures from Asia's Fabled Silk Route." *New York Times*, 18 May 1997.

———. "Silken Badges Bearing Mysterious Messages." *New York Times*, 20 November 1995.

Ribbon Art Publishing Co. *Old-Fashioned Ribbon Art Ideas and Designs for Accessories and Decoration*. New York: Dover 1986.

Rutt, Richard. *A History of Hand Knitting*. Loveland, Colo.: Interweave, 1987.

Schoeser, Mary. *World Textiles: A Concise History*. London: Thames & Hudson, 2003.

"The Story of Cotton." National Cotton Council of America. www.cotton.org /pubs/cottoncounts/story/index.cfm. [accessed 19 February 2007].

"Synthetic Fiber." From Wikipedia, the Free Encyclopedia. http://en.wikipedia .org/wiki/Synthetic_fiber [accessed 3 March 2007].

Thornton, Peter. "Weaving History from 1830–2005." *Women's Wear Daily*, 23 February 2005.

Welch, Nancy. *Tassels: The Fanciful Embellishment*. Ashville, N.C.: Lark Books, 1992.

c. Technology

Braddock, Sarah E., and Marie O'Mahony. *Techno Textiles*. New York: Thames and Hudson, 1998.

Clark, Evan. "Fiber's Future Down on the Farm." *Women's Wear Daily*, 14 December 2004.

Colchester, Chloe. The *New Textiles: Trends + Traditions*. London: Thames and Hudson, 1994.

Collier, B. J., and P. G. Tortora. *Understanding Textiles*. 6th ed. Upper Saddle River, N.J.: Prentice Hall.

Gan, Stephen. "Great Moments in Stretch." *Harper's Bazaar*, 1997.

Jackson, Jennifer. "Mostly Mohair." *Harper's Bazaar*, October 1994.

Laue, Dietmar. "New Technologies and Materials." *Textile Forum*, April 2002.

McQuaid, Matilda. *Extreme Textiles*. New York: Princeton Architectural Press, 2005.

Menkes, Suzy. "Scorned No Longer, Synthetics Go Modern." *New York Times*, 1 January 1995.

"Patagonia's Infurno Jacket." From Treehugger. www.treehugger.com/files /2004/12/patagonias_infu.php [accessed 3 March 2007].

"Polar Fleece." From Bookrags. www.bookrags.com/research/polar-fleece -woi/ [accessed 11 December 2006].

"Polar Fleece." From Wikipedia, the Free Encyclopedia. http://en.wikipedia .org/wiki/Polar_fleece [accessed 16 December 2006].

"Polyester." From Wikipedia, the Free Encyclopedia. http://en.wikipedia.org /wiki/Polyester [accessed 3 March 2007].

"Polyester Fiber." From Fiber Source. www.fibersource.com/f-tutor/polyester .htm [accessed 3 March 2007].

"Polyethylene terephthalate." From Wikipedia, the Free Encyclopedia. http:// en.wikipedia.org/wiki/Polyethylene_terephthalate [accessed 3 March 2007].

"Production Costs, Scale Economies, and Technical Change in U.S. Textile and Apparel Industries." Atlantic Economic Journal, 2005. www.highbeam .com/library/doc3.asp?DOCID=1G1:13853355andnum=1a nDCtrlInfo [accessed 12 November 2005].

G. APPAREL

1. Accessories

a. General

Chase, Deborah, and Carleen Powell. *Terms of Adornment: The Ultimate Guide to Accessories*. New York: Harper Collins, 1999.

Crawford, T. S. *A History of the Umbrella*. New York: Taplinger, 1970.

Cudlip, E. *Furs*. New York: Hawthorn, 1978.

Grass, M. N. *History of Hosiery*. New York: Fairchild, 1955.

Peacock, John. *Fashion Accessories: The Complete 20th Century Sourcebook*. London and New York: Thames and Hudson, 2000.

Yuan, Li. "Cell Phone Accessories Enter Realm of Couture." *Wall Street Journal*, 1 March 2006.

b. Gloves

Collins, C. C. *Love of a Glove*. New York: Fairchild, 1947.
Cummings, V. *Gloves*. New York: Drama, 1982.

c. Handbags

Ettinger, R. *Handbags*. 2nd ed. Atglen, Pa.: Schiffer, 1998.
Foster, V. *Bags and Purses*. London: B. T. Batsford, 1982.
Wilcox, C. *A Century of Bags: Icons of Style in the Twentieth Century*. Edison, N.J.: Chartwell, 1997.

d. Hats

Clark, E. *Hats*. London: B.T. Batsford, 1982.
Ginsburg, Madeleine. *The Hat*. Hauppauge, N.Y.: Barron's, 1990.

e. Neckwear

Curan, C. "Ties of the Times: A Look Back at Fifty Years of Neckwear and the NAA." *Daily News Record*, 6 June 1997: 28.
Dyer, R., and R. Spark. *Fit to Be Tied: Vintage Neckwear of the Forties and Early Fifties*. New York: Abbeville, 1987.
Gibbings, S. *The Tie: Trends and Traditions*. Hauppauge, N.Y.: Barron's, 1990.

2. Childrenswear

Rubinstein, Ruth P. *Society's Child: Identity, Clothing, and Style*. Boulder, Colo.: Westview, 2000.

3. Couture

Agins, Terri. "Not So Haute: French Fashion Loses Its Primacy as Women Leave Couture Behind." *Wall Street Journal*, 29 August 1995: A1, A8.
Bertin, Célia. *Paris à la Mode*. London, 1956.
De Marly, Diana. *The History of Haute Couture, 1850–1950*. London: B. T. Batsford, 1980.

Dietz, Paula. "Haute Couture Is Never Passé." *New York Times*, 29 August 1993.

Garnier, Guillaume, et al. *Paris-Couture, Années Trente*. Paris: Musée de la Mode et du Costume, Editions Paris-Musées, 1987.

"Haute Couture." From Wikipedia, the Free Encyclopedia. http://en.wikipedia.org/wiki/Haute-couture [accessed 29 May 2006].

Lyman, Ruth. *Couture: An Illustrated History of the Great Paris Designers and Their Creations*. New York: Doubleday, 1972.

Martin, Richard, and Harold Koda. *Haute Couture*. New York: Harry Abrams, 1995.

Milbank, Caroline Rennolds. *Couture: The Great Fashion Designers*. London: Thames and Hudson, 1985.

Spindler, Amy M. "Unashamedly Couture." *New York Times*, 24 January 1995.

"Voice of the Couture." *Vanity Fair*, December 1984.

4. Footwear

"1890–1930 J. W. Foster and Spikes of Fire." www.reebok.com/useng/history/1890.htm [accessed 2 December 2005].

Abel, Katie. "Dress Revival Boosts Nine West Fortunes." *Footwear News*, 24 May 2004.

Anderson, Fiona. "Men's Shoes," in *Encyclopedia of Clothing and Fashion*, ed. Valerie Steele. Detroit: Gale, 2005. Vol. 3, 171–72.

Anniss, Elisa. "The Sole of Klein." *Footwear News*, 12 August 1996.

"Athletic Shoe." From Wikipedia, the Free Encyclopedia. http://en.wikipedia.org/wiki/Athletic_shoe [accessed 18 December 2005].

Baran, Michelle. "Finding Ferragamo." *Footwear News*, 28 November 2005.

"Birkenstock." www.birkenstockusa.com/our_company/history/ [accessed 27 November 2005].

"Brown Shoe, Our History." www.brownshoecompany.com/history/index.asp [accessed 27 November 2005].

Butler, Simon. "It's a Madden, Madden, Madden World." *Footwear News*, 26 May 1997.

Cheskin, M. P. *The Complete Handbook of Athletic Footwear*. New York: Fairchild, 1987.

"Clothesline by Marylou Luther." From the Fashion Group International, Inc. http://www.fgi.org/files/New_York/documents/clotheslinesdec2006.pdf [accessed 18 December 2006].

"Company News; Nine West Group to Eliminate About 175 Jobs." *New York Times*, 22 July 1995.

"The Converse Story" www.converse.com/zinside.asp [accessed 27 November 2005].

Davis, Johnny. "Sneaker Pimps." *Independent* (London), 10 May 2005.

Dazman, Manan. "Jimmy Choo Gets Another Award." *New Straits Times*, 4 March 2004.

DeCarlo, Lauren. "Madden Breaks in New Role." *Women's Wear Daily*, 17 October 2005.

Deeney, Godfrey. "Kelian Offer Raises $5.4M." *Footwear News*, 16 March 1992.

Farnsworth, Steve. "Nine West to Go Public" *Footwear News*, 4 May 1992.

"Here Comes the NBA." *Charlie's Sneaker Pages*, 24 November 2005. www .sneakers.pair.com/index.html [accessed 26 November 2005].

"History and Background of Charles Jourdan." 2 May 2005. www.frangrancex .com/rdanchar.html [accessed 30 November 2005].

Hoeymakers, Mandy, "Roger Vivier." *Sixties Central*, 1 June 2003. www .geocities.com/FashionAvenue/Catwalk/1038/vivier.html?20052.

"Jerome Fisher Appointed Chairman Emeritus of Nine West." *PR Newswire*, 2 August 1999.

"Jimmy Choo Forges Ahead." www.fashionunited.co.uk./news/shoes.htm [accessed 30 November 2005].

Kaplan, Fred. "Isaac Mizrahi, Fashion House Partner for Footwear Deal." *Footwear News*, 20 March 2006.

Larson, Kristin. "Dream Weaver." *Footwear News*, 8 December 2003.

Lawlor, L. *Where Will This Shoe Take You?* New York: Walker and Company, 1996.

"Nike, Inc." www.nike.com/nikebiz/nikebiz.jhtml?page=3anditem=facts [accessed 2 December 2005].

"Nine West Acquires LJS." *Women's Wear Daily*, 13 February 1995.

"Nine West Taps G-III." *Women's Wear Daily*, 11 November 1997.

"Our Roots—Dr. Martens History." www.drmartens.com/base.cfm?secId=-1andid=-1andprodId=-1andprodType=-1anddirect [accessed 27 November 2005].

Pattison, Angela. *A Century of Shoes: Icons of Style in the 20th Century*. Edison, N.J.: Chartwell Books, 1997.

"PF Flyers." From Wikipedia, the Free Encyclopedia. http://en.wikipedia.org/ wiki/Pf_flyers [accessed 19 December 2005].

"Puma." www.about.puma.com/puma.jsp?type=companyandparent=13andid= 13andlang=engandyear=192 [accessed 2 December 2005].

"Puma and Christy Turlington Team with Amazon to Launch New Yoga Collection." *Business Wire*, 31 March 2004.

Rachmansky, Anna. "Independent Thinker." *Footwear News*, 9 December 2002.

Rath, Jay. "Sole Survivor Classic PF Flyers Shoes Experience a Rebirth for New Generations to Enjoy." *Wisconsin State Journal*, 15 December 2004.

"Reebok." From Wikipedia, the Free Encyclopedia. http://en.wikipedia.org/wiki/Reebok [accessed 2 December 2005].

Reed, Julia. "Walk this Way." *Vogue*, November 2003.

Rexford, N. E. *Women's Shoes in America, 1795–1930*. Kent, Ohio: Kent State University Press, 2000.

"Roger-Vivier." www.designerhistory.com/historyoffashion/shoevivier.html [accessed 2 December 2005].

"Stark Raving Madden (Shoe Designer Steve Madden Up and Coming)." www .highbeam.com/library/doc3.asp?DOCID=1G1:1564512andnum=10anDCtr lInfo [accessed 30 November 2005].

Solnik, Claude. "S is for Success." *Footwear News*. 7 December 1998.

"Takeover Stephané Kellan." 9 January 2003. www.fashionunited.couk/news /flg.htm [accessed 30 November 2005].

"A Tale of Two Giants." *Footwear News*, 21 May 1996.

"Targeted E-mail Messaging is Sure Fit for Nine West." *Peppers and Rogers Group*, 1 October 2002.

Walford, Jonathan. "Shoes" in *Encyclopedia of Clothing and Fashion*, ed. Valerie Steele. Detroit: Gale, 2005. Vol. 3, 168–69.

———. "Women's Shoes" in *Encyclopedia of Clothing and Fashion*, ed. Valerie Steele. Detroit: Gale, 2005. Vol. 3, 173–78.

"Watching Nine West." *Women's Wear Daily*, 4 January 1999.

Weisman, Katherine. "From Paris with Love." *Footwear News*, 1 June 1992.

Zmuda, Natalie. "As Jones' Shadow Grows, Industry Debates Impact." *Footwear News*, 28 June 2004. www.highbeam.com/library/doc3.asp?DOCID=1 G1:118858133andnum=19andctrlInfo [accessed 10 June 2006].

5. Intimate

Chang, Lia. "Intimate Architecture." *Asian Week*, 29 November 2001.

Chenoune, Farid. *Beneath: A Century of French Lingerie*. New York: Rizzoli, 1998.

Cunnington, C. W., and P. Cunnington. *The History of Underclothes*. New York: Dover, 1992.

Ewing, E. *Underwear: A History*. New York: Drama, 1990.

Farrell-Beck, Jane, and Colleen Gau. *Uplift: The Bra in America*. Philadelphia: University of Pennsylvania Press, 2002.

Fontanel, Beatrice, and Willard Wood. *Support and Seduction: A History of Corset and Bras*. New York: Harry N. Abrams, 1997.

Rexford, N. E. "Dressing the Mothers of the Men Who Rule the World: The Role of Negligée Dress in the 19th Century," in *Appearance and Gender Identity*, ed. Louise Wehrle. Costume Society of America Symposium Abstracts, 1990.

Schiro, Ann-Marie. "Out of the Boudoir and Into the Real World." *New York Times*, 23 March 1994.

6. Jewelry

"Daniel Swarovski's Invention." www.swarovski.com/index/0,2768,language %3Den%26contentId%3D342%26channe [accessed 8 May 2006].

"David Yurman." From Wikipedia, the Free Encyclopedia. http://en.wikipedia .org/wiki/David_Yurman [accessed 2 June 2006].

"Elsa Peretti." From Wikipedia, the Free Encyclopedia. http://en.wikipedia .org/wiki/Elsa_Peretti [accessed 19 April 2006].

"Harry Winston." www.harrywinston.com [accessed 31 May 2006].

"Harry Winston." From Wikipedia, the Free Encyclopedia. http://en.wikipedia .org/wiki/Harry_Winston [accessed 12 May 2006].

Kaiser, Amanda. "Bulgari to Open Tokyo Flagship." *Women's Wear Daily*, 16 March 2006.

Landman, Neil H., et al. *Pearls: A Natural History*. New York: American Museum of Natural History, 2001.

"A Look at Peretti's Work and Life." *Women's Wear Daily*, 27 April 1990.

Maurois, Patrick. *Jewelry by Chanel*. London: Thames and Hudson, 1993.

Newman, Jill. "Tiffany's Mesh Show Features Peretti's Work." *Women's Wear Daily*, 12 June 1992.

"Noted Jeweler David Yurman to Collaborate with the American Red Cross in Support of Hurricane Relief." *PR Newswire*, 3 November 2005.

Patterson, Jean. "David Yurman Jewelry, Like Your Most Expensive Pair of Blue Jeans." *Orlando Sentinel*, 29 March 2006.

Schupak, Hedda. "Vivienne Westwood Debuts 'Hardcore': 'High Priestess of Punk' Goes Precious." *Jewelers Circular Keystone*, 1 June 2005.

Subki, Sofianni. "Peretti's Contoured Jewellery." *New Straits Times*, 10 January 2005.

"Swarovski." From Wikipedia, the Free Encyclopedia. http://en.wikipedia .org/wiki/Swarovski [accessed 7 May 2006].

"Swatch." From Wikipedia, the Free Encyclopedia. http://en.wikipedia.org/ wiki/Swatch [accessed 7 May 2006].

"Swatch." www.swatch.com/index_flash.php [accessed 8 May 2006].

"Swatch Announces New Swatch Smart Watch that Delivers Exclusive Entertainment Information and More via Microsoft's MSN Direct Service." *PR Newswire*, 20 October 2004.

"Swatch Unveils Plans for E-Mail Watch." *Newsbytes News Network,* 12 July 1999.

"Tiffany and Co." www.tiffany.com/about/timeline.asp? [accessed 9 May 2006].

"Tiffany and Co." From Wikipedia, the Free Encyclopedia. http://en.wikipedia .org/wiki/Tiffany_and_Co..

"Tiffany and Co. Crafts the Vince Lombardi Trophy for Super Bowl XXXIX." *Business Wire,* 24 January 2005.

"Tiffany and Co. Obtains $600,000 Judgment Against Counterfeiter." *Business Wire,* 4 November 2004.

"Tiffany and Co. to Open Stores in Beijing and Shanghai in 2006." *Business Wire,* 30 March 2006. http://en.wikipedia.org/wiki/Tiffany_%26_Co [accessed 20 April 2006].

"Tiffany Announces the Establishment of the Tiffany and Co. Foundation." *Business Wire,* 11 April 2001.

"Through the Years." *Women's Wear Daily,* 2 May 2005.

7. Knitwear

Black, Sandy. *Knitwear in Fashion.* London: Thames and Hudson, 2002.

Jenkins, David, ed. *Cambridge History of Western Textiles.* Cambridge, U.K.: Cambridge University Press, 2003.

Jerde, Judith. *Encyclopedia of Textiles.* New York: Facts on File, 1992, 106–15.

Kadolph, Sara J., and Anna L. Langford. *Textiles.* 8th ed. Upper Saddle River, N.J.: Merrill, 1998, 217–42.

McGregor, Sheila. *The Complete Book of Traditional Fair Isle Knitting.* New York: Scribner's Sons, 1981.

Schoeser, Mary. *World Textiles: A Concise History.* London: Thames & Hudson, 2003.

8. Menswear

"1500–1550 in Fashion." From Wikipedia, the Free Encyclopedia. http:// en.wikipedia.org/wiki/1500–1550_in_fashion [accessed November 2006].

"1550–1600 in Fashion." From Wikipedia, the Free Encyclopedia. http:// en.wikipedia.org/wiki/1550–1600_in_fashion [accessed November 2006].

"1600–1650 in Fashion." From Wikipedia, the Free Encyclopedia. http:// en.wikipedia.org/wiki/1600–1650_in_fashion [accessed November 2006].

"1650–1700 in Fashion." From Wikipedia, the Free Encyclopedia. http:// en.wikipedia.org/wiki/1650–1700_in_fashion [accessed November 2006].

"1700–1750 in Fashion." From Wikipedia, the Free Encyclopedia. http://
en.wikipedia.org/wiki/1700–1750_in_fashion [accessed November 2006].
"1750–1795 in Fashion." From Wikipedia, the Free Encyclopedia. http://
en.wikipedia.org/wiki/1750–1795_in_fashion [accessed November 2006].
"1795–1820 in Fashion." From Wikipedia, the Free Encyclopedia. http://
en.wikipedia.org/wiki/1795–1820_in_fashion [accessed November 2006].
"1820s in Fashion." From Wikipedia, the Free Encyclopedia. http://en.wikipedia
.org/wiki/1820s_in_fashion [accessed November 2006].
"1830s in Fashion." From Wikipedia, the Free Encyclopedia. http://en.wikipedia
.org/wiki/1830s_in_fashion [accessed November 2006].
"1840s in Fashion." From Wikipedia, the Free Encyclopedia. http://en.wikipedia
.org/wiki/1840s_in_fashion [accessed November 2006].
"1850s in Fashion." From Wikipedia, the Free Encyclopedia. http://en.wikipedia
.org/wiki/1850s_in_fashion [accessed November 2006].
"1860s in Fashion." From Wikipedia, the Free Encyclopedia. http://en.wikipedia
.org/wiki/1860s_in_fashion [accessed November 2006].
"1870s in Fashion." From Wikipedia, the Free Encyclopedia. http://en.wikipedia
.org/wiki/1870s_in_fashion [accessed November 2006].
"1880s in Fashion." From Wikipedia, the Free Encyclopedia. http://en.wikipedia
.org/wiki/1880s_in_fashion [accessed November 2006].
"1890s in Fashion." From Wikipedia, the Free Encyclopedia. http://en.wikipedia
.org/wiki/1890s_in_fashion [accessed November 2006].
"1895–1914 La Belle Époque." From Fashion Era. www.fashion-era.com
/1890-1914_la_belle_epoque.htm [accessed November 2006].
"1920–1930." From Fashion Era. www.fashion-era.com/1920s/index.htm [ac-
cessed November 2006].
"1930–1940." From Fashion Era. www.fashion-era.com/1930s/index.htm [ac-
cessed November 2006].
"1940–1950." From Fashion Era. www.fashion-era.com/1940s/index.htm [ac-
cessed November 2006].
"1950–1960." From Fashion Era. www.fashion-era.com/1950s/index.htm [ac-
cessed November 2006].
"The 1960s." From Nostalgia Central. www.nostalgiacentral.com/sixties.htm
[accessed November 2006].
"1960–1970." From Fashion Era. www.fashion-era.com/1960s/index.htm [ac-
cessed November 2006].
"The 1970s." From Nostalgia Central. www.nostalgiacentral.com/seventies
.htm [accessed November 2006].
"1970–1980." From Fashion Era. www.fashion-era.com/1970s/index.htm [ac-
cessed November 2006].

"1980–1990." From Fashion Era. www.fashion-era.com/fashion_after1980 .htm [accessed November 2006].

"The 1980s." From Nostalgia Central. www.nostalgiacentral.com/eighties .htm[accessed November 2006].

"1980s in Fashion." From Wikipedia, the Free Encyclopedia. http://en.wikipedia .org/wiki/1980s_in_fashion [accessed November 2006].

"1990s in Fashion." From Wikipedia, the Free Encyclopedia. http://en.wikipedia .org/wiki/1990s_in_fashion [accessed November 2006].

"1990s Fashion History—The Mood of the Millennium." From Fashion Era. www.fashion-era.com/the_1990s.htm [accessed November 2006].

"The 1990s Fashion History Part 2." From Fashion Era. www.fashion-era .com/part_2_1990s.htm [accessed November 2006].

"2000s in Fashion." From Wikipedia, the Free Encyclopedia. http://en.wikipedia .org/wiki/2000s_in_fashion [accessed November 2006].

"The Beatles." From Sixties Central. www.geocities.com/FashionAvenue /Catwalk/1038/beatles.html [accessed November 2006].

"The Beatles." From Wikipedia, the Free Encyclopedia. http://en.wikipedia .org/wiki/The_beatles [accessed November 2006].

Bennett-England, R. *Dress Optional: The Revolution in Menswear.* Chester Springs, Pa.: Dufour, 1968.

Boyer, B. *Elegance: A Guide to Quality in Menswear.* New York: Norton, 1984.

Breward, Christopher. *Fashion-Oxford History of Art.* Oxford, U.K.: Oxford University Press, 2003.

Byrde, Penelope. *The Male Image: Men's Fashion in England 1300–1970.* London: B. T. Batsford, 1979.

Carlson, P., and W. Wilson. *Manstyle: The GQ Guide to Fashion, Fitness, and Grooming.* New York: Clarkson, 1977.

Chenoune, Farid. *A History of Men's Fashion.* Paris: Flammarion, 1993.

Cobrin. H. *The Men's Clothing Industry: Colonial through Modern Times.* New York: Fairchild, 1971.

Colavita, Courtney. "Marni Does Men's." *Daily News Record,* 8 October 2001.

Constantino, M. *Men's Fashion in the Twentieth Century: From Frock Coats to Intelligent Fibers.* New York: Costume and Fashion, 1997.

De Marly, Diana. *Fashion for Men: An Illustrated History.* London: B. T. Batsford, 1985.

Dolce, D. *The Consumer's Guide to Menswear.* New York: Dodd, 1983.

"Fashion History." From Ask Men. www.askmen.com/fashion/austin_60/63 _fashion_style.html [accessed November 2006].

Feldman, E. *Fit for Men.* Washington, D.C.: Public Affairs Press, 1960.

Flusser, A. *Clothes and the Man.* New York: Villard, 1985.

Gellers, Stan. "Sizing Up the Men of Measure." *Daily News Record*, 27 March 1998: 14–15.

———. "Clothing Men Use Soft Suit to Play Hardball." *Daily News Record*, 31 October 1994: 10–11.

"History of Fashion 1900–1910." From American Vintage Blues. www.vintage blues.com/history_main.htm [accessed November 2006].

"History of Fashion 1910–1920." From American Vintage Blues. www.vintage blues.com/history1.htm [accessed November 2006].

"History of Fashion 1920–1930." From American Vintage Blues. www.vintage blues.com/history2.htm [accessed November 2006].

"History of Fashion 1930–1940." From American Vintage Blues. www.vintage blues.com/history3.htm [accessed November 2006].

"History of Fashion 1940–1950." From American Vintage Blues. www.vintage blues.com/history4.htm [accessed November 2006].

"History of Fashion 1950–1960." From American Vintage Blues. www.vintage blues.com/history5.htm [accessed November 2006].

"History of Fashion 1960–1970." From American Vintage Blues. www.vintage blues.com/history6a.htm [accessed November 2006].

"History of Fashion 1970–1980." From American Vintage Blues. www.vintage blues.com/history7a.htm [accessed November 2006].

"History of Fashion 1980–1990." From American Vintage Blues. www.vintage blues.com/history8.htm [accessed November 2006].

"The Impact of Fitness on the Cut of Clothes." *New York Times, Men's Fashions of the Times*, 5 September 1985.

Jackson, C., and K. Luow. *Color for Men*. New York: Ballantine, 1984.

Laver, James A. *Dandies*. London: Weidenfeld and Nicholson, 1968.

Lohrer, R. "Dressing Up the Business of Men's Wear: An Industry with a Split Personality Sends a Mixed Message to Men." *Daily News Record*, 19 September 1997.

"Men's Fashion History." From Southern California Lindy Society. www.lindy hopping.com/fashionhistm.html [accessed November 2006].

Martin, Richard, and Harold Koda. *Men's Styles in the Twentieth Century*. New York: Rizzoli, 1989.

McDowell, Colin. *The Man of Fashion: Peacock Males and Perfect Gentlemen*. New York: Thames and Hudson, 1997.

"Metrosexual." From Wikipedia, the Free Encyclopedia. http://en.wikipedia .org/wiki/Metrosexual [accessed November 2006].

Palmieri, J. "Financial Analysts Give High Marks to Dep't Stores' New Emphasis on Men's." *Daily News Record*, 5 September 1994.

Paoletti, Jo B. "Ridicule and Role Models as Factors in American Men's Fash-

ion Change, 1880–1910." *Costume* 19, 1985.

Peacock, J. *Men's Fashion: The Complete Sourcebook*. New York: Thames and Hudson, 1996.

"Pop Culture." From Nostalgia Central. www.nostalgiacentral.com/pop.htm [accessed November 2006].

"Savile Row." From Wikipedia, the Free Encyclopedia. http://en.wikipedia .org/wiki/Saville_Row [accessed 3 May 2006].

"Seventy-Five Years of Men's Wear Fashion 1890–1965" in *Menswear*, ed. Fairchild staff. New York: Fairchild, 1965.

Tolman, R. *Selling Men's Fashion*. New York: Fairchild, 1982.

Trebay, Guy. "Milan Evokes Boardroom James Bonds." *New York Times*, January 2006.

"Viktor and Rolf Show a Merry Men's Line." *Women's Wear Daily*, 13 January 2003.

Wagenvoord, J. *The Man's Book: A Complete Manual of Style*. New York: Avon, 1978.

Walker, Richard. *Savile Row: An Illustrated History*. New York: Rizzoli, 1989.

Wilson, W., and Editors of *Esquire* Magazine. *Man at His Best*. Reading, Mass.: Addison-Wesley, 1985.

9. Performance

"If You Have a Body, You Are an Athlete." Nikebiz.com. www.nike.com /nikebiz/nikebiz.jhtml?pge=3 [accessed 2 December 2005].

Jackson, Jennifer. "Sports Illustrated." *Harper's Bazaar*, September 1994.

"Marmot Mountain Teams Up with OUTLAST Temperature Regulation." *Business Wire*, 30 November 2000.

"Marmot's History." www.marmot.com/service/about/index.php [accessed 22 April 2006].

"The North Face." From Wikipedia, the Free Encyclopedia. http://en.wikipedia .org/wiki/The_North_Face [accessed 6 June 2006].

"The North Face—Our Story." www.thenorthface.com/na/our-store.html [accessed 6 June 2006].

"Patagonia Company History" www.patagonia.com/culture/patagonia_history .shtml [accessed 22 April 2006].

"Performance Apparel Markets—Issue 5." *Textiles Intelligence*, January 2003. www.researchandmarkets.com/reports/45730/ [accessed 22 April 2006].

Socha, Miles. "Yohji Teams Up with Adidas for Apparel Collection." *Daily News Record*, 15 July 2002.

"Speedo." From Wikipedia, the Free Encyclopedia. http://en.wikipedia.org/ wiki/Speedo [accessed 3 May 2006].

"Speedo." www.speedo.com "Speedo Introduces FASTSKIN FSII Ice Speed Suit for 2006 Winter Olympics." *PR Newswire* [accessed 1 December 2005].

Walsh, Chris. "New Ski Products Take Your Breath Away." Denver *Rocky Mountain News*, 29 December 2004.

Warner, Patricia Campbell. "Clothing the American Woman for Sport and Physical Education, 1860 to 1940: Public and Private." ACPTC Proceedings: National Meeting, 1986.

10. Womenswear

"1500–1550 in Fashion." From Wikipedia, the Free Encyclopedia. http:// en.wikipedia.org/wiki/1500–1550_in_fashion [accessed November 2006].

"1550–1600 in Fashion." From Wikipedia, the Free Encyclopedia. http:// en.wikipedia.org/wiki/1550–1600_in_fashion [accessed November 2006].

"1600–1650 in Fashion." From Wikipedia, the Free Encyclopedia. http:// en.wikipedia.org/wiki/1600–1650_in_fashion [accessed November 2006].

"1650–1700 in Fashion." From Wikipedia, the Free Encyclopedia. http:// en.wikipedia.org/wiki/1650–1700_in_fashion [accessed November 2006].

"1700–1750 in Fashion." From Wikipedia, the Free Encyclopedia. http:// en.wikipedia.org/wiki/1700–1750_in_fashion [accessed November 2006].

"1750–1795 in Fashion." From Wikipedia, the Free Encyclopedia. http:// en.wikipedia.org/wiki/1750–1795_in_fashion [accessed November 2006].

"1795–1820 in Fashion." From Wikipedia, the Free Encyclopedia. http:// en.wikipedia.org/wiki/1795–1820_in_fashion [accessed November 2006].

"1820s in Fashion." From Wikipedia, the Free Encyclopedia. http://en.wikipedia .org/wiki/1820s_in_fashion [accessed November 2006].

"1830s in Fashion." From Wikipedia, the Free Encyclopedia. http://en.wikipedia .org/wiki/1830s_in_fashion [accessed November 2006].

"1840s in Fashion." From Wikipedia, the Free Encyclopedia. http://en.wikipedia .org/wiki/1840s_in_fashion [accessed November 2006].

"1850s in Fashion." From Wikipedia, the Free Encyclopedia. http://en.wikipedia .org/wiki/1850s_in_fashion [accessed November 2006].

"1860s in Fashion." From Wikipedia, the Free Encyclopedia. http://en.wikipedia .org/wiki/1860s_in_fashion [accessed November 2006].

"1870s in Fashion." From Wikipedia, the Free Encyclopedia. http://en.wikipedia .org/wiki/1870s_in_fashion [accessed November 2006].

"1880s in Fashion." From Wikipedia, the Free Encyclopedia. http://en.wikipedia .org/wiki/1880s_in_fashion [accessed November 2006].

"1890s in Fashion." From Wikipedia, the Free Encyclopedia. http://en.wikipedia .org/wiki/1890s_in_fashion [accessed November 2006].

"1895–1914 La Belle Époque." From Fashion Era. www.fashion-era.com/1890-1914_la_belle_epoque.htm [accessed November 2006].

"1920–1930." From Fashion Era. www.fashion-era.com/1920s/index.htm [accessed November 2006].

"1930–1940." From Fashion Era. www.fashion-era.com/1930s/index.htm [accessed November 2006].

"1940–1950." From Fashion Era. www.fashion-era.com/1940s/index.htm [accessed November 2006].

"1950–1960." From Fashion Era. www.fashion-era.com/1950s/index.htm [accessed November 2006].

"1960–1970." From Fashion Era. www.fashion-era.com/1960s/index.htm [accessed November 2006].

"1970–1980." From Fashion Era. www.fashion-era.com/1970s/index.htm [accessed November 2006].

"1980–1990." From Fashion Era. www.fashion-era.com/fashion_after1980 .htm [accessed November 2006].

"1980s in Fashion." From Wikipedia, the Free Encyclopedia. http://en.wikipedia .org/wiki/1980s_in_fashion [accessed November 2006].

"1990s in Fashion." From Wikipedia, the Free Encyclopedia. http://en.wikipedia .org/wiki/1990s_in_fashion [accessed November 2006].

"1990s Fashion History—The Mood of the Millennium." From Fashion Era. www.fashion-era.com/the_1990s.htm [accessed November 2006].

"The 1990s Fashion History Part 2." From Fashion Era. www.fashion-era .com/part_2_1990s.htm [accessed November 2006].

"2000s in Fashion." From Wikipedia, the Free Encyclopedia. http://en.wikipedia .org/wiki/2000s_in_fashion [accessed November 2006].

"Amelia Bloomer." From Wikipedia, the Free Encyclopedia. http://en.wikipedia .org/wiki/Amelia_Bloomer [accessed November 2006].

"Artistic Dress Movement." From Wikipedia, the Free Encyclopedia. http:// en.wikipedia.org/wiki/Artistic_Dress_movement [accessed November 2006].

"Biography of Sonia Delaunay." From Brain-Juice. http://brain-juice.com/cgi-bin/show_bio.cgi?p_id=74 [accessed November 2006].

"Bloomers." From Wikipedia, the Free Encyclopedia. http://en.wikipedia.org/ wiki/Bloomers_%28clothing%29 [accessed November 2006].

Breward, Christopher. *Fashion (Oxford History of Art)*. Oxford, U.K.: Oxford University Press, 2003.

"Brigitte Bardot." From Sixties Central. http://www.geocities.com/Fashion Avenue/Catwalk/1038/bardot.html [accessed November 2006].

"Charles Dana Gibson." From Wikipedia, the Free Encyclopedia. http://en.wikipedia.org/wiki/Charles_Dana_Gibson [accessed November 2006].

"Coco Chanel—Biography and Links." From About: Women's History. http://womenshistory.about.com/library/bio/blbio_chanel_coco.htm [accessed November 2006].

De Osma, Guillermo. *Fortuny: Mariano Fortuny, His Life and Work.* London: Aurum Press Ltd., 1980.

"Elsa Schiaparelli." From Wikipedia, the Free Encyclopedia. http://en.wikipedia.org/wiki/Elsa_Schiaparelli [accessed November 2006].

"Flapper Fashion." From Fashion Era. www.fashion-era.com/flapper_fashion_1920s.htm [accessed November 2006].

"Futurism in Fashion." From Sixties Central. http://www.geocities.com/FashionAvenue/Catwalk/1038/futurism.html [accessed November 2006].

"Hippy and Ethnic Influences." From Sixties Central. www.geocities.com/FashionAvenue/Catwalk/1038/ethnic.html [accessed November 2006].

"History of Fashion 1900–1910." From American Vintage Blues. www.vintageblues.com/history_main.htm [accessed November 2006].

"History of Fashion 1910–1920." From American Vintage Blues. www.vintageblues.com/history1.htm [accessed November 2006].

"History of Fashion 1920–1930." From American Vintage Blues. www.vintageblues.com/history2.htm [accessed November 2006].

"History of Fashion 1930–1940." From American Vintage Blues. www.vintageblues.com/history3.htm [accessed November 2006].

"History of Fashion 1940–1950." From American Vintage Blues. www.vintageblues.com/history4.htm [accessed November 2006].

"History of Fashion 1950–1960." From American Vintage Blues. www.vintageblues.com/history5.htm [accessed November 2006].

"History of Fashion 1960–1970." From American Vintage Blues. www.vintageblues.com/history6a.htm [accessed November 2006].

"History of Fashion 1970–1980." From American Vintage Blues. www.vintageblues.com/history7a.htm [accessed November 2006].

"History of Fashion 1980–1990." From American Vintage Blues. www.vintageblues.com/history8.htm [accessed November 2006].

"Jackie Onassis." From Sixties Central. www.geocities.com/FashionAvenue/Catwalk/1038/jackieo.html [accessed November 2006].

"Katharine Hepburn." From Sixties Central. http://www.geocities.com/FashionAvenue/Catwalk/1038/khepburn.html [accessed November 2006].

Kirke, Betty. *Madeleine Vionnet.* San Francisco: Chronicle Books. 1998.

"Left Bank Look." From Sixties Central. www.geocities.com/FashionAvenue/Catwalk/1038/leftbank.html [accessed November 2006].

"The Mini Skirt." From Sixties Central. www.geocities.com/FashionAvenue

/Catwalk/1038/miniskirt.html [accessed November 2006].

"Pants for Women." From Sixties Central. www.geocities.com/FashionAvenue /Catwalk/1038/slacks.html [accessed November 2006].

"Pop Art in Clothing." From Sixties Central. www.geocities.com/Fashion Avenue/Catwalk/1038/popclothes.html [accessed November 2006].

"Princess Diana 1980–90s Fashion Icon." From Fashion Era. www.fashion-era .com/diana_80s_fashion_icon.htm [accessed November 2006].

"Thin Is In." From Sixties Central. www.geocities.com/FashionAvenue /Catwalk/1038/thinisin.html [accessed November 2006].

"Twiggy." From Sixties Central. www.geocities.com/FashionAvenue /Catwalk/1038/twiggy.html [accessed November 2006].

"Victorian Dress Reform." From Wikipedia, the Free Encyclopedia. http:// en.wikipedia.org/wiki/Victorian_dress_reform [accessed 9 December 2006].

"Women's Fashion History." From Southern California Lindy Society. http:// www.lindyhopping.com/fashionhist.html [accessed November 2006].

"Yves Saint Laurent." From Sixties Central. www.geocities.com/Fashion Avenue/Catwalk/1038/stlaurent.html [accessed November 2006].

H. INTERNET RESOURCES

1. Research

www.americanhistory.si.edu/collections/costume
www.apparelsearch.com
www.atexinc.com
www.britannica.com
www.businesstown.com
www.costumes.org
www.designerhistory.com
www.easysourcing.net
www.Encyclopedia.theFreedictionary.com
www.fashioncareercenter.com
www.fashioncenter.com
www.fashionencyclopedia.com
www.fashionunited.com
www.firstview.com
www.ftc.gov/bpcwww.geocities.com
www.gidc.org
www.highbeam.com
www.hintmag.com
www.hoovers.com

www.infomat.com
www.just-style.com
museum.nist.gov
www.newyorkmetro.com
www.npdfashionworld.com
www.nypl.org
www.otexa.ita.doc.gov
www.summitreports.com
www.techexchange.com
www.thomasregister.com
www.tipcoeurope.com
www.vault.com
www.wgsn.com
www.wikipedia.org
www.world-newspapers.com
www.wwd.com

2. Trends

www.cfda.com
www.Fashionlines.com
www.fashiontribes.com
www.Firstview.com
www.fortherunway.com
www.Iconique.com
www.Ivenus.com
www.Lumiere.com
www.made-in-italy.com
www.Mocacouture.com
www.modeaparis.com
www.Models.com
www.shop.org
www.shop.style.com
www.shoutfit.com
www.Style.com
www.wgsn.com
www.wwd.com

About the Authors

Francesca Sterlacci was born in New Jersey. She earned her A.A.S. degree in fashion design from the Fashion Institute of Technology in New York, her B.A. from New Jersey City University, and her M.S.Ed. at Baruch College in New York. She was an assistant professor (1990–2007) and chairperson of the Fashion Design Department at FIT. Professor Sterlacci created several certificate programs at FIT, including the Leather Apparel Certificate, the Haute Couture Certificate, and the Outerwear & Performance Apparel Certificate. She has made major contributions to FIT's international programs in Italy, the Philippines, China, and Turkey, as well as conducted numerous seminars that connected the FIT community—along with other leading international design schools—to the Korean, Indian, Japanese, Taiwanese, and Belgian fashion industries. Professor Sterlacci is engaged in numerous research projects for FIT and teaches graduate-level fashion design at the Academy of Art University San Francisco. She is the author of *Leather Apparel Design* and a contributing author to the *Encyclopedia of Clothing & Fashion* and *You Can Do It! The Merit Badge Handbook for Women*. She has written and been quoted extensively in magazines, periodicals, journal articles, radio, and television and was a nominee for the Fashion Group International's Rising Star Award and the More Fashion Award. She is a winner of the North American Fur Association Contest. Professor Sterlacci has owned and operated her own eponymous better women's clothing company, the clothing of which was sold in major department and specialty stores throughout the United States. She is a member of the Association of Women in American Community Colleges, Fashion Group International, and is listed in *The International Who's Who of Professional & Business Women*.

Joanne Arbuckle was born in New Jersey. She earned an A.A.S. degree in fashion design from the Fashion Institute of Technology (FIT) in New York; a B.S. degree in fashion design from Empire State College, the State University of New York; and an M.A. degree in educational administration in higher education from New York University. A professor and full-time member of the Fashion Institute of Technology faculty since 1994, Professor Arbuckle has served as assistant department chair and acting assistant dean. She is presently dean of the School of Art & Design at FIT. She initiated the FIT Childrenswear Advisory Board, serving as the college liaison for eleven years. In addition to her numerous contributions to the college, Professor Arbuckle has been an avid fundraiser for student scholarships and a tireless coordinator of sponsorship for international student internships and educational travel. She is the recipient of the State University of New York Chancellor's Award for Excellence in Teaching. She is also a contributing essay author for the *Encyclopedia of Clothing and Fashion*. A former designer in the sportswear, intimate apparel, and childrenswear industries, Professor Arbuckle is frequently consulted to provide her expertise in regard to garment classification and flammability issues as they relate to the designing and marketing of apparel.

DATE DUE			

Bib# 560337

CPSIA information can be obtained
at www.ICGtesting.com
Printed in the USA
LVOW01s0909080516

487239LV00019B/501/P